John Smibert

John Smibert

Colonial America's
First Portrait Painter

Richard H. Saunders

A Barra Foundation Book

Yale University Press New Haven and London

Designed by James J. Johnson and set in Baskerville types
by The Composing Room of Michigan, Inc. Printed in the
United States of America by Thomson-Shore, Inc., Dexter,
Michigan.

A catalogue record for this book is available from the Brit-
ish Library.

The paper in this book meets the guidelines for perma-
nence and durability of the Committee on Production
Guidelines for Book Longevity of the Council on Library
Resources.

Library of Congress Cataloging-in-Publication Data

Saunders, Richard H., 1949–
 John Smibert : colonial America's first portrait
painter / Richard H. Saunders.
 p. cm.
 "A Barra Foundation book."
 Includes bibliographical references (p.) and index.
 ISBN 0-300-04258-2

 1. Smibert, John, 1688–1751. 2. Portrait painters—
United States—Biography. 3. Smibert, John, 1688–
1751—Catalogues raisonnés. I. Smibert, John, 1688–
1751. II. Title.
ND1329.S63S28 1995
759.13—dc20
[B] 94-42682

10 9 8 7 6 5 4 3 2 1

For Barbara

Contents

Preface

When I began my dissertation on Smibert at Yale University, in 1975, I was intrigued by the recent discovery and publication of the artist's notebook. This document, which is among the most comprehensive records of Anglo-American painting to survive, records more than four hundred portrait commissions, of which fewer than one hundred were then located. Of the 175 portraits Smibert painted in London fewer than half a dozen were known. It was with considerable anticipation and naïveté that I believed that dozens of these portraits could be matched up with numerous surviving portraits in British collections where the sitter was identified but where the artist was listed as "unknown" or "School of Kneller." As a recipient of a Samuel H. Kress Foundation Fellowship to the Courtauld Institute (1976–77), I had the opportunity to search intensively in Great Britain for these paintings and any additional clues that would help to place Smibert's work in context. Although my initial hopes for numerous discoveries were not to be fulfilled, this disappointment has been cushioned by the high quality of the twenty-six London works I have been able to identify, and the opportunity they have afforded for grasping the entire arc of Smibert's career.

During the period that my dissertation was being written I benefited greatly from the thoughtful and considered direction provided by Professor Jules D. Prown, my dissertation adviser. It was he who encouraged me to stay on track and to submit the dissertation to the Barra Foundation for possible publication.

In 1981 the Barra Foundation formally expressed interest in supporting the rewriting of my dissertation as a catalogue raisonné on Smibert. Little did I know then that the "rewriting" would take a decade and involve a reformulation of many of the ideas I originally held about the artist and what inspired him.

In a project that has taken many years to complete there are many people and institutions that need to be thanked. First and foremost, this book would never have been published without the wholehearted support of Robert L. McNeil, Jr., the president of Barra Foundation. His support has been unfailing, as has his patience. I particularly wish to thank the Foundation for providing me with financial support for a sabbatical during the spring semester of 1989 and for a subsidy to pay for travel, photography, and student and clerical assistance. I also wish to thank the Foundation for providing me with the editorial advice of Regina Ryan.

Over the years assistance and guidance have come from a wealth of sources. While at Yale I was fortunate to receive an Andrew Wyeth Fellowship from the Wyeth Foundation for American Art, as well as Samuel H. Kress Foundation funds to travel to England during the summer of 1975. During my years as curator of American paintings at the Wadsworth Atheneum (1978–1981) I had the great fortune to work for Phillip Johnston, whose understanding permitted me to tailor my schedule to suit the needs of my Smibert research and writing.

Over the past decade I have made numerous trips around the United States to examine virtually every painting attributed to Smibert. Travel funds from the University Research Institute at the University of Texas at Austin enabled me to see a number of paintings in the United States. Over the past five years Faculty Research and Development Funds from Middlebury College have enabled me to make repeated trips to London and Edinburgh and this same source has assisted in the acquisition of photographs, the hiring of a summer intern, and in preparing the final manuscript. I am particularly grateful to John C. McCardell, President, Middlebury College, for his support in acknowledging the importance of this project and enabling me to receive these funds.

All the owners of John Smibert's paintings have been most cooperative in providing access to the paintings themselves, moving the paintings about to have them photographed, and in general going out of their way to be cooperative. I am sure Smibert himself would be pleased that all his paintings seem to be in such caring hands. In particular I wish to acknowledge the assistance of Lady Jean Grant, Monymusk, Scotland, who permitted me free access to the family muniment room. This led directly to the discovery of letters and notes between Smibert and his most important Scottish patrons.

Every scholar who works on a project of this length amasses considerable debts. There is no real substantive way to repay the collectors, curators, dealers, and art historians who have made countless suggestions, provided access to paintings and/or information, or simply shared their own ideas about Smibert and related topics. But as their kindness is legion I would like to acknowledge some particular thanks here. R. Peter Mooz first inspired me to look at Smibert's career when I was a student in the Winterthur Program in Early American Culture. I have found kindred spirits in James Holloway at the Scottish National Portrait Gallery and in Dr. Ellen G. Miles at the National Portrait Gallery, Washington, D.C., with whom I wrote *American Colonial Portraits: 1700–1776* (1987). That publication and the accompanying exhibition provided a preliminary forum for many of my ideas about Smibert which have been more fully developed here.

Among Smibert's Boston patrons the Oliver family was paramount. It is fitting that the late Andrew Oliver, a direct descendant of a number of Smibert sitters, embraced this project, provided the author with photographs, and was a frequent source of encouragement in its early stages. Another Bostonian,

Robert C. Vose, Jr., who has probably looked at more colonial portraits than anyone, showed me particular kindness and answered an embarrassingly large number of my letters. Without their assistance, as well as that of the following people, I would still be floundering: the late Anthony Blunt, Iain Gordon Brown, Jean Cadogan, the late John Caldwell, Teresa A. Carbone, Edward Croft-Murray, Marie Elwood, the late Anne Farnam, Stuart P. Feld, Alan Fern, Roger Howlett, Robin E. Hutchison, John Kerslake, Laura C. Luckey, Dr. Rosalind K. Marshall, Professor William T. Oedel, Andrew Oliver, Jr., Professor Ronald C. Paulson, Professor William Pressly, the late Oswaldo Rodiquez Roque, Marvin S. Sadik, Basil Skinner, the late Sir Ellis Waterhouse, the late Hereward T. Watlington, and Dr. Katharine J. Watson.

Several libraries and repositories have played an instrumental role in providing the archival material and photographs upon which this study is based. Particularly crucial were the photographic collections of the Frick Art Reference Library, the Witt Library, the Paul Mellon Centre for Studies in British Art, the Scottish National Portrait Gallery in Edinburgh, and the National Portrait Gallery in London. The Public Record Office, London; the National Register of Archives, Scotland; the Society of Antiquaries of London; and the New England Historic and Genealogical Society (which houses the records of the Scots Charitable Society) contain important archival holdings for the study of Smibert.

For permission to reprint manuscript materials in their possession or copyright, I am grateful to the following: the Bodleian Library; National Library of Scotland, National Register of Archives, Scotland; Scots Charitable Society; and the Society of Antiquaries of London.

Introduction

I N 1728 the forty-year-old John Smibert aban-
doned a successful but personally unsatisfying
career as a Scottish artist living in London
to embark on an uncertain adventure to teach
at a college planned for Bermuda. When the
college did not materialize, Smibert found himself in
Boston, where he remained for the rest of his life.
There he became the first portrait painter of any
distinction to attempt to carve out an existence in
colonial America. Smibert's visual record does not
rival that of John Singleton Copley, the most notable
of his successors, but his portraits convey an impres-
sion of the pomp and pageantry associated with the
late baroque world of the early eighteenth century.
More important, they provide essential clues to the
nature of portraiture in colonial society.

Leaving London for Boston, in spite of the trans-
atlantic journey, was much like going to any other
provincial town, such as Edinburgh. The distance
was as much a state of mind as a matter of miles.
American colonists considered themselves trans-
planted Britons, which most of them were, and
Smibert's visual record of them documents this atti-
tude.

What is not immediately apparent from Smibert's
work is the crucial importance of his Scottish Presby-
terian upbringing, which tempered both his portraits
and his outlook on life. In particular, his intensely
moral way of life colored his view of London, made
him a logical candidate to depart for a society domi-
nated by Presbyterians and Congregationalists, and
ultimately conditioned the pattern of his life in the
New World.

As central as Smibert is to understanding colonial
painting, what has been said about him over the past
one hundred and fifty years is remarkably repetitive.
Smibert scholarship gained renewed vigor with the
surprising discovery and publication, two hundred
years after the artist's death, of his notebook, which

documents his European travels, more than four
hundred portrait commissions, and a handful of de-
tails about his personal life. No comparable chronol-
ogy exists for any other colonial artist.

Smibert first came to the attention of American
scholars in the work of William Dunlap, but his con-
tribution derives almost exclusively from what Horace
Walpole gleaned from George Vertue's firsthand im-
pressions of Smibert as a man and an artist. Until now
the primary discussion of Smibert's life and his por-
traits has been Henry Wilder Foote's immensely use-
ful study of Smibert's life and works, published in
1950. It is a testament to that author's sound instincts
that so many of the portraits he judged to be by
Smibert are corroborated by the notebook.

As with Copley, for many years art historians
dwelled on Smibert's American career under the mis-
taken impression that his British and Italian career
was of little consequence. This book is intended to
correct this inaccuracy. Smibert's surviving London
portraits vindicate Vertue's opinion of him as one of
the best portait painters of his generation. This fact is
essential to understanding Smibert's initial success in
America and is crucial to the interpretation of his
later American years, when his outward struggle for
artistic achievement was overshadowed by an internal
one for spiritual well-being and a sense of commit-
ment to colonial society. What becomes evident is that
he was an artist of considerable determination and
moral fiber, who overcame the challenge of a colonial
environment frequently indifferent to the arts. He
emerges as a painter whose intense love for painting
instilled in his own son a desire to carrry on in a
profession in which financial struggle and hardship
were offset by the personal satisfaction of creative
achievement.

Smibert's legacy, then, is as a model for the next
generation of artist-aspirants. His London training
and exposure to European culture, as well as his per-

sonal collection of copies after the Old Masters, be-
came signposts to future artists charting their way to
success. His career typifies the ambitions of many
immigrants lured to the colonies, and his experience
in America provides a vivid sense of the rewards and
frustrations of such a life.

John Smibert

1

Scotland

I N 1724, George Vertue (1683–1756), the noted English engraver, antiquary, and diarist, recorded a lengthy biographical note on "Mr John Smibert," a thirty-six-year-old Scottish-born painter, who he noted had been "first apprentice in Edenbourough servd 7 years to a house painter and plaisterer."[1]

Within five years Smibert had left Great Britain altogether, eventually settling in Boston, where he became the undisputed portrait painter of record and, directly or indirectly, nurtured the development of younger colonial artists. To a great degree, John Smibert's importance is as much an accident of fate as the result of design. He was spurred to his final destination by a sense of adventure, tempered by a moral code that conditioned virtually all his responses to the major social and professional decisions of his life. These factors were both a curse and a blessing. While on the one hand his humble Scottish background was a severe handicap, on the other it led him to choose America over Great Britain, a decision that heightened the expectations of all colonial painters who succeeded him.

Smibert, the second youngest of six children, was born in Edinburgh, the Scottish capital, on March 24, 1688.[2] Sited on a wind-swept bluff above the Firth of Forth, Edinburgh gave the appearance of being a medieval city (fig. 1). Dominated by Castle Rock, it was surrounded by a sixteenth-century wall and could be entered by six principal gates. Although Scotland's largest city, it was small by contemporary standards, as only forty thousand of Scotland's approximately one million inhabitants called it home.[3] Its climate led Robert Louis Stevenson to wail that "the weather is raw and boisterous in winter, shifty and ungenial in summer, and a downright meteorological purgatory in the spring."[4]

As the center of Scottish politics, justice, business, and culture, Edinburgh was far and away Scotland's most important community. Its center was High Street, one mile long and stretching downwards from the Castle at its northernmost tip to the palace of Holyroodhouse, the home of Scottish rulers, at its southern terminus. To either side "lanes and alleys, which are there called *wynds* and *closes*, extend like slanting ribs, so that, upon the whole it bears a striking resemblance to a turtle, of which the castle is the head, the high street the ridge of the back, the *wynds and closes* the shelving sides and the palace of Holyroodhouse the tail."[5] Space was at a premium, and few residents owned independent dwellings within the city proper. Families of diverse economic and social standing were crowded together into multi-storied tenements along High Street. Even judges, clergy, and more opulent citizens lived in flats, often approached from these ill-ventilated courts or alleys.[6] In an era not known for hygiene Edinburgh was notoriously squalid. The picturesque quality of the town's lofty stone structures, ten to twelve stories in height, in which many residents lived, was greatly mitigated by the evening emptying of chamber pots, stoups, and cans from the upper floors (a practice common in London as well).[7] By ten o'clock each night, at the warning call of 'Gardy loo' (Gardez l'eau) servants cast out the filth that had collected that day, frequently drenching the periwig of the unsuspecting passerby.[8]

Despite these conditions, Scots in Edinburgh were economically better off than their fellow countrymen in outlying areas. Scotland was miserably poor, and more than four-fifths of the population derived their meager existence from agriculture.[9] Scottish trade and industry were in their infancy. Misguided legislation largely had ignored the potentially lucrative development of such industries as coal to support the manufacture of woolen cloth, which could not hope to compete with its well-developed English counterpart. But it was the woolen industry that provided the

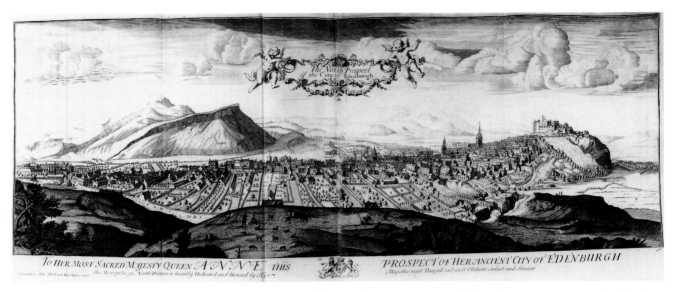

1. *The North Prospect of the City of Edenburgh,* from John Slezer, *Theatrum Scotiae* (Edinburgh, 1647; repr. 1718 by Andrew Johnston). National Library of Scotland.

elder Smibert with a livelihood, for as a litster he spent his days dyeing wool, which was then woven into cloth.[10] In fact, seven of the twelve Edinburgh guilds depended on sheep farming for the development of their crafts.

The Smibert family resided in the southwest parish of Edinburgh. The elder Smibert came to Edinburgh for his apprenticeship as a litster in the 1660s from Middletown, in the parish of Borthwick, about twenty miles southeast of Edinburgh. The elder Smibert became a burgess (citizen) in 1681.[11] As a litster he probably had a dye shop, above which his family lived, on the Grassmarket. It was an open market square a few hundred yards to the south of Castle Rock, where dyers and brewers lined its southern side to draw the excellent well water found there. The Grassmarket (fig. 2) was one of the largest open spaces within Edinburgh's walled city. As such, it was the marketplace for the sale of "sheep, horses, and Beasts" as well as the site of public executions.[12]

The litster's role came toward the end of the chain of events that took wool from fleece to finished cloth. Individual tradesmen specialized in the various steps of carding, spinning, weaving, scouring, fulling, and stretching before cloth was dyed and dressed. The dyes used were made from wines, iron, fruit, oil, woad (a herb used as a source of blue dye) and other materials largely imported and obtained through trade for finished products. Dyers for the most part were independent craftsmen who owned their own

dye houses, furnaces, vats, and other implements of the trade.[13] They were in essence subcontractors. The clothier was the general contractor, as well as owner, who oversaw the final stage of the dressing of cloth. In Edinburgh litsters, in conjunction with weavers and waulkers, had a dubious reputation. They had been found guilty of fraud in the use of dyes that were not colorfast, and as a result regulations were established to prevent such practices.[14]

It was into such a world that Smibert was born. His birth coincided with the Glorious Revolution: the deposition of James II (James VII of Scotland) and the ascendancy of William III, which heralded positive developments for most Scots. The foremost was the Act of Settlement (1690), which cast out the episcopacy installed by Charles II and reestablished Presbyterianism as the state religion. Although the religious and political scene in Scotland was complex and riddled with frequently shifting allegiances, some generalizations can be made. The vast majority of lowland Scots were Presbyterian; however, some nobles, such as the Earl of Mar, were Episcopalian and were chagrined by the abdication of James II. These sympathies soon manifested themselves in the Jacobite movement, which actively plotted the former king's return. Gaelic-speaking highlanders were generally viewed with suspicion by their countrymen to the south. Uncontrollable and warlike, they largely sympathized with James II.[15]

Like the majority of lowland Scots, the Smibert

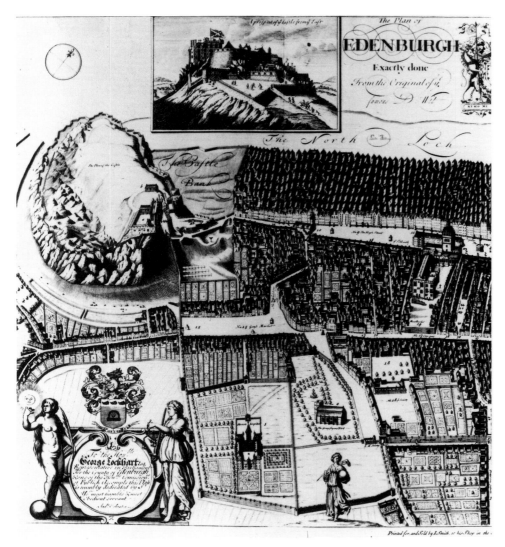

2. Edinburgh, showing the Grassmarket, the Castle, and Greyfriars Church (detail), from D. Wit, *The Plan of Edenburgh* (1647; repr. c. 1718 by Andrew Johnston). National Library of Scotland.

family was Presbyterian. Since Smibert's baptism record indicates that they lived in the southwest parish, they worshiped at the historically rich Greyfriars Kirk on Candlemaker Row, one of Edinburgh's seven parish churches. As a youth in the 1690s and the first decade of the eighteenth century, he was subject to a strict religious code. Religion wielded immense power over the population. In Presbyterian families daily life was grave and sober; severe discipline, authority, and formality were the guiding precepts. Sunday was a day of deep solemnity, and church attendance was obligatory. During services elders went out to "perlustrate" the streets, peeking through win-

dows and opening doors either to bring deserters to the kirk or to report them to the kirk-session.[16]

As a boy, Smibert probably attended the local parish grammar school, arriving at about seven in the morning and remaining there until evening.[17] According to an unsubstantiated tradition, he was intended for the ministry but was inclined toward drawing.[18] Despite this aptitude, a conscientious parent might well have wished to discourage such interests, as artistic life in Scotland around the time of Smibert's birth was stagnant. The greatest demand, such as it was, was for portraits and, to a far lesser degree, decorative painted ensembles for room inte-

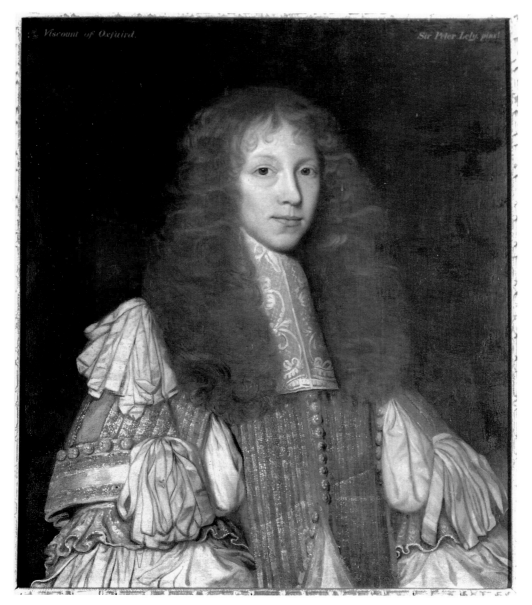

3. David Scougal, *Robert Macgill, 2nd Viscount Oxfuird*, c. 1666. Oil on canvas, 30 × 25 in. (76.2 × 63.5 cm.). Private collection.

riors. Scottish portrait painters took their cue from London, the style center of greatest influence. As a result, for most of the seventeenth century much of what was painted in Scotland, such as portraits by David Scougal (fl. 1654–1677), tended to be a pale reflection of work further south, although on occasion, as in the case of *Robert Macgill, 2nd Viscount Oxfuird* (fig. 3), the Scottish portraits are more pleasing, direct, and less pretentious than their English counterparts.

Soon after the Restoration of Charles II in 1660 Edinburgh experienced a brief artistic renaissance. Holyroodhouse was transformed from an old-fashioned tower house into a spectacular baroque palace, intended as an expression in stone of the king's power and presence in Scotland.[19] This transformation was supervised by Sir William Bruce, who brought the sculptor Jan van Santvoort (fl. c. 1685) and the painter Jacob de Wet (1640–1697) from Holland to assist in the palace's decoration. Another

4. John Michael Wright, *Sir William Bruce*, c. 1664. Oil on canvas, 28 1/2 × 24 in. (72.4 × 61.0 cm.). Scottish National Portrait Gallery.

recipient of patronage was John Michael Wright (1617–1694), whose portrait of Sir William Bruce (fig. 4) is perhaps the high-water mark in Scottish portraiture prior to the reign of William and Mary.

By the 1690s leading patrons were turning their attention to a new arrival, John de Medina (1659–1710). In 1694 he had been lured to Edinburgh from the relative security of London by the persuasive pleas of Margaret, Countess of Rothes (fig. 5). Whereas Scottish gentlemen could wait until they were in London to have a portrait painted, this option passed most women by. Travel was arduous, dirty, and time-consuming, and Scottish ladies made no more than one or two trips to London in a life-time.[20] In exchange for his making the onerous journey north, Medina was promised either twenty-three three-quarter lengths or forty head-and-shoulders portrait commissions. His obstinacy about leaving London was based on the well-founded fear that in his absence fickle clients there might abandon him for other painters. His effort to stay in Scotland as briefly as possible led to his well-known advance preparation "to doe the drapery work of some to take alongst with him, so that ther will be little to do except add a head and neck."[21]

As a result of his trip, Medina learned that there

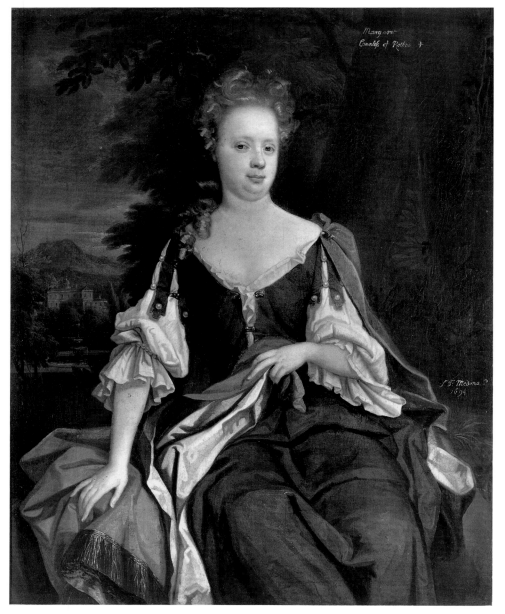

5. Sir John de Medina, *Margaret, Countess of Rothes*, 1694. Oil on canvas, 49 × 39 1/2 in. (124.5 × 100.3 cm.). Private Scottish collection.

was a significant portrait market in Edinburgh. Shortly thereafter he relocated with his wife and six children to an apartment in Edinburgh's Canongate, halfway between the Castle and Holyroodhouse. There over the next fifteen years he received a steady stream of Scottish nobles, gentlemen, and income. Perhaps the pinnacle of his career was the invitation to paint a series of portraits for members of the Royal College of Surgeons in Edinburgh, a commission he completed by 1708.[22]

The role Medina played in the development of painting in Scotland is like that played by Smibert thirty-five years later in Boston. Although but a member of the chorus in the London artistic cast that starred Sir Godfrey Kneller (1646–1723), in Edinburgh Medina was the principal performer. Medina

arrived in the city when Smibert was only six. If as he approached his fourteenth birthday, the traditional age of apprenticeship, Smibert harbored thoughts of tutelage from the painter, they went unrewarded. In April 1702 Smibert became an apprentice to Walter Melville (also Melvill, fl. 1681–1729), an Edinburgh house painter and plasterer.[23] Any number of reasons might have prevented the young Smibert from being taken under the wing of Medina. By this date his father had died, and certainly Smibert's family had no wealth or political power with which to influence such a decision.[24] But tangible assets certainly must have aided William Aikman (1682–1731), who became Medina's de facto apprentice. Aikman came from a family of consequence, was a graduate of the University of Edinburgh, and had the good fortune to be the nephew of Sir John Clerk of Penicuik, the leading Scottish art patron of his day, not to mention a patron of Medina's.

Smibert, then, could only observe from a distance the activities of Medina and his studio assistants. For the time being he had to content himself with learning the skills of a decorative painter. During the years

6. Walter Melville (attrib.), *Herald Shield*, c. 1708. Oil on panel. Magdalen Chapel, The Cowgate, Edinburgh.

Smibert served his apprenticeship with Melville there were eight painters active in Edinburgh. They met as part of the guild of wrights and masons in a hall in Niedry's Wynd off the High Street.[25]

Walter Melville had served his own apprenticeship with the Edinburgh painter George Porteous. He was first named to the roll of St. Mary's Chapel in 1687, at which time he subscribed as evidence of his ability "a buffet stool with a moothead thereon in its proper collours." His activities for much of his career are well documented, and during the 1690s he was employed both at Holyroodhouse and at Edinburgh Castle. At the former he was paid for "whitening and painting severall places in the kings apairtment," while at the latter his activities included painting chimney pieces and "guilding and painting a learg thean [board?] with thair majesties armes on both syds within the gerter."[26]

Smibert was apprenticed to Melville during the year his master also completed work at Magdalen Chapel, in the Cowgate, the meeting place of the guild of hammersmiths, less than two hundred yards from where Smibert lived. In 1708 and 1709 Melville was paid £46 Scots for work of an unspecified nature. It is believed that these payments are for the series of eight heralds shields (fig. 6) representing the eight chief trades that were united in the Hammersmiths Incorporation. As such they provide a clear indication of just what Smibert would have been expected to carry out himself by the end of his apprenticeship, and it is not too venturesome to suggest he had a hand in their creation.

At the time of Smibert's apprenticeship many houses in Edinburgh were of made of stone and outfitted with whitened plaster walls. Wallpaper was still a novelty, so it fell to Scottish painters to enliven the walls and ceilings with a wide variety of decorative motifs. In 1703 one Edinburgh resident, Sir John Foulis, had his best room painted white with black-bordered japanned panels on which were "pictures of flowers, men, etc., and gilded." About the same time the dining room of a house in Glasgow was ornamented with bunches of grapes and the drawing room painted with landscapes and festoons of flowers.[27] But the preponderance of low ceilings and small rooms also reduced the opportunities for extensive painting ensembles.[28]

As a "plaisterer" Smibert may also have helped create some of the raised decorative plaster ceilings that had become fashionable in the seventeenth century. Elaborate examples from the 1670s included a dwelling in the first Court of Riddle's Close, Lawnmarket, where "the ceiling, which is richly ornamented in

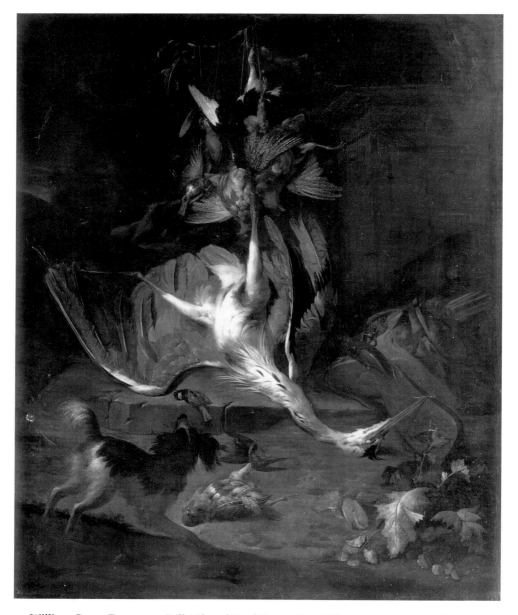

7. William Gouw Ferguson, *Still-Life and Dead Game,* 1677. Oil on canvas, 59 × 49 in. (149.9 × 121.9 cm.). National Gallery of Scotland.

stucco, in the style that prevailed during the reign of Charles II, has a large circle in the centre, containing the Royal Crown, surrounded by alternate roses and thistles, and with the date 1678. The remainder of the ceiling is arranged in circular and polygonal compartments with the Scottish Lion Rampant and the Lion Statant Gardant, as in the English crest alternately."[29]

Living in Edinburgh provided Smibert with an op-portunity to see a number of the most important artistic achievements in Scotland. In the square in front of Parliament Hall stood a lead equestrian statue of Charles II, which was erected in 1685. As early as 1693 William Ferguson, a noted painter of still lifes (fig. 7), held an auction in the Lawnmarket, where eight of his pictures were sold.[30] Auctions of one kind or another continued into the early eighteenth century, including one in 1705 at which several dozen

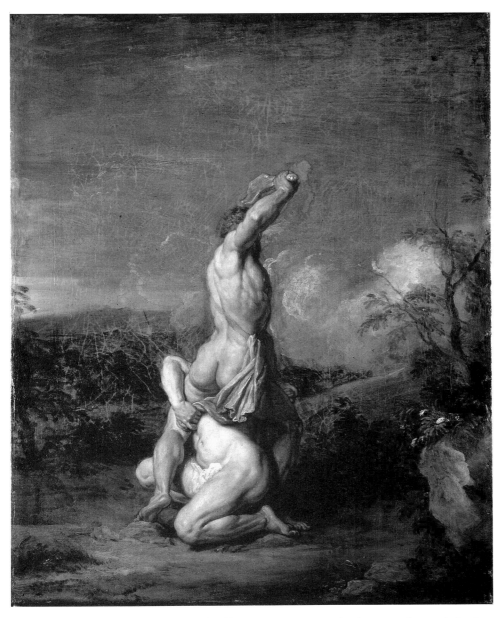

8. Sir John de Medina, *Cain and Abel.* Oil on canvas, 29 × 23 in. (73.7 × 58.4 cm.). In the collection of Sir John Clerk of Penicuik.

"pictures all finely painted and well framed" were sold, while nearby a maker of "effigies of the most exact resemblance of persons in wax either living or dead" opened up shop.[31]

During the years of Smibert's apprenticeship the Edinburgh artistic community was small and closely knit. Many artists' homes were spread out along High Street, a few blocks from the Grassmarket and a short distance from each other, and they must have en-

countered each other both socially and professionally. As Smibert traveled about Edinburgh decorating domestic interiors he undoubtedly had ample opportunity to see portraits by Scougal and Medina. A visit to Medina's flat and studio also would have afforded Smibert a visual feast. Spread out on the walls and stacked against them were over seventy paintings, most likely the richest concentration of art in the city. In addition to portraits in progress they

included original Old Master paintings as well as copies, plaster-of-paris sculptures, mezzotints, and pattern books. The cast of characters was what one might expect: Cleopatra and the sixth-century Lombard queen Rosamond, both "originals"; Venus and Cupid copies in some number, Adam and Eve, and a sampling of landscapes.[32]

One painting displayed there was "a coppie picture of Cain and Abell, not finished," which may well be *Cain and Abel* (fig. 8), acquired by one of Medina's patrons, Sir John Clerk of Penicuik. Most likely derived from a small plaster after Giambologna's Samson and the Philistine (thought at the time to represent Cain and Abel), it amply displays Medina's lively painting abilities.

Medina's well-equipped studio would have impressed even the most cosmopolitan Scottish visitor. To a youthful apprentice like Smibert, Medina's obvious sophistication and prosperity would have been intoxicating. It certainly left an indelible impression, as the contents of Smibert's Boston studio at the time of his death echo the eclecticism of Medina's taste —and that of most ambitious British eighteenth-century artists.

Smibert probably knew by description, if not by sight, the handful of large-scale decorative wall paintings that had been done in the vicinity of Edinburgh over the preceding thirty years. They were relatively few in number and, by London standards, mostly undistinguished but nevertheless physically impressive. Furthermore, the artists, like Medina, were all foreigners, and were a reminder to all native-born artists of their second-class status at the end of the seventeenth century. Charles II had set a heady pace for grand-scale painting when in 1675 he imported the Dutch painter de Wet to create a gallery of imaginary portraits of the kings of Scotland for Holyroodhouse. While there he also made it possible for the king to look upwards in his bedchamber to a ceiling from which an assembly of gods, animals, and birds gazed down approvingly.[33] As Melville, Smibert's master, from time to time painted at Holyroodhouse, it seems reasonable to assume that his apprentice would have known this work firsthand.

More recent artistic developments included a ceiling painting of Aurora, created circa 1703 by the French Protestant émigré Nicholas Heude (act. 1672–1703) for the Duke of Queensberry at Caroline Park, and a suite of wall paintings, overmantels, and overdoors done in 1704 by the German-born painter Philipp Tidemann (1657–1705) for Charles Hope, first Earl of Hopetoun at Hopetoun House, West Lothian.[34] The latter depict an assortment of allegories and Roman gods as was the fashion, but their overall awkwardness only served to encourage local Scottish painters to seek further recognition.

One reason that large-scale decorative paintings failed to find favor may have been ideological, as the tradition of painting them was kept alive largely in Catholic population centers. The one exceptional Baroque ceiling painting (now destroyed) was created about 1720 by John Alexander for the Duke of Gordon; both patron and artist were Roman Catholic and Jacobite.[35]

Also, Scottish art patrons, many of whom had taken the grand tour to Italy and knew the snob appeal of London painters, dismissed without justification the local aspirants. The painters of the guild of St. Mary's Chapel must have been a frustrated lot, for they possessed considerable skills that went largely untapped. The best evidence of this is the single still life (fig. 9) of Thomas Warrender (fl. 1673–1713), who otherwise spent his productive years painting the walls, staircases, and ceilings of Edinburgh. During the first decade of the eighteenth century, however, Edinburgh-area painters, vexed by this disregard, sought increased visibility and prestige. It was not until 1703, the year after Smibert began his apprenticeship, that painters became affiliated with the trades guilds' incorporation, formally known as the Incorporation of St. Mary's Chapel, to raise the status of their trade. Six years later Roderick Chalmers (fl. 1721–1730), a contemporary of Smibert's, presented his trial piece to the chapel on completion of his apprenticeship and in lieu of the customary fee, giving it a status akin to the diploma piece presented by member artists to the Royal Academy later in the century.[36]

In 1720 Chalmers was again involved in events related to the status of painters. He was invited by St. Mary's Chapel to depict the various masons' and wrights' trades together. The result (fig. 10) must have precipitated discussion, for while nine of the figures are dressed as tradesmen, wearing caps and aprons, the painter, in a velvet frock coat and full-bodied wig, is portrayed as a gentleman. Clearly, the artists of Smibert's generation were seeking a radical shift in their social status, which they undoubtedly hoped would lead to better incomes and enhanced social opportunities. This was to be a century-long campaign for recognition by both Scottish and English artists, of which these were the opening salvos.

The years of Smibert's apprenticeship coincided with the major Scottish political event of the century: the Act of Union, ratified by the Scots parliament on January 16, 1707. The political and legal results of

9. Thomas Warrender, *Still-Life,* c. 1708. Oil on canvas, 23 1/4 × 29 1/4 in. (59.1 × 74.3 cm.). National Gallery of Scotland.

10. Roderick Chalmers, *The Edinburgh Trades of Holyrood,* 1721. Oil on canvas, 41 1/2 × 72 in. (104.4 × 182.1 cm.). In the collection of the Trades Maiden Hospital on loan from the Joint Incorporation of Wrights and Masons of Edinburgh.

unification with England were swift. The Scots parliament, which consisted of 145 nobles and 160 commoners, was subsumed to Parliament in London; Scots were given forty-five seats in the House of Commons in addition to sixteen elected peers to the House of Lords.[37] Other major ramifications included acceptance of the Hanoverian succession, freedom of trade in the United Kingdom and the colonies, and the creation of uniform coinage, weights, and measures. Scottish laws, however, were respected, and the main law courts remained in Edinburgh. Despite optimistic economic forecasts from those who favored union, the immediate results were a disappointment. Although English markets were now open to Scottish products, the woolen cloth trade virtually collapsed.[38]

Unification made London more accessible to Scots. It also reduced the attractiveness of Edinburgh, since Scottish members of Parliament now traveled to Westminster. A gloom settled over the city: business was dull, society was moribund, and lodgings once occupied by the wealthier strata of Edinburgh society were left empty, some decaying for lack of tenants.[39] Smibert was witness to this economic decline, and it very likely affected the number of commissions his master received.

As a painter and plasterer, Smibert's potential income was meager. At a time when claret cost one shilling four pence a bottle, sugar eight pence a pound, a six-once loaf of bread six pence, and use of a cold bath four shillings, house painters in London were paid three shillings a day. Portrait painters, on the other hand, might earn ten times that amount.[40] Simple arithmetic, as well as an awareness of the prosperous lifestyle of a painter like Medina, left little doubt in Smibert's mind as to which direction his career should take.

The end of Smibert's apprenticeship in 1709 left him armed with more envy than skill. His contemporaries Aikman, John Medina II (before 1686–1764), and Andrew Hay (fl. 1710–1754), had all benefited from training with Medina and were steps ahead of him on the painting ladder.[41] Vertue provides a valuable clue to Smibert's mental state in Edinburgh with his observation that "in all that time tho' he had a strong inclination to drawing & studying but no oppertunity to improve."[42] Given the economic condition of Edinburgh and the limited prospects there as a house painter, Smibert must have quickly realized that his immediate future would be far better served by going to London than by remaining in a city reduced to the status of a provincial capital. Departing Scotland for a more promising environment was a course of action followed by numerous other Scots, both before and after Smibert, among them James Gibbs, Robert Mylne, William and Robert Adam, and James Watt. Many natives felt that, as the saying went, "Scotland [is] good enough to be buried in but not good enough to live in."[43]

Before leaving Edinburgh, however, on what was presumably his first trip outside Scotland, Smibert acquired a pocket-size book bound in brown leather (fig. 11) suitable for recording travel impressions. Smibert probably had no inkling then that this small book would remain with him until his death and be the primary repository for all accounts related to his career as an artist: his travels to London, Italy, and America, and commissions he received over a twenty-six-year span.

11. Leather cover of Smibert's notebook. Public Record Office, London.

2
London and Edinburgh

ON JUNE 2, 1709, only two months after leaving Walter Melville, Smibert, now twenty-one, departed for London with two companions.[1] Their journey lasted nine days, and their itinerary took them 251 miles by the most direct overland route through Durham, York, and Newark. Such a trip was not taken lightly, as it was expensive, tedious, and adventurous. It cost Smibert just under £34 Scots currency, which was the equivalent of £2 16s sterling, a considerable sum to a fledgling house painter.[2] Nevertheless, it was far less than the £30 sterling it cost two gentlemen in 1725 to hire a carriage and six horses to cover the same distance. Roads, by and large, were wretched, tracks of mire in wet weather, marshes in winter, until the frost made them sheets of ice covered with drifting snow. Traveling in June was less worrisome, but highwaymen were a threat and the mode of transportation left much to chance. Carriages were an expensive rarity and Smibert, like most others traveling the route to London, probably combined travel in wagons, on pack-horses, agonizing two-wheeled carts later abandoned as instruments of torture, and by foot. Not until forty years later was there regularly advertised stagecoach service between Edinburgh and London.[3]

For some time London had been growing steadily in population and area. In 1700 it had approximately 575,000 inhabitants, fifteen times the size of Edinburgh, and it dwarfed all other European cities as well. It had become a trading center and entrepôt of world importance, with twenty docks and thirty repair yards. Of the £3 million of goods imported annually, most passed through London. At the turn of the century the city stretched along the river Thames from Westminster to Wapping, and north and south from Clerkenwell to Kennington. The most desirable area was the West End, where the court was located at St. James's and Kensington palaces, and Pall Mall

(fig. 12), constructed in 1660, was the most fashionable walk in London. It is estimated that one-third of Westminster's population was in the employ of the various noble households situated in the vicinity (such as Marlborough House in Pall Mall, Burlington House in Piccadilly, Powis House in Great Ormond Street, and Montagu House in Russell Street). Other areas of London became identified with specific activities—the jewelry and porcelain trades in Cheapside and Cornhill, watchmakers in Clerkenwell and the neighboring parish of St. Luke's, booksellers and mercers in Gracechurch and Lombard streets, Ludgate.[4] Since the early seventeenth century, artists had begun to congregate in Covent Garden, particularly around the Piazza, where London's central produce market flourished. That Sir Peter Lely, and later Sir Godfrey Kneller, both chose to make their homes here gave the area a cachet with artists that was unrivaled in the early eighteenth century.[5]

Smibert's arrival coincided with a political division between, on the one side, the Tory landed interest and the Anglican church and, on the other, the Whig half of the peerage, a few of the squires (landowners who ranked socially below a knight and above a gentleman), some of the yeomen (landowning farmers who ranked socially below the gentry), the bulk of the merchants, Protestant refugees from the Continent, and English Dissenters.[6] Smibert would have found himself in the latter camp. As a Scot, he was immediately stereotyped as a provincial bumpkin. He spoke the broad Scots language of the Lowlands, not English,[7] and would have been suspected of Jacobite sympathies regardless of whether he held them.

Smibert found rooms in the Strand, the preferred neighborhood of many Scots in London because of its proximity to the Presbyterian Meeting House in Peter's Court, St. Martin's Lane.[8] He joined a congregation that, typical of the Scots community in

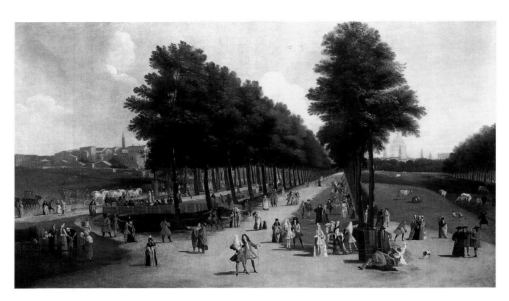

12. Marco Ricci (attrib.), *A View of the Mall from St. James's Park,* c. 1710. Oil on canvas, 45 × 76 1/8 in. (114.1 × 195.1 cm.). National Gallery of Art, Washington, D.C., Ailsa Mellon Bruce Collection.

London, consisted largely of tradesmen and shopkeepers. By coincidence, Smibert's arrival virtually coincided with the attacks on Dissenter meetinghouses in the aftermath of an accusatory Guy Fawkes Day sermon by Dr. Henry Sacheverell, a notorious High Church extremist.[9] In an instant, Smibert must have realized how vulnerable he was as a Presbyterian Scot in an Anglican city. He had no financial security, and if he possessed any letters of introduction (the normal way one gained a foot up on the competition) they were most likely from Walter Melville to members of the Painters-Stainers Company in London. According to Vertue, Smibert began by working as a coach painter. This was the same trade pursued by William Kent, another ambitious artist, who used it as the springboard for his architectural career,[10] and Peter Monamy, who became a noted painter of marine subjects. Smibert painted decorative scenes or heraldic emblems on the sides of coaches, a task for which his Edinburgh apprenticeship undoubtedly had prepared him well.

Coaches during the seventeenth century had become increasingly ostentatious displays of wealth. The fashion of bedecking them with ornamental carvings and decorative painted panels reached its apogee about 1700 with coaches such as that ordered for the Lord Mayor of London (fig. 13). Thereafter, as roads improved and coaches were designed to travel greater distances instead of parading about

London, they became less suited to elaborate decoration. As a result, the need for coach painters declined, as did the social and professional status of its practitioners.[11]

Perhaps in response to this decline, Smibert soon abandoned coach painting for "coppying of paintings for dealers for 3 or 4 years," according to Vertue. Although this was the lowest form of easel painting, the experience was a crucial step in Smibert's career, as he was putting behind him the "mechanical" arts and entering the realm of the fine arts. It also introduced Smibert to the burgeoning world of connoisseurs, collectors, auctions, and art dealers. He may have even received encouragement to take up copying from John Alexander (c. 1690–after 1757), a fellow Scot, who was in London by 1710 painting copies of Scottish historical portraits.[12]

Most of this London art world activity had emerged in the preceding thirty years as a result of the rapid growth in English wealth and the increasing cosmopolitanism of those with money. As the number of collectors grew, different classes of collectors emerged. There were collectors, such as the Earl of Exeter and Giles Isham, who took the grand tour and at the same time began collecting. Some, like Lord Somers, depended upon agents like John Talman (d. 1726), who acted on his behalf or brought to his attention desirable purchases. Others preferred to purchase works through London dealers, such as

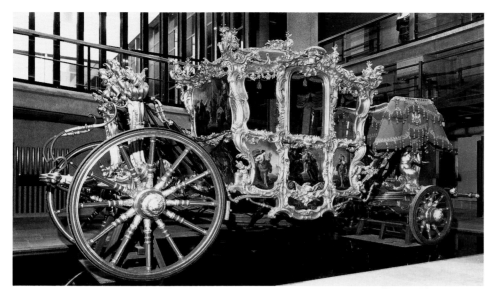

13. Coach of the lord mayor of London, c. 1757. Museum of London.

John Howard and Isaac Collivoe.[13] Smibert probably worked for such a dealer, helping to fill the demand for copies of Old Master paintings. While many collectors, like Richard Mead, Matthew Prior, and the Earl of Egremont, demanded that all their paintings be originals, lesser collectors, particularly those with less financial clout, might fall sway to the popular English belief that a good copy was superior to a deficient original. As England experienced a building boom and patterns of decoration changed, the walls of many houses were increasingly outfitted with large numbers of paintings to fill the background. Kneller had advertised the sale of such paintings from his own house, describing them as "paintings fit for staircases, chimnies or doors." An enormous fashion developed for these painted decorations with both the rich and the middle class. Edward Edwards observed that during the first half of the eighteenth century "the panels of the rooms and more frequently the compartments over the chimney and doors were filled with some kind of picture which was seldom the original work of any master but was commonly the production of some copyist who subsisted by manufacturing such decorative pieces and was glad to furnish a landscape on a half length canvas for forty or fifty shillings."[14]

Joseph Highmore provided a lively description of one such copyist, a Dutchman named Vanderstraaeten (probably Henry Van der Straaten)[15] whom he observed near Drury Lane about 1714. An expeditious painter, Vanderstraaeten is said to have worked with large pans filled with ready-mixed paints containing a wide variety of shades, including one he called "cloud color." He set up a virtual assembly line, painting a great number of canvases in stages—first skies, then middlegrounds, then foregrounds. He is also said to have painted lengths of canvas like wallpaper, which he would then cut to size as required by customers. Highmore marveled at his speed, although one has to believe he had his tongue in his cheek when describing the Dutchman's dexterity:

> [O]ne day when Vanderstraeten's wife called him to dinner he cried out, "I will come presently; I have done our Saviour, I have only the Twelve Apostles to do." Nor is this improbable of such a man, who could paint a figure of the size he usually practiced in a minute, a spot for the head and two or three touches for the rest. And notwithstanding they were so slight even these pictures were not altogether devoid of merit, for he had something like genius and taste and painted much in the style of Francisque and did all that could be done in the time he allowed himself.[16]

English painting in 1710 was—as it always had been—dominated by foreigners. The portrait market was ruled by Kneller (a German) and Michael Dahl (a Swede), while decorative painting for ceilings and walls was controlled by Marco Ricci and Domenico Pellegrini (both Italian) and Louis Laguerre (a Frenchman). There was far less demand for the other branches of painting, such as flower pieces, but there too foreign-born artists, like Pieter Casteels, a native of Antwerp, held sway. Certainly the British

market for painting, such as it was, tipped heavily in favor of portraiture, and it was here that the largest number of English or Scottish-born artists could be found.

This situation helped lead to the creation of London's first formal art academy in 1711. Other influential factors were the changing nature of the art market, which precipitated an increased demand for portraits, the desire for an academy as a sign of a culture's artistic maturity, and artists' wish to enhance their social position.[17] On October 18, 1710, chosen because it was the day of St. Luke (the patron of artists), more than sixty subscribers assembled at a house in Great Queen Street to elect officers for their new organization. Each had been sent a sheet of paper listing all the subscribers and asking them to vote for twelve whom they thought "most fitting to be Directors of ye Accademy." The subscribers unanimously named Kneller, the most successful artist of their generation, to be governor. Of the directors elected, nine were professional artists and three were amateurs. These amateurs (Sir Edmund Anderson, Henry Cooke, and the musician Anthony Cope)[18] were connoisseurs who functioned as the academy's development office, for they "undertook to promote and get subscriptions from many painters and other artists in London." The directors' areas of specialization provide a hint of the academy's priorities: portraits (Jonathan Richardson, Thomas Gibson, and Edward Gouge), history painting (Pellegrini, Laguerre, and James Thornhill), flower painting

(Casteels) were all represented, as were sculpture (Francis Bird), engraving (Nicholas Dorigny), and crayon portraits (Edward Luttrell).[19]

From the outset the academy's membership included virtually all the important artists active in London.[20] Over the course of the next several years membership grew to more than ninety as numerous younger artists joined. Among the fourteen "new subscribers" in 1713 were Joseph Highmore, John Fayram, Alexis Simon Belle, Francis Bindon, and two Scots, Alexander Nisbet and Smibert.

The academy's rules, which were "write and framed," have not survived, but much about them can be deduced from Vertue, who was a founding member: "the subscription was a guinea for each person, paid down; the place for drawing a large room, ground floor, in the great house in the middle of Great Queen Street, near Lincoln's Inn Fields, where formerly many great noblemen had lived, and once the land-bank was kept there, but gone to decay and uninhabited."[21] Although the institution was called an academy of painting, Vertue more accurately describes it as a "place for drawing."[22] In this the London academy followed the pattern established in Continental academies, where the emphasis was on drawing as the foundation of artistic endeavor (fig. 14). Academic training was seen as a precursor to a studio apprenticeship with an individual artist, where the skills of painting would be mastered.[23]

But in other ways the academy was unique. Unlike European academies, it was not organized with the

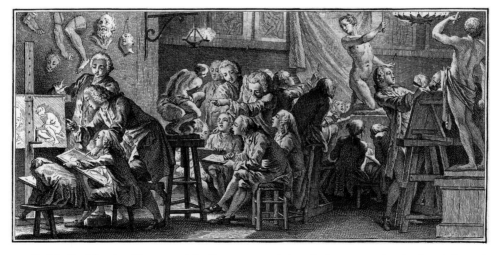

14. C. N. Cochin the Younger, *The Programme of French Art Instruction in the Eighteenth Century,* from Denis Diderot and J. L. R. d'Alembert, *Encyclopédie* (1763). Reprinted with the permission of Starr Library, Middlebury College.

primary purpose of raising the stature of artists, nor was it bent upon relieving restrictions of the Painters-Stainers' Company (which after about 1708 seems to have given up on regulations and quickly diminished in importance). It also was not organized, like the French Academy, as an instrument for orchestrating government, taste, and patronage. It has been most appropriately described as "privately sponsored, entirely unofficial, and governed as democratically as a joint-stock company."[24]

The academy met at night (by lamplight) presumably because the vast majority of members were active artists who needed to generate income during the day.[25] Life drawing was the primary activity, although it is reasonable to assume that, as in most European academies, subscribers drew from casts as well.[26] Perspective drawing and the occasional lecture on theory were most likely also part of the program. Some, if not all, of the directors taught at the academy. Gibson (c. 1680–1751), a capable but little-known portrait painter admired for his "affability & good nature" and who was "much followed by the young students in the Academys," supervised the life drawing. He presumably set the model, corrected the efforts of students, and supplied drawings to be copied by beginners. Pierre Berchet, another member although not a director, who had trained at the French Academy, "made many drawings for the other Artists to work after."[27]

Kneller ran a strict program, although the specific rules are unknown. His authoritarian impulses, as well as the combativeness of fellow artists, particularly Thornhill, led to a struggle for control of the academy. In one story, Kneller arrived one night to discover the model placed in a curious crouching position. Gibson acknowledged that he had determined the pose, but at the request of Thornhill, who was then at work on the ceiling of the Painted Hall at Greenwich Hospital. Thornhill had asked Gibson, a capable draughtsman, to make the drawings and forward them to Greenwich, where Thornhill might use them. Kneller rejoined disparagingly, "I see, I see! Mr. Dornhill is a wise man. But if I was Mr. Dornhill I should let Mr. Gibson draw *all* my figures for me."[28] The intrigues in subsequent years only became thicker; ultimately Kneller resigned and was succeeded in 1716 by his younger rival. Thornhill's election was not unanimous, however, and many supported the candidacy of Laguerre, the godson of Louis XIV, whom Vertue described as "a man free of access, pleasant conversation, and always willing to help and instruct in his art."[29] Through all of this Smibert very likely sided with Kneller, Gibson, and

Laguerre. This subterfuge may in fact be one of the first incidents that were alien to what Vertue later described as Smibert's "particular turn of mind towards honest, fair & righteous dealing—he could not well relish, the false selfish griping, overreaching ways too commonly practiz'd here. nor was he prone to speak much in his own praise. nor any violent ways but a decent modesty."[30]

By 1716, after three years at the academy, Smibert sensed it was time to branch out on his own.[31] Vertue records that he set out for "Edenborough there first try'd to paint faces." It is difficult to gauge whether Smibert received much direct training in portrait painting while in London. He would not have got it at the Academy, but his acquaintance there with Kneller, Gibson, Hans Hysing, and Richardson might have led to some rudimentary form of employment in one of their studios. The other portrait painters who participated in the academy were probably either of too little consequence (Edward Gouge and Anthony Russell) to have attracted Smibert or were no more advanced than he was (Highmore, Bindon, Fayram, John Vanderbank).

Smibert's return to Edinburgh, which occurred in the unsettled period after the failed Jacobite uprising of 1715, was both logical and calculated. Although he had recognized the value of training in London, he must have been much more at home in a city with a slower pace. The return to Scotland also afforded him the opportunity to exploit his exotic (for the times) academic training and his newly acquired cosmopolitanism. But despite these assets Smibert must have found the going rough. Vertue's intimation is that Smibert "try'd" to paint faces but failed. This is not surprising, for Smibert may have misjudged the opportunities created by the changes in the Edinburgh art scene since his departure about seven years earlier. Medina's death in 1711 had paved the way for William Aikman's immediate return from a four-year stay in Italy and Turkey. He settled in High Street[32] and soon won all the local business away from John Scougall (c. 1645–1737), whose style was now seen as old-fashioned. Aikman took total control, garnering the few official commissions that were about (such as the oval commemorative portraits for the Incorporation of Surgeons) and catering to the artistic needs of the aristocracy and gentry.[33] There was little Smibert could do to tempt patrons except to offer lower prices. His contacts were made either through personal and written introductions or word of mouth. Public advertising in newspapers—later, in the nineteenth century, a common practice of artists—was

socially unacceptable, and in any event newspapers were few in number and of limited circulation.[34]

Smibert discovered his Maecenas in Sir Francis Grant (1658–1726), Baronet of Monymusk, who either directly or indirectly was responsible for the artist's five earliest surviving portrait commissions.[35] Grant was patriarch of a moderately wealthy Presbyterian and vigorously anti-Jacobite Whig family which had a modest history in the legal profession and rose to prominence under Queen Anne. In 1709 Grant, known as Lord Cullen, received one of the plums of Scottish government when he was appointed one of fourteen senators (judges) in the Court of Session, the supreme civil court in Scotland. As such he earned an income of £500 sterling, comparable to the income a wealthy Scottish landowner derived from his rent roll.[36] It was a prodigious sum, far above that of the average London salary in 1700 of £25, but dwarfed by the amounts reaped by English temporal lords from tenant rents on their estates. (In 1715 the Duke of Newcastle received about £32,000.)[37]

In 1713 Grant purchased Monymusk, a ten-thousand-acre estate twenty miles from Aberdeen,[38] but his court responsibilities required that he live in Edinburgh. Soon after his appointment as senator, Grant began to outfit his Edinburgh home on the south side of the Lawnmarket at the foot of Libbetoun's close. In November 1709 Roderick Chalmers painted for him three pieces of canvas in imitation of arras hangings, or tapestries, creating what must have been one of the most spectacular Edinburgh interiors of the period. "Pictors," most likely prints of William and Mary, were proudly displayed on the dining-room walls. Grant also had a "press," or storage cabinet, colorfully decorated by the painter Walter Melville, which helps to explain how Smibert probably received his initial introduction to Grant.[39]

The exact order of Smibert's Grant family commissions is difficult to determine, but they probably commenced with his portrait of Anne Hamilton (fig. 15). According to family tradition, it was painted in 1717 on the occasion of her marriage to Archibald Grant (1697–1778), Lord Cullen's eldest son. Its unpretentious size (17 × 12 inches) is unusual for the period and may indicate the initial limits of the Grant family's willingness to try out a portrait painter of unknown ability. As a beginner, Smibert took no chances, and stylistically the painting, although more awkward than work by more experienced painters, reflects the prevailing Scottish taste for the Kneller-Aikman style of portraits: a restrained, almost melancholic

expression and a subdued palette of limited color range.

Smibert's *Anne Hamilton* apparently passed muster, as it was followed by portraits of Sir Francis Grant (fig. 16), Grant's second-eldest son, William (1701–1767), Lord Prestongrange (fig. 17), and Lord Cullen's son-in-law, Alexander Garden (fig. 18). The portraits of Grant and Garden, although conventional, indicate Smibert's increasing deftness as a painter and a subtle but perceptible stylistic tilt away from Kneller and toward Aikman. This manifests itself primarily in the aping of Aikman's preference for a straitjacketed value range with only minimal use of highlights, and for uniformly dark, somber colors that even Kneller rarely used.

More interesting and adventuresome, however, is Smibert's *Lord Prestongrange*, in which the sitter looks in the opposite direction from which his body is turned. Kneller would have certainly disapproved of such a pose, in which movement and animation have displaced decorum. Smibert seems to have been inspired by a portrait of the Jacobite 10th Earl Marischal (Scottish National Portrait Gallery), painted by the Frenchman Pierre Parocel, or by the print after it. This youthful ardor for experimentation, which indicates Smibert's willingness to borrow from contemporary Scottish sources (regardless of the sitter's political persuasion), must have met with a lukewarm reception from the Grant family, as Smibert quickly retreated to the Kneller-Aikman fold.

The effort that Smibert devoted to these early portraits, however, was more than amply rewarded by what came next: a commission from Grant to paint a group portrait, *Sir Francis Grant and His Family* (plate 1). The portrait, painted between January and July, 1718, would have been a challenge for any artist, let alone one at the beginning of a professional career. It is a monumental composition, approximately seven by ten feet, which probably made it the largest painting of its type ever painted in Scotland, and it undoubtedly precipitated a ripple of discussion within the Edinburgh arts community. Certainly Aikman had painted nothing to rival it in scale, although the preceding year he had completed three full-length portraits of King George, King William, and Queen Mary for the town council of Edinburgh.[40]

Smibert was apparently able to charge a considerable fee—£60—the price Aikman charged for his three full-lengths.[41] Somewhat surprisingly, Grant seems to have paid the market price for the painting, and Smibert must have considered it quite a coup to be chosen when Grant could have as easily turned to

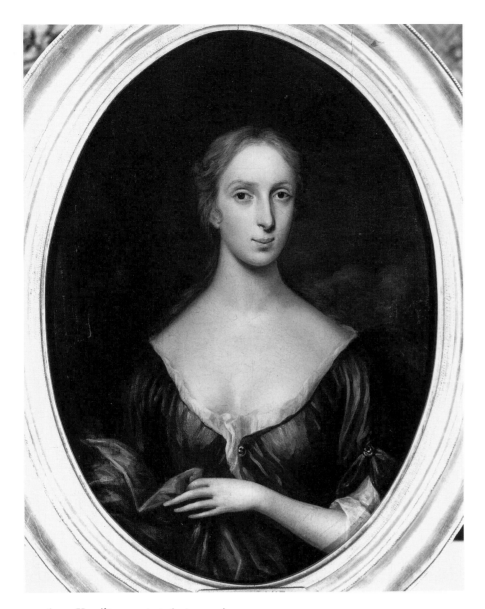

15. *Anne Hamilton*, c. 1717 (cat. no. 1).

Aikman. No doubt Grant would have had difficulty finding any artist in Britain, with the possible exception of Kneller, who had much experience painting group portraits. And given the exigencies of travel, his family would never have journeyed to London for such a purpose. While the handling and placement of some figures are awkward, Smibert nevertheless painted a portrait as modern as those of his London mentors, such as Kneller's *The First Duke of Chandos and His Family* (fig. 19). Smibert, then, was a natural and pragmatic, if not entirely economical, choice.

The final painting was preceded by a small-scale oil sketch (plate 2), one of the few instances from the early eighteenth century where both a finished group portrait and its preliminary study survive. By itself the study resembles a conversation piece—or "family piece in little," to use Vertue's description—which in the next two decades became the scale frequently favored by patrons of William Hogarth, Gawen Hamilton, Francis Hayman, and Arthur Devis. Smibert used the study to give his patron a clear indication of the final composition. Grant may well have

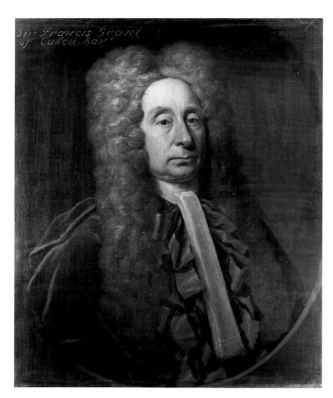

16. *Sir Francis Grant, Lord Cullen*, c. 1718–1719 (cat. no. 2).

17. *William Grant, Lord Prestongrange*, c. 1718–1719 (cat. no. 4).

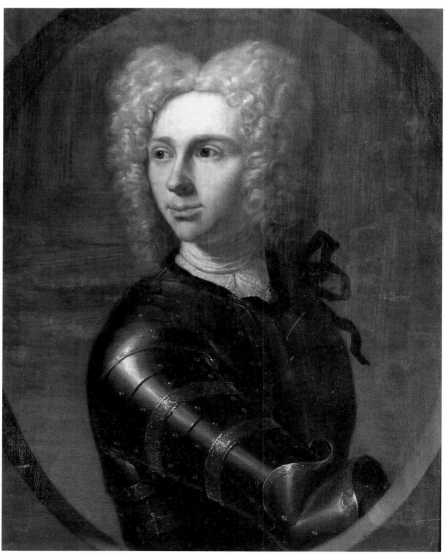

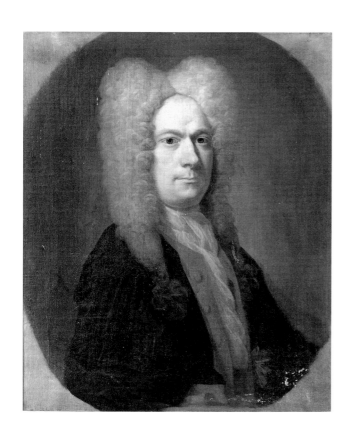

18. *Alexander Garden of Troup*, c. 1718–1719 (cat. no. 3).

19. Sir Godfrey Kneller, *The First Duke of Chandos and His Family*, 1713. Oil on canvas, 58 × 70 3/4 in. (147.3 x 179.7 cm.). National Gallery of Canada, Ottawa.

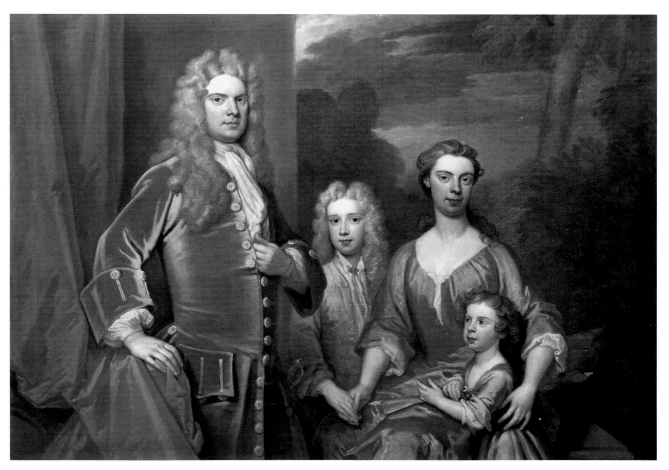

requested it because Smibert's abilities as a painter of group portraits was unknown. The figures in the study are animated and expressive, Smibert's palette atypically resonant. Much of this spontaneity and vitality, however, vanished in the finished painting. Transient expressions and vibrant colors, while perhaps permissible in a sketch, were out of character for a formal portrait. Nevertheless, such details as the treatment of Sarah Grant's head (plate 3) and her father's hand on her shoulder are sensitively modeled.

It was probably during this period in Edinburgh that Smibert painted his first landscapes, two of which were sold in an undated eighteenth-century Edinburgh auction.[42] Smibert enjoyed painting landscapes throughout his life, and even in retirement, two years before his death, he observed that he "hath been diverting my self with somethings in the Landskip way which you know I always liked."[43] This life-long attachment most likely derived from his having participated, as an apprentice, in the creation of decorative landscapes which in the late seventeenth century became part of interior room ensembles.[44] Melville, for example, is known to have painted "a peece of landskip with ane fountain & the figure of a sheepherd with a few cattell."[45] Viewed in this light, Smibert's attraction to the fine arts may have had more to do with landscape than portraiture.

Smibert's lone surviving landscape is his much-later *View of Boston* (1738; plate 25) which gives some idea of his approach to the subject. He must also have had opportunity to see the occasional landscape by the Edinburgh painters William Ferguson and James Norie. Although one can only speculate about the character of his own Edinburgh landscapes, they probably emulated the Franco-Italian tradition of Claude, or Gaspard and Nicholas Poussin, which would have been in keeping with British taste of the period.

Smibert's academic training gave him a credibility in Edinburgh he otherwise would not have had. Upon his return he was accepted as a peer by other like-minded souls. The most important of these was Allan Ramsay (1684–1758), who could appreciate Smibert's ambitious nature. Ramsay, Smibert's senior by four years, had overcome modest beginnings and training as a periwig maker to be a bookseller and would, within a short time, become the most admired Scottish poet of his generation. His family came from Leadhills, a town forty-six miles southwest of Edinburgh, where his father (who died shortly after his son's birth) had been a supervisor in one of the Earl of Hopetoun's lead mines. After leaving for Edinburgh

about 1700, he became an apprentice wigmaker in 1704 and six years later a master wigmaker and burgess. Like Smibert he observed at first hand the debilitating effects that the union with England had on Edinburgh life. In 1712 Ramsay became a founding member of the Easy Club, a coterie of young men with pronounced nationalist sympathies. Another member was Thomas Ruddiman (see fig. 67), an erudite Jacobite who sold books at auction, taught, boarded pupils, and later published Ramsay's works.[46] Like music and theater, clubs such as this were also frowned upon by the church because of their free talk and ribald verse.[47] Despite such opposition, the club lasted three years before being disbanded during the political disturbance of 1715. In this short period, however, it became the vehicle for Ramsay's poetic development.[48] The enthusiasm of Ramsay's cohorts for his verse led them to print his elegiac

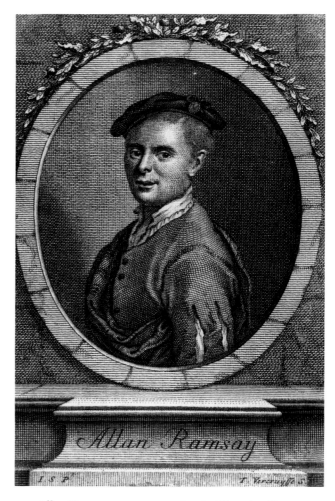

20. *Allan Ramsay*, 1721, engraving by Theodor Vercruysse after cat. no. 409.

"Poem to the Memory of the Famous Archibald Pit-cairne, MD," in which he claimed that Scotland's independence had been sold for English gold.[49]

Ramsay embraced Smibert as a kindred spirit. Not only had he wished to be a painter himself (a career denied him by his father),[50] but true to his generation he was a firm believer in the symbiotic relationship between painting and poetry. Smibert most likely shared Ramsay's misgivings about union with England. He was witness to Edinburgh's stagnant economy and felt its impact on the wool industry because of his father's job as a litster. His experience in London also gave Smibert an opportunity to see at first hand that although since the Act of Union he and his fellow Scots were British, they were by and large ridiculed by the English.

If Smibert arrived in Edinburgh in 1717, his return coincided with Ramsay's decision to abandon wigmaking for the more compatible trade of book-selling, which he did from his house under the sign of Mercury in the High Street.[51] Despite Ramsay's enthusiasm for the book trade there was scant encouragement for letters, no patrons worthy of an author's obsequious dedication, and few book-lovers to subscribe to even the smallest edition.[52]

A natural outgrowth of this friendship between artist and poet was two Smibert portraits of Ramsay, the earliest visual record of him that survives and possibly the first opportunity he had to have his portrait done. One portrait is known only through the engraving after it that appeared in 1728 as the frontispiece to Ramsay's collected works (fig. 20). The second (fig. 21), the most fluidly painted work to this point in Smibert's career, is a recently discovered painting known previously only through a much later copy. In both portraits Smibert endeavored to capture the spirit of Ramsay's patriotism. They are informal likenesses, in the tradition of portraits of scholars and poets, such as Kneller's *Joseph Carreras* (c. 1685). The banyan and unbuttoned shirt that Ramsay wears in one were hints to the viewer that the portrait was the real man, not simply an acknowledgment of office or social status as was the custom in formal British portraits of the period.

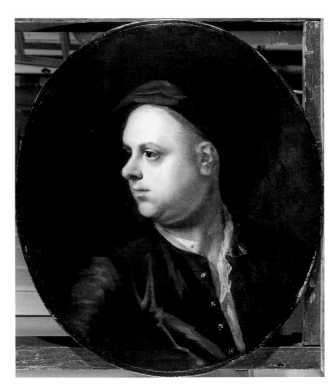

21. *Allan Ramsay,* c. 1717–1719 (cat. no. 7).

The portrait, like Ramsay's poetry, has immediacy and finds virtue in native bluntness. It is only later, when the portrait is altered for publication, that it conveys a sense of national dignity that combines traditional Scottish elements of the tartan and the Tam o' Shanter with the trappings of historicism, such as the stone plinth and surround. Although others of their age may have found this portrait unnecessarily forthright, Ramsay would have championed such directness as a virtue: as he noted in the the introduction to *The Evergreen* (1724), his poetry celebrated the simplicity of a past age "when these good old Bards wrote, we had not yet made use of imported trimmings upon our cloaths, nor of Foreign Embroidery in our writings."

3

Italy

THE HANDFUL of portraits that survive from Smibert's brief return to Edinburgh suggest that he met with limited professional encouragement. By the spring of 1719, a number of forces came together to persuade Smibert to travel to Italy, a move that might boost his career and offer new opportunities for success.

The depressed state of the Edinburgh economy, brought on by the Act of Union, made life difficult for Scottish artists. Smibert in particular may have been frustrated by his inability to compete favorably with a well-established artist like William Aikman. It also appears that Smibert may have received financial backing from one or more individuals, for numerous expensive purchases are documented in the record of his travels. This support could have come from a benefactor, like Sir Francis Grant, who wished to acquire works privately (a common practice)[1] or from a dealer like Andrew Hay, for whom Smibert may have acted as agent.

The international political climate made Italy especially attractive at this moment. Rome had recently become home to the court of James II, the Old Pretender, and his Jacobite supporters, many of whom were Scots. Smibert may have counted on meeting in Rome many potential patrons who would view his Scottish heritage, regardless of his own politics, as a sign of trustworthiness.

Allan Ramsay may also have encouraged Smibert's decision to visit Italy. Although there is no documentation on this point, the savvy and assertive poet would have have been likely to rally Smibert's enthusiasm for such a trip for both his personal benefit and the greater prestige of Scottish artists. And it is surely not coincidence that Smibert took along with him his portrait of Ramsay so that it might be properly engraved in Italy by a more capable artist than was then in Edinburgh.

Another catalyst was the precedent of European travel by at least four other Scottish artists: Medina, Aikman, Alexander, and Thomas Murray (1663–1735), all of whom had made trips to Italy within recent memory.[2] While Smibert's relationship to these artists is largely circumstantial, the Scots' parochial nature and the small size of the Edinburgh art community make it highly likely that Smibert was well aware of them and their travels. It is also possible that Alexander, an Aberdeen-based artist who returned from Italy in 1719, encouraged Smibert's trip. Further, still fresh in Smibert's mind would have been the memory of three of the most prominent artists active in London, Sebastiano Ricci, Marco Ricci, and Antonio Pellegrini—all Italians.

Smibert's decision to set out for Italy would profoundly influence the outcome of his career.[3] Once again Smibert opened his notebook, after ten years of disuse, to record "A memorandum of my voyages and Jurnes to Rome from Edenburgh in the year 1719."[4] Smibert was undoubtedly aware of both the apparent and practical benefits of foreign travel for artists. Since most highly regarded art theorists, among them Carel Van Mander, Joachim Von Sandrart, and Jonathan Richardson, encouraged young artists to visit Rome,[5] Smibert's stature would be enhanced simply by travel. Contemporary treatises such as the English translation of Roger De Piles's *Art of Painting* (1706) must have impressed Smibert with the need to know antique sculpture. Similarly, the work of the Italian Renaissance masters was praised by writers like Richardson, who remarked that "Italy has unquestionably produced the best Modern Painting, especially of the best Kinds, and possess'd it in a manner alone, when no other Nation in the World had it in any tolerable Degree."[6]

But a much more practical benefit for artists was the prospect of patronage from touring cognoscenti, who desired to have painted copies of Italian master-

pieces, portraits of themselves, or assistance in forming collections. Of even greater potential importance was the possibility of continued patronage after returning home.[7] Artists hoped to develop relationships with people like Dr. Richard Mead (1673–1754) and the Scotsmen Sir John Clerk (1684–1755) and the 2nd Marquess of Annandale (c. 1682–1730), who were among the increasing numbers of British visitors to Italy in the early eighteenth century and who began to assemble notable collections of statuary, coins, and paintings. Certainly, the Earl of Shaftsbury's *Characteristicks* (1711), a primary guide to aesthetics during the period, helped fuel the fire for travel and collecting.

While it was still not *de rigueur* for artists to take the grand tour, no less than eleven members of the Great Queen Street Academy had visited Italy by the time Smibert departed Edinburgh. These trips were made despite the frequent wars and political uncertainties. Both the Act of Union (which broadened Scottish contacts with the Continent) and the end of the War of Spanish Succession in 1713 favored increased travel by artists.[8]

The format of the tour, with only slight variation, was quite standard after 1650 and documented by a voluminous Italian travel bibliography.[9] Until that time the itinerary consisted largely of northern Italy and Tuscany. But as fear of the Inquisition subsided, Rome and the Papal States, as well as regions further south, became safer ground, and a regular route developed: Genoa, Florence, Rome (in the winter months), Naples, back to Rome for Easter, then north to Venice for Ascension Day.[10]

On August 1, 1719, Smibert set out from Leith, the port of Edinburgh, on the ship *Union,* one of the packet boats that regularly sailed to London, where he arrived six days later.[11] After three weeks there, presumably to see friends and gather provisions, he crossed the Channel to Calais. With England and France at peace Smibert could travel overland, which allowed him to see Paris and avoid a sea route plagued by pirates.[12]

Smibert spent approximately four weeks in Paris, during which time his activities go unrecorded. Like other British travelers, he probably made excursions to the Louvre, the French Academy, and the gallery at the Luxembourg Palace, and possibly visited some private collections.[13] He then headed south to Avignon, presumably taking time to stop at Fontainebleau.[14] After brief stops at Marseille and Nice (by which time he had at least one traveling companion) Smibert made his way to Genoa, which he reached after passing "over the Alps by Horses in 5 days."[15]

From Genoa Smibert went on to Livorno [Leghorn] by "feluca," a small open boat propelled by oars or sails and used for coastal transport. There he remained five days. Livorno was a magnet for British travelers to Italy; a flourishing trading colony of British lived there, including the house of Aikman, a banking institution founded by a Scot, John Aikman of the Ross, before 1693.[16] Smibert's interest in going there may have been to utilize letters of introduction to the bankers or simply to arrange his finances and exchange currency. This seems plausible, as Smibert's notebook records receipt of payments on the account of "William Aikman," presumably the merchant of that name.[17] Further, knowledgeable British merchants familiar with the myriad local currencies of the numerous independent Italian city-states were undoubtedly a welcome sight to tyros like Smibert, to whom Italy must have seemed both exotic and confusing.

Smibert's stated goal, like that of most British artists in Italy, was Rome. But he first visited Florence, where he stayed the better part of a year. To get there he passed through Pisa and Lucca, where he "stayed 2 days becaus of the graitt rains which swelld the rivers that we were to pase which had no brigiss,"[18] and finally Pistoia. One reason for his lengthy stay in Florence was the accessibility of the tremendously rich art collections there through the generosity of Grand Duke Cosimo III (1642–1723). By the time he reached Florence on November 19, 1719, his meager finances, which had been reduced to just over twenty pistoles (about £10), were replenished with fifty Florentine crowns (about £12) by an unnamed source.[19]

Beginning early the next year, Smibert set about to accomplish one of the primary purposes of his trip: purchasing works of art. Between February 1 and October 28, 1720, Smibert acquired more than three hundred objects, primarily by seventeenth- and eighteenth-century Florentine artists. His purchases consisted of forty-five paintings, two hundred fifty drawings, six pastels, one cartoon, and several elaborate *pietre dure,* or semiprecious-stone boxes, for which Florence had long been famous.[20] The extent of purchases—which omit prints entirely but include two expensive paintings by Onorio Marinari (1627–1715),[21] the late-Baroque Florentine artist—suggests the taste of a connoisseur rather than that of an aspiring portrait painter from Britain's backwater.

Smibert's purchases seem to confirm the preference of British collectors for late-Baroque Florentine painting.[22] He bought a number of "pictors," presumably religious, historical, or mythological works by Marinaro, Tommaso Redi (1685–1726), Giovanni

Romanelli (1610–1662), Cesare Dandini (1595–1658) and his nephew Pietro Dandani (1646–1712), and Antonio Pugliesi (1660–1732). To these he added a landscape by Bartolommeo Torregiano (d. 1673), an *Old Woman* by Giovanni Franceschini (1617–1662), known as *Il Volteranno*, a "flour" picture by an unidentified artist, as well as a *Venus* by Giovanni Biliverti (1576–1644). The only non-Florentine purchases were a *Charity* by the Bolognese painter Carlo Cignani (1628–1719) and a head of Christ by Pietro della Vecchia (1605–1678).[23]

It is conceivable that Smibert's buying spree in Florence may provide the provenance of three drawings in the bequest of James Bowdoin to Bowdoin College. One of these, a caricature of an old man (fig. 22), bears the inscription (now discounted) on the mount in an eighteenth-century but unknown hand "Cosimo the 3d—Grand Duke of Tuscany. 'from the life' by John Smibert." Two others are ascribed, on the basis of old inscriptions, to Florentine artists: an *Entombment* by Giovanni da San Giovanni and a *Woman and Child* (fig. 23) by Tommaso Redi.[24] From these surviving drawings one might conclude that Smibert was able to assemble a small group of works for his personal use in addition to the vast purchases made for someone else.

Smibert's sources for his purchases included *proveditore* (picture dealers) or "brokers," artists, and private individuals. He identifies Tomaso Conte de Federighi, a "Chirurgens [surgeon's] widow," "a father of a convent," Signor Landini the Proveditore delle Fortezze, and "Sigre Salvi," who may be Dr. Salvini, described in contemporary accounts as a professor of Greek and Florentine antiquary.[25] In some instances he seems to have dealt directly with individual artists, as when he "payed to Soderine for 3 pictors." This probably refers to Francesco Soderini (1673–1735). Other purchases from artists include "a pictor" from Tommaso Redi, a "flour pice" from "signe Theodoro landskip painter," presumably Teodoro Helmbrecker, and "50 drayings" from "Sigre. Scatchaiti floure painter."[26]

Most of Smibert's purchases were drawings and paintings. But of the two boxes of *pietre dure* he

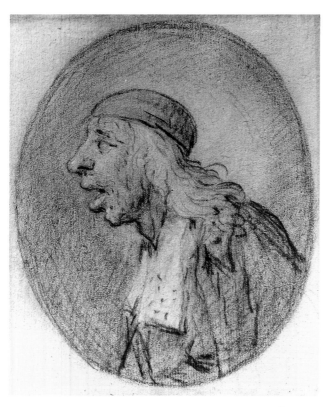

22. Unidentified Italian artist, *Portrait Caricature of a Man*, 17th c. Black and white chalk on brown paper, 6 7/16 × 5 1/4 in. (16.4 × 13.4 cm.). Bowdoin College Museum of Art, Brunswick, Me.

23. Tommaso Redi, *Madonna and Child with Three Holy Women, after Parmigianino*. Red chalk on paper, 8 3/8 × 7 3/8 in. (21.2 × 18.8 cm.). Bowdoin College Museum of Art, Brunswick, Me.

bought, at least one was of considerable importance, as it cost over £30. For it he purchased additional brass decorations and then bought a second box of ebony and brass, which he had gilded by "Cipriani," presumably Pietro Cipriani, whose talents were praised by British travelers.[27]

While acquiring works of art Smibert continued to paint—life portraits done on commission and copies after Old Masters. At some point during the summer of 1720 he made the most important acquaintance of his career: George Berkeley (1685–1753), the prelate and philosopher, who was at the time serving as companion and tutor to St. George Ashe (d. 1721), the son of the bishop of Clogher and vice-chancellor of Dublin University.[28] By August Smibert had apparently garnered portrait commissions from both Ashe and Berkeley. The portrait of Ashe is known only from the artist's record of having bartered it for cloth to make a suit.[29] That of Berkeley (fig. 24) survives and is startlingly reminiscent of William Aikman's *Self-Portrait* (fig. 25).

While it was certainly coincidence that Smibert and Berkeley were both in Florence in the summer of 1720, they seem to have taken an immediate liking to each other. Although their backgrounds were quite different, Berkeley considered himself a judge of painting,[30] and their Italian experience immediately gave them common ground. Further, Berkeley was entirely comfortable with artists, as he had great admiration for the arts. "Those noble arts of architecture, sculpture and painting," he wrote in 1721, "do not only adorn the public but have also an influence on the minds and manners of men, filling them with great ideas, and spiriting them up to an emulation of worthy actions."[31] Berkeley was only three years Smibert's senior; a graduate of Trinity College, Dublin, he had already made a notable if controversial reputation as a philosopher with the publication of *A Treatise Concerning the Principles of Human Knowledge* (1710). This essay attacks the beliefs (particularly held by John Locke and Sir Isaac Newton) in the existence of matter and the human ability to grasp abstract ideas. But most likely it was an earlier publication, *An Essay Towards a New Theory of Vision* (1709), that would have provided the artist and the philosopher with a topic of common interest. *A New Theory of Vision* is concerned with how humans perceive by sight the distance, size, and position of objects. Since Smibert's success or failure as an artist depended in part on how he perceived spatial relationships, the topic was of more than passing interest to him.

Berkeley was by nature engaging, and after departing for London in 1713 he developed most diverse friendships. His acquaintances included Anglicans, Dissenters, and Papists, Whigs and Tories, clerics and council members, lords and commoners.[32] Cleric friends, for example, ranged from Jonathan Swift, dean of St. Patrick's, Dublin, to Francis Atterbury, the most famous of the Jacobite bishops. Few people of Berkeley's generation moved in more eclectic social circles.

Although a Tory, Berkeley was a staunch supporter of the Hanoverian succession. Nevertheless, he had been accused of being a dangerous Jacobite from 1710 to 1716; the reason for this may lie in his having authored three sermons on passive obedience, which he delivered at Trinity College, Dublin, to an audience with largely Jacobite sympathies. It is little wonder, then, that Smibert found kinship with someone who possessed tolerant political views, probably much like his own. Further, Smibert, regardless of whether he harbored Jacobite sympathies, no doubt knew, as a Scot, what guilt by association felt like. Like Smibert, Berkeley was a provincial in the eyes of some Englishmen, because of his Irish birth and education.

Berkeley had been on the continent since the autumn of 1716, enjoying his second trip to Italy. On his previous continental tour (1713–1714) he had been chaplain to the Earl of Peterborough. At the time of Smibert's acquaintance with Berkeley, the artist must have found in the bishop a welcome ally and experienced traveler who undoubtedly was able to provide him the latest information on everything from travel conditions and accommodations to specific collections and monuments. Like Smibert, Berkeley had an agenda to purchase works of art. He was informally acting as a purchasing agent for a close friend, Sir John Percival, later the Earl of Egmont, and while in Italy purchased prints, medals, plaster casts, and terra-cotta busts.

In Florence Smibert had engraved the portrait of Ramsay, which he had brought with him. This task was accomplished—by Theodor Vercruysse (1646–1723), noted for his engravings after paintings in Florentine collections—in time for the portrait to be returned to Edinburgh, where it appeared as the frontispiece to Ramsey's *Poems* (1721).

By the time Smibert returned the engraved plate to Ramsey, he apparently was also able to report a successful visit to the Ducal collections. Such events pleased Ramsay and inspired his ode to Smibert, "An EPISTLE to a Friend in Florence, in his way to Rome," written in 1721 and published two years later:

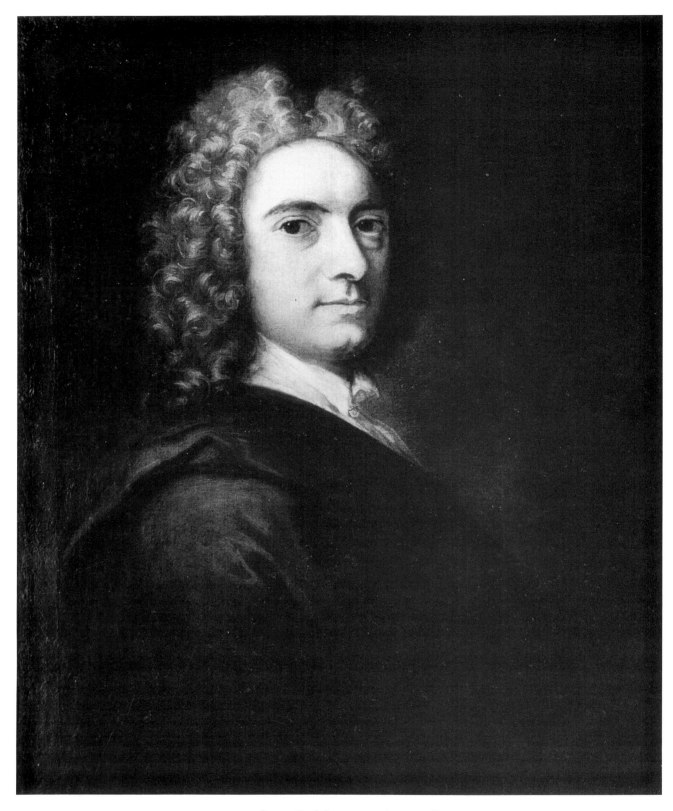

24. *George Berkeley*, c. 1720 (cat. no. 8).

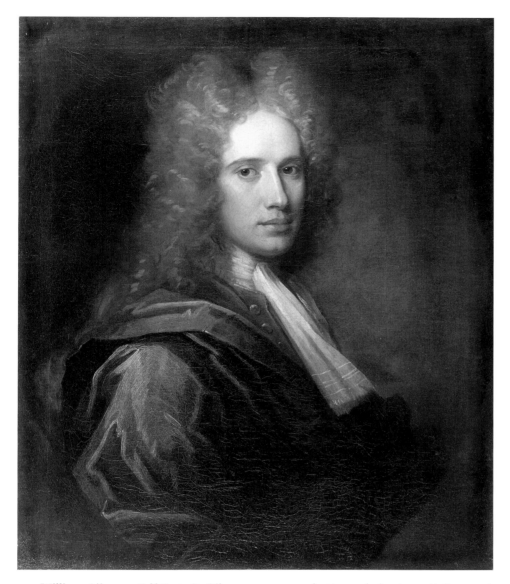

25. William Aikman, *Self-Portrait*. Oil on canvas, 29 1/2 × 24 1/2 in. (74.9 × 62.2 cm.). Scottish National Portrait Gallery, Edinburgh.

Your steady impulse foreign Climes to view,
To study nature, and what art can shew,
I now approve, while my warm fancy walks
O'er *Italy,* and with your Genius talks;
We trace with glowing Breast and piercing Look
The curious Galery of th'illustrious Duke,
Where all those Masters of the Arts divine,
With Pencils, Pens, and Chizels greatly Shine,
Immortalizing the *Augustan* age,
On Medals, Canvas, Stone, or written Page,
Profiles and Busts Originals express,
And antique Scrolls, old e'er we knew the Press.
For's Love to Science, and each virtuous *Scot,*

May Days unnumber'd be great *Cosmus'* Lot.
The sweet *Hesperian* Fields you'll next explore,
'Twixt *Arnu's* banks and *Tiber's* fertile Shore.
Now, now I wish my Organs could keep Pace,
With my fond Muse and you these Plains to trace;
We'd enter *Rome* with an uncommon Taste,
And feed our Minds on every famous Waste;
Amphitheaters, Columns, Royal tombs,
Triumphal Arches, Ruines of vast Domes,
Old aerial Aqueducts, and strong pav'd Roads,
Which seem to've been not wrought by Men but Gods.
These view'd, we'd then survey, with outmost Care,
What modern *Rome* produces fine or rare,

Where Buildings rise with all the Strength of Art,
Proclaiming their great Architect's Desert,
Which Citron Shades surround and Jessamin,
And all the soul of *Raphael* shines within;
Then we'd regale our Ears with sounding Notes,
Which warble tuneful thro' the beardless Throats,
Join'd with the vib'rating harmonious Strings,
And breathing Tubes, while the soft Eunoch sings.
Of all those Dainties take a hearty Meal;
But let your Resolution still prevail:
Return, before your Pleasure grow a Toil,
To longing Friends, and your own native Soil:
Preserve your Health, your Virtue still improve,
Hence you'll invite Protection from above.[33]

Access to these collections, housed in the Uffizi and the Pitti Palace, was a primary reason for Smibert's extended stay in Florence. During Smibert's year there permission was required from Cosimo de'Medici to see and copy pictures. Early biographers of Smibert stressed his closeness to the aged Cosimo, but it seems that the duke, who longed for withdrawal from worldly affairs, simply extended to Smibert the courtesies he granted most visiting artists.[34]

Given the consistency with which many travelers report having seen the works of art at the Pitti Palace, it seems few British visitors were refused.[35] Consequently, it is not difficult to imagine that Smibert had the opportunity to see and copy paintings of his choice.[36] Although Smibert does not specifically mention Cosimo III in his notebook, the latter's affection for British artists was renowned. Not only had Cosimo visited Britain in 1669, but he had collected numerous portraits by British artists, including a set of Sir Peter Lely's full-length female portraits at Hampton Court, the so-called Hampton Court beauties, and several portraits by Kneller. Scottish artists were particularly favored by Cosimo, as he requested and received self-portraits from David Paton, Sir John Medina, Thomas Murray, and William Aikman.[37]

While in Italy, Smibert made at least nine copies after Old Masters, and probably many more. Some of these were commissions from British patrons who desired suitable souvenirs to take home. Others Smibert kept for himself, including examples after Raphael, Titian, Rubens, and Van Dyck, to have with him in Great Britain as suitable models for his subsequent work.

Some of the copies made by Smibert do not survive. Among these are copies of Raphael's *Madonna della Sedia,* perhaps the most admired Renaissance painting of Smibert's generation, and Titian's *Venus, Cupid, and Little Dog.* Both of these paintings hung in the Tribuna (fig. 26), the central gallery of the Uffizi. Another copy known only from Smibert's records is a commission he received for "a copie of the head by Tician." This he painted for Admiral George Byng (1663–1733), Viscount Torrington, then on his way home to England after a naval victory over the Spanish.[38]

Three copies by Smibert do survive. The finest and best known is a bust-length portrait (plate 4) of Van Dyck's striking circa-1623 full-length of Cardinal Guido Bentivoglio in the Pitti Palace. The other two are *Luigi Cornaro* (cat. no. 141), a bust-length copy after Tintoretto's three-quarter-length original in the Pitti Palace, and *Jean de Montfort* (cat. no. 142), a bust-length copy after a three-quarter-length copy in the Uffizi of Van Dyck's original in Vienna. Whereas the portrait of Bentivoglio is mentioned in various guidebooks and is a logical choice for a copyist of his generation, those of Cornaro and Montfort are a bit more puzzling. Neither makes for a particularly compelling copy, and their choice may reflect Smibert's desire to assemble a battery of portrait copies that would impress prospective clients through their sheer number once he hung them in his studio.

Smibert's visit to Florence was of sufficient local interest to be later recorded by his Florentine contemporary Francesco Maria Niccolo Gabburri (1675?–1742) in his *Le Vite de' pittori.* His vita for Smibert, only recently discovered,[39] noted: "John Smibert, English painter. He was very dedicated to study, and particularly in Italy, where he spent much time, having chosen the city of Florence, where he drew the best statues and copied many of the best paintings from the Royal Gallery of Tuscany. Having returned to London, his city, he then went to the island of Bermuda around 1729."[40] How well Gabburri knew Smibert, if at all, seems uncertain, since he refers to the painter as English, rather than Scottish, and refers to "his city" as London. His vita does, however, provide the previously unknown information that in addition to copying paintings Smibert appears to have done drawings of statuary, although none survive.

After almost a year in Florence Smibert continued on to Rome, where he arrived on November 12, 1720. His trip took seven days, but from his terse notations regarding costs, distances, and stops it was apparently uneventful. Political events had recently transformed the international community in Rome. After the failure of the Jacobite uprising of 1715, numerous supporters followed the Pretender into exile, first at Urbino and then, in 1718, at Rome, where the court finally settled. For any Briton this created con-

26. Johan Zoffany, *The Tribuna of the Uffizi*, c. 1772–1777/8. Oil on canvas, 48 5/8 × 61 in. (123.5 × 155 cm.). Her Majesty Queen Elizabeth II.

cern, as a lengthy visit at Rome might call into question an individual's allegiance. Berkeley, who was in Rome at virtually the moment the Pretender arrived, observed in a letter that the English community there consisted of approximately "30 English gentlemen & noblemen" and that the "well affected part meet at the Piazza d'Espagna" (fig. 27), while "the rebels have another part to themselves."[41]

Rome itself, with a population of 150,000 (of which twelve thousand were foreigners), was less spectacular than in antiquity but never ceased to impress visitors. Once there Smibert replenished his resources and continued the pattern of movement he had practiced in Florence. He visited collections, made copies, and, as George Vertue later noted, "painted several persons from life."[42] Two of these survive (plate 5 and cat. no. 10). Although both sitters are unidentified, the former portrait has the distinction of being Smibert's earliest surviving signed and dated painting. It depicts a curiously attired man holding a pipe. Behind him an angel armed with a musket fires at a figure on a donkey. The painting is apparently a complex religious allegory about Protestants in Rome. The pyramid in the painting symbolizes the

pyramid of Caius Cestius, which is adjacent to the only Protestant cemetery in Rome, and the figures represent Balaam and his ass, a clever play on Protestantism's being the true religion in a country of Roman Catholics. Although such jests, if discovered, would have led to severe consequences, Smibert seems to have disregarded such a danger.

As a Scot who in Edinburgh had associated with colleagues like Ramsay with intense Jacobite loyalties, Smibert must have found the Pretender's court a tempting source of potential patronage. Certainly John Alexander, who was both Roman Catholic and Jacobite, had received considerable patronage in Rome from the Jacobite exile, the Earl of Mar.[43] The danger, of course, was that British agents, in the guise of antiquaries or book collectors traveling abroad, might observe such associations and very likely report them. Sir Justinian Isham, a Tory from Northamptonshire, had warned his son in 1719 that "the Pretender being now at Rome 'twill require a good deal of caution how you behave yourself in that respect, for this court have their spies in all parts."[44] One of those spies was Phillip Von Stosch (b. 1691), an outstanding antiquary who in 1721 was commis-

27. Giovanni Battista Piranesi, *Veduta di Piazza di Spagna*, 1769. Etching. Arthur Ross Foundation.

sioned by the British government to report on the doings of the Stuarts, their adherents, and British travelers.[45] To an artist like Smibert with every intention of locating in London, Jacobite patronage was quite a gamble. But on occasion Smibert took the risk. His most overt act was accepting a commission, from the Jacobite Sir Andrew Cockburn, to paint copies of portraits of the Old Pretender and his new bride, Clementina Sobieska, a Polish heiress and princess.[46]

Even being seen with known Jacobites could be enough to merit condemnation. On April 24, 1721, Smibert, along with Andrew Hay, the art dealer, and Thomas Rawlinson (1681–1725), a bibliophile, art collector, and Jacobite, were guests at a wedding. The event, which was performed by "Revd. Mr. Berkeley" (who was previously thought to have left Rome for Brussels months earlier), not only confirms Smibert's continued acquaintance with Berkeley in Rome but also suggests the willingness of both artist and prelate to be seen in public with avowed Jacobites.[47] At other times his visits to the opera or church coincided with the movements of other Jacobites, or the Pretender himself, of which Hanoverian spies made dutiful observation.[48] These were associations that Smibert would live to regret.

Smibert was thirty-two when he reached Rome, and unlike some younger foreign artists who came

there he did not study at the French Academy. Students at the academy were largely concerned with drawing ancient statuary,[49] and although Smibert apparently drew statuary, as suggested by Gabburri's vita, he probably did so on his own. Since his style was already firmly developed he had little interest in studying with one of the resident Italian portrait painters, such as Francesco Imperiali or Benedetto Luti, as other British artists had done.[50] There is likewise no indication that Smibert participated in the organized competitions held by the Accademia di San Luca, such as the Concorsi Clementini.[51] Presumably Smibert, like most other visitors to Rome, timed his visit so that he might view the pageantry of Holy Week; unfortunately, the death of Pope Clement XI that March forced the cancellation of the principal events.[52]

When Smibert returned to Livorno in June, he again found himself busy with commissions (presumably life portraits) from foreign agents, or factors.[53] By December Smibert had once again traveled to Rome, where he delivered paintings and collected final payment before coming back to Livorno. At this point his notations abruptly cease, probably because he was increasingly preoccupied with the details of his impending trip home.[54] On his way back to Great Britain Smibert may well have visited Holland and

Flanders. This certainly was the usual itinerary,[55] and in later years he did offer for sale "Prints, engravd by the best Hands, after the finest Pictures in Italy, France, Holland, and England . . . being what Mr. Smibert collected in the above-mentioned Countries, for his own private Use & improvement."[56]

By the time Smibert departed Italy in the spring of 1722 he had accomplished all that could be reasonably expected of his trip. First and foremost, he had been exposed to the richness of Italian art and had made numerous useful contacts. He had, presumably, also completed his commitment to purchase works of art for his unnamed sponsor. Furthermore, he must have realized that if he hoped to become a British painter of note, he would have to return to Great Britain and use his Italian experience to cement ties and establish a persona. Certainly by this time it must have been obvious to him that this would only be possible in London, not Edinburgh, no matter how much he might have preferred more familiar surroundings and a less intense environment.

One can imagine a confident Smibert, then thirty-four, returning to London armed with letters of introduction and copies of Old Masters to line the walls of his studio and impress prospective clients. Probably at no other time in his career would his confidence in his own abilities be higher. If anything cast a shadow over this scene it was the awareness that London was a fickle home to artists. The difference between success and failure depended less on outright ability than on the whim of fashion and the vagaries of taste. Smibert would quickly be reminded that social conditions were the real arbiters of London's artistic life.

4

A London Studio

SMIBERT returned to London during the summer 1722. At this particular moment there was some uncertainty about the hierarchy of the portrait painters there (in part, because Kneller, the high priest of Augustan portraiture, was ill and had stopped painting), but there was no disagreement that British portraiture bore the imprint of Renaissance ideals and French seventeenth-century Classicism. The greater the idealization in a portrait, the more likely that portrait was to be esteemed. The moral role of the portrait painter was to praise virtue and depict ideal statesmen, soldiers, and other notables of society. The inevitable result was a legion of sitters, from tradesmen and merchants to clerics and academics, who all resembled noblemen.[1]

Of the more than eighty painters then active in London, over half were portrait painters of varying abilities and reputations. Among the most successful was a Swede, Michael Dahl, who had been one of the painters favored by Queen Anne and who still maintained a steady following among the nobility, the law, and the church (although his court patronage had largely disappeared). Dahl was joined by Jonathan Richardson and Charles Jervas, the two most prominent native-born portrait painters. Jervas, who had been a fashionable portrait painter for more than ten years, had achieved great popularity almost overnight as a result of his close friendship with Richard Steele, Alexander Pope, and Jonathan Swift. Within a little over a year he would be appointed Kneller's successor as "Portrait Painter to his Majesty," with a salary of £200 per annum.[2] He was wealthy (he married into money) and somewhat aloof, having steered clear of close associations with his colleagues. He was an able painter, particularly of women's portraits, such as *Martha and Theresa Blount* (fig. 28). Vertue, however, commented somewhat derisively that portraits such as this "rather appear to me like. fan paint-

ing fine silks. fair flesh white & of beautifull colours but no blood in them or natural heat or warmness. much a manerist."[3]

Richardson, on the other hand, was a painter's painter. He had been one of the directors of Kneller's academy and had established close ties with other painters of his generation. His portraits, such as *Sir John Vanbrugh* (fig. 29), if not spectacular, were solid, unpretentious likenesses. As the author of the *Theory of Painting* (1715), which championed the elevated status of artists, asserted the necessity of an education in aesthetics for every gentleman, and recommended travel to Italy, he outlined the precepts by which this era of painters was guided and became a spokesman for Smibert's generation.

A commonplace of Augustan aesthetic theory is the unity of the arts. Richardson simply canonized these precepts: an artist's life was intimately related to the quality of his work, to reading, observing nature, writing poetry, studying the masters in painting —all done in the brightest company possible.[4] These were certainly the guidelines for Smibert's life.

Richardson's ideas about portraiture can be traced back to Shaftesbury, who was a firm believer in the "elevated portraits" in which the painter achieves "a fitter opinion of beauty, good sense, breeding, and other good qualities of the person than from seeing themselves."[5] Central to his philosophy is the recognition of truth, goodness, and beauty as evidence of the divine in the universe.[6] For Richardson, the aesthetic sense—taste—played an integral role in artistic achievement. While beauty was considered an absolute, taste was thought to be the nonrational intuitive vehicle by which reason possesses and confirms it. Hence, poor taste could be corrected as a person more clearly grasped the inviolate qualities of absolute and universal beauty.

This philosophy also gave prominence to "virtuosos" —persons who had taste and were in harmony with

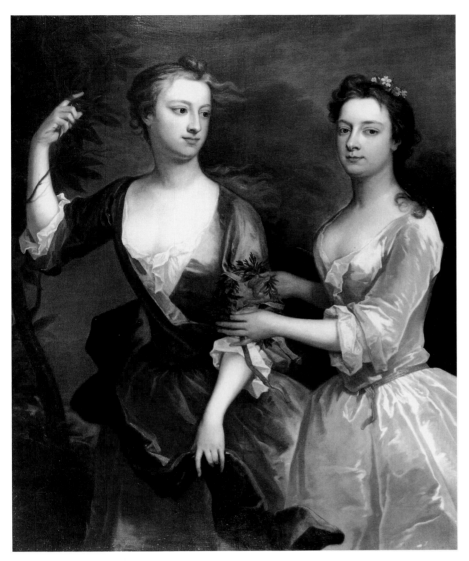

28. Charles Jervas, *Martha and Theresa Blount,* 1716. Oil on canvas, 48 3/4 × 39 in. (124 × 99.5 cm.). Mr. J. J. and Lady Anne Eyston. Photograph, Courtauld Institute of Art.

the universe—and to the Platonic idea that inspiration, enthusiasm, and fantasy are all subordinate to reason. The role of an artist like Smibert, then, was to affirm through his painting the order and harmony apparent in universal laws, and to do so in a language based on rationalism and rules rather than uncontrolled feeling. An artist like Poussin epitomizes this philosophy, although Richardson's elastic canon allowed room for Rembrandt and Rubens as well.

While some London painters lived like gentry, Smibert probably rented a furnished room, or rooms, as was customary for a person of his limited economic means, for a few shillings a week.[7] His residence was "at the sign of the Golden Bodice just by Somerset House" in the Strand,[8] near where he had previously lived in London. Presumably, he continued to worship at the Presbyterian Meeting House, which had in 1719 relocated to Crown Court, Russell Street, adjacent to Covent Garden.[9] By this time there were thousands of Presbyterians among the more than one hundred thousand dissenters living in London. In addition to Presbyterians, they were composed of Calvinists, Congregationalists, Baptists, Quakers, and Unitarians.[10]

The Strand (fig. 30) was the center of the Scots

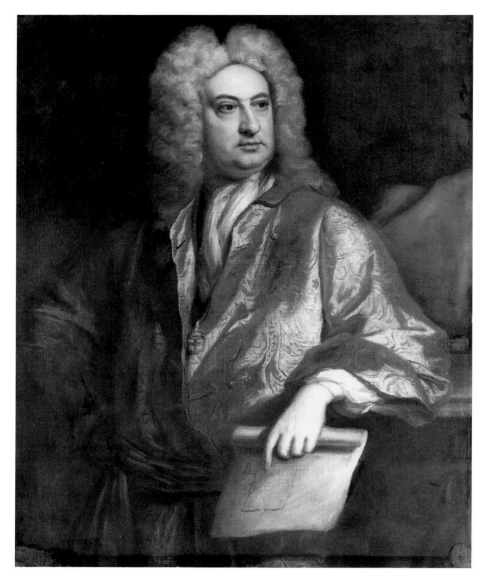

29. Jonathan Richardson, *Sir John Vanbrugh*, 1725. Oil on canvas, 41 1/4 × 33 1/4 in. The College of Arms, London.

community in the City but was a somewhat disreputable neighborhood,[11] a judgment that reflected English attitudes about most areas inhabited by Scots. Smibert probably selected it for reasons of convenience and affordability. It was within walking distance of the Covent Garden Piazza, which ever since Kneller had chosen to live there (1682–1702) had become the geographical and social center of the London art world. This was essential, as Smibert probably made his way about town on foot: virtually no artists owned coaches.[12]

By August Smibert had set up his studio. Although

living in the Strand placed most of London's artists within easy reach, he would have had to travel farther to assemble the supplies (pigments, canvas, brushes) to outfit his studio. The highest-quality and least expensive pigments could be had from colourshops located south of the Thames in Shoreditch and Southwark. And it would have cost Smibert about a shilling an hour to hire a sedan chair to take him there—or send porters in his place.[13]

Smibert recorded in his notebook the names of sitters (fig. 31). His script, which is much clearer and bolder than his Italian travel notes, suggests a pa-

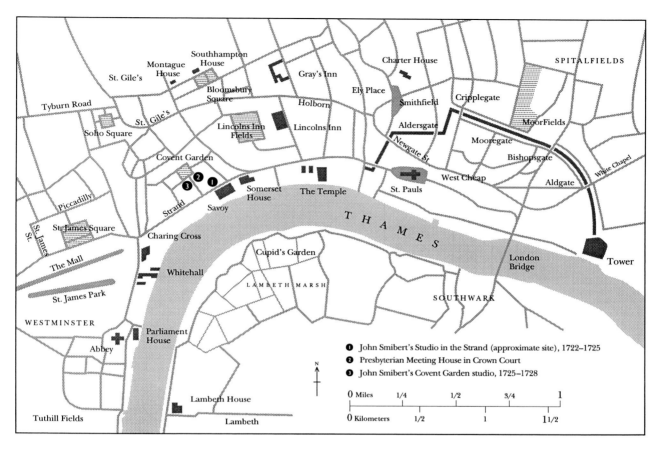

30. London in the reign of George I.

tience and stability consistent with a business ledger. Smibert carefully entered his sitter's name (although surviving portraits confirm that he occasionally omitted a few—see cat. nos. 23 and 29), the size of the portrait, and the price charged.[14]

As a new, unestablished painter in London, Smibert's obstacles to success were considerable. His first challenge was to find enough people to paint so that he could make a living. But to do this he had to take deliberate steps to gain a reputation for himself. First of all, he had no patron of the stature and means of Sir Francis Grant on whom he could depend. The handful of his contemporaries who received substantial individual patronage, such as Vertue and Dahl (from the Earl of Oxford), William Kent (from the Earl of Burlington), and Jervas (from Robert Walpole), were exceptions to the rule.[15]

Like most artists of his generation Smibert undoubtedly conducted business from his home. Kneller had occasionally visited more illustrious sitters, like Lady Mary Wortley Montagu, in their residences, but this was highly unusual. That Smibert's London

address was less fashionable than the addresses of many of his contemporaries meant that right from the beginning he operated at a disadvantage, for wealthy, socially sensitive patrons might resist visiting a studio located in an unfashionable neighborhood. Interior appearances were important, and Smibert probably ringed his room with his copies after Van Dyck, Titian, and Raphael as well as other work collected during his Italian travels. Such an assemblage served to alert potential sitters that they were in the presence of an artist possessed with skill, erudition, and worldly experience.

A portrait might take as little as three days (for a bust-length portrait) or as much as a week (for a three-quarter-length) or longer (for a full-length or multifigure composition) to execute.[16] Portraits typically progressed over several sittings. Hogarth boasted that he could complete a portrait in four fifteen-minute sittings.[17] Alexander Pope, one of Kneller's sitters, observed in a letter to a friend who was having her portrait done, "Sir Godfrey [Kneller] happening to come from London yesterday (as I did

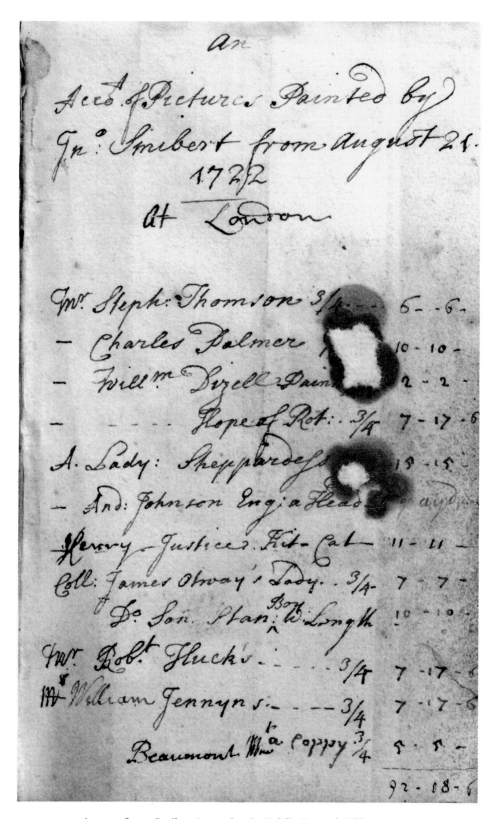

An

Accts of Pictures Painted by
Jnº Smibert from August 21.
1722
At London

Mr Steph: Thomson 3/4 ---- 6 - - 6 -
— Charles Palmer ----- 10 - 10 -
— Willm Dizell Pain- ---- 2 - 2 -
— ---- Slope of Rot: 3/4 7 - 17 - 6
A Lady: Sheppardess ---- 15 - 15 -
— And: Johnson Engia Head ----
Henry — Justice: Kit - Cat — 11 - 11 —
Coll: James Otway's Lady . 3/4 7 - 7 -
Do Son. Stan: Bott W Length 10 - 10 -
Mr Robt Hucks ---- 3/4 7 - 17 - 6
Mr William Jennyns ---- 3/4 7 - 17 - 6
Beaumont Mrs a Coppy 3/4 5 - 5 -
 92 - 18 - 6

31. A page from Smibert's notebook. Public Record Office, London.

myself) will wait upon you this morning at twelve to take a sketch of your dress."[18] Smibert may have begun a portrait by making a life-size pencil or chalk drawing, for that was the method made popular by Kneller, Dahl, and Thornhill.[19] These preliminary sketches were not intended as finished portraits, and that may well explain why none by Smibert survives, although at his death they might have been among the "drawings" included in the inventory of his estate.

But before he could impress potential patrons Smibert first had to alert them to his existence. Most sitters sought out a painter because of his reputation, which came from satisfied customers. Newspaper advertising was not yet an acceptable practice, and displaying a shop sign smacked of being a tradesman—an image inconsistent with the one painters cultivated. One way to achieve renown was to paint freaks, frauds, or notorious criminals. Examples of this practice include Thornhill's portrait of Jack Sheppard (1724), the highwayman, Highmore's portrait of Matthew Buckinger (1730), the crippled German dwarf who visited London, and William Hogarth's portrait of Sarah Malcolm (1733), the murderer. This preoccupation with sensationalism, despite the public curiosity it aroused, was probably among the "false ways" of London painters to which Smibert objected.

Artists also advertised by planting a "newsworthy" story in the paper or having a print engraved after a portrait of a celebrated sitter. One such story was that the Prince of Wales had asked his sister, the Princess of Orange, to draw the portrait of Herman Van Der Mijn (1684–1741), who at the time was completing a royal commission. The story, as it turns out, was fabricated by the artist as a means of self-promotion.[20]

André Rouquet, writing about this English phenomenon later in the century, observed: "the painter's name is at the bottom of the plate, he reads it with secret satisfaction, as he runs thro' the collections in printsellers shops; this is a public testimony of his existence, which in other respects is perhaps very obscure; and that is all he wanted."[21] In Smibert's case, however, the fact is that during his years in London none of his portraits was engraved. This suggests either that Smibert was unwilling to take this shady approach to business or that he felt that none of his sitters was of sufficient prominence to undertake the expense involved in having the print produced.

In face of these methods it is little wonder, then, that among Smibert's first sitters were at least two professional friends: William Diswell, a painter living in Piccadilly, and Andrew Johnston, an engraver, whom Smibert might have cajoled into sitting for

their portraits. If satisfied, they might pass along Smibert's name to their own customers. Smibert painted a bust portrait for Diswell, a member of the Painter-Stainer's Company, and made it a partial gift by charging him only a third of his normal rate. Because of this generosity (and because later he painted a companion portrait of Mrs. Diswell, which he lists as "a present")[22] it seems likely that the artist either befriended Smibert during his earlier years in London or was the coach painter for whom Smibert had worked after leaving Edinburgh in 1709. Smibert's friendship with Johnston, whom the painter charged the full rate for a bust portrait, may have gone back even further. Johnston, who like Smibert served his apprenticeship in Edinburgh, had been an engraver in London since 1714, when he is credited with *The Plan of Edenburgh* (see fig. 2).[23] He lived near Smibert at the new Round Court in the Strand and was a fellow member of Smibert's London church.[24]

Courting Scots in London was certainly part of Smibert's strategy in crafting a reputation for himself. One early commission which fits this category is a portrait for a sitter identified only as "Hope of Rot." Presumably, it depicts a member of the Scottish Hope family of Hopetoun—possibly Archibald Hope (1664–1737), who had been christened at the Scots Church in Rotterdam.[25] Also among Smibert's first Scottish sitters in London were David Miln (c. 1670 or 1675–1760), a merchant from Leith, and his wife, who sat for their portraits in 1723 (figs. 32 and 33). These portraits, the earliest surviving works from Smibert's London period, are good, if conservative, likenesses. Stylistically they fall somewhere between Kneller and Aikman and usher in Smibert's mature work. Smibert may have figured that the Milns' portraits would be taken back to Scotland, where they would be seen by persons most familiar with Aikman. This may have been sufficient reason for him not to veer too far from an established model. In Mrs. Miln's portrait Smibert seems happily in tune with the prevailing taste for an unblemished, long, oval face with a full mouth, aptly described as "a standard impression from a rubber-stamp charged with lip-stick."[26]

Smibert must have expanded this first circle of sitters through letters of introduction he had assiduously collected in Italy. This is the only reasonable explanation of how he came to paint, among his first sitters, Henry Justice (d. 1736), a lawyer; the son of Francis Porten (d. 1726), an up-and-coming dry-goods merchant; and two members of Parliament, Robert Hucks (1699–1745), a brewer, and Samuel Hill (1690/1–1758), who held the minor post of reg-

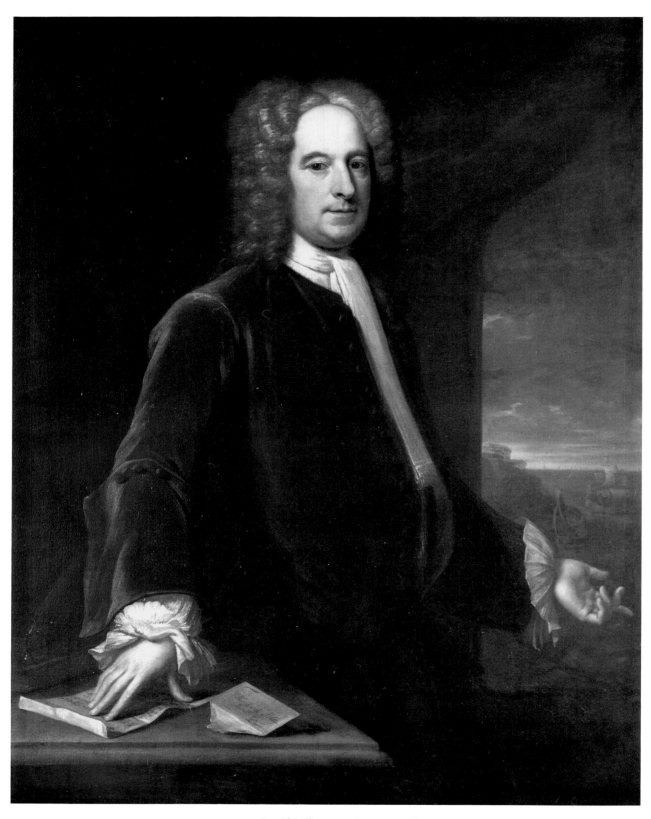

32. *David Miln*, 1723 (cat. no. 12).

33. *Mrs. David Miln*, 1723 (cat. no. 14).

41

34. Enoch Seeman, *Elihu Yale*, 1717. Oil on canvas, 85 × 59 in. Yale University Art Gallery, gift of the Honorable Dudley North.

istrar of the Admiralty (cat. no. 11). One sitter he identifies only as "a Lady-Sheppardess," somewhat surprisingly not recalling her name yet recording that he painted her as a shepherdess—or St. Agnes, who symbolized purity—a practice fashionable since at least the 1680s.

Smibert appears also to have quickly capitalized on commissions from acquaintances made in Italy. Certainly this would explain his portraits of Colonel James Otway (1690–1764; cat. no. 15) and his wife and son. Smibert most likely met Otway in Italy or on his way home, when the army officer was serving as commander of the British fortifications on Minorca. This connection may have led to a recommendation from Otway to Lord Carpenter (1657–1732), who was once governor of Minorca and whom Smibert subsequently painted (see cat. no. 223).

Smibert's return to England coincided with the final years of the most dangerous and widespread Jac-

obite hostility.[27] Election and religious riots, publication of belligerent newspapers like *Mist's Weekly Journal,* and the discovery of the Atterbury Plot (a harebrained scheme to overthrow George I) made the early 1720s one of the most uncomfortable periods in London for anyone remotely suspected of Jacobite sympathies. To make matters worse, on October 31, 1722, Christopher Layer (1683–1723), a Jacobite conspirator with Atterbury, was brought to trial. Smibert must have been dismayed by this event, for he had had the misfortune, or naïveté, to be seen with Layer in Rome the preceding year. As Smibert's return to England virtually coincided with that of Layer, he was subpoenaed to appear at the trial, where he was questioned by the solicitor general:

Sol. Gen. Do you know the prisoner at the bar?
Smeybert. Yes, I do.
Sol. Gen. Recollect whether you have seen him at Rome?
Smeybert. Yes, I have.
Sol. Gen. When?
Smeybert. About a year and a half ago.
Sol. Gen. For how long time was he there?
Smeybert. I think about a week or fortnight.
Sol. Gen. Did you or the prisoner leave Rome first?
Smeybert. I left Rome first.[28]

Later Smibert admitted that he "suffr'd much by attending at Layer's Tryal," since it was "a great prejudice to him in his business." Smibert undoubtedly regretted the visibility of his Jacobite associations in Rome, which by now seemed foolhardy. He immediately disavowed any further associations with Jacobites and went so far as to deny falsely that he had painted a portrait of the Pretender.[29] Clearly, Smibert was desperate, vulnerable, and willing to do almost anything—even lie—to prevent his London career from disintegrating before it had begun.

As Smibert struggled to gain a reputation for himself, his outgoing and amiable nature, as well as his "decent modesty" (Vertue's description), enabled him to establish friendships with a number of colleagues. Good friends included Enoch Seeman (1694–1744), a fellow portrait painter, John Harvey (Jean Hervé; 1681–1735), a decorative painter, and John Wootton (1682–1764), a landscape and sporting-picture painter, each of whom Smibert painted in 1723.[30] The first two were foreign-born—Seeman in Danzig and Harvey in Poitou, France, as was the sculptor Peter Scheemakers (1691–1781), another of Smibert's good friends.[31] This suggests that Smibert felt most at home with others for whom London was a foreign city. Seeman, for example, although he had

The Diabolical Mafquerade, 1725.
Or the Dragons-Feast as Acted by the HELL-FIRE-CLUB, at Somerset-House in the Strand.

Thus impious Wretches, without fear or shame, *Defy Eternal Vengeance, as they sit,* *Well may a Kingdom suffer that can see*
Feast & sing Praises in the Devil's Name: *And deal about vile Blasphemies for Wit:* *Such Evils practis'd with impunity:*
Deride those Sacred Powers they ought to dread *High Altars raise to LUCIFER the proud.* *Nor can we hope to prosper, till we mend,*
And live, as if in Hell, before they're dead. *And, Indian like, adore him as their God.* *Do Justice first and Heav'n will prove our*
 Sold by B Cole at the Lock of Hair next Furnivals Inn, in Holborn London & of Printsellers. *Friend.*

35. Unidentified artist, *The Hell-Fire Club*. The British Museum.

been painting in London with some success at least since 1717 (when he did a full-length portrait of George I for Middle Temple), was very much at Smibert's level. That they also admired each other's abilities is apparent from the similarity of certain aspects of their work, such as the treatment of backgrounds seen through squared-off window openings (fig. 34). Smibert's friendship with Wootton may have been precipitated by the former's lifelong interest in landscape painting (see cat. no. 127). Wootton, who along with Peter Tillemans had been commended by Pope as "the two best landscape painters in England," had been painting landscapes as early as 1716.[32] Vertue's description of Harvey as "a man in his time much admired for his facetious conversation, light loose & prophane," seems consistent with the image emerging of Smibert as someone for whom personal relationships were paramount.

Because the London art world of the early eighteenth century lacked internal organization, social clubs took on a disproportionate significance. Clubs were a place where people from all segments of British society could meet. Although daintily named, the clubs differed little from other haunts, such as taverns, beer shops, and gin cellars, that provided refuge from home in the uneasy and brief hours of leisure.[33] Over the next thirty years literally dozens of clubs, ranging widely in both size and longevity, were formed. Their diversity almost defies description. Clubs were founded to reform manners, promote antiquarian interests, or advance careers.[34] One of the most notorious was the Hell-fires, whose members derided religion; they met at Somerset House, next to Smibert's residence. One debauch they held in 1724 was satirized in print. It typifies their blasphemous nature (fig. 35) and gives some suggestion of the dissolute extremes of club life.

Among the more important clubs for artists were the Rose and Crown Club (1703–1743), the Kit-cat (c. 1700–1720), the Slaughter's Coffee House Group (c. 1720–c. 1760), the Roman Club (1723–1742), and the Virtuosi of St. Luke (1689–1743), which was the most prestigious and exclusive. Smibert belonged to the Rose and Crown. It was the largest and most active of the artists' clubs during his years in London and numbered among its members four Scots: the

architect James Gibbs (1692–1754), Andrew Hay, Alexander Nisbet, and Smibert. It was a bawdy assembly of mostly younger artists and *cognoscenti* who met at a tavern in the Piazza, Covent Garden, on Saturday nights.[35] Smibert celebrated his friendship with the Rose and Crown Club members in a painting which he titled *The Virtuosis of London*. Although it has not survived, it was perhaps the most ambitious painting of its type produced by a British artist. Vertue drew a miniature sketch of the painting (fig. 36) and, perhaps because he was included, described it in detail:

1724 in the painting of the Virtuosi of London
piece
designed & begun by Mr. Smibert
are the following persons.
its divided into three groupes
in the Middle. Harvey. painter bald head.
. . . Wotton . . . Gibson
on the left Keller setting at the
Harpsicord . . . Kinkead setting looking
up backwards . . . Cope standing with
fiddle in his hand leaning . . . Bartaoli
behind him . on the right side
. . . Vertue holding - print Bird
looking on Smybert behind &
. Poit [Pond?] pointing up . . . Lens
on the Easel a profil[36]

The painting was large: it was drawn "on a whole len[gth] cloth," a piece of canvas normally used for a full-length portrait (60 × 100 inches), turned on its side. Vertue's description of the painting was made

36. George Vertue, after John Smibert, *Conversation of Virtuosis*, in Vertue's notebook. The British Library.

the year after it was "designed & begun," but it was apparently unfinished at the time and may well have never been completed. Its great size is curious, and had it been a commission Vertue would most likely have mentioned it. It is possible (although somewhat out of character) that Smibert conceived the painting as a vehicle for attention from his colleagues. Presumably, when finished, Smibert would have kept it as confirmation of his successful integration into the London art world. The painting is but one of a succession of early-eighteenth-century artists' club pictures. The composition was preceded by Thornhill's drawing *The Connoisseurs and James Thornhill* (ca. 1714–1719, Leonora Hall Gurley Memorial Collection, Art Institute of Chicago), which depicts Wootton and Gibbs among its six figures.[37] In the next decade Gawen Hamilton (1698–1737) followed suit with *A Conversation of Virtuosis at the Kings Armes (A Club of Artists)* (fig. 37), whose diminutive size was more in keeping with the vogue for conversation pieces.[38]

Smibert's decision to characterize this group as "virtuosi" was not a casual one, as in his mind a virtuoso was a gentleman interested in every branch of culture, from music and fishing to the physical sciences to the visual arts. A painting depicting the virtuosi of London should then be composed of gentlemen of diverse interests and talents. That Smibert conceived such a painting indicates the degree to which he embraced the existing social order of banding together through clubs, masonic lodges, and the like. More than anything, a painting such as this celebrates the values vital to commercial success: confidence, good credit, connections, fellowship, and consumption.[39]

The painting also says a great deal about who Smibert thought he was and whom he considered part of his artistic milieu. Those depicted (in addition to Smibert) included four painters: John Harvey and John Wootton (both of whom Smibert had painted the preceding year), Thomas Gibson, under whom Smibert had studied at Kneller's academy, and Bernard Lens the Younger (1682–1740), a noted miniaturist. The painting seems to honor other friends from Smibert's years at Kneller's academy as well: Kinkead, a little-known engraver; Anthony Cope, a musician, noted connoisseur, and one of the academy's Directors; Francis Bird (1667–1731), the leading British sculptor since Grinling Gibbonn's death in 1720; and Vertue himself. The remaining figures consisted of "Keller," possibly the son of the German seventeenth-century music teacher and composer Godfrey Kneller (d. 1707), and "Bartaoli,"

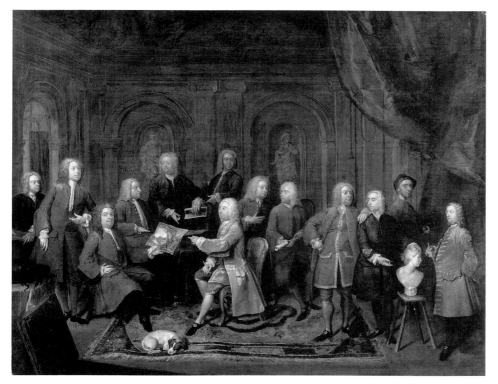

37. Gawen Hamilton, *A Conversation of Virtuosis at the Kings Armes (A Club of Artists)*, 1734–1735. Oil on canvas, 34 1/2 × 43 7/8 in. (87.7 × 111.5 cm.). National Portrait Gallery, London.

possibly the decorative painter Francesco Bartoli. The last figure may represent Arthur Pond (1701–1758), although this identification is highly speculative and suggests a conceit on Smibert's part, as the youthful painter-cum-engraver/art dealer was to become Smibert's lifelong friend.[40]

One characteristic of some of those depicted was, in addition to their prominence in the London art scene, their conviviality and kindness. Gibson, for example, was held in high personal regard by people like Vertue, who considered him "of all the profession my most sincere friend" and "a good ingenious inoffensive man universally beloved for his affability and good nature."[41] Vertue, who became reacquainted with Smibert at least by November 1722, was also generally well-liked.[42] It seems that Smibert was attracted to artists who were outgoing, humorous, honest, and unpretentious, and he may have made it a point to avoid artists who developed a reputation for haughtiness, obsequiousness, pretension, or deprecation. This division may help explain why Smibert nowhere seems to have had much use for artists like Joseph Highmore, whom Vertue accused of having "a desire & affectation of being great in public

reputation," John Vanderbank, who lived extravagantly, Alexander Gordon, who whined and wheedled to curry patronage, or William Hogarth, who ridiculed Scots and was capable of vicious lampoons. Typical of his biting sarcasm at his fellow artist's expense was his reaction to Richardson's remark that because he was little conversant in the study of classical authors he utilized his son as his "telescope." Hogarth's retort, which now only survives in a possibly garbled etching (fig. 38), depicts Richardson peering into a telescope rammed into his son's rectum.

A person curiously absent from Smibert's London circle is Peter Pelham (c. 1697–1751), the mezzotint engraver with whom Smibert developed a close association years later in America. Pelham lived in Covent Garden but did not maintain a high profile, at least socially. He did not, for example, belong to the Rose and Crown Club, and there is hardly any mention of him by Vertue. He had been apprenticed to John Simon (1675–c. 1755) one of the most prolific mezzotint engravers of his generation. Between 1720 and 1726 he produced at least twenty-five mezzotint portraits.[43] Since one of these was of Gibbs and another was after a portrait by Gibson, it seems that Smibert

The complicated R———n

Iknow well enough. my Eye is no Eye at all
I must apply to my Telescope My Son. is my
Telescope tis by his help I read & learned Languages

38. Unidentifed artist, after William Hogarth, *The Complicated R———n*, etching. Vassar College Library, Special Collections.

must have had some contact with Pelham, fleeting though it may have been.

Smibert's modesty and evenhandedness placed him at a disadvantage in competing with opportunistic peers. Despite these circumstances his first two and a half years in London seem to have been good ones. In a space of twenty-nine months (August 1722 to December 1724) he painted more than sixty portraits and earned over £600. His prices—from six guineas (£6 6s)[44] to £7 7s 6d for a bust portrait (30 × 25 in.), from ten to fifteen guineas for a three-quarter-length portrait (50 × 40 in.), and eleven

guineas for a Kit-cat (36 × 28 in.)—fall at the lower end of the spectrum for better-known painters. Kneller, for example, who had received the highest prices of the first two decades of the eighteenth century (fifteen guineas for a bust, twenty guineas for a Kit-Cat, thirty guineas for a three-quarter-length and sixty guineas for a full-length), charged about twice what Smibert did.[45] And when in 1720 Jervas surpassed Kneller with prices of twenty, forty, and seventy guineas for bust, three-quarter-length and full-length portraits, he set a high-water mark for portrait prices in the early eighteenth century.[46] Smibert's prices were in fact less than most of his competitors of the 1720s (Richardson, Dahl and Highmore), who charged twenty to thirty guineas for a three-quarter-length.[47] The only known exceptions to this pricing structure were Aikman, who after settling in London in 1723 charged eight guineas for a bust, and Thomas Gibson, who charged twelve guineas for a three-quarter-length for most of his career, a practice that annoyed many of his ambitious colleagues.[48]

On the whole, however, portrait prices pale in comparison with the fees charged by Thornhill and William Kent for large decorative ensembles. Kent, for example, received more than £5,000 over six years (1722–1727) for painting a series of ceilings and walls at Kensington Palace.[49] Only very few painters, such as Highmore, Vanderbank, and Thomas Hill, had any success pursuing both careers simultaneously. Smibert's annual income (approximately £200–£400 per annum, 1722–1728), which he derived from about thirty pictures annually, places him in the middleground. This is far below someone like Kneller (whom Vertue, in 1721, said earned about £2,000 a year). But Smibert seems to have avoided certain overhead expenses, such as from hiring drapery painters. While such assistance would have enabled him to increase commissions, it also would have increased his expenses by about ten percent or more.[50] And judging by the estimates that other painters gave of the time it took them to paint a portrait (for Highmore, a bust-length or Kit-cat took three to four days, a three-quarter-length four to six days), Smibert already had free time in his schedule. Smibert's income placed him economically and socially on a par with the most humble gentleman, for whom it took about £300 to keep in any style. At that time most petty bourgeoisie earned £50–£100 per annum, a prosperous knight £800, a great peer £10,000—this in a society where a loaf of bread cost 4 pence, a meal in London about one shilling, and a new two-up and two-down brick cottage £150.[51]

Several patterns emerge in Smibert's studio practice. His commissions divide almost equally between bust portraits (32) and three-quarter-lengths (24). Rarely did patrons have special requirements (such as painting a full-length of a child in a 50 × 40 inch format). Smibert, in comparison with more established artists like Richardson or Jervas, may have painted a disproportionately large number of bust portraits because they were the least expensive format and his sitters typically came from a less wealthy stratum of society. Since Smibert was trying to generate income he was not adverse to painting the occasional copy of an existing portrait (by another painter), a practice that more established artists might have avoided. About two-thirds (40) of his portraits were of men; women's portraits seem to have been done mainly as pendant portraits to those of their husbands (4 pairs), while children's portraits appear infrequently. Smibert makes no mention of frames in his accounts, and although he may have made arrangements with frame-makers at the request of sitters, they most likely billed the sitters directly. Wealthy art patrons like Lord Burlington even ordered frames from Paris.[52]

Smibert's sitters were largely upper-middle-class (merchants, lawyers, and professional people); only a handful had titles (Lord Carpenter, Lord Londonderry, the Countess of Erroll, Sir John St. Aubyn, Lady Ross, Lady Ann Heastings, and the Earl of Buchan).[53] Like many other painters, Smibert put business ahead of politics. For example, Kneller was a Whig and Dahl a Tory, but Kneller painted a number of prominent Tories, among them Lords Oxford and Bolingbroke and Alexander Pope. Smibert's sitters ranged from Sir Robert Walpole, to fence walkers like Samuel Hill, to extreme Tories like Sir John St. Aubyn.[54] This apolitical stance was not all that unusual for artists. Andrew Johnston, Smibert's friend, went so far as to engrave a portrait of Dr. Henry Sacheverell, the notorious High Church extremist, who had utter contempt for dissenter Scots. Smibert's efforts to gain Scots patronage were successful, although one would doubt that Willian Aikman, who after settling permanently in London, in 1723, received the lion's share of Scots patronage, ever felt threatened.

By this time the particular mannerisms of Smibert's London style had begun to emerge. Such works as *Colonel James Otway* (plate 6), Smibert's most splendid surviving London portrait, confirm that Vertue's high opinion of him was well-founded. Otway's portrait is crisp, accomplished, and gives another hint that Smibert was attuned to the more polished and animated look of contemporary French portraits. Smibert's use of color is lively, yet controlled, and as a result he avoids some of the murkiness associated with many portraits of the period. He used a gray underpainting to create shadows and modeling—a technique he probably learned from Gibson or indirectly from Kneller. Although other artists, like Highmore, employed this method, it was not universal.[55] Because Otway's armor is painted with such sparkle and precision one might be tempted to speculate that Smibert, like many of his contemporaries, employed a drapery painter. This, however, seems unlikely, as Smibert does not record expenses of this kind in his notebook. Further, Vertue had made a point of complimenting Smibert for what must have been a very similar portrait of "Lord Carpenter in Armo 1/2 length very well," with no reference to drapery painters. His pose, which seems unduly contrived to twentieth-century eyes, exemplifies Richardson's dictum that "the Painter's People much be good Actors, they must have learn'd to use a Humane Body well, they must Sit, Walk, Lye, Salute, do everything with Grace."[56]

Smibert followed established practice for someone indirectly trained by Kneller, and a portrait such as Otway's was completed over several sittings, with a systematic layering of pigments. The painting progressed from "dead colouring" (underpainting), during which the greater areas of form and color were defined using a fitch (a square brush made of hog bristles). This was allowed to dry and was then rubbed with nut oil and varnish.[57] During the next sitting a large, pointed brush (called a pencil) was used to delineate the hair. The pencil was dipped in paint thinned with turpentine, which was then applied in a circular fashion "as the tendency of the Hair requires."[58] During the final stage, and after the colors had been well defined, "sudden lights," or highlights, were applied delicately and using only pointed brushes. Throughout the process the gray ground over which glazes, or transparent layers of color, were painted was used to provide the delicate range of shadows that was desired (see plate 19). The latter method was an early-seventeenth-century technical innovation which had become common practice. In other portraits additional stylistic benchmarks emerge, such as Smibert's penchant for clothing sitters in dressing gowns and nightcaps, as in *Edward Nightingale* (fig. 39), or for interior settings with a heavily framed window opening onto the sitter's estate, as in *Sir John St. Aubyn* (plate 7). Smibert repeatedly returned to these motifs over the next twenty years (see cat. nos. 74 and 133).

39. *Edward Nightingale*, 1724 (cat. no. 17).

But these idiosyncrasies fell well within the accepted limits of fashion for the 1720s. More imaginative practices were limited to the emergence of the conversation piece as a subgenre in portraiture and the occasional exploration of personal physical details. For example, Vertue considered it noteworthy in 1723 when Enoch Seeman depicted a woman "curiously represented as it shows wrinckles, hair, age. the weaving of silk, linen & c."[59] But by and large, an artist was more likely to have success if he followed convention than if he flouted it. Aikman, for example, remarked in 1726 that "it is difficult trying ex-periments here without a very good foundation lest all go to wreck at once."[60] Divergence from accepted norms was a prickly business. The dilemma faced by the portrait painters of Smibert's generation was satirized by John Gay in his 1727 fable "The PAINTER who pleased No body and Every body" (fig. 40). Here it is the painter's plight to show sitters as they wished to be seen instead of revealing the truth, for "Had he the likeness shown, / Would any man the picture own? / But when thus happily he wrought, / Each found the likeness in his thought."

For Smibert, the culmination of these first years in

40. William Kent, *The Painter Who Pleased Nobody and Every-
body,* from John Gay, *Fables* (1727), no. 18. Margaret Clapp
Library, Wellesley College, Special Collections.

London was *Benjamin Morland* (plate 8), a full-length
of the high master of St. Paul's (a select London boys'
school), which both physically and symbolically con-
firmed his ascendancy in the London art world. Al-
though this invitation did not carry the weight of a
commission from a leading political leader or a dis-
tinguished member of the nobility, the opportunity
was a plum. It was the first chance for Smibert to
paint a full-length portrait to be displayed in a more
public setting, and the result is among the most artic-
ulate and well-composed portraits of his career.

Smibert immediately grasped the requirements of
a full-length portrait that would need to dominate a
large room. Morland, who is seated before a library,
makes a rhetorical gesture with his left hand to the
book-topped lectern before him, the very tools of the
educational process. The portrait, which possesses a
formal balance and restrained palette, is both solemn
and dignified, as is appropriate to the occasion. It is a
work of confidence and distinction which avoids both
cliché and hauteur, and it was undoubtedly a work of
which Smibert was justifiably proud.

5

Covent Garden

I N 1725 Smibert moved his studio to Covent Garden, which at that time was the center of London's artistic community.[1] The focal point of Covent Garden was the square, or piazza, designed by Inigo Jones and laid out in the early seventeenth century (fig. 41). Along the northern and eastern edges of the square distinctive, arcaded houses were constructed, which took their names, the Great and Little Piazzas, from the piazza itself. Smibert lived at No. 1 on the Little Piazza, in a residence that adjoined the King's Arms tavern.[2]

During the seventeenth century Covent Garden was the residence of aristocrats like the earls of Bedford, Sussex, and Essex. But even then the square was frequented by those from lower social strata: gardeners and farmers from outlying districts began to set up produce stalls along the south side of the square, outside the walls of Bedford House.[3] By the end of the century the parish still had a number of socially distinguished residents, but the fashionable largely had been drawn away to newer squares: Soho, St. James's, and Leicester, all nearer the court. The parish gradually was taken over by tradesmen, artists, and lodging-house keepers and flourished as a fish and herb market.[4]

At the time Smibert moved to Covent Garden the piazza was alive with commercial and artistic enterprise (fig. 42). Taverns and coffee houses thrived, and at night the area was a playground and marketplace for rakes, pimps, and prostitutes. Drawn by all this activity the number of artists living on or near the piazza continued to swell. A handful of artists chose to live in more socially exclusive areas, such as Lincoln's Inn Fields (Highmore) or Cavendish Square (Wootton). But for the most part Covent Garden became "the rendezvous of most of the celebrated artists,"[5] and their studios were strung out all along the square and adjoining streets. In 1726 Vertue took stock of the artist residents: "1726. Covent Garden Piazza inhabitted by Painters. (a Credit to live

there.) Mr. Gouge at James Street Corner opposite to that . . . Ellis next. Russel . . . Murray. Sr. J. Thornhill . . . Swarts . . . Wright . . . Smybert . . . Angellis . . . VanderVaart . . . Zinke."[6]

Smibert's move was undoubtedly calculated to enable him to cultivate a more prestigious clientele and to charge higher prices. Other London painters were relocating as well. Highmore, in 1727, left Thames Street for Holborn Row, Lincoln's Inn Fields, and Aikman bemoaned the dilemma he faced: that he could not charge more for his portraits unless he rented a more fashionable and better-lit studio, and he could not do the latter unless he first raised prices to set aside the more than £40 a year needed to pay the higher rent.[7] Smibert may well have considered these factors when he moved to Covent Garden. Surprisingly, however, his prices continued at their pre–Covent Garden level (eight guineas for a bust portrait and sixteen for a three-quarter-length). This suggests (as do Smibert's financial records) that his new studio did not bring him the popularity he undoubtedly anticipated.[8]

Not only was his rent higher, but because the new studio was larger and unfurnished Smibert spent over £70, almost thirty percent of his 1725 income, outfitting his new quarters.[9] He detailed his purchases in "An account of Money's laid out in Furniture & other necessarys for My Apartment in Covt. Garden":[10]

	£	s	d
Painting Window .	4:	10:	0
Eight chairs at 1: 2 pr Ch	9:	2:	0
Twelve chairs at 14s pr Ch	8:	8:	6
A Cabinet. .	12:	12:	0
Two Mohogony Tables	3:	16:	0
Bed Stead & Windw. Curtains	23:	15:	0
Glasses & Earthen Ware	1:	0:	0
Pewter. .	3:	6:	0
Turners Ware .	1:	12:	7
Glaziers Work .	0:	16:	0
Looking Glass undr. the Painting Light .	4:	0:	6

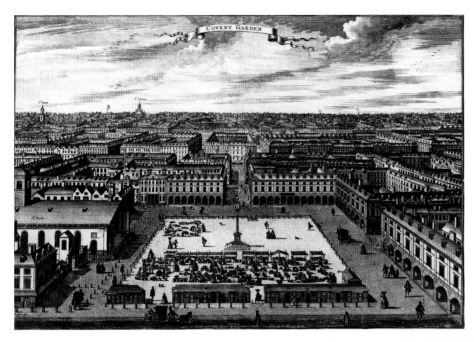

41. Sutton Nicholl, *The Piazza, Covent Garden,* c. 1717–1728. Engraving. The British Museum.

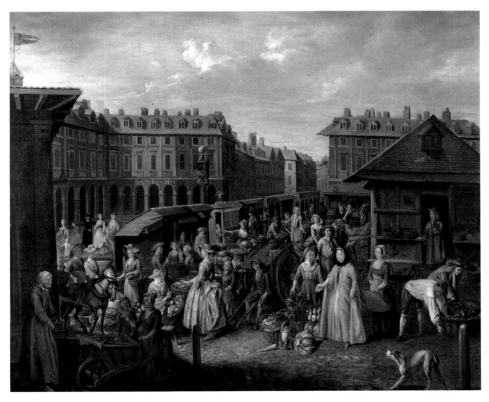

42. Joseph Van Aken, *Covent Garden Market,* c. 1726–1730. Oil on canvas, 25 × 30 1/8 in. (63.5 × 76.5 cm.). Government Art Collection of the United Kingdom.

His studio apartment probably consisted of no more than two rooms: a living room, in which he painted, and sleeping quarters. One can imagine the walls of Smibert's studio hung with his collection of copies and works in progress resembling (on a more modest scale) that depicted by Peter Tillemans about 1716 (fig. 43). The "Painting Window" was perhaps a skylight or large window Smibert had installed in his new quarters. It is also possible, however, that Smibert's painting window was a wooden frame crossed with thread that the artist placed between himself and the sitter (fig. 44). The painting window described in Robert Pricke's *Perspective Practical*, with which Smibert was familiar,[11] provided a grid pattern for painters to enlarge small sketches by means of "squaring up." This practice insured that elements of the composition would remain in proper scale in relation to each other. It had originally been developed to supply the artist with "map references" to transfer small sketches to a large cartoon. By Smibert's time the use of a drawing form was frowned upon by some as an "evil practice" that should be resorted to only for extremely large paintings.[12] Smibert's concern for adequate light shows in his expenditure on "Glaziers Work" and the "Looking Glass undr. the Painting Light." This mirror was probably like that used by Kneller, who "had two looking glasses behind him so that they [his sitters] could see the life & the picture."[13]

During this same year Smibert sought to improve his stature in the community by joining the Society of Antiquaries, in April 1725.[14] If the Rose and Crown Club illuminates Smibert's efforts to gain standing among fellow artists, his membership in the Society of Antiquaries (like Thornhill's and Highmore's membership in the Freemasons) suggests that he was casting his net for patronage further downstream. Smibert of course may have had a sincere interest in antiquarian issues and objects. Certainly many Scots in the time after the Act of Union were looking to rediscover and reassert their Scottish identity, and Scottish nationalism and antiquarianism were inevitably linked.[15] In fact, the Society solicited Scots as members, as their antiquarian mission had another utilitarian goal: to "promote the ends of Union, since Communication with the Scotch will ensure, which begets mutual love."[16] Society records document Smibert's contributions at meetings, and this participation brought him into regular contact with numerous people capable of commissioning portraits from him.

The Society, which was revived in 1717, "agreed to meet one evening in every week to cultivate the Knowledge of Antiquities of England."[17] Smibert was nominated for membership by Henry Johnson (1698–1760), a noted traveler, whose most impressive achievements were his exploits in South America and subsequent writings about them.[18] At the time Smibert joined, the Society consisted of more than a hundred members, including Smibert's professional acquaintance George Vertue. The only other artist members were James Thornhill, John Talman, and James Hill (d. 1728), an amateur. Thornhill and Hill were also members of the Rose and Crown Club,[19] but there is no indication how well Smibert knew them. Most Society members were English, but there

43. Peter Tillemans, *The Artist's Studio*, c. 1716. Oil on canvas, 26 7/8 × 33 in. (68.3 × 84 cm.). Norfolk Museums Service (Norwich Castle Museum).

44. Abraham Bosse, *The Drawing Frame*, 1637. The British Museum.

were a few other Scots: Sir John Clerk and Alexander Gordon (c. 1692–c. 1754) joined in 1725, and James Gibbs joined in 1726.[20] Whether Vertue encouraged Smibert's membership is unknown, but their regular participation at meetings lends further authority to the engraver's biographical comments about him.[21]

Like the Rose and Crown Club, the Society met at a tavern—the Mitre Tavern, in Fleet Street. At each meeting individual members brought antiquities for inspection and discussion: bits of ironwork and pottery, amulets and coins, often decorated with scenes from classical mythology.[22] Among the more macabre objects presented were a "large Sceleton found near Chippenham Cambr., with massy chains and fetters dug near him" and a Roman urn filled with bones.[23] Society members' fascination with such objects may explain why Smibert was paid £5 5s in April 1725, the month he joined the Society, for "A Pictor of a large boon of a leeg [leg bone]."[24] One of the priorities of the Society was the publication of prints of ancient buildings, coins, and other subjects of antiquarian interest, to which the members were expected to subscribe. These promotions served artists like Vertue, who on May 26, 1725, "brought 50 prints of Each of ye Gates of Westminster" to their meeting (fig. 45).[25] Alexander Gordon (1692–1754), a fellow Scot of dubious ethics and generally unpleasant demeanor, also used the Society for self-promotion by seeking subscribers to his *Itinerarium Septentrionale: or, a Journey Thro' most of the Counties of Scotland and Those in the North of England*, which was published the following year.[26] Smibert subscribed to both Vertue's and Gordon's prints. As Gordon's volume had little practical value for a portrait painter, Smibert's interest presumably was diplomatic. At no fewer than two Society meetings Smibert was a contributor, which may suggest that he was a collector at heart. On March 2, 1726, "Mr Smibert brought an Old Book of wooden small prints very well cutt being designs for scenes & characters," and two months later he brough several coins depicting portraits of Queen Elizabeth and James I.[27] After these meetings, however, Smibert's attendance, like that of much of the membership, waned. Since his presence had not encouraged members to seek him out for their portraits, the Society seems to have outlived one of its purposes.

By the 1690s poems had become a vehicle for promoting painters. Dryden's "To Sir Godfrey Kneller" (1694) and Pope's "Epistle" (1715) to Jervas are early examples of this genre. In 1726 one such poem, unpublished but presumably privately circu-

lated, praised Highmore, as did "Design and Beauty" (1728) by Isaac Hawkins Brown. Three years later Joseph Mitchell published "Three Poetical Epistles, To Mr. Hogarth, Mr. Dandridge, and Mr. Lambert, Masters of the Art of Painting," which it has been suggested may have been paid for by Hogarth.[28] Among the most elaborate of these odes was a 1725 poem entitled "A Session of Painters Occasioned by the Death of the Late Godfrey Kneller." The poem describes the appearance of Apelles and his efforts to determine a successor to Kneller. A number of claimants step forth, including Smibert, but none is deemed worthy. The poem mentions several London artists but omits such figures as Jervas, Richardson, and Dahl, so it was probably the work of one of Smibert's younger contemporaries, perhaps a member of the Rose and Crown Club. While some artists were dismissed out of hand, others, like Smibert, were praised:

> The God's piercing eye soon Smy——t saw
> With Dy——r by his side.
> Thy merit Smy——t hust applause will draw,
> Apelles smiling cried
> In Dy——r both the sister arts agree
> To please in painting, and in poetry.[29]

"Dy——r" most likely refers to John Dyer (1699–1757), a Welshman, who apprenticed to Richardson while at the same time pursuing an interest in poetry. His closest friends during the 1720s included Arthur Pond and George Knapton, with whom he founded the Roman Club. The year this poem was published he returned from Rome and Florence, and Smibert may well have become friends with him soon thereafter. Smibert and Dyer had much in common: they believed in the precepts outlined by Richardson, they had made the tour of Italy, and they had tried their hand at landscape painting. In many ways Dyer, who left London in 1730 when his health gave out, resembled Smibert, as he loved books, study, and more contemplative ways. Like Smibert, who found competition a trial, he could not "submit to the assiduity required in his profession."[30]

If Smibert had anticipated a jump in income and a more wealthy clientele as a result of his relocation to Covent Garden, he was sorely disappointed. Not only did his actual income of 1726 drop by one-third from that of the preceding year (from £344 14s in 1725 to £232 14s in 1726), but his range of sitters remained largely unchanged. On the positive side, established clients, such as the Hucks, Ferne, and Sparks families, returned for additional portraits. And Smibert's list of nobility and other reasonably prominent cli-

45. George Vertue, *Gates of Westminster*, 1725. Etching. Author's collection.

ents (Lord James Cavendish, Sir John Rushout, Alderman William Billers, Nathaniel Gould, and the Moroccan ambassador) continued to grow. He also painted a fine portrait of his friend, the French engraver Claude DuBosc, about which Vertue somewhat uncharacteristically crowed: "of many pictures of Mr Smybert's doing a head done of C. Dubosc Engraver. on a Kit-Cat. well disposed. strongly painted tho clear. the action mightily well disposed & like him."[31] But the tenor of this period—unfulfilled anticipation—is exemplified by the visit of Archibald Grant, son of Smibert's former Scottish patron, who came to see the new studio and commissioned a portrait, only to cancel it later.[32]

In an effort to make himself more attractive to potential clients (or at least provide an additional service to them) Smibert began to paint miniatures from life. Although none of his London miniatures have been located, the discovery in 1987 of his American oil-on-copper miniature of Samuel Browne (cat. no. 103) documents his practice of painting them. With whom he studied is not known, but a good possibility is Bernard Lens, one of the leading miniaturists of the period, whom Smibert had included in his por-

trait of the Virtuosi of London. Smibert first records painting a miniature in 1725 ("a head of a Child in littele"), which was a copy of an existing work. In March of that year he also records painting "a Littel Venus," conceivably an allegory about beauty done in miniature, which would be quite rare for the period. The following year he had the opportunity to paint three miniatures for the Hucks family, for which he charged two and three guineas each. Such commissions would not keep the wolves from the door, but they might help to remind patrons of his versatility.

It is not surprising that in these years Smibert did not gravitate towards creating conversation piece–scale portraits in the manner of Philip Mercier or Bartholomew Dandridge. The transition to the format and the informality that the conversation piece conveyed was probably too great an innovation for someone of Smibert's training to undertake. The development of this genre was left to younger artists who either were more flexible in their approach to painting (like Hogarth) or found a niche for themselves as painters of conversation pieces (like Charles Philips or Gawen Hamilton).

Smibert's ability to paint miniatures as well as life-size portraits may have been the reason he received a commission in February 1726 from Sir Robert Walpole to paint a copy of an existing portrait as well as two miniatures.[33] Although he received payment only for the miniatures, not for the copy, he apparently used this opportunity to secure, in exchange, permission to paint a copy of Nicholas Poussin's *Continence of Scipio* (plate 9), the most recent addition to Walpole's considerable art collection. (The original, which was acquired from the Comte de Morville, was apparently sold to Walpole in 1725, when the diplomats had occasion to meet.)[34] Smibert may have been among the first artists Walpole allowed to make copies from his collection, although the collector continued to grant this privilege at least until the early 1740s, when Ranelagh Barrett (fl. 1737–1768) also made a copy of the Scipio (see cat. no. 143).[35]

Smibert's admiration for Poussin's painting was shared by other British artists, and in 1742 it was engraved by Smibert's friend DuBosc. It is conceivable that DuBosc, as he sat the following month for his own portrait by Smibert, had ample opportunity to see the copy in Smibert's studio. Smibert undoubtedly considered this copy a coup. The popularity of Poussin reflected the general British preference for the classicism of the Franco-Italians, including Claude and Gaspard. (The Italian Baroque, particularly Guido Reni and Carlo Maratta, was second in popularity, with the Dutch and Flemish painters like Rembrandt, Poelenburg, Tenirs, Vanderwerff, and Wouverman a distant third.)[36] Having a copy of a Poussin in his studio would by association draw Smibert closer to the classical ideals of beauty and rational order. It was another advertisement of the philosophy that guided Smibert's style. Further, his appreciation of Poussin and the ability to paint such a copy would have impressed visitors as well.

In June 1726 Smibert renewed his acquaintance with George Berkeley. At the time Smibert's reduced commissions and his decision to relocate to Covent Garden were probably weighing heavily on his mind. His personal life may have also given him pause. He was almost forty years old, unmarried, without heirs, and living in what could still only seem to him a foreign country.

For his part Berkeley, after his years of travel on the continent, had returned to England, where he found a nation profoundly agitated by the collapse of the South Sea Company after rampant financial speculation, which he viewed as evidence of national corruption. He was moved to write an *Essay toward Preventing the Ruin of Great Britain*, in which he advocated a greater simplicity of life, the encouragement of art, and the adoption of sumptuary laws.[37]

Two years before reestablishing his ties with Smibert, Berkeley was appointed dean of Derry, in Ireland. It was considered "the best Deanery in the Kingdom" and was worth £1,500 per annum.[38] While there, in the spring of 1722, Berkeley formulated a plan, labeled frivolous by some and visionary by others, to devote his life to philanthropy and establish a college in Bermuda.[39] Debacles such as the South Sea Bubble made Berkeley pessimistic about the future of Great Britain and more particularly about the future of Protestantism there. To him, the American colonies were the last line of defense against the evils of Catholicism and European society. The island of Bermuda (fig. 46), removed from both Europe and America yet having trade with each of the North American colonies, would provide the necessary base of operations for the college. It had an arcadian climate similar to that of the island of Ischia, near Naples, which captivated Berkeley during a visit there in 1717.[40] The college would educate the children of colonists, act as a bastion against the further spread of Catholicism from French and Spanish colonies, and train aboriginal Americans for their role in a massive effort to convert "the savage American races to Christianity."

In 1724 Berkeley set out for London to gather sup-

46. *The Summer Ils. (Bermuda),* from John Smith, *General Historie of Virginie, New England and the Summer Isles* (1624). Public Archives of Nova Scotia, Halifax.

port for his Bermuda project. In June 1725 he obtained a charter for the college, which named him president and appointed the first three of nine fellows.[41] The following year, while still in London, Berkeley looked up Smibert, his old acquaintance from Italy, and for the second time sat for his portrait (plate 10), in which (in contrast to the bewigged gentleman of his Italian trip) the artist depicts him wearing the black cassock and tab collar customary for clerics.

Two months after the portrait was commissioned, in August 1726, Berkeley wrote to a friend, "I have quitted my old lodging, and desire you to direct your letters to be left for me with Mr. Smibert, painter, next door to the King's Arms tavern, in the little piazza, Covent Garden."[42] This living arrangement suggests not only that Smibert was already acquainted with Berkeley's plan but also that by this date he was toying with the idea of accompanying him to Bermuda. In December Berkeley commented on property that had been unexpectedly left to him by Esther Van Homrigh, known as Vanessa, an intimate of Jonathan Swift. The property included some paintings, of which Berkeley wrote, "I shall take care the pictures be sold in an auction. Mr. Smibert, whom I know to be a very honest, skillful person in his profession, will see them put into an auction at the proper time, which he tells me is not till the town fills with company, about the meeting of parliament."[43] Two months later Berkeley reported to Prior that the paintings had been sold for £45 at the house of Anthony Russell, a painter who lived across the piazza from Smibert. Berkeley added that "the truth of it is,

that of late years the taste lies so much towards Italian pictures, many of which are imported daily, that Dutch pictures go off but heavily. Mr. Smibert did not think they would have brought so much."[44]

Russell's auction of 1726 is evidence of the rapid growth in the art market which occurred during the years Smibert was in London.[45] The demand for pictures of all kinds was a reflection of greater spendable income, easier access to the Continent, a heightened awareness of art, and changes in customs duties (1721) so that works were taxed according to size rather than value. Many artists eager to supplement their fluctuating income from painting availed themselves of the opportunity to help clients acquire pictures. In some ways the painter's need to supplement his earnings with other activities, such as dealing, restoring paintings, or operating a color shop, is similar to the predicament faced by men of letters who could not prosper on their income from literary work alone and so became private secretaries (Addison) or took employment with the court or administration (Steele, Congreve, and Prior).[46] There was no clear division between artist and dealer. Scots were particularly visible; Smibert's boyhood acquaintance Andrew Hay (London's first professional art dealer) played a dominant role in seeking works for clients, bringing pictures to England, and arranging auctions; others, like Aikman, Gordon, and Gibbs, did their share of buying, selling, or transporting works of art for collectors.

Between 1711 and 1729 there were at least twenty-two London art auctions and probably many others for which catalogs do not survive.[47] They not only supplied collectors with paintings but also enabled artists like Smibert to see what was in vogue and what was not. Two of Smibert's own patrons, for example, Sir Robert Furnese and Lord James Cavendish, a brother of the Duke of Devonshire (cat. nos. 225 and 295), bought landscapes attributed to Gaspard Poussin at Hay's 1725/26 auction (fig. 47). This suggests that some of Smibert's clients were aspiring connoisseurs and not simply outfitting their houses with portraits, as was frequently the case.

Smibert's own estimate of his predicament during these months may have changed with the seasons. All was not bad. On the one hand he had, as Vertue noted, "very good business here."[48] In fact, 1727 was one of Smibert's most productive London years. By this time he averaged more than thirty portraits a season, (the six or seven months Parliament was in session), and many of these were three-quarter-lengths or multifigured compositions. The greatest activity was in March and June; and although there

COLLECTION of fine *PICTURES*,

Brought from ABROAD by

Mr *ANDREW HAY*.

Will be Sold by AUCTION, at Mr. *Cock's* New-Auction-Room in *Poland-street*, the Corner of *Broad-street* near *Golden-Square*, on *Saturday* the 19th of this *Inst. February*, 1725-6. The Pictures may be view'd on *Wednesday* the 16th, and every Day after till the Hour of *SALE*, which will begin at 11 o'Clock in the Forenoon precisely.
CATALOGUES to be had at the *Place of Sale*, and at Mr Hay's in Monmouth-Court near Suffolk-street.

47. *A Collection of Fine Pictures, Brought from Abroad by Mr. Andrew Hay,* 1726. The British Library.

was usually a lull in painting from July to November, Aikman noted in the summer of 1727 that "business does not att all ebb tho it is the summer season when it used to be very dead."[49] Scottish patrons, such as the Grants, were providing some new opportunities for Smibert, with such commissions as *Sir Archibald and Lady Grant* (plate 11). This painting was Smibert's first attempt to depart from the more rigid formulas that dominate his previous work. As a double portrait, it is a novelty in British painting prior to 1740 (see cat. no. 34). The portrait is, in fact, a combination of old, tested motifs, such as Sir Archibald's attire, and new elements, such as a loose-fitting wrapping gown, a French *bergère* hat, and basket of flowers (symbolic of love), which convey a greater informality. The painting is also evidence of the French influence in the 1720s, as artists like Smibert gently began to accommodate the increased popularity of artists like Watteau with British collectors. Particularly evident is a fluidity of brushwork which sets these (and subsequent) London paintings apart from

his earlier work there. This trend continued with such portraits as *Mrs. Edward Nightingale* (plate 12), done at virtually the same time. The lighter palette, shimmering surface texture, and incipient rococo rhythm most likely reflect the appearance of prints after works by Watteau (who had visited London in 1719) and the rise of Watteau's disciple Philip Mercier (1689–1760).

Unfortunately, despite Smibert's stylistic growth and upsurge in patronage, he may well have been beset by clients who did not pay their bills. The English nabobs expected infinite lines of credit, so artists like Smibert were forced to invest in their betters.[50] The standard practice for artists was to receive half payment at the time a portrait was commissioned. Kneller is said to have left five hundred portraits unfinished at his death, "for which he had been paid half the money beforehand."[51] Some clients, however, paid nothing. In 1729 Aikman lamented that although he had painted several pictures for Lord Burlington, among the wealthiest patrons of the arts, his bills had not been paid. Another Aikman client, "Murray of Broughton," was on his deathbed when Aikman observed that he "left his picture on my hand 3 years a goe."[52] Smibert found himself in a similar position with Sir Archibald Grant, who at the very moment he was sitting for his unpaid portrait was unable to pay his enormous debt to his stockbroker for losses on shares of the York Buildings Company. As Grant sank deeper into the economic morass of his own making he speculated with the funds of the charitable corporation of which he was a director. As a result Smibert was never paid for this portrait or two others Grant most likely commissioned (cat. nos. 30 and 310), although Grant— who declared bankruptcy in 1732[53]—signed a promissory note on which Smibert never collected. Smibert's records are silent on which other patrons stiffed him, although it seems reasonable that on other occasions as well Smibert probably suffered the fate of the painter in John Gay's contemporary fable: "in dusty piles his pictures lay / for no one sent the second pay."[54]

Facing this predicament, Smibert did not hesitate long after Berkeley's formal offer to join his proposed college as a professor of painting. To someone of Smibert's background, temperament, and religion, the invitation was particularly intriguing. Berkeley's noted wit and charm were an irresistible siren's song, as was the prospect of a more tolerant religious climate. Since he was often in poor health, an improved climate would be to his advantage. But above all Smibert seems to have wanted refuge from

the stifling London art scene. As Vertue noted, Smibert was inclined "towards honest, fair & righteous dealing—he could not well relish, the false selfish griping, overreaching ways too commonly practiz'd here. nor was he prone to speak much in his own praise. nor any violent ways but a descent modesty. which he thought in such a retirement, as at Bermudas he might live quietly & for a small expence. & make a great advantage. by ready money declaring he rather sought repose, than profitt."[55]

Smibert's desire to leave London was not all that unusual. His fellow countryman Aikman had felt the same anxiety about being there: he would have rather stayed in his home town but knew "there is no more to be done in my way at Edinburgh."[56] Despite his early success in London—patronage by influential Scots like the Duke of Argyll and by prominent Englishmen like Walpole and Lord Burlington, as well as several royal commissions—all was far from well. Aikman felt constant pressure to move into a larger house in order to increase his income (fancier quarters attracted wealthier clients), but despite patronage and commissions he stayed poor. Like Smibert, he suffered from sitters who paid late or not at all. In order to compensate he worked harder, and his health declined. As he grew more and more homesick he bewailed the hopelessness of his real dream: "as soon as I am able to, I intend to feu [rent] some acres in your neighborhood, to build me a small mansion and to live retired."[57] London wore him out; but whereas he died there, Smibert escaped.

In Smibert's case, part of his anguish over London's cutthroat methods reflected his religious scruples. As a Presbyterian he had been taught a doctrine that emphasized an earnest desire for control over self and others for righteousness' sake. This sense of moderation and morality was unique in English society and ran counter to the general emphasis on personal success at any cost. Occupations did not tend to breed any sense of corporate professionalism or collective good, and individuals climbed over each other in the struggle for advancement. The fierce competition among painters for clients resembled that among physicians for patients: a successful London physician could pocket up to £12,000 a year in fees.[58]

Like the various contributors to the Bermuda project, Smibert was impressed by the nobility of Berkeley's proposal, for he detested society's emphasis on material things at the expense of intellectual beliefs. He seems to have been willing to overlook the absence of precise details as to how the college was actually supposed to function. He certainly would

have looked fondly upon Berkeley's idealized plan to "build villas and plant gardens, and to enjoy health of body and peace of mind" (fig. 48).[59] The proposed city was outlined with an eye for symmetry. Broad avenues radiated out from a central square dominated by a church. The academy for painting, like that for music, was kept distinct from the college, at a distance of a quarter mile.[60] Berkeley seems to have intended that Smibert hold a post similar to Kneller's as the director of an autonomous academy. This idea must have appealed to Smibert, who seems to have

48. *The City of Bermuda, Metropolis of the Summer Isles*, from George Berkeley, *The Works of George Berkeley*, vol. 2 (Dublin, 1784). The British Library.

remembered with affection his evenings spent in the house on Great Queen Street and hoped to emulate that experience by instructing others.

As a professor his role was to teach art in the new college as part of a liberal studies program which would have at its core instruction in history, "Eloquence" (rhetoric), practical mathematics, and "some Skill in Physic."[61] Art was not part of the traditional curriculum of colleges such as Harvard, which provided a grounding in logic and rhetoric, Greek and Hebrew, ethics and metaphysics, and mathematics and natural philosophy.[62] That Smibert would give lectures on painting and architecture to inculcate the virtues of Christian and European civilization borders on the revolutionary. Whether he was at all uncomfortable at the thought of Native American children being plucked from their families for such an education is unknown.

Smibert purchased a copy of Captain John Smith's *The Generall Historiie of Virginia, New England, and the Summer Isles* [Bermuda] . . . (1624) to get an idea of the land in which he would be living.[63] Smith observed that "the air is most commonly clear, very temperate, moist, with a moderate heat, very healthful and apt for the generation and nourishing of all things." Crops were said to grow in abundance and variety and the hills were covered with tall, sturdy cedars. Aside from some rats and cockroaches there was almost nothing to prevent Smibert from believing that Bermuda was Eden on earth. And Smibert may have known that by the end of the seventeenth century Presbyterians were the dominant religious group in Bermuda.[64]

In 1727 Berkeley's proposal was subjected to a devastating critique in Thomas Bray's *Missionalia; or, a Collection of Missionary Pieces Relating to the Conversion of the Heathen* (1727). Bray, who had been a missionary in America, contended that Indians in Virginia were reluctant to send their children a mere forty or fifty miles to the College of William and Mary, let alone six hundred miles across the ocean to Bermuda.[65] He also pointed out that Bermuda's landscape had in recent years been blighted: the great cedars had been cut down, the land was "very poor and barren," and crops were plagued by insects.

Berkeley was aware of the flaws in his plan and early in 1728 made some changes. He chose Rhode Island as a more logical temporary destination until settlement in Bermuda could be arranged. For Smibert, who through 1726 and 1727 remained undecided about whether to accompany Berkeley, the idea of settling in Rhode Island, a pluralistic community that had already attracted a number of Scottish settlers, may have had greater appeal. Even if the Bermuda scheme did not materialize, Smibert's adventurous spirit must have led him to conclude that Rhode Island promised to alleviate the distress he felt in England.

In due course he tried to settle his London accounts, sought to collect outstanding payments from recalcitrant sitters, readied himself for departure by stocking painting supplies (canvas, colors, brushes, and the like), and said goodbye to friends. The organizations to which he belonged, such as the Society of Antiquaries, were quite used to the fluidity of the London art world and simply took stock of his departure with the cryptic (and inaccurate) note after his name, "went to the West Indies."[66] Six years to the month after he had opened his studio, and having painted 175 portraits, Smibert brought his London career to a close.

Berkeley persuaded five people to accompany him to America: Smibert, John James (d. 1741), Richard Dalton (d. after 1770)—described variously as "Men of fortune" and "gentlemen of substance"[67]—Anne Forster, whom Berkeley had married in August 1728, and Forster's traveling companion, a Miss Handcock. On September 5 Berkeley's entourage departed. Smibert's personal description of the event was typically terse: "In September the 4th [*sic*] 1728 I set out for Rhod Island from London in Company with the Revd. Dean Berkeley &c in the Lucy Capn. Cobi. . . ."[68] The *Historical Register* confirmed the group's embarkation in rather indifferent fashion "in a ship of about 250 tons which he [Berkeley] hired. He took several [*sic*] tradesmen and artists with him. Two gentlemen of fortune are gone, with their effects, to settle in Bermuda."[69] Berkeley's last communication before his departure was written to a friend, Thomas Prior, on September 5th: "Tomorrow, with God's blessing, I set sail for Rhode Island, with my wife and a friend of hers, my lady Hancock's daughter, who bears us company. I am married since I saw you to Miss Forster, daughter of the late Chief Justice, whose humour and turn of mind pleases me beyond any thing that I know in her whole sex. Mr. James, Mr. Dalton, and Mr. Smibert, go with us on this voyage. We are now all together at Gravesend, and are engaged in one view."[70] Berkeley and his entourage intended to wait in Rhode Island until Parliament officially approved the £20,000 required to establish the college in Bermuda. Smibert's outlook shows in some verse (undated) that he penned in his notebook:

Let lawles power in the East remain
And never Cros the wide Atlantick main
Here flourish learning trade & wealth increas
The hapy fruits of Liberty and peace[71]

The group's arrival was delayed by an exhausting four-month voyage. One newspaper reported that "they had a tedious Passage; and were oblig'd by contrary Winds, to put into Virginia, where they were handsomly received."[72] On January 6 they sailed up the York River to Williamsburg but remained in Virginia only ten days.[73] During their short stay Berkeley, and presumably the others, dined with Governor William Gooch and visited the College of William and Mary.[74] On January 16 the group set sail for Rhode Island, their original destination.[75] Dalton and James, who were fatigued from the perilous Atlantic crossing,[76] remained behind, planning after sufficient rest to make their way overland to Rhode Island. One week later Berkeley's group arrived in Newport, an event announced in the *Boston Gazette*, 27 January 1729.[77]

Berkeley had selected Newport over Boston or New Haven because in those colonies the "Congregational Way" was established by law. The presence of someone of Berkeley's stature would have been quite threatening to a population dominated by the likes of Cotton Mather and might well have needlessly raised suspicions about his intentions.[78] Newport was home to a diverse population. The main religious group was the Society of Friends (Quakers), but there were also many Baptists, Anglicans, and Congregationalists. Upon arrival, however, Berkeley was amused that there was far more preoccupation with material wealth than he had anticipated. "The men," he observed, were dressed "in flaming scarlet coats and waiscoats, laced and fringed with brightest glaring yellow. The sly Quakers, not venturing on these charming coats and waistcoats, yet loving finery, figured a way with plate on their sideboards."[79] One Quaker, who had purchased a solid-gold teapot, told Berkeley, "I was resolved to have something finer than anybody else. They say that the Queen has not got one."[80]

Berkeley's reception in Newport was diplomatic and cordial.[81] According to one account, his group was greeted by Reverend James Honyman, rector of Newport's Anglican Church. Within a month, on February 18, Berkeley purchased for £2,500 a ninety-six acre farm, which he named Whitehall.[82] The dean planned to use the farm as a temporary base of operations while he awaited Parliament's appropriation of funds for the college. Once the college was relocated in Bermuda, the farm would be retained as a source of provisions.

Smibert apparently remained in Newport for several months. In one, possibly apocryphal, description of Smibert's arrival in Rhode Island it is said that he "was employed by the Grand Duke of Tuscany, while at Florence to paint two or three Siberian Tartars, presented to the Duke by the Czar of Russia. This Mr. Smibert, upon landing at Narragansett Bay with Dr. Berkeley, instantly recognized the Indians to be the same people as the Siberian Tartars whose pictures he had taken."[83]

By April 11th Berkeley wrote in a letter that Smibert was in Boston. He noted that James had still not arrived from Virginia but that "Dalton hath been here some time, he and Smibert are now in Boston where they proposed passing a few daies."[84] Little did Smibert know that what was originally conceived as a few days' visit would turn into a lifetime residence. With approximately thirteen thousand inhabitants, Boston was the largest city in the colonies and roughly three times the size of Newport.[85] And although less than one-third the size of Edinburgh, its similarity of scale must have brought welcome relief from the tumultuous disorder of London.

6

Boston and *The Bermuda Group*

SMIBERT'S trip to America in 1728 was the turning point in his career. This change of venue, however, did not particularly advance his own artistic development, which in a relatively short time came to a virtual halt. In fact, with the exception of the occasion to create his most important painting, *The Bermuda Group*, this great window of opportunity was rather a sentence of exile from all that was vital in the London art world.

But none of this would have been apparent to Smibert as he approached Boston from the sea on a spring day in 1729. There he entered a snug, well-protected harbor, guarded by a fort, Castle William, that boasted 120 cannon. Before him, hugging the jagged peninsular coastline, lay a town perched on a hill (fig. 49). Above the roofs of the four thousand brick and clapboard dwellings were the spires of seven Congregational churches. They physically dominated the landscape the way their parishioners dominated the community. Above them was visible the light tower on the aptly named Beacon Hill, the highest point in Boston.

Smibert most likely landed at Long Wharf. Surrounding it were the numerous docks and wharves that crowded the banks of Town Cove. For its size, Boston's port was impressive—"the metropolis of New England," its citizens called it. Boston was the seat of commerce; more than a thousand ships annually cleared customs, bringing finished goods from England and hogsheads of molasses from the Caribbean, and most of the hundreds of ships built in New England were outfitted there.

Only eleven years earlier one English visitor to Boston had observed:

The Conversation in this Town is as polite as in most cities and towns of England; many of their Merchants having travell'd into Europe; and those that stay at home having the advantage of a free Conversation with Travellers, so that a Gentleman from London would think himself at home in Boston when he observes the Numbers of People, their Houses, their Furniture, their Table, their Dress and Conversation which is perhaps as splendid and showy, as that of the most considerable Tradesman in London. . . . [I]n the Concerns of Civil Life, as in their Dress, Tables and Conversation they affect to be as English as possible, there is no Fashion in London, but three or four Months is to be seen here at Boston[1]

Despite this rosy assessment of colonial life, most Bostonians probably knew better. Such commonplace events as the killing of twenty bears within two miles of Boston during one week in 1725 were none-too-subtle reminders to the citizenry that Boston was a colonial outpost.[2] Currency problems, a trade imbalance, and depressed shipping had led another equally subjective observer in 1720 to remark that whereas Boston had once flourished, it had become "the most miserable Town herein."[3] The reality was somewhere in between.

The town (fig. 50), which celebrated its centennial the following year, was still of modest scale. One could easily walk in less than an hour from the tip of the North End to the gallows just outside the fortifications on Boston Neck, a distance of about two miles. The first building Smibert would have encountered as he stepped off Long Wharf was the Bunch-of-Grapes Tavern, one of literally dozens of licensed drinking houses.[4] Despite its Puritan heritage, Boston in many ways resembled other provincial British towns; the winding, crooked streets may even have reminded Smibert of Edinburgh. Just up King Street was the center of Boston, and at Cornhill stood the recently built brick Town House, the seat of the local and provincial governments, the courts, and the merchant's exchange. Opposite was the First Church, the oldest of Boston's Congregational churches and the

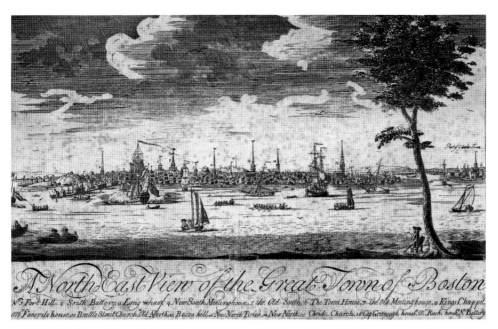

49. William Burgis (attrib.), *A North East View of the Great Town of Boston*, c. 1723. Engraving. Peabody Essex Museum, Salem, Mass.

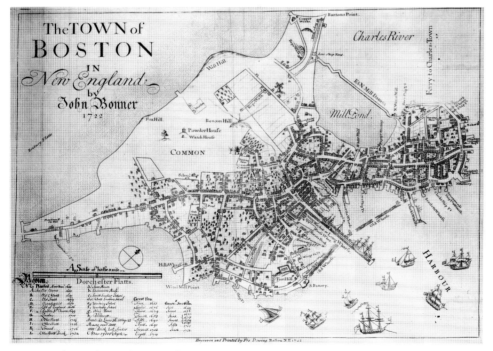

50. Francis Dewing, *The Town of Boston in New England by John Bonner*, 1722, engraving. I. N. Phelps Stokes Collection, Miriam and Ira D. Wallach Division of Art, Prints and Photographs, The New York Public Library, Astor, Lenox and Tilden Foundation.

51. Clark-Frankland House, Garden Court Street, Boston, c. 1712. Oil on wood panel. Courtesy The Bostonian Society/Old State House.

52. Coat of arms of Painter-Stainers Company, London, 1697, with Boston additions dating from before 1701. Courtesy The Bostonian Society/Old State House.

physical and spiritual center of its religious life. A short distance away were the commodious houses of Boston's merchants, such as the lavish, three-story brick house with twenty-six rooms built by William Clark in 1711 (fig. 51). Unlike London, there was no theater here, and not much dancing or music. But there were a number of bookshops, three weekly newspapers, and an intellectual vigor unsurpassed in the colonies. The political climate was heated. Controversies flared over whether to fix the governor's salary at a specific (and sizable) amount annually, and riots broke out over the arrival of Irish immigrants intent to settle property in Maine claimed by prominent Bostonians.[5]

Smibert had very likely heard from Newporters that the painting activity in Boston was largely limited to the work of painter-stainers and of a handful of portrait painters who barely subsisted. Upon his arrival in the city, he might have felt a twinge of nostalgia as he viewed interiors decorated with marbleized woodwork, which would have recalled his own apprenticeship. If Smibert walked up Hanover Street, he very likely saw the most visible symbol of Boston's painter-stainer tradition: the coat of arms of the painter-stainers' company (fig. 52), which hung outside the former shop of Thomas Child. In addition to Child (active 1685–1706), Boston's most recent decorative painters had included Daniel Laurence (active by 1701), John Gibbs (active by 1705), Samuel Robinson (active by 1707), Zabdiel Boylston (active by 1711), Thomas Johnston (active 1726–1767), and Nehemiah Partridge (active 1712–1714).[6] Partridge, who subsequently painted a number of portraits in New York, Rhode Island, and Virginia, had apparently found Boston unsupportive and if

any others among this group did occasional portraits, none has been identified.

It seems reasonable to assume that Smibert heard described, and probably saw, the landscape panels Gibbs painted for the Clark house (fig. 53), which was among the most lavishly decorated interiors in Boston. This evidence that at least one Boston patron had refined tastes may have helped to persuade him that life in Boston might just provide an outlet for the talents of someone of his abilities, if only until he packed his bags for Bermuda.

At the Town House, on King Street, hung a full-length portrait of Queen Anne, undoubtedly an imported work from London, which had been there at least since 1711.[7] While this portrait has long since been lost, it is one indication that Bostonians, even those who had not traveled, had some exposure to prevailing tastes in portraiture. An even more remarkable example of current London fashion was on display in Cambridge, at Harvard Hall: Highmore's 1722 full-length portrait of Thomas Hollis (fig. 54), which hung alongside Thomas Smith's portrait of the theologian Dr. William Ames, commissioned in 1680 by the Harvard Corporation.[8] Smibert may well have greeted this discovery with delight, as a portrait of the

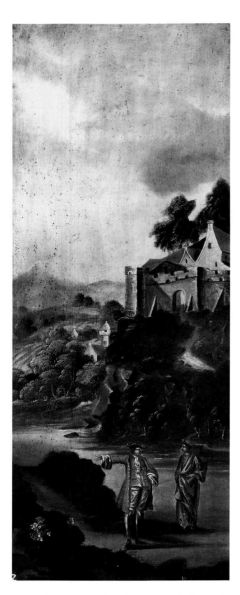

53. John Gibbs (attrib.), *Panel from the Clark-Frankland House*, c. 1712. Oil on wood panel. Courtesy The Society for the Preservation of New England Antiquities, Boston.

"latest London fashion" (to use the term by which merchants touted wares to their fashion-conscious clientele) meant that anything he might hope to paint could be objectively judged. A few wealthy merchants and civic leaders had traveled abroad and returned with portraits painted in London, such as the colonial governor Joseph Dudley (fig. 55); but most of the portraits hanging in Boston's best parlors were the work of local artists—a circumstance that boded well for a fashionable newcomer from Europe like Smibert.

54. Peter Pelham, after Joseph Highmore, *Thomas Hollis III*, 1751. Mezzotint. Courtesy American Antiquarian Society, Worcester, Mass.

The world Smibert entered in Boston was far different from that of London. Boston was still a bastion of conservative Congregational beliefs, though increasingly under siege from Anglicans and more liberal-minded Congregationalists. It was these monied and less doctrinaire members of society who embraced him wholeheartedly and made the town far more attractive to a painter than it had been only a few years before. Of course, Boston and London possessed some obvious surface similarities, largely through commerce in textiles, silver, and tea. But the majority of Bostonians, like most people in colonial society, were of "the middling sort," neither conspicuously wealthy nor distressingly poor—hardly in a position to foster the arts, let alone support even one full-time portrait painter.

To be sure, there were a few resident artists in America, such as the New Yorker Evert Duyckinck III (1677–1727), who billed themselves as "limners." But the tenuous nature of colonial painting made

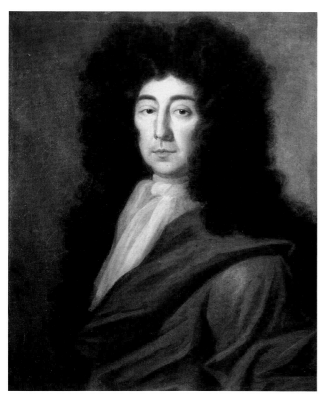

55. Unidentified English artist, *Joseph Dudley,* c. 1693–1701. Oil on canvas, 30 1/8 × 25 in. (76.5 × 63.5 cm.). Courtesy Massachusetts Historical Society.

56. Unidentifed artist, *Rev. James Pierpoint,* 1711. Oil on canvas, 31 1/8 × 25 in. (79.1 × 63.5 cm.). Yale University Art Gallery, bequest of Allen Evants Fostery.

any sensible person prepare to do a variety of tasks. The Philadelphian Gustavus Hesselius, although a portrait painter by choice, advertised that he did "in the best Manner . . . Coats of Arms drawn on Coaches, Chaises, &c, or any other kinds of Ornaments, Landskips, Signs, Shew-boards, Ship and House Painting, Gilding of all Sorts, Writing in Gold or Colour, old Pictures clean'd and mended, &c."[9]

Among the best locally painted Boston portraits were works by four different artists: the Pierpoint Limner, the Pollard Limner, Nathaniel Emmons (c. 1704–1740), and Emmons's former London colleague Peter Pelham. *Reverend James Pierpoint* (1711; fig. 56), by the Pierpoint Limner, and *Henry Gibbs* (c. 1721; fig. 57), by the Pollard Limner, are representative of Boston's best portraits prior to 1725. They are competently painted, albeit a bit wooden, and are typical works of painters in a provincial backwater who had little or no formal training and were striving to emulate a London style they only vaguely knew. Smibert probably paid them no more than passing notice. It is not surprising that the identities of the sitters are known while those of the painters are not:

the artists' reputations and livelihoods rested in their decorative painting or gilding, and their identity as portrait painters was only of marginal consequence to their sitters. They were craftsmen hired to create functional, identifiable "effigies," not great works of art or portraits for public display. The fact that the portraits were done by painters who arose from the painter-stainer tradition also would have served to diminish their importance as status symbols.

Emmons and Pelham were certainly of more interest to Smibert. Both were actively pursuing careers in Boston at the time of Smibert's arrival. Their work also provided an immediate index of the quality of portraits available to potential clients. Emmons, a native-born artist whose most recent accomplishment had been to paint a curious mezzotint look-alike portrait of Andrew Oliver (fig. 58), must certainly have resented Smibert's presence, for a painter with a London reputation was surely a threat to his lucrative employment by one of Boston's most prominent families. Indeed, portraits by Emmons after this date are unknown, and documents show that he was reduced to decorative and commercial painting.[10]

57. Pollard Limner (attrib.), *Henry Gibbs,* c. 1721. Oil on canvas, 28 1/2 × 24 1/2 in. (72.4 × 62.2 cm.). Goodman Fund, 1967.171, photograph © 1991, The Art Institute of Chicago. All Rights Reserved.

58. Nathaniel Emmons, *Andrew Oliver,* 1728. Oil on wood panel, 14 1/2 × 10 1/4 in. (36.8 × 26 cm.). Andrew Oliver, Jr., Daniel Oliver, and Ruth Oliver Morley.

Even the writer of Emmons's obituary fired a parting shot at Smibert by noting that Emmons "was universally own'd to be the greatest master of various Sorts of Painting that ever was born in this Country" and that "his excellent Works were the pure Effect of his own Genius, without receiving any Instructions from others."[11]

Pelham's career was a precise barometer of what Smibert could expect in Boston. The mezzotint engraver had arrived from England two years earlier, in 1727. Why he came to Boston is unclear, but there is a hint in correspondence from his father that he left London in disgrace. Unlike London, where he had jockeyed for position with a number of engravers of similar abilities, in Boston his competition was limited to William Burgis, who that same year produced his first mezzotint (fig. 59), and Thomas Johnston, whose most significant accomplishment to date was a merchant's trade card (fig. 60). While this situation had its benefits, before Smibert's appearance Pelham had been without a portrait painter of stature with whom he could collaborate. His degree of frustration is best documented by the portrait of Cotton Mather

(American Antiquarian Society), the leader of Boston's second Congregational church (Old North), which he found it necessary to paint in order to produce his first American mezzotint (fig. 61). Certainly Pelham, unlike Emmons, had much to gain by Smibert's continued presence. Although Pelham's American experience to this point was limited, he could convey to Smibert an objective appraisal of the harsh realities any artist faced in a colonial community.

Berkeley was under the impression that Smibert's Boston visit would be short. Whatever his personal feelings at this point, Smibert nevertheless decided that Boston would make a more suitable place than Newport in which to keep himself occupied. Smibert apparently found lodgings on Green Lane (Salem Street),[12] in the North End, and most likely then sent for the belongings necessary to set up his studio.

59. William Burgis, *To the Merchants of Boston This View of the Light House*, 1729. Mezzotint. Courtesy The Mariners Museum, Newport News, Va.

60. Thomas Johnston (attrib.), *Thomas Hancock Book-seller at the Bible & Three Crowns*, 1727. Engraving. Courtesy Massachusetts Historical Society, Boston.

61. Peter Pelham, *Cotton Mather*, 1728. Mezzotint. The National Portrait Gallery, Smithsonian Institution, Washington, D.C.

It was probably here that one of the most provocative artistic experiences of Boston's colonial years first unfolded. Smibert laid out around his room many of the copies, casts, drawings, prints, books, and even lay figures he had so carefully assembled over the preceding decade.[13] Such a visual feast was simply not available anywhere else in America. There for visitors to see were his copy after Van Dyck's *Cardinal Bentivoglio* (cat. no. 140), Raphael's *Madonna della Sedia*, and at least one painting by Rubens. Presumably his copies after Titian and Tintoretto (which he is known to have had with him later) were there as well. In addition, Smibert had brought with him—or had had sent later—plaster casts of a bust of Allan Ramsay, a head of Homer, and the Venus de' Medici. These he probably purchased from one of the London statuaries like the Cheere brothers, who supplied casts as library decorations in some of the grander English houses.[14] At this date, sculpture of any kind was virtually unknown in the colonies. These

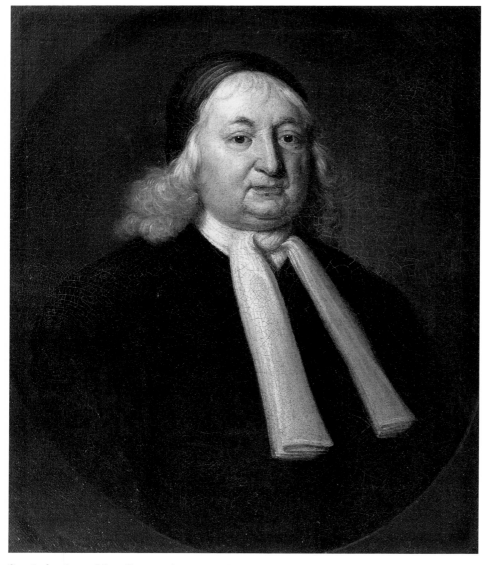

62. *Judge Samuel Sewall,* 1729 (cat. no. 42).

classical casts were valued because they transmitted three-dimensional images of great men or greatly admired works of art, and they were very likely the first of their kind ever seen in America.[15]

Smibert's studio stunned and fascinated his first visitors. Mather Byles (1707–1788), the impressionable twenty-two-year-old nephew of Cotton Mather, was so moved that he penned an eighty-line poem "To Mr. Smibert on the sight of his Pictures." This ode, a piece of mawkish doggerel that found its way into newspapers as far away as Philadelphia and England,[16] was an incredible stroke of good fortune because it finessed the informal social prohibition on

advertising. It must have been with mixture of Presbyterian embarrassment and commercial satisfaction that he read:

In hoary majesty, See Sewell here [fig. 62];
Fixt strong in thought there *Byfield's* Lines appear
 [fig. 63]:
Here in full Beauty blooms the charming maid,
Here Roman ruins nod their awful Head;
Here gloting monks their am'rous right debate
Th' *Italian* master sits in easy state,
Vandike and *Rubens* show their Rival Forms,
And studious *Mascarene* asserts his Arms
 [plate 13].[17]

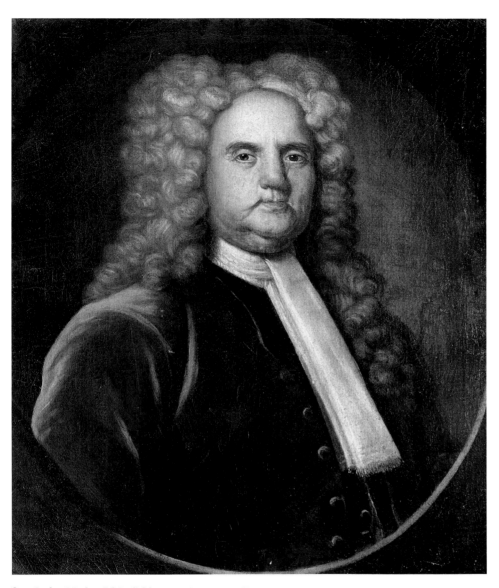

63. *Judge Nathaniel Byfield,* 1729 (cat. no. 46).

Smibert had laid out a feast for Boston; now it was time to see who would attend. Who would seek him out and what would be their expectations? Would the requirements of colonial sitters be any different from those of their London counterparts?

By the time he was ready to receive patrons in May 1729, Smibert had sized up the local portrait market. He knew, for example, that there were relatively few portraits in Boston, and that the majority of these were stylistically behind the times. The few exceptions—the portraits of Queen Anne and Thomas Hollis, and the handful of portraits of colonial mer-

chants and civic leaders done on their visits to London —may have whetted the Boston appetite for portraiture. But unlike Londoners, who frequently commissioned new portraits to keep up with fashion, Bostonians, at least prior to 1729, had not succumbed to the pressures of vogue. Certainly, Puritans and the conservative Congregationalists who succeeded them had little use for portraits. But even if Boston in 1720 had been a hotbed of extravagant living, there was simply no painter in town to whom a cultivated clientele could have turned for portraits. The absence of large numbers of London-quality portraits

in Boston from the first quarter of the seventeenth century may have resulted as much from not having a painter of stature as from societal opprobrium of personal display.

To obtain commissions when he first arrived in Boston, Smibert was dependent on letters of introduction. The key to his early success was a letter written by Henry Newman, a London acquaintance of Berkeley's, to Reverend Henry Harris, assistant to Roger Price as rector of King's Chapel, the older and more prestigious of the two Anglican churches in Boston. The letter was actually written on behalf of Dalton and James, but it asked Harris to introduce them to, among others, Francis Brinley, a leading merchant and prominent member of the Anglican church.[18] This was the opening for which Smibert had waited, and soon after their meeting the Brinley family became the vehicle for Smibert to show colonial Boston what he was capable of.

During May 1729 Smibert painted five portraits for Brinley and his relatives (cat. nos. 37–40). He must have known that his portrait of Francis Brinley (plate 14) would have to withstand the scrutiny of Boston's "portrait class"—that is, those among the town's wealthy citizens who were likely to ask to have their portraits done. For this reason Smibert seems to have taken particular care with the painting and its companion (plate 15). Brinley's plump body is nestled in an amply proportioned armchair. His arms rest on those of the chair, and his clasped hands are drawn across his stomach. He is satisfied and at ease, and very much in tune with the viewer, at whom he directs his gaze. Behind him is a view of Beacon Hill and the townscape of Boston. In every way, except one, the painting might pass for one of Smibert's London pictures. The seated pose, the sitter's expression and attire, as well as a landscape familiar to the sitter as a backdrop are all elements Smibert had used before. Brinley's clasped hands, however, are a significant modification. Never before or after did Smibert employ this motif. Fashion dictated that hands be directed outward, hold an object—such as a book, pen, letter, glove, or hat—or be hidden from view. This concession to informality and directness is a considerable departure for Smibert. It suggests a desire for a degree of informality and intimacy akin to that provided by the dressing gown and mob cap so prevalent in his London portraits. And in painting Brinley, Smibert was competing with a London portrait: Highmore's portrait of Thomas Hollis (see fig. 54) at Harvard. In some ways the clasped hands are a stand-in for Hollis's dressing gown. Fashionable London clients might ask to be depicted in expensive imported dressing gowns, but this was unacceptable to Brinley and many other Bostonians (but not all— see cat. nos. 51 and 59), who were uncomfortable with the idea of being seen by others in informal dress, "it not being customary in Boston to go to dine or appear upon Change [the commercial exchange at the Town House] in caps as they do in other parts of America."[19] Boston's most conservative religious leaders like the Mathers had in the 1720s bemoaned the increasing materialism of Bostonians. The reaction to the pose must have been less than ecstatic, for Smibert did not employ it again. (It resurfaces in Boston portraiture only in 1764, when John Singleton Copley used it for his notably direct and intimate portrait of the silversmith Nathaniel Hurd [Cleveland Museum of Art]).

Although Smibert's first commissions came from Anglicans, Boston's wealth and social hierarchy were dominated by Congregationalists. Until 1686 the Anglican church was outlawed in Boston, and even for a number of years thereafter its adherents found themselves, somewhat curiously, the "dissenter" church in Boston.[20] But in the eighteenth century Anglican influence rapidly rose. By 1714 there were at least eight hundred Anglicans in Boston, and their number—and the political and economic power they wielded—continued to grow during Smibert's years there.[21]

Since word of mouth was the primary means of expanding one's reputation, Smibert's success depended upon the impression he made on the leading Congregationalist families in Boston. Since Boston was a tightly knit society, and intermarriage among the town's leading families was rampant, word of Smibert's talents might spread rapidly, and a few commissions might lead to a succession of many more.

Just as Smibert must have hoped, his first portrait of a Congregationalist, Judge Samuel Sewall (see fig. 62), became the catalyst for dozens of other portraits. In succeeding months a grand array of Boston's leading families—Dudleys, Winslows, Olivers, Cookes, Halls, Belchers, and others—made their way to Smibert's studio. Never before in the American colonies had so many citizens of a provincial town had their portraits made. In the space of five years Smibert painted almost one hundred portraits, probably as many as had been painted in Boston during the preceding thirty years. Had Smibert simply stopped painting at this point his output would have exceeded that of all but perhaps a half dozen other colonial painters and his memory would be assured.

This surge in portraits of Congregationalists coincided with his decision to join Old South Church, which was led by Judge Sewall's son, Reverend Joseph Sewall.[22] It was the most prominent and the wealthiest of Boston's Congregational churches, and Smibert's desire to join this particular church was probably influenced by several factors. First and foremost it was a religious decision. As a Presbyterian, he might have found himself most comfortable with members of the Church of the Presbyterian Strangers. But this was a new church (1729), formed by Irish immigrants of modest economic and social standing with whom Smibert otherwise had little in common.[23] And in joining Old South Church, Smibert was not renouncing Presbyterianism altogether. The leadership of the Boston Congregationalists declared openly, "We are in Denomination, and so in Principle and Practice, Discipline and Worship, Congregational and Presbyterian."[24] Nathaniel Emmons's membership in Old South Church might have been an additional incentive to Smibert's joining it. The membership of Smibert and Emmons in Boston's most prominent church indicates they were held in much higher esteem than most artisans and craftsmen, whom Old South Church consciously excluded.[25] In spite of joining Old South Church, Smibert was still only expecting a short stay in Boston before departure for Bermuda.

What is one to make of Smibert's first American portraits? Are they an accurate depiction of his patrons? What do they tell us about colonial tastes? What do the statistics about his patrons' wealth, income, and social standing, for example, tell us about the conditions surrounding the commissioning of portraits? Most important, are these portraits appreciably different from those he painted in London, and do they confirm an "American" style, as some scholars believe, with a regional emphasis on individualism and naturalism?[26]

Surprising as it seems, there is virtually nothing that is exclusively American about Smibert's colonial portraits. One searches in vain for elements of naturalism and individuality in Smibert's Boston work, and it is a mistake to identify them as the seeds from which sprouted the subsequent independence and originality of artists like John Singleton Copley. Certainly there are differences between Smibert's work in Great Britain and his work in the colonies. But these differences—such as a preference among Boston sitters for wigs over mob caps—reflect a local social code, not a continental one. Further, in virtually every case Smibert's London works of the 1720s and the works of his first years in America (the only

works that possess a level of intensity that warrants such analysis) show evidence of the continuation of his artistic philosophy rather than an abandonment of it.

The surviving London portraits contain the prototypes for virtually all the characteristics of Smibert's Boston work. For example, thoroughly studied background details of local topography, such as the view of Annapolis Royal in *Jean Paul Mascarene* (fig. 64), viewed in isolation might suggest a new interest in realism. But this practice was entirely consistent with his fastidious rendering of Sir John St. Aubyn's country seat, St. Michael's Mount (fig. 65), in the background of that 1727 portrait, which suggests that the portrait requirements of some London sitters differed little from those of their colonial counterparts.

It is a mistake to think of Smibert as a painter in America rather than a painter in a provincial British town whose portraits reflect the requirements of a largely middle-class clientele. This is not to deny that the make-up of colonial society differed from that of cities like Oxford, York, Dublin, Norwich, or Edinburgh. But many middle-class portrait-seekers in these cities (as well as London) resembled sitters of similar stature in colonial towns. William Mosman's portrait of the Edinburgh merchant James Stuart (fig. 66), William Denune's of the Edinburgh printer Thomas Ruddiman (fig. 67), George Beare's of the Grove family from Taunton (fig. 68), and even London portraits such as William Hogarth's portrait of the retired merchant George Arnold (fig. 69) and James Cranke's of the bookseller Thomas Osborne

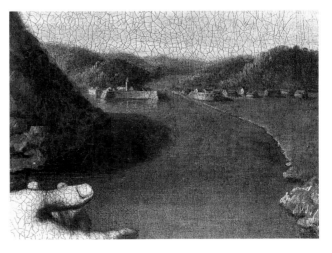

64. *Jean Paul Mascarene* (detail), 1729 (cat. no. 41). Courtesy Hirschl and Alder Galleries, Inc.

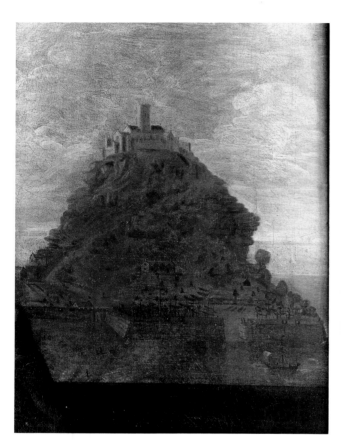

65. *Sir John St. Aubyn* (detail), 1724 (cat. no. 18).

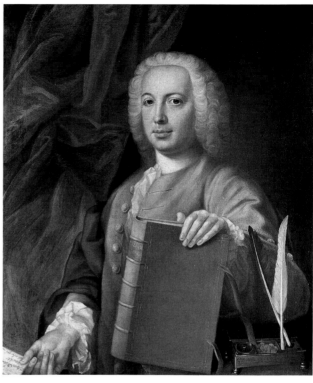

66. William Mosman, *James Stuart*, 1740. Oil on canvas, 33 1/2 × 28 in. (85.0 × 71.1 cm.). City of Edinburgh Art Centre.

(fig. 70), depict the rising middle class by much the same means as portraits anywhere. So if a colonial merchant like Jacob Wendell (fig. 71) specified that a ship of recent design be placed in the background to suggest his success in shipping, it is no more a desire for a realistic and contemporary symbol than George Drummond's wish to have Edinburgh's Royal Infirmary (fig. 72), the most recent evidence of his civic achievement, visible through the sash window of his portrait.

Smibert's finest colonial portraits, like *William Browne* (plate 16), confirm that his style was conditioned by middle-class mores rather than American motives. Its full-length format, rarely used in the colonies, might mark it as English, Scottish, or Irish in origin. The point is that Browne, an extremely wealthy merchant, did not cultivate an image peculiarly American or at odds with his London contemporaries. Rather, he wanted a portrait that would announce that he was a member of the aristocracy, a gentleman elegantly attired and posed according to the rules of etiquette as codified and diagrammed in contemporary guides (fig. 73).

In his first eight months in Boston, Smibert painted twenty-six portraits; by the end of his fifth year there, the number was more than one hundred. Of these, just over fifty survive; the survival rate drops to 40 percent for his entire American career. If we assume a similar survival rate for the works of other colonial artists, it appears that between 1700 and 1750 no more than two thousand portraits were painted in the colonies.

Certainly the readiness with which Bostonians responded to Smibert's arrival suggests a pent-up demand for portraits that had not been met (and in their eyes could not be) by a native artist like Nehemiah Partridge. Part of this dissatisfaction with native artists undoubtedly reflects upper-class colonial concerns with wealth and status. Numerous signs of an increasing preoccupation with such factors can be found in the "unquenchable desire" for "gay and costly clothing," imported furnishings, and lavish country houses.[27] Although local ministers sounded rebukes, many colonists were undeterred in their desire for worldly goods as confirmation of their own success. As an artist with London cachet, Smibert

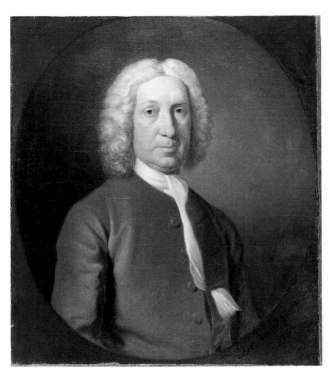

67. William Denune, *Thomas Ruddiman*, 1749. Oil on canvas, 29 1/8 × 25 1/8 in. (74.0 × 63.8 cm.). Scottish National Portrait Gallery, Edinburgh.

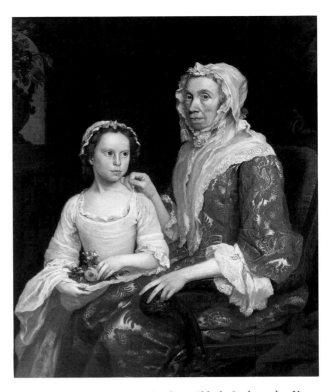

68. George Beare, *Portrait of an Elderly Lady and a Young Girl*, 1747. Oil on canvas, 49 1/16 × 40 1/4 in. (124.6 × 102.2 cm.). Yale Center for British Art, Paul Mellon Collection.

69. William Hogarth, *George Arnold*, c. 1740. Oil on canvas, 35 5/8 × 27 7/8 in. (91 × 70.8 cm.). Fitzwilliam Museum, Cambridge.

70. James Cranke, *Thomas Osborne*, 1747. Oil on canvas, 78 × 56 in. (198 × 142.25 cm.). Yale Center for British Art, Paul Mellon Collection.

71. *Jacob Wendell,* 1731 (cat. no. 74).

provided a valuable service to those in pursuit of such status.

Although Smibert's notebook supplies a wealth of information about his career (such as that almost 20 percent of his commissions came in September and that just over 10 percent of his sitters were college graduates), contemporary comments about how sitters reacted to his portraits are few. Smibert did receive high marks from Ebenezer Turell, who observed that the picture of Reverend Benjamin Colman (fig. 74), "drawn in the year 1734 by the greatest master our country has seen, Mr. John Smibert,

shows both his Face and Aire to Perfection;—And a very considerable Resemblance is given us in the metsotinto done from it by P. Pelham, which is in many of our Houses."[28] The reliability of these comments is open to question, since Colman was Turell's father-in-law and Turell, too, had his portrait painted by Smibert (cat. no. 104).

The merchant Thomas Hancock, who had had his portrait painted by Smibert (fig. 75), wrote to his fellow Bostonian Christopher Kilby, an agent for Massachusetts interests in London, regarding Kilby's portrait, which had recently been delivered to Hancock

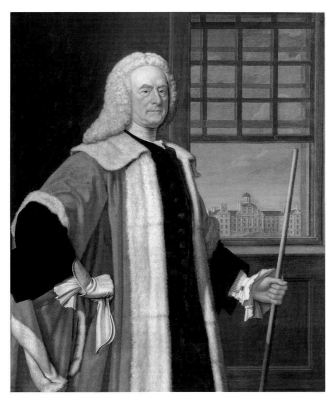

72. John Alexander, *George Drummond*, 1752. Oil on canvas, 49 1/2 × 40 in. (125.7 × 101.6 cm.). In the collection of the Royal Infirmary of Edinburgh.

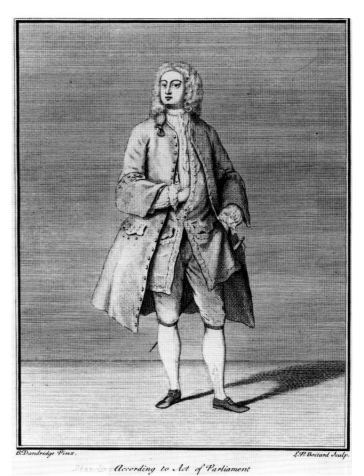

B. Dandridge Pinx. *L. P. Boitard Sculp.*

Standing According to Act of Parliament

73. L. P. Boitard, after Bartholomew Dandridge, from F. Nivelon, *Rudiments of Genteel Behavior* (1737), plate 1. Courtesy Rare Book and Special Collections Division, Library of Congress.

for safekeeping. "Every body that sees it thinks it to be Exceedingly like you, as it really is, I am of opinion it is as Good a Piece as Mr. Smibert has done and full—as like you as my Fathers is like him." By way of confirming the accuracy of the likeness he added, "Sally [Kilby's daughter] was at my house yesterday mighty well, knew your Picture kist it & drank your health."[29] Kilby's portrait is unlocated, but that of Hancock's father, Reverend John Hancock (fig. 76), survives.

The lack of commentary about women's portraits is particularly vexing. Smibert's training and London practice, guided by an emphasis on beauty at the expense of individual character, had led him to paint women in a much more uniform manner that depicted few personal characteristics. Although no doubt women sitters expected a certain resemblance between themselves and their portraits, failure to flatter or "do justice" to a female sitter could jeopardize future commissions. James Logan, secretary to William Penn and later mayor of Philadelphia, in a letter to a relative admonished an unnamed Philadelphia painter (probably Gustavus Hesselius) for

that failing: "We have a Swedish painter here, no bad hand, who generally does Justice to the men, especially their blemishes, which he never fails showing in the fullest light, but is remarked for never having done any to ye fair sex, and therefore very few care to sit for him. Nothing on earth could prevail with my spouse to sit at all, or to have hers taken by any man, and our girls—believing the Originals have but little from nature to recommend them, would scarce be willing to have that little (if any) ill treated by a Pencil the Graces never favour'd."[30] Three of Smibert's sitters, Elizabeth Brinley Hutchinson (fig. 77), Mary Clark Oliver (fig. 78), and Eunice Turner Browne (fig. 79), differ markedly in age (Oliver and Browne were both twenty-one years old at the time of their portraits; Hutchinson was forty-four), yet it is virtually impossible to spot this difference from their

74. *The Reverend Benjamin Colman D.D.*, 1735. Mezzotint by Peter Pelham after cat. no. 236.
Cutler Bequest, Museum of Fine Arts, Boston.

portraits. Smibert was following an unwritten code that women beyond puberty and before menopause must be depicted as though locked in a golden age of feminine beauty—without wrinkles, sagging skin, blemishes, or gray hairs. This practice is entirely consistent with the general treatment of women in colonial society more as property and incubators than as persons with intellect, character, and an individual perspective on life. Smibert's portraits of women by and large should be seen as part of a ritual that has everything to do with social custom and virtually nothing to do with sensitivity to the character of individual female sitters.

But in the case of children and older women,

Smibert is freer to depict the sitter's age. In his portraits of Jane Clark (plate 17), age nine, and Elizabeth Lindall Pitts (fig. 80), age fifty-five, Smibert's ability to paint age accurately when desired is apparent. Although Jane has been posed as an adult, her features convey her age. Although Smibert's efforts to remind viewers of her youth battle with society's efforts to mold her as an adult, the portrait is nonetheless enchanting. Mrs. Pitts, on the other hand, seems curiously at odds—almost uncomfortable—posed in an elegant chair and a fashionable dress. Her features are hard, her skin sags, and her graying hair is evident. Now that she has passed childbearing age, society has lost an interest in asserting through her a

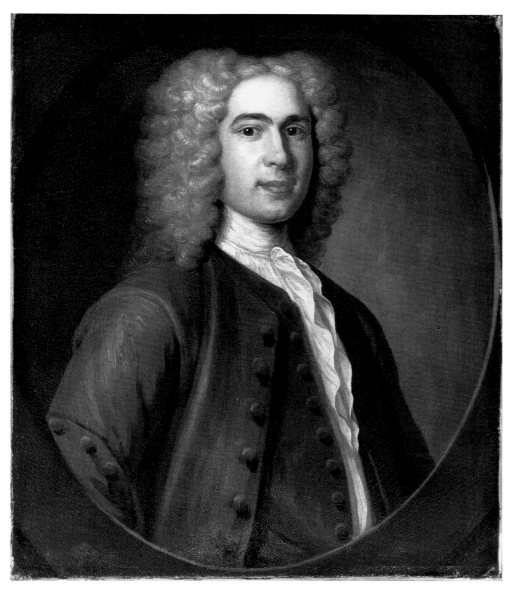

75. *Thomas Hancock,* 1730 (cat. no. 63).

standard of womanly beauty, and the painter may show a person gradually entering old age. Mrs. Pitts is on the threshold of what Mather Byles described, in speaking of Smibert's portrait of Sewall, as "hoary majesty." Smibert never painted a female sitter as hoary or majestic as Sewall, but his portrait of Mrs. Pitts suggests that like his other practices his depiction of aging fell within the bounds of the prevailing social code. And just as in the case of his London portrait of Mrs. Henry Ferne (cat. no. 19) or its Boston counterpart, the portrait of Mrs. Louis Boucher (cat. no. 58), this awareness and acknowledgement of older sitters' ages is an international phenomenon.

There is little indication in the contemporary record of whether or not Smibert's sitters are depicted in their own clothes. Since the vast majority of Smibert's female sitters are depicted in blue gowns that vary only subtly over a great many years, it appears that the choice of dress was a matter of artistic convention and did not reflect current fashion. Informality seems to have governed the way Boston women (but not all colonial women) wished to be seen. Smibert's treatment of them conforms to one contemporary description which allowed that "they appear generally att home in a loose deshabille which, in a manner, half hides and half displays their charms."[31] Elsewhere in the colonies sitters did make specific requests, as in the case of Alida Living-

76. *Rev. John Hancock,* 1734 (cat. no. 92).

ston of New York, who had her portrait returned to
Nehemiah Partridge "so that the clothing must be
changed to a loose dress the neck not so bare and the
clotthing darker."[32]

Men's fashions are no easier to decipher, although
in fifteen years Smibert rarely strayed from a full suit
of dark cloth. Cuffs, pockets, buttons, and other de-
tails barely change. One exception is Smibert's por-
trait of Samuel Browne (plate 18), who wears an eye-
catching green coat trimmed with ornamental gold
frogs. It would seem very odd if sitters were not con-
cerned with such details, given the lengths to which
wealthy colonists went to equip their houses with the

latest fashion. But it may also be that Smibert grad-
ually lost interest in painting details of dress and
discouraged his sitters from making particular de-
mands of this kind.

Few of Smibert's portraits resulted from casual de-
cisions, and many portrait commissions can be linked
to specific events. These include reaching a certain
point of affluence, receiving one's inheritance, as in
the instance of William and Samuel Browne (cat. nos.
94 and 99), or assuming high office (cat. no. 185).
Pairs of portraits were frequently painted to cele-
brate a recent or impending marriage, as with Lydia
Henchman (cat. no. 56) and Thomas Hancock (cat.

77. *Elizabeth Brinley Hutchinson,* 1729 (cat. no. 37).

no. 63). If one of the partners had had a portrait painted prior to the marriage, a companion portrait of the spouse was commissioned. Also, posthumous portraits were painted as a memorial or remembrance (cat. no. 81). Portraits were sometimes done prior to a departure overseas on business or for school, as was the case with Smibert's portraits of Governor Jonathan Belcher's son (cat. no. 184) and Judge Edmund Quincy (cat. no. 125). Portraits were sent or exchanged as gifts of friendship. Smibert had recorded in his notebook that he made gifts of portraits while in London.[33] This is presumably the case with his *Rev. Joseph Sewall* (plate 19), which is not listed

in Smibert's notebook but was presumably painted as a gift to Sewall in gratitude for his having officiated at Smibert's marriage.

Smibert's marriage in July 1730 to Mary Williams (fig. 81), a fellow member of Old South Church, cemented his ties to Boston in ways he may have not anticipated. She was the twenty-two-year-old daughter of Dr. Nathaniel Williams (1675–1738), a graduate of Harvard (1693) and master of what later became the Boston Latin School, regarded as the best of a handful of secondary schools in the colonies.[34]

His impending marriage may well have precipi-

78. *Mrs. Peter Oliver*, 1734 (cat. no. 90).

tated the rumor conveyed to Berkeley by the Earl of Egmont "that Mr. Smibert is married to the lady who accompanied Mrs. Berkeley."[35] In March Berkeley quickly dispelled this rumor in a reply. But within a few weeks Smibert visited Newport and presumably took this occasion to inform his friend of his plans to marry.

But a much more important reason for the visit was to discuss with Berkeley the planned completion of *The Bermuda Group* (plate 20), the most important and influential painting of Smibert's career. The painting is a commemorative portrait of those who participated in Berkeley's plan to establish a college in Bermuda. It was commissioned in the summer of 1728,

just prior to the group's departure, by John Wainwright, a great admirer of Berkeley who had considered accompanying the entourage. Two months before the group set sail for America, Smibert received partial payment for the painting: "A Large picture begun for Mr. Wainwright 10 gunnes [guineas] recd in pairt."[36] Smibert may have outlined the composition at this point, but he would have had little time before the group's departure to make more than sketches of Wainwright, who was not traveling with them.

The most prominent figure in the composition is Berkeley himself, dressed in clerical garb and standing at the far right. Seated across from him is Wain-

79. *Mrs. Benjamin Browne,* 1735 (cat. no. 108).

wright, pen in hand. At the table sits Berkeley's wife, Anne Forster, holding her son, Henry; beside her is Miss Handcock, her traveling companion. Behind and flanking her are Richard Dalton and John James. The artist, in what is the only known portrait of him, stands modestly in the background on the left, a partially unrolled sketch clasped in his right hand. On the table, at the center of the composition, Smibert has discreetly signed the edge of a book, a witty reference to his authorship of the painting, and dated it 1729 to mark the year of their arrival in New England—not the year the painting was completed, as has frequently been stated.

The five people who joined Berkeley on his mis-sion to America were of varied backgrounds, and their motives for joining this venture differed widely. Anne Forster, daughter of John Forster, who had been recorder of Dublin, speaker of the Irish House of Commons, and chief justice of the Common Pleas.[37] Miss Handcock, who came as Mrs. Berkeley's companion, was the daughter of William Handcock, another former recorder of Dublin; perhaps there was some financial inducement for her to participate in Berkeley's scheme. The motives of James and Dalton are more puzzling, since Berkeley never identifies any substantial role for them at the college. James was the son of Sir Cane James of Bury St. Edmunds;[38] Dalton was from Lincolnshire and was an

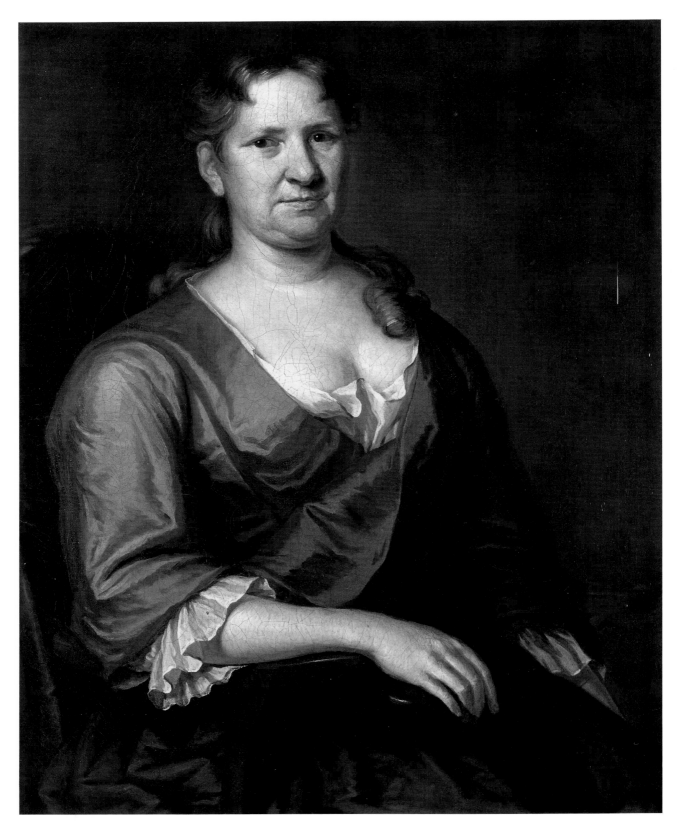

80. *Elizabeth Lindall Pitts*, 1735 (cat. no. 105).

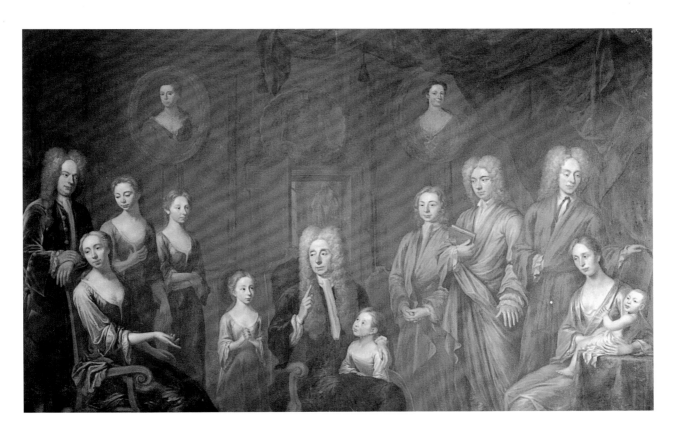

1. *Sir Francis Grant and His Family,* 1718 (cat. no. 6).

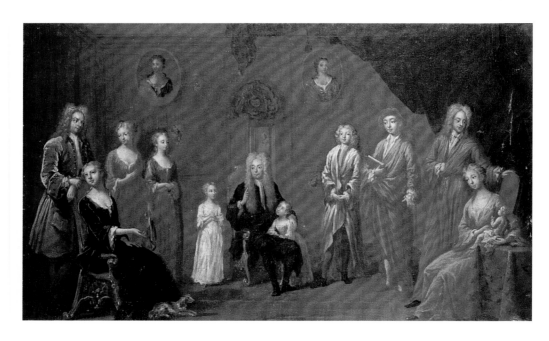

2. *Sir Francis Grant and His Family* (preliminary study), 1718 (cat. no. 5).

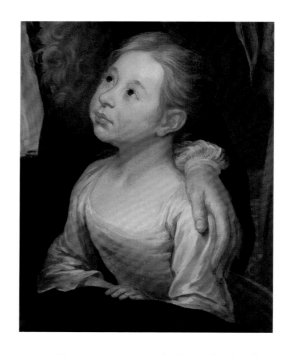

3. *Sir Francis Grant and His Family* (detail).

4. *Cardinal Guido Bentivoglio,* c. 1719–1720 (cat. no. 140).

5. Unidentified man, 1720 (cat. no. 9).

6. *Colonel James Otway*, 1724 (cat. no. 15).

7. *Sir John St. Aubyn*, c. 1724 (cat. no. 18).

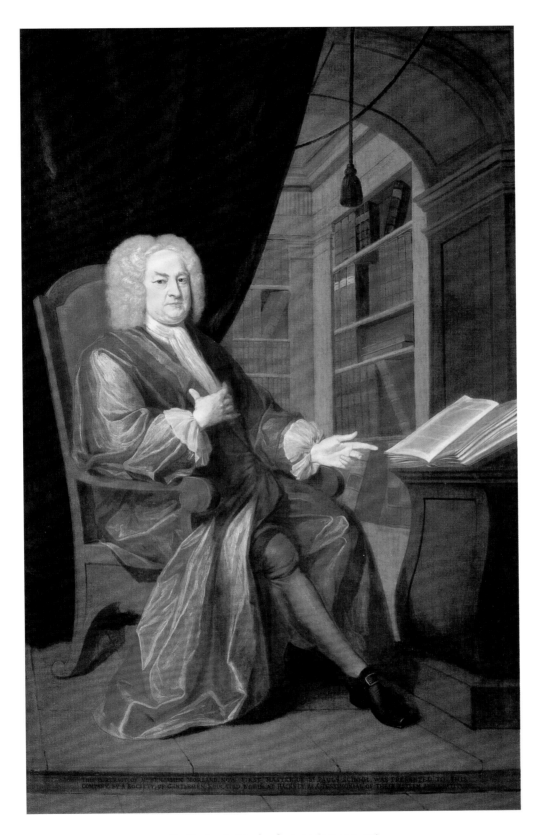

8. *Benjamin Morland*, 1724 (cat. no. 22).

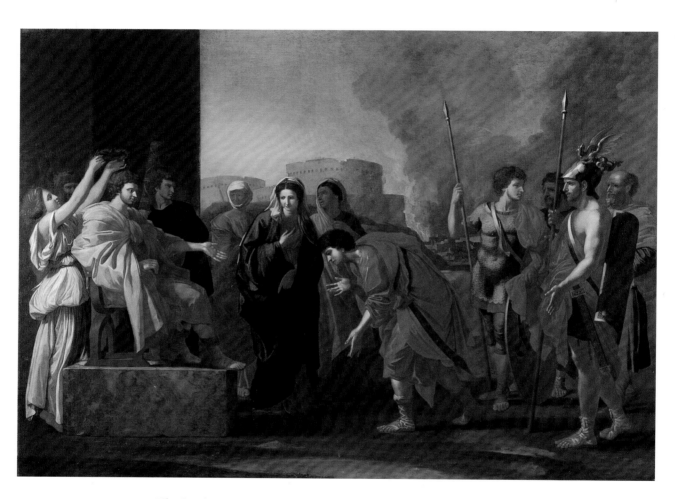

9. *The Continence of Scipio* (after Nicholas Poussin), c. 1726 (cat. no. 143).

10. *George Berkeley,* 1726? (cat. no. 25).

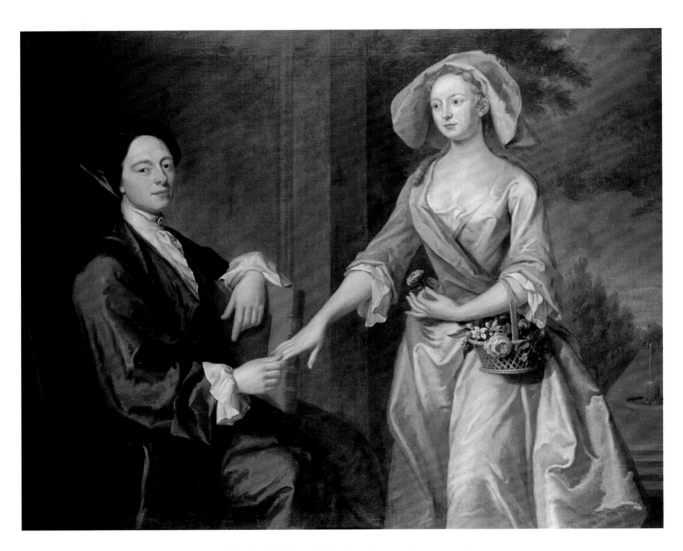

11. *Sir Archibald and Lady Grant*, 1727 (cat. no. 34).

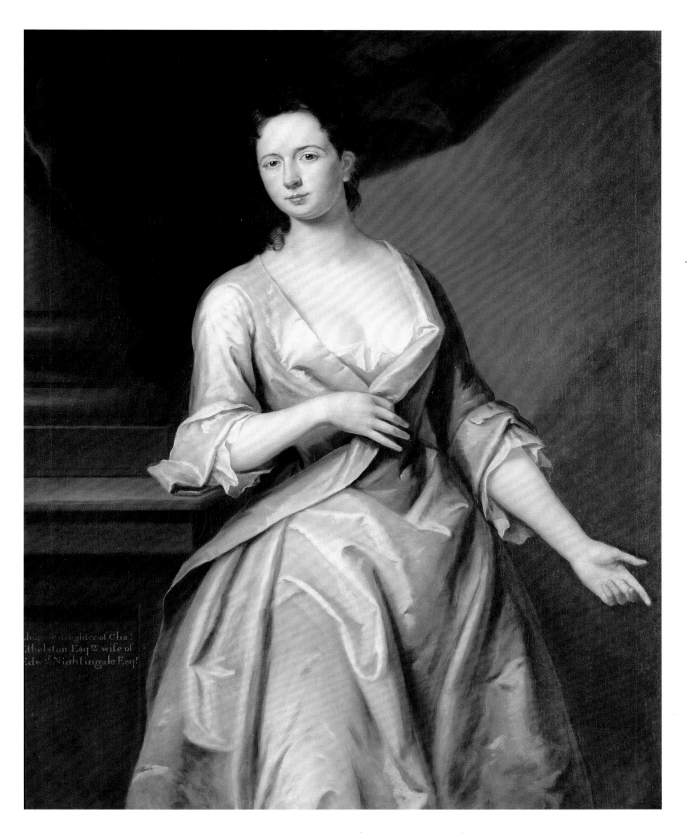

12. *Mrs. Edward Nightingale,* 1727 (cat. no. 31).

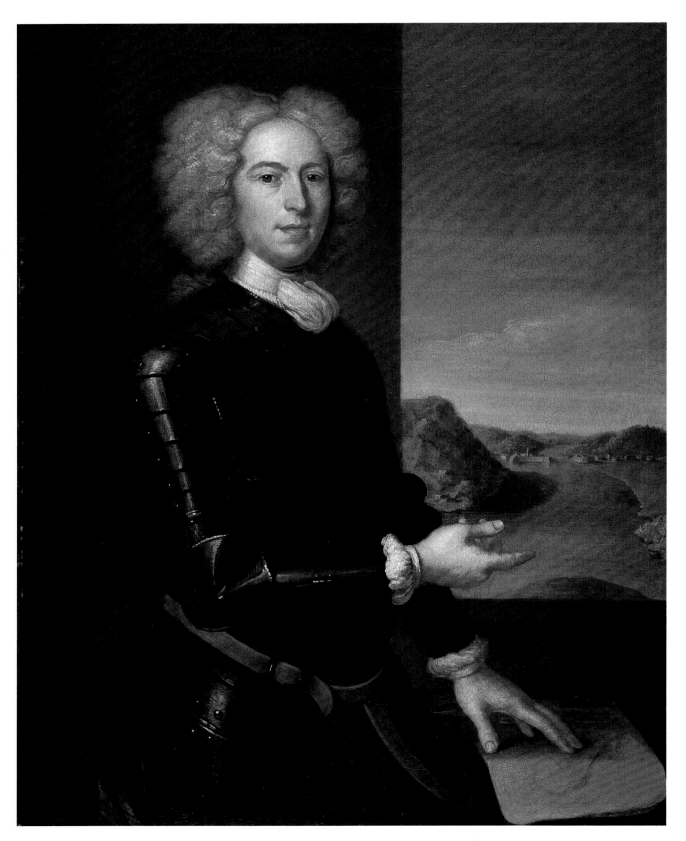

13. *Major Jean Paul Mascarene*, 1729 (cat. no. 41).

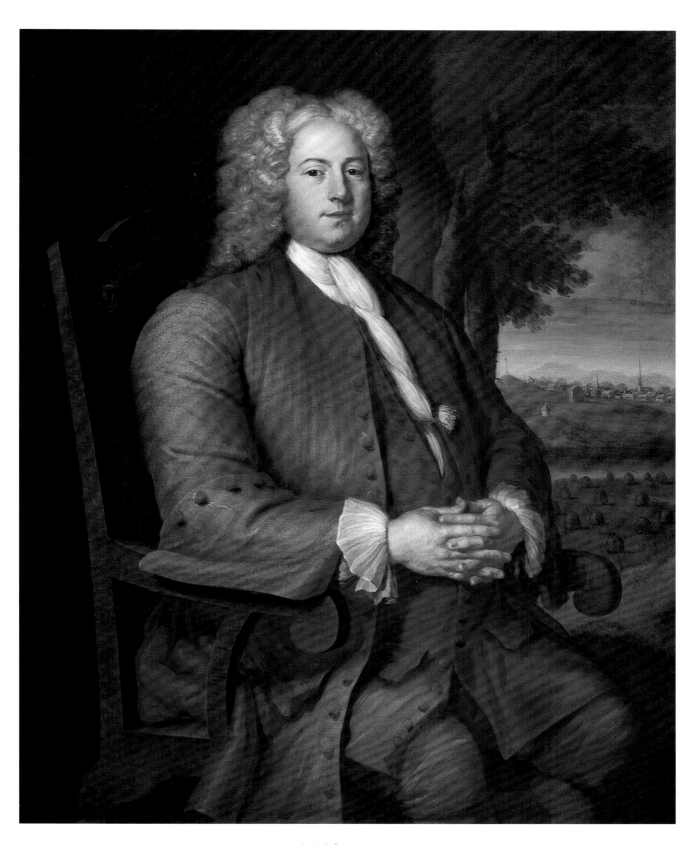

14. *Francis Brinley,* 1729 (cat. no. 39).

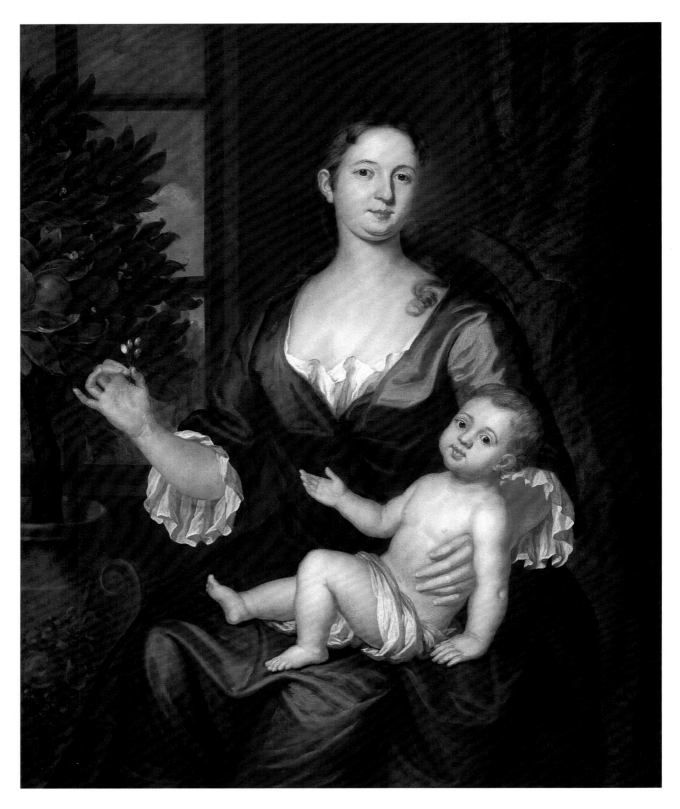

15. *Mrs. Francis Brinley and Son Francis,* 1729 (cat. no. 40).

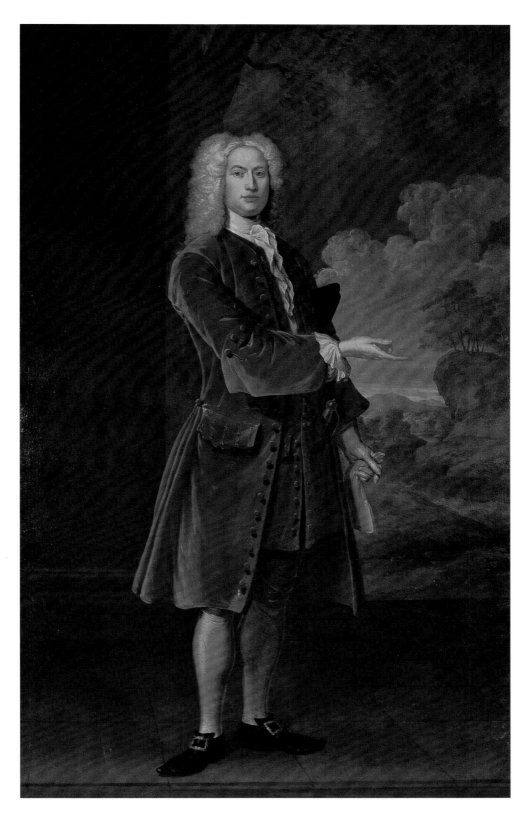

16. *William Browne*, 1734 (cat. no. 94).

17. *Jane Clark*, 1732 (cat. no. 80).

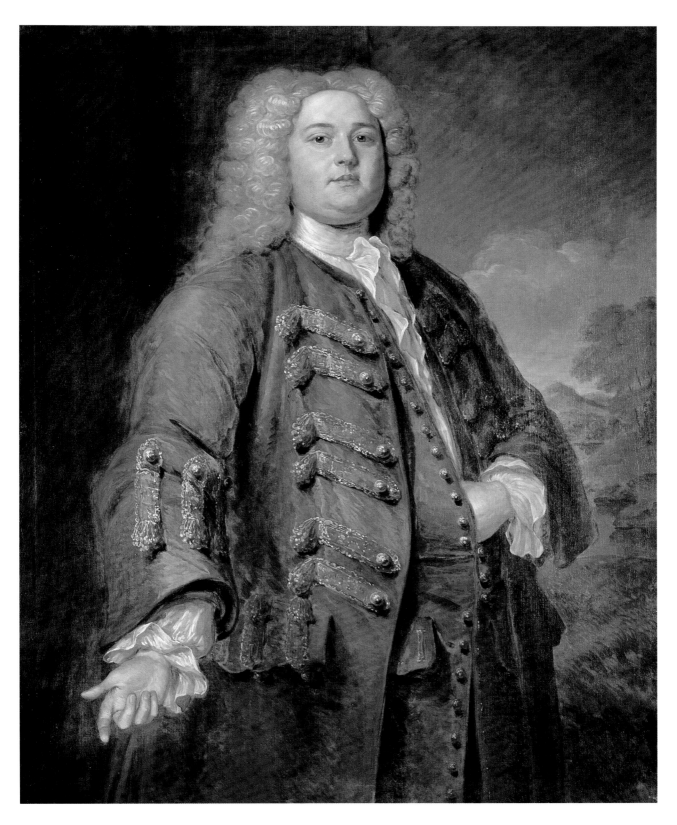

18. *Samuel Browne,* 1734 (cat. no. 99).

19. *Rev. Joseph Sewall*, c. 1735 (cat. no. 61).

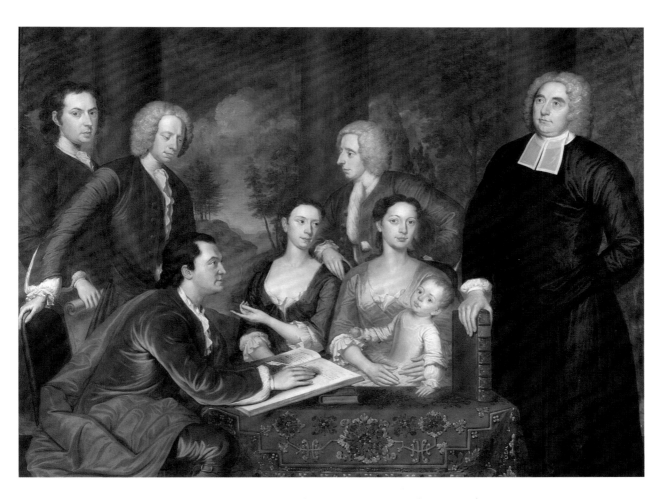

20. *The Bermuda Group,* 1729–1731 (cat. no. 71).

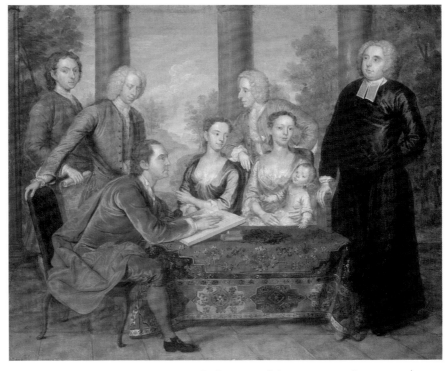

21. *The Bermuda Group* (preliminary study), 1729–1731 (cat. no. 70).

22. *Richard Bill,* 1733 (cat. no. 83).

23. *Daniel, Peter, and Andrew Oliver*, 1732 (cat. no. 81).

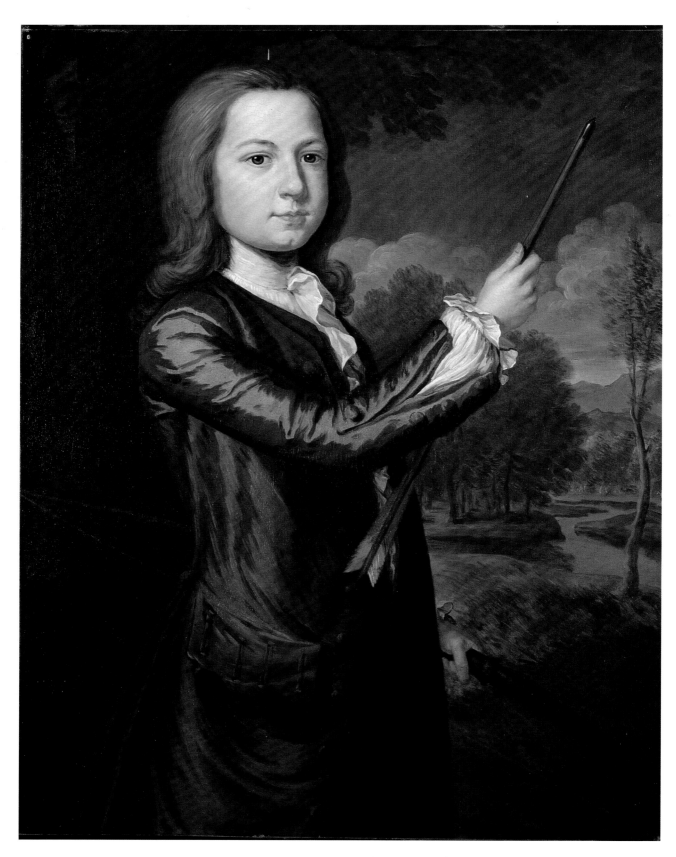

24. *James Bowdoin II*, 1736 (cat. no. 114).

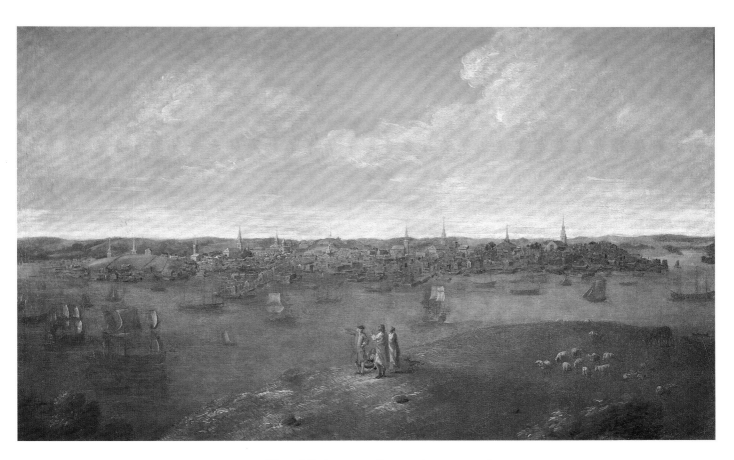

25. *View of Boston*, c. 1738–1741 (cat. no. 127).

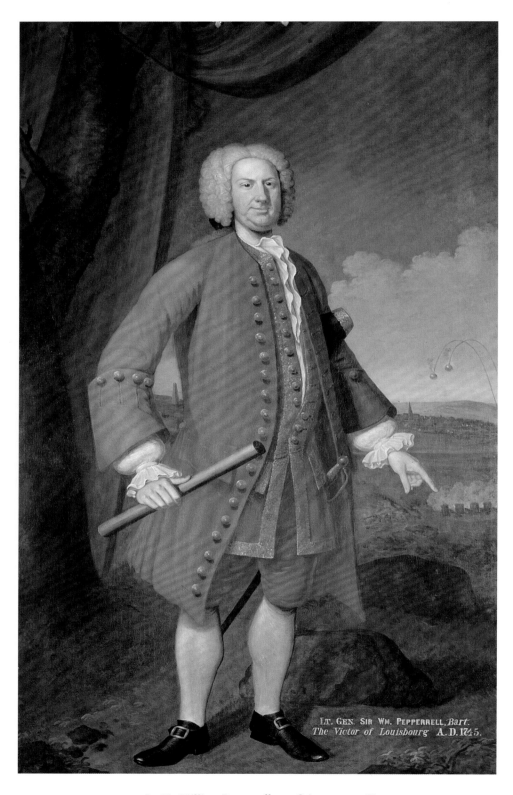

Within the painting:

LT. GEN. SIR WM. PEPPERRELL, *Bart.*
The Victor of Louisbourg A.D. 1745.

26. *Sir William Pepperrell,* 1746 (cat. no. 138).

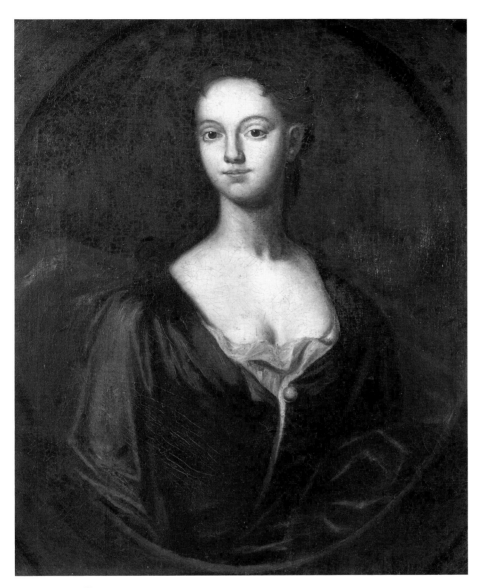

81. *Mary Williams*, 1729 (cat. no. 44).

acquaintance of Berkeley's cleric friends Martin Benson, bishop of Gloucester, and Thomas Secker, archbishop of Canterbury.[39] Henry Newman said they went along "partly for their health & partly out of their great respect for the Dean & his Design,"[40] while the *Maryland Gazette* referred to them as "Men of fortune" and "gentlemen of substance." It seems more likely that they both were in search of fortune rather than possessors of it. After the college was founded they returned to England and acted as intermediaries on its behalf.

Once in America, this grand commemorative paint-

ing was set aside in favor of the numerous portrait commissions that came Smibert's way in Boston. There would be ample opportunity to complete it once the group had settled in Bermuda. But by the time of Smibert's visit with Berkeley in April—another occasion for a portrait (cat. no. 190)—the curate was concerned that the delay in funds from Parliament might (as he wrote to Newman) "cause an alteration in the minds of my associates."[41]

By the following November Parliament's continued delay in releasing the £20,000 necessary to found the college meant that the Bermuda plan was doomed.

If the group portrait was to be completed before the various members dispersed, it had to be done soon. A notebook entry for that month confirms that Smibert was at work on the painting and names those depicted: "John Wainwright Esqr/Revd Dean Berkeley, his Lady, and Son, John James Esqr, Ricd Dalton Esqr/Ms Hendcock John Smibert."[42] The resumption may also have been precipitated by the second and final payment (thirty guineas) from Wainwright.[43] If Smibert had completed the painting in 1729, as has long been believed, it would have had to have been late in the year, as it includes George Berkeley's son Henry, who was born in Newport in May or June 1729.[44] Smibert may well have sketched Henry in Newport as late as January 1731, when his accounts show that he traveled there to paint a family portrait of Berkeley, his wife, and his son.

Smibert's notebook entry for this painting also removes any doubt about who is depicted. Over the years scholars have agreed on the identity of Smibert, Berkeley, his wife and son, and Mrs. Berkeley's companion. But the identity of the four other figures has proved elusive. Wainwright can be positively identified as the seated male figure by comparison to the 1742 mezzotint of him as baron of the exchequer in Ireland (fig. 82). Smibert gave him a conspicuous position in the composition, a common practice in donor portraits since the Renaissance. Dalton and James must then be the two remaining figures. Their virtually identical placement in the composition reflects their social parity.

The Bermuda Group affirms Berkeley's desire to create an island utopia and Smibert's wish to display his abilities as an artist of renown. Having just passed the age of forty and moving away from, rather than into, a cultural center, he was like to see few, if any, commissions of this magnitude again. This is undoubtedly why the painting is the most painstakingly constructed of Smibert's career. The composition is imaginatively balanced in both color and form. The colonnade is an architectural conceit that provides a dignified nonspecific background analogous to the columns and plinths found in other early-eighteenth-century portraits. The suggestion of the New England coast in the distant landscape of conifers and rocky shore is so subtle as not to distract from the painting's primary focus.

In reality, Smibert melded two kinds of paintings: the Renaissance tradition of grand allegory and the contemporary need for group portraits of friends and associates. Because of this, the search for a single precise source for the composition may be futile.

82. John Brooks, after James Lathem, *Baron Wainwright*, 1742. Mezzotint. National Portrait Gallery, London.

Rather, *The Bermuda Group* was constructed in the way that Smibert fashioned less complex compositions, through varied borrowings from individual prints and paintings fused into a hybrid composition. For example, Smibert was intimately aware of Berkeley's reputation as a philosopher and religious scholar. Berkeley is shown poised in thought, whereas Wainwright, as the dutiful scribe, awaits his next utterance. Smibert certainly knew that at the time this painting was being formulated, Berkeley was immersed in writing *Alciphron; or, The Minute Philosopher* (published in 1732), one of his most important philosophical treatises. Consequently, Smibert may owe a spiritual debt to works such as Rubens's *The Four Philosophers* (fig. 83), in which the artist is shown standing while his brother, the philosopher Justus Lipsius, and the philosopher's son are seated before him.[45] Another inspirational source may be Raphael's masterpiece *The School of Athens* (fig. 84),

which celebrates philosophy as one of the four domains of learning. Smibert had ample opportunity to see both paintings while in Rome and Florence. In the Raphael, the grand illusionistic format, the scribes busily recording words of wisdom, and even the artist's portrait discreetly placed to one side are important ingredients in Smibert's painting as well. Such a pretentious analogy certainly would have been in keeping with the dean's exalted view of his project and the future glory of America:[46]

> There shall be sung another golden Age,
> The rise of Empire and of Arts,
> The Good and Great, inspiring epic Rage,
> The wisest Heads and noblest Hearts.
>
> Not such as Europe breeds in her decay;
> Such as she bred when fresh and young,
> When heavenly Flame did animate her Clay,
> By future Poets shall be sung.
>
> Westward the Course of Empire takes its Way;
> The four first Acts already past,
> A fifth shall close the Drama with the Day;
> Time's noblest Offspring is the last.[47]

But Smibert's task differed from Raphael's in that he also had the challenge of painting recognizable portraits on a life-size scale and set within the format acceptable to eighteenth-century eyes. His own recent experience had led him to create his *Virtuosi of London*. It was the fashion for this kind of gathering of friends that prompted Smibert to range his figures around a carpet-covered table, in an accessible, contemporary, and almost domestic way.[48] Even Smibert's own portrait, with sketch in hand and his abundant brown curls falling on his shoulders, pays homage to his mentor, Kneller, at a similar point in his career.

Prior to painting *The Bermuda Group* Smibert completed a conversation-piece-scale modello (plate 21). Although this practice was not unknown in the early eighteenth century, it was not common, and Smibert was repeating the method he had used for *Sir Francis Grant, Lord Cullen, and His Family* (plates 1 and 2). In many ways the modello is identical to the large painting, but there are important differences. In transferring the composition to the finished version, Smibert cropped the lower third and radically compressed the space. The decision was not altogether successful, but it may well have been taken for purely pragmatic reasons. Had Smibert transferred the entire composition with figures shown in full-length, he would have needed a far larger canvas, both in length and

83. Peter Paul Rubens, *The Four Philosophers*. Florence, Pitti Palace. Courtesy Alinari/Art Resource, N.Y.

84. Raphael, *The School of Athens*, 1510–1512. Fresco. Rome, Vatican. Courtesy Alinari/Art Resource, N.Y.

width. As it is, *The Bermuda Group* is the largest painting created in the colonies before 1750 and measures almost 6 × 8 feet. Had Smibert wished to retain the full-length figures and more airy composition he would either have had to acquire a far larger canvas,

measuring 9 × 11 feet, or reduce the scale of the figures. The former choice may have proved too cumbersome; the latter would have conflicted with his standard practice regarding scale. (It was the norm for Smibert and others of his generation to paint portraits life-size.) For whatever reasons, Smibert was reluctant to interrupt this pattern to accommodate his initial concept.

Smibert's modello is visually quite engaging. The contrasts are sharp, the colors resonant, and the overall palette highly keyed. Clearly, Smibert felt comfortable with this scale, and it is unfortunate that the inflexibility of his training (or the tastes of his American patrons) did not permit him further use of it.

Once completed, *The Bermuda Group* remained in Smibert's studio. Wainwright may have lost interest in it when it became clear that Berkeley's project was doomed to failure, but it was still the most ambitious, sophisticated, and complex painting that had been done in the colonies—and would remain so for the rest of the colonial period. Its magnitude mirrors that of Berkeley's grand scheme. As such it was one of the few glorious colonial paintings of the first half of the eighteenth century and became the centerpiece for Smibert's studio, as an indication of his considerable abilities but also a reminder of failed dreams. If the spiritual force that precipitated it was thereafter lost from view, its artistic force remained to embody the great hopes and dreams of many adventurers and utopianists who chose to link their future to the vicissitudes of life in the colonies.

Completion of *The Bermuda Group* became a milestone for Smibert for other reasons as well. In many ways the painting marks not the beginning of an era

for the artist but the end of one. Although the steady stream of commissions that came his way provided a degree of financial security, Smibert must have realized by now that he was now committed to a course of action from which retreat was difficult, if not impossible. For in reality Smibert had not come to America to be Boston's portrait painter, but to be a college don. In some ways the day-to-day lockstep repetition of portraiture was something he may well have longed to escape as much as he had wished to leave London. Like all immigrants to America, he was forced to balance dreams with realities. For the first time in his career the known took on a greater prominence than the unknown. As a forty-five-year-old painter with a wife and a family, the likelihood of his ever leaving Boston and the security it provided was remote.

This mind-set seems to have quickly altered the way in which Smibert viewed the portrait opportunities that came to him. For instead of finding a challenge in the portraits that he was asked to paint after 1731, as he had done upon his arrival in Boston, from this point onward only occasionally did a commission excite him. In the space of two short years he had become the most important influence on colonial painting at the same time as he became frozen in his own past. For the rest of his career he would seek inspiration elsewhere, in collaborative efforts with Peter Pelham, in opening a color shop, in landscape painting, in architecture, and above all in trying to pass on to others the ideas about painting that he believed he would have had the opportunity to disseminate at a college in Bermuda.

7
New Directions

THE 1730s were watershed years in Smibert's life. Although he did not produce many compelling pictures, conflicting forces rocked his internal equilibrium: the need to keep painting to earn a living in a colonial town and the need to gain less quantifiable rewards from life.

The end of one career plan and the beginning of another took place in September 1731. During that month Berkeley made his first and only trip to Boston, preached at King's Chapel, visited Harvard, bid farewell to Smibert, and set sail for England.[1] It seems unlikely that by this point Smibert harbored any thoughts of returning to Great Britain. As a practical matter, such ties to Boston as a wife and daughter, not to mention his in-laws' social connections, made it impractical to depart.

Smibert's paintings in this period are of uneven quality. On the one hand, he could number among his accomplishments such forceful portraits as *Richard Bill* (plate 22); on the other, he turned out a number of conventional likenesses that seem to show a lack of personal pride and a waning of ability. For example, from about 1733 Smibert began to pay far less attention than before to the the bulk of the portraits coming out of his studio. His weaknesses are most apparent in his portraits of women, such as the portrait of Mrs. Edward Tyng (fig. 85), painted that year. Here it is clear he is inwardly fighting the very compositional formulas that he had ridden to success. There are disturbing elements in this portrait, such as the abandonment of proper proportion, which only with great difficulty can one reconcile with his best portraits of the preceding years.

A painter who grasps the principles of proportion, compositional balance, and dynamism—as Smibert clearly did when he painted *Richard Bill* in March 1733—is hardly likely to lose all sense of it in three months' time, yet one has to account for the imbalance created by Mrs. Tyng's massive torso and arms, as well as oversized facial features. Since Smibert maintained a heavy painting schedule during the months in between these two portraits, one can dismiss illness, failing eyesight, or some other physical infirmity as the reason. Smibert clearly must have known that portraits such as Mrs. Tyng's, with such heavy-handed treatment, were pot-boilers. Although some London-trained painters, devoted to personal advancement at all cost and having total disregard for others, might have cynically dispensed portraits of mediocre quality without any qualms, this is highly unlikely for someone of Smibert's intense moral conviction. It is far more believable, and entirely in keeping with Smibert's career-long search for personal happiness, that his thoughts were focused elsewhere. He was frantically in search of other outlets for his interests while at the same time uncomfortable with some of the people, such as Philip Livingston, who turned to him for their portraits. This mental state was exacerbated by a second, equally pressing concern: money. The two portraits (on average) he painted each month provided insufficient income on which to raise a family. In January 1735 he began to require all payments in sterling instead of the increasingly devalued New England currency. It was being exchanged for sterling at a rate of four to one at the time of Smibert's arrival in Boston, but by 1744 one visitor reported that the rate had increased to six to one.[2] Also, as his notebook painfully documents, virtually all his clients only "half paid" at the time he began painting, and his efforts to collect from Boston patrons were apparently no more successful than they had been in London. Smibert's honeymoon with the social elite had ended, the economy was bad, and like every other colonial artist he was desperate to find a means to diversify his income.

By the mid-1730s economic distress in Boston was so great that few people were left untouched by the

85. *Anne Waldo Tyng,* 1733 (cat. no. 86).

depreciation of the local paper currency. The number of idle and poor increased to the point that the town chose twelve overseers for them and authorized the construction of a workhouse. Reverend Benjamin Colman, the minister of Brattle Square Church, bewailed their predicament: "I fear we of this Town and Land are coming apace into too much the like circumstances, both the Rich and the Poor. The poorer Brethren have, too many of them, run themselves into bonds for moneys taken up of the rich. The *rich* are alike to suffer much in that part of their estates that lies in bonds. We are going, I fear, into excessive usury, which may not seem so, considering the yearly fall of our paper-currency."[3] These general words of caution might well have been aimed directly at Smibert, as this was precisely his predicament. In a previously unpublished letter (app. 2) to his former Scottish patron, Sir Archibald Grant, Smibert made an urgent appeal for the sixty pounds owed him for the past six years. He stated that he was a "little behind hand" and that payment was much needed. He even considered abandoning painting for farming and went so far as to buy a farm—fourteen acres of hillside later known as "Smibert's Hill"—a few miles

from town.[4] Friends, however, dissuaded him from this plan, and with much pleasure he informed Grant that he had "now got into a house of my father in laws, who has built me a large & handsome painting room & showroom in al respects to my satisfaction."[5]

The dramatic gesture by Dr. Williams to provide his son-in-law with a painting room and showroom in his house in Queen Street may well have been motivated by a natural desire to protect his daughter's future. If so, it achieved its goal, for it played a definite role in the artist's decision to continue his career. The house, which had been in the Williams family for several generations, had long been divided into two apartments, east and west. The west side had served as a residence and shop for Mary Williams's grandfather and great-grandfather, both of whom had maintained a dry-goods store there, while the east side was generally occupied by married daughters of the family.[6] In his will Dr. Williams bequeathed the western half, upon his wife's death, to Mary Smibert, and the eastern half to his other daughter, Anne, who in 1736 married Dr. Belcher Noyes.[7] Seven years later Smibert bought the eastern half, presumably to give himself more space to accommodate his expanding family.

The new painting room, located in the best residential section of the town (on Queen Street between the Town house and Hanover Street), and near the commercial center, was particularly well suited for its purpose. It was undoubtedly the first of its kind in Boston. Located on the second floor, it was up a flight of stairs from the showroom. The walls were lined with green baize—one of the more dramatic colors favored by eighteenth-century artists—and installed with Smibert's collection of paintings, drawings, prints, and casts.[8] No where else could anyone have found such a visual feast in the colonies, and for the next seventy years virtually anyone with an appetite for painting or aspiring to a career in the arts would be drawn to it.

The new facilities apparently did little, however, to relieve the tedium of Smibert's portrait practice. The uneven quality of his work continued unabated and undoubtedly made him long for the unusual commission and the opportunity to do more than provide social statements for Boston's merchant class.

Scanning the surviving portraits from Smibert's hand during the 1730s, one is immediately struck by a small but significant group of minister portraits that are noteworthy for their uniformly high quality. This group of portraits affords additional evidence of Smibert's special emphasis on the importance of religious beliefs. Clearly, given the intensely moral and

86. *Rev. John Rogers*, 1733 (cat. no. 88).

religious nature of his life, Smibert would have considered it a privilege to paint a minister's portrait, whereas painting society matrons and merchants of suspect moral values may have increasingly become a personal trial. One cannot help but think that Smibert may have even found it at times distasteful to provide a service to those whose moral convictions may have been at odds with his own. He was, after all, a righteous man in a society tainted by the avarice and competition that he had found so distasteful in London.

Smibert painted eighteen portraits of ministers while in America: ten of Congregationalists and eight of Anglicans (four of which were of George Berkeley). Among this number are several of Smibert's most sensitively rendered portraits, such as *Rev. Joseph Sewall* (plate 19) and *Rev. John Rogers* (fig. 86). The portrait of Sewall is devoid of the trappings, such as wigs, inkwells, and ships, that frequently compete for attention in Smibert's merchant portraits; all attention is focused on the sitter himself. The result is an impression of Sewall as a direct and forceful man, an image entirely in keeping with his stature as a leading moral spokesmen for the community. Sewall's deci-

sion to be shown in his natural hair was most likely a philosophical one. Wigs, at least earlier in the century, were considered highly pretentious for Congregational ministers as they smacked of a vain preoccupation with material things and one's self. In 1704, for example, Ebenezer Pemberton (cat. no. 396) cut his hair and entered the pulpit sporting a neatly coiffed wig, much to the disgust of Samuel Sewall and other churchgoers, who responded by wearing their hats during Pemberton's sermons.[9]

The majority of Smibert's portraits of ministers are of established leaders among Boston's clergy, such as Sewall, Rev. Benjamin Colman (see fig. 74) and Rev. William Cooper (fig. 87), both ministers of Brattle Square Church, and Rev. Joshua Gee (fig. 88), minister of Old North Church. Others included some of the up-and-coming clergy from outlying communities, such as Rev. John Barnard (cat. no. 192), who at the time his portrait was painted (1734) was in Marblehead but later moved up to the more prestigious position at Old North Church, and Rev. Elisha Williams (cat. no. 474) of Newington, Connecticut, who was soon to be named rector of Yale College. The Anglican clergy who sat for Smibert were also, by and large, a distinguished group: Rev. James McSparran (fig. 89) of Narragansett, Rhode Island; Rev. Ebenezer Miller (fig. 90) of Braintree, Massachusetts; Rev. Henry Caner (fig. 91) of Fairfield, Connecticut, and Rev. Samuel Johnson (fig. 92) of Stratford, Connecticut.

The circumstances under which these portraits came to be commissioned are not always clear. Unlike the bulk of Smibert's sitters, who were from those families in the colonies most able to pay for portraits, ministers usually earned a meager wage—on average £100 to £150 (New England currency) a year, so they would seem dubious candidates for portraits that might cost up to 20 percent of their annual income. Moreover, the perception that sitting for a portrait smacked of vanity may have prevented even wealthy ministers from commissioning their own portraits. In fact, although at least two of Smibert's minister portraits (Joshua Gee and Ebenezer Turell) were owned by the sitters at the time of their deaths, it cannot be proven that either man commissioned his portrait. More likely, they were commissioned by devoted friends or admiring relatives.

87. *The Revd. Mr. William Cooper*, 1744. Mezzotint by Peter Pelham after cat. no. 241. Courtesy The Winterthur Museum, Del.

88. *Rev. Joshua Gee*, 1733 (cat. no. 85).

89. *Rev. James McSparran*, 1735 (cat. no. 110).

In fact, in most instances it seems that minister portraits were painted as gifts for friends—and possibly relatives—and as business ventures. Smibert's portrait of Sewall, which stylistically recalls the beginning of his American career, may have been given to the sitter as a present for having officiated at the artist's marriage. This may explain why it is one of only a handful of his American portraits that he did not record in his notebook.

Other minister portraits were commissioned by friends. This was the case with a portrait of Berkeley and two portraits of Baptist ministers in Newport commissioned by a communicant of the church, Henry Collins (cat. no. 118), a wealthy merchant, and painted by Robert Feke (1707?–1751).[10] Some portraits may have been commissioned by relatives of the ministers, as appears to have been the case with Smibert's *Rev. John Hancock*, which was most likely paid for by the sitter's son, Thomas Hancock, among the wealthiest Boston merchants. A very few ministers were also wealthy. Joshua Gee (cat. no. 85), for example, was a wealthy man who at his death owned, in addition to his own portrait, one of Cotton Mather. Turell also owned portraits of Charles II, Oliver Cromwell, and Rev. Benjamin Colman, his father-in-law, in addition to those of himself and his wife. As he did not die until 1778, however, these may all have been bequests from relatives.

Some minister portraits actually were painted as commercial fliers. Peter Pelham had painted a portrait of Cotton Mather (American Antiquarian Society) in 1727 in order to have an image from which to make a mezzotint, his real goal. With Smibert's arrival the two artists cooperated. Pelham used minister portraits by Smibert to scrape mezzotints of Sewall (fig. 93), Colman, Caner, and Cooper. These most likely were done in an edition of one hundred or more. Copley, for example, in 1765 suggested doing an edition of three hundred for a subsequent mezzotint of Sewall.[11] Also, according to Vertue, London mezzotint engravers were getting £15 20s sterling for scraping a plate.[12] At that rate someone like Pelham, who charged five shillings for each impression, would have to sell at least 240 prints to do comparably well. As Smibert does not list payments for portraits of either Colman or Cooper, he may well have done them as gifts or, more probably, on speculation that sales from the mezzotints and the free advertising they afforded would warrant the investment of time.

Smibert's life, like any businessman's, was governed by decisions about money and time. During the 1730s he charged £20–£25 for a bust-length portrait, £30–£35 for a Kit-cat, and £40–£50 for a knee-length, all of which seems to have made him the best paid of the small group of portrait painters active in the colonies. Nevertheless, his prices generally were a full 25 percent less then in London, most likely a reflection of the depressed economic state of Boston in the 1730s. Although determining relative values for colonial currency is notoriously difficult, Smibert seems to have demanded somewhat more than his colleague Gustavus Hesselius, who received just under five pounds for two portraits painted in 1722 and eight pounds for others in 1735.[13] In New York, the Scottish-born painter John Watson was earning no more than five pounds each for knee-length portraits. Smibert charged a bit more than the average in the case of commissions for odd-sized portraits. The "little 1/2," 40 × 30 inches, for Jean Paul Mascarene (plate 13), cost almost as much as the next-largest size. A "whole length" of a child painted on the standard 50 × 40 inch canvas, such as Jane Clark (plate 17), warranted a 10 percent surcharge. A multifigure canvas cost 25–50 percent more than a single-figure, as with the portraits of Mrs. Francis Brinley and her son, Francis (plate 15), or Mrs. Andrew Oliver (Mary

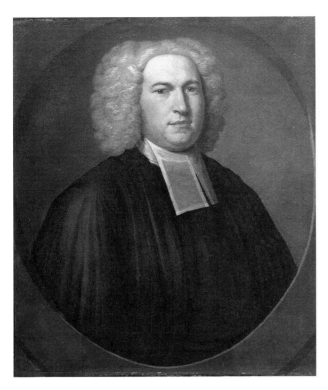

90. *Rev. Ebenezer Miller,* 1735 (cat. no. 113).

91. *Rev. Henry Caner. A.M.,* 1750. Mezzotint by Peter Pelham after cat. no. 220. Yale University Art Gallery. The John Hill Morgan Collection.

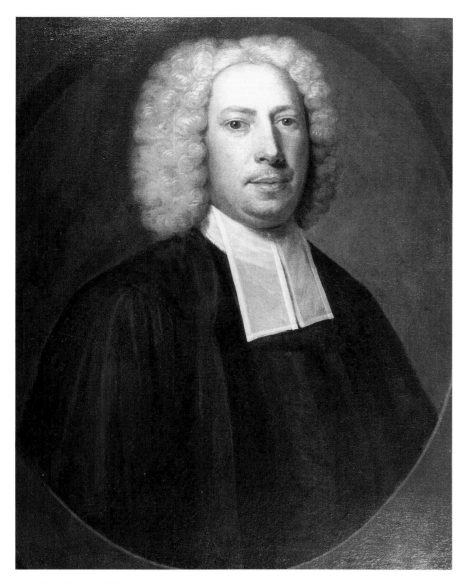

92. *Rev. Samuel Johnson,* 1737 (cat. no. 122).

Fitch) and her son, Andrew Oliver, Jr. (fig. 94). Predictably, Smibert's highest prices were reserved for his largest paintings: £80 for a full-length portrait of Governor Belcher (cat. no. 185) in 1730 and £90 for the group portrait *Daniel, Andrew and Peter Oliver* (plate 23), which included the challenge of painting one of the brothers, who was deceased, from an existing miniature (fig. 95). And on the rare occasion when Smibert painted a miniature himself, such as *Samuel Browne* (fig. 96), he charged the same price as he would have for a life-size portrait of identical format. In so doing, he followed the same price structure as London miniaturists.

Smibert's American income fluctuated from year to year. During his first year in Boston his income (£760 New England currency) was only one-half what he had earned the preceding year in London. In part this decline reflected the severe loss of buying power of colonial money in the decade before Smibert's arrival.[14] During the decade 1729–1738 Smibert's income averaged about 130 guineas a year —far less than what he earned during his best years in London. And, of course, if we consider that many of the people who initially "half-paid" for portraits never completed their payments, Smibert's income was somewhat less each year. In any event, his income

93. *The Reverend Joseph Sewall*, c. 1735. Mezzotint by Peter Pelham, after cat. no. 61. American Antiquarian Society, Worcester, Mass.

was similar to that of a moderately successful merchant, but in no way did his portrait practice make him wealthy. His earnings were not insignificant, but far less than the 300 guineas a year Copley claimed he averaged in the 1760s.[15]

Of the over 240 portraits that Smibert painted in America, the vast majority were in the three standard sizes: bust-length (39 percent), Kit-cat (15 percent), and three-quarter-length (34 percent). Paintings larger than three-quarter-length were extremely rare— and for good reason. Besides their considerable cost, there was virtually no precedent in the colonies for

private ownership of grand-scale portraits, and in most instances ceilings were so low that full-length portraits were unthinkable. As a result, only *William Browne* (plate 16) and *Mrs. William Browne* (fig. 97) were intended for a private residence.

The Browne family was Smibert's greatest patron: over the years they commissioned twelve portraits. William Browne lived in Salem, north of Boston, and was thought to be the wealthiest man in Massachusetts at the time he had Smibert paint his portrait. His immense wealth enabled him to be the most conspicuous of consumers, acquiring such amenities as a

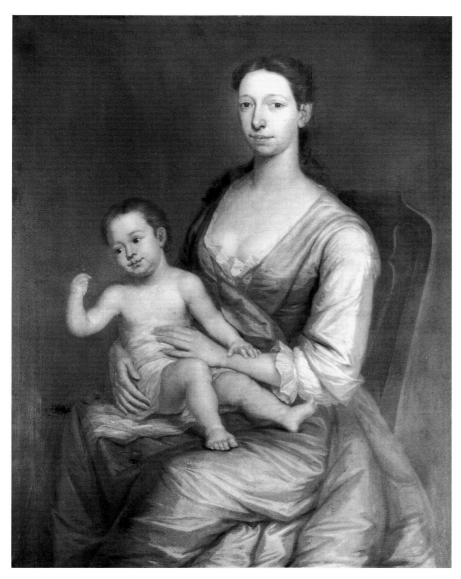

94. *Mary Fitch Oliver and Her Son Andrew Oliver, Jr.*, 1732 (cat. no. 77).

coach (the only one privately owned in Salem), which spawned the ditty:

Billy Brown has come to town,
 With his lady fair;
To make a dash, he spent his cash
 Upon a coach and pair.[16]

The two full-length portraits, of himself and his wife, are entirely consistent with his extravagant life-style. The portraits kept company with an extensive library, portraits of other family members (including that of Sir Anthony Browne, said to be a copy by Gabriel Mathias after Hans Holbein),[17] and a great rarity in the colonies: a tapestry "of scripture history" done by John Vanderbank, Sr.[18] Although his primary residence was in Salem, during the 1730s he built a country estate, Browne Hall, in Danvers, and it was for this residence that the portraits were painted. The lavish but diminutively-scaled Gibbsian villa was eighty feet in length and consisted of two wings, each two stories high, connected by a spacious hall. The hall was the scene of many magnificent entertainments and dinner parties; on one occasion an ox was roasted whole.[19] From a contemporary (1744) de-

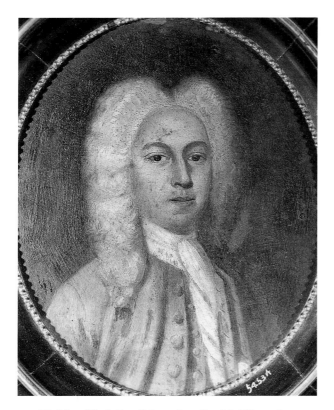

95. Unidentified English artist, *Daniel Oliver, Jr.,* 1727. Oil on copper, 5 × 4 in. Private collection.

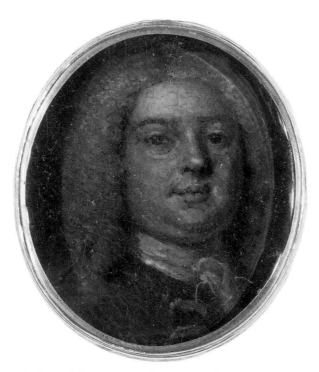

96. *Samuel Browne,* 1734 (cat. no. 103).

scription of the house, it is clear that Smibert has painted it into the background of Mrs. Browne's portrait (fig. 98): "His house stands upon the top of a high hill and is not yet quite finished. It is built in the form of an H with a middle body and two wings. The porch is supported by pillars of the Ionick order about 15 foot high, and betwixt the windows of the front are pilasters of the same. The great hall or parlour is about 40 feet long and 25 wide, with a gallery over the first row of windows, and there are two large rooms upon a floor in each of the wings, about 25 foot square."[20]

While a handful of people like Browne could spend a fortune on portraits, this certainly was not the usual case. The cost of a portrait ranked very high among possible luxuries. Furniture and silver invoices from the period suggest that the more expensive portraits (three-quarter-lengths) cost about as much as a significant piece of case furniture or a moderate piece of hollowware, such as a teapot. For example, Daniel Henchman, a Boston bookseller and the father-in-law of Thomas Hancock, paid Smibert six guineas in 1736 for his bust-length portrait (fig. 99). Two years later he paid £50 colonial currency (or twelve guineas at the prevailing rate of exchange)—the very price Smibert was then charging for a three-quarter-length—to Job Coit for a top-of-the-line mirrored desk and bookcase (fig. 100).[21] At about the same time, the Philadelphia silversmith Joseph Richardson charged customers just under ten pounds for an average-sized teapot.[22]

The only chance average citizens had to see a full-length portrait was if they attended a meeting in the council chamber at the Province House. Although most royal portraits have vanished either in fires or at the hands of overzealous patriots at the time of the Revolution, they are well documented, and it appears that each seat of government probably displayed them. In Boston's Town House, for much of the eighteenth century, full-lengths of the reigning British monarch had hung. Portraits of George II and Queen Caroline arrived sometime between 1727 and 1730, a gift of the king to the province. They joined a full-length of Queen Anne which had hung there since 1711. By 1740 commemorative full-length portraits of William and Mary had been commissioned in London by the province and installed there as well. These presumably joined the full-lengths of Charles II and James II that Pierre Eugene Du Simitière saw during his 1767 visit to Boston. Similar installations of British monarchs were documented in the council chambers of the governor's mansion in New York, the stately ballroom in the governor's palace in Wil-

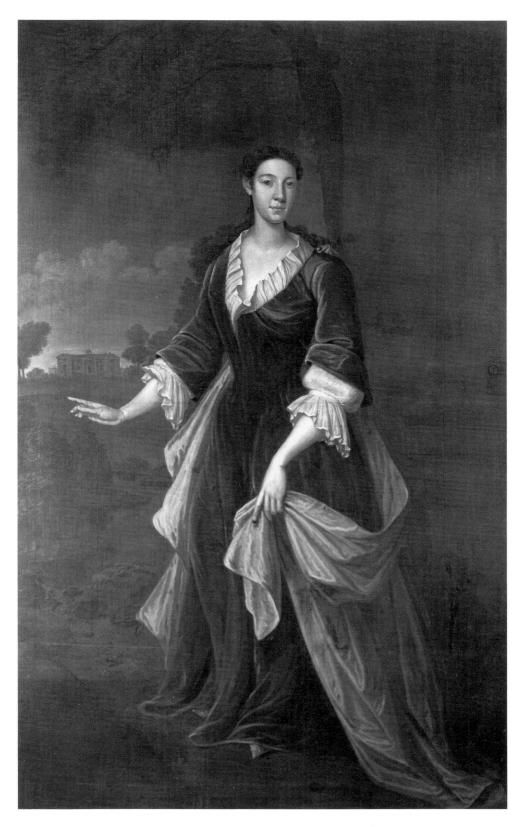

97. *Mrs. William Browne*, 1738 (cat. no. 126).

98. *Mrs. William Browne,* detail.

100. Job Coit, *Bookcase desk,* 1738. American black walnut. Courtesy The Winterthur Museum, Del.

99. *Daniel Henchman,* 1736 (cat. no. 116).

liamsburg, and the second state house in Annapolis, Maryland.

These now-vanished royal portraits, probably not unlike John Vanderbank's 1736 full-length of Queen Caroline (fig. 101), set the standards of formality and decorum by which Smibert and other artists were judged. The presence of royal portraits probably also contributed to a desire to honor and preserve likenesses of colonial governors and other worthies. We know, for example, that the gift of portraits of George II and Queen Caroline c. 1727–1730 prompted Jonathan Belcher, the recently appointed governor of Massachusetts, to commission (at his own expense) a full-length portrait of himself (cat. no. 185). This he did, a contemporary noted, "to answer the King and Queen's."[23]

For the most part, publicly exhibited portraits of colonists in the first half of the eighteenth century were limited to the governors. In Boston at least three portraits were commissioned to hang beside royal portraits in the council chamber and in the public space at Province House, the governor's residence. The portraits of the Massachusetts governors—Winthrop, Endicott, Leverett, Bradstreet, and Burnet—were observed hanging in the council chamber in the 1760s.[24] Occasionally official portraits were gifts to

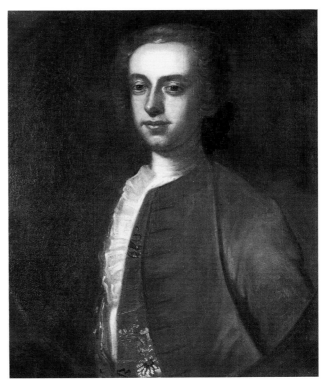

102. Edward Truman, *Thomas Hutchinson*, 1741. Oil on canvas, 31 × 23 5/8 in.(71.9 × 60. 2 cm.). Courtesy Massachusetts Historical Society, Boston.

101. John Vanderbank, *Queen Caroline*, 1736. Oil on canvas, 93 × 57 in. (236.2 × 144.8 cm.). Goodwood House, Chichester, West Sussex.

the colonies. This was the case with Belcher and with Governor Thomas Pownall, who gave his portrait to Massachusetts, as well as Charles Calvert, the fifth Lord Baltimore, who brought his portrait with him on a 1732 visit to Maryland.

Other Massachusetts governors, like Thomas Hutchinson, made a point of having their portrait painted on a trip to London (fig. 102). At the beginning of the century there may not have been anyone in Boston who could have done an adequate job. After Smibert's arrival this was no longer the case, but a degree of one-upmanship no doubt motivated some people to bring a London portrait back to Boston.

During Smibert's Boston years there were rare public occasions when portraits were commissioned at the request of the public. Such was the case with Smibert's portrait of Peter Faneuil (cat. no. 130), the

Boston merchant who contributed funds to build a central public market with a second-floor chamber for public meetings. At the first meeting held there, on September 13, 1742, it was resolved that the hall should be named after its benefactor and that a full-length portrait be commissioned "at the expense of the town" to hang there.[25] The following year Gov. William Shirley informed the town through the selectmen that he had received His Majesty's picture from the Lord Chamberlain (the Duke of Grafton) and that he intended to present it to the town to be hung in Faneuil Hall.[26] Two years later, in the euphoria over the defeat of the French, a large group of gentlemen, merchants, and other citizens of Boston approached Governor Shirley "and requested of him to permit 'em to have his Picture drawn at their Expense with a design of preserving it in the Town as a memorial of his Excellency's publick Services, which word of their respect his Excellency was pleas'd to accept."[27] This portrait by Smibert (cat. no. 425), like that of Faneuil, was hung in the hall rather than the council chamber, where the other governors' portraits were, presumably because the townspeople commissioned it.

During his moments of indirection during the 1730s Smibert searched for ways to ease his financial burden and generate additional income. In 1734 Smibert at first planned to lease the new showroom created for him by his father-in-law, but upon further reflection he settled on a far more ambitious idea: to open "a printshop with Fanns Colours and other things in my own way."[28] This decision reflected the blossoming of specialized retail trade in Boston of the 1730s. During these years a variety of shops sold imported groceries, dry goods, garments, tobacco, and other household items.[29] Smibert's shop was apparently the first comprehensive "colour shop" in the colonies, although Boston artists like Zabdiel Boylston had advertised as early as 1711 that they had "painter's colors" for sale.[30] Smibert stocked artist's colors, brushes, canvas, and related materials obtained from London. The shop was operated by John Moffatt (c. 1704–1777), Smibert's nephew, who had joined him in Boston. The shop was first advertised the week of October 10–17, 1734, in the *Boston News-letter* and the *Boston Gazette:* "JOHN SMIBERT, PAINTER, sells all sorts of Colours, dry or ground, with Oils, and Brushes, Fans of Several Sorts, the best Mezotints, Italian, French, Dutch and English Prints, in Frames and Glasses, or without, by Wholesale or Retail at Reasonable Rates: at his House in Queen Street, between the Town-House and the Orange Tree, Boston."

Although it is not known whether Smibert's color shop turned a profit, it did give him the much-needed satisfaction that he was doing all he could to supplement his unpredictable income from painting. Letters from old friends during these years, such as those from Berkeley (1735) and Ramsay (1736) (app. 2), may have made him pause to take stock of his activities. But Berkeley's question, "whether it might be worth your while to embark with your busts, your prints, your drawings, and once more cross the Atlantic," probably only stoked Smibert's determination to make the color shop a success.

Smibert's shop was modeled after London shops he frequented. In the 1740s the merchant Gerard Van der Gucht (1696–1776) announced on his trade-card that he "Sells all sorts of Italian, Dutch, French & Flemish Prints & Drawings both of the Antient & Modern Masters with the greatest variety of Japaning, Water Colours, Crayons, Black, Red & White Chalk, India Ink, Port Crayons & every Article relating to Drawing. Prints Fram'd & Glaz'd in the best & Cheapest Manner. Pictures Carefully Clean'd Lin'd & Repair'd."[31]

Smibert was reluctantly following the simple rule that governed the habits of most eighteenth-century British artists: use ingenuity to survive by any possible means. This he must have done with very mixed emotions, for like other colonial painters he was forever seeking to raise his status above that of the tradesmen. It was common for a portrait painter to work also in related jobs such as japanning (Partridge); gilding (Gerardus Duyckinck); selling paints, prints, and other artist's supplies (Smibert, Partridge); doing other types of painting, such as painting coaches (Hesselius, Jeremiah Theus), hatchments (Emmons, Bishop Roberts), tavern signs (John Greenwood), or the interiors and exteriors of houses (Joseph Badger, Emmons, Roberts). Peter Pelham resorted to performing a musical concert "on sundry Instruments"; Another time he taught "Dancing, Writing, Reading, Painting upon Glass, and all sorts of Needlework."[32] That colonial painters were forced to pursue a variety of mundane activities to enhance their chances of survival only reinforced society's impression of them as tradesmen. The most enterprising souls turned to other fields entirely. John Watson, for example, who was among the wealthiest of colonial artists active in the first half of the century, made his fortune as a merchant, a land speculator, and a moneylender.[33]

Smibert clearly anticipated selling commodities wholesale to coastal traders and professional painters and retail to amateurs. Probably typical of the sales Smibert and Moffatt made were those to the Boston bookseller Daniel Henchman, who purchased a cask of Spanish brown paint for £4 4s 6d in 1739, and Christopher Kilby, who the same year bought various quantities of Spanish brown, white lead, and indigo pigments, linseed oil, a pail, and a jar.[34] Smibert stocked a line of fans specifically because "there are many women that paints Fanns for the country use."[35]

Like Smibert's portrait practice, the operation of his color shop was governed by business principles. In addition to the paints and brushes he was able to sell retail, he assembled at his shop other painting supplies that he thought would be likely to attract New England purchasers. By 1743 his primary supplier of artist's supplies was his old London friend Arthur Pond, who had established himself as a leading wholesaler and retailer of prints. From him Smibert ordered bust-length canvases (30 × 25 inches), already on strainers, larger canvases (Kit-cat, half-length, and full-length) primed and rolled up, large quantities of fan paper, pigments, pallet knives,

brushes, silver and gold leaf, and colored prints "for Japanning" (see app. 2). As opportunities arose, he did make purchases from colonial sources, such as an auction in 1745 at which he bought gold leaf.[36]

Since oil portraits were quite expensive and owned by no more than 1 percent of the population,[37] there was a secondary market for portrait prints as well as landscapes, reproductions of old masters, and a variety of contemporary subjects. Initially prints produced in New England were limited to a few topographical views and portraits of local divines, and frequently they were published posthumously. John Foster's 1670 woodcut of Richard Mather (fig. 103) is a good early example of this phenomenon. Other prints were done on speculation, such as that of Rev. Samuel Willard, scraped in London for sale in Boston. The market for such a print, like that for Pelham's mezzotints, was among members of the congregation, to provide social models of "the Virtuous actions, blameless Lives, and Christian Deportment of Deceas'd Persons, to the Worthy Imitation of the sorrowful Living." These kinds of prints were considered "fit for any Gentleman's Dinningroom or Staircase."[38]

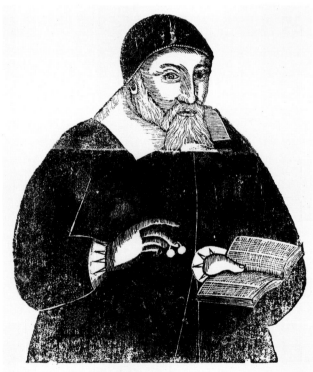

Mr. Richard Mather.

103. John Foster, *Mr. Richard Mather*, 1670. Woodcut, 6 1/8 × 4 7/8 in. American Antiquarian Society, Worcester, Mass.

A number of the earliest portrait prints made or sold in the colonies had been memorial portraits of deceased spiritual leaders, but by the 1730s engravers like Pelham had helped to establish an interest in portraits of living ministers. There was also a market for portrait prints of monarchs past and present. In 1719 one resident of York County, Virginia, still displayed small pictures of King William and Queen Mary decades after their deaths. In time, a vogue developed for displaying portrait prints of international leaders, political supporters of the colonies, Native Americans, and English military leaders, as well as actors and singers. In 1739 one collection in Virginia consisted of "neat pictures of King Charles the 2nd, the Judges of England, the King of Prussia, King Ferdinand, Admiral Boscowan, Mr. Gerick [sic], Mr. Beard, Singer and the Hon. William Pitt Esq."[39]

Owning prints of prominent political, religious, and cultural leaders was popular and accepted, but commissioning a print of oneself was taboo. In 1734, when Jonathan Belcher's son took it upon himself to have a mezzotint of the elder Belcher scraped in London, his father was outraged:

> I am surprised & much displeased at what your Uncle Writes me of Mr [Henry] Newman & your having my Picture done on a Copper Plate—how cou'd you presume to do such a thing without my special leave and Order—you should be wise and consider the consequences of things before you put 'em in Execution, such a foolish affair will pull down much Envy, and give occasion to your Father's Enemies to squirt & Squib & what not—It is therefore my order, if this comes to hand timely that you destroy the plate & burn all the Impressions taken from it.[40]

This severe reprimand is another indication that all portraits seen in the colonies were subject to a well-understood but largely unstated code of social etiquette.

Smibert was eager to complement the sale of prints produced locally with images of all kinds obtained abroad. He initially culled from his own collection prints he wish to sell; then, in the spring of 1734, he began to supplement this group with old-master and contemporary prints ordered from London. In March 1735, to promote his fledgling enterprise, he placed another advertisement alerting residents of New England to the resource in their midst:

> JOHN SMIBERT. To be Sold, at Mr. Smibert's, in Queen Street, on Monday, the 26th Instant, A Collection of valuable PRINTS, engrav'd by the best Hands, after the finest Pictures in Italy, France, Holland, and England,

done by Raphael, Michael Angelo, Poussin, Rubens, and as History, etc, most of the Prints very rare, and not to be met with except in private Collections: being what Mr. Smibert collected in the above-mentioned Countries, for his own private Use & Improvement: The Price of each single Print or Book to be mark'd upon 'em, and to be the same, which Mr. Smibert, who bought 'em at the best Hand, himself gave for them.

At the same Time, there will be Sold a Collection of Pictures in Oil Colours; the price of each Picture, to be mark'd upon it. N.B. The Sale will last from Monday morning till the Saturday Evening following, and no longer: Those Prints that shall remain then unsold, will be sent to England.

This effort seems to have met with immediate results, for soon thereafter Smibert shipped to Sueton Grant, a Newport merchant and budding virtuoso, a variety of works, including a large naval combat by Giovanni Battista Britano, Cornelius Cort's engraving after Raphael's *Battle of the Elephants,* a Virgin after Carlo Maratta, and a set of Hogarth's six prints *A Harlot's Progress* (fig. 104).[41] Such an assemblage of diverse prints suggests that the tastes of some New Englanders were rapidly becoming cosmopolitan and, like the seventeenth-century virtuosos, were looking to acquire a little bit of everything.[42] Certainly, Grant had some pretensions about him. He was a member of Newport's fledgling Society for the Promotion of Knowledge and Virtue by a Free Conversation, organized in 1730. Apparently the society's activities were somewhat less ethereal that its name: one visitor recalled, "I was surprised that no matters of philosophy were brought upon the carpet. They talked of privateering and building of vessels; then we had the history of some old familys in Scotland where by the by, Grant told us a comic piece of history relating to General Wade and Lord Loveat."[43] Grant had Smibert supply him with his coat of arms, perhaps the most obvious symbol of colonial cravings for aristocratic affectation. Its primary purpose was to remind others of the owners' lineage and distinction; in America, more often than not, they were produced for families not entitled to them.[44] It may also be—although this is less likely—that in Grant Smibert may have stumbled upon a patron both sensitive to the high-water marks of past European art while at the same time in tune with the most recent artistic developments that Hogarth's work represented.

It is not hard to imagine that in an artistically practical environment like New England, buyers felt most comfortable with such topographical prints as *The*

104. William Hogarth, *A Harlot's Progress,* 1732. Engraving, plate 2. Yale Center for British Art, Paul Mellon Collection.

View from One-Tree Hill in Greenwich (fig. 105), such classical landscapes as *The Falls of Tivoli* (fig. 106), or such images of ancient Rome as *Roman Antiquities No. 3: Basilica of Antoninus, Temple of Fortuna Virilis, Mausoleum of Hadrian, Medicean Vase* (fig. 107). Each of these prints (the latter two being part of sets) Smibert obtained from Arthur Pond. At virtually the same moment Smibert opened his color shop, Pond began selling prints, for many of which he acted both as producer and wholesale distributor. Surviving correspondence (app. 2) suggests that Pond was Smibert's principal print supplier although, as with artist's supplies, he presumably obtained prints from other sources as well. One such possibility was Claude DuBosc, another of Smibert's old friends, who operated a printshop in London.[45] In one sales report to Pond, Smibert noted, "The smal sett I have sold and desire you will send 5 setts of the 7 numbers on the smal paper which with the sett already received will amount to eight guineas allowing the 20 per cent for those who sell them again. its probable more will sell but we will try them first." A subsequent letter informed Pond that "ye View from Greenwich & Antiquities by P. Panini please more here than ye others and I hope some number of them wil sell," and was accompanied by an order for one dozen of each. Clearly, Smibert's shop was an important New England oasis catering to the ever-expanding artistic tastes of a small but growing coterie of armchair tourists and citizens.

Some prints Smibert began to sell in the 1730s were

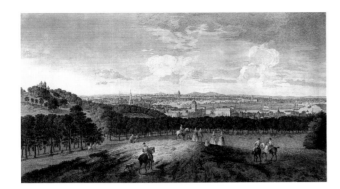

105. J. Wood, after Peter Tillemans, *The View from One-Tree Hill in Greenwich*, 1744. Engraving. National Maritime Museum, London.

107. J. S. Muller, after Giovanni Paolo Pannini, *Roman Antiquities No. 3: Basilica of Antoninus, Temple of Fortuna Virilis, Mausoleum of Hadrian, Medicean Vase*, 1746. Engraving. The British Museum.

106. James Mason, after Gaspard Poussin, *The Falls of Tivoli*, 1744. The British Museum.

billed as examples he personally purchased in Europe "for his own private Use & Improvement." These were brought to America both as teaching aids in Bermuda and as a repository to which he might refer in his own studio practice. Most portrait painters in the early eighteenth century made consider-

able use of prints or compiled notebooks of drawings as design sources for compositions. Joshua Reynolds outlined this practice when he first went to London to train with Thomas Hudson in the early 1740s: "They have got a set of postures which they apply to all persons indiscriminately: the consequence of which is that all their pictures look like so many signpost paintings, and if they have a history or family piece to paint, the first thing they do is look over their commonplace book containing sketches which they have stolen from various pictures, then they search their prints over, and pilfer one figure from one print and another from a second, but never take the trouble to think for themselves."[46]

It was typical for the colonial portrait painter to assemble a collection, like the trunk of two hundred prints owned by William Dering (active 1735–1751), a Virginia painter, to assist artist and patron in making decisions about how a portrait should look. It seems to have been acceptable for an artist to utilize the composition of a decades-old print—such as when Smibert used the 1699 mezzotint of the Countess of Ranelagh (fig. 108) for his 1730 portrait of Mrs. Nathaniel Cunningham (fig. 109)—as long as the details of dress were in keeping with the taste of the period. What goes unsaid here is that the code of manners and gestures used in the early eighteenth century remained far more stable than fashion governing the shape or color of clothing. This goes a long way toward helping to explain why the similarities between colonial portraits of 1725 and 1750 outweigh the differences. We are given a tantalizing hint of how such prints were used when Smibert asked Pond for "A Set of Ships published by Lempriere and

108. John Smith, after Sir Godfrey Kneller, *Countess of Ranelagh*, 1699. Mezzotint. Courtesy The Winterthur Museum, Del.

sold by H. Toms in Union court Holburn. . . . These ships I want sometime for to be in a distant view in Portraits of Merchts etc who chuse such, so if there be any done since send them but they must be in the modern construction."[47] Smibert used these prints (fig. 110) or similar examples for such portraits as that of the merchant Richard Bill (plate 22).

Like any proprietor of a small business, Smibert faced a variety of responsibilities, obligations, and challenges: overworked subcontractors, late deliveries, lost mail, deadbeat clients, personnel problems, requests for contributions to worthy causes, and discharge of onerous civic duties. It was presumably not uncommon for him to have to notify clients that "it was impossible to send [your order] sooner. the frame makers having so much work bespoke before and being also not disposed to work any more than necessity forced, occasioned me to call upon them at least twenty times, before Mr. McSparran's frame and yours could be got from them."[48] Another time he advertised a reward for a runaway slave named

"Cuffee" who was distinguished by "a pair of Leather Breeches stain'd with divers sorts of paints."[49] He was not particularly prominent in the governance of Boston, but at various times he contributed £15 to the workhouse and served on committees to report on the feasibility of placing a battery on Long Wharf (1740) and to keep the streets clean (1747).[50] In March 1735 the town excused Smibert, "for reasons given by him," from serving as constable.[51] This was a particularly distasteful task—required of all able-bodied citizens but dodged by many—which entailed such pleasantries as pursuing thieves and peace breakers, collaring drunks and vagrants, and conducting searches for the unlicensed sale of beer and wine.[52]

Smibert had to take care to maintain good relations with frame-makers. It is not known who supplied Smibert with frames—most likely they came from several sources—but one of the suppliers may have been the Boston engraver Thomas Johnston, who is documented as making frames some years later.[53] The frames selected by Smibert's patrons were of three types: plain, low-relief, and high-relief. The simplest and least expensive of Smibert's frames, like that for *Joseph Turner* (see fig. 116), consisted of a three-inch-wide bolection molding, painted black to resemble ebony, with a carved gold liner. This type of frame was inspired by seventeenth-century Dutch channel frames. More expensive and equally popular were frames like that for *Rev. James McSparran* (see fig. 89), which were entirely carved in low relief, with a pattern of C-scrolls and floral motifs, and then gilded. This type of frame was the most stylistically up-to-date, anticipating the style of Louis XIV, which was popular in both France and England. Clients least concerned about expense, of whom David Cheseborough (fig. 111) was apparently one, opted for a high-relief frame, with extensive gadrooning, and entirely gilded. This last type, in the style of Louis XIII, is a carryover from the late seventeenth century and, despite its cost, was the most stylistically dated.[54] Although only a fraction of Smibert's portraits retain their original frames, there is enough evidence to suggest each of these frame types remained popular throughout the period Smibert painted in Boston. It seems that frames added about 20 percent to the cost of paintings; at least on one occasion Smibert suggested that imported frames could be had cheaper than those made locally.[55]

If the activities of these years contributed to Smibert's emotional and financial stability, they did so at considerable expense to his artistic motivations. By the late 1730s Smibert's portraits of note were

109. *Mrs. Nathaniel Cunningham,* 1730 (cat. no. 68).

110. Claude Lempriere, *Merchantman,* 1738. Engraving. Courtesy The Board of Trustees of the Victoria and Albert Museum, London.

111. *David Cheseborough,* 1732 (cat. no. 78).

mannerisms, expressions, and the small talk they most likely exchanged. If at first glance Smibert was indifferent to him, by the time he had finished his instincts had taken control. Although in the portrait Livingston possesses a certain handsomeness, he seems detached, vain, and unforgiving. If Livingston's reputation preceded him Smibert must have learned that in his youth he had had a winning way with women but used it "breaking hearts promiscuously." Others who attended his church remarked that a sermon on avarice had been pointedly spoken "particularly for Mr. Livingston, a rich but very covetous man in town who valued himself much for his riches. But unfortunately Livingston did not come to church to hear his reproof."[56] Whether Smibert's subliminal feelings about Livingston were apparent to his sitter is unknown. In any event, Smibert—at least in his later years—seems to have found a subtly satisfying way of reprimanding those in society whose code of behavior was most at odds with his personal philosophy of life.

becoming more scarce with each succeeding year. What little passion he retained for his sitters' portraits was distributed in a most selective manner. In fact, the last truly glorious portrait of Smibert's career is *James Bowdoin* (plate 24), painted in 1736, almost a full decade before Smibert ceased painting. Here, in what may be the freshest and most sparkling of his American portraits, Smibert seems to have been particularly moved by this small boy, not yet ten, who was heir to a vast fortune. Perhaps Smibert, only two years short of his fiftieth birthday, saw in this boy much of the spirit and will to succeed that had sustained him through his long and gritty Edinburgh apprenticeship. Like Smibert, Bowdoin was later noted as modest, polite, and philanthropic, personal characteristics on which Smibert placed a premium.

If Smibert smiled upon certain sitters, he was indifferent to many others and outright hostile to a few. One object of his disdain appears to have been Philip Livingston (fig. 112), who during a visit from Albany, New York, sat for his portrait. If the young Bowdoin stood for everything Smibert admired, Livingston stood for much he abhorred. By the time Smibert looked upon Livingston, well over three hundred people had sat for him. Even if he knew little of Livingston's life history, the artist in him was sensitive to

112. *Philip Livingston*, 1737 (cat. no. 124).

8

"Above All, an Exemplary Christian": Smibert's Final Years

ACH shift in Smibert's career was marked by geographical or spiritual change, or both. The last of these occurred in 1737, when he abandoned Old South Church to become one of the founding members of West Church, the town's newest Congregational society. In so doing he broke his wife's family's long-standing ties with Old South to worship at a newly constructed wooden meeting-house erected on Lynde Street at the northwest edge of town (now Cambridge Street), much farther from his home.[1] While his decision to make this change has long been known, his reasons for it—an essential factor in assessing the final years of the artist's life and career—have been overlooked.

Like so many earlier decisions in Smibert's life, this one seems to have been motivated by intense moral scruples and a belief that spiritual sanctification came from personal restraint and hard work. West Church was formed by a group of liberal-minded people drawn from Boston's existing Congregational churches. Their conflict with fellow members came over ideas about man's intrinsic ability and worth and the idea (disturbing to others) that one might earn salvation through one's own works (as opposed to the belief in predestination espoused by many Congregationalists). The most extreme among this group, which included Rev. William Hooper, the first minister of West Church, tended toward Arminianism, a position which held that worldly success was an indication of God's approval.[2]

The fact that there was virtually nothing to be gained professionally by changing churches says much about Smibert's priorities. Had such a switch been motiviated by a drive for personal wealth he would have done far better to join the more upscale Brattle Street Church, or to do the unthinkable: join the Anglican church. But to him worldly matters had always been secondary to the righteous conduct of one's life. As he neared fifty he seems to have been increasingly preoccupied with moral rectitude.

Smibert continued a long-standing participation in the Scots Charitable Society. This Boston organization, which met quarterly at the Sun Tavern, was founded in 1657. It helped the poor, fed the sick, and buried the dead by distributing the interest generated by funds collected from local Scots. At its founding it was unique in the colonies in its dedication to aiding the unfortunate, and it became a model for similar organizations in other colonial towns.[3] Smibert's involvement was simultaneous with his opening a studio in May 1729 and his activity was steadfast during his years in Boston.[4] Although the society may initially have served to acquaint him with potential sitters and fellow countrymen, in later years its purpose far exceeded the self-serving motivations that would have been sufficient for most artists. Few of Smibert's sitters attended the regular meetings, so Smibert's own attendance must betoken a genuine interest in the work of the society.

The membership of the society consisted of approximately forty Scots living in Boston. Attendance at meetings varied from as few as a dozen to virtually the entire membership. At each meeting members made quarterly contributions of £5 (New England currency). A number of prominent Scots were active in the society: Dr. William Douglas, a leading Boston physician; Captain John Erving; Sueton Grant and David Cheseborough, two of Smibert's clients from Rhode Island; and Dr. Alexander Hamilton, the diarist from Maryland. Smibert's nephews John and Thomas Moffatt were active as well. The society's success in promoting Scottish influence in the colonies and as a social club at which one might have some punch and "chat on news and politicks"[5] led to the establishment of branches in Charleston (1729), Philadelphia (1749), and New York (1756). But social concerns were secondary, as Smibert could easily

have joined the Society of Free Masons (as Pelham did), which was organized in Boston in 1733 and frequently staged lavish entertainments.[6]

Smibert's activity in the Scots Charitable Society may well have played an influential role in his decision to change churches. For it was at these meetings that he met Reverend Hooper, a graduate of the University of Edinburgh (1723),[7] who was invited to lead the new West Church congregation. Smibert also seems to have been urged on by John Moffatt, his nephew, who in 1736 was one of the signers of its covenant. Smibert's formal participation in the church began on February 7, 1737, when he was named one of the sixty-eight pew proprietors, those who formally paid an annual fee for the privilege of leasing a pew in the church. Smibert's pew (no. 39) was next to that reserved for the minister's family and second in prominence only to that reserved by James Gooch, Jr., who was the first deacon.[8]

In succeeding years West Church became the most progressive church in Boston, and under the direction of Jonathan Mayhew it became boldly Unitarian long before that name was given to those with such convictions.[9] Hooper, who lasted nine years, became disenchanted with a rebuke by the congregation, converted to Anglicanism, and became rector of Boston's Trinity Church. Throughout these difficulties Smibert was unwavering in his commitment to West Church, always paying a bit more than was required for his pew and serving on various committees.[10]

During these years diversions of varying intellectual and moral value seem to have stimulated Smibert. It may have been around this time that Smibert's antiquarian proclivities reemerged, after he journeyed forty miles south of Boston to Dighton Rock, a sandstone boulder covered with ancient pictographs. The rock, which sits in the stream of a tidal estuary, had intrigued colonists as early as 1680, when it was drawn by Rev. John Danforth and subsequently reported to the Royal Society by Cotton Mather.[11] Smibert also made a drawing, which was inherited by Williams Smibert and seen by Boston visitors in the 1760s.[12]

Another of Smibert's activities was to paint landscapes. As he indicated in a letter from the late 1740s, he had for some time been "diverting my self with somethings in the Landskip way which you know I always liked."[13] One result of this interest is a *View of Boston* (plate 25), which appears to have been painted in 1738. It is possible that Smibert did the painting not simply for his own amusement but also on speculation, as he took time to record a painting of this title in his notebook.

113. John Harris, after William Burgis, *A South East View of ye Great Town of Boston in New England in America,* 1736. Engraving. The British Library.

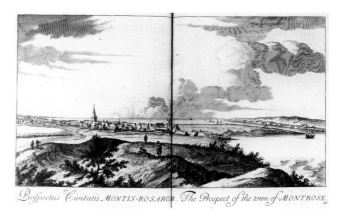

114. *The Prospect of the Town of Montrose,* from John Slezer, *Theatrum Scotiae* (Edinburgh, 1647; repr. 1718 by Andrew Johnston). National Library of Scotland, Edinburgh.

115. *The Prospect of the Town of Air from the East,* from John Slezer, *Theatrum Scotiae* (Edinburgh, 1647; repr. 1718 by Andrew Johnston). National Library of Scotland, Edinburgh.

The painting is a vast panorama for which there is ample precedent in colonial printmaking but virtually none in colonial painting. Certainly the lineage for such a view can be traced back to William Burgis's *A South East View of ye Great Town of Boston* (fig. 113), which had gone through several printings beginning in 1725. And it in turn is linked to an international phenomenon of topographical views which had found an ample following since the seventeenth century. Smibert was intimately familiar with this tradition, as his good friend Andrew Johnston, an Edinburgh engraver, had reissued the most famous of Scottish publications in the this vein, John Slezer's *Theatrum Scotiae* (1693, reissued 1718). In fashioning his own view of Boston, Smibert fused two existing views: the Burgis view of Boston and foreground elements from two Scottish town views from Slezer (figs. 114 and 115).

But there is more meaning here than simply a desire by Smibert to paint landscapes. For Smibert, landscape represented the pastoral side to human existence, while the town suggested its desires and foibles. The landscape also provided a release for him from the tedium of portrait painting. For although his Boston view closely follows the established construct for urban landscapes of this kind, it did give him respite from the one-to-one relationship with a sitter and the emphasis on replication. If portraiture for him was prose, landscape was poetry.

Smibert has also particularized the convention of employing arcadian shepherd figures as foreground elements in landscape—a commonplace from Gaspard Poussin to John Slezer (to call up the range of historical reference most relevant to Smibert). But here the figures consist of a pair of colonists, undoubtedly Bostonians, who are paired with Native Americans, to whom the wonder of colonial civilization is being revealed. Smibert may have intended these images to show that Native Americans were to benefit from Western society through harmonious assimilation, but the figural arrangement suggests a kind of ecclesiastical and moral imperialism.[14] Certainly, Smibert would have been well acquainted with Berkeley's plan to recruit children of "savage Americans" as "Missionaries for spreading the Gospel among their Countrymen,"[15] which had as its ultimate goal the absorption of Indian life by colonial culture.

In these years following the failure of the Bermuda enterprise, it appears that Smibert was determined to find the kind of satisfaction for himself that he felt he had missed by not becoming a college don. He took an avid interest in landscape painting, architecture, and informal teaching through contact with Feke, Greenwood, and Nathaniel Smibert. His late portraits are almost an aside, hollow shells devoid of the inspiration that had governed his earlier work.

Nevertheless, the practicalities of his life in Boston required him to persevere in his painting practice as long as he was physically capable of doing so. There had been hints from Vertue as early as the 1720s that Smibert was inclined to delicate health, and clearly by 1739 his physical well-being was in jeopardy. By the following year, however, Smibert had decided to make the only major painting trip of his American career. To accomplish it he made use of what might be termed the "Scottish connection," a loose network of Scottish merchants and professionals, particularly physicians who had carved out a significant niche for themselves in colonial society.[16] On May 12 Dr. William Douglas sent a letter to a fellow Scot in New York, Cadwallader Colden, a wealthy merchant and later lieutenant governor, in which he wrote: "this comes or is forwarded by my particular good friend Dr Thomas Moffet Physician. He travels with his Unkle Mr Smibert to see the Country and for the benefit of his Health."[17]

Smibert probably had other, equally pragmatic reasons for traveling as well. Although he had lived in the colonies for eleven years, he had since his arrival in Newport never ventured farther south. Now, as he could see the end of his professional career nearing, he may have wished to see New York and Philadelphia before he became too old to travel. More important, Gustavus Hesselius's focus on decorative painting in Philadelphia and John Watson's retirement in New York had created portrait markets for him that may not have existed for much of the preceding decade. Further, like John Singleton Copley in 1771, who traveled from Boston for a similar purpose, he was most likely given some assurance of commissions before he set out. It is virtually certain that his trip was preceded by correspondence mentioning some of the sitters he might paint. His work would have already been well known in New York, for in the late 1730s he had painted two portraits for sons of Lieutenant Governor George Clarke (cat. nos. 232–235), and another of his sitters, Ebenezer Pemberton (cat. no. 396), was minister of the Presbyterian congregation there.

But as his first stop was Philadelphia, where his work was less familiar, letters of introduction were most likely his means of making contacts. He apparently traveled by boat, the normal mode of transportation from one port city to another, and arrived during late May or early June. There over the course

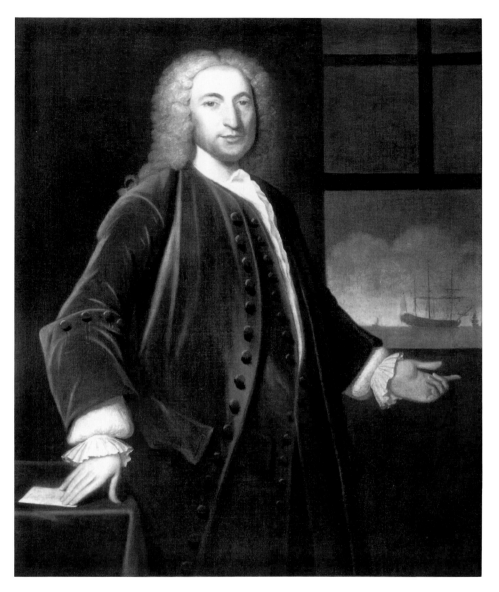

116. *Joseph Turner,* 1740 (cat. no. 133).

of eight weeks Smibert painted fourteen portraits, and in each instance he raised his price by more than 50 percent. All were commissions from eight families interrelated by marital, commercial, or social ties. His sitters, as one would expect, were from Philadelphia's leading families, and several, such as Andrew Hamilton (cat. no. 317) and William Allen (cat. no. 163), were native Scots and Presbyterians as well. Although Quakers—who for religious reasons tended to frown on portraits[18]—had played the dominant political and social role in Philadelphia up to this time, during the 1730s, more recent Presbyterian arrivals from Scotland began to play a key role in government,

business, and society in general. Among the most influential was Hamilton, a judge of the Court of Common Pleas and an active participant in Philadelphia's political scene. He also was known throughout the colonies for his 1735 defense of the New York newspaper publisher John Peter Zenger. His son James (cat. no. 319) was a member of the Pennsylvania Assembly and the brother-in-law of Allen, who had been mayor of Philadelphia (1735). Smibert's portrait of Joseph Turner (fig. 116), a merchant, whose business partner was married to Andrew Hamilton, Jr., is the only one from his Philadelphia visit to be identified today. Its doggedly conservative style confirms

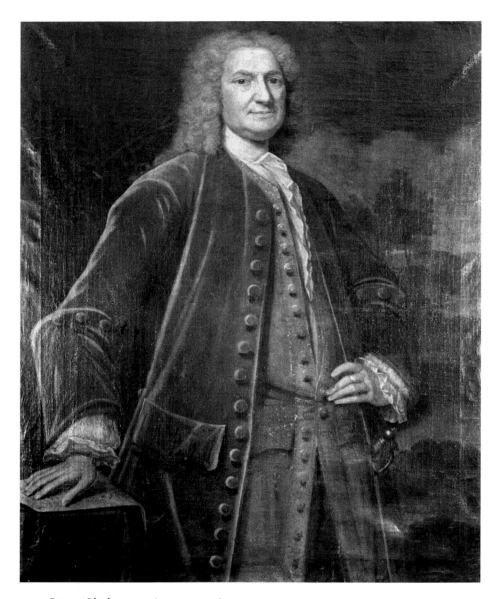

117. *George Clarke*, 1740 (cat. no. 134).

that this exposure to the Mid-Atlantic colonies had virtually no effect—either positive or negative—on Smibert's artistic direction.

Smibert had to be satisfied with his Philadelphia visit, as the fourteen commissions equaled his most productive period in America (September–October 1729). Given the rapid rate at which he was taking commissions it is likely that he began each portrait in Philadelphia, painting the face and sketching the remainder, and then shipped the portraits back to Boston to be completed and framed. This would explain why he did not receive final payment for the Phila-

delphia pictures, as indicated by James Hamilton's surviving cash book,[19] until two years later.

Upon concluding his business of these successful months he traveled overland through New Jersey to New York. Probably traveling by the stage that ran from Philadelphia to Perth Amboy, he lingered in Burlington, which then served with Perth Amboy as the capital of New Jersey, long enough to paint Lewis Morris, the septuagenarian governor of that state, and his wife (cat. nos. 366 and 367). By September Smibert had reached New York, and in his one month there he received eleven commissions, more than any

other month of his career. As in Philadelphia, his sitters were the politically powerful. They included Alexander Hamilton's friend and colleague William Smith, who had also acted as counsel for Zenger, and George Clarke (fig. 117), the lieutenant governor, whose sons had sought Smibert out in Boston.

Although only two portraits have been identified from this immensely fruitful trip, they suggest that there is little pleasure to be gained from a concerted search for more. The trip is, in fact, much more interesting from the vantage point of what it may have done for Smibert's mental and financial state. When he totaled up his receipts at the end of 1740 he could happily report over thirty portraits started, if not yet completed, and more five hundred guineas in income on the books, if not yet in hand. It was financially the most productive year of his American career, rivaling his best years in London. And it is fortunate for him that it was, for the following year, 1741, was a financial disaster. Smibert contracted a "dangerous illness,"[20] possibly aggravated by the most severe winter in colonial history, and he was unable to paint at all.

But if 1741 cast a shadow on Smibert's own painting career, it lighted that of Robert Feke, the most naturally gifted artist to paint in the colonies before 1750. Hardly anything is known about Feke's life. One of the few irrefutable facts about his early career, however, is that in 1741 he painted a large and imposing group portrait, *Isaac Royall and His Family* (fig. 118), which he carefully signed and dated on the reverse. That an artist otherwise unknown in Boston could receive such a significant and costly commission is something of a mystery. But the explanation most likely is that Smibert provided Feke with an introduction to Royall, one of the wealthiest young men in Massachusetts.[21] Royall's father had been painted by Smibert only two years before (cat. no. 414), and one can easily imagine that the youthful Royall would have turned to Smibert as the appropriate painter for such an ambitious portrait group. But, as Smibert was incapacitated, he may well have seen a bit of himself in Feke and provided him with the opportunity that Sir Francis Grant had given him more than thirty years before. This would certainly help to explain why Feke's masterpiece so closely resembles *The Bermuda Group*. Feke could simply have seen Smibert's painting in his Boston studio, or for that matter Royall could have encouraged the selection of the composition. But the intelligent and observant way in which Feke translated the composition to a family portrait suggests a familiarity with Smibert's painting that goes far beyond a brief encounter.

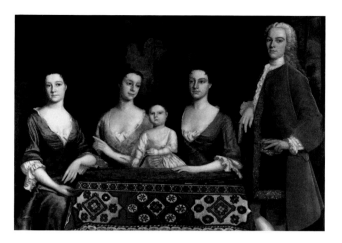

118. Robert Feke, *Isaac Royall and His Family*, 1741. Oil on canvas, 56 3/16 × 77 3/4 in. (142.5 × 190.5 cm.). Harvard Law Art Collection.

It is tempting to speculate further on the Feke-Smibert relationship. Certainly, Feke could not have painted such a complex picture without significant contact with one or more other painters. Despite the willingness of some historians to explain his abilities entirely on the basis of natural gifts, it far less romantic but more realistic to assume that his perceptions came about in great part from the kind of informal apprenticeship that occasionally nurtured other native painters, such as Benjamin West with William Williams or Gilbert Stuart with Cosmo Alexander.

In any case, Feke sensed that some elements of Smibert's painting style, such as his dark palette, were out of step with the tastes of stylish young Beau Brummells like Royall. For this reason, it is startling to look at the Royall family portrait next to virtually any of Smibert's portraits from the late 1730s to the end of his career. Feke represents the arrival of more contemporary (and hence more fashionable) poses, an eye-catching and glittery metallic palette, and a delicate style of brushwork to more successfully flatter female sitters.

As the passion for portraiture in him dimmed, Smibert sought comfort in architecture. This outlet, along with his interest in landscape painting and antiquities, was for an artist like Smibert, who was weaned on Jonathan Richardson's *Theory of Painting* and a belief in the unity of the arts, part of a larger cultural web. Smibert's opportunity to leave an architectural legacy arose in 1740 when Peter Faneuil, Boston's leading merchant, turned to him for the design of Faneuil Hall (fig. 119), the town's first public market. Boston merchants had for a number of years sought a central market in which the price of goods

119. *Faneuil Hall*, 1740–1742. Engraving by Samuel Hill from *Massachusetts Magazine*, 1789. Courtesy The Winterthur Library, Printed Book and Periodical Collection.

could be properly regulated. Farmers, however, preferred a "black market" system, in which goods were bought up by speculators and then resold at exorbitant prices.[22] Faneuil offered to build a market hall at his own expense for the city of Boston. A petition outlining his offer, supported by more than 340 prominent citizens, was sent to the selectmen. In July 1740, while Smibert was in Philadelphia, the citizens of Boston gathered to consider and vote to accept Faneuil's proposal. At a second meeting, September 2, 1740, the mason Joshua Blanchard, probably in Smibert's absence, presented a plan for the market and it in turn was approved by a small margin. In November the selectmen met to consider a location, and subsequently Smibert submitted a plan. The hall, "completed in a most substantial and elegant manner in September, 1742, after a design by Mr. Smibert,"[23] was a two-story brick structure with an open-stalled arcade on the ground level and a commodious meeting room above. Soon thereafter a visitor to Boston noted: "we next viewed the new market house, and [*sic*] elegant building of brick, with a cupola on the top, in length about 130 foot, in breadth betwixt 40 and 50. This was built att the proper expence of one Funell, a substantial merchant of this place."[24]

Smibert's Faneuil Hall was the first structure built expressly as a public market in a colonial city. It has the air of an British country market or town house—akin to that designed by William Adam (1689–1748)

for the town of Dundee (fig. 120)—and is clothed in the latest Palladian vocabulary: a building of two equal stories with Doric pilasters alternating with rounded windows on the upper level and an open arcade below. As such, it was among the first colonial buildings to make use of the rising interest in classicism. In developing its design Smibert most likely drew from various sources. In organization, Faneuil Hall recalls such buildings as Edward Jerkman's Royal Exchange (1671) in London, which consisted of an open arcade below an enclosed upper floor. Shem Drowne's remarkable grasshopper weathervane, which caps the apex of the cupola, is a copy of one atop the Royal Exchange.[25] Smibert would have known this building firsthand as well as through prints. Another source may well have been a copy of *Rules for Drawing the Several Parts of Architecture* (1732) by Smibert's old friend James Gibbs. It included a plate demonstrating "the Arcades and Intercoluminations of each Order," which would have provided him with much of the detail for the exterior façade.[26]

Faneuil most likely knew of Smibert's interest in architecture as a result of conversations with him at the time his 1739 portrait (fig. 121) was painted. Smibert had developed his architectural abilities in the course of his general education in the arts. He certainly had learned the principles of perspective and proportion as part of his academy training. Further, during the late 1720s, when Smibert was pre-

120. William Adam, *Dundee Town House*, 1732–1734. Courtesy Royal Commission on the Ancient and Historical Monuments of Scotland.

121. *Peter Faneuil*, 1739. Courtesy Massachusetts Historical Society.

paring to take up teaching responsibilities in Bermuda, he must have made some effort to assemble an adequate architectural library. Certainly, Berkeley believed firmly that a knowledge of architecture contributed to a person's general intellectual well-being, and he planned on having architecture taught at the college. Smibert also continued to acquire books related to architecture, such as Pricke's *Perspective Practical* (1707), which was designed as a guide to proper perspective "for painters and architects."[27]

Even if Smibert arrived in the colonies with only a rudimentary interest in architecture, he soon became aware that there were at the time no resident professional architects. Most houses were designed by housewrights or builders, and more ambitious projects, such as college buildings or churches, were designed by talented amateurs. Such was the case with Boston's Christ Church (Old North, 1723) designed by William Price, a print seller and the church's first organist; Philadelphia's Christ Church (1727–1754), designed by John Kearsley, a physician; Philadelphia's Old State House (1732–1748), designed by

Andrew Hamilton, the eminent lawyer; and Newport's Old Colony House (1739–1741), designed by Richard Munday, a carpenter.[28] Even the remarkable Sir John Van Brugh, who had not designed a house prior to Castle Howard, was initially better known as a playwright.

Smibert apparently got enough satisfaction from doing architectural designs for him to accept an invitation to design Holden Chapel (fig. 122) for Harvard College. This diminutively scaled building, a small brick box thirty-two feet wide and forty feet long, was the first college chapel built in America. It was constructed with a gift of £400 from Jane Holden, the widow of Samuel Holden, a wealthy English Dissenter, member of Parliament, and director of the Bank of England.[29] Its quiet exuberance stood in stark contrast to the imposing solemnity of even the recent steepled meetinghouses of Boston. Although Smibert's authorship of the design is based entirely upon circumstantial evidence, the attribution seems well founded. The vocabulary of ornament, paired pilasters with crisply detailed brownstone capitals and bases, round-headed windows, and a full wooden entablature mirror that used by Smibert in Faneuil Hall. Further, given Harvard's

122. *Holden Chapel*, 1742. Courtesy Harvard University Archives.

123. Paul Revere, *A Westerly View of the Colledges in Cambridge New England*, 1767. Engraving. American Antiquarian Society, Worcester, Mass.

role in training hundreds of ministers for Congregational flocks throughout the colonies, Smibert would take particular pride in contributing a design for such an auspicious purpose. Such elements as the paired pilasters and the handsomely carved coat of arms in the tympanum of the west gable were architectural ingredients favored by his fellow Scots, Gibbs and Adam, since the 1720s. In any event, the chapel's architectural grace, achieved through a sparing and well-reasoned level of architectural ornament, was revolutionary for Harvard and pointed to the more ambitious direction college buildings would take in the 1760s with Hollis Hall (1762) and Harvard Hall III (1764) (fig. 123).

It must have been particularly satisfying for Smibert, as he entered his final years as a painter, to see such architectural manifestations of his interest in the community and moral well-being. Certainly these achievements far outweigh the simultaneous results of his painting career. The roster of those whom Smibert painted in the 1740s is more interesting the actual portraits. The death of Peter Faneuil in 1743, for example, precipitated a commission by the selectmen of Boston for a full-length of him (cat no. 285), for which Smibert received 32 guineas. Within a few months of this Smibert was asked to paint nine portraits of the family and friends of William Vassall (cat. no. 451), a wealthy young merchant with a notoriously explosive personality and a litigious streak unrivaled in the colonies. It is one of the few known instances in the eighteenth century where one patron commissioned several portraits of his friends, presumably for display in his own house. Vassall requested a copy of the deceased Peter Faneuil, along with portraits of Faneuil's four brothers-in-law. These accompanied portraits of himself, his wife, and two of his children. (Regrettably, none of this group is now located.) Vassall became a Tory, and these portraits, like numerous others painted by Smibert, eventually migrated to England when the sitter and family fled there at the time of Revolution.

Smibert's professional career as a painter ended in 1746, much as it had begun in Edinburgh, with the opportunity for large-scale painting. Smibert was

asked to paint a series of portraits of the heroes of the 1745 campaign to unseat the French at Louisburg. Smibert had described his uneasiness over the events of this period in a letter of March 1745:

at present here is litle talked or thought of but war, our forces are imbarking for Cape Bretton, four Vessels of force are sailed to ly off Lewisbourg harbour to prevent any succours or provisions going in. This Expedition is a great undertaking for this Country if it succeeds wil be of great importance & be a terrible blow to France as it wil effectualy destroy their fishery & make ye navigation to Canada very dangerous. but if it dos not succeed we shal be almost undone here, for our best men, the flower of ye country are going & ye expence wil be a prodigious sum of money, which if we are not assisted in ye charges of it from home must ruin this Province.[30]

When war in Europe broke out between Britain and France in 1744, Louisburg became the focal point in America for the struggle to control transatlantic shipping. Louisburg, located on Cape Breton Island in eastern Nova Scotia, had an excellent harbor, which had been extensively fortified by the French. After British colonial ships were harassed by the French, William Shirley proposed to the Massachusetts General Court that they finance an expedition to seize the Louisburg stronghold. New England contributed four thousand militiamen to the assault.

On May 1 the New England ships reached Nova Scotia, where they were joined by forces led by the British commodore Peter Warren. The accompanying land forces were commanded by William Pepperrell, president of the Massachusetts Council and colonel in charge of the Maine Militia. They landed on the hills surrounding Louisburg and for six weeks bombarded the fort. During the siege Commodore Warren captured the French supply ship *Vigilante*, which attempted to run his blockade.[31] On June 16 the French had surrendered. Warren, his fleet intact (fig. 124), sailed triumphantly into Louisburg harbor.

The reaction in Boston was tumultuous. The victors' rejoicing spurred Pelham to scrape a plan of the city and fortress (fig. 125) based on a drawing by one of the participants. Less than two months after hostilities ceased, Smibert offered this print for twenty shillings a copy.[32] At about this time a group of prominent Bostonians decided to honor Governor Shirley (who had sailed to Louisburg in August) by having his portrait painted in full-length. The portrait, as described by Thomas Hancock, one of those who commissioned it, was intended as a gesture of respect "with a design of preserving it in this Town as a Memorial of his Excellencys publick Services."[33]

124. Peter Monamy, *The Taking of Louisbourg, 1745*, c. 1745. Oil on canvas. National Maritime Museum, Greenwich.

125. Peter Pelham, *A Plan of the City and Fortress of Louisbourg*, 1746. Mezzotint. Worcester Art Museum.

Despite Smibert's failing abilities he was—in the absence of a more able painter—given the commission. The portrait (cat. no. 425) is unlocated, but Pelham, taking advantage of the situation, published a mezzotint after it (fig. 126). Responding as best he could to the occasion, Smibert adapted his standard formula for a merchant portrait to include a plan of the Louisburg fortifications and two dozen ships setting sail, as didactic reminders of the successful mission.

In succeeding months the Louisburg victory continued to generate portrait sales for Smibert. They came in the form of a commission from Commodore Warren, who was returning to England. Warren, it seems, wanted three portraits: one of himself (fig. 127) and portraits of Pepperrell (plate 26) and a second officer, Sir Richard Spry (cat. no. 139). Sadly, such ambitious portraits were physically beyond Smibert by this point. For during the very months he entered these commissions in his notebook he was

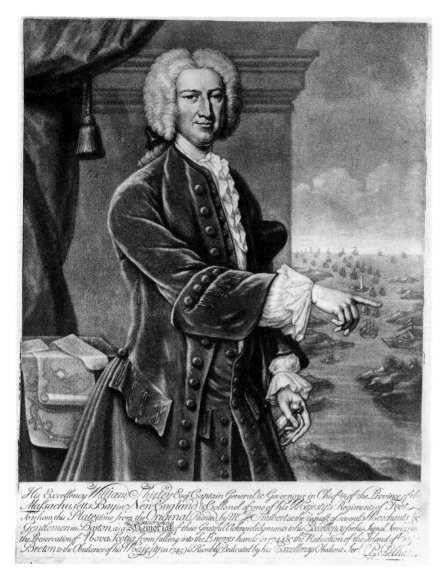

126. *William Shirley*, 1744. Mezzotint by Peter Pelham after cat. no. 245. Metropolitan Museum of Art, bequest of Charles Allen Munn, 1924.

being treated by Dr. William Clark (1709–1760), his Boston physician, for an unspecified illness.[34] Whatever his ailments, they brought his painting activity to a close, and there is no reason to believe Smibert painted any portraits after this time.

Not only had his abilities all but evaporated, but the most tangible evidence that both artist and patron were ready to accept this fact is Feke's full-length *Brigadier General Samuel Waldo* (fig. 128), painted circa 1748. It is the most magnificent full-length portrait painted in America before Copley and, like *Isaac Royal and His Family,* indicates Feke's unusual ability to paint on a grand scale. Here, as before, Feke abandoned the palette and textures that Smibert employed. His light, bright colors were a refreshing change and were to some degree in keeping with the tastes of a younger clientele that had discarded the somber attire of Smibert's generation.

Waldo had been second in command to Pepperrell at Louisburg, and had Smibert still been able to paint this commission would likely have come to him. Further, Waldo was a fellow member of West Church, so Smibert had ample opportunity to speak with him about the portrait.[35] Feke, who had painted in Newport in 1745 and Philadelphia in 1746, may simply have had the good fortune to pick this moment to be

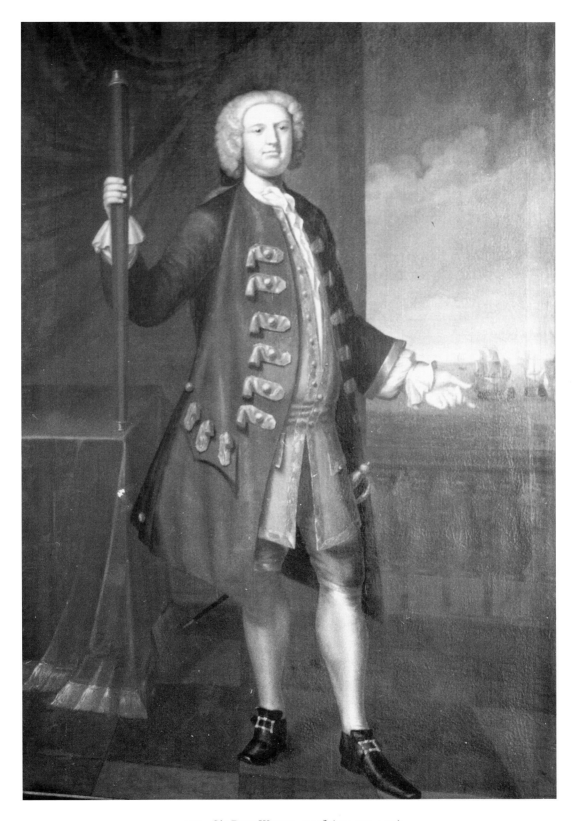

127. *Sir Peter Warren*, 1746 (cat. no. 137).

119

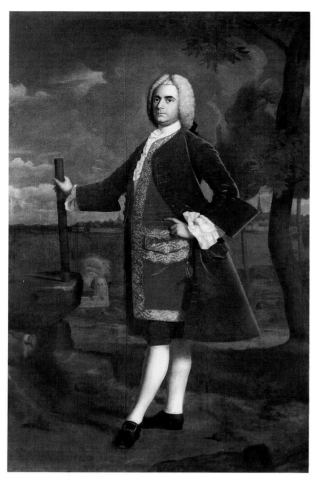

128. Robert Feke, *Brigadier General Samuel Waldo*, c. 1748. Oil on canvas, 96 3/4 × 60 1/4 in. (244.4 × 153 cm.). Bowdoin College Museum of Art, Brunswick, Me., bequest of Mrs. Lucy Flucker Knox Thatcher.

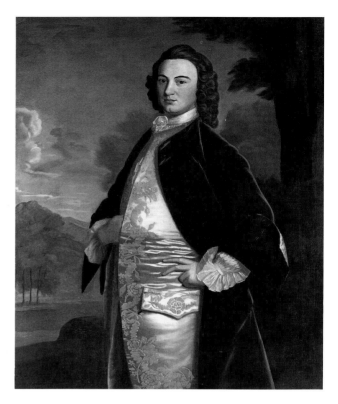

129. Robert Feke, *James Bowdoin II*, 1748. Oil on canvas, 50 × 40 in. (127 × 101.6 cm.). Bowdoin College Museum of Art, Brunswick, Me., bequest of Mrs. Sarah Bowdoin Dearborn.

at Boston in search of commissions. Alternatively, Smibert, who had been in a position to steer the Royall family commission Feke's way, may have interceded once again, knowing that Feke was the most capable artist available. In any event, if Smibert harbored any thoughts about continuing portrait painting they went unfulfilled.

During this same visit to Boston Feke painted his finest known work, a series of portraits for a number of the leading families of Boston: the Bowdoins, Boutineaus, Apthorps, and Winslows. Among those who sat for him was James Bowdoin II (fig. 129), one of a class of young sitters restless with the stodginess of their parents' portraits.

Smibert should have been delighted with Feke's appearance, since it allowed him to retire gracefully from painting. Feke, however, was not alone in the

Boston portrait market. Two other artists, Joseph Badger (1708–1765) and John Greenwood (1727–1792), joined him in competition for business in the wake of Smibert's decline. The inability of any one of them to dominate the Boston market is a significant indication of the ongoing difficulties confronting native-born artists who aspired to regional importance.

At the time of Smibert's decline Badger was well positioned to improve his standing. Like Smibert, he had joined the West Church.[36] This friendship may help explain how Badger maneuvered to get a 1747 commission to paint James Bowdoin I (fig. 130), who had formerly patronized Smibert. But Badger's subdued palette and overly linear technique was, predictably, the least likely to satisfy a younger generation ready for some aesthetic fresh air. If Feke represented the youthful, ambitious, adventuresome element in Boston painting of the 1740s, Badger was the opposite. Largely self-trained, he seemed content to mimic Smibert and was either unwilling or unable to adopt a varied palette and more contemporary poses. Over the course of his career, which spanned

more than twenty years and included periods when he was the only portrait painter in Boston, he painted many portraits, of which approximately 150 survive. But despite this large number of commissions his conservative style destined him to operate in the shadow of his contemporaries. Like so many other colonial artists, for whom painting portraits was the primary but not sole occupation, Badger supplemented his income from portraits by painting houses and glazing windows; he is also said to have painted signs, hatchments, and other heraldic devices.[37] Although Badger continued to paint through the 1750s, his income from portrait painting was probably never stable, and until the end he remained a secondary presence on the Boston scene.

Greenwood, too, should have been assured a level of success impossible before Smibert ceased painting. He was trained as an engraver with Thomas Johnston, and highly ambitious. Since engraving held little promise of wealth, he abandoned it for painting. Perhaps symbolic of his sense of self-importance, he initiated his painting career, as Feke had done,

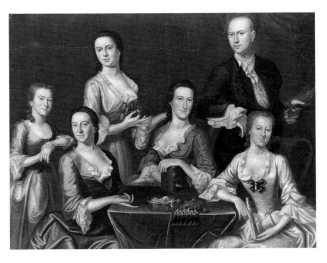

131. John Greenwood, *The Greenwood-Lee Family*, c. 1747, Oil on canvas, 55 5/8 × 69 1/4 in. (141.3 × 176 cm.). Bequest of Henry Lee Shattuck in memory of the late Morris Gray, 1983, Courtesy Museum of Fine Arts, Boston.

with *The Greenwood-Lee Family* (fig. 131), a large-scale visual counterpoint to Feke's Royall family portrait. His playful sense of line, appreciations of bold colors, and willingness to utilize contemporary poses should have made him serious competition for Feke, but neither artist stayed in Boston long enough to determine who would take the lion's share of commissions.

In fact, although Feke, Badger, and Greenwood all undoubtedly frequented Smibert's studio and had discussions with him about careers in painting, it was Greenwood who seemed to most readily grasp the worldliness represented by the studio's contents. For Greenwood was the first native-born artist who understood the limitations the colonies imposed on an artist with ambition. As a result, despite the likelihood of success in Boston, he departed for more fertile territory and achieved success as a portrait painter, printmaker, and auctioneer in South America, Amsterdam, and London. He was really the first in a long line of artists of the next twenty-five years who learned enough from Smibert's experiences to understand the importance of travel and the necessity of firsthand experience in London, the artistic fountainhead of the English-speaking world.

Smibert set down his brush for the last time in 1746. Although in a letter to Arthur Pond as late as 1749 he claimed to be "diverting my self with somethings in the Landskip way," this would appear at best to show a desire to deny the poignant truth that "as for myself I need not tell you that I grow old, my eyes has been some time failling me."[38]

130. Joseph Badger, *James Bowdoin I*, c. 1747. Oil on canvas, 50 1/4 × 40 1/4 in. (127.6 × 102.3 cm.). Bowdoin College Museum of Art, Brunswick, Me., bequest of Sarah Bowdoin Dearborn.

But even physical infirmities cannot diminish a willing spirit. As he abandoned painting, Smibert turned his attentions to his remaining interests, in particular his family, the color shop, the Scots Charitable Society, and the church, each of which had sustained him in moments of uncertainty. Up until 1746 he regularly attended the quarterly meetings of the Scots Charitable Society, and attended sporadically thereafter as age took its toll. Certainly Vertue would not have been surprised to learn that even in November 1750, five months before his death, the Scotsman was present at the society's meeting.[39] Smibert died on April 2, 1751. Two days later his obituary appeared in the Boston News-Letter:

> JOHN SMIBERT. On Tuesday last died here, much lamented, Mr. John Smibert, well known for many fine Pictures he has done here, and celebrated in Italy, as well as Britain, for a good Painter, by the best judges. As a Member of Society, he was a valuable Gentleman of a happy Temper, great Humanity and Friendship, a Kind Husband, tender Father, and steady Friend: But what is above all, an exemplary Christian, eminently so in Practice and constant Resignation to the Will of God. We hear his Funeral will be Tomorrow Evening.

"Above all, an exemplary Christian": no epitaph could better describe the spirit of this devout painter.

Smibert was buried in the tomb of his father-in-law in the Granary burying ground, less than four blocks from his house. Within a short time word of his death reached Vertue, who reflected that Smibert had not been content in London "to be a level with some of the best painters. but desir'd to be were [sic] he might at the present, be lookt on as the top. his profession then, & here after. in which no doubt, he there succeeded in. and Smibert's name in after Times. by his works will be there remembered in a superior degree."[40]

In December 1752 John Moffatt wrote to Pond to let him know, rather belatedly, of Smibert's death. He recalled that his uncle "had been for many years in a Declining State of health, and for some years unable to paint at al, but to ye last preserved his cheerfulness & serenity of temper, free from al uneasiness & happy in his family."[41] Moffatt asked Pond if he might oblige a last request from his uncle for a modest marble tomb carved by Peter Scheemakers, Smibert's London friend. Smibert's wishes, however, were not met, and to this day his tomb is unmarked.[42]

Within a year of Smibert's death, in February 1752, an inventory was taken of his estate by John Greenwood and two other appraisers.[43] His estate (see app. 3), valued at over £1,300, left his family reasonably secure. His personal possessions included a silver hilted sword, "foyles and flutes," and a "Horse chaise & runners." The contents of his studio are quite revealing, for there, in the room created for him by his father-in-law, were assembled more than ninety paintings: "35 portraits," "41 History pieces & pictures in that taste," "13 Landskips," and "2 Conversation Pieces." In addition, the appraisers listed "Bustoes & figures in Paris plaister & models," "Prints and books of prints," and "Drawings."

Smibert's studio had reached its most developed state only in the decade before his death, when the last of the approximately ninety paintings and numerous casts arrived from London. Although less than 10 percent of the contents can now be identified, these works are revealing. The centerpiece of the studio was certainly The Bermuda Group and its modello, identified in the inventory as "2 Conversation Pieces." Stacked against the walls were probably a number of unfinished portraits that had either been rejected, or never paid for, or never picked up. The copies of old masters divided among the four areas most admired by critics and collectors since the turn of the century: seventeenth-century Flemish and Dutch painting, Italian High Renaissance, French classicism, and Italian Baroque. The studio contents included copies after Van Dyck's Cardinal Bentivoglio, Charles and James 2nd, and Jan de Monfort; Raphael's Madonna della Sedia; Titian's Venus; Tintoretto's Luigi Cornaro; and Poussin's Continence of Scipio; as well as an unknown copy after Rubens. Also present were copies (and very possibly originals) of Poelenburgh's Venus and Nymphs (fig. 134), a Brueghel "Dutch Ferry picture," probably by Jan Brueghel, the elder (fig. 132), and a battle picture by "Michan" (probably Theobald Michau, 1676–1765). Around the room on shelves or on cabinets were casts of ancient and contemporary sculpture: the Venus de' Medici and a bust of Homer, on the one hand, and Allan Ramsay (artist unknown) and Peter Scheemaker's William Shakespeare (sent as a gift by the sculptor; fig. 133), on the other. Circumstantial evidence suggests that some of the other works there were classical and scriptural histories: copies of Danae and the Golden Shower and Venus Blinding Cupid, after Titian, as well as Lot and His Daughters and Diana and Nymphs Bathing, both after unknown artists.[44] Smibert's View of Boston was presumably among the "13 Landskips" there— although all the others are unlocated. Despite the numerous pictures that can not now be identified, the surviving sample is sufficient to confirm that

132. Jan Brueghel (The Elder), *Canal Scene*, 1612. Oil on panel, 15 × 24 in. (38.1 × 61 cm.). © Indianapolis Museum of Art, Clowes Fund Collection.

134. Cornelis van Poelenburgh, *Diana and Her Nymphs* (which Smibert calls *Venus and Nymphs*). Oil on copper. In the collection of the Duke of Buccleugh Kt., Bowhill, Scotland.

133. John Cheere, after Peter Scheemakers, *William Shakespeare*, c. 1740. Plaster. York City Art Gallery, York.

Smibert's collection was a microcosm of the English art world transported to America. It is this quality that gave the studio such relevance to artists, patrons, collectors, and connoisseurs both during his life and for the next generation.

Even after Smibert's death the studio continued to be the greatest assembly of works of art anywhere in the colonies. Unlike virtually every other colonial artist's studio, it was not immediately dispersed after the artist's death. If in life Smibert had stood as a beacon to native-born colonists who aspired to become painters, during the next fifty years this second-floor room of a Boston town house became a virtual museum to be seen by residents of Boston and culturally minded visitors to the city. Year after year it gave refuge to a succession of aspiring artists. This, then, was an important part of Smibert's legacy.

During the years immediately after his death the color shop was run by Smibert's nephew, John Moffatt, and remained virtually unchanged. Of far greater and lasting significance, however, was Smibert's collection, both of his own work and of others' work, which was preserved much like a shrine to which many artists made pilgrimage.

Mary Smibert, who was only forty-three at the time of her husband's death, helped her nephew run the color shop.[45] Her date of death is unrecorded, but presumably she died around 1760, the time when Moffatt assumed an increasingly important role in the rearing of Smibert's first son, Williams. Moffatt seems to have taken particular pride in Smibert's son Nathaniel, whom he observed "inclines to Painting & seems to me a promising Genius."[46]

If Smibert's studio was one aspect of Smibert's legacy, his son Nathaniel was another. Had he not died before reaching his twenty-second birthday, Nathaniel might well have instanced his father's influence on the next generation.[47] As it was, the younger Smibert

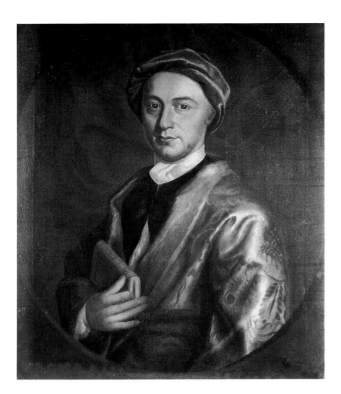

135. Nathaniel Smibert, *Ezra Stiles*, 1756. Oil on canvas, 28 3/4 × 25 in. (73 × 63.5 cm.). Yale University Art Gallery, gift of a number of subscribers through Anson Phelps Stokes.

seems only to have painted professionally for about five years. The handful of portraits by him which survive, such as *Ezra Stiles* (fig. 135), painted less than seven months before the artist's death, suggest that he possessed the necessary tools to carve out a niche for himself in the art world. It seems unlikely, however, that this "tender and delicate" youth, who suffered "a Thousand Infirmities"[48] and enjoyed playing the spinet,[49] was destined for greatness. Had he lived he would have had considerable difficulty keeping pace with Copley, who, although three years Nathaniel's junior, was by the mid-1750s already painting more ambitious and inventive works. The young Smibert was certainly unable to live off the income from portraits: Stiles paid only two guineas for his portrait, a quarter of the price the elder Smibert received at the end of his career.[50]

Smibert's eldest son, Williams (1732–1774), was among the first ten colonists graduated from the University of Edinburgh (1762) with a degree in medicine. While in Edinburgh he exchanged letters regularly with his cousin John Moffatt, who provided the funds for Williams's education. Upon graduation he returned to Boston, lived with Moffatt, practiced medicine, and acted as custodian for his father's col-

lection. By 1767 Moffatt's brother Thomas, who was a prominent Tory and a bon vivant, settled in New London, Connecticut, after his Newport house was ransacked by radicals in a political action. Once there he hounded Williams to send him pictures to decorate his "bare white washed walls."[51] In 1769 Moffatt's nagging paid off and he received a group of paintings and sculptures which included "the miniature picture of the Bishop of Cloyne and your Father," as well as plaster statues of Allan Ramsay and Shakespeare.[52] These appear to be the first art works to have left the studio since John Smibert's death and were the first of a series of distributions over the next forty years.

Because so much of what Smibert collected and painted remained together in Boston for the second half of the eighteenth century, local artists like Copley found refuge and inspiration there while painters from as far as Philadelphia availed themselves of its riches. A typical reaction is that of Pierre Du Simitière, who observed in 1767: "at Dr. William [*sic*] Smibert is a large collection of original Drawings of the best masters Prints mostly Italian, Pictures, several of them originals & some done by his father John Smibert a good painter chiefly portraits & a good collection of casts in plaister of Paris from the best antiques, besides basso relievos seals & other curiosities."[53] Two years earlier the visit of Charles Willson Peale, who was "hunting for colours," produced an equally admiring response: "becoming a little acquainted with the owner of the shop he told me that a relation of his had been a painter, and he said he would give me a feast. Leading me upstairs he introduced me into a painter's room, an appropriate apartment lined with green cloth or baise, where there were a number of pictures unfinished. He had begun a picture, several heads painted, of the ancient philosophers, and some groups of figures, these were the last works of Smibert. He had been in Italy and spent a fortune in travelling to gain knowledge in the art. Mr. Copley very probably can give a full account of him."[54]

These were years in which Copley so dominated the Boston portrait market that visitors came and went very quickly. Following the brief stop by Peale was Cosmo Alexander (1724–1772), who Smibert noted "sees so little prospect of business here that like all other artists of merit he leaves us soon."[55] Although Copley's natural abilities were such that he would have risen to greatness in any colonial town, his access to Smibert's studio afforded him a historical perspective, aided his own development, and sparked his genius. His first exposure to the paintings of Van

Dyck, Raphael, Poussin, and Titian came from studying Smibert's copies. Of each of these he made mental notes, and upon seeing the originals in Europe he did not hesitate to write his brother Henry Pelham to explain how they differed from the copies (see cat. nos. 140, 248).

In 1774, the year Copley's ambitions led him to depart Boston for Italy and England, Smibert's studio underwent further change. Williams Smibert died, leaving his estate to John Moffatt.[56] For a period John Moffatt went to live with his brother in New London but returned to Boston, probably just before the outbreak of hostilities, when his Tory brother Thomas left for England.[57] By June 15, 1777, John Moffatt, in failing health, rented the southern portion of the living quarters to Susanna Sheaff. The following month he died, leaving his house to Suriah Waite, who had cared for him during his final illness. He left the remainder of his estate, which according to his will must have included the bulk of the studio contents, to Thomas on the condition he return to Boston within three years.[58] Since his brother was seventy-five years old and did not return, the estate passed to Suriah Waite, who had since become Suriah Thayer.

Belcher Noyes was the executor of Moffatt's estate, and one of the first things he did was to sell to the young artist John Trumbull some of the remaining paintings for his own improvement:[59]

Boston September 1778
Bot. [bought] of Mr Noyes Executor to Mr Moffatt

A small Landscape with Nymphs bathing an exquisite Specimen of Cornelius Polenburg	}	£2.8
a small battle, an Army on thier March by Michaun a Dutch ferry, probably by Breughel at Gu[?]	}	£4.4
		£6.12
The preceding are still (1818) in my possession		
	equal to	£4.18
a Head of Cardinal Bentivoglio, copied from a Copy by Mr Smibert, of Vandyck's wonderful picture at Florence given to Harvard College, 1789	}	£5.12
Heads of two Boys copied from Vandycks by Smibert Charles & James 2d at Buckingham house given to Mrs Sheaffe	}	£4.4
An unfinished Sketch of a prophet, by some of the later Galeans	}	£1.10
Coin	Lawful money	£11.6
		£6.12
	equal to Dollars 59.66	£17.18

The painting by "Polenburg" was presumably the one Smibert offered to Pond in 1743, and the "small battle" was most likely the "little Picture of Mischan" Smibert had asked Pond to send him. Other contents

of the studio were also probably dispersed at this time, including *The Continence of Scipio*, which apparently appealed to James Bowdoin III. Court records indicate that the estate gained more than £235 from the sale of effects.[60]

But even as it was being emptied of most of its contents, Smibert's studio still was an attractive space to local artists. Trumbull rented the studio in 1779, prior to any sales, for he noted that it still contained "a copy from Vandyck's celebrated head of Cardinal Bentivoglio" as well as "one from the *Continence of Scipio*, by Nicolo Poussin, and one which I afterwards learned to be from the *Madonna della Sedia* by Raphael."[61] He also seems to have made use of whatever remained of Smibert's library.[62]

Over the course of the next sixteen years at least six more artists—Mather Brown (1780), Ebenezer Mack (1780), Joseph Dunkerly (1780), Samuel King (c. 1780–1785), John Mason Furnass (1785), and John Johnston (c. 1795)—held sway in the studio. In one sense, the appeal of Smibert's studio is analogous to Sir Peter Lely's in London, which was inhabited successively by Kneller, Thornhill, and Richard Wilson.[63] By 1795, however, when Suriah Thayer's estate was sold at public auction, the remaining objects had been dispersed. At the time of sale there remained one picture "in Johnstons room unsold."[64] This painting was *The Bermuda Group*, presumably too large and cumbersome to find a home elsewhere in Boston. Johnston took possession of it and sold it to Isaac Lathrop of Plymouth, Massachusetts, who in turn gave it to Yale University.

It is both fitting and remarkable that the removal of *The Bermuda Group* brought to a formal close Smibert's legacy to the two generations of painters who succeeded him. By the time Johnston sold the painting, for what was presumably a modest price, virtually all of Smibert's other original portraits had passed into back hallways, upper chambers, and attics. For the most part they had become merely ancestral records that with each passing year had less relevance to the painters of the Federal period. Perhaps the last painter to openly acknowledge a debt to Smibert was Washington Allston. While a student at Harvard (1800) he copied Smibert's copy after Van Dyck's *Cardinal Bentivoglio*, which had by this time been given to the college. Some years later he recalled that "at that time it seemed to me perfection."[65]

Most painters of Gilbert Stuart's generation were quick to dismiss the portraits of the first half of the eighteenth century. But the elements of colonial life that allowed Copley, Peale, and other portrait painters to flourish in last years of the colonial period were

for the most part present earlier. What had been missing was a culture of art. Smibert and his generation, then, exposed younger artists to a range of artistic temperaments and styles, helped establish a market for portraits and prints, and put artwork on public and private display. Without this groundwork it seems unlikely that colonial portraiture would have reached the zenith it did in the decades that followed.

Notes

CHAPTER 1: SCOTLAND

1. Vertue 1930–1955, vol. 3, p. 14. See app. 1.
2. Bolton 1939, pp. 375–376. There were at least two John Smiberts who came to Edinburgh from Middletown in the 1660s, and it is unclear which was most likely the artist's father. The family name, Smibert, is rare and found only in Edinburgh and neighboring southeastern Scotland. In Scottish records of the sixteenth and seventeenth centuries the name Smibert appears in a variety of forms, among them Smythbeard, Smeberd, and Smiebeard; all apparently derive from "smooth beard." Foote 1950, p. 2.
3. William Ferguson, *Scotland, 1689 to the Present* (Edinburgh, 1968), pp. 70, 85.
4. Robert Louis Stevenson, *Edinburgh,* London, 1954, p. 17.
5. Arnot 1779, p. 233.
6. Rogers 1884, pp. 299–300.
7. George 1925, p. 101.
8. Graham 1909, p. 83.
9. Ferguson, *Scotland,* p. 70.
10. The litsters had been only recently incorporated (1684) with the bonnet-maker's guild, an amalgam that for reasons of changing taste also included the hatters. See Colston 1891, pp. 137–138.
11. Foote 1950, p. 2.
12. Maitland 1753, p. 204; Wilson 1891, vol. 1, p. 133.
13. Ramsay 1965, pp. 13–15, 18, 20–21, 23–24.
14. Maitland 1753, p. 316.
15. Ferguson, *Scotland,* pp. 91–92.
16. Graham 1909, pp. 22, 121, 315.
17. Ibid., p. 21.
18. Foote 1950, p. 3.
19. Holloway 1989, p. 23.
20. Marshall 1988, p. 4.
21. Ibid., p. 8.
22. Ibid., p. 12.
23. Edinburgh University Library, Minute Book of St. Mary's Chapel.
24. When John Smibert's sister married Thomas Moffatt on February 2, 1702, she was recorded as "daughter of deceased John Smibert litster, burgess." Foote 1950, p. 3. The artist's father may be the John Smibaird, litster, who died January 29, 1690, and who was buried in the Mckenzie tomb at Greyfriars. See Paton 1902, p. 598.
25. Maitland 1753, p. 301.
26. Apted and Hannabuss 1978, p. 65.
27. Plant 1952, pp. 34–35.
28. Graham 1909, p. 69.
29. Anon., *James Norie Painter, 1684–1757* (Edinburgh, 1890), p. 6.
30. Holloway 1989, p. 43.
31. *Edinburgh Courant,* no. 28, April 23–25, 1705, and no. 49, June 11–13, 1705.
32. Marshall 1988, pp. 28–29.
33. Croft-Murray 1962, vol. 1, p. 260.
34. Ibid., pp. 139, 248, 259.
35. MacMillan 1986, p. 9. The modello for this work, *The Rape of Proserphine,* survives (National Gallery of Scotland).
36. MacMillan 1986, p. 16.
37. Graham 1909, p. 81.
38. Ferguson, *Scotland,* pp. 166–167, 180.
39. Graham 1909, p. 82.
40. In 1725, for example, Smibert earned on the average £1 5s a day: Smibert 1969, pp. 12–14, 80–82. Commodities: Arnot 1779, p. 197. House painters: George 1925.
41. John de Medina II carried on, with much less success, the career of his father. Andrew Hay, who painted at least one portrait copy under the elder Medina's direction, by the 1720s had given up painting for picture-dealing trips to Italy. Waterhouse 1981, pp. 163, 237; Marshall 1988, p. 28.
42. Vertue 1930–1955, vol. 3, p. 14.
43. Graham 1909, pp. 38, 65.

CHAPTER 2: LONDON AND EDINBURGH

1. Smibert 1969, pp. 2, 73.
2. Plant 1952, p. 221. The exchange rate of Scots money to sterling was about 12 to 1.
3. Graham 1909, pp. 39, 42–44.
4. Population and areas: Speck 1977, pp. 121, 123. Import: Jarrett 1965, p. 65.
5. Survey of London 1900, vol. 36 (1970), p. 10.
6. George M. Trevelyan, *Illustrated History of England* (New York, 1956), p. 501.
7. The Scottish members of Parliament and the Scottish judges and lawyers could hardly be understood at Westminster. Memoirs of the time are full of witticisms at their expense. Scots had not yet learned the English language, but they were rapidly acquiring it. See Walter Blaikie, "Edinburgh at the Time of the Occupation of Prince Charles," in *The Book of the Old Edinburgh Club,* vol. 2 (Edinburgh, 1909), p. 6.
8. Scottish Record Office, London, Crown Court, Kirk Session CH2/852/1 "Minutes 1714–6. List of Members and Subscriptions, c.1713–29," p. 36: "c / Mr Smebert 1–oo -." Although Smibert's entry is not dated 1713, it is written in the same hand as other 1713 entries.
9. Jarrett 1965, p. 142.
10. Wilson 1984, pp. 1–2.
11. Pears 1988, p. 114.
12. Waterhouse 1953, p. 229.
13. Pears 1988, pp. 68–69, 75.
14. Whitley 1928, vol. 1, p. 23.
15. Walpole 1828, vol. 2, pp. 235–236.
16. Ibid., vol. 2, pp. 23–24.

17. Pevsner 1940, p. 80.

18. Vertue adds Peter Tillemans (c. 1684–1734), as a painter of "Landskips etc," but Tillemans may have become a director the following year.

19. Vertue 1930–1955, vol. 6, p. 169; vol. 3, p. 7.

20. One prominent exception was the fashionable portrait painter Charles Jervas (c. 1675–1739). Other notable nonmembers included William Kent (1685–1748), who was in Italy from 1709 to 1719, and Thomas Hill (1661–1734).

21. Vertue 1930–1955, vol. 3, p. 45.

22. Rica Jones, "The Artist's Training and Techniques," *Manners & Morals: Hogarth and British Painting, 1700–1760*, exhibition catalogue (London, 1987), p. 19.

23. Indeed this continued to be British practice: Hans Hysing apprenticed to Dahl, Thomas Hudson apprenticed to Jonathan Richardson, Francis Hayman apprenticed to Robert Brown, and so on. Pevsner 1940, p. 92.

24. Stewart 1983, p. 59.

25. Vertue 1930–1955, vol. 3, p. 92 and vol. 6, p. 169, where he noted that Pierre Berchet was forced to withdraw from membership because he "cou'd not bear the smoke of the lamp."

26. Vertue, whose writing style is frequently cryptic, refers to Smibert's lack of artistic training prior to his arrival at the academy, noting that he "never copyd any thing from ye life. till he come to ye Accademy. haveing never drawn from plaister" (vol. 3, p. 14). This is Vertue's only reference to plaster casts in conjunction with the academy, but it seems to confirm their use. Circumstantial evidence suggested by Paulson 1971, vol. 1, p. 96, for the casts in use at the St. Martin's Lane academy a few years later offers a reasonable account of what was probably in use at Great Queen Street as well. The casts were most likely of the Farnese *Hercules*, the *Apollo Belvedere*, the *Laocoön*, the *Venus de Medici*, and probably the *Gladiator, Antinous*, and some of Fiammingo's putti.

27. Gibson: Whitley 1928, vol. 1, p. 12; Pevsner 1940, p. 91. Berchet: Vertue 1930–1955, vol. 1, p. 87.

28. Whitley 1928, vol. 1, p. 13.

29. Ibid., vol. 1, p. 14.

30. Vertue 1930–1955, vol. 3, p. 36. See app. 1.

31. Pears 1988, p. 245, n. 114, states that Smibert was in Italy with Andrew Hay in 1716, although he does provide documentation for this.

32. Graham 1909, p. 38.

33. Holloway 1988, p. 10.

34. Speck 1977, p. 82.

35. There does not seem to be any evidence to substantiate the romantic tradition mentioned by Updike 1907, vol. 1, p. 523, that Smibert's "first essay in colours is said to have been the portrait of a young negro, brought from Martinique to Scotland." See cat. no. D.372.

36. Brunton and Haig 1849, p. xlvii; Graham 1909, p. 4.

37. Speck 1977, pp. 35, 134.

38. Henry Hamilton, ed., *Selections from the Monymusk Papers (1713–1755)* (Edinburgh, 1945), p. ix.

39. Scottish Record Office, Monymusk Papers, GD 345–745, 1702–1722 Trade Accounts due Lord Cullen; GD 345–975–1, Inventory ca. 1710–1720; and GD 345–731.

40. Holloway 1988, p. 10.

41. Ibid. and Monymusk Papers, GD 345–1156–6-46, "To Mr Smibert & Receipt for Picture Sterling £ 60." This undated receipt is filed with other papers for 1719.

42. National Library of Scotland, *A Catalogue of Pictures, Drawings, and Prints, Tuesday February 17th*, "[Lot] 1. A Landskip by Smibert. [Lot] 2. Its Companion." I wish to thank James Holloway for calling this discovery to my attention.

43. John Smibert to Arthur Pond, April 6, 1749. See app. 2.

44. Whinney and Millar 1957, p. 272.

45. Gifford 1989, p. 43.

46. Graham 1909, p. 113.

47. Ibid., p. 93.

48. Another notable Edinburgh group was the Rankenian Club, formed in 1716, for "mutual improvement by liberal conversation and rational inquiry." It has been repeatedly and erroneously stated (most recently in Gaustad 1979, p. 56) that Smibert was a member of this club. There is no evidence for this, and the source cited as documentation (*Scots Magazine*, Edinburgh, 1771, p. 341) makes no mention of him.

49. Kinghorn and Law 1987, p. 66.

50. Brown 1984, p. 10.

51. *DNB* 1855–1901, "Allan Ramsay."

52. Graham 1909, p. 112.

CHAPTER 3: ITALY

1. Hugh Howard (1675–1738) accompanied the Earl of Pembroke in 1696; Charles Jervas was in Rome in 1703, his trip financed by the politician and virtuoso George Clarke; William Kent's trip in 1709 was financed by a group for whom he was expected to make purchases and paint copies of Old Masters.

2. Little is known of Medina's trip to Italy, although a self-portrait, c. 1695–1700, does survive (Uffizi, Florence). Thomas Murray, who in the 1720s lived near Smibert in the Piazza, Covent Garden, also contributed a self-portrait to the Uffizi during a visit to Italy in 1708. Aikman likewise painted a self-portrait during his travels (Pitti Palace, Florence). Alexander was in Italy from 1711 to 1719.

3. It has been suggested—erroneously, I believe—by Sir David Evans ("The Provenance of the Notebook," Smibert 1969, p. 7) that Smibert may have been in Italy in 1717 and by Pears (1988, p. 245, n. 114) that Smibert was in Rome in 1716. Although Smibert's movements between 1715, the earliest point at which he is like to have left the academy, and August 1719, the date he set out for Italy, are not entirely known, the portraits he painted for the Grant family between 1717 and 1719 make a 1716–1717 trip to Italy improbable.

4. Smibert 1969, p. 74.

5. Nisser 1927, p. xxxii.

6. Richardson 1915, p. 40.

7. Waterhouse 1953, p. 112.

8. Skinner 1966, p. 3.

9. Among the more useful travel diaries to someone like Smibert were Andrew Balfour, *Letters . . . containing advices for travelling in France and Italy* (1700); Richard Lassels, *An Italian Voyage, or, A Compleat Journey Through Italy* (1670, reprinted 1698), a Roman Catholic perspective; and Francis Misson, *Nouveau Voyage d'Italie* (1691; English edition 1695).

10. Stoye 1952, p. 175.

11. Smibert 1969, p. 74.

12. Sells 1964, p. 140.

13. Richardson 1722, pp. 6–22.

14. Both Richardson and Lassels stopped at Fontainebleau. James Russel, *Letters from a Young Painter Abroad to His Friends at Home*, 2 vols. (London, 1750), specifically mentions a coach that stopped at Fontainebleau.

15. Smibert 1969, p. 75.

16. Skinner 1966, p. 9.

17. Scottish National Portrait Gallery, Photo File, Cosmo Alexander, *William Aikman, Merchant at Leghorn 1695–1784* (W. H. Robertson-Aikman).

18. Smibert 1969, p. 75.

19. From c. 1600 the term *pistole* was the name given to a Spanish gold coin worth from 16s 6d to 18s (*OED*). For currency values in Italy, see Kirby 1952, pp. 201–202.

20. Interspersed with these purchases are eight payments from Signore Filippi on the account of William Aikman, which total over £440. The prices are recorded in Roman *scudi*, or crowns. Four crowns equaled one pound sterling. Smibert received 1,178 *scudi* 9 *paoli*, or £444. Although the references to William Aikman may be to the artist of that name, they more likely refer to a representative of the Livorno banking house.

21. Smibert 1969, p. 101: "Septr. 19 [1720] payed to sigr Tommaso Conte de Federighi for 2 pictors of Orinorio Marinari large 488- 2- 4 [Roman scudi]."

22. Waterhouse 1979, pp. 32–37; McCorquodale 1979, pp. 171–176.

23. Smibert 1969, p. 101. The identification of several of these artists was first made by Chappell (1982, p. 137).

24. Ibid., 134, 137.

25. Vertue 1930–1955, vol. 6, p. 165, "A List of Virtuosi in Italy [c. 1724]."

26. Smibert 1969, pp. 99–101, and Chappell 1982, p. 137.

27. Edward Wright, *Some Observations Made in Travelling through France, Italy . . . in 1720–22*, vol. 2, p. 412: "When my Lord Parker was at *Florence* and greatly delighted with these statues, Signor *Pietro Cipriani*, an excellent Artist and formerly a scholar of *Soldani*, and his Assistant in casting those Statues for the Duke of Marlborough, undertook to make for him Copies in Copper of the *Venus and Faunus.*"

28. On July 20, 1720, Berkeley wrote a friend that he and Ashe were in Florence. See Luce 1949, p. 80.

29. Smibert 1969, p. 76.

30. Berkeley to Percival, March 1, 1717. See Berkeley 1948–1957, vol. 8, pp. 101–102.

31. George Berkeley, *Essay towards Preventing the Ruin of Great Britain* in *The Works of George Berkeley, Bishop of Cloyne*, in Berkeley 1948–1957, vol. 6, p. 80, quoted in Gaustad 1979, p. 69.

32. Conroy 1971, p. 86.

33. Allan Ramsay, *Poems* (Edinburgh, 1728), vol. 2, pp. 355–357. This copy (in the Beinecke Rare Book and Manuscript Library, Yale University) was owned by Smibert and is inscribed (by him) with his name ("Smibert's") on the frontispiece to each of the two volumes. In the 1720 index to the edition this verse is listed as "To Mr. Smibert."

34. Foote 1950, pp. 13–14; Chappell 1982, p. 135.

35. Rossi 1967, p. 20. Richard Lassels visited the Pitti Palace (see Lassels 1698, p. 119) and gives no indication that he was being accorded special treatment. On the contrary, he notes, "The Duke himself also, who makes this Court, makes it a fine Court. His extraordinary Civility to Strangers, made us think our selves at home there. . . . He admits willingly of the visits of strangers, if they be men of condition" (p. 141).

36. Smibert's name is linked directly to Cosimo III in a number of contemporary and later eighteenth-century references. Not only does Vertue specifically mention copies that Smibert made of paintings owned by Cosimo III (Vertue 1930–1955, vol. 3, p. 14), but Thomas Moffatt (c. 1702–1787), Smibert's nephew, includes in his will a painting described as "St. Peter's head being the present of the Duke of Tuscany to Smibert" (Foote 1950, p. 47). Smibert is also said to have painted portraits for Cosimo III ("of two or three Siberian Tartars presented to the Duke by the Czar of Russia," Foote 1950, pp. 42–43). It is conceivable that some of these incidents are apocryphal and that Smibert either encouraged them or did not actively discourage them, so as to enhance his own professional prestige.

37. Ormond 1971, p. 169.

38. Smibert 1969, pp. 75–76. See cat. nos. 248, 251, and D. 243.

39. Chappell 1982, p. 133.

40. Translation by Miles Chappell of Florence, Biblioteca Nazionale F. M. N. Gabburri, MSS "Le Vite de' pittori," Codice Palatina E.B. 9 V., vol. 3, 1352: "Gio: Smibert Pittore Inglese. Questo fu molto applicato allo Studio, e particularmente in Italia, dove si trattenne molto tempo essendosi eletto la Citta di Firenze, dove disegno le migliori statue e copio molti dei migliori quadri della Real Galleria di Toscana. Tornato a Londra suo Paese, Passo all' Isola Bermudes, circa il 1729."

41. Berkeley 1948–1957, vol. 8, pp. 110–111.

42. Vertue 1930–1955, vol. 3, p. 14. One copy that Smibert painted in Rome of *The Blinding of Cupid*, after Titian's original at

the Villa Borghese, is now known only from a later copy of it. See cat. no. 244.

43. Holloway 1989, p. 86.

44. Sedgwick 1970, vol. 2, p. 170.

45. Lewis 1961, pp. 49, 61.

46. Stuart Papers, Royal Archives, Windsor Castle. Hon. Clare Stuart Wortley, "Thesis on Stuart Portraits" (typescript), pp. 33–34, Andrew Cockburn to James Edgar, Secretary to the Pretender, September 23, 1734: "Some years ago I had a friend a Limner in Rome [Smibert], he at my desire procured an original picture of the King and Queen which he copied and gave me. They are both on one canvas"; and Edgar's reply, November 3, 1734: "I remember very well the time of Mr. Smibert's doing you the pictures you have of their Mtys [Majesties]."

47. Bodleian Library, Oxford. Diary of Thomas Rawlinson, Bodleian Mss. Rawl d1181, vol. 2., pp. 354: "Campbell was married to the sister of Mrs. Trotter by the Revd. Mr. Berkeley in the presence of her Brother, Mr. Andrew Hay and his wife and Mr. John Smybert, a Scotsman and Painter, before whom they were also wedded according to the common form made use of in such cases."

48. Public Record Office, SP 35, vol 52/23, September 1724.

49. Rudolph Wittkower, *Art and Architecture in Italy 1600–1750* (Baltimore, 1973), p. 235.

50. Hugh Howard (1696, at age 21), John Closterman (1699–1702, at age 39), and William Aikman (1707, at age 25) studied with Carlo Maratta; Henry Cooke is said to have studied with Salvator Rosa; Willaim Kent (1708, at age 24) studied with Benedetto Luti and others.

51. Skinner 1966, p. 28.

52. Wright, *Some Observations*, vol. 1, pp. 188–189.

53. Smibert 1969, p. 77.

54. Vertue 1930–1955, vol. 3, p. 14, noted that while in Italy Smibert visited Naples, a city the artist does not mention but which was frequently visited by British travelers (including Berkeley). But as Smibert's travel summary is fragmentary, with gaps of months when his whereabouts are unknown, it is conceivable that he visited Naples.

55. Lassels 1698, n.p. 12 verso: "The common course is, to go first into *France*, and then into Italy, an so home by Germany, Holland and Flanders, as I did once."

56. *Boston News-Letter*, May 15–22, 1735.

CHAPTER 4: A LONDON STUDIO

1. Brian Allen, *Francis Hayman* (New Haven and London, 1987), p. 27.

2. British Museum Print Room, Whitley Papers, vol. 7, p. 809, as reported in the *Daily Journal*, November 4, 1723.

3. Vertue 1930–1955, vol. 3, pp. 16–17.

4. Williams 1956, p. 34.

5. Burke 1976, p. 93.

6. Luigi Salerno, "Seventeenth-Century English Literature on Painting," *Journal of the Warburg and Courtauld Institutes*, vol. 14 (1951), p. 252.

7. George 1925, pp. 91–92.

8. Public Record Office, SP 35, vol. 52, item 23, September 10, 1724, "The Deposition of Mr. John Smibert."

9. Kenneth Macleod Black, *The Scots Churches in England* (Edinburgh and London, 1906), p. 77.

10. Jarrett 1965, p. 68.

11. George 1925, p. 83.

12. Lippincott 1983, p. 15.

13. Ibid.; Macky 1722, as quoted in Phillips 1964, p. 58.

14. The first thirty entries are written in clear script and are equally spaced, suggesting that they may have been compiled from receipts and entered at the same time. See Sir David Evans, "The Provenance of the Notebook," in Smibert 1969, p. 4.

15. Lippincott 1983, p. 31, and Pears 1988, p. 144.

16. Elizabeth Johnston, ed. "Joseph Highmore's Paris Journal, 1734," *Walpole Society Journal*, vol. 42 (1969–1970) pp. 61–104.

17. Richard Wendorf, *The Elements of Life* (Oxford, 1990), p. 173.

18. Stewart 1983, p. 149.

19. J. Douglas Stewart, "Some Portrait Drawings by Michael Dahl and Sir James Thornhill," *Master Drawings*, vol. 11 (1973), pp. 34–45.

20. Whitley 1928, p. 37.

21. Rouquet 1755, pp. 82–83.

22. Smibert 1969, p. 11.

23. Watson 1929a, p. 50: "Johnston, Andrew, eldest s[on] of Mr Allan J. Minr. of the Gospell, p. to John Law, goldsmith."

24. Scottish Record Office, London, Crown Court Kirk Session, CH 2/852/1 Minutes 1714–6, List of Subscribers, c. 1713–29, p. 130: "March 17 [1719] Andrew Johnston engraver in new Round Court had a son baptiz'd named Andrew."

25. Murray 1980, p. 118.

26. Piper 1978, p. 146.

27. Monod 1989, p. 11.

28. T. B. Howell, *A Complete Collection of State Trials . . .* (London, 1812), vol. 16, 1722–1725, p. 231 (November 21, 1722).

29. PRO SP 35/52, item 23, 1724, September 10.

30. Vertue 1930–1955, vol. 3, p. 12.

31. See app. 1, sec. J.

32. Harris 1979, p. 79; Meyer 1984, p. 15.

33. Fussell 1974, p. 20.

34. Allen 1933, p. 79.

35. Vertue 1930–1955, vol. 6, p. 35.

36. Ibid., vol. 3, p. 24.

37. J. Douglas Stewart, "Some Portrait Drawings by Michael Dahl and Sir James Thornhill," *Master Drawings*, vol. 11 (1973), p. 43.

38. Hamilton's painting was commissioned by his fellow artist and won in a raffle by Joseph Goupy, one of those depicted. See Manners 1987, p. 85.

39. Porter 1982, p. 99.

40. Vertue made a sketch of the Rose and Crown Club, and his annotations describe those depicted describe them in the most ribald terms. For example, Marcellus Laroon (1679–1774), whom Vertue named "Captain Narcissus" is described as "meeting the maid who is bringing drink. Catches at her belly, & shows her his Puntle. She looks back & holds one hand before her face. . . . *My dear* let me F . . . you." (Vertue 1930–1955, vol. 6, p. 34).

41. Vertue 1930–1955, vol. 3, pp. 155, 45.

42. Ibid, p. 11.

43. Smith 1884, pp. 964–978.

44. Eighteenth-century monetary values are frequently given in pounds and guineas. The British pound was worth twenty shillings. The guinea, so called because the gold was from Guinea, was worth twenty-one shillings.

45. Stewart 1983, p. 189.

46. Waterhouse 1981, p. 310.

47. For Highmore's prices, see Lewis 1975, p. 8; for Dahl's and Richardson's prices, see Waterhouse 1981, pp. 97, 310.

48. Waterhouse 1981, pp. 23, 145.

49. Croft-Murray 1962, vol. 2, p. 234. At virtually the same time (1721) Francis Bird was paid £2,040 for his carved statues of various apostles and evangelists for the west side and south front of St. Paul's. See Gunnis 1968, p. 54.

50. Lewis 1975, p. 9.

51. Porter 1982, pp. 13, 63.

52. William Aikman to Sir John Clerk, November 2, 1723, Clerk of Penicuik Mss. GD 18/ 4589, National Register of Archives, Edinburgh.

53. One nineteenth-century account of Smibert's activities (Perkins 1878, pp. 392, 396) stated that the Earl of Bristol patronized Smibert during these years. There is, however, no mention of Smibert in the index to the Earl of Bristol's correspondence (Archives, County Hall, Suffolk, England).

54. Among other Smibert sitters whose political affiliation can be determined are Whigs (George Douglas [cat. no. 33], George Carpenter [cat. no. 223], and Robert and William Hucks [(cat. nos. 332 and 334]), and Tories (Sir John Rushout [cat. no. 24] and Sir John Molesworth [cat. no. 32]).

55. Lewis 1975, pp. 102–103.

56. Richardson 1715, p. 180.

57. Talley 1981, p. 393.

58. Marshall Smith, *The Art of Painting* (1692), p. 81; quoted in Talley 1981, p. 393.

59. Vertue 1930–1955, vol. 3, p. 15.

60. William Aikman to Sir John Clerk, August 17, 1726; quoted in Irwin 1975, p. 43.

CHAPTER 5: COVENT GARDEN

1. Smibert 1969, p. 82.

2. During 1726 George Berkeley stayed with Smibert in Covent Garden and directed his mail be sent there "next door to the King's Arms tavern, in the little piazza, Covent Garden" (see p. ?). The King's Arms was the next house [number 2] north of Hummums [turkish bath at number 3] . See Green 1866, p. 20. Consequently, Smibert lived either at Hummums, an unlikely choice, or at No. 1, on the corner of Russell Street, which would have afforded him windows facing north and west. Other artists had lived in the Little Piazza, including William De Ryck, history painter, 1691–1692, and Thomas Hawker, portrait painter, c.1705–1707 (London Survey Committee, Survey of London, XXXVI, *The Parish of St. Paul Covent Garden*, 1970, p. 97. Hogarth was probably living in the Little Piazza in 1730 (Paulson 1971, I, p. 205).

3. Webber 1969, pp. 10–13, 26.

4. London Survey Committee, *The Parish of St. Paul Convent Garden*, pp. 82–83.

5. Vertue 1930–1955, III, p. 27. By "artists" here Vertue meant painters, as sculptors gravitated to the area between Piccadilly and Hyde Park Corner. William Aikman to Sir John Clerk, November 9, 1724, GD 18/4547, Clerk of Penicuik Mss., National Register of Archives, Edinburgh.

6. Vertue 1930–1955, vol. 3, p. 30. The artists identified by Vertue are Edward Gouge (d. 1735), portrait painter, described by Sir John Percival as "a good face painter on his return [from Rome] to England; but falling into drunken company, lost his business & dide worse than nothing in 1735" (British Museum, Whitley Papers, vol. 5, p. 613); Gouge lived at Number 3, Great Piazza, 1714–c. 1734; John Ellis (also Ellys, 1700/1–1757), portrait painter, who studied under Thornhill and succeeded in 1739 to Vanderbank's house and business; Anthony Russel (also Russell, c. 1663–1743), portrait painter, follower of Riley; Thomas Murray (1663–1735), portrait painter and a Scot; a pupil of Riley, Murray's professional career lasted more than forty years, and though his later style was conservative and prosaic he was successful enough to leave an estate of £40,000 (Waterhouse 1953, p. 100); he lived at Number 8, Great Piazza; Sir James Thornhill (1675–1734); John David Swarts (also Swartz, 1678–c. 1740), assistant to Kneller; Thomas Wright, portrait painter and a teacher of Richard Wilson; John Smibert; Peter Angellis (also Angillis, 1685–1735), painter of landscapes and conversation pieces; John Vandervaart (c. 1653–1727), who came to England in 1674 and began painting draperies for William Wissing, after which he painted portraits; lived at 8 Tavistock Row in 1712; Christian Friedrich Zincke (1684–1767), leading miniature painter, 14 Tavistock Row, 1715–1748.

7. Willaim Aikman [to Sir John Clerk?], portion of letter, undated, GD 18/4583, Clerk of Penicuik MSS, National Register of Archives, Edinburgh.

8. From August 1722 to September 1725 Smibert averaged 2.3 portraits a month, according to his notebook. After he moved to Covent Garden the average, from October 1725 to August 1728, dropped to 2.1 portraits a month.

9. Smibert earned £244 14s in 1725, yet he spent £72 18s 1d on furnishing his new studio.

10. Smibert 1969, p. 77.

11. See app. 2, sec. G.

12. John Elsum, *The Art of Painting after the Italian Manner* (1704), pp. 29–30.

13. British Museum, Whitley Papers, vol. 5, p. 860.

14. Evans 1956, p. 59.

15. Iain Gordon Brown, "Modern Rome and Ancient Caledonia: The Union and Politics of Scottish Culture," *The History of Scottish Literature, Vol. 2: 1660–1800* (Aberdeen, 1987), pp. 33ff., and David Daiches, *The Paradox of Scottish Culture* (London, 1964), p. 27.

16. Pears 1982, p. 26.

17. Ibid., p. 60.

18. G[ordon] G[oodwin], "Johnson, Henry," *DNB* (1917).

19. Vertue 1930–1955, vol. 6, p. 35.

20. *A List of the Members of the Society of Antiquaries of London, from Their Revival in 1717, to June 19, 1796* (London, 1798), p. 4; Pears 1982, p. 26; Friedman 1984, p. 273.

21. Both Smibert and Vertue are listed as attending the same meetings throughout 1725 and 1726. See Society of Antiquaries, Minute Book, vol. 1, January 1718 to October 26, 1732, Manuscript Collection.

22. Evans 1956, pp. 51, 80.

23. Ibid., p. 67.

24. Smibert 1969, p. 81.

25. Society of Antiquaries, Treasurer's Accounts, 1718–1738, p. 260.

26. One contemporary declared that Gordon "had some learning, some ingenuity, much pride, much deceit, and very little honesty." See Evans 1956, p. 84.

27. Society of Antiquaries, Minute Book, vol. 1, January 1718 to 26 October 1732, p. 186.

28. Lewis 1975, pp. 86–88.

29. The poem is quoted in its entirety in Killanin 1948, pp. 91–94.

30. Williams 1956, p. 80.

31. Vertue 1930–1955, vol. 3, p. 28.

32. Smibert 1969, p. 82.

33. Ibid., p. 82.

34. *Biographic Universelle, Ancienne et Moderne . . .* (Paris, 1821), vol. 30, p. 228.

35. Vertue 1930–1955, vol. 3, p. 112.

36. Pears 1988, pp. 166, 168.

37. Rand 1932, p. 10.

38. Ibid.

39. In 1724 Berkeley published *A Proposal for the Better Supplying of Churches in Our Foreign Plantations, and for Converting the Savage Americans to Christianity.*

40. Benjamin Rand, *Berkeley and Percival* (Cambridge, 1914), p. 168.

41. *The Weekly Journal; or the British Gazetteer,* July 17, 1725, lists Berkeley as president and identifies the first three fellows as William Thompson, Jonathan Rogers, and James King.

42. George Berkeley to Thomas Prior, August 24, 1726; noted in Foote 1950, p. 31.

43. Berkeley to Prior, December 1, 1726; noted in Foote 1950, p. 31.

44. Berkeley to Prior, February 27, 1727; noted in Foote 1950, p. 31.

45. Pears 1988, chap. 3, "The Art Market," pp. 51–106.

46. Geoffrey Holmes, *Augustan England* (London, 1982), p. 32.

47. Ms 86-00-18/19 (J. Houlditch), Transcripts of [London] Auction Sales, 1711–1758, Victoria and Albert Museum, London.

48. Vertue 1930–1955, vol. 3, p. 36.

49. William Aikman to Sir John Clerk [1727], GD 18/4610, Clerk of Penicuik Mss., National Register of Archives, Edinburgh.

50. Porter 1982, p. 86.

51. Roquet 1755, p. 33.

52. William Aikman to Sir John Clerk, November 2, 1723, GD 18/4589, and February 8, 1729, GD 18/4616, Clerk of Penicuik Mss., National Register of Archives, Edinburgh.

53. Einberg and Egerton 1988, p. 74.

54. As quoted in Paulson 1971, vol. 1, p. 464.

55. See app. 1.

56. William Aikman to Sir John Clerk, December 8, 1720, GD 18/4578, Clerk of Penicuik Mss., National Register of Archives, Edinburgh.

57. William Aikman to Sir John Clerk, August 17, 1726, GD 18/4602, Clerk of Penicuik Mss., National Register of Archives, Edinburgh.

58. Porter 1982, pp. 92, 195–196.

59. Rand, *Berkeley and Percival,* pp. 6, 36.

60. A slightly different plan is described in *Biographia Brittania* (London, 1784), vol. 3, p. 10f: "Dean Berkeley was an excellent architect, and he had completed elegant plans of his projected town, as well as of his seminary. The last edifice was to have occupied the center of a large circus; and this circus was to have consisted of the houses of the Fellows to each of which in front a spacious garden was allotted. Beyond this academical circus was another, composed of houses for gentlemen, many of which houses had actually bespoken, and the Dean had been requested to superintend the building of them. Beyond this circus was one more, which was calculated for the reception of shops and artificers. Dr. Berkeley disliked the custom of burying in Churches; for which reason a Cypress Walk, called 'The Walk of Death,' was to be solemnly appropriated to the purpose of interment."

61. *A Proposal for Better Supplying of Churches in Our Foreign Plantations,* in Berkeley 1948–1957, vol. 7, p. 348.

62. Samuel Eliot Morison, *Three Centuries of Harvard, 1636–1936* (Cambridge, Mass., 1946), pp. 29–30, 89.

63. Smibert's copy, inscribed with his last name in sepia, is owned by the Public Archives of Nova Scotia. It was a bequest by Thomas Beamish Akins (1809–1891), a bibliophile. How Akins acquired it is unknown; it may have come to him from someone who obtained it from Smibert's estate, possibly a Boston loyalist who settled in Halifax at the time of the Revolution.

64. Henry C. Wilkinson, *Bermuda in the Old Empire* (Oxford, 1950), p. 261.

65. Gaustad 1979, p. 45.

66. *A List of the Members of the Society of Antiquaries of London, from Their Revival in 1717, to June 19, 1796* (London, 1798).

67. *Maryland Gazette,* Annapolis, April 22, 1729.

68. Smibert 1969, p. 89.

69. *Historical Register* (London, 1729), vol. 13, pp. 289–290; quoted in Foote 1950, p. 35.

70. Foote 1950, p. 35.

71. Smibert 1969, p. 102.

72. *Maryland Gazette,* Annapolis, April 22, 1729, p. 2.

73. Smibert 1969, p. 86.

74. Quoted in Foote 1950, p. 37. Colonel William Byrd to Lord Percival, Virginia, June 10, 1729.

75. Smibert 1969, p. 86.

76. *Maryland Gazette,* April 22, 1729, p. 2.

77. Quoted in Foote 1950, p. 38.

78. Bridenbaugh 1962, p. 73n.

79. Dean Berkeley's daughter-in-law (from Monck Berkeley's *Memoirs*), as quoted in Antoinette F. Downing and Vincent J. Scully, Jr., *The Architectural Heritage of Newport, Rhode Island* (New York, 1952; repr. 1967), p. 45.

80. From Monck Berkeley's *Memoirs,* as quoted in Stanley Hughes, "Very Rev. Dean George Berkeley, D.D.," p. 90, in *Early Religious Leaders of Newport* (Newport, 1918).

81. Quoted in Foote 1950, p. 38.

82. Foote 1950, pp. 38, 40.

83. Ezra Stiles, *The United States Elevated to Glory and Honor; A Sermon . . .* (Worcester, 1785), pp. 16–17.

84. Foote 1950, p. 39.

85. Bridenbaugh 1938, p. 303.

CHAPTER 6: BOSTON AND
THE BERMUDA GROUP

1. Neal 1747, vol. 2, p. 225.
2. Drake 1856, p. 572.
3. [John Colman]. *The Distressed State of the Town of Boston Considered, etc.* Quoted in Hallam 1990, p. 153.
4. H. B. Parkes, "New England in the Seventeen-Thirties," *New England Quarterly*, vol. 3 (1930), p. 402.
5. William Pencak, *War, Politics, & Revolution in Provincial Massachusetts* (Boston, 1981), p. 81.
6. Abbott Lowell Cummings, "Decorative Painters and House Painting in Massachusetts Bay, 1630–1725," in *American Painting to 1776: A Reappraisal* (Charlottesville, Va., 1971), pp. 92–104; Louisa Dresser, "Portraits in Boston, 1630–1720," *Journal of the Archives of American Art*, vol. 6 (1966), pp. 1–34.
7. "The Queen's portrait was saved from the Town Hall at the time of the great fire." *Boston News-Letter*, March 1/8, 1711. Quoted in Dow 1927, p. 5.
8. Miles 1983, p. 49.
9. *Pennsylvania Gazette*, September 25, 1740.
10. In 1734 he painted two chimney pieces in exchange for a book, pens, pencils, and ink. Four years later he and another decorative painter, John Gibbs, did much of the painting necessary to outfit two merchant ships. Lastly, in 1739 he did decorative painting for the merchant William Clark. See Saunders and Miles 1987, p. 133.
11. *New England Journal*, May 27, 1740.
12. Foote 1950, p. 52.
13. The probability that he owned one or more lay figures (flexible, jointed dolls with various sets of clothes, used as substitutes for the sitter) is suggested by Copley, who encouraged his brother to "get an Anatomical figure; It may be had at Smibert's" (Copley-Pelham 1914, p. 338), and by the presence of "models" in Smibert's estate inventory. See app. 3.
14. David Piper, "Development of the British Literary Portrait," *Proceedings of the British Academy*, vol. 54 (1968), p. 65.
15. Haskell and Penny 1981, p. 90. The following year John Watson (1686–1768), another Scottish emigre, apparently returned from a trip to Scotland with a bust of Homer. This seems to have been displayed among studies and copies of paintings in his own hand in his studio at Perth Amboy, New Jersey. His somewhat strange melange included images of Caligula, Louis XIII, and Louis XIV. See Miles 1983, p. 50, and *The Classical Spirit in American Portraiture*, exhibition catalogue (Providence, 1976), p. 24.
16. Vertue 1930–1955, vol. 3, p. 42. See app. 1. He entered the poem in his notes after reading it in the *London Courant*.
17. *American Weekly Mercury* [Philadelphia], February 10–19, 1730.
18. Society for Promoting Christian Knowledge, London, Manuscript Collection, New England Letters, vol. 3, March 16, 1727/8–April 3, 1731, Henry Newman to Revd. Mr. Harris at Boston, August 24, 1728.
19. Bridenbaugh 1948, p. 134.
20. Bridenbaugh 1962, p. 56.
21. Bridenbaugh 1938, p. 259.
22. *1669–1882: An Historical Catalogue of the Old South Church (Third Church) Boston* (Boston, 1883), p. 36: "July 12, 1730, John Smibert."
23. Harold F. Worthley, *An Inventory of the Records of the Particular (Congregational) Churches of Massachusetts Gathered 1620–1805* (Cambridge, 1970), p. 79.
24. Bridenbaugh 1962, p. 67.
25. Bridenbaugh 1938, p. 258
26. Craven 1986, p. 170.
27. From Philopatria, "A Discourse [1721]," and [Anon.], "A speech Without-door," quoted in T. H. Breen, *The Character of the Good Ruler: A Study of Puritan Political Ideas in New England, 1630–1770* (New Haven, 1970), p. 216.

28. Ebenezer Turell, *The Life and Character of the Reverend Benjamin Colman* (Boston, 1749), p. 231.
29. New England Historic Genealogical Society, Boston. Hancock Papers, Thomas Hancock Letterbook, March 6, 1735–September 3, 1740, p. 80.
30. James Logan to Dr. William Logan, May 31, 1733, Logan Letter Books, vol. 4.
31. Historical Society of Pennsylvania, Philadelphia, Bridenbaugh 1948, p. 136.
32. Ruth Piwonka, *A Portrait of Livingston Manor 1686–1850* (Livingston Manor, N.Y., 1986), p. 24.
33. Smibert 1969, pp. 79, 81, 82, 85.
34. Within ten months they would welcome the birth of the first of nine children, only two of whom, Williams (1732–1774) and Nathaniel (1735–1756), would reach adulthood. John and Mary Smibert's children were Allison (May 14, 1731–May 18, 1732); Williams (June 29, 1732–1774); John (November 24, 1733–August 1, 1734); Nathaniel (January 20, 1735–November 3, 1756); John (April 23, 1738–after 1751); Samuel (October 11, 1739–September 16, 1747); Thomas (November 4, 1741–July 1, 1742); Mary Anne (August 19, 1746–before 1751); Thomas (August 19–September 27, 1746).
35. Foote 1950, p. 49.
36. Smibert 1969, p. 85.
37. Foote 1950, p. 34.
38. *Gentleman's Magazine* (London), February 1831, p. 99.
39. Fraser 1871, vol. 4, p. 153.
40. Society for Promoting Christian Knowledge, London, Manuscript Collection, New England Letters, vol. 3, March 16, 1727/28–April 3, 1731, p. 12.
41. Berkeley 1948–1957, vol. 8, p. 207: George Berkeley to Henry Newman, March 29, 1730.
42. Smibert 1969, p. 90.
43. After the entry for the "Large picture begun for Mr. Wainwright," Smibert later added that he had been paid "at Boston 30–30–0," presumably the remaining payment for the picture.
44. Gaustad 1979, p. 163.
45. I am grateful to Professor Ronald Paulson for suggesting this as a possible source for Smibert.
46. Painting file, *The Bermuda Group*, Garvan Office, Yale University Art Gallery, New Haven.
47. Berkeley 1948–1957, vol. 7, p. 373.
48. Sarah B. Sherrill, "Oriental Carpets in Seventeenth- and Eighteenth-Century America," *Antiques*, vol. 109 (1976), pp. 154–155.

CHAPTER 7: NEW DIRECTIONS

1. Rand 1932, pp. 44–45.
2. Bridenbaugh 1948, p. 146.
3. Drake 1856, pp. 597–598.
4. Superior Court of Judicature, Suffolk County, Docket No. 92419: Erving & Moffatt, October, 1776.
5. John Smibert to Sir Archibald Grant, January 19, 1734. See app. 1.
6. Foote 1950, p. 68.
7. Suffolk County Probate Records, Suffolk County Court House, Boston, vol. 33, pp. 381–382.
8. Ayres 1985, p. 31. For example, Arthur Pond used green damask on his studio walls.
9. James Fenimore Cooper, Jr., "A Participatory Theocracy: Church Government in Colonial Massachusetts, 1629–1760" (Ph.D. diss., University of Connecticut, 1987), p. 301.
10. A third minister portrait, Feke's *Rev. Nathaniel Clap* (1745, Newport Historical Society), was commissioned by John Bannister, another Newport merchant. See Mooz 1970a, p. 48.
11. Copley-Pelham 1914, p. 31.
12. Vertue 1930–1955, vol. 3, p. 54.
13. Saunders and Miles 1987, pp. 19, 153.

14. Bridenbaugh 1932, pp. 800-811.

15. Copley-Pelham 1914, p. 66.

16. Sibley and Shipton 1873–1956, vol. 8, p. 121.

17. Gilbert Burnet Lewis, "Record of Browne Family Portraits Which Hung in 'Browne Hall' on Folly Hill," *Essex Institute Historical Collections*, vol. 86 (1950), p. 285.

18. Bridenbaugh 1948, pp. 120–121.

19. Ezra D. Hines, "Browne Hill," p. 209.

20. Bridenbaugh 1948, p. 120–121.

21. Nancy Goyne Evans, "The Genealogy of a Bookcase Desk," *Winterthur Portfolio*, vol. 9 (1974), pp. 213–222.

22. Martha Gandy Fales, *Joseph Richardson and Family: Philadelphia Silversmiths* (Middletown, Conn., 1974), p. 292.

23. John Boydell to John Yeamans and William Campbell, March 1, 1730, David S. Greenough Papers, Box 1, Massachusetts Historical Society, Boston.

24. Paul G. Sifton, "Pierre Eugene Du Simitière (1737–1784): Collector in Revolutionary America" (Ph.D. diss., University of Pennsylvania, 1960), p. 387. But Simitière's report is hard to reconcile with the fire reported in the *Boston Evening Post* on December 14, 1747: "with this noble Edifice, the Fine Picturs and other Furniture in the Council Chamber were destroyed."

25. Foote 1950, p. 82.

26. Drake 1856, p. 613.

27. Boston Selectmen 1885b, p. 260, town meeting of August 7, 1745.

28. John Smibert to Sir Archibald Grant, May 20, 1734. See app. 1.

29. Bridenbaugh 1938, pp. 341–342.

30. Dow 1927, p. 237.

31. Pears 1988, p. 74.

32. Oliver 1973, pp. 139, 149.

33. John Hill Morgan, "John Watson, Painter, Merchant, and Capitalist of New Jersey, 1685–1768," *Proceedings of the American Antiquarian Society*, vol. 50 (1940), p. 197.

34. New England Historic Genealogical Society, Hancock Papers, Box 14, Daniel Henchman Domestic Bills 1725–1741, Folder 3, January 24, 1738/9, and Hancock Papers TH-1, Journal of Christopher Kilby 1737–1739, September 22, 1739. In 1747 Andrew Belcher purchased oil and paints for his "Warehouse & New Garden fence" (See Foote 1950, p. 77n), and the following year Thomas Hancock spent £35 on paint (Massachusetts Historical Society, Thomas Hancock Receiptbook, p. 47).

35. Appendix 2.

36. Foote 1950, p. 92.

37. Saunders and Miles 1987, p. 44.

38. *Boston News-Letter*, January 5/12, 1726/7, quoted in Dow 1927, pp. 14, 18–19.

39. Dolmetsch 1970, p. 70.

40. Jonathan Belcher to Jonathan Belcher, Jr., August 7, 1734, Jonathan Belcher Letterbooks, vol. 4, Massachusetts Historical Society.

41. See app. 2.

42. Pears 1988, p. 160.

43. Ralph E. Carpenter, Jr., *The Arts and Crafts of Newport, Rhode Island, 1640–1820* (Newport, 1954), p. 121.

44. *The Great River: Art and Society of the Connecticut Valley, 1635–1820*, exhibition catalog (Hartford, Conn.: Wadsworth Atheneum, 1985), p. 402.

45. Lippincott 1983, p. 128.

46. Charles Robert Leslie and Tom Taylor, *Life and Times of Sir Joshua Reynolds* (London, 1856), vol. 1, p. 100, quoted in Saunders and Miles 1987, p. 66.

47. Appendix 2.

48. Ibid.

49. *Boston Gazette*, October 3–10, 1737.

50. Robert Francis Seybolt, *The Town Officials of Colonial Boston* (Cambridge, Mass., 1939), p. 197.

51. Robert Francis Seybolt, *The Town Officials of Colonial Boston* (1939), p. 197.

52. Bridenbaugh 1938, pp. 63–64.

53. Sinclair Hitchings, "Thomas Johnston," in *Boston Prints and Printmakers* (Boston, 1973), p. 116.

54. Grimm 1981, pp. 136, 193–194, 204.

55. See cat. nos. 285 and 479.

56. Bridenbaugh 1948, p. 68.

CHAPTER 8: "ABOVE ALL, AN EXEMPLARY CHRISTIAN": SMIBERT'S FINAL YEARS

1. Foote 1950, p. 80.

2. William T. Youngs, Jr., *God's Messengers: Religious Leadership in Colonial New England* (Baltimore and London, 1976), p. 8.

3. Bridenbaugh 1938, pp. 81–82.

4. New England Historic Genealogical Society, SCS4, p. 208: May 6, 1729, "Mr. John Smibert Enters & gives £5."

5. Bridenbaugh 1948, p. 133.

6. Bridenbaugh 1938, p. 426.

7. New England Historic Genealogical Society, SCS4, pp. 260, 269.

8. Record Book, 1736–1854, West Church, p. 7, Rare Books and Manuscripts Collection, Boston Public Library.

9. Samuel A. Eliot, "A Cradle of Liberty: Being the Story of the West Church in Boston, 1737–1797," *Proceedings of the Unitarian Historical Society*, vol. 5 (1937), p. 5.

10. Treasurer's Accounts, 1737–1754, and Record Book, 1736–1854, West Church.

11. Foote 1950, p. 50.

12. During the winter of 1767–68 Pierre Eugene Du Simitière observed: "There was in the Collection of Doctor Smibert at Boston, an accurate drawing of the Supposed inscription at Taunton, done by his Father John Smibert an eminent portrait painter that came over to America with dean Berkeley and afterwards settled in Boston."

13. See app. 2.

14. Hallam 1990, p. 157.

15. *A Proposal for the Better Supplying of Churches in Our Foreign Plantations* (1724), in Berkeley 1948–1957, vol. 7, p. 347.

16. Graham 1956, pp. 110, 134.

17. Colden 1918–1937, vol. 2, p. 204.

18. For example, Hannah Logan, the younger daughter of James Logan, William Penn's secretary and commissioner, and a Quaker, had her portrait painted in her youth only to disapprove later of such exhibitions of worldliness and state that she planned to destroy it. See *Hannah Logan's Courtship* (Philadelphia, 1904), pp. 8, 9.

19. Historical Society of Pennsylvania, James Hamilton Papers, Cash Book, 1739–1757, Box 1, Folder 11:

Sept. 23d 1742. I sent by mr. Vassal to be d[elivere]d to Mr Smibert at Boston the following Bills of Exchange, viz.
Emerson & Graydon on Mesrs Beckford
& Neat pble to A: H. £ 22: 1 :—
Joseph Turner on David Barclay & Son
pbl to J:S £ 22:10
Joseph Turner on David Barclay & Son
pbl to Jno Smibert 10–10
William Till on Laurence Williams
pbl to White & Taylor £ 30:—
William Allen on Jno Simpson & Comp
pble to Jno. Smibert £ 31:10
John Sober on David Barclay & Son
pble to Jno. Smibert £7: 17:6
and ten guineas in gold
James Hamilton
Mr. Smibert acknowledged the receipt of these Bills in a Letter to me

I wish to thank Professor Willaim Oedel of the University of Massachusetts, Amherst, for this information.

20. See app. 2.

21. Mooz 1970a, p. 39.

22. Bridenbaugh 1938, p. 352.

23. "On the Original Building & Enlargement of Faneuil Hall," undated manuscript, possibly by Charles Bulfinch, who remodeled Faneuil Hall, 1805–1806; Boston Public Library, Prints Department.

24. Bridenbaugh 1948, p. 111.

25. Hugh Morrison, *Early American Architecture* (New York, 1952), p. 441.

26. Friedman 1984, p. 273.

27. John Smibert to Arthur Pond, March 23, 1744. See app. 2.

28. Leland M. Roth, *A Concise History of Architecture* (New York, 1979), p. 42; and Richard Holman, "William Burgis," in *Colonial Prints and Printmakers* (Boston, 1973), p. 68.

29. Bainbridge Bunting, *Harvard, an Architectural History* (Cambridge, Mass., 1985), p. 26.

30. John Smibert to Arthur Pond, March 15, 1745. See app. 2.

31. Miles 1983, p. 58.

32. *Boston News-Letter*, September 4, 1746, and *Boston Gazette*, September 16, 1746: "PLAN OF LOUISBOURG. This day is published (Price Twenty Shillings, Old Tenor.) A Plan of the Harbour. Done in Metzotinto on Royal Paper. by Mr. *Pelham*, from the original Drawing of Richard Gridley Esq: Commander of the Train of Artillery at the Siege of *Louisbourg*. Sold by J. Smibert in Queen-Street, Boston." The same advertisement appeared in the *Maryland Gazette* on September 30 and in the *New-York Weekly Post-Boy* on October 6.

33. Boston Selectmen 1885b, p. 260, Town Meeting, August 7, 1754.

34. Massachusetts Historical Society, Manuscript Collection, Ledger of William Clark(e), 1733–1746, pp. 108, 152. Douglas treated Smibert from July 1744 to October 1746.

35. West Church Record Book, 1736–1854, p. 7.

36. Ibid., p. 2.

37. Park 1917, p. 160.

38. John Smibert to Arthur Pond, April 6, 1749. See app. 2.

39. SCS4, p. 37.

40. Vertue 1930–1955, vol. 3, p. 161. See app. 1.

41. John Moffatt to Arthur Pond, December 28, 1752. See app. 2.

42. His tomb is the third to the right of the entrance gate but is now marked "Thomas and John Bradlee Tomb 1816."

43. See app. 3.

44. See cat. nos. 246 and 244 and JBIII.

45. Massachusetts Historical Society, R. T. Paine Papers, Deed of Land from John Moffatt to R. T. Paine, February 21, 1760, witnessed by Mary Smibert.

46. John Moffatt to Arthur Pond, December 28, 1752. See app. 2.

47. Foote 1950, pp. 257–274, provides the most substantial summary of what little is known of Nathaniel Smibert's life.

48. Obituary of Nathaniel Smibert, *Boston Gazette*, November 8, 1756.

49. Josephine Setze, "Portraits of Ezra Stiles," *Bulletin of the Associates in Fine Arts at Yale University*, vol. 23, p. 4, citing a 1754 visit to Smibert's studio by Ezra Stiles.

50. Ezra Stiles Account Book, Beinecke Rare Book and Manuscript Library, Yale University, June 2, 1756: "To Nathaniel Smibert/ 2 guineas @ 21 /for my picture."

51. CP Part I, Thomas Moffatt to Williams Smibert, April 2, 1767.

52. CP Part I, Thomas Moffatt to Williams Smibert, February 22, 1769; Williams Smibert to Thomas Moffatt, March 6, 1769.

53. Foote 1950, p. 123.

54. John Sartain, *The Reminiscences of a Very Old Man 1808–1897*, pp. 146–147, quoted in Foote 1950, p. 123.

55. CP Part I, Williams Smibert to Thomas Moffatt, October 2, 1769.

56. Suffolk County Probate Records, Suffolk County Court House, Boston, vol. 73, pp. 382–383.

57. CP Part I. John Moffatt signed a receipt for goods at New London on May 28, 1776.

58. Foote 1950, pp. 255–256. As listed here the contents omit a "painted Chimney Board" valued at £16 22s. See Suffolk County Probate Records, Suffolk County Court House, Boston, vol. 78, p. 419.

59. Jaffe 1976, p. 212.

60. Suffolk County Probate Records, Suffolk County Court House, Boston, vol. 74, p. 556.

61. Foote 1950, p. 124.

62. Jaffe 1975, p. 329.

63. Ayres 1985, p. 36.

64. Suffolk County Probate Records, Suffolk County Court House, Boston, vol. 94, p. 14.

65. Jared B. Flagg, *The Life and Letters of Washington Allston* (New York, 1892), p. 13.

Catalog

This catalog of the works of John Smibert consists of five parts:

A. Accepted works
B. Copies after paintings by other artists
C. Disputed works
D. Works known only through prints, references in Smibert's notebook, or descriptions
E. Works wrongly attributed to Smibert

Part A is in chronological order. Parts B–E are in alphabetical order.

Catalog entries convey the following information:

Title and date: A question mark after the sitter's name indicates that his or her identity is uncertain. Parentheses around a title indicate a tentative identification. An asterisk after a title indicates that the work is known only through photographs and has not been seen in person. Smibert's notebook allows the vast majority of his paintings to be firmly dated. In rare instances, when works do not appear in the notebook, approximate dates are given.

Collection: The present owner's name is given where permitted.

Medium: Unless otherwise stated, the medium is oil on canvas.

Size: Dimensions are given first in inches, then in centimeters (in parentheses). Height precedes width.

Signature or inscription: "Inscribed" means that the signature is not in the artist's handwriting.

Provenance: The history of each picture is included where known.

Engraved: Engravings listed are those published during Smibert's lifetime.

Notebook: The page number and portrait number in the *transcription* of the text of Smibert's notebook (Smibert 1969) is given, if the artist made reference to the painting. I have corrected errors in the transcription. Smibert used the following abbreviations for portrait sizes: " 3/4" (30 × 25 inches); " 1/2" (50 × 40 inches); "w[hole] lenth" (full-length, approximately 96 × 60 inches); "lit[tle] 1/2" (40 × 30 inches); "KK" or "KC" (Kit-cat, 36 × 28 inches); "O.S." (odd size?, approximately 40 × 30 inches). Each notebook reference is preceded by the month (if known) and the year the portrait was commissioned (but not necessarily completed). Also given is the painting's price—in sterling for the periods 1722–1728 and November 1734–September 1746, and in New England currency for the period 1729–October 1734.

Literature: The more significant secondary sources are listed here.

Subject: A brief biographical sketch of the sitter is given.

Entries end with a brief commentary, particularly regarding palette, history, present condition, and conservation history.

A. Accepted Works

1 Anne Hamilton, Lady Grant, c. 1717

Registered with the Scottish National Portrait Gallery and in the collection of Sir Archibald Grant, Bt

17 × 12 (43.2 × 30.4)

Provenance: Direct descent in Grant family from sitter to present owner, Sir Archibald Grant

Notebook: Not recorded

Literature: Caw 1908, p. 26; Foote 1950, pp. 6, 160; Saunders 1979, vol. 1, pp. 14–15, 47n; vol. 2, pl. 18

Subject: Anne Hamilton (d. 1721), daughter of James Hamilton of Pencaitland, East Lothian; married Archibald Grant (1696–1778) April 17, 1717[1]

See figure 15

The sitter wears a blue gown that has a jewel clasp at the bodice and on the sleeve. A label on the back of the painting reads, "Miss Hamilton 1st Lady to 1st A. G. [Archibald Grant] Symbert pinxt." Caw is the first to note the painting as being by Smibert, describing it as "a cabinet-sized oval of Lady Grant, dated 1717."[2] The date is actually on a label attached to the front of the frame, not on the painting itself. Foote accepted the attribution to Smibert and repeated Caw's description, although neither author actually saw the painting.[3] Foote mistakenly concluded that the portrait was of the wife of Sir Francis Grant (no. 2) when it is actually the wife of his son, Sir Archibald Grant.[4]

This small oval format is unusual for the early eighteenth century, although Vertue remarked on similar portraits painted in the early 1720s by James Maubert.[5]

NOTES

1. Sedgwick 1970, vol. 2, p. 77.
2. Caw 1908, p. 26.
3. Foote 1950, p. 160.
4. Ibid., pp. 6, 160.
5. Vertue 1930–1955, vol. 22, p. 28.

2 Sir Francis Grant, c. 1718–1719

Scottish National Portrait Gallery, Edinburgh

30 × 25 (76.2 × 63.5)

Inscribed upper left (in a later hand): "Sir Francis Grant / of Cullen Bar[t]."

Provenance: Descent in Grant family from sitter to Sir Arthur Grant (1911–1944); acquired by the Scottish National Portrait Gallery from a Glasgow dealer, who had bought it at a wartime sale in Edinburgh[1]

Engraved by Samuel Taylor, 1744. Inscribed below biographical description of Grant, "Jo Smibert pinxit - Saml. Taylor Fecit" (cat. no. 2a)

Notebook: Not recorded

Literature: Foote 1950, pp. 6, 20, 25, 159–160; Saunders 1979, vol. 1, pp. 16, 17; vol. 2, pl. 21

Subject: Sir Francis Grant, 1st baronet of Cullen of Buchan, Banff, born 1658[2]; educated at Kings College, Aberdeen, and Leyden; admitted an advocate, 1691: married (1) Jean Meldrum, daugh-

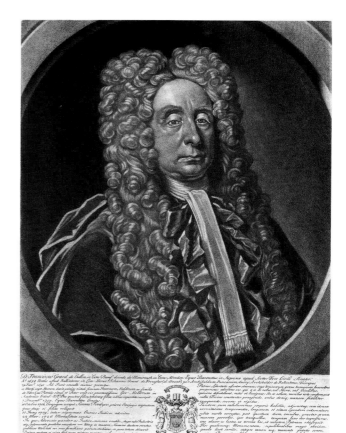

2a

ter of Rev. William Meldrum of Meldrum, Aberdeen, March 15, 1694, (2) Sarah, daughter of Rev. Alexander Fordyce of Ayton, October 18, 1708, (3) Agnes, daughter of Henry Hay, July 18, 1718;[3] lawyer and philanthropist; created a baronet of Nova Scotia in 1705; appointed a senator of the College of Justice of Scotland in 1709 by the title of Lord Cullen; died March 23, 1726[4]

See figure 16

The portrait compares favorably with Sir John de Medina's set of oval portraits painted c. 1695–1710 for members of the Incorporation of Surgeons, Edinburgh.[5] Grant, dressed in his court robes, seems every bit as pious and dignified as he is said to have been.[6]

NOTES

1. Foote 1950, p. 159.
2. Smith 1884, vol. 3, p. 1357.
3. Burke's Peerage 1970, p. 1156.
4. Brunton and Haig 1849, pp. 488–490.
5. David Manings, "Sir John Medina's Portraits of the Surgeons of Edinburgh," *Medical History* 23 (1979), pp. 176–190.
6. Brunton and Haig 1849, p. 490.

3 Alexander Garden of Troup, c. 1718–1719

Registered with the Scottish National Portrait Gallery and in the
 collection of Sir Archibald Grant, Bt
28 1/2 × 23 (72.4 × 58.4)
Provenance: Descent in Grant family to present owner, Sir Archi-
 bald Grant
Notebook: Not recorded
Literature: Saunders 1979, vol. 1, pp. 16–17; vol. 2, pl. 22.
Subject: Alexander Garden, absentee sheriff's-deputy, 1716–
 1728, and absentee civilist at King's College, Aberdeen, 1717–
 1724;[1] husband of Sir Francis Grant's eldest daughter, Jean

See figure 18

 The portrait is similar in style to that of Sir Francis Grant
(cat. no. 2) and was probably painted about the same time.
A label on the front of the frame is inscribed "ALEX[r] GAR-
DEN / of Troup / By SMYBERT."

NOTES

 1. New Spalding Club, *Records of the Sheriff Court of Aberdeenshire*
(1907), vol. 3, p. 109.

4 Sir William Grant, c. 1718–1719

Registered with the Scottish National Portrait Gallery and in the
 collection of Sir Archibald Grant, Bt
28 × 23 (71.1 × 58.4)
Provenance: Direct descent in Grant family from sitter to present
 owner, Sir Archibald Grant.
Notebook: Not recorded.
Subject: William Grant (1701–1764), of Prestongrange, Had-
 dington, was the second son of Sir Francis Grant, Lord Cullen.
 He was admitted advocate in 1722 and in 1737 was appointed
 solicitor-general for Scotland. In 1746 he took office as lord
 advocate. In politics Grant was returned to Parliament as a mem-
 ber for the Elgin burghs and was a principal agent in the move to
 secure the abolition of heritable jurisdictions in Scotland. He
 also saw through a bill aimed at annexing to the crown estates
 forfeited in the Jacobite rebellions. In 1753 Robert Dundas, lord
 president of the court of session, writing to Lord Hardwicke
 about the shortcomings of the law officers for Scotland, referred
 to Grant as one who, being "well employed in private business,
 loves his money better than public business."[1] He became a Lord
 of Session in 1754 with the title of Lord Prestongrange. He died
 May 23, 1764.[2]

See figure 17

 The pose of the sitter is similar to that of the 10th Earl
Marischal (Scottish National Portrait Gallery) by Pierre
Parocel, c. 1715–1720, which may indicate that Smibert
was familiar with that painting.

NOTES

 1. Sedgwick 1970, vol. 2, p. 80.
 2. George W. T. Omond, *The Lord Advocates of Scotland* (Edin-
burgh, 1883), pp. 29–30, 58.

5 Sir Francis Grant and His Family, 1718

Registered with the Scottish National Portrait Gallery and in the
 collection of Sir Archibald Grant, Bt
17 × 27 3/4 (43.2 × 70.5)
Provenance: The history of this sketch prior to the 1950s is un-
 clear, although it apparently descended in the family in the
 hands of a collateral descendant until reacquired by the Grants
 of Monymusk (c. 1957). A letter in the painting files at the Scot-
 tish National Portrait Gallery reveals that "this small version was
 in the ownership two years ago [1955] of an elderly lady, a con-
 nection of the family, who lived in the North of England. The
 picture was in a store in Aberdeen."[1]
Notebook: Not recorded
Literature: Saunders 1979, vol. 1, pp. 9, 10, 12, 147; vol. 2, pl. 3;
 Holloway 1989, p. 76.
Subject: (from left to right) Alexander Garden of Troup; his wife
 Jean Grant, daughter of Sir Francis Grant; Christina Grant,
 daughter of Sir Francis Grant, later Mrs. George Buchan of
 Kelloe; Helen Grant, daughter of Sir Francis Grant, later Mrs.
 Andrew McDowell of Bankton; Lady Grant, Jane Meldrum, first
 wife of Sir Francis Grant (oval portrait on wall); Sarah Grant,
 daughter of Sir Francis Grant; Sir Francis Grant (1658–1726);
 Anne Grant, daughter of Sir Francis Grant; Lady Grant, Sarah
 Fordyce, second wife of Sir Francis Grant (oval portrait on wall);
 Francis Grant, son of Sir Francis Grant; Sir William Grant, Lord
 Prestongrange, son of Sir Francis Grant; Sir Archibald Grant
 (1696–1778), son of Sir Francis Grant; Lady Grant, Anne Ham-
 ilton (d. 1721), wife of Sir Archibald Grant; William Grant, son
 of Sir Archibald Grant. As there are no inscriptions or family
 documents to assist in the dating of this sketch and the final
 version (cat. no. 6), it is fortunate that the group portrait in-
 cludes so many family members. The painting was most likely
 done between January and June, 1718, because Sir Francis
 Grant's third wife, Agnes Hay, whom he married July 18, 1718,
 is missing, while William Grant, presumably born at least nine
 months after his parents' marriage, April 17, 1717, is pictured.[2]

See plate 2

NOTES

 1. Scottish National Portrait Gallery, Painting File: Lord Cullen
and Family, letter from Basil Skinner to Mrs. Waddington, Octo-
ber 14, 1957.
 2. Saunders 1979, vol. 1, p. 44n.

6 Sir Francis Grant and His Family, 1718

Registered with the Scottish National Portrait Gallery and in the
 collection of Sir Archibald Grant, Bt
85 × 125 (210.8 × 328.9)
Provenance: Direct descent in Grant family from Sir Francis Grant
 to present owner, Sir Archibald Grant
Notebook: Not recorded
Literature: Caw 1908, p. 26; Hagen 1940, p. 56; Foote 1950, pp. 6,
 20, 44, 149, 160; Rowan 1972a, pp. 952, 953 (fig. 9); Saunders
 1979, vol. 1, pp. 8–17, 147, 149, vol. 2, pl. 2; Holloway 1989,
 p. 75.
Copies: (1) A copy or replica, measuring approximately 36 × 50
 inches, is in the collection of the Museum of the Americas, East
 Brookfield, Vt. (2) Another copy is owned by the Grant family
 and housed in the Monymusk Chapel, Monymusk, Scotland.

Approximately two-thirds the size of the original, it is by an unidentified artist. It was acquired by the Grant family sometime after 1950.
Subject: Same as in cat. no. 5

See plate 1

In painting the finished version of this composition Smibert reduced the figures from full-length to three-quarter-length. In this more crowded design the figures cluster in the foreground. The atmosphere is transformed from that of an intimate conversation piece to that of a more formal Baroque portrait.

Most late-seventeenth and early-eighteenth-century British group portraits were set on a generic terrace with an arcade of columns, sky, and landscape in the background. Consequently Smibert's use of a domestic interior setting is innovative and reflects the influence of Dutch and Flemish seventeenth-century portraits. Further, the head of the family, a man, is normally placed to one side, with his wife at the center. The wife is invariably shown seated; the psychological bonds to her children are implicit in their physical contact. As Sir Francis Grant was a widower, Smibert confronted an atypical situation and chose to place him at the center of the composition.

The inclusion of deceased family members (Jane Meldrum, Sir Francis Grant's first wife, and Sarah Fordyce, his second wife) by means of framed portraits in the background of the composition is a device that had been used since the 1670s.[1] The portrait that provided the model for Smibert's rendering of Sarah Fordyce has disappeared, but a portrait of Jane Meldrum, c. 1695, by an unknown artist, is still owned by the Grant family. Lord Cullen's achievement is displayed prominently over the door in the center of the painting, his coat of arms (which he was not granted until 1720) supported by seraphim.[2] As Smibert is not known to have visited Edinburgh after 1720, these may have been added by another hand.

The absence of any paintings in a 1731 inventory of Monymusk, the Grant family's country house,[3] indicates that this the painting was probably still in Edinburgh.

NOTES

1. Praz 1971, p. 248.
2. Holloway 1989, p. 75.
3. Henry Hamilton, ed., *Selections from the Monymusk Papers (1713–1735)* (Edinburgh, 1945), pp. 1–8.

7 Allan Ramsay, c. 1717–1719

James Holloway
24 × 20 1/4 (61.0 × 51.3)
Provenance: Newhall House, Scotland (1804), when a sepia drawing was made from it; London Art Market 1987
Notebook: Not recorded
Literature: Holloway 1989, p. 77, fig. 56
Copies: (1) a nineteenth-century copy attributed to Smibert

("ALLAN RAMSAY NO. 1")[1], Scottish National Portrait Gallery; (2) a sepia drawing, 6 × 4 3/4 inches, by Alexander Carse (fl. 1812–1829), a Scottish painter who worked in Edinburgh in the nineteenth century, marked as having been drawn from the portrait by Smibert, Scottish National Portrait Gallery
Subject: Allan Ramsay (1686–1758), was born in Lanarkshire, Scotland, October 15, 1686. He was the son of Robert Ramsay and Alice (Bowyer) Ramsay. In 1701 he was apprenticed to an Edinburgh wigmaker. By 1712 he had married, become a successful wigmaker, and joined the Easy Club, a social and literary group composed of Jacobites. Between 1716 and 1718 he abandoned wigmaking for bookselling and by 1720 had published his collected works, *Poems*. He published extensively throughout the 1720s, during which time his best-known work, *The Gentle Shepard*, was written, but by 1730 he had practically ceased writing. He lived quietly in Edinburgh until his death on January 7, 1758. His works were reprinted frequently during the eighteenth and early nineteenth centuries. Ramsay and Smibert were lifelong friends (see appendix 2). Smibert took with him to America a plaster bust of the poet.

See figure 21

This oval format is unusual for Smibert and he apparently only employed it in Scotland. The virtual profile view is also a rare experiment.

NOTES

1. Foote 1950, p. 185.

8 George Berkeley, c. 1720

Private collection
28 3/16 × 23 (71.7 × 58.4)
Provenance: By family descent from the sitter to his brother, Dr. Robert Berkeley, rector of Middleton, County Cork; his daughter, Mrs. Sackville Hamilton; Mr. Robert Berkeley, Q.C., Dublin (d. 1873); his eldest son, Major George Sackville Berkeley (d. 1889); George F. A. Berkeley, Esq. (1870–1955), Hanwell Castle, Banbury; Colonel Maurice Berkeley; his wife, Mollie Berkeley, the present owner
Notebook: Not recorded
Literature: Fraser 1871, p. 348; Luce 1949, p. 240; Foote 1950, pp. 17, 129–130; Saunders 1979, vol. 1, pp. 31–33; vol. 2, pl. 31; Houghton, Berman, and Lapan 1986, pp. 32–33
Subject: George Berkeley (1685–1753), born at Thomaston, Kilkenny, Ireland, March 12, 1685; Trinity College, Dublin, B.A. 1704, fellow of Trinity College 1707; took Anglican orders; traveled on the Continent 1713–1720; was appointed Dean of Derry 1721; lived at Newport, R.I., 1729–1732; was appointed bishop of Cloyne 1734; died at Oxford January 18, 1753[1]

See figure 24

On the back of the canvas and stretcher are the following paper labels: on the upper edge of the stretcher, "George Berkeley Bishop of Cloyne / Painted at Rome, before he had / Taken orders"; attached to the upper stretcher to the right of first label, "Relined but not restored by George C. Roller / Park Cottage / Pelham Street SW 7"; bottom

stretcher, "This picture of Bishop Berkeley is / to be the property of George Sackville / Berkeley Captain in the Royal Reserves."

Foote accepted this painting as by Smibert but dated it 1718, on the belief that Smibert was in Italy from 1717 to 1720 and that Berkeley was in Rome from January to March 1717 and from April to November 1718.[2] Smibert's notation that he painted a "copie of a head by Tician [sic]" at Florence in August 1720 for a "Mr. Ashe,"[3] in all probability St. George Ashe (d. 1721), who was in Florence with his tutor, George Berkeley, suggests a more likely date for Berkeley having had this portrait done.[4]

NOTES

1. Foote 1950, p. 129.
2. Ibid., pp. 16–17, 129.
3. Smibert 1969, p. 76.
4. Saunders 1979, vol. 1, pp. 20–32.

9 Unidentified man, 1720

Wadsworth Atheneum, Hartford, Connecticut
37 1/2 × 28 1/2 (95.3 × 72.4)
Signed on reverse: "Jo. Smibert pinxit Romae, 1720"
Provenance: Sale Christie's, London, June 27, 1927; purchased by dealer named Feldman; Leger & Son, London; Julius H. Weitzner (dealer), New York; Wadsworth Atheneum, 1942
Literature: *Parnassus* 4, no. 4 (April 1932), rep.; New Haven 1949, no. 30; Foote 1950, pp. 224–225; Saunders 1984, pp. 312–314

See plate 5

This is the earliest signed and dated portrait by Smibert that has yet been identified. In 1927 it was sold at Christie's in London along with a second portrait of a man (cat. no. 10), which also is by Smibert.[1] The paintings were eventually acquired by Leger & Son and brought to the attention of Foote. According to the dealer Sidney Leger, this portrait was inscribed on the reverse: "Jo. Smibert pinxit/ Romae, 1728." Unfortunately the portrait was in poor condition and was lined prior to being seen by Foote. The inscription, however, was copied onto the lining canvas.

The signature should have insured the painting's acceptance as a work by Smibert, but it did precisely the opposite. The portrait appeared at a time when the art market was inundated with portraits embellished with Smibert signatures to enhance their value in America. This situation made scholars like Foote, who later identified seventeen portraits bearing forged Smibert signatures (see cat. nos. 510–526), extremely cautious about accepting "signed" Smibert portraits of untraceable provenance. Foote initially speculated that the painting, along with cat no. 10, might be self-portraits by Smibert but later concluded about this one, "the picture is regarded as dubious by good judges who question (1) whether it is a self-portrait by Smibert; (2) whether it may represent him but be by another hand; (3) whether it may represent another individual and be of continental European origin. There are at present no de-

9a

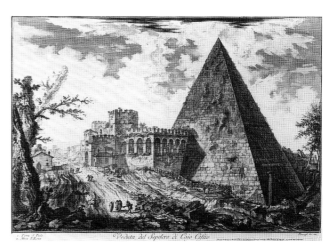

9b

finitive answers to these questions, nor any satisfactory solution of the problem presented by the picture."[2]

Part of Foote's hesitancy to accept the painting was what he thought to be its date: 1728. Foote knew it was highly unlikely that Smibert was in Italy in 1728, since he left for America with George Berkeley in August of that year. Once discounted by Foote, the painting was ignored by subsequent scholars.

In 1980, however, the lining canvas was removed, revealing a legitimate Smibert signature on the original canvas, which reads, "Jo Smibert pinxit Roma 1720" (cat. no. 9a). The last digit, which was transcribed incorrectly on the lining canvas as "8," is partially obliterated but appears to be "o." The inscription is entirely consistent with Smibert's writing style as seen in his notebook and on other signed portraits, although after his departure from Italy he signed his portraits on the front.[3]

This portrait depicts a man curiously attired in a dressing cap and tricorne hat, and holding a long-stem clay pipe. His left arm is raised and gestures to two figures behind him. The figure on the left is a man riding a donkey, and

an angel holding a musket impedes his progress. The vignette is thought to represent the Old Testament story of the prophet Balaam (Num. 22:1–25). The king of the Moabites, Balak, sends for Balaam to place a curse on the Israelites. On his way to see the king, Balaam is intercepted by an angel armed with a sword, who is invisible to Balaam but can be seen by the donkey. God instructs Balaam to resist the king's demand and instead to bless Israel.

One possible explanation of why Smibert painted this vignette concerns the pyramid in the background. The only pyramid in in Rome—that of Caius Cestius (cat. no. 9b)—was adjacent to the sole Protestant cemetery there. Cestius' pyramid thus came to symbolize a Protestant presence at the seat of Roman Catholicism.[4] In the painting, the story of Balaam may have been intended as a playful reference to the plight of Protestant visitors in Italy. Like the Israelites among the mighty tribes of gentiles, the small community of Protestants in Rome would have God's blessing.

NOTES

1. Foote 1950, pp. 32–33, 223–25.
2. Ibid., pp. 224–225. The painting was said to have come from "an old court in Kent" (p. 32).

3. Sixteen other signed and dated portraits by Smibert are known, of which fifteen were painted in London, 1722–1727. See cat. nos. 12–13, 15–16, 19–20, 23–25, 27–29, 31, 33, 36.
4. Christian Elling, *Rome: The Biography of Her Architecture from Bernini to Thorvaldsen* (Boulder, Colo., 1975), p. 515.

10 Unidentified man, c. 1719–1722

Collection of the Montclair Art Museum
49 × 39 (124.5 × 99.1)
Provenance: Sale Christie's, London, June 27, 1927, no. 126; Leger & Son, London; Julius Weitzner, New York (1934); gift of Mr. and Mrs. W. Skinner to the Montclair Art Museum (1957)
Literature: *Parnassus* 4, no. 4 (April 1932) rep.; Foote 1950, pp. 223–224; Montclair Art Museum, *The American Painting Collection of the Montclair Art Museum* (1977), p. 32 rep., 224; Saunders 1984, pp. 312–314.

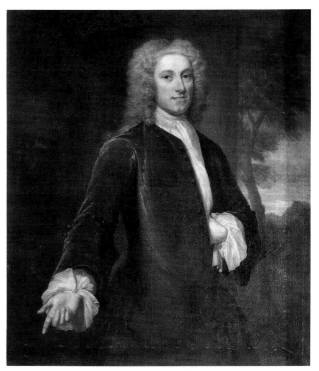

11

11 Samuel Hill (replica), c. 1722–1723

The National Trust, Attingham Park, Shropshire
46 1/2 × 38 1/2 (118.1 × 96.8)
Provenance: The sitter; to his brother, Thomas Hill (d. 1782), the owner of Attingham Park (then called Tern Hall); his son, Noel Hill (d. 1789), 1st Lord Berwick; direct descent to Thomas Henry (d. 1947), 8th Lord Berwick; The National Trust
Notebook: c. 1722–1723, p. 78, no. 16: "[Mr. Hill] afterwards mead 1/2 7–17–6"

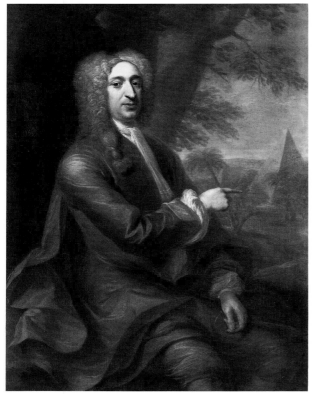

10

Literature: The National Trust, *Attingham Park, Shropshire* (n.d.), p. 16 [attributed to J.S.]; Saunders 1979, vol. 1, pp. 59–60*nn8–11;* vol. 2, pl. 24

Subject: Samuel Hill (1690/1–1758), born Samuel Barbour but upon inheriting Shenstone Park, Staffordshire, from his uncle Richard Hill (1654–1727) he changed his name. Hill's uncle also paid for his Cambridge education, sent him on the grand tour for six years, and enabled him to succeed to his own seat in Parliament. Hill served as M.P. from Lichfield, Staffordshire, from 1715 to 1722, and was considered a Tory who would often voted Whig. In 1722, at age thirty, he retired from Parliament and married Lady Elizabeth Stanhope, who brought him a £10,000 dowry.[1]

Hill wears a blue-green frock coat and is shown standing before a wall. Behind him, to the viewer's right, is a mountainous landscape. The portrait is neither signed nor dated but the attribution to Smibert is well founded. Early estate inventories name the artist as "Seibert,"[2] and Smibert's notebook does record two London commissions (a bust portrait and a three-quarter-length replica) for a sitter identified only as "Mr. Hill." This is the three-quarter-length replica; the bust portrait is unlocated.[3]

NOTES

1. Sedgwick, *The House of Commons 1725–1754* (1970), vol. 2, pp. 138–139.
2. National Trust Painting Files, London, no. 103 (Attingham no. 118).
3. There is a second portrait of Samuel Hill at Attingham Park. It is a bust portrait (30 × 25 inches) and is much repainted, making the identification of the original artist difficult. It does not appear to be the work of Smibert.

12 David Miln, 1723

Anglo-American Art Museum, Louisiana State University, gift of James J. Bailey III, Mrs. John B. Noland, and P. Foster Bailey, in memory of their mother, Fairfax Foster Bailey

49 7/8 × 39 7/8 (126.7 × 101.6)

Signed lower right: "Jno. Smibert 1723" (no longer visible)[1]

Inscription lower left : "To / Mr. David Miln / Mercht in / London"

Provenance: The sitter; his niece, Jane Miln, who married Alexander Carmichael; their daughter (?), Margaret Carmichael, who married John Campbell, December 11, 1763; their son (?), Captain Robert Campbell, RN; his son (?), Robert Campbell, D.S.C., Lt. Commander RN; his son (?), Peter Campbell; estate of Mr. Archibald Dundas; purchased by C. G. Dolward, Art Dealer, Sloane Avenue Mansions, London; purchased (c. 1960) at the White Plains Antiques Show by Joseph L. Graham, Philadelphia;[2] Childs Gallery, Boston, 1983; Fairfax Foster Bailey, Baton Rouge, Louisiana, 1983

Notebook: 1723, p. 79, no. 27: "Mr. Miller [mistranscribed; notebook actually reads "Milln"] Mercht. 1/2 10–10–0"

Literature: Oliver 1970, p. 920; Saunders 1979, vol. 1, pp. 61–62, 82–83*nn15–18*, vol. 2, fig. 35.

Subject: David Miln (c.1670/75–1760), merchant in London and Edinburgh; married Eupham Hutchieson, daughter of William

Hutchieson of Throwburn, in the southwest parish, Edinburgh, August 20, 1712.[3]

See figure 32

Miln wears a rust-brown velvet frock coat, and his right hand rests on a letter lying on a marble-topped table. Next to the letter is an envelope inscribed, "To Mr David Miln / Mercht in London." His portrait documents the correlation between social etiquette and body language. Manners dictated the poses artists chose. Miln's left arm, for example, is held out, away from the body, because to allow the arms to hang at one's sides was considered suitable for servants but beneath the dignity of gentlemen.[4] The preoccupation with social customs was demostrated in a contemporary guide to deportment:

A Gentleman ought not to run or walk too fast in the Streets, lest he be suspected to be going a Message; nor ought his Page be too slow; nor must he take large steps, nor too stiff and stately, nor lift his legs too high, nor stamp hard on the Ground, neither must he swing his Arms backward and forward, nor must he carry his knees too close, nor must he go wagging his breech, nor with his feet in a straight Line, but with the In-side of his Feet a little out, nor with his Eyes looking hither and thither, but with a sedate countenance.[5]

In short, Miln exemplifies Jonathan Richardson's dictum that "the Painter's People must be good Actors, they must have learn'd to use a Humane Body well, they must Sit, Walk, Lye, Salute, do everything with Grace."[6]

NOTES

1. National Portrait Gallery, London, Artist File. J. L. Graham to John Kerslake, May 20, 1968, noted: "In cleaning the portraits (by Charles Olin of the Smithsonian) Mr. Miln was found to have "Jno. Smibert 1723" in the lower right hand corner." This inscription was not visible when the painting was examined by the author in September, 1977.
2. The first seven generations of this provenance were determined from a hand-written note attached to the back of the portrait.
3. Robin Hutchison, Scottish National Portrait Gallery, to J. L. Graham, May 23, 1968 (in possession of owner).
4. Joan Wildeblood and Peter Brinson, *The Polite World: A Guide to English Manners and Deportment from the Thirteenth to the Nineteenth Century* (London, 1965), p. 213.
5. Adam Petrie, *Rules of Good Deportment or of Good Breeding* (1720), p. 6, in *The Works of Adam Petrie* (Edinburgh, 1877).
6. Richardson 1715, p. 180.

13

13 Unidentified man, 1723

Arthur Byron Phillips
21 1/4 × 16 (54.0 × 40.6)
Signed lower right: "Jo. Smibert fec. 1723"
Provenance: Anthony Gilbert Storer, England, c. 1840; Sotheby's
New York, May 29, 1986, lot 1; Arthur Byron Philips

This portrait is an unusual size for Smibert and, although I have not examined it personally, it may have been
cut down.

14 Mrs. David Miln, 1723

Anglo-American Art Museum, Louisiana State University, gift of
James J. Bailey III, Mrs. John B. Noland, and P. Foster Bailey, in
memory of their mother, Fairfax Foster Bailey
49 7/8 × 40 (126.7 × 103.4)
Provenance: Same as cat. no. 12
Notebook: [c. 1723–1724], p. 79, no. 28: "Mr's. Miller [mistranscribed; actually is 'Mrs. Milln'] 1/2 10–10–0"
Literature: Oliver 1970, p. 920; Saunders 1979, vol. 1, pp. 63–64,
83n23, vol. 2, fig. 37
Subject: Mrs. David Miln, married David Miln (1670/5–1760),

London and Edinburgh merchant, August 20, 1712 (see entry
for cat. no. 12)

See figure 33

Mrs. Miln is shown seated in a landscape setting and
wearing a blue velvet gown. Her right arm rests on a plinth
with a relief depicting a female figure holding a basket.
Mrs. Miln has cherries in her hands, and over her right
shoulder a parrot holds a cherry in its talons.

The pose is virtually identical to one Smibert used for his
portrait of Mrs. Daniel Oliver (cat no. 65), painted seven
years later.[1]

NOTES

1. First noted in Oliver 1970, p. 920.

15 Colonel James Otway, 1724

Courtesy Royal Sussex Regiment Museum, Chichester
48 × 40 (121.9 × 103.4)
Signed lower left: "Jo Smibert/ fe. 1724"
Provenance: Descent in family from sitter to Captain Otway
Ruthven, Penns, Genghill, Guildford; purchased 1953 by the
Royal Sussex Regiment, Chichester
Notebook: p. 79, no. 33: "Coll. James Otway 1/2 10–10–0"
Literature: Foote 1950, p. 177; E. Hollist, *Country Life*, vol. 113
(August 18, 1955), p. 330; Kerslake 1965, p. 150, and fig. 3;
Major J. F. Ainsworth, *The Royal Sussex Regiment* (Derby, England, 1972), rep. inside cover; Saunders 1979, vol. 1, pp. 67–69,
84nn34–36, vol. 2, pl. 39.
Subject: Colonel Charles James Otway (1690–1764), career military officer, colonel of the 35th Foot (Royal Sussex) Regiment,
1717–1764; appointed Captain in Lord Mohun's Regiment of
Foot in March 1702; promoted major in Lord Slanes's Regiment
on the Irish Establishment before 1711; placed on half-pay in
1712; made major of the Innis Killing Dragoons July 22, 1715,
afterwards known as the 35th Foot; promoted to brigadeergeneral November 28, 1735, and to major-general July 2, 1739;
retained the colonelcy of his Regiment until his death as a full
general in 1764[1]

See plate 6

This portrait, which is in excellent condition, represents
the artistic pinnacle of Smibert's London career and is the
only portrait that survives from at least seven portraits
painted for the Otway family.

Otway gestures with his left hand to the scene behind
him—a battlefield littered with men and cannon. This is
presumably a generic reference rather than a reference to
a specific battle, as during Otway's colonelcy the regiment
was stationed in Ireland except for a seven-year tour in
Minorca, where no battles were fought. During the period
the regiment was in Minorca Otway was lieutenant governor and second in command to Lord Carpenter (no. 223).

NOTES

1. Dalton 1910–1912, vol. 1, p. 110.

16

16 Unidentified man, 1724

Present location unknown
29 1/2 × 24 (74.9 × 60.9)
Signed lower right: "Jo. Smibert/ fe. 1724"
Provenance: Sale Christie's, London, March 27, 1972, no. 31; purchased by Douglas Wing, director, Old Hall Gallery Limited, Iden, Rye, Sussex, England; sold to an unidentified American customer
Literature: Sale Christie's, London, March 17, 1972, no. 31; *Apollo* 96, no. 125 (July, 1972), p. 50, rep. [as Rev. Mr. Hengs]; Saunders 1979, vol. 1, pp. 72–73, 86n48, vol. 2, fig. 4

The dealer who owned the painting in 1972 tentatively identified the sitter as "Rev. Mr. Hengs" apparently based on Smibert's notebook entry.[1] In 1977 he thought this identification was determined by a label attached to the back of the painting, but he could not recall exactly.[2] When Christie's sold the painting in 1972 they made no mention of this label. If the sitter is "Rev. Mr. Hengs" it may possibly be Rev. Obadiah Huges (b. c. 1695), a minister in London who is said to have had Scottish connections.[3]

NOTES

1. Smibert 1969, p. 79.
2. Douglas Wing to the author, February 23, 1976.
3. National Portrait Gallery, London; artist file, Douglas Wing to R. Ormond, assistant keeper, April 5, 1972.

17 Edward Nightingale, 1724

Dallas Museum of Art, General Acquisitions Fund and gift of Tom and Eleanor May
49 1/2 × 39 1/2 (125.8 × 100.3)
Provenance: The Sporting Gallery, Middleburg, Virginia; Sale Christie's, March 18, 1977, no. 95 b.i.; purchased by Steven R. Koman, Winchester, Virginia
Notebook: [1724], p. 79, no. 41: "Mr. Nightinggell 1/2 15–15–0"
Literature: Sale Christie's (London), March 18, 1977, no. 95 rep.; *Antiques* 115 (January 1979), p. 66 rep.; Saunders 1979, vol. 1, pp. 69–70, 95n39, vol. 1, fig. 42.
Subject: Edward Nightingale (1696–1750), admitted at Christ's College, Cambridge University, March 17, 1714–15; B.A. 1718–19; admitted at Gray's Inn, April 5, 1720; succeeded as 7th Baronet of Kneesworth, co. Cambridge, c. 1730, but did not assume the title;[1] married Eleanor, daughter of Charles Ethelston;[2] died at Bath, October 20, 1750

See figure 39

This portrait, in contrast to those such as *Colonel James Otway* (see cat. no. 15), in which the sitter wears a wig and formal attire, indicates that some of Smibert's clientele preferred informal compositions. In this instance, Nightingale, who wears a pastel gray dressing gown trimmed in violet, sits in his library, self-consciously ensconced in an upholstered side chair. Prevailing fashion dictated that gentlemen shave their heads and wear wigs. Consequently, when at home they wore négligée caps to protect their bald heads from the cold.

NOTES

1. Venn, *Alumni Cantabrigienses* (1924), vol. 3, p. 258.
2. Burke's Peerage 1970, p. 1969.

18 Sir John St. Aubyn, c. 1724

Courtesy Pencarrow House, Cornwall
49 × 39 (124.5 × 99.1)
Provenance: Descent in family to present owner, Lt. Colonel J. A. Molesworth-St. Aubyn, M.B.E.
Notebook: [1724], p. 79, no. 47: "Sir John St. Abane 10 paid 1/2 16–16–0"
Literature: Saunders 1979, vol. 1, pp. 70–71, 85nn40–41, vol. 2, pl. 43
Subject: Sir John St. Aubyn (1696–1744), 3rd Baronet of Clowanee and St. Michael's Mount, Cornwall, born September 27, 1696, son and heir of Sir John St. Aubyn (d. 1714) and Mary, daughter and heiress of Peter de la Hay of Westminster; entered as gentleman-commoner at Exeter College, Oxford University, June 10, 1718, and created M.A. on July 19, 1721;[1] member of Parliament from Cornwall, 1722–1744; married Catherine, daughter of Sir Nicholas Morice, 2nd Baronet of Werrington, Devon, in 1725; died August 15, 1744.[2] Politically, St. Aubyn was an extreme Tory, and in 1730 the Pretender was asked "to write to Sir John St. Aubyn to acknowledge his sense of his service." In Parliament is described as "constant in his attendance and application to the business of the House of Commons; he soon learnt

to speak well but spoke seldom, and never but on points of consequence."

See plate 7

St. Aubyn's portrait is one of the few instances where Smibert chose to delineate a specific, highly detailed background. In this instance the inspiration for St. Michael's Mount probably came from an unidentified print, as the mount is steeped in British history and had been depicted in print as early as 1597.[3]

NOTES

1. W.[illiam] P.[rideaux] C.[ourtney], "St. Aubyn, Sir John," *DNB* (1917).
2. Sedgwick 1970, vol. 2, pp. 401–402.
3. John St. Aubyn, *St. Michael's Mount* (Norwich, 1974).

19

19 Mrs. Henry Ferne, 1724

Worcester Art Museum, Worcester, Massachusetts
50 3/8 × 40 3/16 (128 × 102.3)
Signed lower left: "Eliza ʰ Fern / Aged 70 / Jo. Smibert / fe 1724"
Provenance: The sitter; to her eldest daughter, Elizabeth (Langton) Turner (d.1763) of Stoke Rochford, county of Lincoln; to her daughter Diana Langton, wife of B. Langton, Esq., Langton Hall, Spilsby, Lincolnshire; by descent to Bennet Langton, Esq.,

Langton Hall, Spilsby, Lincolnshire to his nephew, John C. P. Langton (1955); purchased by the Worcester Art Museum (1958)
Notebook: p. 79, no. 48: "Mrs. Fairenn 1/2 15–15–0"
Literature: Foote 1950, pp. 25, 152–153; Dresser 1959, pp. 12–19, fig. 8; Louisa Dresser, "Studies in the Portraiture of New England, Mrs. Freake and Baby Mary to Mrs. Perez Morton," *Apollo* 94 (December 1971), pp. 474–475, fig. 3; Saunders 1979, vol. 1, pp. 71–72, 85–86nn42–45, vol. 2, pl. 45; Dagmar Reutlinger, *The Colonial Epoch in America* (exh. cat.) 1975, pp. 10–11, fig. 6
Subject: Elizabeth Dayrel Ferne (1654–1733), youngest daughter and co-heiress of Nicholas Dayrel, Esq., of Kingsclear, county of Southhampton; married Henry Ferne (see cat no. 28) of Smitherton, county of Lincoln, receiver general of the customs; died May 7, 1733

Mrs. Ferne was widowed July 12, 1723, and is depicted in traditional mourning attire. The similarity of the portrait to the figure of Elizabeth Staats Wendel Schuyler in the double portrait (cat. no. 528) at the New-York Historical Society has been previously noted.[1] It has been suggested that an unlocated common prototype served both artists.

NOTES

1. Dresser 1959, pp. 13, 17, 19n7; Dresser, "Studies in the Portraiture of New England, Mrs. Freake and Baby Mary to Mrs. Perez Morton," *Apollo* 94 (December 1971), p. 475.

20 Lady Anne Hastings, 1724

Private Collection, England
50 1/4 × 39 1/2 (127.7 × 100.3)
Signed lower left: "Jo Smibert fe 1724"
Inscription lower left (by a later hand): "THE LADY ANNE HASTINGS / DAUʀ: OF THEOPHILUS 7ᵀᴴ E: OF: HUNTINGDON
Provenance: Sale Christie's, December 10, 1971, no. 143; purchased by Leger Galleries, 13 Bond Street, London, purchase price 5500 guineas ($14,135);[1] Sale Christie's July 16, 1982, no. 54; private collection, England
Notebook: p. 79, no. 50: "Lady Ann Heastings half pd. 1/2 15–15"
Literature: E. Mayer, *International Auction Records* 1972, p. 744; *Exhibition of English Paintings* (exh. cat.), Leger Galleries, 1973, no. 20 rep.; Saunders 1979, vol. 1, pp. 73–74, 86n49, vol. 2, fig. 47
Subject: Lady Anne Hastings, (1691–1755), eldest daughter of Theophilus, 7th Earl of Huntingdon, by his second marriage in 1690 to Frances Leveson Fowler, widow of the 6th Viscount Kilmorey.[2] Lady Anne mostly lived with her sister, Lady Elizabeth Hastings (1682–1739), who inherited the family estate, Ledstone Hall, Yorkshire, upon the death of their brother. Lady Elizabeth was known for her philanthropy and was a munificent subscriber to the fund for Dean Berkeley's project to establish a college in Bermuda. There is a statue of Lady Anne along with one of her sisters, Lady Frances, flanking the tomb monument to Lady Elizabeth at Ledsham, Yorkshire. Lady Anne Hastings died June 28, 1755.[3]

Lady Anne Hastings represents an important stylistic shift toward a lighter, brighter Rococo palette. The sitter's sil-

20

21

very white gown is in abrupt contrast to the dark colors favored by Smibert up to this point. This portrait is similar in formula to *Mrs. David Miln* (cat. no. 14). Here, however, the parrot motif is replaced by a bust of Minerva, goddess of wisdom, which is consistent with the trend beginning about 1715 away from the Baroque and toward a style based on antiquity. The bust may be derived from a print after the Minerva Giustiniani in the Musei Vaticani, Rome, reproduced in at least one seventeenth-century publication.[4]

NOTES

1. E. Mayer, *International Auction Records* (1972), p. 744.
2. Leger Galleries, *Exhibition of English Paintings, 1720–1850* (London, 1973), no. 20.
3. J[ohn] H. O[verton], "Hastings, Lady Elizabeth," *DNB* (1937–1938), vol. 9, p. 114; Sir William Musgrave, *Obituary prior to 1800* (London, 1900), vol. 3, p. 167.
4. Haskell 1981, pp. 269–270.

21 Mrs. Robert Cay,* 1724

Present location unknown
28 3/4 × 23 3/4 (73 × 60.2)
Bears inscription
Provenance: Salto Montgomery Cay, 1910; Sale Christie's, July 8, 1910, no. 107 (unsold); Sale Christie's, May 14, 1982, no. 146
Notebook: [1724], p. 79, no. 51: "Mrs. Kay 3/4 7–17–6"
Subject: Elizabeth Hall Cay (1646–1742), wife of Robert Cay (cat. no. 35)

22 Benjamin Morland, 1724

Yale Center for British Art, Paul Mellon Collection
95 1/4 × 59 (242 × 149.75)
Inscription: Lower edge of picture: "THIS PORTRAIT OF Mᴿ BENJAMIN MORLAND, NOW FIRST MASTER OF Sᵀ PAULS SCHOOL, WAS PRESENTED TO THIS / COMPANY BY A SOCIETY OF GENTLEMEN, EDUCATED BY HIM AT HACKNEY, AS A TESTIMONIAL OF THEIR ESTEEM AND GRATITUDE"
Provenance: The Mercer's Company, London; transferred to St. Paul's School (1929); purchased by Paul Mellon (1968); Yale Center for British Art (1981)
Notebook: p. 80, no. 62: "Mr. Moreland Master of St. Paulls Schoole a wholle lenth 36–15–0"
Literature: "An Antiques Book Preview, *The Notebook of John Smibert*," *Antiques*, vol. 95, no. 3 (March 1969), p. 364 rep.; Saunders 1979, vol. 1, pp. 75–76, 86n54, 87n55, vol. 2, pl. 50;

Malcolm Cormack, *A Concise Catalogue of Paintings in the Yale Center for British Art* (New Haven, 1985), pp. 204–205
Subject: Benjamin Morland (1657–1733), eldest son of Martin Morland, a Wykehamist and graduate of Wadham College, Oxford. Benjamin was admitted to Jesus College, Cambridge, May 18, 1676, but took no degree. In 1672 Benjamin's father was granted a license to be a teacher in his house in Hackney, and Benjamin taught at that school for a number of years. He succeeded to the headmastership on his father's death in 1685,[1] and under his direction the school was very successful. On March 19, 1706, he was elected a Fellow of the Royal Society, a rare if not unique distinction for the headmaster of a private school. On June 23, 1721, Morland succeeded to the headmastership of St. Paul's School, Westminster, where he remained until his death. Under his leadership the school prospered. He died October 9, 1733, and is buried at Hackney.[2]

See plate 8

This portrait is Smibert's only surviving full-length from the years he painted in London (1722–1728). Many of its compositional elements—the floppy cuffs, the loosely fitting gown, the cross-legged pose and the library setting—are motifs Smibert employed in earlier portraits. The firm, taut likeness, the successful grasp of human proportion and the balanced pose confirm that he rose to the occasion of such a major commission.

The painting is in good overall condition. No major areas are repainted, although considerable fill is noticeable in the crackle pattern. The painting has been lined twice. It was cleaned and given a new stretcher by Frank Sullivan at the time it was acquired by Mr. Mellon.

NOTES

1. Letter to author from Jean Imray, archivist, Mercers' Company, London, April 4, 1977.
2. McDonnell, *The Annals of St. Paul's School* (Privately printed, 1959), p. 281.

23 Robert Balfour, 1724

Reproduced by permission of John and Jean Balfour
30 × 25 (76.2 × 63.5)
Signed lower right: "J.S. 1724"
Provenance: By family descent to Colonel E. W. S. Balfour; Major John C. Balfour.
Notebook: Not recorded
Literature: Saunders 1979, vol. 1, pp. 74–75, 86n53, vol. 2, pl. 49.
Subject: Robert Balfour (1698–1767), son of George Balfour 3rd of Balbirnie; married Anne, daughter of Sir Andrew Ramsay of Whitehill, May 30, 1736;[1] died 1767

This is one of a handful of extant portraits by Smibert not recorded in the notebook. The painting is somewhat atypical of Smibert in the choice of color, rich brocaded waistcoat, and the rather mechanically painted wig. The signature, however, appears genuine, and there seems no reason to doubt the painting's authenticity. It is possible

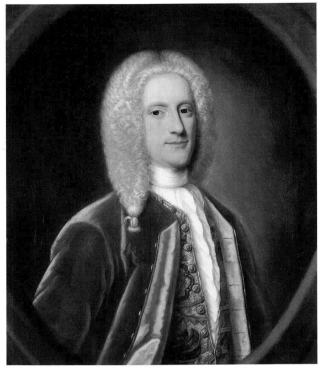

23

that Smibert, in this rare instance, employed a drapery painter to paint the wig and coat. The painting has undergone considerable restoration, particularly to the face.

NOTES

1. Henry Paton, ed., *The Register of Marriages for the Parish of Edinburgh, 1701–1750* (Edinburgh, 1905), p. 31.

24 Sir John Rushout, 1726

Yale Center for British Art, Paul Mellon Collection
1726
39 1/4 × 28 3/4 (99.75 × 73)
Signed lower left: "John Smibert 1726"
Provenance: Descent in family to Captain E. G. Spencer-Churchill, M.C., Northwick Park, Worcestershire; Sale Christie's, June 25, 1965, no. 53 (size given incorrectly as 28 × 23 inches); purchased by "Buckley" (dealer?); purchased by C. Doward (dealer), Little Neck, New York; purchased by Paul Mellon (1965)
Notebook: [June 1726], p. 83, no. 113: "Sr. John Rushout OS. 14-14-0"
Literature: *Catalogue of Paintings at Northwick Park* (London, 1864), no. 227; Sale Christie's, June 25, 1965, no. 53; Saunders 1979, vol 1, pp. 94–94, 117nn23,24; vol. 2, pl. 54; Malcolm Cormack, *A Concise Catalogue of Paintings in the Yale Center for British Art* (New

24

Haven, 1985), pp. 204–205

Subject: Sir John Rushout, (1685–1775), 4th baronet of North-wick Park, Worcestershire; born February 6, 1685, son of Alice, daughter of Edward Pitt of Harrow, widow of Edward Palmer; younger son of Sir James Rushout (d. 1698), 1st Baronet of Milnst-Maylards, Essex; married Lady Anne Compton, daughter of George, 4th Earl of Northampton, October 16, 1729; succeeded his nephew as 4th Baronet, September 21, 1711; served in the army, 1705–1715; M.P. for Malmsbury, 1713–1722, then Evesham, 1722–1768; died March 2, 1775.[1] Rushout was described as a frequent and boring speaker in Parliament. Politically, he was an opponent of Walpole, after he failed to be named treasurer of the Household.[2] Under Lord Carteret he served as lord-commissioner of the Treasury (1742), then in the very lucrative position of treasurer of the Navy (1743–1744).[3]

Rushout wears the informal attire favored by a number of Smibert's London sitters, and sits reading a volume inscribed "Journal of the House of Commons."

NOTES

1. Sir William Musgrave, *Obituary prior to 1800* (London, 1901), vol. 5, p. 185.
2. Sedgwick 1970, vol. 2, pp. 395–396.
3. W.[illiam] R. W.[illiams] "Rushout, Sir John," *DNB* (1937–1938), vol. 17, p. 418.

25 George Berkeley, 1726?

National Portrait Gallery, London
41 × 29 1/2 (104.2 × 74.9)
Signed lower right: "John Smibert. p./ 1728"
Provenance: The sitter to his wife, Anne Berkeley; to Rev. Mr. Kennedy (d. 1819); purchased c. 1819 by J. Winter; purchased 1840 by Rev. Thomas W. Bowdler (1782–1856); to Rev. Dr. William Josiah Irons of Brompton, 1856; bequest to National Portrait Gallery, 1882[1]
Notebook: [June 1726], p. 83, no. 115: "Mr. Dean Berkeley KC 25–4–0" (listed with a second portrait)
Literature: Fraser 1871, p. 32; National Portrait Gallery, London, *Twenty Fifth Annual Report of the Trustees of the National Portrait Gallery* (1882), p. 3; George Sampson, *Works of George Berkeley* (London, 1898), rep. frontispiece, vol. 1; National Portrait Gallery, London, *Catalogue of the National Portrait Gallery, 1856–1947* (1949), p. 20; Foote 1950, p. 130; Kerslake 1965, pp. 145–152; Saunders 1979, vol. 1, pp. 96–97, 117n29, 118nn30–32; vol. 2, pl. 55; Kerslake 1977, vol. 1, pp. 18–19; Berman and Berman 1982, p. 78, and fig. 5; Houghton, Berman, and Lapan 1986, pp. 46–47
Subject: See cat. no. 8

See plate 10

Behind and to the right of Berkeley is a vista which, though indistinct, has an islandlike silhouette, possibly intended to represent Bermuda. The book in Berkeley's left hand may also be a reminder of Bermuda, as in 1724 he had published *A Proposal for the Better Supplying of Churches in Our Foreign Plantations, and for Converting the Savage Americans to Christianity.*

The painting bears Smibert's signature and the date 1728, which Kerslake has shown quite convincingly to have been repainted twice, on the basis of the presence of an earlier legitimate signature.[2] Kerslake has also argued, less persuasively, that the portrait could have been painted after Smibert reached America.[3] The great similarity of this picture to other dated Smibert portraits from 1726 to 1727 (such as cat. no. 24) seems to confirm that it was painted in England. Further, the majority of Smibert's London portraits are signed, and the only American work with a signature is his masterpiece, *The Bermuda Group* (cat. no. 71).

This is probably the painting Berkeley commissioned in June 1726, when he was living with Smibert.[4] It is a more vigorous painting than a second version (cat. no. 26), which appears to be a replica of this painting.

NOTES

1. The following handwritten label was formerly on the back of the painting and is now in the picture's file in the National Portrait Gallery archives: "This portrait painted shortly before Berkeley's departure for the Bermudas, is offered to the Rev. W. J. Irons D D in testimony of sincere esteem & regard by his affectionate friend. T. Bowdler 24th Oct. 1856."
2. Kerslake, "The Date and Early Provenance of Smibert's *George Berkeley*," *Art Quarterly*, vol. 28, no. 3 (1965), pp. 145–146. Kerslake quotes from a letter that came to the National Portrait Gallery with the painting and is worth repeating here. Dated May 21, 1840, it was written by J. Winter, the former owner of the portrait, who had just sold it to Rev. Bowdler:

Maidstone
May 21ˢᵗ 1840
Dear Sir

On the right side of the picture immediately over the hand supported by a book, is written "John Smibert".—"1725" The writing is not however as strong & conspicious as German text, & requires a strong light nearly approaching to sun shine to be readily made out. Heckford who lined & cleaned it, overlooked the name of the Painter & unluckily rendered the letters still *fainter* & the two last figures of the date actually rubbed out; so that when it was returned back I was obliged to restore them (see the 25 with my pen) as by a strong light you will perceive).

The picture was sold by auction at the death of the Revᵈ Mr. Kennedy, late Vicar of Teston whose widow who was distantly related to me, assured me that he had been Curate to Dr. Berkley the Bishops son for many years & that on the death of the Dr. both his own & his fathers portrait were left him. This is the whole history of this picture as far as I possess it: and in looking over my papers I find that in disposing of it for 10£ I am minus £1.9s not including the packing case. I mention this to satisfy you that I have not been playing the sharper with you.

3. Ibid., p. 150.
4. Smibert 1969, p. 83, no. 115.

26 George Berkeley, 1726

The National Portrait Gallery, Smithsonian Institution, gift of the Morris and Gwendolyn Cafritz Foundation
39 1/2 × 29 1/2 (100.3 × 74.9)
Inscription, upper left: "Geo. Berkeley S.T.P. [Sacre Theologiae Magister] / Dec. Derenfis [Dean of Derry]"
Provenance: Sarah Monck, wife of John Monck; by descent through the Moncks of Coley Park, Reading, England; Stanley Bligh Monck, eldest son of Arthur Stanley Monck, great-great-grandson of John Monck, until 1970; sale Christie's (London), June 19, 1970, no. 102, p. 34; purchased at auction by John Kerslake, 1970; Hirschl & Adler Galleries, New York, 1982
Notebook: [June 1727], p. 84, no. 147: "Doctor Berkeley Dn. of Dy. Cop. o.s. 12–12–0"
Literature: Sale Christie's (London), June 19, 1970, no. 102, p. 34; Saunders 1979, vol. 1, pp. 106, 107, 120*n61;* vol. 2, pl. 68; Kerslake 1977, vol. 1, p. 19
Subject: See cat no. 8

It has been suggested that this painting is the original and cat. no. 25 a replica,[1] but the more mechanical quality of this painting makes that unlikely.

NOTES

1. Kerslake 1977, p. 19.

26

27

27 Mohammed Ben Ali Abgale,* 1726

The Tetlie Collection
48 5/8 × 39 1/8 (123.5 × 99.4)
Signed lower center (on sword): "Jo. Smibert 1726"
Inscription: (on sword, above signature) "Mahamet Ben Ali/ Abagle Mowe Embea Mohammed Ben Ali Abgale, Moorish Embassy"
Provenance: James MacMahon, Viewmount, Inverness, Scotland, 1944; Robin Hutchison, Edinburgh, Scotland; The Tetlie Collection
Notebook: [September 1726], p. 83, no. 121: "Mohamed Ben Ali Abagli, the Moroco Embasador 1/2 8–8–0"
Literature: *Country Life*, vol. 95 (May 19, 1944), p. 858 rep.; Saunders 1979, vol. 1, pp. 98–99, 118nn35–38, vol. 2, pl. 56
Subject: Mohammed Ben Ali Abgale, Moroccan ambassador to George I, August 1725–February 1727[1]

Like other exotic visitors to London, ambassadors from Morocco were the subject of many portraits. Kneller had painted an earlier Moroccan ambassador. In 1707 (Buccleugh Collection, Drumlanrig) Smibert's good friend Enoch Seeman also painted Mohammed Ben Ali Abgale (T. Cottrell-Dormer, Rousham House). In Smibert's portrait the ambassador poses stoically while mounted horsemen engage in battle around him.

NOTES

1. This information is inscribed on the portrait of Mohammed Ben Ali Abgale (Collection of T. Cottrell-Dormer, Rousham House) attributed to Enoch Seeman.

28 Henry Ferne, 1727

Worcester Art Museum, Worcester, Massachusetts
50 1/8 × 40 3/16 (127.3 × 102.1)
Signed lower right: (on edge of table) "Jo Smibert fe 1727"
Inscription: (on folded letter on table) "To / Henry Ferne Esq[r] / Receiver General of her / Majestys Customes / London"
Provenance: Mrs. Henry Ferne, then same as cat. no. 19
Notebook: [November 1726], p. 83, no. 123: "Mr. Fern a coppie 1/2 16–16–0"
Literature: Foote 1950, p. 153; Dresser 1959, pp. 12–19, figs. 1, 4, 7; Saunders 1979, vol. 1, pp. 99, 100, 119nn42–43, vol. 2, pl. 59; Reutlinger, *The Colonial Epoch in America* (Worcester, Mass., 1975), pp. 10–11, fig. 5
Subject: Henry Ferne (1660–1723) of Smitherton; receiver general of the customs under William III, Anne, and George I.

The portrait was painted posthumously, probably after an earlier painting by another artist which is now lost. It is the second of two portraits of Ferne by Smibert,[1] both probably commissions by his widow (cat. no. 19).

NOTES

1. The first was a bust portrait (Smibert 1969, p. 82, no. 110).

28

29

29 John Balfour, 1726

Reproduced by permission of John and Jean Balfour
30 × 25 (76.2 × 63.5)
Signed lower right: "J. Smibert / fe. 1726"
Provenance: By family descent to Colonel E. W. Balfour; Major
 John C. Balfour
Notebook: Not recorded
Literature: Saunders 1979, vol. 1, pp. 100–101; vol. 2, pl. 60
Subject: John Balfour (b. 1699), son of George Balfour 3rd of
 Balbirnie, younger brother of Robert Balfour

Like the portrait of his brother, Robert Balfour (cat. no. 23), this painting is not recorded in the notebook, although it is quite representative of Smibert's polished London style. The treatment of the wig—with clearly delineated short hair curls—is particularly typical of Smibert.

30 Mrs. Charles Potts, 1727

This picture is registered with the Scottish National Portrait Gallery and is in the collection of Sir Archibald Grant Bt
50 × 40 (127 × 103.4)
Provenance: Descent in Grant family to present owner, Lady Jean
 Grant
Notebook: [January 1727], p. 83, no. 127: "Mrs. Potts 1/2 16–
 16–0"
Literature: Saunders 1979, vol. 1, pp. 101–102, 119n46, vol. 2,
 pl. 62
Subject: Anne Potts, wife of Charles Potts (d. 1725); mother of
 Anne Potts (cat. no. 34), wife of Sir Archibald Grant (cat. no. 34)

This painting is entirely characteristic of Smibert in composition and technique. The sitter wears a deep red velvet gown and behind her, to the viewer's left, is an Arcadian landscape through which a stream flows. The painting is in generally good condition, although the surface varnish is discolored and there are some minor paint losses.

The identification of this sitter was made by the Grant family.

31 Mrs. Edward Nightingale, 1727

Dallas Museum of Art, General Acquisitions Fund and gift of Tom
 and Eleanor May
49 1/2 × 39 1/2 (125.8 × 100.3)
Signed lower left: "J.S. fe 1727"
Inscription lower left (above artist's initials and date): "Eleanor
 daughter of Chas / Ethelson Esqre wife of Edwd Nightingale esqr
Provenance: Same as cat. no. 17
Notebook: [January 1727], p. 83, no. 129: "Mrs. Nightingell 1/2
 16–16–0"
Literature: Sale Christie's (London), March 18, 1977, no. 95 rep.;
 Antiques, vol. 115 (January 1979), p. 66 rep.; Saunders 1979,
 vol. 1, pp. 102, 119nn47–49; vol. 2, pl. 63

30

Subject: Eleanor Nightingale, daughter of Charles Ethelston;
 married Edward Nightingale (cat. no. 17)

See plate 12

This portrait, Smibert's most appealing London portrait of a female sitter, announces an important shift in his style. While he does not abandon the greater formality and darker palette of his earlier work, he does, for certain younger sitters, offer this more *de rigueur* alternative. The lighter palette and more informal pose seen here reflect the influence of the French painter Watteau through the paintings and prints of his London follower Philip Mercier. Prints like *Philip Mercier, His First Wife and Children* (British Museum), engraved 1723–1725, could easily have inspired Smibert when he painted such portraits as this.

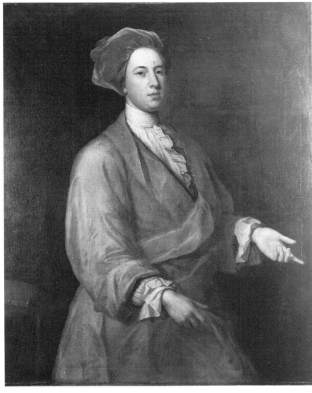

32

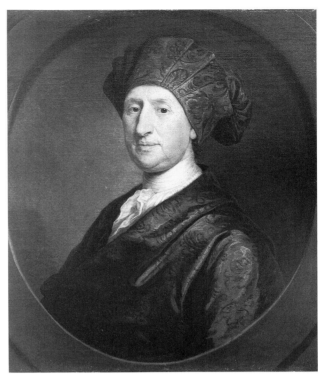

33

32 Sir John Molesworth, 1727

Courtesy Pencarrow House, Cornwall

49 × 39 (124.5 × 99.1)

Provenance: Descent in family to present owner Lt. Colonel J. A. Molesworth-St. Aubyn, M.B.E.

Notebook: [March 1727], p. 84, no. 133: "Sr. John Mollesworth 1/2 16–16–0"

Literature: Saunders 1979, vol. 1, pp. 102–103, 119nn50–51; vol. 2, pl. 64

Subject: Sir John Molesworth (1705–1766), 4th baronet of Pencarrow, Cornwall, first son of Sir John Molesworth, 3rd Baronet, by Jane, daughter of John Arscott of Tetcott, Devon; succeeded his father as Baronet June 1723 and married Barbara, daughter of Sir Nicholas Morice, 2nd Baronet of Werrington, Devon, in 1728; M.P. from Newport, 1734–1741, then Cornwall, 1744–1761; died April 4, 1766. Politically a Tory, Molesworth voted consistently against the Walpole-Pelham governments.[1]

Molesworth wears a violet evening gown (a color Smibert favored in the 1720s) and is posed against a stark, dark-brown background. Behind him, to the viewer's left, is a cloth-covered table on which rests a book. Although the figure is well painted, the composition is less than convincing. Some of the incongruity between the figure and the background may be because the surface varnish is yellowed. The painting retains its original carved gilt frame.

NOTES

1. Sedgwick 1970, vol. 2, p. 262.

33 George Douglas, 12th Earl of Morton, 1727

National Gallery of Scotland

30 × 25 (76.2 × 63.5)

Signed lower left: "Jo Smibert / fe 1727"

Provenance: Descent in family; purchased from the Trustees of the Earl of Morton by the National Gallery of Scotland, 1959

Notebook: [March 1727], p. 84, no. 139: "Collonell Douglas 3/4 8–8–0"

Literature: Margaret Swain, "The Nightgown of Governor John Trumbull," *Wadsworth Atheneum Bulletin*, Winter 1970, p. 39 rep. fig. 6; Saunders 1979, vol. 1, pp. 100, 119n52; vol. 2, pl. 65

Subject: George Douglas, 12th Earl of Morton, born 1662, fourth son of James Douglas, 10th Earl of Morton, by Anne, eldest daughter of Sir James Hay, 1st Baronet of Smithfield Peebles; married (1) a daughter of Alexander Muirhead of Linhouse, Edinburgh, and (2) before 1702 Frances, daughter of William Adderley of Halston Kent; succeeded his brother as 12th Earl of Morton January 22, 1730; died January 4, 1738. Douglas was a professional soldier who entered the army in 1685 as a lieutenant in the Foot Guards and was retired with the rank of colonel after the Union of Scotland and England, which he supported. He was a Whig M.P. from 1708 until 1730, when he became a representative peer.[1]

NOTES

1. Sedgwick 1970, vol. 1, p. 617.

34 Sir Archibald and Lady Grant, 1727

This picture is registered with the Scottish National Portrait Gallery and is in the collection of Sir Archibald Grant Bt
52 × 65 (132 × 165)
Provenance: Descent in family to present owner
Notebook: [May 1727], p. 84, no. 145: "Sir Archbald Grant, 1/2 / and Lady in one cloth, 1/2, 33–12–0"
Literature: *Catalogue of Paintings in Aberdeen* (1858), p. 15, no. 85 [as by Hogarth]; Rowan 1972b, p. 1049, fig. 10; Aberdeen Art Gallery, *Artist and Patron in the North East, 1700–1860* (exh. cat., 1975), p. 5; Saunders 1979, vol. 1, pp. 104, 105, 119nn53–54, 120nn55–57; vol. 2, pl. 66; Rosalind K. Marshall, *Women in Scotland, 1660–1780* (exh. cat., Edinburgh, 1979), pp. 24–25; Holloway 1989, pp. 57–58
Copy: Oil painting, exact size unknown. Illustrated in John Drury, *The Heritage of Early American Houses* (New York, 1969), p. 233. A copy was formerly (1978) in a private collection, Dallas, Texas. Present location unknown.
Subjects: Archibald Grant (1696–1778), first son of Sir Francis Grant by his first wife, Jean, daughter of Rev. William Meldrum of Meldrum, Aberdeen; shown with his second wife,[1] Anne Potts (c. 1708–d. 1744), daughter of Charles Potts of Castleton, Derbyshire, whom he married in April or May 1726; after Anne's death remarried, August 18, 1751, to Elizabeth Clark (d. 1759), widow of Andrew Millar of Pall Mall, publisher and bookseller; succeeded his father as 2nd baronet, March 1726; M.P. for Aberdeenshire 1722–1732; died September 17, 1778. Grant became involved in the infamous York Buildings Company scandal, in which he and three others speculated with the funds of the Charitable Corporation and by 1731 left it insolvent, with net liabilities of more than £450,000. He was subsequently indicted and expelled from the House of Commons. After protracted litigation Grant succeeded in preserving his property, and he spent the rest of his life improving his estate at Monymusk (where he is credited with introducing modern agricultural methods to Scotland) and mending his shattered fortune by marrying rich widows.[2]

See plate 11

This double portrait celebrates the marriage of Archibald Grant to his second wife, Anne Potts. But it is of dual significance, because Grant's father, Sir Francis Grant (cat. no. 2), had died less than two months earlier and Archibald had assumed his title.

Double portraits are relatively rare in the early eighteenth century, although Medina, Kneller, Richardson, and Jervas had all painted them. In this instance, Smibert has fused a traditional male portrait with a woman's portrait derived from the *fête galante* pictures beginning to be seen in England. As this was Smibert's first double portrait —and to some degree was experimental—its lack of unity can be excused. Lady Grant reaches out to her husband in a gesture of union that traces back to Van Eyck's *Arnolfini Marriage* nearly three hundred years earlier. The gesture of linked hands as a symbol of marriage, however, had been used as recently as 1720 by Smibert's friend George Verture, who employed it for his own marriage portrait. Smibert painted only one other double portrait in England (cat. no. 334) and never painted a marriage double portrait again.

It seems certain that because of Grant's overwhelming financial difficulties (he declared personal bankruptcy in 1732), Smibert was never paid for this portrait. Grant did give Smibert a promissory note,[3] but Smibert's letters of 1734 (see appendix 2) probably went unheeded, as by that year he was £18,000 in debt.

Technically, Smibert's later London works are much more accomplished than those of a decade earlier. His technique is more fluid (he is obviously using a much wetter brush), and he does not labor so much over individual details such as folds of cloth. The application of color, too, is less plodding and mechanical.

The painting was at one time attributed to Hogarth, probably because in 1729 Grant had purchased a version of Hogarth's *Beggar's Opera*.[4]

NOTES

1. His first wife was Anne Hamilton (cat. no. 1).
2. Sedgwick 1970, vol. 2, pp. 77–78.
3. Scottish Record Office, Edinburgh, Monymusk Papers, GD345/1156/5: "Sir Archibald Grant's Bond to Mr. Smibert to pay 60 [pounds] with interest ye 25th of March is set[?]."
4. Paulson 1971, vol. 1, pp. 183–184.

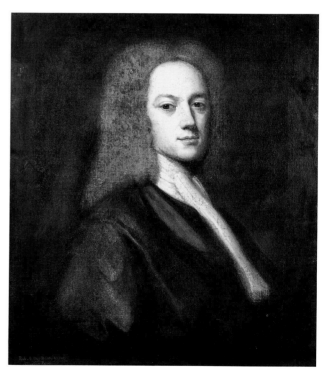

35

35 Robert Cay,* 1727

Present location unknown
29 × 24 (73.6 × 61)
Bears inscription and signature

Provenance: Same as cat. no. 21
Notebook: [June 1727], p. 85, no. 154: "Mr. Keey h.p. 3/4 8–8–o."
Literature: Foote 1950, p. 203
Subject: Robert Cay (1694–1754), a merchant from Newcastle-on-Tyne

Described as "dressed in a brown coat with a white stock" (Sale Christie's, May 14, 1982, no. 146).

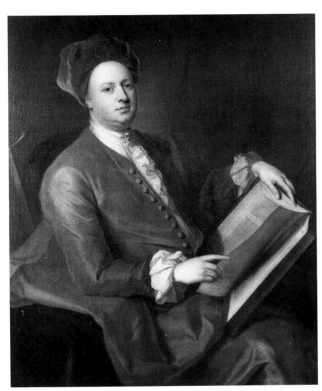

36

36 John Olmius? 1727

Sir Charles Mott-Radclyffe, Barningham Hall, Matlaske, Norwich, England
50 × 40 (127 × 103.4)
Signed lower right (on open page of book): "Jo Smibert / fe. 1727"
Provenance: Sir Charles Mott-Radclyffe, 1949
Notebook: Not recorded as presently identified
Literature: Saunders 1979, vol. 1, pp. 105, 106, 120n58; vol. 2, pl. 67
Subject: John Olmius (d. 1731) of New Hall, Essex; merchant of Dutch origin who came to England with William III; deputy governor of the Bank of England at the time of his death in 1731

The portrait depicts a man wearing a brown jacket, a reddish-brown cap and a reddish-brown drape over his left arm and legs. This somber palette is further intensified by the painting's pea-green background.

There is no record in the notebook of a portrait of John Olmius. The identity of the sitter is not absolutely certain.

In a letter to the author,[1] the present owner noted that "the picture was originally thought to be John Olmius, the first Lord Waltham, 1711–1762, whose daughter married my great-grandfather, but when the cleaning revealed the signature and the date (1727), it was clear that the sitter could not be a boy of 16. I think, therefore, the picture is much more likely to be of Lord Waltham's father, John Olmius, who was a City merchant of Dutch origin and came over with William III."

It seems very possible, however, that the portrait represents Sir William Billers (cat. no. 194), John Olmius's father-in-law, who commissioned Smibert to paint a three-quarter-length portrait in August 1726.

NOTES

1. Letter to author from Sir Charles Mott-Radclyffe, October 7, 1976.

37 Elizabeth Brinley Hutchinson, 1729

Virginia Museum of Fine Arts, Richmond, the Adolph D. and Wilkins C. Williams Fund
30 1/2 × 25 1/2 (77.5 × 65)
Provenance: Elizabeth Brinley Hutchinson; her son, Shrimpton Hutchinson; his daughter, Catherine Hutchinson Putnam (Mrs. George Brinley); her son, George Brinley; his daughter, Catherine Hutchinson Brinley;[1] her daughter, Katharine F. Adams, by 1938; her niece, Katharine Adams Kulmala; Vose Galleries, Boston, as agent, 1975; Virginia Museum of Fine Arts, 1977
Notebook: [May 1729], p. 87, no. 1: "Mrs. Huchison half pyd 3/4 20–0–0"
Literature: Foote 1950, pp. 217–218; Saunders 1979, vol. 1, p. 126; vol. 2, pl. 73
Subject: Elizabeth Brinley Hutchinson (1685–1755), sister of Francis Brinley (cat. no. 39) and wife of William Hutchinson, whom she married in 1707

See figure 77

This painting is Smibert's first recorded American portrait. The sitter's sharply defined features, full cheeks, and pursed lips recall Smibert's well-devised London formula, although here the features are more pronounced than was formerly his custom. Perhaps the nine-month interval since he had last painted contributed to the effect.

NOTES

1. Letter to the author from Faneuil Adams, November 8, 1973.

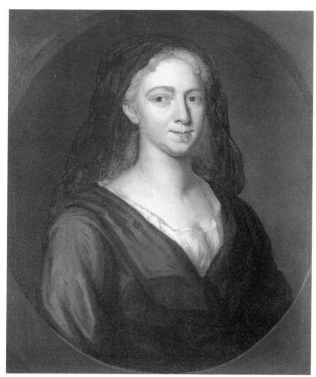

38

NOTES

1. Marcella R. Putnam to Stuart Feld, September 25, 1963, Painting Files, Metropolitan Museum of Art.
2. Sibley and Shipton 1873–1956, vol. 7, p. 206.

39 Francis Brinley, 1729

Metropolitan Museum of Art, Rogers Fund, 1962.79.1
50 × 39 1/4 (127 × 99.7)
Provenance: Son of sitter, Francis Brinley, by 1790; his great-grandson, Edward L. Brinley, Philadelphia, by 1878; his daughter, Mrs. Henry Wharton, Philadelphia, by 1909 until ca. 1924; her son, Henry Wharton, 1926; his wife, Mrs. Henry Wharton, by 1949; with David Stockwell, Wilmington, by 1951; with James Graham & Sons, New York, by 1962; purchased by Metropolitan Museum of Art, 1962
Notebook: [May 1729], p. 87, no. 3: "Francis Brinly Esqr. H.P 1/2 40–0–0"
Literature: Perkins 1878, p. 394; Metropolitan Museum of Art, *Hudson-Fulton Celebration* (exh. cat., 1909), no. 35; Bolton 1933, p. 11f; New Haven 1949, no. 5; Foote 1950, pp. 64, 71, 136; Feld 1963, pp. 296–308; Gardner and Feld 1969, p. 3; Boston University School of Fine and Applied Arts, *Boston Painters* (exh. cat., 1968), no. 2, p. 17; Saunders 1979, vol. 1, pp. 127–128, vol. 2, pl. 75; Craven 1986, pp. 166–171; Caldwell and Rodriguez-Roque, vol. 1, pp. 13–14
Subject: Francis Brinley (1690–1765), although born in London and educated at Eton, was the son of Americans, Thomas Brinley of Newport and Catherine Page of Boston (cat. no. 38). Brinley came to America in 1710 so that he might inherit the considerable fortune of his grandfather, for whom he was named. In 1718 he married Deborah Lyde (cat. no. 40), granddaughter of Judge Nathaiel Byfield (cat. no. 46). Upon the death of Judge Byfield in 1719 he inherited a fortune, which enabled him to build Dachet House in Roxbury, a dwelling noted for its splendor. He served as deputy surveyor-general of Massachusetts and as a colonel in the Roxbury militia. As a member of

38 Catherine Lyde, 1729

Private collection
30 × 25 (76.2 × 63.5)
Provenance: Mrs. John L. Hall (Dorothy Brinley Morgan); her son, Richard Hall, Boston, Mass.; Child's Gallery, as agent, 1983–1986
Notebook: [May 1729], p. 87, no. 2: "Mrs. Loyde H.P. 3/4 20–0–0"
Literature: Saunders 1979, vol. 1, p. 127; vol. 2, pl. 74; *Antiques* 115 (May 1979), p. 834
Copy: A copy, or replica, is said to have been owned in Connecticut in 1963[1]
Subject: Catharine Page (1663–1755). Her first husband, in England, was Thomas Brinley, who died in 1693. By him she had two children that survived: Francis Brinley (cat. no. 39) and Elizabeth Brinley (cat. no. 37). In 1709 she became the third wife of Edward Lyde (d. 1724), a judge and warden of King's Chapel.[2] As Mrs. Lyde, she was step-mother to Deborah Byfield Lyde (cat. no. 40), who ten years later married her natural son, Francis. At her death she was buried in the Lyde family tomb at King's Chapel.

This portrait is typical of Smibert's first American works. The most notable aspect of its appearance is that the sitter is dressed as a widow five years after the death of her husband. The painting is in very good condition. Some overpaint was removed when it was treated by Gustav Klimann in 1978.

39a

King's Chapel he was a significant contributor to Peter Harrison's new stone sanctuary, constructed in 1749.

See plate 14

This is the most ambitious and finest of Smibert's first American portraits. While the format is a continuation of his London work, such elements as the treatment of the sitter's hands are a significant departure. The portrait was most likely intended by Smibert as evidence of his abilities and must have been instrumental in his obtaining a number of the commissions that he received during his first year in Boston.

Behind the sitter, to the viewer's right, is a view of Boston (cat. no. 39a). It is among the first painted views of the town (the earliest appears in Thomas Smith's *Major Thomas Savage*, 1679). The vantage point is nearby Roxbury, where Brinley maintained a country home, Dachet House, erected in 1723. This subtle reminder of Brinley's social position would have been immediately recognizable to any Bostonian viewing the portrait. On the left is Beacon Hill; the two buildings standing in isolation are the watch house and powder house. To the right, the church with the short steeple is King's Chapel, of which Brinley was a founder, and the taller steeple is Old South Church. Brinley would have had difficulty finding another artist more sensitive to his need for a portrait that commemorated his likeness, extolled his place in society as a landowner, and provided a view of the town that contributed to his success.

Dachet House was among the most spectacular colonial dwellings of the period. One contemporary glimpse of its decor suggests that Smibert's portrait was a fitting embellishment: "There were colonnades and a vestibule whose massive mahogany doors, studded with silver, opened into a wide hall, whose tessellated floors sparkled under the light of a lofty dome of richly painted glass. Underneath the dome two cherubs carved in wood extended their wings, and so formed the centre from which an immense chandelier of cut glass depended. Upon the floor beneath the dome there stood a marble column, and around it ran a divan formed of cushions, covered with satin of Damascas, of gorgeous coloring. Large mirrors with ebony frames filled the spaces between the grand staircases at either side of the hall of entrance. All the panelling and woodwork consisted of elaborate carving done abroad, and made to fit every part of the mansion where such ornamentation was required. Exquisite combinations of painted birds and fruit and flowers abounded everywhere, in rich contrast with the delicate blue tint that prevailed upon the lofty walls. The staterooms were covered with Persian carpets, and hung with tapestries of gold and silver arranged after some graceful artistic foreign fashion."[1]

NOTES

1. Francis S. Drake, *The Town of Roxbury* (Boston, 1905), p. 328.

40 Mrs. Francis Brinley and Son Francis, 1729

Metropolitan Museum of Art, Rogers Fund, 1962.79.2
50 × 39 1/4 (128 × 99.7)
Provenance: Same as cat. no. 39
Notebook: [May 1729], p. 87, no. 5: "Mrs. Brinly & son Fras. H.P 1/2 50–0–0"
Literature: Perkins 1878, p. 394; Metropolitan Museum of Art, *Hudson-Fulton Celebration* (exh. cat., 1909), no. 36; Bolton 1933, p. 11f; New Haven 1949, no. 6; Foote 1950, pp. 64, 137; Feld 1963, pp. 296–308; Gardner and Feld 1965, vol. 1, pp. 3–4; Stuart Feld, "Recently Acquired American Paintings at the Metropolitan," *Antiques*, vol. 87, no. 4, pp. 439–443; Saunders 1979, vol. 1, pp. 127–129; vol. 2, pl. 76; Craven 1986, pp. 166–169; Caldwell and Rodriguez-Roque, vol. 1, pp. 14–15
Copy: Oil painting, 50 × 40 inches, owned by Mr. and Mrs. Edward Brinley, Avon, Conn. It is inscribed in pencil on back, "copied by C. V. Boud [?] from the original by Smybert."
Subject: Deborah Lyde, granddaughter of Judge Nathaniel Byfield (cat. no. 46); married Francis Brinley in 1718; son Francis, born 1729

See plate 15

Mrs. Brinley steadies her son with one hand while she plucks an orange blossom from the potted orange tree next to her. This gesture is largely a symbolic reference to fertility—orange trees are not known to have been available in Boston.

Feld suggests that the source for Mrs. Brinley's pose may be A. Browne's mezzotint after Peter Lely's *Lady Prince*.[1] But the pose is virtually identical to another Lely portrait, *Elizabeth, Countess of Kildare* (Tate Gallery), c. 1679, although a print after it has not been located.

NOTES

1. Feld 1963, p. 305.

41 Major Jean Paul Mascarene, 1729

Los Angeles County Museum of Art, Museum purchase with funds provided by Mr. and Mrs. William Preston Harrison Collection, Mr. Charles H. Quinn Bequest, Eli Harvey and other donors
40 1/2 × 31 5/8 (102.9 × 80.3)
Provenance: Abigail Hutchinson, Halifax, N.S., 1839;[1] Mr. Sterling, Halifax, N.S., 1871;[2] Frank W. Bayley Copley Gallery, Boston, by 1930;[3] purchased by Paul Mascarene Hamlen, Boston, 1930; Hirschl and Adler, New York, 1975–1978; purchased by the Los Angeles County Museum of Art, 1979
Notebook: [June 1729], p. 88, no. 7: "Major Maskareen 10 pd. lit 1/2 35–0–0"
Literature: Mather Byles, "To Mr. Smibert on the sight of his Pictures," *Daily Courant*, London, April 14, 1730; Bayley 1929, p. 403 rep.; Museum of Fine Arts, Boston 1930, p. 55 rep.; *Art in America*, vol. 30, no. 2 (April 1942), p. 111 rep.; New Haven 1949, no. 20; Foote 1950, pp. 21, 53, 55, 57, 70, 167–168; "Portraits by John Smibert," *Connoisseur*, vol. 125, no. 515 (March 1950), 42 rep.; Saunders 1979, vol. 1, pp. 129–130; vol. 2, pl. 78; *Antiques*,

vol. 117, June 1980, p. 124 rep.; Quick 1981, p. 83, pl. 3; Lorna Price, *Masterpieces from the Los Angeles Museum of Art Collection* (Los Angeles, 1988), p. 12 rep.; Ilene Susan Fort and Michael Quick, *American Art: A Catalogue of the Los Angeles County Museum of Art* (Los Angeles, 1991), pp. 88–89

Copies: There are three copies: (1) in Fort Anne National Historic Park, Annapolis Royal, N.S., by Rebeakah T. Furness; (2) an 1840s copy painted by Dr. Thomas Atkins, now in the library of the University of King's College, Halifax, N.S., from which was made (3) a 17 × 14 inch copy by William H. Whitmore, 1871, presented to the Massachusetts Historical Society.[4]

Subject: Jean Paul Mascarene (1684–1760), born at Castras, France. Mascarene was of Hugenot extraction, and his father left France at the revocation of the Edict of Nantes. He was in England by 1706, where he became a British Army officer, rising to the rank of major general. He arrived in Boston in 1709, where he was employed by the governors of Massachusetts and New Hampshire to aid in negotiations with the Indians. By 1720 he was appointed chief engineer of Annapolis Royal, Nova Scotia. He lived in New England from 1725 to 1729, and married Elizabeth Perry of Boston. From 1740 to 1749 he was lieutenant-governor and acting governor of Nova Scotia. Mascarene died in Boston, January 22, 1760.[5]

See plate 13

The fact that the sitter is attired in armor makes this, on the surface, the least typical of Smibert's colonial portraits. The ceremonial armor recalls Smibert's earlier portrait of Col. James Otway (cat. no. 15). The picture met with almost instant approval and is mentioned in Mather Byles's poem "To Mr. Smibert, on viewing his pictures," in which he remarks: "And studious *Mascarene* asserts his Arms."

The painting is of unusual dimensions, which Smibert defined as a "little 1/2" and can be transcribed as a three-quarter-length portrait painted on a reduced format. Mascarene is shown standing next to a table on which rest drafting tools and a map. Behind him and to the viewer's right is the harbor at Annapolis Royal, where Mascarene was in part responsible for the design of the fortifications. Apparently Smibert must have drawn the harbor on the basis of Mascarene's memory rather than any elevation, as the landscape design differs from the actual topography and the next earliest view of the harbor is a 1757 watercolor.[6] The vantage point of the landscape is from Goat Island, the tip of which can be seen below Mascarene's extended right hand. On the promontory to the left can be seen the ruins of "the Scots fort." Mascarene himself gave a description of the town in 1721: "Two leagues above Goat Island is the fort, seated on a sandy, rising ground on the south side of the river, on a point formed by the British River and another small one, called the Jenny River. The lower town lies along the first, and is commanded by the fort. The upper town stretches in scattering houses a mile and a half southeast from the fort on the rising ground between the two rivers. From this rising ground to the banks of each river, and on the other side of the less one lie large flats or meadows, etc. On both sides of the British River are a great many fine farms, inhabited by about two hundred families.[7]

Mascarene may well have taken this portrait to Nova Scotia with him. In December 1740 he wrote to his daughter Margritt, "The white walls are hung in part with four large Pictures of Mr. Smibert. a Walnutt chest of Drawers. a mahogany table and six pretty good chairs fill in some measure the remainder—over the mantle piece are Dozen of arms kept clean and in good order with other warlike accoutrements."[8]

NOTES

1. Mascarene Papers, Massachusetts Historical Society, Abigail Hutchinson to John Mascarene, September 19, 1839: "I do not know whether you have any portrait of your Grandfather Mascarene, I have a likeness of him taken by Smibert, one of the famous American Artists, it belonged to my mother."
2. Foote 1950, p. 167.
3. Painting file notes, Hirschl & Adler, New York.
4. Foote 1950, p. 167.
5. Ibid.
6. Michael Bell, *Painters in a New Land* (Greenwich, Conn., 1973), p. 31; J. H. Bastide, *Annapolis Royal, Nova Scotia* (1757); watercolor and letter to the author from Marie Elwood, Chief Curator of History, Nova Scotia Museum, February 5, 1980.
7. W. A. Calnek, *History of the County of Annapolis* (Toronto, 1897), p. 70. I wish to thank Marie Elwood for providing me with this citation.
8. Mascarene Papers, Massachusetts Historical Society.

42 Judge Samuel Sewall, 1729

Bequest of William L. Barnard by exchange and the Emily L. Ainsley Fund, courtesy Museum of Fine Arts, Boston

30 1/4 × 25 1/2 (76.8 × 65)

Inscription: Barely visible in the upper spandrels, "The Honble Samuel Sewall Esq. Chief Justice—of the—of probate for the County of Suffolk Aetatis 78"; and in the lower spandrels, "Auris mens oculus manus os pes munere fungi dum pergunt praestat ere velle mori" ["As long as the ear, mind, eye, hand, lips and feet continue to perform their duty, it is best not to wish to die"]

Provenance: Rev. Joseph Sewall, the sitter's son, 1730; Samuel Sewall, 1769; Judge Samuel Sewall, 1776; Rev. Samuel Sewall, Burlington, Mass., 1814; Samuel Sewall, 1866; Nellie L. Sewall Bennet;[1] purchased by Benjamin Flayderman, Boston, 1943; Vose Galleries, 1957;[2] purchased by Museum of Fine Arts, Boston, 1958

Notebook: [June 1729], p. 88, no. 8: "Judge Sewell H.P. 3/4 20–0–0"

Literature: Mather Byles, "To Mr. Smibert on the sight of his Pictures," *Daily Courant*, London, April 14, 1730; Winsor 1880–1881, *Memorial History of Boston*, vol. 2, p. 148; M. E. Sewell Curtis, *Ye Olde Meeting House, Burlington, Mass.* (Boston, 1909), rep. opp. p. 54; Foote 1935, p. 18; New Haven 1949, no. 28; Foote 1950, pp. 189–190; Robert C. Vose, Jr., "Samuel Sewall by Smibert" (unpub. ms., 1957); Boston 1969, vol. 1, p. 235; vol. 2, fig. 4; Saunders 1979, vol. 1, pp. 130–131; vol. 2, pl. 79; Museum of Fine Arts, Boston, *New England Begins: The Seventeenth Century* (Boston 1982), vol. 3, p. 476, no. 450 rep.

Subject: Samuel Sewall was born in Bishopstoke, Hampshire, England, March 28, 1652,[3] son of Henry and Jane Dummer Sewall of Newbury, Massachusetts. The family returned to America in 1661. Sewall graduated from Harvard in 1671 and four years later married Hannah Hull, daughter of the mint master John Hull, who brought him a dowry of £30,000. Sewall ran the only licensed printing press in the colony (1681–1684); he was a captain of the militia in Boston and major of the regiment (1675–1676).[4] In 1683 he was deputy to the General Court from Westfield and from 1684 to 1686 was ex-officio judge of the Superior Court. In 1692 he was appointed one of the judges to try the witches of Salem and was the only member of that tribunal to publicly recant his part in the matter. In 1692 he was appointed a judge of the Superior Court and was its chief justice from 1718 to 1728. His extensive diaries (Massachusetts Historical Society) are incomparable documents for the period.[5] Sewall died January 1, 1730, and was buried in the Granary Burying Ground.[6]

See figure 62

This painting, like those of Mascarene (cat. no. 41) and Byfield (cat. no. 46), was hailed by Mather Byles in his poem "To Mr. Smibert, on viewing his pictures": "In hoary majesty, see *Sewall* here." The portrait was lined and put on new stretchers in 1957–1958 when at Vose Galleries.

Sewall had sat for Nathaniel Emmons in 1728 (Massachusetts Historical Society), but the portrait, which appears to have remained in the artist's possession, lacks the freshness and life characteristic of Smibert's portraits of the elderly. Sewall correctly surmised that a more accurate and revealing likeness would be painted by Smibert.

NOTES

1. Boston 1969, vol. 1, p. 235.
2. Paintings files, Vose Galleries, Boston.
3. Foote 1950, p. 189.
4. Whitman 1842, p. 208.
5. Boston 1969, vol. 1, p. 235.
6. J[ames] T. A[dams], "Samuel Sewall," *DAB* (1964 ed.), vol. 16, p. 611.

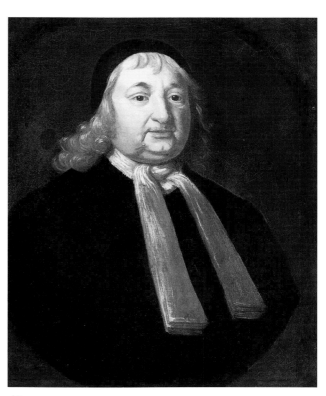

43

43 Judge Samuel Sewall, 1733

Courtesy Peabody Essex Museum, Salem, Mass.
30 × 25 (76.2 × 63.5)
Provenance: George R. Curwen, 1900, bequest to Essex Institute
Notebook: [July 1733], p. 91, no. 84: "Judge Sewells a Coppy 20 3/4 25–0–0"
Literature: Charles K. Bolton, *Portraits of the Founders* (Boston, 1919), vol. 2, p. 473 rep. [incorrectly identified as Stephen Sewall]; Essex Institute [incorrectly identified as Stephen Sewall by unknown artist]; Foote 1950, p. 190; Saunders 1979, vol. 1, p. 131; vol. 2, pl. 80; Andrew Oliver and Bryant F. Tolles, Jr., *Windows on the Past: Portraits at the Essex Institute* (1981), pp. 26–27

This portrait is a replica of cat. no. 42. It is generally more linear and less subtle than the original. The painting was cleaned in 1975 by Morton Bradley.

44 Mary Williams, 1729

Courtesy Massachusetts Historical Society
30 × 25 (76.3 × 63.5)
Provenance: Samuel Parker, who presented it to the Massachusetts Historical Society, November 27, 1848
Notebook: [July 1729], p. 88, no. 9: "Mis Marey Williams H.P. 3/4 20–0–0"
Literature: MHS *Proc.*, 2nd series, vol. 2 (January 1886), p. 418; vol. 16 (1878), p. 399; Bayley 1929, p. 427; Foote 1950, p. 191; Boston University School of Fine and Applied Arts, *Boston*

Painters (exh. cat., 1968), p. 28 rep.; Massachusetts Historical Society, *The Metropolis of New England: Colonial Boston, 1630–1776* (1976), n.p. 11 verso; Saunders 1979, vol. 1, pp. 131–132; vol. 2, pl. 81; Oliver, Huff, and Hanson 1988, p. 120
Subject: Mary Williams (c. 1707/8–after 1760), daughter of Dr. Nathaniel Williams (cat. no. 475); married John Smibert, July 30, 1730

See figure 81

The sitter wears a greenish-blue gown, and there is a crudely painted red drape over her left shoulder. The lower half of the painting has been much restored and needs cleaning.

Only twenty-two at the time of the painting, Mary Willams is both beguiling and haunting. While her face is one of the most successful female portraits of Smibert's career, the relation between the head and the long body is discordant. Her neck is attenuated, and her bodice is weighty and clumsy. Even in some of Smibert's first Boston portraits, such as this one, he seems reluctant to work out details of proportion.

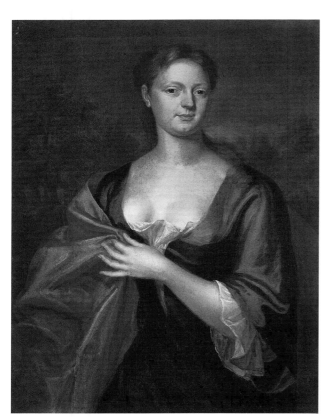

45

45 Mrs. William Dudley, 1729

Gift of Mrs. J. Brooks Fenno
Courtesy Museum of Fine Arts, Boston
35 1/4 × 27 1/8 (89.6 × 68.9)

Provenance: Direct descent in Dudley family to Mrs. Henry Bardlee (Hephsibah Hall, b. 1821), by 1893; her son-in-law Edward N. Fenno; his daughter Mrs. Arthur W. Bell, by 1950;[1] her cousin J. Brooks Fenno, by 1976; gift of Mrs. J. Brooks Fenno to the Museum of Fine Arts, Boston, 1979
Notebook: [August 1729], p. 88, no. 12: "Mrs. Dudley H.P. KK 30–0–0"
Literature: MHS *Proc.* (January 1886), p. 197; Bayley, p. 379 [incorrectly as Mrs. Paul Dudley]; Foote 1950, pp. 150–151; Saunders 1979, vol. 1, pp. 132–133, vol. 2, pl. 82; Carol Troyen, *The Boston Tradition: American Paintings from the Museum of Fine Arts,* exh. cat. (Boston, 1980), pp. 46–47 rep.
Subject: Elizabeth Davenport (1704–1756), daughter of Addington and Elizabeth Wainwright Davenport; married William Dudley (cat. no. 49) March 10, 1721[2]

This was Smibert's first American opportunity to paint a portrait in the stylish and popular Kit-cat format, 36 × 28 inches.

NOTES

1. Letter to the author from Mrs. J. Brooks Fenno, 1976.
2. Foote 1950, p. 150.

46 Judge Nathaniel Byfield, 1730

Metropolitan Museum of Art, Bequest of Charles Allen Munn, 1924
30 × 25 (76.2 × 63.5)
Inscription lower left: "Ætatis 78, 1730"
Provenance: Family of Sir William Pepperrell through Sparhawk-Jarvis-Cutts line; Mrs. R. W. King, Montclair, N.J., 1919; purchased by Charles Allen Munn, 1919, as a portrait of Governor Belcher; bequest of Charles Allen Munn to the Metropolitan Museum of Art, 1924[1]
Notebook: Not recorded
Literature: Bolton 1919–1926, vol. 2, pp. 359–360; vol. 3, pp. 741, 934; *Bulletin of the Metropolitan Museum of Art,* vol. 20, no. 1 (January 1925), 20; *Catalogue of Paintings, Metropolitan Museum,* 8th ed. (1926); Bayley 1929, p. 363 rep.; New Haven 1949, no. 9; Foote 1950, pp. 53, 55, 57, 70–71, 115, 140–141; Gardner and Feld 1965, p. 2; Saunders 1979, vol. 1, pp. 133–134; vol. 2, pl. 84; Yale University Art Gallery, New Haven, and Victoria and Albert Museum, London, *American Art, 1750–1800,* exh. cat., 1976), pp. 69, 275; Caldwell and Rodriguez-Roque 1994, vol. 1, pp. 17–18
Copy: At the Byfield School, Bristol, Conn., by Jane Stuart[2]
Subject: Nathaniel Byfield, twenty-first child of Rev. Richard Byfield of Long Ditton, Surrey, England; born 1653;[3] came to Boston in 1674; married (1) Deborah, daughter of Captain Thomas Clarke, 1675, (2) Sarah, daughter of Gov. John Leverett, 1718; lived for a time at Bristol, R.I., where he owned land; became a member of the Ancient and Honorable Artillery Company in 1679, rising to the rank of colonel;[4] probate judge and later first judge of the Court of the Vice-Admiralty, 1699–1700, 1703–1715, 1728–1733; died at Boston, June 6, 1733[5]

See figure 63

This portrait, along with cat. nos. 47 and 48, is a replica by Smibert of a 50 × 40 inch original painted in August 1729 (see cat. no. 217) and now unlocated. That three replicas survive attests to the high esteem in which Byfield was held. The original, from which the two other replicas were derived, was most likely the painting extolled by Mather Byles in his poem "To Mr. Smibert, on viewing his pictures": "Fixt strong in thought there *Byfield's* Lines appear."

The bewigged and toothless Byfield is depicted wearing a rust-colored frock coat and a steinkirk tie, typical attire for a member of his generation. Although known to be aggressive and dictatorial, he seems relatively harmless as rendered by Smibert. Smibert's realistic approach to Byfield's features, with the effects of age so emphatically stated, captures the resilience of a man nearing the age of eighty during an era when many people did not survive adolescence.

NOTES

1. Foote 1950, p. 141.
2. Ibid.
3. Ibid.
4. Whitman 1842, p. 207.
5. Foote 1950, pp. 140–141.

Provenance: Nathaniel Byfield Lyde (d. 1808), from his mother (a sister of Gov. Jonathan Belcher);[1] his son, George Lyde, New York; gift to Byfield Parish, Byfield, Mass., 1835; on loan to Essex Institute, 1949–1970; to Vose Galleries, 1979; sold to William Underwood Co., 1980; given by them to George Seybolt, 1980–1993; private collection
Notebook: Not recorded
Literature: Foote 1950, p. 141, "Judge Nathaniel Byfield no. 2"; *Essex Institute Historical Collections* (1953), p. 89 rep.; *Additions to the Catalogue of Portraits in the Essex Institute* (1950), pp. 4–5

When the painting was at Vose Galleries (1979) it was still on its original strainers. On the back of one strainer was a typed paper label that read, "portrait of Hon. Nathaniel / Byfield given to Byfield Parish / June 1, 1835, by one of his descendants George Lyde of New York."

NOTES

1. George Lyde to John Cleaveland, June 1, 1835, Essex Institute Manuscript Collection.

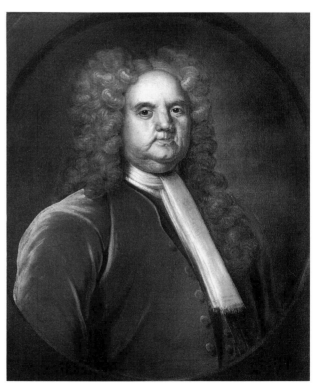

48

48 Judge Nathaniel Byfield, c. 1730

R. H. Love Galleries, Inc., Chicago
30 × 25 (76.2 × 63.5)
Provenance: Francis Brinley, Newport, R.I., 1880;[1] Mrs. Francis Brinley; purchased by George Tucker Bispham, Philadelphia, by 1919;[2] to his sister, Mrs. Bispham McKean, Ithan, Penn.; her

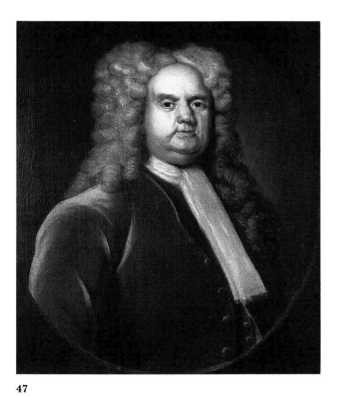

47

47 Judge Nathaniel Byfield, c. 1730

Private collection
29 × 24 (73.6 × 61)

daughter Nancy McKean; Mrs. Alicia Atkinson Waterston; sold by Alicia Atkinson Waterson to Vose Galleries, Boston, 1981
Notebook: Not recorded
Literature: Bolton, 1919–1926, vol. 2, pp. 359–361; Foote 1950, p. 141, "Judge Nathaniel Byfield No. 3"; New Haven 1949, no. 10; *Antiques*, vol. 121, no. 1 (January 1982), p. 8 rep.

Francis Brinley (cat. no. 39) married a granddaughter of Judge Nathaniel Byfield, which helps explains why a portrait of Byfield descended in the Brinley family.

NOTES

1. Foote 1950, p. 141.
2. "American Portraits, 1620–1825, Found in Massachusetts," Historical Records Survey, Works Progress Administration, mimeograph (Boston 1939), vol. 1, p. 65, no. 345.

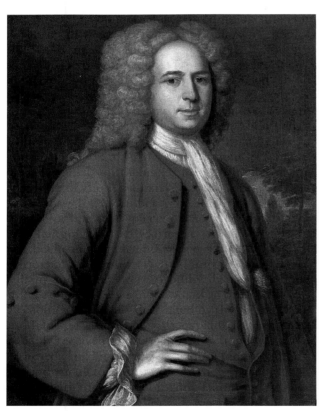

49

49 William Dudley, 1729

Gift of Mrs. J. Brooks Fenno
Courtesy Museum of Fine Arts, Boston
35 1/8 × 27 1/2 (89.4 × 69.9)
Provenance: Direct descent in Dudley family to Mrs. Henry Bradlee (Hephsibah Hall, b. 1821), by 1893; her son-in-law Edward N. Fenno; his daughter Mrs. Arthur W. Bell, by 1950;[1] her cousin J. Brooks Fenno, by 1976; gift of Mrs. J. Brooks Fenno to the Museum of Fine Arts, Boston, 1979
Notebook: [September 1729], vol. 88, no. 17: "Coll. Dudley H.P. KK 30–0–0"

Literature: MHS *Proc.*, 2nd series, vol. 2 (January 1886), p. 197; *Art in America*, vol. 17, no. 4 (June 1929), opp. 176 [incorrectly as Paul Dudley]; Bayley 1929, p. 377 rep. [incorrectly as Paul Dudley]; Foote 1950, p. 150; Museum of Fine Arts, Boston, *The Museum Year: 1979–80* (1980), p. 26 rep.; Carol Troyen, *The Boston Tradition: American Paintings from the Museum of Fine Arts, Boston*, exh. cat. (1980), pp. 44–45 rep.
Subject: William Dudley, born October 20, 1686; son of Gov. Joseph Dudley (see fig. 55) and Rebecca (Tyng) Dudley. Dudley was graduated from Harvard in 1704, where he was described as the "most disorderly member of a small and orderly class." He served in various capacities while his father was governor and at one point was sent to Quebec. Around 1710 he was made a major in William Tailer's regiment and the following year he was made a lieutenant-colonel on the Canada expedition under Samuel Vetch. When peace came in 1713 Dudley, along with his older brother, Paul, became involved in land speculation. Beginning in 1718, with his election to the Massachusetts House of Representatives, he assumed the first of a series of political offices. He married Elizabeth (cat. no. 45), the eldest daughter of Judge Addington Davenport, on March 20, 1721, and built a house for her in Roxbury. He worked actively in Massachusetts until his death on August 22, 1749.[2]

The painting retains its original frame, but it has been regilded.

NOTES

1. Letter to the author from Mrs. J. Brooks Fenno, 1976.
2. Sibley and Shipton 1873–1956, vol. 5, pp. 244, 247, 250.

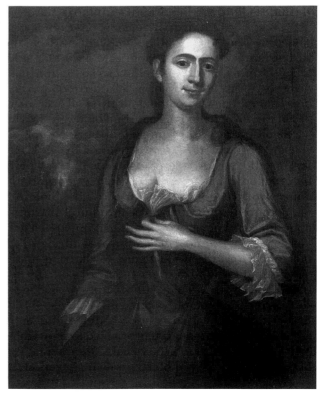

50

50 Mrs. Joshua Winslow, 1729

Boston Atheneum

35 1/4 × 27 3/4 (89.6 × 70.5)

Provenance: Son of sitter, Isaac Winslow (1743–1793), by 1778; his son Isaac Winslow, Jr. (1774–1856), by 1793; his daughter Margaret Catherine Winslow, by 1856; her niece Adelia Isabel Winslow, Brookline, by 1890;[1] Arthur Winslow, Boston, by 1906; his daughter Sarah Winslow Cotting, by 1938;[2] on loan to Boston Atheneum from Sarah Winslow Cotting, 1945–1983; gift from Sarah Winslow Cotting to Boston Atheneum, 1983

Notebook: [September 1729], p. 88, no. 18: "Mrs. Winslow H. P. KK 30–0–0"

Literature: Arthur Winslow, *Francis Winslow* (Norwood, Mass., 1935), p. 62 rep.; Foote 1950, p. 228; R. Peter Mooz, *The Winslows, Pilgrims, Patrons, Portraits*, exh. cat. (Brunswick, Me., 1974), pp. 16, 25 rep.; Saunders 1979, vol. 1, p. 134; vol. 2, pl. 87; Jonathan P. Harding, *The Boston Atheneum Collection: Pre-Twentieth Century American and European Painting and Sculpture* (Boston, 1984), pp. 47, 120

Subject: Elizabeth Savage (1703–1778) was the youngest daughter of Thomas and Margaret (Lynde) Savage. Around 1720 she married Joshua Winslow.[3]

The portrait has been extensively repainted. At the time the painting was last restored (1972–1973) by R. Findlayson, Museum of Fine Arts, Boston, he noted "many areas of missing pigment throughout the picture. Not much original pigment left in background and lower half of dress."[4]

NOTES

1. Boston Atheneum, Winslow portrait file.
2. Foote 1950, p. 228.
3. Harding, *Boston Atheneum Collection*, p. 57.
4. Boston Atheneum, Winslow portrait file.

51 Joshua Winslow, 1729

Boston Atheneum

35 1/2 × 27 3/4 (90.2 × 70.5)

Provenance: See cat. no. 50

Notebook: [September 1729], p. 88, no. 19: "Mr. Winslow H. P. KK 30–0–0"

Literature: Arthur Winslow, *Francis Winslow* (Norwood, Mass., 1935), pp. 61–62, rep.; Foote 1950, pp. 226–228; R. Peter Mooz, *The Winslows, Pilgrims, Patrons, Portraits*, exh. cat. (Brunswick, Me., 1974), pp. 15, 24 rep.; Saunders 1979, vol. 1, pp. 134–135; vol. 2, pl. 86; Jonathan P. Harding, *The Boston Atheneum Collection: Pre-Twentieth Century American and European Painting and Sculpture* (Boston, 1984), pp. 56, 120

Subject: Joshua Winslow (1694–1769), merchant and shipowner; son of Edward Winslow (cat. no. 55) and Hannah (Moody) Winslow; married Elizabeth Savage (cat. no. 50) around 1720[1]

This is one of the few American portraits where Smibert depicts the sitter in a dressing cap. Like its pendant (cat. no. 50), the portrait of Joshua Winslow has been extensively repainted. In 1935 the two portraits were described as being "in a very dilapidated condition" and were restored.[2]

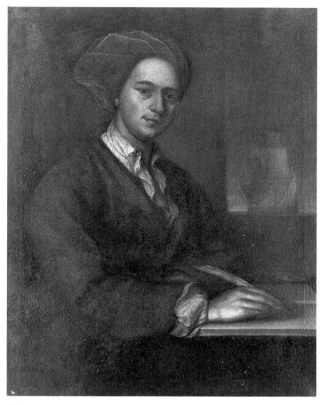

51

They were restored again in 1945 by Alfred Lowe of the Museum of Fine Arts, Boston. They were were recorded in Joshua Winslow's estate inventory as:

2 Family pictures Mr. Winslow & W.Fe	4.3.0
1 Gilt picture Olde Mr. Winslow in the back parlor.[3]	2.0.0

The portrait described as "Olde Mr. Winslow" most likely refers to Joshua's father, Edward Winslow (cat. no. 55).

NOTES

1. Foote 1950, pp. 226–227.
2. Winslow, *Francis Winslow*, p. 61.
3. Foote 1950, p. 227.

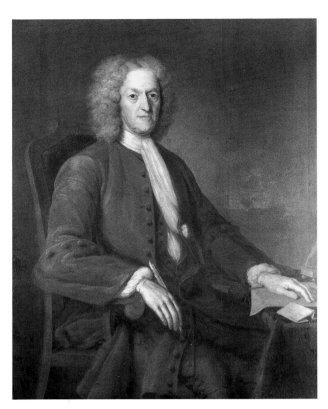

52

52 Daniel Oliver, 1729

Andrew Oliver, Jr., Daniel Oliver, Mrs. Daniel Morley
50 × 39 5/8 (127 × 100.6)
Inscription: On letter at lower right, "Daniel Oliver, / Merchant / Boston"
Provenance: Sitter's son, Andrew Oliver; his son Andrew;[1] his son Dr. B. Lynde Oliver; his sister Sarah Pynchon Oliver, 1844; purchased by her brother Rev. Andrew Oliver (d. 1898); his son William H. P. Oliver, Morristown, N.J.; his son Andrew Oliver, Boston, 1958–1981; Andrew Oliver, Jr., Daniel Oliver, Mrs. Daniel Morley
Notebook: [September 1729], p. 88, no. 22: "Daniel Olliver Esq. H. P. 1/2 40–0–0"
Literature: Foote 1950, pp. 173–174; Oliver 1960, p. 3, no. 1 rep.; Oliver 1970, p. 920 rep.; Saunders 1979, vol. 1, pp. 135–136; vol. 2, pl. 88
Subject: Daniel Oliver, born in Boston, February 28, 1664; son of Peter and Sarah Oliver of Boston; married Elizabeth Belcher (cat. no. 65) April 23, 1696; died April 23, 1732. Oliver was one of the wealthiest merchants in Boston and was active in Old South Church.[2]

Daniel Oliver was one of the builders of the Long Wharf.[3] He was described as "a businessman who amassed great wealth by industry and a well-deserved reputation for honesty."[4] The knee-length format of his portrait, commissioned the month his brother-in-law, Jonathan Belcher, became governor, is typical for colonial merchants. Oliver holds a quill pen in his right hand and on the table beside

him is a letter inscribed with his name and profession. Behind him, through an open window, a full-rigged ship, only faintly visible, provides a further reminder of Oliver's source of income. Although similar in format to earlier Smibert portraits, the artist's primary emphasis here is on the individual facial qualities. The result is a unified portrait in which the accessories complement but do not compete for the viewer's attention. There is also a sense of weight and volume to Oliver's figure. His body seems to fit easily into the dignified armchair, and its elaborately carved crest rail echoes Oliver's thin, almost gaunt frame.

NOTES

1. However, the sitter's son, Gov. Andrew Oliver, noted in his will, "I give to my beloved son Daniel a half length Picture of his Grandfather whose name he bears, and another of his Grandmother, both done by Smibert." Quoted in Foote 1950, pp. 173–174. The portraits, though intended for Daniel, were acquired by his brother Andrew when Daniel fled to England at the time of the Revolution. See Foote 1950, p. 173.
2. Foote 1950, p. 173.
3. Warden 1970, p. 68.
4. Sibley and Shipton 1873–1956, vol. 7, p. 383.

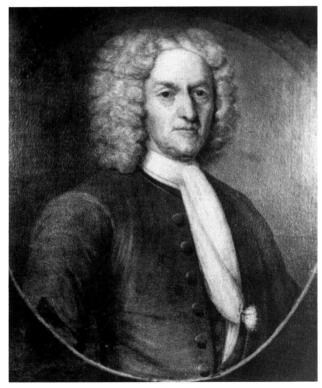

53

53 Daniel Oliver, c. 1731–1732

Andrew Oliver, Jr., Daniel Oliver, and Mrs. Daniel Morley
30 × 25 (76.2 × 63.5)

Provenance: The sitter; his son Peter Oliver, Boston (taken to London at the time of the Revolution); by descent to Thomas Hutchinson Oliver; Mrs. Walsham Howe, by 1938; purchased by W. H. P. Oliver, Morristown, N.J., c. 1938; his son Seabury Oliver, Morristown, N.J., by 1949;[1] his brother Andrew Oliver, Boston, by 1973; Andrew Oliver, Jr., Daniel Oliver, and Mrs. Daniel Morley
Notebook: Not recorded
Literature: Foote 1950, p. 174; Oliver 1960, p. 3 rep.; Saunders 1979, vol. 1, p. 152; vol. 2, pl. 107
Subject: See cat. no. 52

NOTES

1. Foote 1950, p. 174.

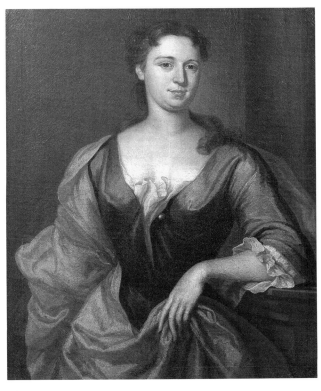

54

54 Mrs. Tyng, 1729

Bequest of George Nixon Black
Courtesy Museum of Fine Arts, Boston
35 3/4 × 28 1/2 (93.3 × 72.4)
Provenance: Descent in the Tyng family to W. B. T. Smith; purchased by George Nixon Black; bequest of George Nixon Black to the Museum of Fine Arts, Boston, 1929
Notebook: [October 1729], p. 88, no. 24; "Mrs. Ting H P KK 30–0–0"
Literature: Bayley, p. 433 [as Mrs. Edward Tyng]; Museum of Fine Arts, *Bulletin*, vol. 27, n. 34 (April 1929); Virginia Robie, "Waldo Portraits by Smibert and Blackburn," *The American Society of the Legion of Honor Magazine* (Spring 1949), p. 49; Foote 1950, p. 195; Boston 1969, vol. 1, no. 891; vol. 2, fig. 11; Saunders 1979, vol. 1, p. 136; vol. 2, pl. 89

Subject: An unidentified member of the Tyng family

Foote accepted this portrait as by Smibert but questioned the identification of the sitter as Mrs. Edward Tyng (cat. no. 86).[1] It is probably another member of the Tyng family. The painting has been cleaned at least twice, once in 1934 and again in 1949.

NOTES

1. Foote 1950, p. 195.

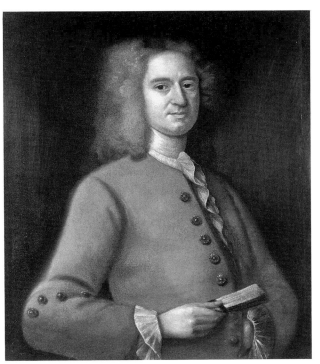

55

55 Sheriff Edward Winslow, 1730

Yale University Art Gallery, the Mabel Brady Garvan Collection
32 3/8 × 27 1/4 (82.2 × 69.2)
Provenance: Sitter's son Joshua Winslow; his son Isaac Winslow; his daughter Elizabeth Winslow Pickering; her granddaughter Miss Susan Pickering; purchased by Francis Gravan, 1935; gift to Yale University Art Gallery, 1935[1]
Notebook: [January 1730], p. 88, no. 27: "Sheriff Winslow H. P. KK 30–0–0"
Literature: MHS *Proc.*, vol. 16 (1878), p. 475; J. M. Phillips, "Edward Winslow, Goldsmith, Sheriff, and Colonel: Portrait by J. Smibert in the Mabel Brady Garvan Collection," *Bulletin of the Associates in Fine Arts at Yale University*, June 1935, pp. 45–46; Foote 1950, p. 199; Saunders 1979, vol. 1, p. 134; vol. 2, pl. 85; R. Peter Mooz, *The Winslows, Pilgrims, Patrons, Portraits*, exh. cat. (1974), pp. 16, 26 rep.; Barbara M. Ward and Gerald W. R. Ward, *Silver in American Life*, exh. cat. (1979), p. 19 rep.
Copies: (1) Painted by Joseph Blackburn and signed "J. Blackburn pinx 1757." According to Foote, it is "similar to the original except that the right forearm and hand are not shown." Owned

by Miss Julia Winslow, New York (1937), and later by Mrs. Ernest Newsome (1949). Present location unknown. (2) Replica by Blackburn or copy by another artist owned by Willard Winslow, Scarsdale, New York (1950). Present location unknown. (3) Nineteenth-century copy of no. 2. Owned by Arthur Winslow and later by Mrs. Robert Lowell, Boston (1949). Present location unknown. (4) A copy after Smibert, c. 1870, owned by Charles Parker, Boston (1949). Reproduced in the *New York Herald-Tribune,* June 23, 1935 (rotogravure section), and in *Art Digest,* vol. 9, no. 11 (August 1, 1935).[2] Present location unknown.

Subject: Edward Winslow, born in Boston November 1, 1669; son of Edward Winslow and Elizabeth Hutchinson, daughter of Anne Hutchinson; grandson of Josiah Winslow (c. 1629–1680), governor of Plymouth Colony. Winslow was a leading Boston silversmith, but also served as overseer of the poor, 1711–1712; selectman, 1714; high sheriff of Suffolk County, 1728–1743; Captain of the Ancient and Honorable Artillery Company; and judge of the court of common pleas, 1743. Married (1) in 1692 Hannah Moody (1672–1711); (2) in 1712 Elizabeth Dixie, widow of Benjamin Pemberton; (3) in 1744 Susanna Farnum, widow of Caleb Lyman.[3] Winslow was a member of Old South Church.[4] He died December 1, 1753.[5]

This portrait is heavily restored. Winslow, who wears a brick-red coat, is shown holding a letter or document which probably originally bore an inscription. The portrait was included in the probate inventory of Joshua Winslow, the sitter's son: "1 Gilt picture Olde Mr. Winslow £2.0.0 / In the back parlor."[6]

According to one note by John Marshall Phillips (c. 1935), "on the back of the stretcher in the handwriting of Isaac Winslow, 1774–1856, great-grandson of Edward and genealogist of the family, appears the identification as to the sitter together with a wealth of genealogical data concerning him and his family."[7]

NOTES

1. Foote 1950, p. 199.
2. Ibid.
3. Ibid.
4. Whitman 1842, p. 240.
5. K[atherine] A. K[ellock], "Edward Winslow," *DAB* (1964 ed.), vol. 10, pp. 394–395.
6. Foote 1950, p. 199.
7. Garvan Office, painting file, Yale University Art Gallery.

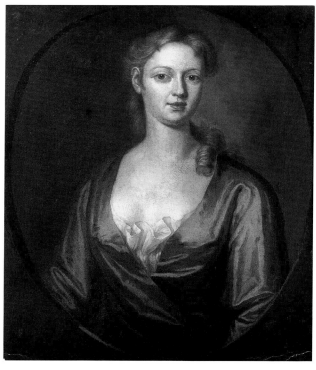

56

56 Lydia Henchman, 1730

Colby College Museum of Art
30 3/4 × 25 (78.1 × 63.5)
Provenance: Mrs. Lydia Taft, Milton, Mass., by 1902;[1] transferred to Roy Baker Taft, 1935; transferred to Mrs. William E. Faulkner, Keene, N.H., 1938–1949; on loan to Museum of Fine Arts, Boston, 1948;[2] Vose Galleries, 1964; purchased by Mr. and Mrs. Ellerton Jette; gift to Colby College, 1964
Notebook: [January 1730], p. 88, no.28: "Ms. L Hinksman H.P. 3/4 20–0–0"
Literature: Foote 1950, pp. 162–163; Colby College Art Museum, *American Arts of the Eighteenth Century,* exh. cat. (1967), p. 8; Colby College, *Handbook of the Colby College Collection* (Waterville, Me., 1973), p. 9 rep.; Saunders 1979, vol. 1, pp. 139–140; vol. 2, pl. 91
Subject: Lydia Henchman, born in Boston October 4, 1714; daughter of the leading Boston bookseller, Daniel Henchman (cat. no. 116), and Elizabeth Gerrish Henchman (cat. no. 117); married her father's protege, Thomas Hancock (cat. no. 63), November 5, 1730; died in Fairfield, Conn., April 15, 1776[3]

See figure 112

NOTES

1. Label on stretcher.
2. Foote 1950, p. 163.
3. Ibid., p. 162.

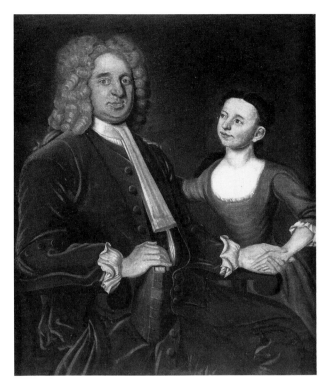

57

58

57 John Jekyll and His Daughter, 1730

Courtesy Massachusetts Historical Society
44 × 36 (111.1 × 90.4)
Provenance: Gift of Mrs. F. P. Webber, Boston, 1872
Notebook: [February 1730], p. 88, no. 30: "Mr. Jekell and Daughter H.P. 1/2 60–0
Literature: Oliver, Huff, and Hanson 1988, p. 55
Subject: John Jekyll, born in England c. 1673; collector of customs and justice of the peace for Suffolk and Middlesex counties; died December 30, 1732

This portrait shows Jekyll seated, wearing a maroon coat, with one of his two daughters, either Hannah or Mary, standing next to him. He holds a book marked on the spine "Book of Rates." The painting has been cut down from 50 × 40 inches and is heavily restored. The best preserved part of the painting is the figure of the girl.

58 Mrs. Louis Boucher, 1730

Courtesy Winterthur Museum
50 × 40 (127 × 101.6)
Provenance: By descent to Alexander S. Porter; his daughter-in-law Mrs. Alexander Breeze Porter, by 1949;[1] Alexander B. Porter, by 1976; on loan to the Colonial Society of Massachusetts, c. 1951–1976;[2] sold by H. Hornblower III (dealer) to Vose Galleries, 1978; purchased by the Henry Francis duPont Winterthur Museum, 1978
Notebook: [February 1730], p. 89, no. 33: "Mr. [mistranscribed—should read Mrs.] Cunninghams Mother H.P. 1/2 40–0–0"

Literature: John Hill Morgan and Henry Wilder Foote, "An Extension of Lawrence Park's Descriptive List of the Work of Joseph Blackburn," *Proceedings of the American Antiquarian Society*, n.s., vol. 46 (April 1936), 41–42; Foote 1950, p. 135; Saunders 1979, vol. 1, p. 140; vol. 2, pl. 92; *Antiques*, vol. 114 (August 1978), p. 197 rep.; *Winterthur Newsletter*, vol. 25, no. 1 (January 1978), rep.; Craven 1986, pp. 173–175
Subject: Sarah Middlecott (Mrs. Louis Boucher), born in Boston June 2, 1678; daughter of Richard Middlecott and Sarah Winslow Middlecott; granddaughter of John and Mary Chilton Winslow; date of death unknown[3]

NOTES

1. Foote 1950, p. 135.
2. Letter to the author from Alexander B. Porter, June 7, 1976.
3. Foote 1950, p. 135.

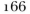

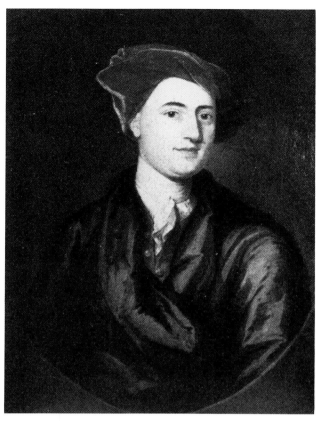

59

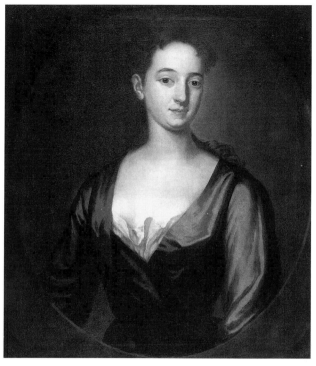

60

59 Colonel Benjamin Pollard,* 1730

Private collection
Notebook: [March 1730], p. 89, no. 34: "Capn. Pollard H.P. 3/4
20–0–0"
Literature: *Antiques*, vol. 101 (April 1972), p. 641; Oliver, Huff,
and Hanson 1988, p. 77
Subject: Benjamin Pollard, born 1695; son of Jonathan and Mary
Winslow Pollard; married Margaret Winslow, 1746. Pollard was
a prominent merchant, a colonel in the local militia, and a mem-
ber of the Ancient and Honorable Artillery Company. He suc-
ceeded his uncle Edward Winslow (cat. no. 55) as sheriff of
Suffolk County in 1743. Winslow died December 24, 1756.

A copy of this portrait painted by Joseph Blackburn in
1755 is owned by the Massachusetts Historical Society (see
Oliver, Huff, and Hanson 1988, p. 77).

60 Mrs. Bishop (?), c. 1729–1734

Collection of Mr. and Mrs. Russell Wilkinson, New York City
30 × 25 1/2 (76.2 × 65)
Provenance: Doll and Richards, Boston, 1966; Coe Kerr Gallery,
New York, by 1975; purchased by Nickolas Wyeth, New York,
1977
Notebook: Not recorded as presently identified

Literature: Saunders 1979, vol. 1, p. 136; vol. 2, pl. 90; *Antiques*, vol.
109 (April 1976), p. 644 rep.

The portrait is a typical example of Smibert's work from
his first years in Boston. The sitter is shown wearing a blue
gown, which is how the majority of Smibert's American
women are depicted.

61 Rev. Joseph Sewall, c. 1730

Yale University Art Gallery, bequest of Ruby P. Woolsey in memory
of her husband, T. Salisbury Woolsey, B.A. 1901
29 7/8 × 24 3/4 (75.6 × 62.9)
Provenance: Descent in Salisbury family to Miss Salisbury; her
cousin, Professor Theodore S. Woolsey, New Haven;[1] his wife,
Ruby P. Woolsey, New Haven; bequest of Ruby P. Woolsey to
Yale University, 1973[2]
Notebook: Not recorded
Engraved: Mezzotint (see fig. 93) by Peter Pelham, c. 1735; 8.7 ×
7.3 inches
Stauffer 1907, p. 2473; Smith 1884, p. 34
Inscribed: "The Reverend Joseph Sewall D.D. / I. Smibert / Pinx.-
P. Pelham Fecit"
Imprints at: American Antiquarian Society; Essex Institute, John
Carter Brown Library; Worcester Art Museum
Literature: MHS *Proc.*, vol. 16 (1878), p. 399; NEHGS *Register*,
vol. 46 (January 1892), p. 10, frontispiece; *Art and Progress*, vol. 3
(February 1912), p. 485 rep.; Bolton 1933, p. 42; New Haven
1949, no. 27; Foote 1950, pp. 188–189; Oliver 1973, pp. 145,

147, 171; Saunders 1979, vol. 1, pp. 189–190; vol. 2, pl. 148
Copy: Old South Church, Boston
Subject: Joseph Sewall; born in Boston August 26, 1688; son of
Chief Justice Samuel Sewall (cat. no. 42) and his wife, Hannah
Hull Sewall; graduated from Harvard, 1707; ordained as pastor
of Old South Church, 1713; elected president of Harvard Col-
lege in 1724 but declined. Sewall's general benevolence won him
the title "the Good." At his death, on June 27, 1769, he had been
associated with Old South Church for fifty-six years.[3]

See plate 19

This portrait is among the very best of Smibert's career.
Its absence from the notebook is probably because Smibert
did it as a gift for the sitter, who was the minister of his
church. It was most likely painted about the time Smibert
was married in 1730. Sewall, his own hair falling in ringlets
to his shoulders, has a kind yet powerful face. The portrait
is direct and closely observed; it succeeds because Smibert
focuses exclusively on the man and is not distracted by
trappings of composition and clothing, as he sometimes
was in larger-format portraits. Although thinly painted,
the portrait is in excellent condition.

NOTES

1. Foote 1950, p. 189.
2. Painting files, Yale University Art Gallery.
3. Foote 1950, p. 189.

62

62 Portrait of a Woman (possibly Mrs. James Gooch IV), c. 1730–1735

Brooklyn Museum, 27.947, Carll H. de Silver and A. T. White
Memorial Funds
35 3/4 × 28 1/8 (90.8 × 70.4)
Notebook: [April 1730], p. 89, no. 38 "Mrs. Gowedg H.P. KK 30–
0–0"
Literature: *Antiques* (November 1939), p. 225 rep.; Brooklyn Mu-
seum, *American Paintings: A Complete Illustrated Listing of Works in
the Museum's Collection* (New York, c. 1979), p. 130 rep.

Since the 1920s the sitter has been identified as Elizabeth
Craister (1693–1786), who married James Gooch in 1761.
The identification is apparently incorrect, and the por-
trait may well represent Hester Stanton, widow of Francis
Plaisted of Nevis. She married Captain James Gooch, Jr.,
on August 21, 1729, the year she came to Boston. Alter-
natively the portrait may represent another member of the
Gooch family. The portrait is certainly by Smibert, al-
though it is not one of the more forceful examples of his
American work.

63 Thomas Hancock, 1730

Courtesy Museum of Fine Arts, Boston, gift of Amelia Peabody
30 × 25 (76.2 × 63.5)
Provenance: Wife of the sitter, Lydia Henchman Hancock (cat. no.
56), 1764; her nephew John Hancock, 1776; his wife, Dorothy
Quincy Hancock, 1793–1830; purchased at auction by Lydia B.
Taft, Milton, Mass., by 1919;[1] Ray Baker Taft, Hingham, Mass.,
by 1935; Miss Ellyn L. Edwards, York, Me., 1938; on loan to
Museum of Fine Arts, Boston, 1949; sold by the estate of Ellyn L.
Edwards to Vose Galleries, 1964; Miss Amelia Peabody, Boston,
1964; gift to Museum of Fine Arts, Boston, 1965
Notebook: [September 1730], p. 89, no. 40: "Mr. Hendcock H P.
3/4 20–0–0"[2]
Literature: Foote 1950, p. 162; Boston 1969, vol. 1, no. 887; vol. 2,
fig. 9; Museum of Fine Arts, Boston, *Paul Revere's Boston*, exh.
cat., 1975; Saunders 1979, vol. 1, pp. 141–142; vol. 2, pl. 94
Subject: Thomas Hancock, who was among Boston's most pros-
perous merchants of the 1740s and 1750s, was born July 13,
1703, the son of Rev. John Hancock (cat. no. 91) and Elizabeth
Clark Hancock (cat. no. 97). He grew up in Lexington, Mass.,
where his father was minister, and by age thirteen was appren-
ticed to a Boston bookseller. He married Lydia Henchman
(cat. no. 56) November 5, 1730. During the 1730s he prospered,
building the famed Hancock House in 1737. He died August 1,
1764.[3]

See figure 75

This is among Smibert's finest Boston half-length por-
traits. It depicts a healthy, vigorous person with a ruddy
complexion. His expression is confident and optimistic. He
wears a warm chestnut-brown waistcoat and frock coat,
which is complemented by the grayish background and
dark gray spandrels. Smibert's use of back lighting, with the
wall at the right of the sitter slightly lighter than the wall at
the left, gives the figure a sense of volume and substance.
The portrait served as a pendant to the animated and

youthful portrait of his fifteen-year-old fiancée, Lydia Henchman (cat. no. 56). As in practically all Smibert's pairs of portraits, the male sitter faces right and the female sitter faces left, so that when hung together they create a visual unit.

John Hancock's inventory for 1793 listed in the bed chamber "2 Small pictures TH and Lady." The will of Dorothy Scott (née Quincy, ex-Hancock), dated January 7, 1830 (inv. vol. 128, p. 174), included "Thos Hancock & Lady 10 [dollars?]" and "Deacon Henchman & Lady $5. Sir H. Frankland 5."[4]

NOTES

1. Letter from William E. Faulkner to Laura Luckey, January 18, 1966, Museum of Fine Arts, Boston, painting file.
2. Hancock papers, New England Historic Geneological Society, box 5, 1728–1766, "Sales Receipts, bills of lading . . . ," under "Debts outgoing [1729–1730]," n.p. 13 recto lists "Jho. Smibert 7–7" which may have been a partial payment for this portrait.
3. Foote 1950, p. 162.
4. Museum of Fine Arts, Boston, painting file.

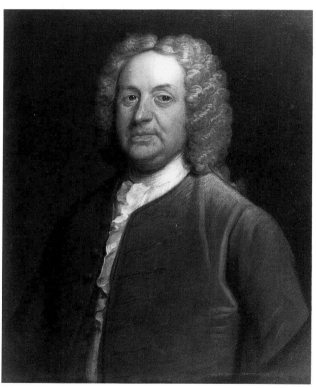

64

64 Unidentified Man, c. 1730

Childs Gallery, Boston
28 1/2 × 23 3/4 (72.4 × 60.2)

Provenance: Art market to Charles D. Childs Gallery, c. 1950; personal collection of Charles D. Childs, 1969–1979; Childs Gallery, Inc., 1980[1]
Literature: *Childs Gallery Painting Annual* (1982–1983), p. 7 rep.

This is a handsome portrait of a male sitter wearing a gray frock coat. At some point during its life the portrait was removed from its strainers and the tacking edge folded under on one side and cut away on the others. When the painting was acquired by Childs Gallery, it was restored to its original size by replacing the missing tacking edge.

NOTES

1. Childs Gallery, painting file.

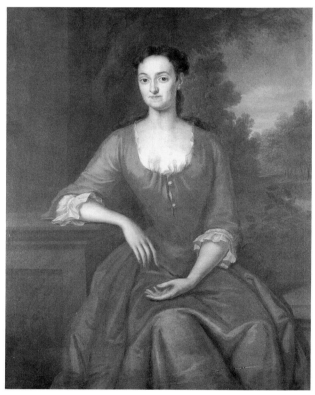

65

65 Mrs. Daniel Oliver, 1730

Andrew Oliver, Jr., Daniel Oliver, Mrs. Daniel Morley
50 × 39 1/2 (128 × 100.3)
Inscription: On reverse "Madam Elizabeth Oliver, daughter of the Hon. Andrew Belcher"[1]
Notebook: [October 1730], p. 89, no. 44: "Mrs. Olliver H.P. 1/2 40–0–0"
Literature: Foote 1950, p. 174; Oliver 1960, p. 3, no. 1 rep.; Oliver 1970, p. 920 rep.; Saunders 1979, vol. 1, pp. 142–143; vol. 2, pl. 95
Copy: In oil by Mrs. W. H. P. Oliver[2]

Subject: Elizabeth Belcher (1678–1735), daughter of Hon. Andrew Belcher and sister of Gov. Jonathan Belcher; married Daniel Oliver (cat. no. 52), April 23, 1696[3]

NOTES

1. Foote 1950, p. 174.
2. Ibid.
3. Ibid.

66

66 Mrs. Daniel Oliver, c. 1731–1732

Andrew Oliver, Jr., Daniel Oliver, Mrs. Daniel Morley
30 × 25 (76.2 × 63.5)
Provenance: The sitter; her son Peter Oliver, Boston (taken to London at time of the Revolution); by descent to Thomas Hutchinson Oliver; Mrs. Walsham How, by 1938; purchased by W. H. Oliver, Morristown, N.J.; Alice Oliver, Morristown, N.J., by 1949;[1] Andrew Oliver, Boston, by 1973
Notebook: Not recorded
Literature: Foote 1950, pp. 174–175, "Mrs. Daniel Oliver No. 2"; Oliver 1960, pp. 3–4, 2A rep.; Saunders 1979, vol. 1, pp. 150–151; vol. 2, pl. 106
Subject: see cat. no. 65

This portrait is a half-length replica of cat. no. 65.

NOTES

1. Foote 1950, pp. 174–175.

67

67 Mrs. Daniel Oliver, c. 1732–1735

Courtesy Massachusetts Historical Society, gift of Mrs. Lawrence and Mrs. Harper
30 × 25 (76.3 × 63.9)
Provenance: Same as Hon. Andrew Oliver, Jr. (cat. no. 52); his son Dr. B. Lynde Oliver of Salem; his sister Sarah Pynonon Oliver; her nephew Rev. Andrew Oliver, 1844; his son William H. P. Oliver, 1898; his three sons (jointly), 1950; Peter Oliver, 1958; his daughters Mrs. Starr Oliver Lawrence and Mrs. Oliver Harper; gift to the Massachusetts Historical Society, 1985
Notebook: Not recorded
Literature: Foote 1950, p. 175 "Mrs. Daniel Oliver No. 3"; Oliver 1960, p. 4 rep., no. 2B; Saunders 1979, vol. 1, p. 152; vol. 2, pl. 108; Oliver, Huff, and Hanson 1988, pp. 70–71
Subject: Same as cat. no. 65

The sitter's husband, Daniel Oliver, died July 23, 1732, and the sitter died May 31, 1735. Since the sitter is dressed as a widow the portrait, based on either cat. no. 65 or cat. no. 66, was most likely painted during this period.

68 Mrs. Nathaniel Cunningham, 1730

Toledo Museum of Art 1948.19. Purchased with funds from the Florence Scott Libbey bequest in memory of her father, Maurice A. Scott

49 1/2 × 40 (125.8 × 103.4)

Provenance: By descent to Mrs. Henry D. Rogers, 1882;[1] Mrs. Charles F. Russell, Boston, by 1922; Miss Mary Otis Porter; Miss Frances R. Porter and Mrs. William Stanley Parker, Boston, 1942; on loan to the Museum of Fine Arts, Boston, 1916–1947; sold by Thomas J. Gannon Inc. (dealer) to Vose Galleries, 1947; purchased by the Toledo Museum of Art, 1948[2]

Notebook: [November 1730], p. 89, no. 46: "Mrs. Cunningham H.P. 1/2 40–0–0"

Literature: Bayley 1929, p. 374 [maiden name erroneously given as Sarah Kilby and her dates as 1732–1779]; Foote 1950, p. 149; Sellers 1957, pp. 434, 438 rep.; Belknap 1959, pp. 298, 348 rep. pl. 25; Prown 1966, vol. 1, p. 19, rep. fig. 24; Mahonri Sharp Young, "From Howling Wilderness to Queensborough Bridge," *Apollo*, n.s., vol. 86 (December 1967), p. 496 rep.; "An *Antiques* book preview, *The Notebook of John Smibert*," *Antiques*, vol. 95, no. 3 (March 1969), p. 369 rep.; Saunders 1979, vol. 1, pp. 144–145; vol. 2, pl. 96; Toledo Museum of Art, *American Paintings, The Toledo Museum of Art* (1979), pp. 99–100; Quick 1981, p. 85, pl. 14

Subject: Ann Boucher (b. 1703), daughter of Louis Boucher and Sarah Middlecott Boucher (cat. no. 58); married Nathaniel Cunningham, a Boston merchant, 1722[3]

See figure 110

This is one of Smibert's best three-quarter lengths of a woman. The sitter wears a blue gown and has a violet drape on her lap. The painting is in very good condition.

A label on the back of the painting reads "Boston Museum 1882."[4]

NOTES

1. Toledo Museum of Art, painting file.
2. Foote 1950, p. 149.
3. Ibid.
4. Toledo Museum of Art, painting file.

69 James Gooch, 1730

Brooklyn Museum, 1927.203

35 1/8 × 28 1/8 (89.4 × 68.9)

Provenance: By descent to Otis Barker, La Mesa, Calif.; purchased by Andre Rueff, Brooklyn; purchased by the Brooklyn Museum, 1927

Notebook: [November 1730], p. 89, no. 47: "Mrs. [transcribed incorrectly: should read "Mr."] Goudge Senr. H.P. KK 30–0–0"

Literature: F. A. Gooch, *The History of a Surname: The Line of John Gooch in New England* (New Haven, 1906), opp. p. 100 rep.; *Brooklyn Museum Quarterly*, vol. 24, no. 3 (July 1927); Mrs. R. Hastings, "Some Franklin Memorabilia Emerge in Los Angeles," *Antiques*, vol. 36 (November 1939), p. 223 rep.; New Haven 1949, no. 13; Foote 1950, p. 158; Saunders 1979, vol. 1, p. 144; vol. 2, pl. 97; Brooklyn Museum, *American Paintings: A*

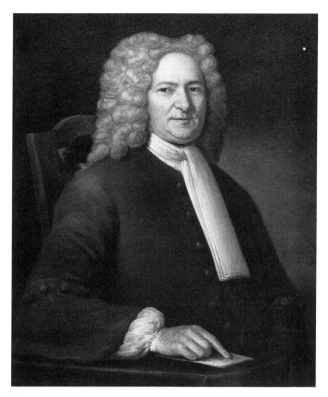

69

Complete Illustrated Listing of Works in the Museum's Collection (Brooklyn, c. 1979), p. 105

Subject: James Gooch (d. 1738), a Boston merchant and a captain in the Ancient and Honorable Artillery Company;[1] said to have rented Smibert a room when he first moved to Boston. Gooch's son, like Smibert, was a prominent member of West Church (founded 1737).

This is more likely a portrait of James Gooch, Jr., than of his son, also called James Gooch, Jr. (1693–1786), as identified by Foote.[2] The painting's carved and gilded frame is original.

NOTES

1. Whitman 1842, p. 260.
2. Foote 1950, p. 158.

70 The Bermuda Group, 1729–1731

Courtesy National Gallery of Ireland

24 × 27 9/16 (61 × 70)

Provenance: The artist; his wife, Mary Smibert, by 1751; her son Williams Smibert, Boston, c. 1760; his cousin Dr. Thomas Moffatt, New London, Conn., 1769 (taken with him to London in 1776); bequeathed to George Chalmers, 1786; purchased from Mr. J. Mossop of Hampstead by the National Gallery of Ireland, 1897[1]

Notebook: Not recorded
Literature: National Gallery of Ireland, *Concise Catalogue of the Paintings* (Dublin, 1971), p. 152, no. 465; Luce 1949, p. 113; Foote 1950, pp. 133–134; Mooz 1970b, pp. 147–157 rep.; Sara Sherrill, "Oriental Carpets in Seventeenth and Eighteenth-Century America," *Antiques,* vol. 109, no. 1 (January 1976), p. 154 and pl. 5; Saunders 1979, vol. 1, pp. 145–147; vol. 2, pl. 100; Mahonri Sharp Young, "British Paintings in the National Gallery of Ireland," *Apollo,* vol. 99 (February 1974), p. 34 rep.; Houghton, Berman, and Lapan 1986, pp. 53–54; Saunders and Miles 1987, pp. 116–117
Copy: A modern copy by Donald E. Forrer is at Berkeley College, Yale University, 1933.52[2]
Subjects: Left to right, John Smibert, John James [or Richard Dalton], John Wainwright (1689–1742), Miss Handcock, Richard Dalton [or John James], Mrs. Anne Berkeley, Henry Berkeley (b. 1729), George Berkeley (1685–1753)

See plate 21

Before painting his large version of *The Bermuda Group* (cat. no. 71) Smibert completed this conversation piece–scale preliminary study. It has been suggested that this version is a replica painted after the large version.[3] Not only is this inconsistent with Smibert's working practice, but there are *pentimenti* here that indicate Smibert made several other adjustments in creating the large painting. The two most obvious changes are the inversion of Miss Handcock's left arm, presumably to create a more casual gesture, and the change in color, from gray to green, of the frock coat worn by the figure next to Smibert. It seems improbable that Smibert would have made such changes if he was simply painting an exact replica of *The Bermuda Group.*

This study is very thinly painted on a light gray ground. The grid pattern of the floor was first drawn in pencil or chalk. Each figure was first sketched and then painted with a thin wash to determine the color scheme, but allowing the ground to show through. Smibert then went back over each figure with more concentrated pigment, first with the darkest colors, then highlights.

Smibert shows himself holding a drawing in his right hand. In between his forefinger and index finger is a piece of red chalk, which does not appear in the finished painting.

Like the Yale painting, this study remained in Smibert's studio during his lifetime. Since the carpet used by Robert Feke to drape the table in *Isaac Royall and His Family* closely resembles the one here (it is cropped in the Yale painting), he was certainly familiar with this version as well.

In the years after Smibert's death (1751), his son Williams, a physician, lived with his father's cousin John Moffatt, who continued to run the artist's color shop. During this period, Thomas Moffatt, John's brother, lived in Newport, where he too was a physician. In 1765 he took office under the Stamp Act, and as a result his house was ransacked and he was burned in effigy. He left Newport for England, but a year later was appointed comptroller in New London, Conn. There he repeatedly wrote Williams,

begging him to send some paintings to decorate his "bare white washed walls."[4] Among the paintings he desired most was this one, "the miniature picture of the Bishop of Cloyne and your Father," which Williams shipped him in 1769 along with plaster statues of Allan Ramsay and Shakespeare.[5]

In 1776 Thomas Moffatt departed for London, where he died ten years later. He left this study, along with other paintings that he owned, to the Scottish antiquary and historian George Chalmers (1742–1825).[6] In 1897 it was purchased by the National Gallery of Ireland from J. Mossop.[7]

NOTES

1. Foote 1950, p. 133.
2. Ibid., p. 134.
3. R. Peter Mooz, "Smibert's Bermuda Group—A Reevaluation," *Art Quarterly,* vol. 33, no. 2 (1970), pp. 150–155.
4. Thomas Moffatt to Williams Smibert, April 2, 1767, Chancery Masters' Exhibits, Curgenven v. Peters (c. 106–193), Public Record Office, London. A second letter from Moffatt to Smibert, dated August 10, 1796, noted, "I have received the pictures which are very acceptable especially the Bermuda Company which is an excellent picture."
5. Thomas Moffatt to Williams Smibert, February 22, 1769; Williams Smibert to Thomas Moffatt, March 6, 1769, Chancery Masters' Exhibits, Curgenven v. Peters (c. 106–193), Public Record Office, London.
6. The will begins: "In the name of God, Amen. I Thomas Moffatt of Charlotte Street Pimlico Doctor of Physics being sound of mind but weak of body think proper to make by last *Will* as follows, vis . . . Fourthly,—I bequeath . . . to George Chalmers of Berkeley Square the following pictures—The Bermuda Group painted by Smibert, a naked man painted by Carrach, St. Peter's head being the present of the Duke of Tuscany to Smibert, The Marquis of Montrose by Jamieson, Allen Ramsay by Smibert, a small picture of Salvator Rosa, being a present from Mr. Richard Cumberland" (quoted in Foote 1950, p. 47).
7. Michael Wynne, assistant director, National Gallery of Ireland, to C. Gouge, May 20, 1970, Yale University Art Gallery, Garvan Office, painting file.

71 The Bermuda Group, 1729–1731

Yale University Art Gallery, gift of Isaac Lothrop of Plymouth, Mass.
69 1/2 × 93 (176.6 × 236.1)
Signed lower center (on edge of book): "Jo. Smibert fecit 1729"
Provenance: The artist; his wife, Mary Smibert, by 1751; her son Williams Smibert, Boston, c. 1760; his cousin John Moffatt, Boston, 1774; his caretaker, Suriah Waite Thayer, 1777; John Johnston, Boston, c. 1795–1808; purchased by Isaac Lathrop, Plymouth, Mass., 1808; gift to Yale College, 1808
Notebook:

1. [July 1728], 85, no. 170: "A Large picture begun for 10–10
Mr Wainwright 10 ginnes at Boston
rec in pairt 30–30–0
2. [November 1730], 89, no. 48: "John Wainwright Esqr.
Revd Dean Berkeley, his lady
and son John James esqr
Ricd Dalton esqr
Ms Hendcock John Smibert"

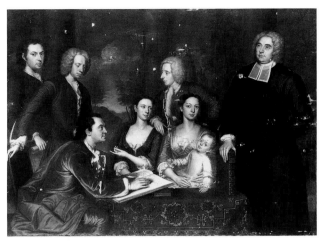

71a

Literature: Dunlap 1918, vol. 1, pp. 17, 25, 27; Yale University, *Catalogue of Paintings in the South Room of the Trumbull Gallery* (New Haven, 1852), pp. 7–10, no. 6; Tuckerman 1867, pp. 42–43; MHS *Proc.*, 16 (1878), p. 475; F. B. Dexter, *Catalogue, with Descriptive Notices of the Portraits, Busts, etc., belonging to Yale University* (1892), pp. 9–12; Benjamin Rand, *Berkeley and Percival* (Cambridge, 1914), pp. 36–37, 39, 257; Coburn 1929, p. 185; Lee 1930, pp. 118–119; T. Bolton 1933, pp. 4, 15, 41; Theodore Sizer, "The College Portrait," *Bulletin of the Associates in Fine Arts of Yale University*, June 1934; Burroughs 1942, pp. 110, 113; New Haven 1949, no. 1; Foote 1950, pp. 131–133 [includes an extensive list of reproductions, exhibitions and bibliography prior to 1949]; Prown 1966, vol., pp. 10–12; Mooz 1970b, pp. 147–157; Riley 1971, p. 164; Yale University, *Selected Paintings and Sculpture from the Yale University Art Gallery* (New Haven, 1972), no. 3; "George Berkeley with His Wife and Friends," *Apollo*, vol. 99 (February 1974), p. 134; Saunders 1979, vol. 1, pp. 145–150; vol. 2, pl. 71; Berman and Berman 1982, p. 77; Houghton, Berman, and Lapan 1986, pp. 53, 54–58; Saunders and Miles 1987, pp. 118–21

Copies: (1) copy by Will(?) Hart in the Redwood Library, Newport, R.I. (2) copy by Matthew Pratt, Brown University, Providence, R.I. (3) copy owned by the University of California, Berkeley

Subjects: Left to right, John Smibert, John James [or Richard Dalton], John Wainwright (1689–1742), Miss Handcock, Richard Dalton [or John James], Mrs. Anne Berkeley, Henry Berkeley (b. 1729), George Berkeley (1685–1753)

See plate 20

The Bermuda Group is a commemorative portrait of those who participated in Dean George Berkeley's venture to establish a college in Bermuda. It is the most sophisticated group portrait painted in the colonies during the first half of the eighteenth century and was a source of inspiration to numerous artists during the succeeding eighty years. The painting was commissioned in the summer of 1728—just prior to the group's departure from England—by John Wainwright, a great admirer of Berkeley who had considered accompanying the entourage. The most prominent

figure in the composition is Berkeley himself, dressed in clerical garb and standing at the far right. Seated across from him is Wainwright, pen in hand. At the table sits Mrs. George Berkeley, holding her son Henry, and beside her is Miss Handcock, her traveling companion. Behind and flanking her are Richard Dalton and John James. The artist stands modestly in the background at the left, a partially unrolled sketch clasped in his right hand. On the table, at the center of the composition, Smibert has discreetly signed the end of a book and added the commemorative date 1729.

The five people who joined Berkeley on his mission to America were from a variety of backgrounds. In addition to Smibert, they included Berkeley's wife of four weeks, Ann Forester, daughter of John Forester, who had been recorder of Dublin, speaker of the Irish House of Commons, and chief justice of the Common Pleas.[1] Miss Handcock was the daughter of William Handcock, who had also been a former recorder of Dublin. James and Dalton have been described as "Men of Fortune" and "gentlemen of substance."[2] John James was the son of Sir Cane James of Bury St. Edmunds and later received the title Sir John James, Bart. He was the last male heir of a family whose seat had once been at Crishall, Essex.[3] Dalton was from Lincolnshire and was an acquaintance of Berkeley's cleric friends Martin Benson, bishop of Gloucester, and Thomas Secker, archbishop of Canterbury.[4] Dalton and James traveled with Berkeley "partly for their health & partly out of their great respect for the Dean & his Design."[5]

Berkeley's ill-fated plan to establish a college in Bermuda was conceived as early as May 1722. The island of Bermuda, removed from both Europe and America, would provide the necessary base of operations for the college. It would educate the children of colonists, act as a bastion against the further spread of Catholicism from French and Spanish colonies, and train American Indians for their role in a massive effort to convert their brethren to Christianity.

Upon leaving London Smibert abandoned the practice of signing portraits, presumably because in Boston his work did not have to be distinguished from that of dozens of other artists. The only exception is *The Bermuda Group*. After the painting was cleaned in 1969 it was revealed that the date, which had always been accepted as 1729, was now so abraded that it could be read as 1739:[6] "An infrared photograph shows a paint loss between the upper half of the figure and its bottom line, thus changing the date to 1739."[7] In any event, the date 1729 is not the date the painting was completed but the date of the event it commemorates.

Since Wainwright commissioned *The Bermuda Group*, Smibert probably planned to send it to him. But the ultimate failure of Berkeley's mission, coupled with opinions "representing him a madman and disaffected to the Government,"[8] diminished its desirability. Such hostility suggests that Wainwright might well have resented a constant visual reminder of an incident that contemporaries considered foolish and ill-conceived. Thus, once completed, the

painting remained in the artist's studio, where the event it commemorated became far less important than the visual essay it provided for aspiring artists.

During Smibert's lifetime *The Bermuda Group*, as has often been noted, had a pronounced influence on Robert Feke's *Isaac Royall and His Family* (fig. 120) and John Greenwood's *The Greenwood-Lee Family* (fig. 133). To put its impact in perspective requires recalling that few paintings of this size existed in the colonies, and of those the majority were portraits of single figures. To an artist's or patron's eyes, *The Bermuda Group* was both physically impressive and a sign of the sophisticated level of painting possible from an artist with proper training. It is not surprising that so many of the artists who saw it realized that to achieve a similar accomplishment meant a transatlantic crossing.

After Smibert's death *The Bermuda Group* remained in his studio, where it was seen by numerous artists, among them John Singleton Copley, Charles Willson Peale, and Pierre Eugène Du Simitière, who observed, "At Dr. William Smibert is a large collection of original Drawings of the best masters Prints mostly italian, Pictures, several of them originals & some done by his father John Smibert a good painter chiefly portraits and a good collection of casts in plaister of Paris from the best antiques, besides basso relievos seals and other curiosities."[9] After Williams Smibert's death in 1774, the painting passed, along with the contents of the studio, to Smibert's cousin John Moffatt, who in turn left it (in 1777) to his tenant, Suriah Waite Thayer. During the next decade Moffatt's executor, Belcher Noyes, sold some of Smibert's collection to John Trumbull and rented the painting studio to a succession of artists: John Trumbull, Mather Brown, Ebenezer Mack, and Joseph Dunkerly.[10] These artists were followed by Samuel King, John Mason Furnass, and lastly John Johnston.

When Suriah Thayer's estate was sold at public auction in 1795, one painting remained "in Johnstons room unsold."[11] This was presumably *The Bermuda Group*, which John Johnston (1753–1818), son of the engraver Thomas Johnston, still had in his possession in 1808. That year he sold it to Isaac Lathrop of Plymouth, Mass., who in turn gave it to Yale University.

In 1808 the painting was outfitted with a new frame. It has also been restored at least three times: once prior to the 1920s, once during the 1920s, and most recently in 1969 (by Theodor Siegl, conservator, Philadelphia Museum of Art). During this last conservation treatment the painting was photographed (cat. no. 71a) before the inpainting was done. Although the painting is in remarkably good condition for its age, it has suffered some tears and losses, particularly at the center of the composition.

NOTES

1. Foote 1950, p. 34.
2. *Maryland Gazette* (Annapolis), April 22, 1729.
3. *Gentleman's Magazine* (London), February 1831, p. 99.
4. Fraser 1871, vol. 4, p. 153.
5. Society for Promoting Christian Knowledge (London),

Manuscript Collection, New England Letters, March 16, 1727/28–April 3, 1731, p. 12.
6. Mooz 1970b, pp. 147–157.
7. Theodor Siegl, "Recording Technical Evidence," in *American Painting to 1776: A Reappraisal*, Charlottesville, Va., 1971, p. 302.
8. Henry Newman to Reverend Cutler at Boston, August 24, 1728, Society for Promoting Christian Knowledge (London), Manuscript Collection, New England Letters, March 16, 1727/28–April 3, 1731, p. 11.
9. Foote 1950, p. 123.
10. Suffolk County Probate Records, Suffolk County Court House, Boston, vol. 84, pp. 555–556.
11. Ibid., vol. 94, p. 14.

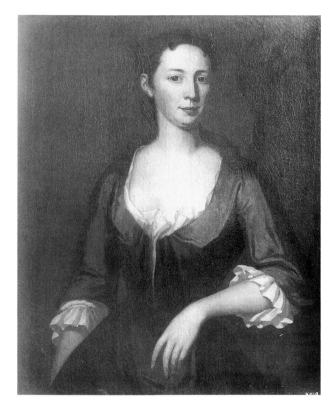

72

72 Unidentified Woman,* c. 1730–1732

Present location unknown, courtesy Frick Art Reference Library
35 1/4 × 27 1/8 (89.6 × 68.9)
Provenance: Mrs. Henry Bradlee (Hephsibah Hall, b. 1821), by 1893; her son-in-law Edward N. Fenno; his daughter Mrs. Arthur W. Bell, by 1950; her cousin J. Brooks Fenno, Chestnut Hill, Mass.; sold to a Boston dealer, c. 1960–1970
Notebook: Possibly [February 1731], vol. 90, no. 50: "Mrs. Dummer H.P. KK 30–0–0"
Literature: Bayley 1929, p. 379 rep. [as Mrs. Paul Dudley]; Foote 1950, p. 157; Belknap 1959, p. 244; Saunders, 1979, vol. 1, pp. 144–145; vol. 2, pl. 99

This portrait was described by Foote as depicting a woman wearing a blue dress and "seated against a dark background with what appears to be a cliff on the right." Foote dismissed the early twentieth-century identification of the sitter as Mrs. Paul Dudley (as being too old) and suggested as a possible alternative her daughter Rebecca Dudley Gerrish (d. 1809). Since this portrait has the same line of descent as those of Mr. and Mrs. William Dudley (cat. nos. 45, 49), it may well depict another member of the William Dudley family. One possibility is William Dudley's sister, who married Jeremiah Dummer (c1679–1739). If this is the case, the portrait may be associated with Smibert's February 1731 *Notebook* entry for a missing kit-cat portrait of "Mrs. Dummer."

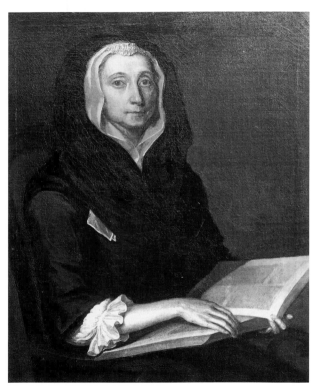

73

73 Mrs. Stephen Sewall, 1731

Peabody Essex Museum, Salem, Mass.
36 × 30 (91.4 × 76.2)
Provenance: The sitter's daughter, Mrs. Higginson, Beverly, Mass., before 1797; to her daughter Lee, Beverly;[1] George Rea Curwen, Salem; bequeathed by George Rea Curwen to the Essex Institute, 1900[2]
Notebook: [April 1731], p. 90, no. 51: "Mrs. Sewall H.P. K.K. 30–0–0"
Literature: *Antiques*, vol. 18, no. 3 (August 1930), rep.; *Essex Institute Historical Collections*, vol. 72 (July 1936), opp. p. 238; Essex Institute 1936, p. 202, no. 285; Foote 1950, p. 190; Saunders 1979, vol. 1, pp. 150–151; vol. 2, pl. 104; Andrew Oliver and

Bryant F. Tolles, *Windows on the Past: Portraits at the Essex Institute* (Salem, Mass., 1981), pp. 40–41
Copy: In oil by an unknown nineteenth-century artist, collection of the Essex Institute[3]
Subject: Margaret Mitchell (1664–1736), daughter of Rev. Jonathan Mitchell, an eminent divine of Cambridge, and Margaret Borrowdale Mitchell, both born in England; married Major Stephen Sewall, a brother of Samuel Sewall (cat. no. 42) of Baddesley, Warwickshire, June 13, 1682; mother of seventeen children[4]

The portrait is a highly conservative yet sensitive portrayal of an elderly widow.

NOTES

1. Foote 1950, p. 190.
2. Essex Institute, painting file.
3. Foote 1950, p. 190, and Essex Institute 1936, p. 201, no. 284.
4. Essex Institute 1936, p. 202, no. 285.

74 Jacob Wendell, 1731

Milwaukee Art Museum, purchase, Layton Art Collection
48 1/2 × 38 1/2 (123.2 × 96.8)
Inscription lower right (on letter on table): "To / Jacob Wendell / Boston"
Provenance: Descent in the family to Wendell Phillips; John C. Phillips; his son Arthur H. Phillips;[1] on loan from the Museum of Fine Arts, Boston, 1973–1978; Hirschl & Adler, New York, 1980; purchased by the Milwaukee Art Museum, 1982
Notebook: [April 1731], p. 90, no. 52: "Mr. Windall H.P. 1/2 40–0–0"
Literature: NEHGS *Register*, vol. 36 (1882), p. 246n; vol. 54 (1900), p. 419n; New Haven 1949, no. p. 34; Foote 1950, pp. 198–199; Saunders 1979, vol. 1, p. 151; vol. 2, pl. 105; Milwaukee Art Museum, *American Colonial Portraits from the Fogg Art Museum and Harvard University*, exh. cat. (1983), n.p. rep.
Subject: Jacob Wendell (1691–1760), son of Johannes Wendel; moved to Boston from New York (?) in his youth and became a successful merchant; married Sarah Oliver, daughter of Dr. James and Mary Bradstreet Oliver of Cambridge, Mass., August 12, 1714; active in the Ancient and Honorable Artillery Company, 1735–1745; a member of Council, 1737–1760[2]

See figure 71

This painting, which is among the most handsome of Smibert's three-quarter-length American merchant portraits, has undergone some restoration, particularly to the sitter's left eye. The portrait apparently escaped a 1745 fire, described in the *Boston News-Letter*, which broke out when lightning struck the house of Jacob Wendell, Jr., of Boston; the fire "scorch'd the cieling and some Pictures that hung up near it."[3]

Wendell's deep red frock coat is in the color range that Smibert favored for many of his merchant sitters, although whether this was the choice of the artist or the sitter is unknown.

NOTES

1. Foote 1950, p. 198.
2. Ibid.
3. Dow 1927, p. 6.

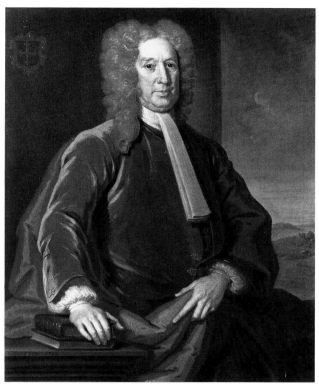

75

75 John Nelson, 1732

The Fine Arts Museums of San Francisco. Gift of Mr. and Mrs.
John D. Rockefeller 3rd, 1979.7.93.
44 1/4 × 36 (112.4 × 91.4)
Inscription lower left: "Aet.78:1732"; upper left is a coat of arms
Provenance: The sitter; Senator James Lloyd, Boston, 1824; to
John Nelson Lloyd, Lloyd's Neck, Long Island; his son, Henry
Lloyd, by 1886;[1] a Mrs. Higbee, by 1890;[2] Mr. Richard H. Derby,
New York, c. 1895; James Lloyd Derby, Syosset, Long Island; his
brother Roger Alden Derby; his son Roger Alden Derby, Jr.,
Cambridge, Mass., by 1949; James Graham & Sons, New York,
1956;[3] Kennedy Galleries, New York, 1969; purchased by Mr.
and Mrs. John D. Rockefeller 3rd, 1969; gift to the M. H. de
Young Memorial Museum, 1979
Notebook: [February 1732], p. 90, no. 58: "Mr. Nellson Sinr 1/2
40–0–0"
Literature: MHS *Proc.*, vol. 17 (1879–1880), p. 93; Temple Prime,
*Descent of John Nelson and of His Children with Notes on the Families
of Tailer and Stoughton* (New York, 1886), pp. 22–23; Rev. Me-
lancthon Lloyd Woolsey, *The Lloyd Manor of Queens Village*
(Baltimore, 1925), p. 17; Bolton 1919–1926, vol. 3, pp. 970–
972, rep. 799; Bolton 1933, p. 42; *Preliminary Catalogue of Early
American Portraits Found in New York* (Boston, Historical Records
Survey, 1942), vol. 2, p. 339; Foote 1950, p. 172; Saunders 1979,
vol. 1, pp. 152–153; vol. 2, pl. 109; Edgar P. Richardson, *Ameri-

can Art: An Exhibition from the Collection of Mr. and Mrs. John D.
Rockefeller 3rd*, exh. cat. (New York, 1976), pp. 18–19 rep.; Marc
Simpson, Sally Mills, and Jennifer Saville, *The American Canvas:
Paintings from the Collection of the Fine Arts Museum of San Francisco*
(New York, 1989), pp. 24–25
Copies: (1) A copy by Frothingham (?) was owned by John Nelson
Borland, New York, 1949. (2) A copy was made by O. L. Lay,
New York, 1869[4]
Subject: John Nelson was born in 1653 in or near London. He was
the son of Robert Nelson, a member of Gray's Inn, and Mary
Temple Nelson, daughter of Sir John Temple of Stanton Bury,
Buckinghamshire. His uncle Sir Thomas Temple was pro-
prietor and governor of Nova Scotia, 1656–1670. Nelson
emigrated to Boston c. 1667. Around 1683–1684 he married
Elizabeth, sister of William Tailer, who was later lieutenant gov-
ernor. In 1691 he was captured by the French in Nova Scotia,
then spent a year as a prisoner in Quebec and two more years
imprisoned in France. In 1698 he returned to Boston, where he
became a successful fur trader. He died in Boston November 15,
1734.[5]

This competent and imposing portrait, were it not
dated, might pass for one of Smibert's London pictures. In
1949 on the back of the frame there was a label that read,
"H. Lloyd, Lloyd's Dock." The coat of arms on the painting
is said to be of the Temple family.[6]

NOTES

1. Temple Prime, *Descent of John Nelson and of His Children with
Notes on the Families of Tailer and Stoughton* (New York, 1886),
pp. 22–23.
2. Foote 1950, p. 172.
3. Henry Francis duPont Winterthur Museum, Decorative Arts
Photographic Collection, painting file.
4. Foote 1950, p. 72.
5. P[aul] C. P[hillips], "Nelson, John," *DAB* (1964 ed.), vol. 7,
pp. 417–418. I wish to thank Professor Richard R. Johnson for
clarifying details of Nelson's biography.
6. Foote 1950, p. 172.

76 Dean George Berkeley, c. 1732

Courtesy National Gallery of Ireland
45 1/2 × 35 1/2 (115.6 × 90.2)
Provenance: Purchased from J. Crampton Walker, Dublin, 1927[1]
Notebook: (Possibly) [March 1732], p. 90, no. 60: "Dean Berkeley
lit 1/2 35–0–0"
Literature: *Art News*, vol. 69 (October 1950), p. 35 (as by unknown
artist); National Gallery of Ireland, *Catalogue of Paintings*
(Dublin, 1971), 83, no. 895; Saunders 1979, vol. 1, pp. 153–154;
vol. 2, pl. 110; Houghton, Berman, and Lapan 1986, p. 70
Subject: See cat. no. 8

This portrait is here attributed to Smibert for the first
time in print.[2] It was most likely painted in 1732 after
Berkeley returned to England. Since Smibert could no
longer simply travel to Newport for a life study, he resorted
to Berkeley's portrait in *The Bermuda Group*. Working from
this model Smibert was forced to have Berkeley face left, as

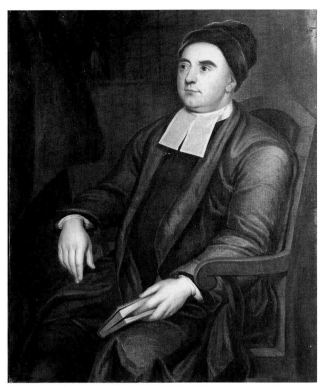

76

opposed to his standard practice for male knee-length portraits, in which the sitter faces to the right.

Berkeley is shown seated in a study, informally dressed in a brown dressing gown and matching cap. Behind him are shelves filled with books, and a partially drawn curtain. His face resembles that in *The Bermuda Group,* and the chair in which he is seated is similar to those used for other American portraits, such as *Francis Brinley* (cat. no. 39). Further, Berkeley's hands resemble those used in Smibert's *John Nelson* (cat. no. 75) commissioned the previous month. The portrait is slightly larger than Smibert's standard size for a "little 1/2" (40 × 30 inches), but stylistically it dates from around 1732. When the painting was examined in 1977 it was dirty but otherwise in good condition.

NOTES

1. Letter to the author from Michael Wynne, assistant director, National Gallery of Ireland, December 15, 1976.
2. Ibid.

77 Mary Fitch Oliver and Her Son Andrew Oliver, Jr., 1732

Andrew Oliver, Jr., Daniel Oliver, Mrs. Daniel Morley
50 1/2 × 40 1/2 (128.3 × 102.9)

Provenance: Husband of the sitter, Andrew Oliver; his son Andrew; his son Dr. Be. Lynde Oliver; his sister Sarah Pynchon Oliver, 1844; purchased by her brother Rev. Andrew Oliver, 1844; Mrs. F. E. Oliver; her son Edward P. Oliver; W. H. P. Oliver, Morristown, N.J., 1920–1958; Andrew Oliver, Boston, 1958–1981;[1] Andrew Oliver, Jr., Daniel Oliver, Mrs. Daniel Morley
Notebook: [June 1732], p. 90, no. 63: "Mrs. Oliver and Son HP. 1/2 60–0–0"
Literature: MHS *Proc.,* vol. 16 (1878), p. 397; Foote, pp. 172–173; Oliver 1960, p. 6 rep.; Brock Jobe, "The Boston Furniture Industry, 1720–1740," *Boston Furniture of the Eighteenth Century* (Boston, Colonial Society of Massachusetts), vol. 48 (1974), p. 43, fig. 31
Subject: Mary Fitch, born October 28, 1706, in Boston; married Andrew Oliver (cat. no. 81), lieutenant governor of Massachusetts; a son, Andrew Oliver, Jr., born in 1731; died November 26, 1732

See figure 94

This painting is one of only three surviving Smibert portraits depicting two sitters (see also cat. nos. 34, 40) and one of the few opportunities he had to depict an infant. The portrait (in contrast to cat. no. 40) is somewhat stark, and the figures are accentuated by being set against a monochromatic gray background. Smibert has depicted Mrs. Oliver in a dull yellow gown—a color he used only sparingly (as in cat. no. 71). The portrait is generally representative of Smibert's increasing indifference toward and discomfort with images of women.

NOTES

1. Oliver 1960, pp. xv–xvi, 6.

78 David Cheseborough, 1732

Stonington, Conn., Historical Society
30 1/2 × 25 1/2 (77.5 × 65)
Provenance: The sitter; his daughter Abigail Cheseborough (Mrs. Alexander Grant); her daughter Elizabeth Grant Smith; her son David Cheseborough Smith; his daughter Betsy Smith Williams; his daughter, Bessie S. Williams Sherman, Chicago; gift from Bessie S. Williams Sherman to the Stonington Historical Society, c. 1916;[1] sold to Vose Galleries, 1970–1976;[2] resold to Stonington Historical Society
Notebook: [July 1732], p. 91, no. 65: "Mr. David Cheesebrook H.P. 3/4 20–0–0"
Literature: Bayley 1929, p. 367; Foote 1950, p. 144; *Antiques,* vol. 99, no. 1 (January 1971), p. 18 rep.; Saunders 1979, vol. 1, p. 154; vol. 2, pl. 111
Subject: David Cheseborough (also Chesebro and Chesebrough), born in Newport, R.I., February 2, 1702; married (1) Abigail Rogers, June 1729, (2) Margaret Sylvester. In 1737 Cheseborough built an imposing house on Mary Street, which survived until 1908. At about the time of the Revolution he moved to Stonington, Conn., where he died February 27, 1782.[3]

See figure 113

Cheseborough is wearing a light gray coat and waistcoat. The painting is attractive but has been extensively repainted. Bayley 1929, p. 367, shows the portrait before restoration. The painting retains its original frame

NOTES

1. Foote 1950, p. 144.
2. *Antiques,* vol. 99, no. 1 (January 1971), p. 18.
3. Foote 1950, p. 144.

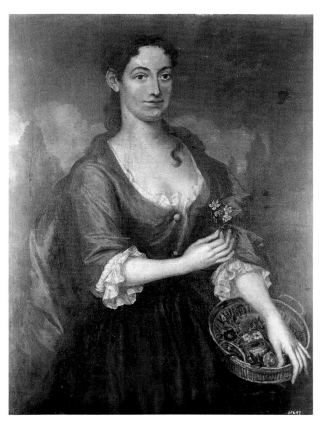

79

79 Mrs. James Allen,* 1732

Present location unknown
41 × 32 (104.2 × 81.3)
Provenance: Her nephew Andrew Oliver, Jr.; his great-grandson Mr. Oliver; his daughter Mrs. George Francis Crane, New York (d. 1960)
Notebook: [July 1732], p. 91, no. 67: "Mrs. Allen HP.L 1/2 35–0–0"
Literature: Boston 1930, p. 15
Subject: Marth Fitch, born September 25, 1704; sister of Mary Fitch Oliver (cat. no. 77); married James Allen when she was fifty-one years old; died March 6, 1763

A photograph of this portrait is at the Frick Art Reference Library. The sitter's face is almost completely repainted but the lower half of the painting seems intact. According to the file at the Frick she "wears a greenish blue dress fastened in front with two silver buttons." She holds a yellow basket with pink, blue, and white flowers.

80 Jane Clark, 1732

Massachusetts Historical Society
50 × 40 (127 × 101.6)
Provenance: Son of the sitter, Jonathan Clark Lewis, Groton, Mass.; Mrs. Henry Edwards; Miss Susan Minns; gift of Minns to the Massachusetts Historical Society, 1916[1]
Notebook: [September 1732], p. 91, no. 70: "Ms Clark whole lenth H.P. 1/2 45–0–0"
Literature: Flexner 1947, p. 128 rep.; Foote 1950, pp. 144–145; Massachusetts Historical Society, *Portraits of Women, 1700–1825* (Boston, 1954), n.p.; Gerdts and Burke 1971, p. 21; Saunders 1979, vol. 1, pp. 155–156; vol. 2, pl. 115; Oliver, Huff, and Hanson 1988, p. 60
Subject: Jane Clark, born c. 1723, daughter of Jonathan and Mary Phillips Clark; came to Boston from England with her parents; married Ezekiel Lewis (Harvard, 1735), a prominent merchant, 1741; died, leaving four children, 1753

See plate 17

Jane Clark is one of Smibert's most delightful and meticulous American portraits. Weaknesses of anatomy (such as her somewhat arthritic-looking hands) are more than compensated for by the artist's pleasing palette, attention to composition, overall detail, and generally sympathetic treatment of the subject. This is Smibert's one surviving portrait depicting a "whole len[g]th" done on the 50 × 40 inch format he normally reserved for three-quarter-length portraits of adults.

On the back of the frame is a label that reads, "Portrait of Miss Jane Clark at age 17 years, painted in England about 1739. Artist unknown, possibly Blackburn." There is a second label on the back of the painting, which reads, "Presented to the Trustees of the Museum of Fine Arts by Mrs. Henry Edwards." As noted by Foote, since the painting is now at the Massachusetts Historical Society it may have been refused by the Museum of Fine Arts.[2]

NOTES

1. Foote 1950, p. 145.
2. Ibid.

81 Daniel, Peter, and Andrew Oliver, 1732

Emily L. Ainsley Fund, 1953, Courtesy Museum of Fine Arts, Boston
40 × 57 1/2 (101.6 × 146)
Inscription: On reverse "Andrew Oliver / Lt. Gov., Mass. Peter Oliver; / Chief Justice, Mass. Daniel Oliver / 1727"
Provenance: See cat. no. 77

Notebook: [September 1732], p. 91, no. 71: "Mesrs. Daniell Andr.
Peter Olivers in one cloth / H.P.O.S. or L 1/2 90–0–0"

Literature: MHS *Proc.*, vol. 16 (1878), p. 397; Bayley 1929, p. 429;
Coburn 1929, no. 5, p. 77 rep.; Boston 1930, p. 59; New Haven
1949, no. 21; Oliver 1960, p. 4, no. 3; Boston 1969, vol. 1,
pp. 236–237, no. 888; vol. 2, fig. 8; Saunders 1979, vol. 1, p. 156;
vol. 2, pl. 116; Carol Troyen, *The Boston Tradition: American Paint-
ings from the Museum of Fine Arts, Boston* (Boston, 1980), pp. 48–
49 rep.

Copy: Modern copy by George Smith for W. H. P. Oliver; present
location unknown

Subjects: Daniel, Peter, and Andrew Oliver were all sons of Daniel
Oliver (cat. no. 52) and Elizabeth Belcher Oliver (cat. no. 65).
Daniel was born in Boston, January 14, 1704, graduated from
Harvard in 1722, and died of smallpox in London, July 5, 1727.
Peter was born March 26, 1713, graduated from Harvard in
1730, and became chief justice of the Superior Court in Massa-
chusetts. He died in Birmingham, England, in 1791. Andrew
was born March 28, 1706, graduated from Harvard in 1726,
became lieutenant-governor of Massachusetts, and died in 1774.

See plate 23

Although Smibert's commissions consisted overwhelm-
ingly of single portraits, paintings such as this one are im-
portant exceptions. This group portrait exhibits both the
strengths of this training—his ability to capture a likeness
—and the limitations of this imbalance, such as his struggle
to find socially and artistically acceptable means to place the
sitters' hands. An added complication was that Daniel, the
oldest of the three brothers, had died in 1726. Thus,
Smibert had to paint the portrait from an existing minia-
ture (cat. no. 81a), which helps account for Daniel's rigid
pose and masklike appearance. In contrast, Andrew, who
supports his head with his hand in studied concentration, is
an unusual—if not unique—departure for Smibert. Both
in composition and palette (based on the primary colors)
the portrait is a successful effort to provide an equitable
balance to the painting. This work is one of only a handful
of opportunities Smibert had in America to truly test his
abilities.

Andrew Oliver, in his will dated March 23, 1773, identi-
fies this work as "a painting by Smibert of my two Brothers
and myself."[1]

NOTES

1. New Haven 1949, no. 21.

82 Mrs. James McSparran, 1732

Gift of Mrs. Margaret Allen Elton, Courtesy Museum of Fine Arts,
Boston

30 1/4 × 25 1/2 (76.8 × 65)

Provenance: Great-grandniece of sitter, Mrs. Margaret Elton, Dor-
chester, Mass., by 1876;[1] gift to the Museum of Fine Arts, 1888[2]

Notebook: [October 1732], p. 91, no. 72: "Mrs. McSparon 3/4 20–
0–0"

Literature: Updike 1907, vol. 1, p. 70 rep. opp.; M. H. Elliott,

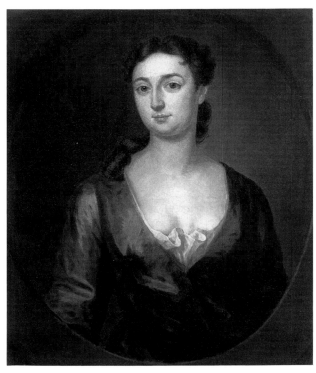

82

"Some Recollection of Newport Artists," Historical Society Bul-
letin (Newport, 1921), no. 35, p. 2; Bayley 1929, p. 407 [dates
of birth and death incorrect and name misspelled]; *Antiques*,
vol. 18, no. 3 (August 1930); Burroughs 1942, no. 2, p. 119; New
Haven 1949, no. 19; Foote 1950, p. 169; Boston 1969, vol. 1,
p. 234, no. 884; vol. 2, fig. 6; Saunders 1979, vol. 1, p. 154; vol. 2,
pl. 112

Copy: Nineteenth-century copy in oils by Mary Updike in the
Rhode Island Historical Society[3]

Subject: Hannah Gardiner, born in Narragansett, R.I., December
7, 1704; daughter of William Gardiner; married Rev. James
McSparran (cat. no. 110), May 22, 1722; died while visiting En-
gland, June 24, 1755[4]

The sitter wears a dark blue dress typical of many of
Smibert's portraits of women. An early-twentieth-century
photograph in the painting file at the Museum of Fine
Arts, Boston, shows the portrait in a frame identical to that
on the portrait of her husband, Rev. James McSparran
(cat. no. 110). The frame now on the painting is a modern
reproduction. A label on the back of the canvas reads,
"Hannah Gardiner, wife of Rev. Dr. James McSparren [*sic*],
Daughter of William Gardiner of South Kingston, R.I.,
born Dec. 7, 1704; died in England of small pox June 24,
1755. Great aunt of Mrs. Frederick Allen of Gardiner, Me.
Mrs. McSparren was a great granddaughter of Sir Thomas
Gardiner, Kt—the first of the Gardiners that emigrated to
this country. Painted by Smibert at Newport, R.I. / MARGA-
RET ALLEN ELTON / Great-grandniece of Mrs. McSpar-
ren / 19 Brooks Ave., Dorchester, Mar. 13, 1876."

NOTES

1. Label on back of canvas.
2. Foote 1950, p. 169.
3. Ibid.
4. Ibid.

NOTES

1. Foote 1950, p. 134.
2. Ibid.
3. Ibid.
4. Ibid.

83 Richard Bill, 1733

The Art Institute of Chicago, Friends of American Art Collection, 1944.28, photograph © 1991, The Art Institute of Chicago, All Rights Reserved
50 1/4 × 40 1/4 (127.7 × 102.2)
Inscription: Letter on table reads "To / Richard Bill, Esq. / in Boston"
Provenance: The sitter's daughter Elizabeth Henshaw; Andrew Henshaw Ward, Newton, Mass., 1866; her daughter Mrs. Warren P. B. Weeks, Boston, 1934; M. Knoedler & Co., New York, 1944; purchased by the Art Institute of Chicago, 1944[1]
Notebook: [March 1733], p. 91, no. 73: "Mr. Bill H.P. 1/2 50–0–0"
Literature: J. Avery, *History of the Town of Ledyard* (Norwich, Conn., 1901), p. 105; Bayley 1929, p. 355; Bolton 1933, p. 41; *New-York Historical Society Quarterly Bulletin*, vol. 18, no. 33 (July 1934); Barbara N. Parker, "Paintings of Old and New England," *Antiques*, vol. 47, no. 4 (April 1945), p. 215; Foote 1950, p. 134; Art Institute of Chicago, *Paintings Catalogue* (1961), p. 419; Saunders 1979, vol. 1, pp. 156–158; vol. 2, pl. 118; David Hanks, "American Paintings at the Art Institute of Chicago: Part I, The Eighteenth Century," *Antiques*, vol. 104 (September 1973), p. 411 rep.
Copies: (1) Painted about 1865 by E. H. Emmons of Norwich, Conn., for Ledyard Bill of New York; reproduced in *The Bill Genealogy* by Ledyard Bill (New York, 1867), attributed to John Singleton Copley. (2) By Henry E. Kinney, 1898, hanging in the Executive Department, Massachusetts State House, Boston[2]
Subject: Richard Bill, born in Boston, March 25, 1685; son of Samuel and Elizabeth Bill; married (1) Sarah Davis (1683–1727), June 30, 1709, (2) Mehitable Minot (1692–1741), daughter of Col. Stephen and Mercy Clark Minot of Boston, October 1, 1733; lieutenant in the Ancient and Honorable Artillery Company and member of the Provincial Council, 1737–1741; died 1757. Although a successful merchant in the 1730s, Bill died penniless.[3]

See plate 22

Richard Bill is among the very best of Smibert's American portraits. Although it utilizes a time-worn pose employed for over a decade (see cat. no. 12), this particular portrait possesses a freshness and dynamism unsurpassed in his merchant portraits. The figure has substance and weight and inhabits a definable space. Supporting elements, such as the merchant ship visible behind Bill, are also accorded a level of attention that provides balance without distracting from the overall unity of the composition. There is perhaps no better portrait than this to symbolize the niche Smibert filled in colonial society.

Bill's picture is recorded in the inventory of his estate (Suffolk County Probate Records, vol. 52, p. 769): "The Decd. Picture—15 [pounds]."[4]

84 Mrs. Hugh Hall, 1733

Denver Art Museum
50 1/8 × 40 1/8 (127.3 × 101.9)
Provenance: The sitter; her daughter Elizabeth Hall (Mrs. John Welch); by descent to Mrs. Marcus Morton, Cambridge, by 1949; on loan to the Museum of Fine Arts, Boston, 1928–1940; purchased by Mrs. Morton's niece Mrs. Charles R. Leonard, by 1973;[1] on loan to Colby College, 1976–1983; sold by Mrs. Raymond Hill to Vose Galleries, 1983; Denver Art Museum, 1984
Notebook: [April 1733], p. 91, no. 74: "Mrs. Hall HP 1/2 50–0–0"
Literature: New Haven 1949, no. 14; Foote 1950, p. 160; Saunders 1979, vol. 1, p. 158; vol. 2, pl. 120
Subject: Elizabeth Pitts, daughter of John Pitts (cat. no. 105); married Hugh Hall III, 1722[2]

This portrait, which is in very good condition, depicts a woman wearing a violet-colored gown.

NOTES

1. Letter to the author from Mrs. Charles R. Leonard, March 22, 1973.
2. Foote 1950, p. 160.

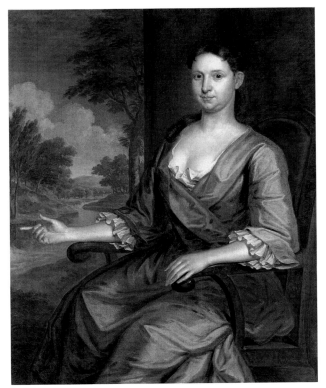

84

85 Rev. Joshua Gee, 1733

Courtesy Harold E. Fitzgibbons's children
28 1/4 × 22 (71.7 × 55.9)
Provenance: The sitter; his third wife, Sarah Gardiner Gee; her daughter Susanna Gee (Mrs. Nathan Davies); her son Joshua Gee Davies; his son Joshua Gee Davies 2d; his daughter Lucy Richards Davies (Mrs. Warren Lewis); Miss Alice Neilson; on loan to Widener Library, Harvard University, 1949; estate of Miss Alice Neilson, 1952; Mr. George Miles Nelson, Woodstock, Vt., 1952; Vose Galleries, 1953; Mr. Harold Fitzgibbons, Duxbury, Mass., 1953;[1] Harold E. Fitzgibbons's children
Notebook: [May 1953], p. 91, no. 76: "Rd. Mr. Gee H.P. 3/4 25–0–0"
Literature: Foote 1950, pp. 156–157
Copy: An eighteenth-century copy in oils is owned by the Massachusetts Historical Society. This copy was thought by Foote to be by Smibert.[2] However, it has a very smooth finish, which is untypical of him, and was more likely painted later in the century.
Subject: Joshua Gee; born in Boston, June 29, 1698; son of Joshua and Elizabeth Thacher Gee; colleague of Cotton Mather as pastor of the Second Church, Boston, 1723–1748; married (1) Sarah Rogers, 1722, (2) Anna, daughter of Captain John Gerrish (cat. no. 120) and widow of Samuel Appleton, 1734, and (3) Sarah Gardiner, 1740; died in Boston, May 22, 1748[3]

See figure 88

The painting is mounted on masonite and has been cut down from the 30 × 25 inch size.

NOTES

1. Robert C. Vose, Jr., "Reverend Joshua Gee," unpub. ms., Vose Galleries, Boston.
2. Foote 1950, p. 156.
3. Ibid.

86 Mrs. Edward Tyng, 1733

Yale University Art Gallery, gift of the Associates in Fine Arts
50 1/8 × 40 1/8 (127.3 × 101.9)
Provenance: The sitter; her son William Tyng; his son-in-law Rev. Timothy Hillard; his son William Tyng Hilliard; his granddaughter Miss Mabel Harlow; Miss Elsie P. Lord, 1940; Yale University Art Gallery, 1944[1]
Notebook: [May 1733], p. 91, no. 77: "Mrs. Ting H.P. 1/2 50–0–0"
Literature: William Goold, *Portland of the Past* (Portland, Me., 1886), opp. 25 [attributed to Blackburn]; Waldo Lincoln, *Genealogy of the Waldo Family* (Worcester, Mass., 1902), vol. 1, p. 110 [attributed to Blackburn]; New Haven 1949, no. 33; Foote 1950, p. 194; Saunders 1979, vol. 1, p. 158; vol. 2, pl. 121
Subject: Anne Tyng; born in Boston, April 13, 1708; daughter of Jonathan Waldo and Hannah Mason Waldo; sister of Brig. Gen. Samuel Waldo; married Edward Tyng (1683–1755), a Boston merchant, January 27, 1731 (his second wife); died January 14, 1754[2]

See figure 85

This portrait is in excellent condition, with only minor inpainting.

NOTES

1. Foote 1950, p. 194.
2. Ibid.

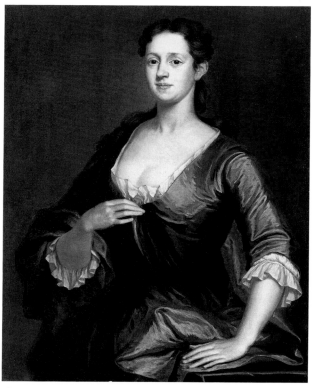

87

87 Mrs. John Erving, 1733

Smith College Museum of Art, Northampton, Mass., purchased with funds realized from the estate of Maxine Weil Kunstadter ('24), 1981
39 3/4 × 30 3/4 (100.9 × 78.1)
Provenance: By descent to great-great-grandson John Erving V, New York; his daughter Sarah Erving King (Mrs. James Gore King), New York, 1917–1955; her son James Gore King, New York, 1955–1979; the estate of James Gore King; on loan to the Wadsworth Atheneum, Hartford, Conn., 1981; Smith College Museum of Art, 1982[1]
Notebook: [June 1733], p. 91, no. 81: "Mrs. Irwin HP L 1/2 45–0–0"
Literature: Foote 1950, p. 151, rep. opp. 80; Sellers 1957, p. 437 rep.; Belknap 1959, pl. 26, 22D; Saunders 1979, vol. 1, p. 158; vol. 2, pl. 119
Subject: Abigail Phillips, born 1702; daughter of John Phillips and Mary Grosse Phillips; married, in 1725, John Erving, a Boston merchant who had emigrated from the Orkney Islands around 1705. Four of her seven children married extremely well: John married Gov. William Shirley's daughter Maria Catherina; George married (1) a daughter of Isaac Winslow, (2) a daughter of Isaac Royall; Elizabeth married James Bowdoin (cat. no. 114); Sarah married Samuel Waldo. She died in 1759 and is buried at King's Chapel.[2]

Stylistically, this is a typical Smibert portrait, although the figure is painted somewhat more forcefully than was normal for Smibert. The portrait format—"little 1/2" or 40 × 30 inches—is unusual, although Smibert did on occasion employ it (see cat. no. 41). The painting is largely in good condition, but at some point the canvas suffered a tear to the right side of the face and hair.

NOTES

1. Statement about the portrait which accompanied a letter to the author from Ms. Blue Balliett, March 12, 1981.
2. Ibid.; Foote 1950, p. 151.

88 Rev. John Rogers,* 1733

Courtesy John Rogers, New Canaan, Conn.
30 1/2 × 25 (77.5 × 63.5)
Inscription: On Reverse "AE 66"
Provenance: By descent to Daniel Denison Rogers; his son John Rogers, Boston; his daughter; her nephew Derby Rogers, New Canaan, Conn.; Miss Katherine Rebecca Rogers, by 1955;[1] on loan to New-York Historical Society, 1955–1973; John Rogers, New Cannan, by 1978
Notebook: [June 1733], p. 91, no. 82: "The Revd. Mr. Rogers HP 3/4 25–0–0"
Literature: New Haven 1949, no. 26; Foote 1950, p. 187; Saunders 1979, vol. 1, p. 159; vol. 2, pl. 122
Subject: John Rogers, born 1666; son of Rev. John Rogers, fifth president of Harvard College, and Elizabeth Denison Rogers, granddaughter of Gov. Thomas Dudley; graduated from Harvard, 1684; married Martha Whittingham, March 4, 1691, minister at Ipswich, Mass., until his death, December 28, 1745[2]

See figure 86

This portrait, like several others Smibert painted of ministers, is among the most sensitively rendered of his American career.

NOTES

1. Letter to the author from Mary Alice Kennedy, assistant curator, New-York Historical Society, November 2, 1977.
2. Foote 1950, p. 187.

89 Rev. John Rogers, 1733

Peabody Essex Museum, Salem, Mass.
32 1/2 × 24 1/2 (82.5 × 62.2)
Inscription: On reverse [no longer evident] "Smibert fecit, Aetas suae 66"
Provenance: Gift of Nathaniel L. Rogers to Essex Institute
Engraved: By T. Kelley, c. 1745: "Engraved from a copy of the original by Smibert—T. Kelley / Rev. John Rogers / of Ipswich, Mass., AE66 / Died Dec. 28th 1745, in his 80th year
Notebook: Not recorded
Literature: NEHGS *Register,* vol. 2, no. 2 (August 1851), rep.; Bayley 1929, p. 421; Lee 1930, rep.; Essex Institute 1936, opp. p. 184; Burroughs 1936, p. 38; Foote 1950, p. 188
Subject: See cat. no. 88

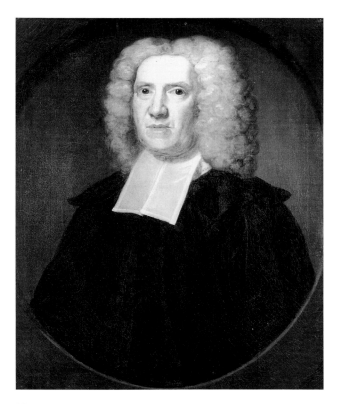

89

This portrait is a replica of cat. no. 88.

90 Mrs. Peter Oliver (Mary Clark Oliver), 1734

Andrew Oliver, Jr., Daniel Oliver, and Mrs. Daniel Morley
29 1/2 × 24 1/2 (74.9 × 62.2)
Provenance: The sitter (portrait taken to London at time of Revolution); by descent to Thomas Hutchinson Oliver; Mrs. Walsham How, by 1938; purchased by W. H. P. Oliver, Morristown, N.J., c. 1938;[1] Andrew Oliver, Boston, by 1973
Notebook: [January 1734], p. 92, no. 86: "Mrs. P. Oliver H.P. 3/4 26–0–0"
Literature: Foote 1950, pp. 175–176; Oliver 1960, p. 11, no. 9 rep.; Saunders 1979, vol. 1, pp. 177–178; vol. 2, pl. 123
Subject: Mary Clark (1713–1775), daughter of William Clark and Hannah Appleton Clark; married Peter Oliver (cat. no. 93), July 5, 1733[2]

See figure 78

NOTES

1. Foote 1950, p. 176.
2. Ibid., 175.

91 Rev. John Hancock, 1734

Lexington Historical Society, Lexington, Mass.

28 × 23 (71.1 × 58.4)

Provenance: Son of sitter, Thomas Hancock; his nephew John Hancock; on loan to Cary Library, Lexington, 1878; Washington Hancock; purchased with the portrait of Mrs. Hancock (cat. no. 97) for $325 from the estate of Washington Hancock, by Lexington Historical Society[1]

Notebook: [March 1734], p. 92, no. 88: "The Rd. Mr. Handcock H.P. 3/4 25–0–0"

Literature: MHS *Proc.*, vol. 16 (1878), p. 389 [as by Blackburn]; Foote 1950, p. 161; Dean T. Lahikainen, *Lexington Portraits: A Catalogue of American Portraits at the Lexington Historical Society* (Lexington, Mass., 1977), pp. 13–15; Saunders 1979, vol. 1, pp. 178–179; vol. 2, pl. 128

Copy: This portrait and its pendant (cat. no. 97) were copied by a Mr. Lowe in 1929 at the Museum of Fine Arts, Boston. There is also evidence that the originals were restored at this time.

Subject: John Hancock, born 1671; son of Nathaniel Hancock, a Cambridge shoemaker, and Mary, daughter of Henry Prentice; graduated from Harvard College, 1689; minister in Lexington, 1697–1752; married Elizabeth, daughter of Rev. Thomas Clark of Chelmsford; five children; died December 1752[2]

See figure 76

Rev. John Hancock was the father of John Hancock, first signer of the Declaration of Independence, president of the Continental Congress, and first governor of Massachusetts after independence. The second son, Ebenezer, served as his father's colleague, 1734–1740. A third son, Thomas (cat. no. 63), became a prominent Boston merchant. Two daughters, Elizabeth and Lucy, married ministers.

This portrait and its pendant (cat. no. 97) were among the original furnishings of the house (now called Hancock-Clarke House) that Thomas Hancock bought for his parents in 1734.[3]

NOTES

1. Frick Art Reference Library, Smibert, John Hancock, painting file.

2. Sibley and Shipton 1873–1956, vol. 3, pp. 429ff.

3. Dean T. Lahikainen, *Lexington Portraits: A Catalogue of American Portraits at the Lexington Historical Society* (Lexington, Mass., 1977), p. 14.

92 William Lambert, 1734

© Addison Gallery of American Art, Phillips Academy, Andover, Mass., All Rights Reserved

35 1/8 × 27 (89.4 × 68.6)

Provenance: The sitter; his nephew William Lambert, 1749;[1] his son William Lambert; his daughter Harriet Lambert (Mrs. William Blanchard); her daughter Susanna Lambert Blanchard, Roxbury;[2] her great-grandson William Lambert Barnard, Brookline, by 1926;[3] bequest to Museum of Fine Arts, Boston, 1955; purchased by Addison Gallery of American Art, 1958

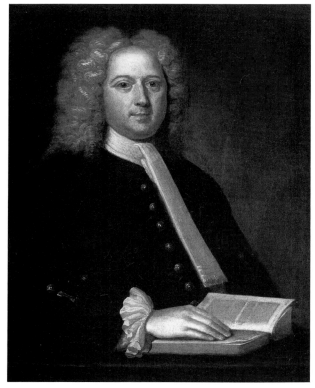

92

Notebook: [March 1734], p. 92, no. 89: "Mr. Lambert H P KK 37–10–0"

Literature: New Haven 1949, no. 16: Foote 1950, p. 165; Saunders 1979, vol. 1, p. 179; vol. 2, pl. 132

Subject: William Lambert, an Anglican, born in England, 1681; emigrated to Boston before 1731; comptroller of customs for Massachusetts Bay; died 1749

This painting, along with a portrait of Mrs. William Lambert (cat. no. 109), is mentioned in the sitter's will, probated December 5, 1749: "I give to my nephew William Lambert my Picture & my Wife's Picture which was drawn by Mr. Smibert."[4]

NOTES

1. William Lambert's will, see Foote 1950, p. 166.

2. Letter to Kathryn [Buhler] from Charles E. Blanchard, n.d., copy at Addison Gallery of American Art, painting file.

3. William Lambert Barnard to Frank Bayley, October 9, 1926, American Antiquarian Society, Frank W. Bayley Papers.

4. Foote 1950, p. 165.

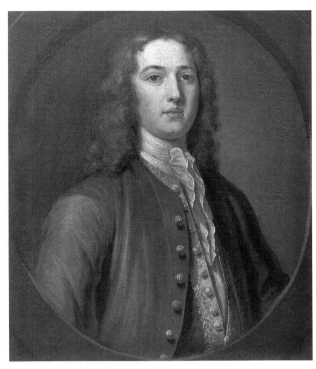

93

93 Peter Oliver,* 1734

Andrew Oliver, Jr., Daniel Oliver, and Mrs. Daniel Morley

29 1/2 × 24 1/2 (74.9 × 62.2)

Provenance: The sitter (portrait taken to London at time of Revolution); by descent to Thomas Hutchinson Oliver; Mrs. Walsham How, by 1938; purchased by W. H. P. Oliver, Morristown, N.J., c. 1938; Peter Oliver[1]

Notebook: [March 1734], p. 92, no. 90: "Mr. P. Oliver pyd. 3/4 12–10–0"

Literature: Sibley and Shipton 1873–1956, vol. 1, opp. p. 738 rep.; Foote 1950 p. 175; Oliver 1960, no. 8 rep.; Saunders 1979, vol. 1, p. 178; vol. 2, pl. 127

Subject: See cat. no. 81

Oliver wears an olive-green coat trimmed with silver buttons. Foote believed that he is shown wearing a brown wig, but it is equally possible that this is his own hair. This portrait was painted as a pendant to cat. no. 90.

NOTES

1. Foote 1950, p. 175.

94 William Browne, 1734

Johns Hopkins University, Halsted Collection

92 1/2 × 57 (234.9 × 144.8)

Provenance: The sitter; his son William Burnet Browne, who moved to Virginia in 1769; by descent to J. L. Deans, "Rosewell," Gloucester County, Va.; his cousin Junius Browne; purchased by

Dr. W. L. Halstead; bequest of Dr. W. L. Halstead to Johns Hopkins University

Notebook: [April 1734], p. 92, no. 92: "William Brown Esqr. / whole Lenth H.P. 100–0–0"

Literature: *Essex Institute Historical Collections,* vol. 32 (July–December, 1896), engraving after rep.; Bayley 1929, p. 357; New Haven 1949, no. 7; Foote 1950, p. 138–139; Eleanor S. Quandt, "Technical Examination of 18th Century Paintings," in *American Painting to 1776: A Reappraisal* (Winterthur, Del., 1971), p. 368, n. 12; Saunders 1979, vol. 1, pp. 179–180; vol. 2, pl. 133

Subject: William Browne, wealthy New England merchant; born in Salem, May 7, 1709; son of Samuel Brown (cat. no. 123) and Abigail Browne; along with his older brother, Samuel (cat. no. 99), graduated from Harvard, 1727; Congregationalist; married (1) Mary (cat. no. 126), daughter of Gov. William Burnet, 1737, (2) Mary French of New Brunswick, N.J.; died April 27, 1763.[1] During the 1730s Browne built a lavish country house, Browne Hall, in Danvers, Mass.

See plate 16

Were it not for the known identification of the sitter and the provenance of this portrait, it might easily be mistaken for a work by one of Smibert's contemporaries. Full-length portraits by colonial artists are rare, and probably fewer than twenty-five survive. This was Smibert's first American full-length and one of only six he painted (see cat. nos. 126, 127, 138, 185, 425). Comparison with Smibert's only surviving London full-length (cat. no. 22) indicates that there was little falloff in Smibert's ability to paint the full-length figure.

Along with the Oliver family, the Brownes were Smibert's most important and conspicuous American clients. Between 1734 and 1738 various Brownes commissioned twelve portraits at a cost of more than £175, including two full-lengths, two miniatures (nos. 103, 210), and several half-lengths and three-quarter-lengths.

This portrait was painted on a commercially prepared London canvas, which Smibert imported. The painting was restored and lined in 1970 by Victor B. Covey and Kay Silberfield.[2]

NOTES

1. Foote 1950, p. 138.

2. Eleanor S. Quandt, "Technical Examination of 18th Century Paintings," in *American Painting to 1776: A Reappraisal* (Winterthur, Del., 1971), p. 358.

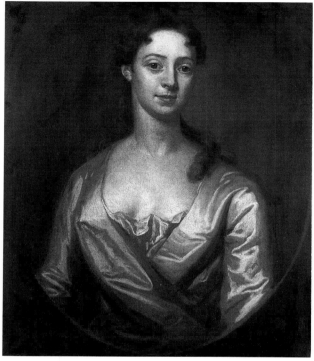

95

95 Anna Gerrish Gee, 1734

Courtesy Massachusetts Historical Society
30 × 25 (77.3 × 65)
Provenance: Acquired by the Massachusetts Historical Society by
 1878[1]
Notebook: [April 1734], p. 92, no. 93: "Mrs. Gee H.P. 3/4 25–0–0"
Literature: Tuckerman, 1867, p. 42; MHS *Proc.,* vol. 16 (1878),
 p. 395; Champlin and Perkin 1913, vol. 4, p. 192; Bolton 1919–
 1926, vol. 3, p. 1032; Bayley 1927, p. 389; Foote 1950, p. 157;
 Saunders 1979, vol. 1, p. 178; vol. 2, pl. 124; Oliver, Huff, and
 Hanson 1988, p. 42
Subject: Anna Gerrish, born 1700; daughter of Captain John Ger-
 rish (cat. no. 120) and Sarah Hobbes Gerrish; married (1) Sam-
 uel Appleton (d. 1728), 1719, and (2) Rev. Joshua Gee (cat. no.
 85), April 27, 1734; died September 4, 1736

The sitter is depicted wearing a white satin gown.
Another portrait of her (private collection) was painted
c. 1719–1727 as a companion to that of her first husband,
Samuel Appleton.

NOTES

 1. Foote 1950, p. 157.

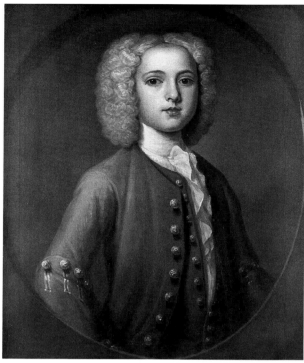

96

96 Samuel Pemberton, 1734

Bayou Bend Collection, Museum of Fine Arts, Houston
30 1/4 × 24 1/4 (76.8 × 61.6)
Provenance: Miss Julia Ward, Boston, c. 1900; her cousin George
 H. Davenport, Boston; his daughter Mrs. William Truman Al-
 drich, Brookline, Mass., 1932–1949; sold by George Aldrich to
 Vose Galleries, Boston, 1972; purchased by Miss Ima Hogg,
 Bayou Bend, Houston, Texas, 1972
Notebook: [May 1734], p. 92, no. 94: "Mr. J. Pembertons yr.
 son / H.P. 3/4 25–0–0"
Literature: Boston 1930, p. 68; Foote 1950, pp. 178–179; New
 Haven 1949, no. 23; *Antiques,* vol. 101 (June 1972), p. 912; Saun-
 ders 1979, vol. 1, p. 179; vol. 2, pl. 131; David B. Warren, *Bayou
 Bend: American Furniture, Paintings, and Silver from the Bayou Bend
 Collection* (Houston, 1975), p. 125 rep.
Subject: Samuel Pemberton, born 1723; son of James Pemberton
 and Hannah Penhallow Pemberton, members of First Church
 (Congregationalist); brother of Hannah (cat. no. 100) and Mary
 (no. 101) Pemberton; graduated from Harvard, 1743; became a
 merchant in his father's business and later served as selectman,
 1769–1772; died August 21, 1779[1]

The sitter is shown wearing a gray coat and waistcoat. His
portrait retains its original frame (which matches that of
cat. no. 101).

NOTES

 1. Foote 1950, p. 178.

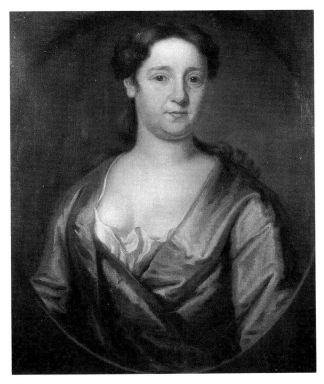

97

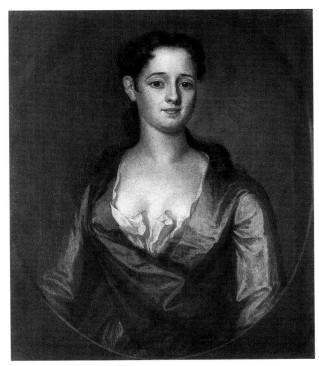

98

97 Mrs. John Hancock, 1734

Lexington Historical Society, Lexington, Mass.
28 × 23 (71.1 × 58.4)
Provenance: See cat. no. 91
Notebook: [May 1734], p. 92, no. 95: "Mrs. Handcock H.P. 3/4 25–0–0"
Literature: MHS *Proc.*, 16 (1878), p. 389; Foote 1950, p. 162; Dean T. Lahikainen, *Lexington Portraits: A Catalogue of American Portraits at the Lexington Historical Society* (Lexington, 1977), pp. 13–15; Saunders 1979, vol. 1, p. 179; vol. 2, pl. 129
Subject: Elizabeth Clark (1687–1760), born in Chelmsford, Mass.; daughter of Rev. Thomas Clark;[1] at age thirteen married Rev. John Hancock (cat. no. 91).

Mrs. Hancock is shown wearing a plum-colored satin gown. It has been suggested that since this portrait and cat. no. 91 were painted the same year that Thomas Hancock built a parsonage for his parents that he may well have given them their portraits as well.[2]

NOTES

1. Sibley and Shipton 1873–1956, vol. 3, p. 429.
2. Lahikainen, *Lexington Portraits: A Catalogue of American Portraits at the Lexington Historical Society* (Lexington, Mass., 1977), p. 15.

98 Mrs. Thomas Bulfinch (?), c. 1734

Cleveland Museum of Art, Hinman B. Hurlbut Collection, 3919.20
29 × 24 1/4 (73.6 × 61.6)
Provenance: By descent to Mrs. Francis Alexander, Florence, Italy;[1] Miss Emily Hallowell, by 1920; purchased by Cleveland Museum of Art, 1920[2]
Notebook: Not recorded as presently identified
Literature: Cleveland Museum of Art, *Bulletin,* vol. 8, no. 1 (January 1921), rep.; Bayley 1929, p. 361 rep.; Bolton 1933, p. 42; Burrough 1936, pp. 32 rep., 35; Burroughs 1942, p. 119; Charles E. Slatkin and Regina Schoolman, *Treasury of American Drawings* (New York, 1947), pp. 5–6; Foote 1950, p. 140; Cleveland Museum of Art, *Handbook* (1958), rep. no. 525; Cleveland Museum of Art, *Handbook* (1966), p. 155; Milton Brown, *American Art to 1900* (New York, 1977), pp. 94–95 rep.; Saunders 1979, vol. 1, p. 179; vol. 2, pl. 130
Subject: Judith Colman, born in Boston, May 1, 1707; daughter of John Colman and Judith Hobby Colman; married Dr. Thomas Bulfinch (1694–1757), a physician educated in Paris, June 1724; grandmother of the architect Charles Bulfinch; died in Boston, July 20, 1765[3]

Smibert did not record painting a portrait of Mrs. Bulfinch. It is conceivable that he simply neglected to enter the portrait in his notebook, but the present identification of the sitter also may be incorrect. The sitter wears the blue gown typical of many of his American portraits of women around 1734. Particular care was given to painting the shaded oval that separates the portrait from the surround-

ing spandrels. This emphasis gives the portrait a pleasing but unusual (for Smibert) sense of recessed space.

NOTES

1. Cleveland Museum of Art, painting files.
2. Foote 1950, p. 140.
3. Ibid.

99 Samuel Browne, 1734

Rhode Island Historical Society
50 × 40 (127 × 101.6)
Provenance: Mrs. Destailleur, New Forest, Hampshire, England, by 1891; purchased by Edward Perry Warren, 1891; gift of Edward Perry Warren to Rhode Island Historical Society, 1891
Notebook: [June 1734], p. 92, no. 97: "Samewell Broun Esqr. / H.P. 1/2 50-0-0"
Literature: Updike 1907, vol. 2, p. 281, n. 615; Bayley 1929, p. 453 rep. [as Joseph Wanton]; Coburn 1929, "John Smibert," 2d pl. following p. 176; Jarvis M. Morse, "The Wanton Family and Rhode Island Loyalism," *Rhode Island Historical Society Collections* (April 1938), pp. 33–45; Foote 1950, p. 196; Belknap 1959, pp. 294–295 rep.; Frank H. Goodyear, Jr., "The Painting Collection of the Rhode Island Historical Society," *Antiques*, vol. 100 (November 1971), pp. 750–752 rep.; Frank H. Goodyear, Jr., "Paintings at John Brown House," *Rhode Island History*, vol. 31 (Spring/Summer 1972), pp. 38–39 rep.; Goodyear 1974, pp. 3–4 rep.; Saunders 1979, vol. 1, pp. 180–181; vol. 2, pl. 134
Subject: Samuel Browne, born April 7, 1708; son of Col. Samuel Browne and Abigail Keech Browne, perhaps the richest family in Salem; graduated from Harvard, 1727; married Katherine Winthrop (cat. no. 102), 1731. Also in 1731, he and his brother, William (cat. no. 94), inherited a vast entailed estate. He was a successful merchant before his death at age thirty-four, November 26, 1742,[1] at which time he left an estate valued at £21,000.

See plate 18

In 1891, when this portrait of a corpulent young man was given to the Rhode Island Historical Society, it was thought to depict Joseph Wanton (1705–1780), a governor of Rhode Island. Foote accepted that the portrait was by Smibert but questioned the identification because the picture did not resemble another known portrait of Wanton.[2] Goodyear identified the sitter as Samuel Browne when he realized that a copy of this portrait's pendant (cat. no. 102) was known to represent Katharine Winthrop Browne.[3]

Samuel and William were sons of the successful merchant, public servant, and philanthropist Col. Samuel Browne (cat. no. 123). He was a chief justice of the county court and a member of the provincial council, and he added to the endowment of a family scholarship at Harvard. In response, Browne's sons received favored treatment at college and were ranked first and second in their class (1727), at a time when rank was determined by social status. The Harvard Corporation leaped at the opportunity to favor young Samuel: "Whereas Samuel Brown, Eldest Son of Samuel Brown Esq. of Salem, now about to be admitted into the College, is a Youth that labours under that bodiely Infirmity which disables him from the going on Errands,[4] as is usual for the Fresh-men to do, And Whereas his Honourable Ancestors have been Generous Benefactors to the Value of Eight hundred pounds. And also whereas his Honoured Father has now proposed his Son's presenting the College with A piece of Plate upon his Admission of much greater Value than would Entitle him to the Priviledges & Honours of a Fellow-Commoner; It is therefor Order'd by the Corporation that the said Samuel Brown shalbe entirely Exempt from going of Errands, during his Freshmanship.[5]

His attire—an olive-green coat with ornamental gold frogs—is among the most elaborate of any American sitter and was presumably requested by Browne. The painting is generally in sound condition but experienced a tear (immediately above the face), which has been repaired. The frame is original but has been regilded.

NOTES

1. Sibley and Shipton 1873–1956, vol. 8, pp. 118–119.
2. Foote 1950, p. 196.
3. Goodyear 1974, pp. 3–6.
4. According to Samuel Eliot Morison, it was normal for upperclassmen to require freshman to do menial work ("errands") for them. *Harvard College in the Seventeenth Century* (Cambridge, Mass., 1936), vol. 1, p. 83.
5. Sibley and Shipton 1873–1956, vol. 8, p. 118.

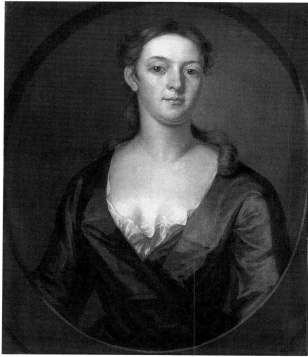

100

100 Hannah Pemberton, 1734

Metropolitan Museum of Art, Rogers Fund, 1943
29 1/2 × 24 1/2 (74.9 × 62.2)
Provenance: The sitter; her daughter Mary Colman Ward; her daughter Phoebe Ward Cutler; her grandson Henry Davenport, by 1878;[1] his first cousin Ellen Maria Ward, Boston, by 1896; on loan to Dr. Colman W. Cutler, New York (owner, 1933–1935); his son Paul C. Cutler, Rocky River, Ohio, 1934–1938; MacBeth Gallery, New York, as agent, 1938–1943; purchased by Metropolitan Museum of Art, 1943
Notebook: [July 1734], p. 92, no. 98: "Mrs. [transcription is incorrect: should read Ms.] Hannah Pemberton H.P. 3/4 25-0-0"
Literature: MHS *Proc.,* vol. 17 (1879), pp. 93–95 [as Mrs. Benjamin Colman]; Henry H. Edes, *Publications of the Colonial Society of Massachusetts,* vol. 6 (1904), p. 89; Bolton 1933, p. 42; L. Burroughs, *Metropolitan Museum of Art Bulletin,* vol. 3 (December 1944), pp. 98–99; Foote 1950, pp. 177–178; Gardner and Feld 1965, vol. 1, pp. 4–5 rep.; D. B. Warren, *Bayou Bend: American Furniture, Paintings, and Silver from the Bayou Bend Collection* (Houston, 1975), p. 125; Saunders 1979, vol. 1, pp. 178–179; vol. 2, pl. 125; Caldwell and Rodriguez-Roque 1994, p. 19
Subject: Hannah Pemberton, born March 10, 1715; daughter of James Pemberton and Hannah Penhallow Pemberton; sister of Samuel (cat. no. 96) and Mary (cat. no. 101) Pemberton; married the Boston merchant Benjamin Colman (cat. no. 132), August 16, 1739; date of death is unknown, although she was alive in September 1753, when her ninth child was born.[2]

This is one of three portraits that Smibert painted of the Pemberton siblings during 1734. The similarity of their format and appearance suggests that they may well have been intended to hang together.[3] A label on the back of the frame reads, "Subject portrait of Hannah (Pemberton) owner Henry Davenport-1878."

NOTES

1. Metropolitan Museum of Art, American Wing, painting files.
2. Sibley and Shipton 1873–1956, vol. 8, p. 132.
3. Caldwell and Rodriguez-Roque 1994, p. 19.

101 Mary Pemberton, 1734

Bayou Bend Collection, Museum of Fine Arts, Houston
30 1/2 × 25 1/2 (77.5 × 65)
Provenance: Miss Julia Ward, Boston; her cousin George H. Davenport, Boston, c. 1900–1932; his daughter Mrs. William T. Aldrich, b. 1932; sold by George Aldrich to Vose Galleries, Boston, 1972; Miss Ima Hogg, Bayou Bend, Houston; bequest to Museum of Fine Arts, Houston
Notebook: [July 1734], p. 92, no. 99: "Mrs. [transcription incorrect: should read "Ms."] Marey Pemberton H.P. 3/4 25-0-0"
Literature: Bayley 1929, p. 411 rep.; Boston 1930, p. 68; New Haven 1949, no. 22; Foote 1950, p. 178; Warren 1975, p. 125, no. 237 rep.
Subject: Mary Pemberton (1717–1763), daughter of James Pemberton and Hannah Penhallow Pemberton; sister of Samuel (cat. no. 96) and Hannah (cat. no. 100) Pemberton

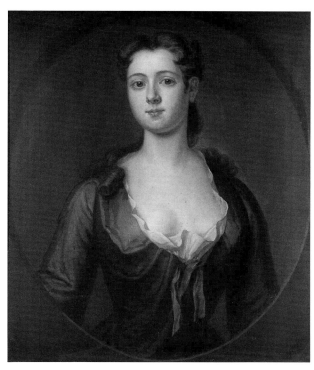

101

The sitter wears a greenish-blue gown with a pink ribbon at the bodice. The portrait retains its original frame, which matches that of cat. no. 96.

102 Katherine Winthrop Browne, 1734

Courtesy Rhode Island Historical Society, 1891.2.2
50 × 40 (127 × 101.6)
Provenance: See cat. no. 99
Notebook: [August 1734], p. 92, no. 100: "Mrs. Brown 3/4 [incorrect transcription: should read " 1/2"] 50-0-0"
Literature: Updike 1907, vol. 2, p. 281, n. 615; Foote 1950, p. 196; Belknap 1959, pp. 294–295 rep.; MFA 1969, vol. 1, pp. 1–2; Frank H. Goodyear, Jr., "The Painting Collection of the Rhode Island Historical Society," *Antiques,* vol. 100 (November 1971), pp. 750–752 rep.; Frank H. Goodyear, Jr., "Paintings at John Brown House," *Rhode Island History,* vol. 31 (Spring/Summer 1972), pp. 38–39 rep.; Goodyear 1974, pp. 3–4 rep.; Saunders 1979, vol. 1, pp. 180–181; vol. 2, pl. 135
Copy: In oils, 50 1/2 × 40 3/4 inches, Museum of Fine Arts, Boston, 1929.784. This copy was also identified by Foote. The surface is not at all typical of Smibert, and the painting probably dates from the early nineteenth century.
Subject: Katherine Winthrop, born March 9, 1711; daughter of John Winthrop and Anne Dudley Winthrop of New London, Conn.; younger sister of Mary Wanton (1708–1767), wife of Gov. Joseph Wanton; married (1) Samuel Browne (cat. no. 99), 1732, (2) Col. Epes Sargent II of Gloucester, 1744; died January 11, 1781[1]

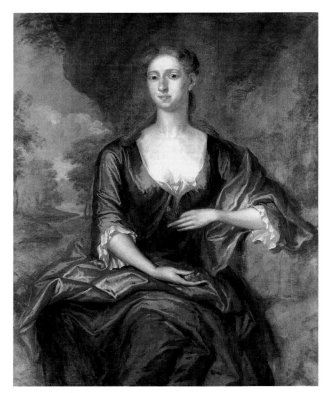

102

Notebook: [August 1734], p. 92, no. 101: "Mr. S. Brown in Littell
 H.P. 1/2 25–0–0"
Literature: Saunders and Miles 1987, pp. 122–123
Subject: See cat. no. 99

See figure 96

In August 1734 Smibert painted this portrait of Samuel Browne, perhaps the earliest oil miniature painted in the colonies. In June he had painted a three-quarter-length portrait of Browne, along with one of his wife (cat. nos. 99 and 102). Smibert presumably copied directly from the life-size portrait, as the sitter wears the same olive-green coat with stylish gold tassels evident there. He entered this tiny portrait in his notebook as "In Littell,"[1] the phrase used by artists since the Elizabethan period to distinguish paintings on a miniature scale. This miniature is one of only three recorded by Smibert. The others are a copy of a child's portrait painted in London in 1725 and one of William Browne, Samuel's younger brother. Neither miniature is now located.

One of the reasons that Smibert may have painted so few miniatures is their cost: he charged the same for a miniature as for a life-size half-length portrait. Apparently, few of Smibert's patrons were ready to invest that much money in a portrait intended primarily for intimate viewing. Browne's portrait has a gold clasp so that it might be worn on a chain about the neck, and it is mounted in a gold frame made by Boston's leading goldsmith, Jacob Hurd (1703–1758), whose stamp is imprinted on the reverse. The maker's mark, "Hurd," in an oval, appears on numerous pieces made by the goldsmith between 1725 and 1750.[2]

It is not surprising that of all Smibert's patrons, a member of the Browne family chose to have a miniature painted. The Brownes were among the wealthiest families in Massachusetts, with vast land and mercantile holdings. This miniature remained in the hands of Browne descendants until earlier in this century. Even before its rediscovery, several of Smibert's other paintings, particularly his preliminary studies for *Sir Francis Grant and His Family* (cat. no. 5) and *The Bermuda Group* (cat. no. 70), indicated he had mastered the delicate skills of the miniaturist.

In 1891, when this portrait was given to the present owner (along with its pendant, cat. no. 99), it was identified as Mary Wanton, the wife of Rhode Island's governor, Joseph Wanton. Foote accepted it as a Smibert but questioned the identification.[2] When Goodyear saw a copy of cat. no. 102 identified as Katherine Winthrop Browne he realized that this particular painting represented Mary Wanton's sister.[3]

The painting is generally in poor condition. It is thinly painted and abraded. Its frame, which matches that of cat. no. 99, is original but regilded.

NOTES

1. Foote 1950, pp. 213–214.
2. Ibid., pp. 196–197.
3. Goodyear 1974, pp. 3–6.

NOTES

1. Smibert 1969, p. 92.
2. Buhler 1970, vol. 1, pp. 124–125.

103 Samuel Browne, 1734

Woodside Trust
Oil on copper: 1 1/2 × 1 3/8 (3.8 × 3.5)
Case marked on reverse: "Hurd" (in oval)
Provenance: The sitter; his son William Browne; his daughter Mary Browne; her son Somers Tucker; his son Alexander Tucker; gift to Herward Trott Watlington

104 Rev. Ebenezer Turell, 1734

Collection of the Newark Museum, purchase 1972 Members' Fund and Katherine Coffey Fund
29 1/2 × 24 1/2 (74.9 × 62.2)
Provenance: Sitter; his nephew Turell Tufts; First Parish, Medford, Mass., by 1842; later Unitarian Universalist Church of Medford; Childs Gallery, as agent, 1972–1973; purchased by Newark Museum, 1972
Notebook: [October 1734], p. 92, no. 105: "Rd Mr. Tewrill H.P. 3/4 25–0–0"

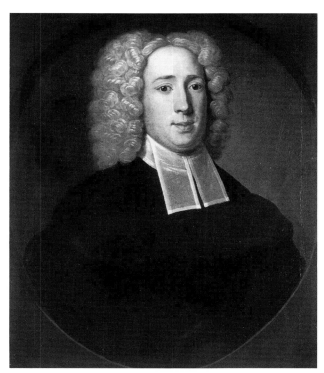

104

Literature: Charles Brooks, *History of the Town of Medford* (1855), engraving of rep.; Sibley and Shipton 1873–1956, vol. 6, opp. p. 574; Foote 1950, pp. 192–193; *Newark Museum News Notes*, September 1973, rep.; *Antiques*, vol. 104 (December 1973), p. 990 rep.; Newark Museum, *American Art in the Newark Museum* (Newark, 1981), p. 22 rep.; Saunders 1979, vol. 1, p. 183; vol. 2, pl. 137

Subject: Ebenezer Turell, born in Boston, February 5, 1702; son of Samuel Turell and Lydia Stoddard Turell; after graduation from Harvard (1721) became minister of First Parish, Medford, Mass., 1724–1778; married (1) Jane Colman (d. 1735), daughter of Rev. Benjamin Colman, (2) Lucy Davenport (d. 1759), daughter of Addington Davenport, (3) Jane Pepperrell; died 1778[1]

This is a competent portrait in excellent condition. At the time of his death Turell owned this portrait and one of his wives, as well as portraits of Charles II, Oliver Cromwell, Benjamin Colman (cat. no. 236), Addington Davenport, and Judge Isaac Addington. He left this portrait to Turell Tufts so that "his shadow might remain in Medford."[2]

NOTES

1. Foote 1950, pp. 192–193.
2. Sibley and Shipton 1873–1956, vol. 6, p. 580.

105 Elizabeth Lindall Pitts, 1735

Detroit Institute of Arts, Founders Society Purchase, Gibbs-Williams Fund

36 1/8 × 28 3/4 (91.7 × 73)

Provenance: By descent to Lendall Pitts, Paris; his wife, Mrs. Lendall Pitts, Norfolk, Va., by 1949; on loan to Mrs. Arthur Maxwell Parker, Grosse Point Farms, Mich.;[1] Detroit Institute of Arts, 1958

Notebook: [January 1735], p. 93, no. 107: "Mrs. Pitts HP KK 9 Ginnes"

Literature: NEHGS *Register*, vol. 7 (1853), p. 17; Daniel Goodwin, *Memorial of the Life and Service of James Pitts and His Sons* (Chicago, 1881), p. 33; Daniel Goodwin, *The Dearborns: A Discourse Commemorative of the 80th Anniversary of the Occupation of Fort Dearborn* (1884), rep.; Daniel Goodwin, *Provincial Pictures by Brush and Pen* (Chicago, 1886), rep. opp. pp. 7, 14; Foote 1950, pp. 166–167 [as Mrs. James Lindall]; Detroit Institute of Arts, *Eight Generations of the Pitts Family*, exh. cat. (Detroit, 1959), p. 14 [as Mrs. James Lindall]; Saunders 1979, vol. 1, pp. 184–185; vol. 2, pl. 139; Craven 1986, pp. 173, 175–176; *American Paintings in the Detroit Institute of Arts* (New York, 1991), vol. 1, pp. 182–183

Subject: Elizabeth Lindall, born July 16, 1680; daughter of James and Susannah Lindall; married John Pitts (1668–1731), September 10, 1697; died 1763[2]

See figure 80

Until now this portrait has been identified as Mrs. James Lindall (1660–1733), the mother of Mrs. John Pitts.[3] Smibert's portrait, however, was not painted until 1735, two years after Mrs. Lindall's death. Further, the portrait depicts a woman in late middle age, and Mrs. John Pitts was fifty-four at the time of the portrait.

Although this sitter is far from beautiful, Smibert's portrait of her is much more memorable than many of his other portraits of women. This stern, masculine-looking woman with piercing eyes was painted with a force seldom found in Smibert's female portraits. The artist did not mask her lack of ease or her ill-fitting gown. His handling of paint is firm and confident; the details are clear and precise. With her gray-flecked hair, sagging cheeks, double chin, and ruddy complexion, Mrs. Pitts was painted as she undoubtedly looked rather than in an idealized manner. It is in portraits such as this that Smibert presented a much less refined, but probably much more accurate, image of the inhabitants of Boston.

NOTES

1. Foote 1950, p. 166.
2. Detroit Institute of Arts, *Eight Generations of the Pitts Family*, p. 17.
3. Foote 1950, pp. 166–167.

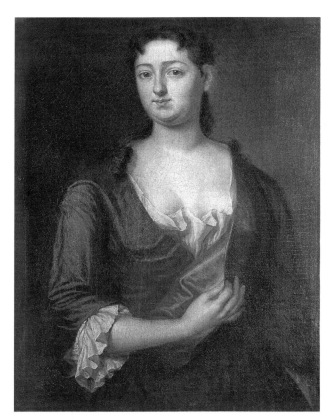

106

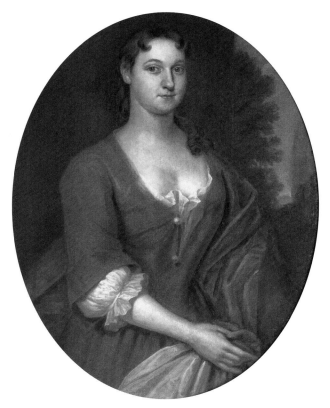

107

106 Mrs. James Pitts, 1735

Detroit Institute of Arts, Founders Society Purchase, Gibbs-Williams Fund

36 1/2 × 28 1/8 (95.3 × 71.4)

Provenance: See cat. no. 105

Notebook: [January 1735], p. 93, no. 108: "young Mrs. Pitts H P KK 9 Ginnes"

Literature: NEHGS *Register*, vol. 7 (1853), p. 15; Daniel Goodwin, *Memorial of the Life and Service of James Pitts and Sons* (1881), pp. 2, 73; Daniel Goodwin, *The Dearborns: A Discourse Commemorative of the 80th Anniversary of the Occupation of Fort Dearborn* (1884), rep.; Daniel Goodwin, *Provincial Pictures by Brush and Pen* (Chicago, 1886), pp. 14–15, rep. opp. 10; Foote 1950, p. 184 [as Mrs. John Pitts]; Detroit Institute of Arts, *Eight Generations of the Pitts Family* (Detroit, 1959), pp. 16–17 rep.; Saunders 1979, vol. 1, pp. 184–185; vol. 2, pl. 139; *American Paintings in the Detroit Institute of Arts* (New York, 1991), pp. 181–182

Subject: Elizabeth Bowdoin, born 1716; daughter of James Bowdoin and Hannah Portage Bowdoin; sister of James Bowdoin (cat. no. 114); married James Pitts (1710–1776), a wealthy Boston landowner, October 26, 1732; died October 10, 1771[1]

Until now the sitter in this portrait has been identified as Mrs. John Pitts. Smibert identified her as "young Mrs. Pitts" to distinguish her from her mother-in-law, Mrs. John Pitts (cat. no. 105).

NOTES

1. Sibley and Shipton 1873–1956, vol. 9, pp. 76–81.

107 Sarah Lyde, c. 1735–1743

R. H. Love Galleries, Inc., Chicago

36 × 28 1/2 (91.4 × 72.4)

Provenance: Owned in England 1880–1989; purchased in England, 1989

Notebook: Not recorded

Subject: Sarah Belcher (1708–1768), daughter of Gov. Jonathan Belcher (cat. no. 185) and Mary Partridge Belcher (cat. no. 186); four brothers, two of whom were also painted by Smibert: Jonathan (cat. no. 184) and Andrew (cat. no. 183); married Byfield Lyde, son of a Boston merchant, August 17, 1727

This portrait appeared on the art market in 1989 after it was discovered in England. On the reverse is an inscription that identifies the portrait as "Susannah, wife of Byfield Lyde, Judge, Massachusetts. American daughter of Jonathan Belcher Esquire, Governor of New England. Painted by Smibert 1754. Restored by Clifford in 1880." A further inscription reads, "C. E. Clifford / The St. James's Gallery of Art / 30 Piccadilly." Although the inscription identifies the sitter as Susannah Lyde, Byfield Lyde was married to Sarah Belcher, which would appear to be the correct identity of the sitter.

The portrait, which depicts a woman wearing a brown gown with a red drape over her shoulder, is typical of Smibert's later American work. The one anomaly is the oval format, which is unique among Smibert's surviving American portraits. It is conceivable (but not certain) that the

portrait was modified from a rectangular format. The paint surface is in good condition, although there is some restoration to the background.

108 Mrs. Benjamin Browne, 1735

Colby College Museum of Art, gift of Mr. and Mrs. Ellerton M. Jette
49 1/2 × 39 1/4 (125.8 × 99.4)
Provenance: Mrs. Arthur W. Bell, Boston, by 1949; sold by Brooks Fenno to Vose Galleries, Boston, 1968; purchased by Ellerton Marcel Jette, 1968; gift to Colby College, 1969; Vose Galleries, Boston, 1972–1973
Notebook: [January 1735], p. 93, no. 109: "Mrs. Benn. Broun H.P. / 1/2 12 Guini"
Literature: Bayley 1929, p. 345 rep. [as Mrs. Joseph Balston]; Foote 1950, p. 137; Saunders 1979, vol. 1, p. 185; vol. 2, pl. 142
Copies: (1) Owned by the late Edward N. Fenno, 1949; (2) in House of Seven Gables, Salem, Mass.
Subject: Eunice Turner, born April 17, 1713; daughter of John Turner and Mary Kitchen Turner of Salem; sister of John Turner (cat. no. 119); married (1) Benjamin Browne of Salem, June 19, 1729, (2) Nathaniel Balston, 1751; died March 1783[1]

See figure 79

The sitter is shown wearing a golden-brown gown. She holds a rose-colored drape in her left hand. The somewhat awkward standing pose is not particularly successful, and Smibert has failed to relate the figure to the background.

NOTES

1. Foote 1950, p. 137.

109 Mrs. William Lambert, 1735

Bayou Bend Collection, Museum of Fine Arts, Houston
35 1/4 × 27 1/2 (89.6 × 69.9)
Provenance: The sitter; her nephew William Lambert, 1749;[1] his son William Lambert; his daughter Harriet Lambert (Mrs. William Blanchard); her daughter Susanna Lambert Blanchard, Roxbury, Mass.;[2] her great-grandson William Lambert Barnard, Brookline, Mass., by 1926;[3] bequest to Museum of Fine Arts, Boston, 1955; sold by Museum of Fine Arts, Boston, to Vose Galleries, Boston, 1958; Miss Ima Hogg, Bayou Bend, Houston; bequest to Museum of Fine Arts, Houston, Bayou Bend Collection
Notebook: [April 1735], p. 93, no. 110: "Mrs. Lambert H.P. KK 9–0–0"
Literature: New Haven 1949, no. 17; Foote 1950, p. 166; *Antiques*, vol. 90 (December 1966), p. 802; Warren 1975, p. 126, no. 238 rep.; Saunders 1979, vol. 1, p. 185; vol. 2, pl. 143
Subject: Wife of William Lambert (cat. no. 92)

This portrait is the pendant to cat no. 92. The sitter wears a red gown and is shown seated in an upholstered chair. The palette is pleasing and the painting retains its original frame, but the surface of the painting has undergone some restoration.

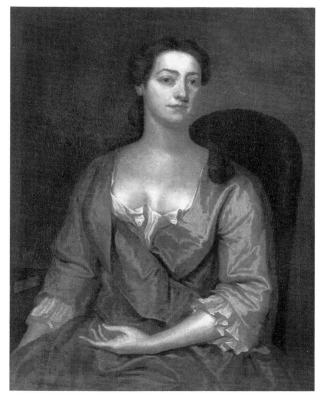

109

NOTES

1. William Lambert's will, see cat. no. 92.
2. Letter to Kathryn [Buhler] from Charles E. Blanchard, n.d., Addison Gallery of American Art, Phillips Andover Academy, Andover, Mass., painting file.
3. William Lambert Barnard to Frank Bayley, October 9, 1926, American Antiquarian Society, Worcester, Mass., Frank W. Bayley Papers.

110 Rev. James McSparran, 1735

Bowdoin College Museum of Art, bequest of Charles Edward Allen, 1897
30 × 25 (76.2 × 63.5)
Provenance: The sitter; his brother-in-law Dr. Silvester Gardiner; his daughter Mrs. Oliver Whipple; her daughter Mrs. Frederic Allen; her son Charles E. Allen; bequest of Charles E. Allen to Bowdoin College, 1897.[1]
Notebook: [May 1735], p. 93, no. 111: "The Rd. Mr. McSparon 3/4 6 Ginnes"
Literature: MHS *Proc.*, vol. 16 (1878), p. 397; Bowdoin 1906, p. 58; Updike 1907, vol. 1, p. 405; Bayley 1929, p. 405 rep.; Lee 1930, p. 119 rep.; Hagen 1940, fig. 75; Foote 1950, pp. 168–169; Sadik 1966, pp. 27–29; Saunders 1979, vol. 1, pp. 187–188, vol. 2, pl. 145; Houghton, Berman, and Lapan 1986, p. 67
Copy: In oils by Mary Updike, daughter of Wilkins Updike, Rhode Island Historical Society[1]

Subject: James McSparran, born in Dungiven, County of Derry, Ireland, September 10, 1693; parents thought to have come from Kintore, Scotland; graduated University of Glasgow, 1709; came to America, 1718; married Hannah Gardiner (cat. no. 82), May 22, 1722; became minister of St. Paul's, the Anglican church in Narragansett, R.I., April 28, 1721, where he remained, aside from two trips to England (1736–1737, 1754–1756), until his death, December 1, 1757[2]

See figure 89

The Vestry minutes for May 25, 1735, indicate that McSparran went to Boston from Rhode Island on church business.[3] During this visit he took time to have his portrait painted. The portrait retains its original frame, which was discussed in Smibert's letter of September 22, 1735, to Sueton Grant (see app. 2). The painting was cleaned in 1967 by Clements L. Robertson, at which time it was observed that almost the entire background was overpainted and the surface had suffered considerable abrasion. The following labels were formerly on the frame and stretcher and are now in the painting file, Bowdoin College Museum of Art:

1. Brown paper label, black paint, red ink inscription: MUSEUM OF ART / RHODE ISLAND SCHOOL OF DESIGN / PROVIDENCE RHODE ISLAND / LOAN from Bowdoin College

2. Bowdoin label printed in orange, typed inscription: BOWDOIN COLLEGE MUSEUM OF ART / WALKER ART BUILDING, BRUNSWICK, MAINE / REV. JAMES MCSPARREN—1735 / JOHN SMIBERT / American, 1688–1751 / Bequest of Charles Edward Allen / 1897.1

3. Gray paper label, printed in black, ink corrections: 5312 / CHAS. E. ALLEN / COUNSELLOR AT LAW / -AND- / COMMISIONER FOR MAINE / office 12 Loyd Building / no xxx Street / 81 Washington St / (Third Story) Boston.

4. Paper label, printed in black, ink corrections: M. H. de YOUNG MEMORIAL MUSEUM / Exhibition: American Painting (1935) / Title: Portrait of the Rev. J. McSparran / Artist: John Smibert (1688–1751) / Owner: Bowdoin Museum of Fine Art / No.: 22

5. Blue border, paper label, ink inscription: 650 Rev. James McSparran, D.D. / Bequeathed by Chas. E. Allen, Esq. Bowdoin / 1835 By John Smibert / Catalogued—Boyd Gallery

NOTES

1. Foote 1950, p. 169.
2. I[sabel] M. C[alder], "MacSparran, James," *DAB* 1928–1937 (1964 ed.), vol. 6, pp. 167–168.
3. Updike 1907, vol. 2, p. 515.

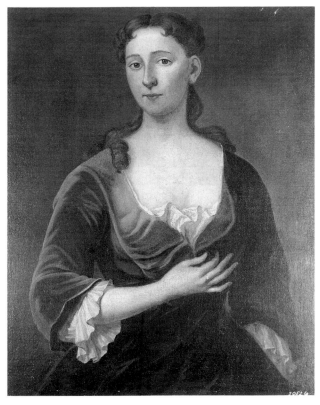

111

111 Mrs. William Pepperrell, 1735

Mrs. Arthur L. Shipman, Jr.
36 × 28 (91.4 × 71.1)
Provenance: By descent to Mary Pepperrell Sparhawk Cutts (Mrs. Hampden Cutts); David E. Wheeler; Everett P. Wheeler, New York [great-grandson of Mrs. William Pepperrell]; his daughter Constance Wheeler; her first cousin's daughter Mrs. Arthur Shipman, by 1949[1]
Notebook: [June 1735], p. 93, no. 112: "Coll. Pappereles Lady H.P. / KK 9 Guineas"
Literature: Foote 1950, p. 181: Belknap 1959, pl. 126; Saunders 1979, vol. 1, p. 185; vol. 2, pl. 141
Copy: In oils, at the Lady Pepperrell House, Kittery Point, Me.
Subject: Mary Hirst (1703–1759), daughter of Grover Hirst and Elizabeth Sewall Hirst; married William Pepperrell (cat. no. 138), 1722 or 1723[2]

The face in this portrait is heavily overpainted, which accounts for its masklike quality. The sitter is wearing a blue gown, which is painted in a manner technically consistent with Smibert's other American portraits.

NOTES

1. Letter to the author from Mrs. Arthur Shipman, June 16, 1976.
2. Foote 1950, p. 181.

112

112 George Rogers, 1735

Charles P. Russell Collection of Deerfield Academy
36 × 30 1/8 (91.4 × 76.5)
Inscription: The letter against the inkstand is addressed "To the
. . . Joshua Gee, Boston." The sitter's right hand rests on a letter
that begins "Dear Br . . . 1735 . . . to . . . Rogers, Esq." and is
signed "Joshua Gee."
Provenance: Miss Helen Keeling Mills, Kent, Conn., 1935–1939;
Mr. and Mrs. Robert Brumbacher, Salt Lake City, by 1949;[1] sold
by Mrs. Robert Brumbacher to Vose Galleries, Boston, 1956;
purchased by Mrs. Lucius D. Potter, Greenfield, Mass., 1960;
bequest to Deerfield Academy, 1962[2]
Notebook: [July 1735], p. 93, no. 113: "Mrs. Rogers KK 9 Ginnes"
Literature: Sibley and Shipton 1873–1956, vol. 7, pp. 251–252
rep.; Burroughs 1942, opp. p. 113 rep.; New Haven 1949,
no. 25; Foote 1950, pp. 186–187; Saunders 1979, vol. 1, p. 187;
vol. 2, pl. 133
Subject: George Rogers, Boston merchant; son of Rev. Nathaniel
Rogers and Sarah Perkins Rogers of Portsmouth, N.H.; en-
tered Harvard with the class of 1723 but left before receiving
his degree; married (1) Rebekah Parr, (2) Lydia, daughter of
Hon. Thomas Hutchinson;[3] died September 5, 1747.[4] Rogers's
sister Sarah married Rev. Joshua Gee (cat. no. 85), pastor of the
Second Church, where Rogers was a member.

There is little in Rogers's biography as a successful and
well-connected merchant to document the jovial person-
ality this portrait suggests. Certainly, his half-smile is atypi-
cal for Smibert's merchant portraits and conveys a degree
of informality that is at once memorable and refreshing.

Rogers's kit-cat portrait possesses much of the detail of
the larger format merchant portraits—the cloth-covered
table, quill pen, inkwell, armchair, and window through
which a merchant vessel is visible. Smibert has made a con-
siderable effort to give the sitter his money's worth, and he
seems genuinely pleased with the results.

NOTES

1. Foote 1950, p. 186.
2. "George Rogers," Smibert painting file, Frick Art Reference
Library.
3. Foote 1950, p. 186.
4. Sibley and Shipton 1873–1956, vol. 7, p. 252.

113 Rev. Ebenezer Miller, 1735

Courtesy Winterthur Museum
30 × 24 1/2 (76.2 × 62.2)
Provenance: Descent in Miller family to Miss Caroline Armory,
Boston; her nephew Alexander F. Wadsworth, Dedham, Mass.;[1]
sold by Alexander F. Wadsworth to Vose Galleries, Boston,
1950; purchased by the Henry Francis duPont Winterthur Mu-
seum, 1951[2]
Notebook: [September 1735], p. 93, no. 115: "The Rd. Mr. Miller
3/4 6 Ginnes"
Literature: Sibley and Shipton 1873–1956, vol. 7, opp. p. 94 rep.;
Foote 1950, p. 170; Saunders 1979, vol. 1, p. 187; vol. 2, pl. 146
Subject: Ebenezer Miller, born June 20, 1703; son of Samuel Mil-
ler and Rebecca Belcher Miller of Milton, Mass.; graduated
from Harvard, 1722; ordained an Anglican minister in En-
gland, 1727; minister of Christ Church, Braintree, Mass., 1727–
1763; died February 11, 1763.[3] While in London in 1726 Miller
married Martha Mottram, whose father was described as "a
Gentleman of a plentiful Estate." That a young provincial could,
considering the low social position of the minor English clergy at
that time, obtain such a wife, is indication that he had excep-
tional personality or promise.[4]

See figure 90

NOTES

1. Foote 1950, p. 170.
2. Henry Francis duPont Winterthur Museum, painting files.
3. Foote 1950, p. 170.
4. Sibley and Shipton 1873–1956, vol. 7, p. 95.

114 James Bowdoin II, 1736

Bowdoin College Museum of Art, bequest of Sarah Bowdoin Dear-
born
34 7/8 × 26 7/8 (88.5 × 68.3)
Provenance: The sitter; his son James Bowdoin III; his wife, Sarah
Bowdoin Dearborn; bequest of Sarah Bowdoin Dearborn to
Bowdoin College, 1826.[5]
Notebook: [September 1735], p. 93, no. 117: "James Bodween Jnr.
H.P. KK 9 Guinias"[1]
Literature: Bowdoin 1870, p. 83; Foote 1930, pp. 46–47 (as by
Feke); College Art Association, *Seventeenth and Eighteenth Century*

Portraiture [1935], no. 25 (as by Feke); Foote 1950, pp. 135–136; Bowdoin 1950, p. 24, fig. 21; Sadik 1966, pp. 30–31 rep.; Saunders 1979, vol. 1, p. 189, vol. 2, pl. 147; Bowdoin 1981, pp. 86–88, rep. 87

Subject: James Bowdoin, merchant and statesman, born in Boston, August 7, 1726; son of James Bowdoin and Hannah Portage Bowdoin; graduated from Harvard, 1745; married Elizabeth, daughter of John Erving (cat. no. 87), September 15, 1748; delegate to the First Continental Congress; governor of Massachusetts, 1785–1787; first president of the American Academy of Arts and Sciences and a Fellow of the Royal Society of London; died 1790[2]

See plate 24

Early in 1736 Smibert painted the nine-year-old James Bowdoin II, creating perhaps the freshest and most sparkling portrait of his American career. He employed a pose that, if not new to portraits of children, was new to his repertoire. Bowdoin is depicted as a youthful but manly hunter, armed with bow and arrow. He has fine features, clear skin, and wears his thick, shoulder-length hair brushed back from his forehead. The rich blue silk frock coat shimmers in the light, and a sense of stopped action is created by one raised hand, balanced by a bow lowered with the other.

Bowdoin's portrait shows why the kit-cat format so appealed to sitters. Smibert is known to have used it as early as 1722, but his London patrons preferred the more traditional three-quarter-length or half-length sizes. Americans may have preferred the kit-cat because it gave the appearance of a grand portrait but cost one-third less than the larger three-quarter length. It was particularly suitable for children's portraits, as their diminutive size made them appear lost on larger canvases. Here, however, the portrait takes on a majestic and almost monumental quality.

The landscape background, which so often in early eighteenth-century portraits seems an afterthought, here is more fluid and expansive. The terrain slopes gently away from the youthful hunter toward a meandering stream. The stream, the copse of trees, the distant hills, and the popcorn-shaped clouds are all traditonal elements of Smibert's vocabulary. But in this instance they are the proper foil for Bowdoin, and their muted shades of green, blue, and gray create a composition of unusual tonal harmony. Few of Smibert's portraits painted after 1736 were painted with such enthusiasm.

NOTES

1. According to Smibert's notebook, p. 25, the date for this painting may also be read as March 1736.
2. W[illiam] A. R[obinson], "Bowdoin, James," *DAB* 1928–1937 (1964 ed.), vol. 1, pp. 498–501.

115

115 Unidentified Man, c. 1736–1737

From the collection of the Gilcrease Museum, Tulsa
30 1/2 × 25 1/4 (77.5 × 64.1)

Provenance: Purchased from a dealer by John E. Thayer, Boston, c. 1850; his widow, later Mrs. R. C. Winthrop; their daughter Adele G. Thayer; bequest to John E. Thayer, Lancaster, Mass.; Mrs. John E. Thayer, Sr., Lancaster, Mass.; Mr. John E. Thayer, Milton, Mass., by 1949;[1] purchased by the Gilcrease Foundation, Tulsa, Okla., 1950;[2] acquired by the City of Tulsa, 1955

Literature: Drake 1856, p. 158 rep.; Bolton 1919–1926, vol. 2, pp. 561–563; Sibley and Shipton 1873–1956, vol. 5, p. 517; Foote 1950, pp. 147–149; Thomas Gilcrease Institute of American History and Art, *American Scene*, vol. 2, no. 1 (Spring 1959), pp. 2–3 rep.; *American Scene*, vol. 15, no. 1 (1974), pp. 15–16 rep.; Saunders 1979, vol. 1, pp. 183–184; vol. 2, pl. 138

The sitter, who wears a golden-brown coat, was formerly identified as Rev. John Cotton (1693–1757). Foote, however, observes that he is unlikely to be Cotton as he is not dressed in clerical garb.[3] Smibert's notebook does not record any portrait of Cotton; moreover, Cotton was in his thirties at the time Smibert painted this portrait, and the sitter is clearly an older man. A label on the reverse of the painting reads, "Boston Atheneum / John Cotton / Mrs. E. Thayer / Brookline."

NOTES

1. "John Cotton," Smibert painting file, Frick Art Reference Library; Foote 1950, pp. 147–149.
2. Letter to the author from William Best, director, Thomas Gilcrease Institute of American History and Art, Tulsa, Okla., September 28, 1977.
3. Foote 1950, p. 148.

116 Daniel Henchman, 1736

Courtesy Cincinnati Historical Society
30 × 25 (76.2 × 63.5)
Provenance: Presented to the Cincinnati Historical Society by Mrs. Chase H. Davis (Charlotte F. Rowe), 1957
Notebook: [April 1736], p. 93, no.120: "Capn. Hincksman HP 3/4 6 Guinias"
Literature: Saunders 1979, vol. 1, p. 190; vol. 2, pl. 150
Subject: Daniel Henchman, Boston bookseller and publisher, born January 21, 1689; son of Hezekiah and Abigail Henchman of Boston; married Elizabeth Gerrish (cat. no. 117), January 14, 1713; published with Thomas Hancock *The Vade-Mecum for America; or, A Companion for Traders and Travellers,* 1720; Captain, by 1746, in the Ancient and Honorable Artillery Company; served as deacon of Old South Church, justice of the peace, and overseer of the poor;[1] daughter Lydia (cat. no. 56) married Thomas Hancock (cat. no. 63); died February 25, 1761[2]

See figure 99

The sitter is shown wearing his own long gray hair and is attired in a matching olive-green coat and waistcoat. Until 1980–1981, when it was restored, the painting retained its original frame (painted black with carved gold liner). At one point, presumably before the canvas was lined, the painting bore an inscription or label which read, "Daniel Henchman Esq-Greatly respected . . . and esteemed—his daughter Lydia 5th beloved married Thomas Hancock, Esqr."[3]

NOTES

1. Whitman 1842, p. 258.
2. Cincinnati Historical Society, portrait file of Daniel Henchman.
3. Letter to the author from Laura Chace, Librarian, Cincinnati Historical Society, December 3, 1973.

117 Mrs. Daniel Henchman, 1736

Courtesy Cincinnati Historical Society
25 1/2 × 19 3/4 (65 × 50.2)
Provenance: See cat. no. 116
Notebook: [April 1736], p. 93, no.121: "Mrs. Hinksman H. P. 3/4 6 Guinis"
Literature: Saunders 1979, vol. 1, p. 207, n. 50
Subject: Elizabeth Gerrish, daughter of Capt. John Gerrish (cat. no. 120) and Lydia Watts Gerrish;[1] married Daniel Henchman (cat. no. 116), January 14, 1713; sister Anna (cat. no. 95) married Rev. Joshua Gee (cat. no. 85); daughter Lydia (cat. no. 56) married Thomas Hancock (cat. no. 63)

117

This portrait has been cut down (from 30 × 25 inches), and the lower half of the canvas is completely repainted. The following typed statement is attached to the back of the frame: "Mrs. Hinchman [*sic*] whose daughter Lydia the beloved, married Thomas Hancock, esq. one of the salt of the earth. He gave his whole fortune to his wife, with the only direction that it should revert to his only adopted son, John Hancock, Esq. The above inscription was written by Henry J. Koch, formerly cashier of the Cincinnati Art Museum, and verified by L. H. Meakin. Restored in 1932 by Wm. McPeak and H. H. Wessel."

NOTES

1. Cincinnati Historical Society, portrait file of Daniel Henchman.

118 Henry Collins, 1736

Gladys Moore Vanderbilt Széchényi Memorial Collection, Redwood Library and Athenaeum, Newport, R.I.
49 × 39 (124.5 × 99.1)
Inscription: A letter on the table is addressed "to Mr. Henry Collins, Newport"
Provenance: The sitter; his half-brother Richard Ward; W. J. Flagg; by descent to Countess Lazlo Széchényi, New York, by 1949; her daughter Nadine Széchényi (Mrs. Alexander E. Eltz), by 1976; Redwood Library and Athenaeum, by 1990

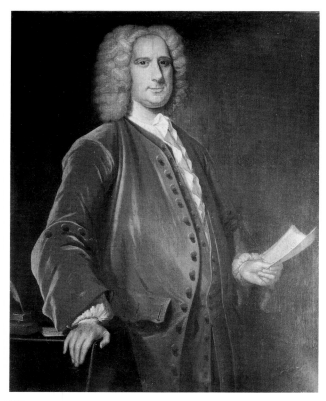

118

Collins was an unusual client in that he also commissioned portraits of local ministers—Thomas Hiscox, John Callender, and Nathaniel Clap. He is said to have commissioned Smibert to paint a portrait of George Berkeley as well.[3]

In most ways this portrait, in which the sitter is depicted wearing a rust-brown coat and waistcoat, is typical of Smibert's American merchant portraits. Stylistically, it is one of the exceptions to the generally downward trend of his abilities beginning in the mid-1730s.

NOTES

1. Foote 1950, pp. 48, 145.
2. Belknap 1953, pp. 225–226.
3. Foote 1950, p. 64.

Engraved: In *The Seventh Day Baptist Memorial* (c. 1750), in reverse
Notebook: [May 1736], p. 94, no. 112: "Mr. Collins HP 1/2 12 Guin."
Literature: G. C. Mason, *Reminiscences of Newport* (Newport, R.I., 1884), vol. 6, p. 12 rep.; Bridenbaugh 1938, front. (from engraving c. 1880 in *Newport Historical Magazine*); *Rhode Island Historical Magazine*, vol. 5, no. 2 (October 1884), front.; Foote 1950, p. 145; Belknap 1953, pp. 225–226; Preservation Society of Newport County, *The Arts and Crafts of Newport, Rhode Island, 1640–1820* (Newport, 1954), pp. 121–122 rep.; Wichita Art Museum, *American Printings from Newport*, exh. cat. (Wichita, 1969), pp. 14–15; Saunders 1979, vol. 1, pp. 190–191; vol. 2, pl. 151; Dara L. D. Powell, *The Flagg Family: An Artistic Legacy and the Provenance of a Collection* (Pound Ridge, N.Y., 1986), pp. 46–47
Subject: Henry Collins, merchant, born March 25, 1699; son of Arnold Collins, silversmith, and Ammi Almy Collins; educated in England; died April 29, 1765[1]

Benjamin Waterhouse described Collins as the Lorenzo de'Medici.of Rhode Island for his forceful role in the cultural and civic life of Newport, although late in life he lost his property. His most significant contributions were his donation of the land on which the Redwood Library was built (as well as funds to help construct it), his active membership in the local philosophical club, and his direction of the construction of a new meetinghouse for the Seventh Day Baptists. His benevolence is hinted at by his friendly countenance, which is also evident in another portrait of Collins, by Robert Feke.[2]

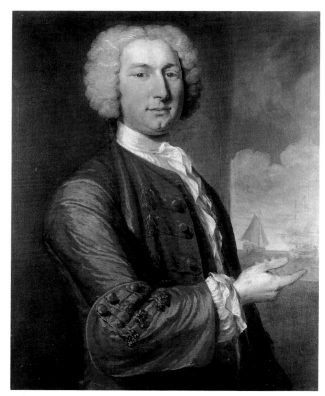

119

119 John Turner, 1737

Gift of Mrs. Horatio A. Lamb in memory of Mr. and Mrs. Winthrop Sargent, Museum of Fine Arts, Boston
35 1/4 × 27 3/4 (89.5 × 70.5)
Provenance: By descent to Winthrop Sargent; his sister-in-law, Mrs. Horatio Appleton Lamb; gift of Mrs. Horatio A. Lamb to the Museum of Fine Arts, Boston, 1918.663[1]
Notebook: [February 1737], p. 94, no. 134: "Mr. John Turner H P / KK 9 Guineas"

Literature: Bayley 1929, p. 431; Burroughs 1936, p. 36; Burroughs 1942, p. 119; New Haven 1949, no. 32; Foote 1950, p. 193; Boston 1969, vol. 1, p. 237, no. 890; vol. 2, fig. 10; Saunders 1979, vol. 1, p. 192; vol. 2, pl. 153
Copy: A modern copy is in the House of Seven Gables, Salem, Mass.
Subject: John Turner; born in Salem, Mass., May 20, 1709; son of John Turner and Mary Kitchen Turner; older brother of Eunice Turner (Mrs. Benjamin Browne, cat. no. 108); married September 29, 1752;[2] naval officer, member of the House of Deputies (1757–1758), collector of the port of Salem (1772); died December 19, 1786[3]

This is one of the most appealing of the portraits that survive from the last decade of Smibert's activity as a portrait painter. It is forcefully painted in a pleasing and direct manner. The shimmering surface of Turner's pea-green coat recalls cat. no. 114. The painting is in very good condition and retains its original frame.

NOTES

1. Foote 1950, p. 193.
2. "John Turner," Smibert painting file, Frick Art Reference Library.
3. Foote 1950, p. 193.

120 Captain John Gerrish, 1737

Gift of Barrett Wendell, Jr., 1959.517, © 1991 The Art Institute of Chicago, All Rights Reserved
29 7/8 × 24 5/8 (75.6 × 62.5)
Provenance: The sitter; his daughter Sarah Gerrish (Mrs. John Barrett), Boston: by descent to Sarah Dow Barrett, Boston, 1878;[1] Professor Barrett Wendell; his son Barrett Wendell, Jr.; anonymous gift to the Art Institute of Chicago, 1959
Notebook: [February 1737], p. 94, no. 135: "Capn Garish H.P. 3/4 6 Gunnes"
Literature: MHS Proc., vol. 16 (1878), p. 395; vol. 43 (1910), p. 200; Champlin and Perkins 1913, vol. 4, p. 192 [as Judge J. Gerrish]; L. V. Briggs, The Cabot Genealogy (1927), vol. 2, p. 42 rep.; Bayley 1929, p. 391 rep.; Foote 1950, pp. 157–158; Art Institute of Chicago, Catalogue of Paintings (Chicago, 1961), p. 419; David Hanks, "American Paintings at the Art Institute of Chicago," part 1, Antiques, vol. 104 (September 1973), p. 409; Saunders 1979, vol. 1, p. 192; vol. 2, pl. 154
Subject: John Gerrish (1668–1738), merchant and investor in Boston's Long Wharf; son of Judge John Gerrish of New Hampshire; married (1) Lydia Watts (d. 1697), (2) Sarah Hobbes; fathered thirteen children, among them Elizabeth (cat. no. 117) and Anna (cat. no. 95); member of the Ancient and Honorable Artillery Company and of Old South Church; lived on King Street[2]

This portrait, which is well painted, stylistically bears a considerable resemblance to cat. no. 115.

NOTES

1. MHS Proc., vol. 16 (1878), p. 395.
2. Foote 1950, p. 157; Hanks, "American Paintings at the Art Institute," p. 409.

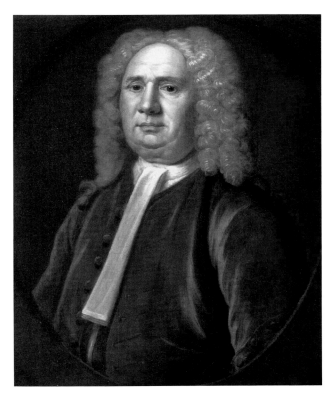

120

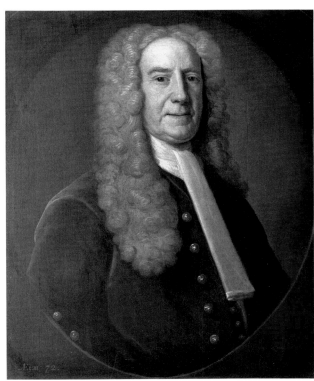

121

121 Judge Benjamin Lynde, 1737

Henry E. Huntington Library and Art Gallery, San Marino, Calif.
30 × 25 (76.2 × 63.5)
Inscription, lower left (possibly by a later hand): "AEtat: 72"
Provenance: By descent to Mrs. William B. Richards, Boston, 1878; Helen C. Moseley, by 1911; Mr. F. S. Moseley, Boston; Mrs. F. S. Moseley, Boston; Mr. Frederick S. Moseley, III; Huntington Library
Notebook: [June 1737], p. 94, no. 137: "Judge Lynds H.P. 3/4 6 Guinias"
Literature: MHS *Proc.*, vol. 16 (1878), p. 396; *The Diaries of Benjamin Lynde* (Boston, 1880), front.; Winsor 1880–1881, vol. 2, p. 558 rep.; C. W. Bowen, *The History of Woodstock, Connecticut* (Norwood, Mass., 1926), p. 66 rep.; Bayley 1929, p. 401 rep.; Burroughs 1942, p. 115 rep.; Foote 1950, p. 167; Saunders 1979, vol. 1, p. 192; vol. 2, pl. 152
Copies: (1) In *The Diaries of Benjamin Lynde* a copy is said to be in the possession of Samuel H. Russell, Boston; (2) by an unknown artist, in the Social Law Library, Boston; (3) at the Peabody Essex Museum, Salem, 30 × 25 inches, probably by John Greenwood. The latter portrait is discussed in Foote 1950, pp. 218–219 as "Benjamin Lynde, Sr. No. 2."
Subject: Benjamin Lynde, born in Massachusetts, September 22, 1666; son of Simon Lynde and Hannah Newgate Lynde; graduated from Harvard, 1686; studied law at the Middle Temple in London, 1692–1697; married Mary Browne (1679–1753), daughter of William Browne and Hannah Curwen Browne of Salem, April 27, 1699; justice of the Superior Court of Massachusetts, 1712–1728, and chief justice, 1728–1745; lived in Salem on the corner of Essex and Liberty streets in a house built for his wife by her father;[1] died in Salem, January 28, 1745. The *Boston Evening Post* stated that "Inflexible Justice, unspotted Integrity, Affability and Humanity were ever conspicuous in him. He was a sincere Friend, the most affectionate towards his Relations, and the Delight of all that were honoured with his Friendship and Acquaintance."[2]

The following labels are on the back of the frame:

1. Paper label in ink:
Hon. Ben: Lynde Born Bost Mass 22 Sept / 1666 died Salem Mass 28 Jan 1745. / Married Mary Browne 27 Apr. 1699. / Chief Justice of the Province of / Mass 1728 / This is the original portrait by / Smybert came into the possession / of Helen (?) C. Moseley May 1911 / cousin (?) Fred & Helens 5th great grandfather
2. Printed label:
Phillips Academy / Andover Massach . . . / J. Smibert / Benjamin Lynde / Lent by / Mrs. F. S. Moseley

In 1878 Augustus T. Perkins described no. 121 as a "quite remarkable picture, and one in which the artist seems to have excelled himself."[3] While the portrait may not rival the best of Smibert's first American pictures, it is handsome and in excellent condition. Lynde wears an elaborate judicial wig and a plum-colored coat with gold buttons. Cat. no. 121 retains its original and elaborately carved frame, which is identical to that on cat. no. 78.

NOTES
1. Essex Institute 1936, p. 121.
2. Sibley and Shipton 1873–1956, vol. 3, p. 357.
3. MHS *Proc.*, vol. 16 (1878), p. 396.

122 Rev. Samuel Johnson, 1737

Columbia University in the City of New York
30 × 24 3/4 (76.2 × 62.9)
Provenance: Gift to King's College (now Columbia University) from Laurence Kilbourn, c.1757–1770
Notebook: [June 1737], p. 94, no. 139: "The Rvd. Mr. Johnson H.P. / 3/4 6 Guinias"
Literature: Samuel Johnson, *President of King's College: His Career and Writings* (New York, 1929), vol. 4, front.; Foote 1950, pp. 163–164; Saunders 1979, vol. 1, pp. 192–193; vol. 2, pl. 155; Houghton, Berman, and Lapan 1986, p. 66
Copy: Owned in 1873 by grandson, William Samuel Johnson of Stratford[1]
Subject: Samuel Johnson, born in Guilford, Conn., October 14, 1696; son of Samuel Johnson and Mary Sage Johnson; attended Collegiate School at Saybrook (which was later removed to New Haven and renamed Yale College). In 1720 Johnson was ordained pastor of the Congregational church in West Haven, but two years later he joined the Episcopal church and sailed to England. He returned the following year and at Stratford opened the first Episcopal church in Connecticut. Married (1) Charity Nicoll, a widow, daughter of Col. Richard Floyd of Brookhaven, Long Island, September 26, 1725, (2) Mrs. Sarah Hull Beach, widow of William Beach of Stratford, Conn., June 18, 1761. Johnson was appointed the first president of King's College (now Columbia University) in 1754, but returned to Stratford in 1763. He was a close friend of George Berkeley. Along with Jonathan Edwards, he is considered the most important exponent of idealistic philosophy in colonial America. Died January 6, 1772.[2]

See figure 92

This portrait was painted during a trip Johnson made to Boston in June 1737 along with Rev. Henry Caner (cat. no. 220), his friend and fellow Anglican clergyman from Fairfield, Conn. The portrait was recorded in an undated "List of the Benefactors to King's College": "Mr. Kilbourn painter gave the President Dr. Johnson's portrait." "Mr. Kilbourn," as recognized by Foote, was the New York portrait painter Laurence Kilbourn (fl. 1754–1775). Since this is the only portrait of Johnson owned by Columbia it is presumably the one given by Kilbourn. How he came to acquire it is unknown. The portrait has been recognized as by Smibert at least since April 15, 1842, when William Dunlap wrote, "See G. G. Verplank at City Library—Smybert is noticed by him in his Historical discourse. One of his pictures in Columbia College," and later, "We [Verplank and himself] go to Columbia College to see a Smibert."[3] The frame is no longer with the painting, which has been set

into the wall of the Trustees' room. The portrait was cleaned and restored in 1981 by the Edward J. Brown Studio, New York.

NOTES

1. E. Beardsley, *Samuel Johnson* (1873), vii.
2. Foote 1950, pp. 163–164; J[ames] T. A[dams], "Johnson, Samuel," *DAB* 1928–1937 (1964 ed.), vol. 5, pp. 118–119.
3. Foote 1950, p. 164.

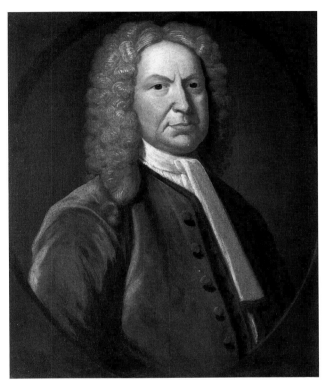

123

123 Samuel Browne, 1737?

Ronald W. White
29 1/2 × 24 1/2 (74.9 × 61.6)
Provenance: By descent to Mrs. James T. Wallis, Germantown, Pa.; her daughter Mrs. Stanard Funsten, Pasadena, Calif., by 1949; her son, by 1974; Vose Galleries, Boston, 1986; Childs Gallery, 1987–1994; Ronald W. White, 1994
Notebook: [September 1737], p. 94, no. 142: "Corll. Broun [copy] 3/4 6 Guins"
Literature: Foote 1950, p. 138; Santa Barbara Museum of Art, *American Portraits in California,* exh. cat. (Santa Barbara, Calif., 1966), no. 1.
Subject: Samuel Browne (1669–1731), "the leading merchant, richest man, and most prominent citizen of Salem in his day" (Foote 1950, p. 138); held various public offices—town treasurer, councillor, judge of the court of common pleas—and was colonel of the regiment; married Abigail Keech; brother-in-law of Judge Benjamin Lynde (cat. no. 121); father of William Browne (cat. no. 94) and Samuel Browne (cat. no. 99)

Smibert's only notebook entry for Browne is a copy. This portrait could either be (1) the original portrait of Browne from life and not recorded in the notebook, (2) a copy by Smibert of another artist's original, or (3) a replica by Smibert of a portrait he painted earlier of Browne but did not record in the notebook. Although Browne died in 1731, his estate was not settled until 1737. This portrait may have been ordered by one of Browne's sons at the time the estate was being divided up. Somber in feeling, it is well painted. It is in sound condition, although the sitter's right eye is partially repainted and there are other small areas of inpainting. The frame appears to be original but regilded.

124 Philip Livingston,* 1737

Mrs. S. Dillon Ripley (Mary Livingston Ripley)
48 × 39 1/2 (121.9 × 100.3)
Provenance: Crawford Livingston, St. Paul, Minn., by 1914;[1] Gerald M. Livingston, New York[2]
Notebook: [September 1737], p. 95, no. 146: "Mr. Liveston Albani 1/2 12 Guines"
Literature: Edwin Brockholst Livingston, *The Livingston Manor* (New York, 1910), pp. 138–142 rep.; John Henry Livingston, *The Livingston Manor* (New York: Order of Colonial Lords of Manors in America, 1914), p. 13 rep.; Belknap 1959, p. 249; Saunders 1979, vol. 1, p. 193; vol. 2, pl. 157; Ruth Piwonka, *A Portrait of Livingston Manor, 1686–1750* (New York, 1986), p. 32
Copy: Owned by Mrs. John Henry Livingston, Tivoli on Hudson, New York[3]
Subject: Philip Livingston, landowner in Albany area, born July 9, 1686; son of Robert Livingston, first lord of Livingston Manor; married Catrina VanBrugh (1689–1756), daughter of Peter VanBrugh, mayor of Albany, and Sarah Cuyler VanBrugh, September 17, 1707; died 1749. Livingston was described as unlike his father in many respects: less subtle, less persevering, less of a financier, and much handsomer. In his youth he is said to have had a winning way with women and to have gone about "breaking hearts promiscuously."[4] Upon visiting Albany in 1744, Alexander Hamilton noted that when the minister of Albany's St. Peter's Church warned the congregation about the evils of excessive wealth, "this discourse, he told me, was calculated for the naturall vice of that people, which was avarice, and particularly for Mr. Livingston, a rich but very covetous man in town who valued himself much for his riches. But unfortunately Livingston did not come to church to hear his reproof."[5]

See figure 114

NOTES

1. John Henry Livingston, *The Livingston Manor* (New York, 1914), p. 13.
2. "Philip Livingston," Smibert painting file, Frick Art Reference Library.
3. Ibid.
4. Livingston, *Livingston Manor,* p. 15.
5. Bridenbaugh 1948, p. 68.

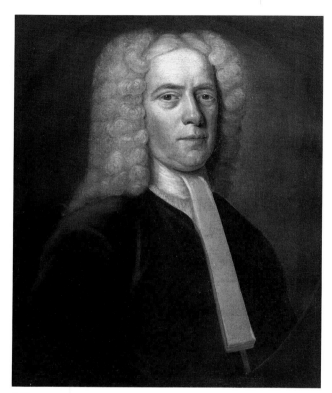

125

125 Judge Edmund Quincy, 1737

Gift of the children of Josiah Quincy, Museum of Fine Arts, Boston
30 1/2 × 24 1/2 (77.5 × 62.2)
Inscription on reverse (visible before canvas was lined): "painted
 by Smibert 1733, Boston, Massachusetts Bay"
Provenance: The sitter's great-grandson, Josiah Quincy, Boston;
 gift of the children of Josiah Quincy to the Museum of Fine Arts,
 1876.348
Notebook: [December 1737], p. 95, no. 148: "Judge Quincy 3/4
 6 Guinias"
Literature: MHS *Proc.*, vol. 16 (1878), pp. 398–399; W. H. Downes,
 "Boston Painters and Paintings," *Atlantic Monthly*, vol. 62,
 no. 369 (1888), p. 91; Sibley and Shipton 1873–1956, vol. 4,
 opp. p. 492 rep.; Burroughs 1936, p. 37, fig. 27; Foote 1950, p. 184;
 Boston 1969, vol. 1, no. 889; Massachusetts Historical Society, *A
 Pride of Quincys* (Boston, 1969), n.p. 11 recto rep.; Saunders
 1979, vol. 1, p. 194; vol. 2, pl. 158
Subject: Edmund Quincy, born in Braintree, Mass., October 4,
 1681; son of Edmund Quincy and Elizabeth Gookin Quincy;
 graduated from Harvard, 1699; married Dorothy Flynt of Dor-
 cester, November 20, 1701; judge of the Superior Court of Mas-
 sachusetts, 1718–1737; died in London, where he was repre-
 senting Massachusetts in a border dispute with New Hampshire,
 February 23, 1738, from an inoculation against smallpox[1]

The painting retains its original frame. A replica, or
copy, of the portrait is now on loan to the Portsmouth
(N.H.) Atheneum from the Frederick Nourse family. This
latter portrait is recorded in Foote 1950, p. 185 as "JUDGE
EDMUND QUINCY, NO. 2."

NOTES

 1. Foote 1950, p. 184; Sibley and Shipton 1873–1956, vol. 4,
pp. 491–494.

126 Mrs. William Browne, 1738

The Johns Hopkins University, Halsted Collection, on extended
 loan to the Baltimore Museum of Art
92 1/2 × 57 (234.9 × 144.8)
Provenance: See cat. no. 94
Notebook: [August 1738], p. 95, no. 158: "Mrs. W. Brown W.
 Lenth H.P. / 16 [guineas]"
Literature: *Essex Institute Historical Collections*, vol. 32 (July–
 December, 1896); Cleveland Museum of Art, *Bulletin*, vol. 8,
 no. 1 (January 1921), rep.; Bayley 1929, p. 359 rep.; New Haven
 1949, no. 8; Foote 1950, pp. 139–140; Saunders 1979, vol. 1,
 pp. 194–195; vol. 2, pl. 159; Quick 1981, p. 12 fig. 6
Subject: Mary Burnet, born 1722; daughter of William Burnet,
 who had been governor of New York, Massachusetts, and New
 Hampshire; married William Browne of Salem (cat. no. 94),
 1737, before her fifteenth birthday; mother of six children; died
 August 1, 1745[1]

See figure 97

In the mid-1730s Smibert's commissions were beginning
at times to exceed his waning skills. This portrait, which is
his only American full-length of a woman and was in-
tended as a pendant to cat. no. 94, painted four years ear-
lier, suffers from this decline. Smibert's inability to control
human proportion in this format is painfully apparent.
The palette—a blue gown with a rose-colored mantle—is a
combination he had favored before (see cat. no. 68). The
building in the background is Browne Hall, the Browne
family's country house, in which this portrait was intended
to hang.

NOTES

 1. Foote 1950, p. 139.

127 View of Boston, c. 1738–1741

Courtesy Childs Gallery, Boston
30 × 50 (76.2 × 127)
Provenance: Sold at auction, W. & F. C. Bonham & Sons, London,
 c. 1967–1969; purchased by Henry Stern, New Orleans; pur-
 chased by William Groves, New Orleans; sold at auction, Adam
 A. Weschler & Son, Washington, D.C., 1975; purchased by
 Childs Gallery, December 1975
Notebook: [possibly August 1738], p. 95, no. 159: "a vew [*sic*] of
 Boston"
Literature: Paula Dietz, "The First American Landscape," *Connois-
 seur*, vol. 212 (December 1982), pp. 28–37; Hirschl and Adler
 Galleries, *American Art from the Colonial and Federal Periods*, exh.

cat. (New York, 1982), pp. 8–9; William H. Gerdts, "American Landscape Painting: Critical Judgements, 1730–1845," *American Art Journal*, vol. 17 (1985), pp. 28–29; Edward J. Nygren, *Views and Visions: American Landscapes before 1830*, exh. cat. (Washington, D.C.), 1986, pp. 111–113, 291; Hallam 1990, pp. 145–162

See plate 25

This is probably the first large-scale cityscape painted in America. The vantage point for this panoramic view of Boston is Camp Hill on Noodles Island, in what is now East Boston; at the time it was used as pasture for sheep. To the far left are the hills of Dorchester. The major identifiable buildings with their dates of construction, from left to right, are Hollis Street Meeting House, first steeple behind Fort Hill on the far left, 1732; New South Meeting House, 1716; Trinity Church, 1735; Third Church (Old South), 1729, brick; Province House, 1679 (only cupola visible); First Church, 1711, brick; Old State House, 1711, brick; King's Chapel, enlarged 1710; West Church (Lynde Street Meeting House), 1737, wood; New North Brick Church, 1721, brick; Old North, Second Church, 1650, wood; New North Church, 1713, wood; Christ Church (now Old North), 1723, brick.[1]

The painting has suffered considerable surface abrasion and overpainting (now removed), but much of the topography of the cityscape itself is still largely intact—enough to allow a fairly close dating.[2] West Church (fourth steeple from the left) was built in 1737, and Smibert transferred his membership there that year. As the painting omits Faneuil Hall, built in 1742, it must have been executed between those years.

Based on internal information, it seems likely that this is the painting Smibert recorded in his notebook in August 1738 as "a vew of Boston." Since no price is recorded, nor is any indication given that the painting was meant as a present, Smibert may well have done it on speculation.

The composition recalls *A South East View of Ye Great Town of Boston*, 1725 (fig. 11), by William Burgis, updated in 1736. This engraving, along with views in John Slezer's *Theatrum Scotiae* (see figs. 116, 117), likely provided Smibert with models for his composition. A landmass in the foreground gives the effect of a raised vantage point. As a dealer in prints, Smibert was also probably aware of Burgis's *South Prospect of New York*, c. 1719–1721, which was sold in Boston as early as 1722 and, like Slezer's work, makes use of such a device.

In the center foreground are four figures. The male figure on the left, dressed in a frock coat, tricorne hat, and stockings, gestures out over the harbor. At his left stand two Native Americans, to whom the first figure is apparently pointing out the sites of Boston. The grouping of such figures in landscapes was quite common, but here the relationship of the figures may be intended to suggest a kind of cultural imperialism.[3]

The attribution of the view of Boston to Smibert seems secure on stylistic grounds. The thinly painted blue sky accentuated with puffy white clouds and the pinkish horizon line are both reminiscent of Smibert's landscape backgrounds. The palette and brushwork resemble Smibert's earlier work. Smibert had painted a partial view of Boston in cat. no. 39 and included similar architectural details in cat. nos. 41 and 126. The diagonal brush strokes that define the grass and rocks in the foreground recall similar details in cat. no. 86.

NOTES

1. Initial identification of buildings was provided by Childs Gallery.
2. Examined by the author with Elizabeth Jones, conservator, Museum of Fine Arts, Boston, 1976.
3. Hallam 1990, p. 157.

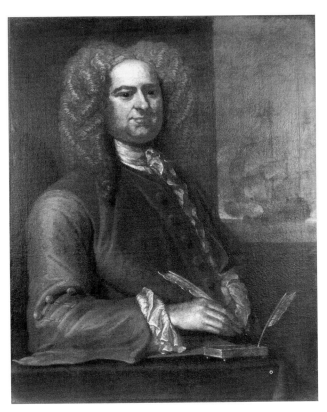

128

128 Unidentified Man, c. 1738–1746

Arthur Cronson
36 3/4 × 28 1/2 (93.3 × 72.4)
Provenance: Purchased from a New Orleans estate by M. Knoedler & Co., 1953; sale at Sotheby's, 1980; purchased by Arthur Cronson, Manhasset, N.Y.

This portrait, which depicts a man wearing a rust-colored frock coat and seated at a cloth-covered table, is typical of Smibert's late work. Although the painting has

been heavily restored, so that some areas (particularly the lower half of the face and the ship visible through the open window) largely consist of overpaint, the brushwork in other areas—such as the wig and the shirt cuffs—is similar to that in works known to be by Smibert. The format of this portrait recalls that of cat. no. 112.

On the reverse of the painting is a Knoedler stock label marked "A5320."

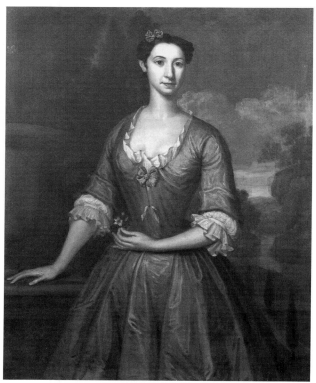

129

129 Mary Ann Faneuil, 1739

Courtesy Massachusetts Historical Society
50 × 40 (127.4 × 101.8)
Provenance: By descent to great-granddaughter Miss Mary Ann Jones; gift of Miss Mary Ann Jones to the Massachusetts Historical Society, 1906[1]
Notebook: [August 1739], p. 96, no. 168: "Ms. Marey A. Funnell 1/2 12 Guinies"
Literature: Bayley 1929, p. 397 rep.; New Haven 1949, no. 15; Foote 1950, p. 165; Saunders 1979, vol. 1, p. 198; vol. 2, pl. 168; Oliver, Huff, and Hanson 1988, p. 40
Subject: Mary Ann Faneuil, born in New Rochelle, N.Y., 1715; daughter of Huguenot refugees Benjamin Faneuil and Ann Bureau Faneuil; lived in Boston with her unmarried brother Peter Faneuil (cat. no. 130) until his death in 1743, after which she married John Jones of Roxbury; died 1790[2]

This is a typical late portrait by Smibert. Although the palette is consistent with his earlier American work (the

sitter wears a golden dress), the sitter's features are coarse, and her figure is awkwardly proportioned.

NOTES

1. MHS Proc., vol. 40 (June 1906), p. 409.
2. Foote 1950, p. 165.

130 Peter Faneuil, 1739

Courtesy Massachusetts Historical Society
50 × 40 1/2 (127.5 × 103)
Provenance: By descent to nephew of sitter Mr. Edward Jones; his son and daughter Mr. Charles Faneuil Jones and Miss Eliza Jones; gift of Mr. Charles Faneuil Jones and Miss Eliza Jones to Massachusetts Historical Society, 1835[1]
Notebook: [September 1739], p. 96, no.169: "Mr. Pr. Funnell 1/2 12 Guinies"
Literature: Perkins 1878, p. 395; Winsor, 1880–1881, vol. 2, p. 260; Magazine of American History, vol. 8, pt. 2 (1882), p. 251; H. W. Foote, Annals of King's Chapel (Boston, 1882), vol. 2, p. 81; Bayley 1929, p. 383 rep.; Coburn 1929, p. 387; New Haven 1949, no. 12; Foote 1950, pp. 151–152 ("Peter Faneuil, No. 2"); Detroit Institute of Arts, The French in America, 1520–1820, exh. cat. (Detroit, 1951), p. 135, no. 335; Museum of Fine Arts, Paul Revere's Boston: 1735–1818, exh. cat. (Boston, 1975), pp. 28–29; Saunders 1979, vol. 1, p. 211; vol. 2, pl. 171; Oliver, Huff, and Hanson 1988, pp. 40–41
Subject: Peter Faneuil, born in New Rochelle, N.Y., June 20, 1700; eldest of eleven children born to Benjamin Faneuil, one of three brothers who came to America after the revocation of the Edict of Nantes, and Anne Bureau Faneuil. After the death of his father, Peter moved to Boston, where his uncle Andrew was a prosperous merchant. He was an Anglican and contributed toward the erection of King's Chapel. In 1738, with the death of Andrew, Peter inherited almost his entire estate, one of the largest fortunes of the day. Peter became the leading merchant in Boston and the largest shipowner in America, but he is best remembered for Faneuil Hall, which was constructed at his expense as Boston's town market and assembly hall. He died March 3, 1743, before the town held its first annual meeting to thank him formally for the gift.[2]

See figure 123

This painting is in every way typical of Smibert's late merchant portraits. The pose is one long-favored by Smibert. The palette is conservative, and the subtleties of earlier portraits have dissipated.

NOTES

1. MHS. Proc., vol. 2 (1880), p. 19.
2. J[ames] T. A[dams], "Faneuil, Peter," DAB 1928–1937 (1964 ed.), vol. 3, pp. 262–263.

NOTES

1. Foote 1950, p. 152.
2. Smibert painted another replica of Peter Faneuil, in August 1744. See cat. no. 286.

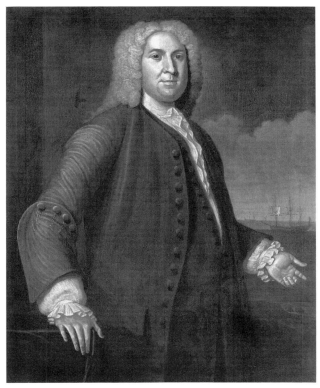

131

131 Peter Faneuil, 1740

In the collection of the Corcoran Gallery of Art, museum purchase, William A. Clark Fund and gift of Orme Wilson
49 3/4 × 40 (126.4 × 101.6)
Provenance: The sitter's sister, Mary Ann Faneuil (Mrs. John Jones); her son Edward Jones; his son Charles Jones; his son Peter Faneuil Jones; his daughter Miss Frances Jones, Cocoa, Fla.; on loan to her nephew Peter Faneuil Robinson, Scituate, Mass., 1949;[1] sold by William M. Gannon (dealer) to Vose Galleries, as agent, Boston, 1957; purchased by the Corcoran Gallery of Art, 1957
Notebook: [March 1740], p. 96, no. 174: "Mr. Funnell; 1/2 12 Guines" [listed as a copy along with that of "Mrs. Funnell," probably Mrs. Benjamin Faneuil, Peter's mother][2]
Literature: New Haven 1949, no. 11; Foote 1950, p. 152 ("Peter Faneuil, No. 3"); Vose Galleries, *Early American Portraits,* exh. cat. (Boston, 1956); Wildenstein and Co., *Masterpieces of the Corcoran Gallery of Art,* exh. cat. (New York, 1959); Corcoran Gallery of Art, *A Catalogue of the Collection of American Paintings in the Corcoran Gallery of Art,* vol. 1, *Painters Born before 1850* (Washington, D.C., 1966), pp. 17–18 rep.; Saunders 1979, vol. 1, p. 198; vol. 2, pl. 169
Subject: See cat. no. 130

This portrait is a replica of cat. no. 130. The contrasts are somewhat sharper, and details (such as the treatment of Faneuil's rust-brown coat) are more mechanical.

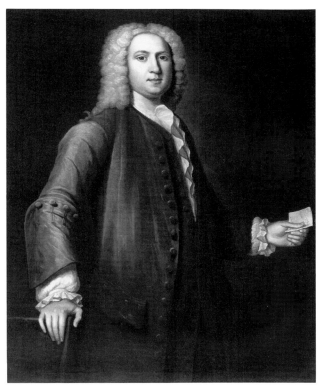

132

132 Benjamin Colman, 1739

From the collection of the New Britain Museum of American Art, Conn., Harriet Russell Stanley Memorial Fund
49 × 39 (124.5 × 99.1)
Inscription: Letter in left hand reads, "To / Mr Benjn Colman / Mercht / Bost[on]"
Provenance: By descent to Dr. Colman W. Cutler, New York;[1] Macbeth Gallery, New York, as agent, 1947; purchased by the New Britain Museum of American Art, 1948
Notebook: [September 1739], p. 96, no. 170: "Mr. B. Colman 60 1/2 12 Guineis"
Literature: *Colonial Society of Massachusetts Publications,* vol. 6 (February 1899), p. 86; Bolton 1919–1926, vol. 3, p. 1025; Sibley and Shipton 1873–1956, vol. 1, pp. 130–132 rep.; Newark Museum, *Early American Portraits,* exh. cat. (1947), p. 9, no. 29; Foote 1950, pp. 145–146; New Britain Museum of American Art, *Catalogue of the Collection* (New Britain, Conn., 1975), p. 59; Saunders 1979, vol. 1, pp. 198–199; vol 2, pl. 170.
Subject: Benjamin Colman, merchant, born in Boston, October 28, 1710; tenth child of John Colman and Judith Hobby Colman; graduated from Harvard, where he was reprimanded for rowdiness, 1727; married (1) Deborah Oulton (died October 12, 1738), daughter of John and Deborah (Legge) Oulton of Mar-

blehead, March 24, 1736, (2) Hannah Pemberton (cat. no. 100), daughter of James Pemberton and Hannah Penhallow Pemberton, August 16, 1739; attended the church in Brattle Square, where his uncle, Rev. Benjamin Colman (cat. no. 236), was minister. Colman and his business partner, Nathaniel Sparhawk of Kittery, had close ties to Sir William Pepperrell (cat. no. 138), who in 1746 enabled them to get contracts to furnish uniforms for Massachusetts troops and construction material, supplies, and workmen for the garrison at Louisbourg, Nova Scotia. By 1758, however, their business had foundered, and Pepperrell filed a commission of bankruptcy against the firm. Just how low Colman's fortunes had sunk at the time of his death, April 20, 1756, is evident from his obituary, which stated that he was "formerly a noted merchant in this Town."[2]

This portrait was probably painted to celebrate Colman's marriage the previous month. At one point the back of the canvas was inscribed "Henry Davenport was the owner October 1, 1878."[3] Henry Davenport is said also to have owned the portrait of Hannah Pemberton (cat. no. 100). The sitter's attire is identical to that in Smibert's other late merchant portraits. The only difference is that here the coat and waistcoat are burgundy.

NOTES

1. The portrait probably followed the line of descent of cat. no. 100.
2. Sibley and Shipton 1873–1956, vol. 8, pp. 130–132.
3. "Benjamin Colman," Smibert painting file, Frick Art Reference Library.

133 Joseph Turner, 1740

Property of Cliveden, a co-stewardship property of the National Trust for Historic Preservation
50 × 40 (127 × 101.6)
Inscription, lower left: Letter on table is addressed "To / Joseph Turner / in / Philadelphia"
Provenance: The sitter; his niece Elizabeth Oswald (Mrs. Benjamin Chew); descent in Chew family to Miss Elizabeth B. Chew (d. 1959); her nephew Samuel Chew; gift of Samuel Chew to the National Trust for Historic Preservation, 1972.
Notebook: [July 1740], p. 97, no. 192: "Mr. Jo: Turner H.P. 1/2 20 Guns."
Literature: Pennsylvania Academy 1971, p. 36, no. 29 rep.; Ellen G. Landau, "Study in National Trust Portraits," Historic Preservation, vol. 27, no. 2 (April–June 1975), pp. 30, 32 rep. (detail); Saunders 1979, vol. 1, pp. 212–213; vol. 2, pl. 172
Subject: Joseph Turner, born in Andover, Hampshire, England, May 2, 1701; died 1783. Turner came to America in 1713/14, where he became a leading Philadelphia merchant and a member of the Governor's Council. For a number of years he was partner with William Allen (cat. no. 163) in the most important commercial firm of the period. In his earlier days Turner had been a sea captain, but he became a manufacturer of iron and an owner of mines, the largest of which was the Union Iron Works in Hunterdon, N.J., which covered eleven thousand acres. Turner owned a house, Solitude, near High Bridge, N.J. In addition to the portrait by Smibert, he also commissioned a

three-quarter-length portrait from John Wollaston (c. 1752, Chester County Historical Society, West Chester, Pa.).

See figure 118

Of the fourteen portraits Smibert painted on his 1740 trip to Philadelphia, this is the only one that is presently located. In format, palette, and execution it closely resembles cat. nos. 130–132 and suggests that the portraits from this trip were extremely conservative and repetitive. The painting was cleaned and restored in 1973 by Theodor Siegl, conservator, Philadelphia Museum of Art, who noted in his conservation report, "The painting had been relined with an aqueous adhesive and very extensively retouched. The retouching was sloppy, ill matched, and excessive. It covered numerous small paint losses as well as substantial sections of original paint."

134 George Clarke, 1740

Private collection
50 × 40 (127 × 101.6)
Provenance: Descent in Clarke family to present owner
Notebook: [September 1740], p. 97, no. 199: "Gor. Clark HP 1/2 20 Guinnes"
Literature: Douglas R. Kent, "Hyde Hall, Otsego County, New York," Antiques, vol. 92 (August 1967), p. 193, fig. 10; Saunders 1979, vol. 1, pp. 214–215; vol. 2, pl. 173
Copy: 50 × 39 1/2 inches, offered at Christies, 4–28–77, no. 84, b.i., owned by Rev. J. E. Hyde-Lynaker
Subject: George Clarke, born 1676; son of George Clarke of Swainswick, Somersetshire, England; appointed secretary of the Province of New York and arrived in America July 23, 1702. In 1705 Clarke returned to England, where he married Anne Hyde. Upon his return to New York he purchased one hundred acres on Long Island, where he built a country house. By 1736 he had amassed a fortune, largely from land dealings. From 1736 to 1743 he was the administrative leader of New York, with the title of lieutenant-governor. In 1745, two years after George Clinton was appointed governor, Clarke returned to England, where he purchased a handsome estate in Cheshire. He died on January 12, 1760, and was buried in Chester Cathedral.[1] Smibert also painted portraits of Clarke's four sons: see cat. nos. 232–235.

See figure 119

This is the only portrait presently located from Smibert's 1740 visit to New York, and it is in a remarkable state of preservation. The painting is on its original strainers, has never been lined, and retains its original frame (painted black with a carved and gilded liner). Although the painting follows the format of Smibert's other late portraits of men, it is somewhat more spirited and forceful. Clarke wears a red velvet frock coat and a fashionable yellow waistcoat, and a sword hilt is visible under his left hand.

There are two paper labels on the back of the frame, which read:

1. In blue pencil: "George Clarke—B at Bath, England 1676 / came to New York about 1698 in a small /

Government post gradually rose in the colonial Government until he became Lieutenant Governor of the Colony about 1730 was always the acting Governor as no Royal Governor was appointed during his term married Anne Hyde whose father Ed. Hyde had been gov of the Carolinas & died in office."

2. In ink: "George Clarke / Lt. Governor / Died at Chester in 1760. / B 1676—at Bath / Married Anne Hyde / Daughter of Edward Hyde / Gov. of No. Carolina / For Edward Hyde Clarke / son of T. O. Clarke My / own Foster son. / signed / J. Clarke / Copied July 12, 1960 from old label on frame at back."

NOTES

1. C[harles] W[orthen] S[pencer], "Clarke, George," *DAB* 1928–1937 (1964 ed.), vol. 4, pp. 151–152.

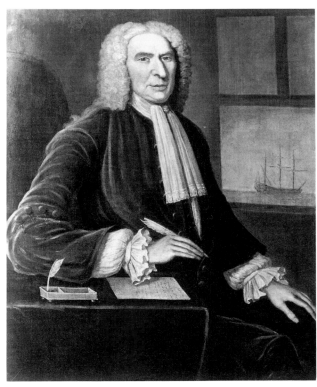

135

135 Charles Chambers, 1743

Gift of Mrs. Charles R. Codman in memory of her husband, Charles R. Codman, and her son, Charles R. Codman, Jr., Museum of Fine Arts, Boston

47 3/4 × 37 3/4 (127 × 96)

Provenance: The sitter; Charles Russell, Lincoln, Mass.; Charles Russell, Lincoln; John Codman, Lincoln; Charles Russell Codman, Lincoln; Russell Sturges Codman, Boston; his son Charles R. Codman, 1941–1949; Mrs. Charles R. Codman, Boston; gift of Mrs. Charles R. Codman to Museum of Fine Arts, Boston, 1968

Notebook: [May 1743], p. 98, no. 215: "Mr. Chamebrs H.P. 1/2 16 Gunnes"

Literature: MHS *Proc.* vol. 17 (1879), pp. 94–97; Bolton 1919–1926, vol. 2, p. 536 rep.; Bayley 1929, p. 365 rep.; Boston 1930, p. 18 rep.; Foote 1950, pp. 142–143; Saunders 1979, vol. 1, pp. 225–226; vol. 2, pl. 178; Museum of Fine Arts, Boston, *Centennial Acquisitions: Art Treasures for Tomorrow* (Boston, 1970), p. 108, no. 74

Subject: Charles Chambers, sea captain, merchant, justice of the peace, and judge of the court of common pleas; born in Torksay, Lincolnshire, England, 1660; son of Edward Chambers and Elizabeth Palmer Chambers; married (1) Rebecca Patefield (1657–1735), daughter of John and Mary Patefield, January 30, 1687, (2) Margaret, daughter of William and Mary Vaughn, widow of Captain Foye, February 10, 1736; died in Charlestown, Mass., April 27, 1743[1]

This portrait is ample proof of the deterioration of Smibert's abilities by the 1740s. Comparison with cat. no. 74 indicates that Smibert continued to rely on stock formats, but that he no longer possessed the skills to pull the various elements of the painting together.

NOTES

1. Foote 1950, p. 142.

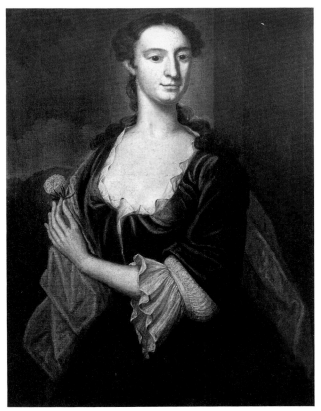

136

136 Mrs. Clark Gayton, 1745

Courtesy New-York Historical Society
36 5/8 × 28 1/4 (93 × 71.7)
Provenance: Mrs. David Murphy, by 1949;[1] gift to the New-York Historical Society from Edmund Astley Prentis, 1951[2]
Notebook: [1745], p. 99, no. 235: "Mrs. Gayton KK 12 Gunnes"
Literature: New Haven 1949, no. 36; Foote 1950, p. 226; NYHS 1974, vol. 1, p. 288; Saunders 1979, vol. 1, p. 230; vol. 2, pl. 181
Subject: Judith Rawlins, born 1712; daughter of Phillip and Hannah Rawlins of Boston; wife of Admiral Clark Gayton and mother of George Clark Gayton

The sitter is dressed in a blue-green gown with a rose-colored mantle. She holds a pink carnation in her left hand. The portrait, which is still on its original strainers, is extremely dirty, hence a full appraisal is difficult.

There are three labels on the back of the stretchers and frame:

1. In ink:
Property of / Mrs. David E. Murphy / 2 West 67th St. N.Y.C. / Temporary loan to The New Haven Colony / Historical Society / Oct. 1947
2. Typed:
Portrait of Mrs. Smith (?) / Painted c. 1735 / By / John Smibert / Loaned by Mrs. David E. Murphy
3. Printed label:
THIS PICTURE WAS / RESTORED / AT THE COPLEY GALLERY / 103 NEWBURY STREET BOSTON MARCH 4, 1920 [date in ink]

NOTES

1. Foote 1950, p. 226.
2. NYHS 1974, vol. 1, p. 288.

137 Sir Peter Warren, 1746

From the collections of the Portsmouth Atheneum, N.H.
92 × 58 (233.6 × 147.3)
Provenance: A gift from the sitter to Sir William Pepperrell, Kittery, Me.; his daughter Elizabeth Pepperrell (Mrs. Nathaniel Sparhawk); sold to John Fisher, Portsmouth, N.H., who presented it to the Portsmouth Atheneum, 1828
Notebook: [August 1746], p. 99, no. 238: "Admirel P. Warran a W Length / 32 Guinnes"
Literature: Parsons 1856, pp. 237, 329, 345; Essex Institute Historical Collections, vol. 31 (1894–1895), pp. 56–58; Bolton 1933, p. 42; Foote 1950, pp. 197–198; Saunders 1979, vol. 1, p. 233; vol. 2, pl. 184; Quick 1981, p. 87, pl. 15; Miles 1983, p. 54 rep.
Subject: Peter Warren, born in Warrenstown, County Meath, Ireland, March 10, 1703; son of Michael Warren and Catherine Aylmer Warren. At age twelve he entered the navy as a midshipman and remained in British waters until 1718. July 7, 1730, he arrived in New York as commander of the H.M.S. Solebay, and for the next seventeen years he made New York his home. He owned three hundred acres of land, known as "Warren Farm," which is now Greenwich Village. In July 1731 he married Susan DeLancey, daughter of Stephen and Anne Van Cortlandt De-

Lancey, sister of James and Oliver DeLancey (cat. no. 160). He commanded two ships in the 1730s and early 1740s, and was in charge of the naval contingent at the successful assault against the French at Louisbourg in 1745, whereupon he was made rear admiral of the Blue Squadron. Subsequently he was made, much to his disgust, governor of Louisbourg and Cape Breton Island, and in 1747 distinguished himself in the British naval victory over the French off Cape Finisterre. After several other promotions, including a knighthood, he returned to London. He died in Dublin, July 29, 1752, and was buried at Knockmark, near Warrenstown, Ireland.[1]

See figure 129

This is one of four portraits Smibert painted of figures associated with the celebrated victory over the French at Louisbourg in 1745. The other portraits are cat. nos. 138, 139, and 425. The series was one of the most ambitious and demanding of his career, and it is unfortunate that it came at a point when his abilities were not equal to the task. Cat. no. 137 (as well as 138 and 425) was a request for a full-length portrait—a format he had not attempted since 1738 when he painted cat. no. 126. Warren wears a British navy captain's blue coat, with a red waistcoat and breeches. He holds a telescope and gestures toward three ships in the distance, two of which can probably be identified as his flagship, the *Superbe,* which flies the British ensign and red pennants, and a French ship, with the white French flag and white pennants. The scene most likely represents Warren's capture of the *Vigilante* during the siege.[2]

Warren's account book for 1746 records two payments (August 30 and October 17) to Smibert, each of 33 pounds, 12 shillings, the equivalent of 32 guineas. A letter from Warren to Sir William Pepperell dated July 12, 1751, long after Warren had returned to England, indicates that his payments to Smibert were for nos. 138, 139, and possibly no. 137. Warren wrote, "Smybert has not sent me your and Captn. Sprys Pictures which I wonder at, and Harry Frankland had commission from me to get them sent me."[3] As Warren's account book payments were insufficient to pay for all three portraits, it is unclear whether no. 137 was intended to be sent as well.

In any event, Warren was planning to send Pepperrell his own portrait (Thomas Hudson, *Sir Peter Warren,* 1751, National Portrait Gallery, London) and possibly one of his wife. In the same letter he noted, "Our pictures should have been with you ere now coud we get the Painter to finish them. Mine is pretty forward and I hope you will have it this Fall, and the other as soon as Possible." For unknown reasons the exchange never took place.

NOTES

1. L. H. R[ogers], Jr., "Warren, Sir Peter," *DAB* 1928–1937 (1964 ed.), vol. 10, pp. 485–486.
2. Miles 1983, p. 55.
3. Warren to Pepperrell, July 12, 1741, Fogg Autograph Collection. Maine Historical Society, Portland. Quoted in Miles 1983, p. 61.

Sir William Pepperrell Bar, Colonel of one of his Majesty's Regiments of Foot, who was Lieutenant General and Commander in Chief of the American Forces Employ'd in the Expedition against the Island of Cape Breton which was happily Reduced to the Obedience of his Britanick Majesty June the 17. 1745. J. Smibert Pinx. P. Pelham fecit et ex: 1747.

138a

138 Sir William Pepperrell, 1746

Courtesy Peabody Essex Museum, Salem, Mass.

96 × 56 (244 × 142.3)

Inscription: l.r. "LT. GEN SIR WM. PEPPERELL, Bart. / The Victor of Louisbourg A.D. 1745"

Provenance: The sitter; his daughter Elizabeth Pepperrell (Mrs. Nathaniel Sparhawk), Kittery, Me.: George A. Ward, Salem, Mass., 1821; presented by George A. Ward to the Essex Institute, 1821[1]

Engraved: Mezzotint (cat. no. 138a) by Peter Pelham, 1747 Stauffer 1907, p. 2471; not in Smith 1884; 11.13 × 9.13 inch

Inscribed: Sir William Pepperrell Bart. Colonel of one of his Majesty's Regiments / of Foot, who was Lieutenant General and Commander in Chief of the American / Forces employed in the Expedition against the Island of Cape Breton which was / happily Reduced to the Obedience of his Britanick Majesty June the 17. 1745 / J: Smibert Pinx / Sold by J. Buck in Queen street Boston / P: Pelham fecit et ex: 1747

Imprints: American Antiquarian Society; Museum of Fine Arts, Boston; Massachusetts Historical Society

Notebook: [August 1746], p. 99, no. 239: "Sr. William Pepperrell a W / Lenth 32 Guinnes"

Literature: *Essex Institute Historical Collections*, vol. 21 (1884), p. 161; vol. 31 (1894), p. 59; vol. 37 (1901), p. 273 rep., pp. 287–289; Winsor 1880–1881, vol. 2, p. 115; Dunlap, vol. 3, p. 334; Bayley 1929, p. 415 rep.; Essex Institute 1936, p. 152; Foote

1950, pp. 179–180; Oliver 1973, pp. 155, 157, 158, 172; Saunders 1979, vol. 1, pp. 233–235; vol. 2, pl. 185; Miles 1983, pp. 48–66, fig. 6

Copies: (1) full size in oils at Portsmouth Atheneum, signed "U.D. Tenney, after Smybert, 1747; (2) in oils, owned in 1949 by Mrs. George L. Montague, Chelsea, Mass.

Subject: William Pepperrell, born in Kittery, Me., June 27, 1695. His father and namesake was a native of Tavistock, near Plymouth, England, who became a successful merchant. Young William emulated his father and became a merchant as well. March 16, 1723, he married Mary Hirst (cat. no. 111), granddaughter of Samuel Sewall (cat. no. 42). Pepperrell was active in the militia and by age thirty had risen to the rank of colonel, in command of all militia in the Province of Maine. Upon his father's death in 1734, he inherited the bulk of the estate and wielded considerable political and economic power. Pepperrell's enthusiasm and discipline were essential to the success of the British and colonial assault on the French stronghold at Louisbourg, Nova Scotia. His achievements were recognized in London, and in November 1746 he was created a baronet, an honor never before conferred on a native American. After additional military exploits in the 1750s, at which point he was commissioned lieutenant-general in the Royal Army, his health failed, and he died July 9, 1759.[2]

See plate 26

Despite the flawed anatomy of the figure, this portrait is still a vividly impressive painting. Pepperrell wears a red uniform coat and waistcoat, decorated with gold buttons and braid, and he holds a baton, the symbol of military leadership. His tricorne hat is tucked under his arm, and a ceremonial sword hangs from his waist. He stands on a rise overlooking the colonial lines at Lighthouse Point opposite Louisbourg and gestures toward a battery of guns. The cannon have just sent two marvelously exaggerated bombs flying toward the French fort in the distance. Below his right arm the lighthouse from which the location took its name is visible. Smibert chose to depict the climactic moment of the siege as described by William Shirley in his letter to the Lords of Trade, July 10, 1745: "our Battery upon the Light House point erected with incredible Labour to our Troops thro the Steepness of the Hill and the bad ground, over which the Artillery was transported by Hand, distress'd the Enemy so exceedingly in their Island Battery, particularly with the Bombs thrown from it (as the General informs me) and the incessant Fire from the Grand Battery and our other Batteries, which was greatly increas'd on the 16th of June beyond what it was before, was so insupportable to the Enemy that they were confined to their cover'd ways, . . . all which besides the Annoyance from our Musketry . . . brought the Enemy on the Same day to beat a Parley and desire a suspension of Hostilities."[3]

This painting was apparently commissioned by Sir Peter Warren (see cat. no. 137) but was never sent to him. During the eighteenth century it hung at the Pepperrell house in Kittery, Me., along with a collection of more than fifty portraits, perhaps the largest in New England.[4]

NOTES

1. Foote 1950, p. 179.
2. J[ames] T. A[dams], "Pepperrell, Sir William," *DAB* 1928–1937 (1964 ed.), vol. 7, pp. 456–457.
3. Charles Henry Lincoln, *Correspondence of William Shirley*, 2 vols. (New York, 1912), vol. 1, pp. 140–141.
4. Byron Fairchild, *Messrs. William Pepperrell: Merchants at Piscatagua* (Ithaca, N.Y., 1954), p. 186.

139

139 Sir Richard Spry, 1746

From the collections of the Portsmouth Athenaeum, N.H.
49 1/2 × 39 1/2 (125.8 × 100.3)
Provenance: Presented by John Fisher to Portsmouth Athenaeum, 1828
Notebook: [September 1746], p. 99, no. 240: "Captain Spray 1/2 16 Guinnis"
Literature: Foote 1950, p. 191; Saunders 1979, vol. 1, pp. 235–236; vol. 2, pl. 187; Miles 1983, pp. 48–66, fig. 8
Subject: Richard Spry (d. 1775), British naval officer who protected the British settlement at Annapolis Royal, Nova Scotia, during the seige on the French installation at Louisbourg; promoted to fleet captain in 1745 and made rear admiral of the Red Squadron in 1775

This is Smibert's last surviving portrait, from the final month of his professional painting activity. It was commissioned after the British victory at Louisbourg by Sir Peter Warren (cat. no. 137) but for some reason was never sent to him. As Spry was not actually at Louisbourg, the naval en-gagement depicted behind him is probably his capture of a French privateer off Nantucket, November 4, 1744.[1] Spry wears a Naval captain's uniform like that in cat. no. 137.

In 1974 the painting was cleaned and lined by Erving Hansen of Portsmouth, and in his opinion it had been cleaned twice previously.[2] A label on the frame reads, "Sir Richard Spry, K.C.B. / Promoted Fleet Captain for services before / Louisbourg 1745. Made Rear Admiral of the / Red Squadron, Royal Navy 1775. / Died in Cornwall, Eng. / 1775."

NOTES

1. Miles 1983, p. 61.
2. Jane D. Kaufmann, "Portraits of the Heroes of Louisbourg at the Portsmouth Atheneum," typescript, Portsmouth Atheneum, painting files.

B. Copies

140 Cardinal Guido Bentivoglio (1579–1644), after Anthony Van Dyck, c. 1719–1720

Courtesy Fogg Art Museum, Harvard University, gift of John Trumbull, transferred from Harvard University Collection
29 7/16 × 24 1/2 (74.8 × 62.2)
Provenance: John Smibert to his wife, Mary Williams Smibert, 1751; her son Williams Smibert; his cousin John Moffatt, 1756; sold to the artist John Trumbull (1755–1834) from the estate of John Moffatt, 1778; Harvard College, gift of John Trumbull, 1789[1]
Notebook: Not recorded
Literature: Dunlap 1918, vol. 1, p. 18; MHS *Proc.*, vol. 16, p. 393; Copley-Pelham 1914, p. 240; Bolton 1933, p. 40; Huntsinger 1936, pp. 17–18; Foote 1950, pp. 11, 13–14, 109, 122, 124–125, 229; Sizer 1953, p. 44; Sizer 1967, p. 20 rep. fig. 5; Fogg Art Museum 1972, no. 20 rep. (attributed to Trumbull); Jaffe 1975, p. 40 (attributed to Smibert); Jaffe 1976, pp. 210–215, rep. fig. 1 (ownership by Smibert accepted, attribution questioned); Saunders 1979, vol. 1, pp. 33–35; vol. 2, pl. 32; Saunders 1984, pp. 312–315

See plate 4

The finest and best known of Smibert's copies after the old masters that survive is this bust-length portrait of Van Dyck's striking full-length (c. 1623) of Cardinal Guido Bentivoglio in the Pitti Palace. It was probably copied by Smibert in 1719–1720, during his stay in Florence.[2] Not among the most frequently copied paintings by touring British artists, it was nevertheless also copied by at least one other eighteenth-century artist, Sir Joshua Reynolds.[3]

In the eighteenth century it was generally held that a good copy was superior to an indifferent original. As a result, Smibert was not hesitant to paint them. He made at least nine copies after old masters, and probably many more.[4] Some of these were commissions from British pa-

trons who desired suitable souvenirs to take home. Other copies Smibert kept for himself, including those after Van Dyck, to have with him in Great Britain as suitable models for his own work.

The authorship of this and other surviving copies associated with Smibert has been disputed for years, with this copy being the most hotly contested. One opinion is that it is too sophisticated to be by Smibert. It has been suggested, rather ingeniously, that the portrait was indeed owned by Smibert but was purchased by him in Florence and then passed off as his own work. This argument has been shown to be unconvincing.[5] A close examination of the copy and the original indicates that the two are stylistically different. Van Dyck's sharp value contrasts between the light areas of the face and the darker background are modulated. The head is elongated, and the highlights of the robe, quite vibrant in the original, are reduced to more tentative strokes. Clearly, this portrait was made by an artist who sought the essence but not the detail of the original.

Smibert invested more effort in the Bentivoglio copy than others that survived, which was evident even in the eighteenth century. This perhaps explains why it was singled out for praise by George Vertue, the English artist and biographer who was a friend of Smibert's, noting, "when he came to Florence there from ye great Dukes pictures he copyd several particularly the Card. Bentivolio of Vandyke & many other heads making that his whole study after Titian Raphael Rubens."[6]

As the most highly regarded of Smibert's copies, it accompanied the artist to America in 1728. Others, such as his *Continence of Scipio* (Bowdoin College Museum of Art), after Poussin, apparently did not arrive in Boston until the 1740s.[7] It is presumably Smibert's *Bentivoglio* that impressed Mather Byles and induced him to write his poetic encomium "To Mr. Smibert on the sight of his Pictures," where after a visit to Smibert's studio he observed that "*Vandike* and *Rubens* show their Rival Forms."[8]

As relatively few important European paintings could be found in the colonies, this and Smibert's other copies provided crucial models to those interested in the techniques of painting. Although they were still translations, they gave some indication of color and technique and served as a needed complement to the more readily available black-and-white prints.

For more than seventy-five years this portrait fascinated and inspired. It had currency in 1774 when Copley, then in London, used it as a way of communicating ideas of color to his half-brother, Henry Pelham, in Boston.[9] Four years later it was purchased from Smibert's estate by the tyro John Trumbull, who in turn made his own copy of it before giving Smibert's copy to Harvard College in 1791.[10] The following year it was admired in the college library by Nathaniel Cutting, who observed "particularly a portrait of Cardinal Bentivolio executed by Smybert from the original by Raphael [sic]. It is certainly an excellent painting and does much honor to the copyist."[11] Later in that decade the artist Washington Allston, while a student at Harvard (class

of 1800), recalled, "In the coloring of figures the pictures of Pine, in the Columbian Museum in Boston were my first masters. But I had a higher master in the head of Cardinal Bentivoglio, from Vandyke, in the college library. . . . This copy was made by Smybert. . . . At that time I thought it was perfection, but when I saw the original some years afterward, I found I had to alter my notions of perfection. However, I am grateful to Smybert for the instruction he gave me—his work rather."[12] Few other pictures in the colonies had such a lasting impact.

NOTES

1. Jaffe 1976, p. 210.
2. Saunders 1984, pp. 312–15.
3. Oliver Millar, *Later Georgian Pictures in the Collection of Her Majesty the Queen*, 2 vols. (London, 1969), vol. 1, p. 161, cat. no. 1237.
4. Saunders 1984, p. 315.
5. Ibid.
6. Vertue 1930–1955, vol. 3, p. 14.
7. John Smibert to Arthur Pond, July 1, 1743. See appendix 2.
8. Foote 1950, p. 55.
9. Copley-Pelham 1914, p. 240. Copley made two comments about the Bentivoglio, the second of which is, "I would have you also observe to get your Picture a new hew of Colours that is rather gay than otherwise, at the same time rich and warm like Bentivoglios."
10. Harvard University, College Book, vol. 8, p. 306: "Voted: That the thanks of this corporation be given to Col. John Trumbull for his polite and generous attention to this University in his present of a copy of the late Mr. Smibert of Boston from a painting by Vandyck of Cardinal Bentivoglio, a portrait highly celebrated." Quoted in Jaffe 1976, p. 210.
11. Foote 1950, p. 125, n. 23.
12. Jared B. Flagg, *The Life and Letters of Washington Allston* (New York 1969), p. 13. Quoted in Jaffe 1976, p. 210.

141 Luigi Cornaro, after Tintoretto, c. 1719–1720

Bowdoin College Museum of Art, Brunswick, Me., bequest of the Honorable James Bowdoin III
30 × 25 (76.2 × 63.5)
Provenance: See cat. no. 143
Notebook: Not recorded
Literature: JBIII, no. 48; Bowdoin 1930, no. 197; Foote 1950, p. 230; Chappell, p. 136; Saunders 1984, pp. 315–317

This portrait was copied from Tintoretto's three-quarter-length original in the Pitti Palace. At the time Smibert copied it, the original had been in the Uffizi less than ten years.[1] Stylistically, this copy is similar to cat. no. 140, although the paint surface is thicker, and individual brush strokes are less evident. Along with cat nos. 142 and 143, it was included in James Bowdoin's bequest to Bowdoin College.

In 1973 the portrait was examined in the Fogg Art Museum conservation laboratory by Elizabeth Jones, who reported extensive losses to the background and damage to the chest but noted that the head (except for the ear) was in fairly good condition.

141

142

NOTES

1. Rossi 1967, p. 51.

142 Jean de Montfort, after Anthony
Van Dyck, c. 1719–1720

Bowdoin College Museum of Art, Brunswick, Me., bequest of the
 Honorable James Bowdoin II
28 1/2 × 23 (72.4 × 58.4)
Provenance: See cat. no. 143
Notebook: Not recorded
Literature: Burroughs 1942, p. 111 rep.; Foote 1950, p. 230;
 Chappell 1982, p. 136 rep.; Saunders 1984, pp. 315–317

Van Dyck's original is in Vienna. Smibert's copy was
made from Van Dyck's replica in Florence at the Uffizi. A
number of other copies exist: (1) Heyl Collection, Worms,
panel, 24 × 18.5 cm, presumably copied from the Vienna
version; (2) Castellane Sale Terris, Nice, March 5–9, 1934,
no. 87, 1.12 × 86 cm, presumably from the Uffizi replica;
(3) Sale Heberle, Cologne, October 1887, no. 50, presum-
ably from Vienna copy.

143 The Continence of Scipio, after
Nicholas Poussin, c. 1726

Bowdoin College Museum of Art, Brunswick, Me., bequest of the
 Honorable James Bowdoin III
45 3/4 × 62 3/4 (116.2 × 134)
Provenance: John Smibert to his wife, Mary Williams Smibert,
 1751; her son Williams Smibert; his cousin John Moffatt, 1756;
 probably acquired from the estate of John Moffatt by James
 Bowdoin III (1752–1811), 1778; bequest of James Bowdoin III
 to Bowdoin College, 1811
Notebook: Not recorded
Literature: JBIII, no. 3; Bowdoin 1852, no. 3 ("[Gilbert] Stuart
 thought it an original or first rate copy"); Bowdoin 1870, no. 3;
 Bowdoin 1906, p. 44, no. 132 (as by Poussin); Hagen 1940, p. 56;
 Flexner 1947, p. 1216; Bridenbaugh 1948, p. 114; Foote 1950,
 p. 229–230; Bowdoin 1950, p. 24 rep. fig. 22; Anthony Blunt,
 The Paintings of Nicholas Poussin (London, 1966), p. 129; Sadik
 1966, pp. 211–213; Saunders 1979, vol. 1, pp. 221–223; vol. 2,
 pl. 177; Pennsylvania Academy 1971, p. 35, no. 28 rep.; Metro-
 politan Museum of Art, France in the Golden Age, exh. cat. (New
 York, 1982), p. 369 rep.

See plate 9

The scene depicts the victorious Scipio Africanus mag-
nanimously returning to the grateful Allutius, the young
prince of the Celtiberians, his betrothed, the captive maiden
who stands in front of her mother and a servant. Scipio's
generosity is symbolized by the laurel crown held above

him. A group of Roman soldiers stands by, admiring the act, and New Carthage burns in the background.

Both the authorship of this painting and its early history have been the subject of discussion. The painting first appears in the manuscript "Catalogue of Pictures belonging to the Estate of the late Hon. James Bowdoin Esq. bequeathed by him to Bowdoin College": "No. 3 Continence of Scipio / Scipio restores to the Celtiberian Prince, / Allucicius, his spouse, a captive in the / Roman camp. / Painter unknown / Copy by Smybert: / Original lost / at Sea."

The painting was most likely acquired from Smibert's studio after John Moffatt's death. It has not been noted until now that James Bowdoin III knew the Sheaffe family of Boston[1], in particular Mrs. Susannah Sheaffe, who rented rooms in Smibert's house at least by 1780.[2] Susannah Sheaffe was the widow of William Sheaffe, deputy surveyor of customs, and the mother of Ann Sheaffe, who married James Bowdoin III's uncle John Erving.[3] Bowdoin conceivably acquired works from the studio in 1778, at the time John Moffatt's estate executor, Belcher Noyes, was making sales from it or during the years immediately thereafter, when Susannah Sheaffe was living in Smibert's house.

Stylistically, the details that make it clear that cat. no. 143 is by Smibert are the treatment of the hands, particularly those of the figure of Allutius, where the digits are extended and the thumbnail flattened. This identical characteristic is found in such works by Smibert as cat. no. 70.

Smibert rightfully considered the *Continence of Scipio* among his most accomplished works. Along with *Cardinal Bentivoglio* (cat. no. 140) it is the best of his surviving copies of old masters. He specifically asked about the painting in his 1743 letter to Arthur Pond (appendix 2), and his son alerted his cousin, John Moffatt, that it was one of the few paintings he "would not chuse were disposed of in any acct such as Scipio africanus, Cardinal Bentivoglio [cat. no. 140], Don Giovani Boucher, The Deans Company [cat. no. 71] nor any of those in the little room off the upper painting room."[4] Visitors to Smibert's studio, among them Alexander Hamilton, were impressed with it. Hamilton remarked, after his 1744 visit, that he had seen "a collection of fine pictures, among the rest that part of Scipio's history in Spain where he delivers the lady to the prince to whom she had been betrothed. The passions are all well touched in the severall faces. Scipio's face expresses a majestic generosity, that of the young prince gratitude, the young lady's gratitude and modest love, and some Roman souldiers standing under a row of pillars apart in seeming discourse, have admiration delineated in their faces. But what I admired most of the painter's fancy in this piece is an image or phantome of chastity behind the solium upon which Scipio sits, standing on tip-toe to crown him and yet appears as if she could not reach his head, which expresses a good emblem of the virtue of this action." Copley recalled it when traveling in Italy (Copley-Pelham 1914, p. 145), and Trumbull copied Smibert's copy himself.[5]

Smibert apparently copied the painting when the original was in the collection of Sir Robert Walpole. On at least one other occasion—in 1742—Walpole permitted it to be copied. Vertue recorded that Ranelagh Barret "got the Favour of Sir Robt Walpole—who gave him leave constantly to be in a room at his house which became a well situated office for Barret who had much business and employment 'and his paintings included' Sr Robt Walpole Scipio Africanus by Nicola Poussin."[6]

The original, which was engraved in 1741 by Smibert's friend Claude Dubosc (cat. no. 259), was sold in 1779 with the Walpole collection to Catherine II of Russia. It is now in the Pushkin Museum, Moscow. Scipio Africanus was also the subject of a play by that name which was performed in London during the 1710s and 1720s.[7]

NOTES

1. J. Bowdoin III to Major General Dearborn, January 9, 1809, in which he recommends to him John Erving: "his mother's name was Sheaffe and died within a few years." Bowdoin family papers, Special Collections, Bowdoin College Library.
2. "By Rent received for the Mansion house viz . . . Mrs. Susanna Sheaff to Sept. 8, 1780 343–." Suffolk County Probate Records, Suffolk County Court House, Boston, vol. 84, p. 555.
3. Sizer 1967, p. 65.
4. CP, Part 1, Williams Smibert to John Moffatt, September 10, 1762.
5. Trumbull made the following entry among paintings he did in Boston, June 1778: "44. Continence of Scipio copied in part from Mr. Smibert's Copy of N Poussin / 1818, I believe at Mr. Wadsworth's Hartford." See Jaffe 1976, p. 213.
6. Vertue 1930–1955, vol. 3, p. 112.
7. Emmett L. Avery, ed., *The London Stage, 1660–1800*, part 2, *1700–1729* (Carbondale, Ill., 1960), pp. 483, 858.

144 John Endecott, after anonymous seventeenth-century portrait, 1739

Massachusetts Historical Society
30 × 25 (76.1 × 64.1)
Provenance: Given by Francis C. Gray, Boston, to the Massachusetts Historical Society, November 24, 1836
Notebook: [before March 1739], p. 95, no. 160: "Gor. Indicoot Coppeys 3/4 paid"
Literature: Foote 1950, p. 231; Saunders 1979, vol. 1, p. 197; vol. 2, pl. 167; Oliver, Huff, and Hanson 1988, p. 38
Subject: John Endecott (1589–1665), governor of the Massachusetts Bay Colony intermittently, 1644–1664; born in Devonshire, England; son of Thomas Endecott and Alice Westlake(?) Endecott; came to Naumkeag (now Salem) with his wife, Ann Gower, in 1628 as an incorporator of the Massachusetts Bay Colony and was in charge until John Winthrop arrived in 1630

As a founder of the Massachusetts Bay Colony, Endecott was much revered. His seventeenth-century portrait by an anonymous artist (now in the Massachusetts State House Collection 1941.2) was repeatedly copied in the eighteenth and early nineteenth centuries—perhaps more so than any other colonial leader's portrait. Smibert's copy is one of as

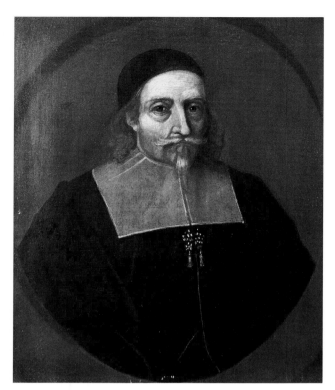

144

many as nineteen copies that are thought to have been done. A second copy, by another artist, was given to the Essex Historical Society (now Peabody Essex Museum) in 1821 by John Treadwell. On the back is inscribed, "Drawn from the Picture of Governor Endicott / in ye Council Chamber at Boston."

John Adams may have been referring to the Peabody Essex Museum copy when he wrote in 1774, "Rode to Ipswich, and put up at the Old place Treadwells. The old lady has a new copy of her great grandfather, Governor Endicott's picture hung up in the house."[1]

NOTES

1. "John Endecott, Acc. 106, 816," Peabody Essex Museum, painting file.

C. Disputed Works

145 George Berkeley, c. 1730–1735

Courtesy Massachusetts Historical Society
30 × 25 (75.7 × 63.4)
Provenance: Given by Thomas Wetmore to the Massachusetts Historical Society, 1801
Notebook: Not Recorded
Literature: Massachusetts Historical Society, *Catalogue of Portraits* (1885), p. 11; Bayley 1929, p. 349 rep.; New Haven 1949, no. 2; Foote 1950, pp. 130–131; Ralph E. Carpenter, Jr., *The Arts and Crafts of Newport, Rhode Island, 1640–1820*, exh. cat. (1954), pp. 123–124; Ann Millspaugh Huff and Ross Urquhart, "Paintings in the Massachusetts Historical Society," *Antiques,* vol. 128, p. 360; Houghton, Berman, and Lapan 1986, p. 48; Oliver, Huff, and Hanson 1988, p. 17
Subject: See cat. no. 8

This portrait was recorded in the Massachusetts Historical Society's *Catalogue of Portraits* as "Painted by Smibert, on his passage to Newport, R.I., in 1728. Restored by Darius Chase, 1845. Given by Thomas Wetmore, Esq." The portrait shows a man who appears to be in his early forties, which would suggest that the work dates from the early 1730s. Although the portrait is not entirely characteristic of Smibert (particularly the treatment of the wig), this is probably a result of overcleaning and repainting. If the portrait is by Smibert, which in its present state is difficult to determine, it is most likely a replica and may relate to one of the portraits of Berkeley that are recorded in the notebook but do not now survive (cat. nos. 190, 191).

145

146 Joanna and Elizabeth Perkins (?), c. 1735–1746

Saint Louis Art Museum
25 × 30 (63.5 × 76.2)
Provenance: Francis C. Loring, 1878; Misses Loring, 1922; estate of William Powell Perkins; Paul M. Hamlen, Boston, 1938; Mrs. Daniel K. Catlin, Saint Louis, 1942; gift of Mrs. Daniel K. Catlin, 1965
Notebook: Not recorded as presently identified
Literature: MHS *Proc.*, vol. 16, pp. 395–396; Bolton 1933, p. 42; Burroughs 1936, pp. 38–39 rep.; Foote 1950, pp. 220–221; *City Art Museum Bulletin* (September–October, 1965), pp. 1–2 rep.; *Antiques,* vol. 89 (1966), p. 138 rep.

This portrait depicts two young children, probably neither older than three, seated on green cushions with their bodies turned toward each other. They wear white caps and white dresses. The child on the left holds two cherries in its right hand, and its left hand rests on a basket. The child on the right holds a rattle with silver bells in its right hand.

The attribution of this portrait to Smibert is open to question. Although Smibert painted portraits of children (see cat. nos. 40, 71, 77), they are neither dressed like the "Perkins" children nor posed in that fashion. The children's faces, however, do bear some similarity to Smibert's portraits of children, and for this reason alone the attribution cannot be entirely dismissed. If this painting is by Smibert, it is unlikely to represent the Perkins children, who were not born until 1745 and 1747, respectively.

147 Unidentified Saint, c. 1719–1722

Bernard and S. Dean Levy, New York
4 × 3 1/8 (10.2 × 8.1)
Inscription: On reverse, "J Smibert / R [illegible] 1717 (?)"
Medium: Oil on copper (oval),
Provenance: Sale, Christies 3923, 11-20-76, no. 987 (with a Queen Anne inlaid block-front secretary-bookcase); private collection; Bernard and S. Dean Levy, New York, 1982
Notebook: Not recorded
Literature: Christies, 3923, 11-20-76, no. 987 rep.

It is highly unlikely that this miniature is by Smibert. The signature on the back, although rubbed and partially obliterated, is similar to Smibert's, and he may conceivably have acquired the work. The subject, however, is an unusual one for a Protestant to have owned, let alone painted. For Smibert to have painted such a work in 1717 is even more puzzling.

148 Unidentified woman, 1722

Mrs. Clark Merrill, Brigantine, N.J.
30 × 25 (76.2 × 63.5)
Inscription: On reverse, now covered by lining canvas, "Smebert Pinxit / 1722" (?)
Provenance: Inherited, 1979, by Mrs. Clark Merrill from her uncle, who bought it at a Philadelphia auction c. 1935–1940 for thirty dollars

This painting was damaged by fire in 1974. During a subsequent restoration the inscription was discovered on the back of the canvas. This inscription, of which I have only seen a photograph, is difficult to read, and the "S" in "Smibert" is not apparent. It seems possible that the inscription might be the name of another artist. Stylistically the painting dates from the 1720s, but in its present restored condition is not particularly close to Smibert's work.

149 William King,* c. 1722–1728

29 1/4 × 24 1/4 (74.2 × 61.5)
Bears inscription
Provenance: Sholto (Salto?) Montogomery-Cay, Esq.; Sale, Christie's, London, 7/8/10, lot 110 (unsold); Sale, Christie's, London, 7/30/82, lot 14
Notebook: Not recorded

This painting depicts an elderly man dressed in a wig and red judicial robes. The portrait has the same provenance as cat. nos. 21 and 35.

D. Unlocated Works

150 "a head of a Child in littele a Coppie 5–5 o"

Notebook: [March 1725], p. 80, no. 71

151 "a Lady a copy 3/4 20–0–0"

Notebook: [November 1731], p. 90, no. 56

152 "A Lady 3/4 25–0–0"

Notebook: [July 1733], p. 91, no. 83

153 "A lady in blue 1/2 16–16–0"

Notebook: [January 1725], p. 80, no. 63

154 "A. Lady: Sheppardess 1/2 [?] 15–15–"

Notebook: [c. 1722–1723], p. 78, no. 5

155 "a Lady with a doge"

Notebook: [March 1725], p. 80, no. 67

156 "a Littel Venus 8–8–"

Notebook: [March 1725], p. 80, no. 68

157 "A pictor of a large boon of a leeg KC 5–5–0"

Notebook: [April 1725], p. 81, no. 76
Subject: Possibly a painting of a large legbone, perhaps painted in conjunction with the Society of Antiquaries

158 Aliston

Notebook: [November 1734], p. 93, no. 106: "Ms. Aliston att Starting / and all for the futur K K / Price 9 Ginnes"

159 Allan, Jeremiah

Notebook: [May 1733], p. 91, no. 78: "Treasurer Allan N.P 1/2 44–0–0"
Subject: Jeremiah Allan, made treasurer of Massachusetts, 1715; married Mary Caball; son of Reverend James Allen, minister of the First Church of Boston

160 Allan

Notebook: [September 1732], p. 91, no. 69: "Mr. Allan HP.L 1/2 35–0–0"
Subject: Possibly James Allen (December 25, 1697–January 8, 1755), son of Jeremiah Allen, who became treasurer of the province in 1715; Harvard 1717; Boston merchant; Congregationalist and one of the promoters of West Church

161 Allan

Notebook: [June 1740], p. 96, no. 185: "Mrs. Allan & Son HP 1/2 30 Guns."
Subject: Possibly (1) Mrs. William Allen (Margaret Hamilton), wife of William Allen (1704–1780); (2) Mrs. James Allen; (3) Mrs. John Allen

162 Allan

Notebook: [July 1740], p. 97, no. 187: "Do for Mr. Allan 3/4 10 Guns"
Subject: Possibly (1) Mr. William Allen (1704–1780), a Presbyterian and mayor of Philadelphia, 1735, married Margaret Hamilton, daughter of Andrew Hamilton (cat. no. 317); (2) Mr. John Allen; (3) Mr. James Allen. William Allen's portrait was also painted by Robert Feke (Independence National Historical Park, Philadelphia).

163 Allan

Notebook: [July 1740], p. 97, no. 188: "Mrs. Allan Sr. H P 1/2 20 Guns."
Subject: Possibly Mrs. William Allen, mother of the William Allen who might be the sitter in cat. no. 163

164 "ancient philosophers"

Literature: Foote 1950, p. 231

When Charles Willson Peale visited Smibert's studio in 1767–1768, he noted among the unfinished pictures one with "several heads painted of the ancient philosophers, and some groups of figures, these were the last works by Smibert." These works are otherwise unidentified, but one of them might possibly be that purchased by John Trumbull from Belcher Noyes as "an unfinished Sketch of a prophet, by some of the later Galeans."[1]

NOTES

1. Jaffe 1976, p. 212.

165 Aplebe

Notebook: [July 1725], p. 81, no. 86: "Mr. Aplebe half pd. 1/2 16–16–0"

166 Ashe

1720
Provenance: A gift to the sitter
Notebook: [August 1720], p. 76: "receved of Mr. Ashe in Agust, 9 breds of fine Engs Cloth for a shut [suit] of cloths in a presant I having given him his head which I painted."
Literature: Saunders 1979, vol. 1, pp. 30–31

167 Auchmuty, Robert

Notebook: [April 1734], p. 92, no. 91: "Judge Achmuty H.P. 3/4 25–0–0"
Subject: Robert Auchmuty (1687–1750), judge of the Admiralty Court, 1733–1747, succeeding Judge Byfield (cat. no. 46); resided in Roxbury, having on August 20, 1733, purchased an estate of fourteen acres with a house formerly owned by Joseph Scarborough

168 Aynsworth

Notebook: [March 1725], p. 80, no. 66: "Rowland Aynsworth Esqr. 1/2 32–1–"
Subject: Probably Roland Ainsworth, a London merchant. See also cat. no. 274

169 Bacon

Notebook: [c. 1722–1723], p. 78, after no. 22 (not numbered in the transcription): "[Sr. Bacon] the original painted all over / excepp the head 8–8–"

170 Bacon

Notebook: [c. 1722–1723], p. 78, no. 22: "Sr Bacon a coppy 3/4 5–5 –"

171 Baird

Notebook: [1724], p. 80, no. 52: "Mr. Baird 3/4 8–8–0"

172 Ball

Notebook: [February 1727], p. 84, no. 132: "Mr. Ball 3/4 8–8–0"

173 Ball

Notebook: [March 1727], p. 84, no. 138: "Mr. Ball Coppie 3/4 8–8–0"
Probably a replica of cat. no. 172

174 Bannister

Notebook: [May 1736], p. 94, no. 123: "Mrs. F. Bannister KK 9 Guineas"
Subject: Probably Frances Bannister, wife of Thomas Bannister (1684–1716), Boston merchant, and member of King's Chapel; their son John founded the Bannister family of Newport, R.I.

175 Barnes

Notebook: [c.1722–1723], p. 78, no. 14: "Mrs. Barnes 7–7–."

176 Barrett

Notebook: [July 1725], p. 81, no. 88: "Mrs. Barret 1/2 16–16–0"

177 Beaumont

Notebook: [c. 1722–1723], p. 78, no. 12: "Beaumont Mert [merchant?] a Coppy 3/4 5–5–0"

178 Becher

Notebook: [April 1726], p. 82, no. 107: "Mr. Becher 16–16–0"
Subject: Possibly Sir Edward Beecher, elected Alderman for Bishopsgate ward in 1718, served office of sheriff in 1727 and that of lord mayor in 1728

179 Becher

Notebook: [January 1727], p. 83, no. 128: "Mrs. Becher 1/2 16–16–0"

180 Becher

Notebook: [June 1727], p. 84, no. 148: "Mr. Becher another 1/2 16–16–0"
Subject: Probably a replica of cat. no. 178

181 Beelless

Notebook: [July 1727], p. 85, no. 155: "Mrs. Beelless. 8–8–0"

182 Bekford

Notebook: [1742], p. 97, no. 206: "Mrs. Bekford begun KK"
Subject: Possibly Mrs. Ballard Beckford (c. 1720–1758), who was a daughter of George Clarke (cat. no. 134) and a sister of the brothers Clarke in cat. no. 232–235. She spent her married life in Jamaica.

183 Belcher, Andrew (1706–1771)

Notebook: [April 1732], p. 90, no. 62: "Mr. Andrew Belcher H.P. 1/2 50–0–0"
Subject: Andrew Belcher (November 7, 1706–January 24, 1771), oldest son of Jonathan Belcher and Mary Partridge Belcher; merchant, member of family mercantile house Foye, Belcher, and Lyde. Sailed with his father to London, March 10, 1728/9, and upon his return "delivered the King's gifts of silver to Christ Church, Boston, Henry Newman's gift of mathematical instruments to Yale, and Dean Berkeley's donations to both colleges" (Sibley and Shipton 1873–1956, class of 1724, p. 306); founded the first Masonic lodge in Massachusetts, 1733

184 Belcher, Jonathan

Notebook: [May 1731], p. 90, no. 53: "Mr Jonathan Belcher H.P. 1/2 40–0–0"
Subject: Jonathan Belcher (July 23, 1710–March 29, 1776), son of Jonathan and Mary Partridge Belcher; Harvard, 1728; lieutenant governor of Nova Scotia (1761–1763)

185 Belcher, Governor Jonathan

Provenance: The sitter; it is probably the picture he had with him in New Jersey and gave to the College of New Jersey (now Princeton University), 1755; the Princeton portrait is said to have been destroyed during the Revolution
Notebook: [November 1730], p. 89, no. 45: "Govr. Belcher H. P. who. lenth 80–0–0"
Literature: Foote 1950, pp. 72, 201–202; Saunders 1979, pp. 144
Subject: Jonathan Belcher, born January 8, 1682; son of Andrew Belcher and Sarah Gilbert Belcher of Cambridge. After graduation from Harvard (1699) he traveled to Europe, then returned to Boston, where he prospered as a merchant. Married (1) Mary Partridge (d. 1736), daughter of Lieutenant-Governor William Partridge of Portsmouth, N.H., January 8, 1705; (2) Mary Louisa Emilia Teal in Burlington, N.J., September 9, 1748; served on the Massachusetts Council intermittently from 1718 to 1729, when he was appointed governor of Massachusettes to succeed the late William Burnet. Belcher's high-handed ways with the opposition eventually led to his ouster as governor in 1741, but in 1746 he was once again appointed governor, this time of New Jersey, in which office he remained until his death on August 31, 1757.[1]

NOTES

1. J[ames] T. A[dams], "Belcher, Jonathan," *DAB* (1928–1937; 1964 ed.), vol. 1, pp. 143–144.

186 Belcher, Mrs.

Notebook: [October 1730], p. 89, no. 43: "Mrs. Belcher H.P 1/2 40–0–0"
Subject: Probably Mary Partridge Belcher (d. 1736), wife of Gov. Jonathan Belcher, whom Smibert painted the following month (cat. no. 185)

187 Bennerman

Notebook: [1724], p. 80, no. 60: "Mr. Robert Bennerman Jnr. 1/2"

188 Benson

Notebook: [April 1728], p. 85, no. 165: "Mr. Benson's sister A Copy 3/4 8–8–0"
Subject: Possibly Catherine, sister of Martin Benson (1689–1752), bishop of Gloucester and a friend of George Berkeley; married Thomas Secker, archbishop of Canterbury, October 28, 1725

189 Bent

Notebook: [September 1735], p. 93, no. 116: "Mr. William Bent H.P. 3/4"

190 Berkeley, George

Notebook: [April 1730], p. 89, no. 37: "Dean Berkley lit 1/2 35–0–0"
Subject: See cat. no. 8

191 Berkeley, George, his wife and son

Notebook: [January 1731], p. 90, no. 49: "The Revd. Dean Berkeley his / Lady and son for him / self in one clothe half / lenths 120–0–0"
Subject: See cat. no. 8

192 Bernard

Notebook: [May 1734], p. 92, no. 96: "the Rd Mr. Bernard & Lady 3/4 HP 50–0–0"
Subject: Possibly (1) John Barnard (b. February 26, 1689/90; d. June 14, 1757), minister of Andover, North Parish; son of Rev. Thomas Barnard and Elizabeth Price Barnard of Andover; Harvard, 1709; married Sarah Martyn, October 20, 1715; or, more likely, (2) John Barnard (November 6, 1681–January 24, 1770), Congregational clergyman; Harvard, 1700; ordained July 18, 1716, at the church in Marblehead; married Anna Woodridge of Ipswich, 1718; friendly with Gov. Joseph Dudley and Edward Holyoke, president of Harvard; preached in Boston, June 1, 1734: *The Throne Established by Righteousness . . . a Sermon Preached . . . the Day for the Electing, His Majesty's Council* (Boston, 1734)

An "admirable likeness" of Barnard is mentioned in William Bentley's diary, vol. 1 (April 1784–1792), p. 305.

193 Berwick

Notebook: [January 1738], p. 95, no. 150: "Coll. Berwicks Lady 3/4 8 Guinies"

194 Billers, Sir William

Notebook: [July 1726], p. 83, no. 118: "Alderman Billers 1/2 16–0–0"
Subject: Sir William Billers, d. 1745; became an alderman in 1709; served as sheriff, 1721, and lord mayor, 1734; knighted January 31, 1727

195 Bolt

Notebook: [c. 1723–1724], p. 79, no. 29: "Mr. Bolt Lawyer 3/4 7–17–6"

196 Bondish

Notebook: [December 1737], p. 95, no. 149: "Mrs. Bondish 6 Guinias"

197 Bonnell

Notebook: [c. 1722–1723], p. 79, no. 26: "Mr. Bonnell 3/4 7–17–6"

198 Bonnell

Notebook: [May 1726], p. 83, no. 112: "Mrs. Bonnell 1/2 16–16–0"

199 Bradshaw

Notebook: [May 1727], p. 84, no. 146: "Mr. Bradshaw 1/2 15–15–"

200 Brigman

Notebook: [November 1725], p. 82, no. 98: "Mr. Brigman a coppie from a head 1/2 15–15–0"

201 Brookbanks

Notebook: [March 1727], p. 84, no. 140: "Mr. Brookbanks / and Lady with two Children / whole lenths 84–0–0"

202 Brooke, Lord

Notebook: [April 1725], p. 80, no. 73: "Lord Brooke 1/2 16–16–0"
Subject: William Greville, 7th baron; married November 8, 1716; died July 28, 1727

203 Brookline Lady, Portrait of a

Present location unknown
c. 1730–1735
30 × 25
Provenance: Mrs. Gilman Prichard, Concord, Mass., c. 1950

A bust portrait of a middle-aged woman. She faces to the right and wears a loose dress with a button at the bodice. She has a prominent nose and distinctive hair curls, which fall on her forehead and shoulders. The portrait seems quite typical of Smibert and probably dates from c. 1730–1735. There is a photograph of this portrait at the Frick Art Reference Library (FARL 17942).

204 Broome

Notebook: [August 1728], p. 86, no. 175: "Captain Broome 3/4 present"
Subject: Possibly the Captain Broome of Westminster who was described at the time of his death in 1734 as "a picture dealer" (*Gentleman's Magazine*, 1734, p. 550) and who may well have supplied Smibert with some of the pictures he took to America

205 Broun

Notebook: [September 1727], p. 94, no. 142: "Corll. Broun [a copy] 6 Guins"

206 Broun

Notebook: [September 1737], p. 94, no. 143: "[Corll. Broun] and Lady [a copy] 6 Guin"

207 Broun

Notebook: [September 1737], p. 94, no. 144: "Majr. Broun [a copy] [3/4] 6 Guines"

208 Broun

Notebook: [September 1737], p. 94, no. 145: "Mr. Benn. Broun [a copy] 1/2 12 Guines"
Subject: Probably a copy of cat. no. 209

209 Brown

Notebook: [August 1734], p. 92, no. 102: "Mr. Bn Brown HP 12/ 25–0–0"
Subject: Possibly (1) Benjamin Browne (July 25, 1706–February 3, 1749/50), a Salem merchant; son of Capt. John Browne and Sarah Burroughs Browne; Harvard, 1724; married Eunice Turner (cat. no. 108), daughter of Col. John Turner of Salem, June 29, 1729; member of the House of Representatives, 1732–1740; appointed justice of the peace for Essex, 1734; took an active part in First Church and was a colonel in one of the Essex regiments; four children and was survived by his widow; or (2) Benjamin Browne (February 15, 1715/6–April 23, 1737), baptized in First Church, Salem; youngest son of Samuel Browne and Abigail Keech Browne; brother of Samuel (cat. no. 99) and William (cat. no. 94) Browne; his guardian was his cousin Benjamin Lynde; Harvard, 1735

210 Brown

Notebook: [August 1736], p. 94, no. 126: "Willm. Brown Esqr. In littell 6 Guines"
Subject: See cat. no. 94

211 Brudnell

Notebook: [July 1725], p. 81, no. 85: "Mr. Brudnell half pd. 3/4 8–8–0"

212 Buchan, Earl of

Notebook: [1724], p. 80, no. 58: "the Earle of Buchan 16–16–0"
Subject: David Erskine (1672–October 14, 1745), 9th earl of Buchan, who succeeded as Lord Cardross, May 21, 1693, and succeeded to the earldom, 1698

213 Buleno

Notebook: [March 1739], p. 95, no. 162: "Mrs. Buleno H.P. 1/2 12 Guinies"
Subject: Probably a member of the Boutineau family

214 Bull

Notebook: [July 1743], p. 98, no. 218: "Dr. William Bull 3/4 8 Gunnes"
Subject: Possibly William Bull (September 24, 1710–July 4, 1791), colonial governor of South Carolina; born at Ashley Hall, S.C.; second son of Lt. Gov. William Bull (1683–1755) and Mary Quintyne Bull; studied medicine at Leyden and was the first native-born American to receive the degree of Doctor of Medicine; member of the Commons House, 1736–1749; speaker, 1740–42 and 1744–49; governor five times, beginning 1760/61; married Hannah Beale, daughter of Othneal Beale, August 17, 1746

215 Butler

Notebook: [June 1725], p. 83, no. 116: "Mr. Butler Clergyman K D 25–4–0 [price includes preceding portrait]"
Subject: Probably Joseph Butler (1692–1752), bishop of Durham and a close friend of George Berkeley

This portrait and a portrait of Berkeley were paid for together.

216 Buttons

Notebook: [August 1744], p. 99, no. 232: "Mr. Buttons H.P. 1/2 16 Gunnies"
Subject: Probably James Boutineau (1710–1778), married to sister of Peter Faneuil

217 Byfield, Nathaniel (1653–1733)

Notebook: [August 1729], p. 88, no. 13: "Coll. Byfild 1/2 40–0–0"
Subject: Judge Nathaniel Byfield (1653–1733); see cat. no. 46

This is the portrait from which at least three replicas (cat. nos. 46–48) were painted.

218 Byfield, Mrs.

Notebook: [October 1729], p. 88, no. 23: "Mrs. Byfild 1/2 40–0–0"
Subject; Probably Sarah Leverett Byfield, daughter of Gov. John Leverett; second wife of Judge Nathaniel Byfield (cat. no. 46), whom she married in 1718

219 Campbell

Notebook: [October 1729], p. 88, no. 25: "Mrs. Campbell H.P 3/4 20–0–0"
Subject; Probably Mary Clarke; married (1) a Pemberton; (2) John Campbell (1653–March 4, 1727/8, his second wife), a journalist who founded the *Boston News-Letter* (1704), the first established newspaper in America; (3) Herbert Lloyd

220 Caner, Rev. Henry, 1737

Notebook: [June 1737], p. 94, no. 138: "The Rvd. Mr. Kenner H P 3/4 6 Ginnes"
Engraved: Mezzotint by Peter Pelham, 1750
 Stauffer 2462; Smith 41 1/12 × 9.13
Inscribed: "The Reverend Henry Caner. A:M / Minister of Kings Chapel Boston / J: Smibert pinx—P: Pelham fecit, 1750. Sold by P: Pelham in Boston."
Imprints: American Antiquarian Society; Harvard University; John Carter Brown Library; Museum of Fine Arts, Boston; Yale University Art Gallery
Literature: H. W. Foote, *Annals of King's Chapel* (1896), vol. 2, p. 23 rep.; Foote 1950, pp. 202–203; Oliver 1973, pp. 162 rep., 166, 172–173; Saunders 1979, vol. 1, pp. 192–193; vol. 2, pl. 156
Subject: Rev. Henry Caner (1700–1793); son of Henry and Abigail Caner of Fairfield, Conn.; Yale, 1724; appointed missionary for the church at Fairfield by the Society for the Propagation of the Gospel, where he stayed from 1727 to 1746, until called to King's Chapel, Boston. Caner's father was a master builder and carpenter who was involved in the enlargement of King's Chapel Boston and who in 1717 removed to New Haven to superintend the erection of the first hall for Yale College.

See figure 90

Caner came to Boston to have his portrait painted, as he observed in a letter to John Dennie in Boston, November 19, 1736: "In the spring I hope to see Boston" (University of Bristol Library, Henry Caner Letterbook (1728–1778). The mezzotint after his portrait was not scraped until 1750, when Caner was minister of King's Chapel, Boston (1747–1776).

221 Cardross, Lord

Notebook: [July 1725], p. 81, no. 87: "Lord Cardrose son to ye E. of Buch[an] 1/2 16–16–0"
Subject: Probably Henry David Erskine (b 1710), son of David Erskine (1672–1745, cat. no. 212)

222 Carlisle, Earles of

Notebook: [1724], p. 80, nos. 54 and 55: "two Earles of Carlile for the Earle of Kinnowle Coppies 1/2 lenths 30–5–0"
Subject: Probably James, 2d earl of Carlisle, copy after Cornelius Jansen, and James Hay, 1st earl of Carlisle, copy after Van Dyck, both attributed to Smibert in the 1780 inventory of pictures at Dupplin House, Scotland

223 Carpenter, Lord, c. 1722–1723

Notebook: [c. 1722–1723], p. 78, no. 20: "The Lord Carpenter 1/2 10–10–0"
Subject: George Carpenter, born February 10, 1657; son of Warncombe Carpenter and Eleanor Taylor Carpenter; married Alice, daughter of Viscount Charlemont; served in British army in Flanders and Spain and rose to the rank of lieutenant-general by 1709; governor of Minorca, 1716; created Baron Carpenter of Killaghy, Kilkenny County, Ireland, 1719; M.P. for Whitechurch, 1715–1722, and Westminster, 1722–1727; died February 10, 1732

In his notes about Smibert c. 1724, George Vertue observed about this portrait, "the Lord Carpenter in Armo [armor] 1/2 length very well." There is a mezzotint portrait of Lord Carpenter by J. Faber after a portrait by J. Van Diest.

224 Cary, Samuel

35 1/2 × 28
Provenance: Descent in the Cary family, the Folger family, and the Vincent family; purchased c. 1930 by Mr. Frank Sylvia from a member of the Vincent family who had moved to California; purchased by Mr. Herbert Lawton, Boston, c. 1937; purchased by Miss Katrina Kipper, by 1949
Notebook: Not recorded
Literature: Foote 1950, p. 141
Subject: Samuel Cary (1688–1740), prosperous Boston ship chandler and merchant

As no photograph of this portrait is known, the attribution to Smibert cannot be verified.

225 Cavendish, Lord

Notebook: [May 1726], p. 82, no. 111: "Lord James Cavindish O.S. 14–14–0"
Subject: Either Lord James Cavendish (c. 1698–1741), son of William Cavendish, M.P. and 2d duke of Devonshire, or Lord James Cavendish (c. 1673–1751) of Staveley, Derbyshire, 3d son of William Cavendish, 1st duke of Devonshire and governor of Fort St. George

226 Chandler

Notebook: [May 1729], p. 87, no. 4: "Col. Chandler with hands 3/4 25–0–0"
Subject: Probably John Chandler (1693–1762) of Worcester, Mass.; judge, colonel of the militia, member of the local Congregational church and of the governor's council of Massachusetts
Literature: Perkins, 394; NEHGS *Register*, vol. 49 (1895), p. 141

Foote 1950, pp. 214–215, describes a portrait that in the nineteenth century was identified as John Chandler. The portrait was also included in the 1927 "Historical Records Survey, American Portraits Found in Massachusetts," no. 382, where the owner was listed as Mrs. Gordon Dexter, 55 Beacon Street, Boston. When contacted by Foote, however, Mrs. Dexter declared that she had no knowledge of the portrait. The portrait was described as a man in a "single-breasted gray coat, with black cuffs and buttons, powdered wig, white muslin neckcloth. A book in his left hand."

227 Chandler, Mrs. John (?)

Approx. 29 × 24
Literature: Foote 1950, p. 215
Notebook: Not recorded

This portrait was never located by Foote. It was included in the 1937 "Historical Records Survey, American Portraits Found in Massachusetts," no. 381, and the provenance was supposedly the same as for cat. no. 226. It was described as a woman in a "green overdress trimmed with lace, dress fastened with gold clasps, black scarf over head, lace cap, fan in right hand." As no photograph of this portrait is now known, the attribution to Smibert cannot be verified.

228 Checkley, Reverend John

Approx. 27 × 21
Provenance: The sitter; his daughter Deborah Paget; her daughter Anne Olney, wife of Capt. Joseph Olney, Jr.; her daughter Rebecca Olney Malcolm, wife of Dr. Henry Malcolm; her daughter Angelica Malcolm, wife of Joseph Gibbons Malcolm; her daughter Ester Malcolm, wife of John Lloyd; her daughter Mary Lloyd, wife of Norman Harriott Jones; her daughter Ethel Jones, wife of Edmund Gosling, Bloomfield Cottage, Paget, Bermuda.
Notebook: Not recorded
Literature: Foote 1950, p. 143
Subject: John Checkley (c. 1680–1754), born in Boston; educated at the Boston Latin School and by private tutors at Oxford, England; said to have traveled in Europe and collected works of art there; returned to Boston around 1710 and set up as a merchant and bookseller; married Rebecca Mille, daughter of Samuel Mille of Milton, Mass., sister of Rev. Ebenezer Miller (cat. no. 113), May 28, 1713; ordained in 1738 by the Church of England; rector of King's (now St. John's) Church, Providence, R.I., 1739–1754

Foote, who did not see the painting, observed from a photograph of it that it had experienced considerable re-painting. As no photograph of this portrait is now known, the attribution to Smibert cannot be verified. A Boston wit, Joseh Green, observed in a poem that Checkley had had his portrait painted by Smibert:

> John, had thy sickness snatched thee from our Sight
> And sent thee to the realms of endless night,
> Posterity would then have never known
> Thine eyes, thy beard, thy cowl and shaven crown;
> But now redeemed by Smibert's faithful hand,
> Of immortality secure you stand,
> When nature into ruin shall be hurled
> And the last conflagration burn the world,
> This piece shall then survive the general evil,—
> For flames, we know, cannot consume the devil.[1]

NOTES

1. E. F. Slafter, *John Checkley, or the Evolution of Religious Tolerance in Massachusetts Bay* (Boston, 1897), vol. 1, p. 5.

229 Chisholme

Notebook: [August 1728], p. 86, no. 173: "Mr. Chisholme 3/4 payd"

230 Clark

Notebook: [January 1732], p. 90, no. 57: "Mr. Thomas Clark H.P. 1/2 40–0–0"
Subject: Possibly Maj. Thomas Clark, who was living in Boston in 1737

231 Clark

Notebook: [1724], p. 79, no. 38: "Mr. Geo[rge?] Clark a coppy 3/4 5–5–0"

232 Clark

Notebook: [February 1737], p. 94, no. 133: "Mr. Clark Jr. of N York H.P. 1/2 12 Gins"
Subject: Possibly George Clarke (b. 1715), son of George Clarke (cat. no. 134)

233 Clark

Notebook: [March 1737], p. 94, no. 136: "Mr. Heyd Clar HP 1/2 12 Ginns"
Subject: Possibly Hyde Clarke, son of George Clarke (cat. no. 134) and brother of Clark in cat. no. 232

234 Clark

Notebook: [June 1737], p. 94, no. 140: "Captn. Clark 40 H.P. 1/2 12 Ginnias"
Subject: Possibly Edward Clarke, son of George Clarke (cat. no. 134). Edward Clarke was in Boston, June 8, 1737, where he attended a Mason's meeting (Johnson 1924, p. 175).

235 Clarke, Robert

Notebook: [September 1740], p. 97, no. 201: "Capn. Rt. Clark H P 1/2 20 guinnes"
Subject: Possibly Robert Clarke, son of Lt. Gov. George Clarke (cat. no. 134)

236 Colman, Rev. Benjamin, 1734

Notebook: [October 1734], p. 93, no. 104: "Rd. Dr. Coleman H.P. 3/4"
Engraved: Mezzotint (pl. 125) by Peter Pelham, 1735
 Stauffer 2463; Smith 7
 8.9 × 7.6
Inscribed: The Reverend Benjamin Colman D.D. / I. Smibert Pinx—P. Pelham Fecit / 1735
Imprints at: American Antiquarian Society; Essex Institute; John Carter Brown Library; Museum of Fine Arts, Boston (two states); Massachusetts Historical Society; Worcester Art Museum
Literature: Winsor 1880–1881, vol. 2, p. 212; Foote 1950, pp. 203–204; Oliver 1973, pp. 143–144, 147, 170–171; Saunders 1979, vol. 1, pp. 181–182; vol. 2, pl. 136
Subject: Benjamin Colman, born 19 October 1673; Harvard, 1692; first minister of Brattle Square Church, where he remained until 1747; treasurer of Harvard, 1717–1728, but declined the presidency of the college in 1724; married (1) Jane (d. 1731), daughter of Thomas and Jane Clark, June 5, 1700; (2) Sarah Crisp Clark (d. 1744), May 6, 1732; (3) Mary Frost, who survived him, August 12, 1745; died August 28, 1747

See figure 74

237 Cook

Notebook: [January 1725], p. 80, no. 64: "Mr. Milleys Cook Merchant 12/"

238 Cook

Notebook: [March 1726], p. 82, no. 105: "a Lady for Mr. Cook 3/4 8–8"

239 Cooke, Elisha

Notebook: [March 1730], p. 89, no. 35: "Elisha Cook Esqr H.P. 1/2"
Subject: Elisha Cooke, physician and statesman; born December 20, 1678; Harvard, 1697; grandson of Gov. John Leverett and son of Elisha Cooke (d. 1715); married Jane Middlecott, great-granddaughter of Gov. Edward Winslow, 1703; at odds with the Dudley family; appointed to court of common pleas of Suffolk County, 1731; died August 24, 1737

240 Cooper, Thomas

Notebook: [September 1735], p. 93, no. 114: "Mr. Thoams Copper KK 9 Guines"
Subject: Thomas Cooper, son of Thomas Cooper and Mehitable Minot Cooper of Boston; younger brother of Rev. William Cooper (1694–1743, cat. no. 241), who was a minister of Brattle Square Church

241 Cooper, Rev. William, 1743

30 × 25 (probably)
Engraved: Mezzotint, by Peter Pelham, 1743
 Stauffer 2469; Smith 11
 11.12 × 9.9
Inscribed: I. Smibert Pinx.—P. Pelham fecit / The Revd Mr William Cooper / of Boston in New England Aet. 50. 1743. / Printed for & sold by Stepn Whiting at ye Rose & Crown in Union Street, Boston
Impressions: American Antiquarian Society; Essex Institute; Harvard University; Museum of Fine Arts, Boston (two states); Worcester Art Museum; Henry Francis duPont Winterthur Museum
Copley reused this plate for his portrait of Rev. William Welsteed.
Notebook: [December 1743], p. 98, no. 225: "Rd. Mr. Couper 3/4"
Literature: Foote 1950, p. 146; Oliver 1973, pp. 152, 153 rep., 171; Saunders 1979, vol. 2, pl. 179.
Copy: The Massachusetts Historical Society owns a copy of the portrait, probably painted by Joseph Badger; Foote 1950, pp. 146–47, thought this copy was Smibert's original, although heavily repainted; Oliver, Huff, and Hanson, 1958, pp. 27–28, still attribute it to Smibert
Subject: William Cooper, born March 20, 1694; son of Thomas Cooper and Mehitabel Minot Cooper of Boston; Harvard, 1712; joined Rev. Benjamin Colman (cat. no. 236) as pastor of Brattle Square Church; declined the presidency of Harvard, 1736; married (1) Judith Sewall, May 12, 1720; (2) Mary Foye, November 8, 1742; died December 13, 1743[1]

See figure 87

Although it could just be a coincidence that Smibert painted this portrait the month Cooper died, he would have had to do so before December 5, the day Cooper fell ill. It seems possible that this was a posthumous portrait.

NOTES

 1. Foote 1950, p. 146; Sibley and Shipton 1873–1956, pp. 624–632.

242 Copy, "a lady's head," after Titian

Literature: Foote 1950, p. 87.

Smibert refers to this painting as "the lady's head after Titian" in his letter of March 24, 1744 (app. 2) to Arthur Pond. There is no other reference to the painting, and it is not certain that Smibert painted it.

243 Copy, after Titian, 1720

Provenance: Painted at Florence for "Adl Binge," presumably Adm. George Byng (1663–1733), who was then in Italy
Notebook: [August 1720], p. 76: "Agust 14 receved of Adl. Binge 5 new Itan. pistolls for a copie of a head by Tician"
Literature: Saunders 1979, vol. 1, p. 30

244 Copy, *The Blinding of Cupid,* after Titian, c. 1719–1722

Provenance: A copy was in Smibert's studio when it was rented by John Trumbull in 1779
Notebook: Not recorded
Literature: Sadik 1966, p. 215; Chappell 1982, p. 134; Saunders 1984, pp. 317–318

John Trumbull probably referred to this painting when he noted that he had painted a copy of the "Education of Cupid after Smibert after Titian in the Borghese Gallery."[1] Neither Smibert's copy or Trumbull's copies survive; another copy of the same subject, however, is owned by Bowdoin College (1813.23). This latter copy came to the college with the notation "No. 2 Venus Blinding Cupid / an Original by Titian Presented to Smybert as a reward for his Industry by the Grand Duke of Tuscany from his own Gallery."[2] Although Sadik and Chappell both accepted this copy as Smibert's work, it is more likely an early nineteenth-century copy based on Smibert's missing copy.[3] The original is in the Borghese Gallery, Rome, as it was in Smibert's day.

NOTES

 1. Foote 1950, p. 231.
 2. Sadik 1966, p. 215.
 3. Saunders 1984, pp. 317–318.

245 Copy (copies), *Charles and James Stuart,* after Van Dyck

Provenance: Purchased by John Trumbull from Belcher Noyes, executor of John Moffatt's estate, 1778
Notebook: Not recorded
Literature: Foote 1950, p. 230

Trumbull's records show that he purchased from Belcher Noyes "Heads of two Boys, copied from Vandyks by Smibert / Charles & James 2ᵈ at Buckingham house; given to Mrs. Sheaffe."[1]

NOTES

1. Jaffe 1976, p. 212.

246 Copy, *Danae and the Golden Shower,* after Titian

Notebook: Not recorded
Literature: Foote 1950, pp. 230–231; Sadik 1966, p. 220, n. 25

If Smibert painted a copy after Titan of *Danae and the Golden Shower* there are no contemporary references to it. But among the paintings left by James Bowdoin to Bowdoin College was an unattributed copy of Titian's painting —one of four paintings of "doubtful decency" disposed of by the college in 1850. Foote 1950, p. 230, discusses a copy of *Danae and the Golden Shower,* but he confuses this painting with another Smibert copy, *The Blinding of Cupid,* after Titian (see cat. no. 244).

247 Copy, James Francis Edward Stuart, the "Old Pretender," and Maria Clementina Sobieska, c. 1719–1720

Provenance: Painted in Rome for Sir Andrew Cockburn, a Jacobite supporter
Notebook: Not recorded
Literature: Stuart Papers, Royal Archives, Windsor Castle, Hon. Clare Stuart Wortley, "Thesis on Stuart Portraits," (typescript, 1936), pp. 33–34; Kerslake 1977, p. 180; Saunders 1979, vol., p. 37; Saunders 1984, pp. 317–318
Subject: James Francis Edward Stuart (1688–1766), son of James II and pretender to the British throne, and his consort, Maria Clementina Sobieska (1702–1735) of Poland

Two single portraits or a double portrait Smibert copied from an unidentified life portrait.

248 Copy, *Madonna della Sedia,* after Raphael, c. 1719–1722

Provenance: In Smibert's studio when it was rented by John Trumbull in November 1779
Notebook: Not recorded
Literature: Sizer 1953, p. 45; Foote 1950, pp. 122, 124; Jaffe 1975, p. 46

When Trumbull rented Smibert's studio he painted a copy of a madonna there, "which I afterwards learned to be from the *Madonna della Sedia*":[1] Smibert presumably painted the copy during his stay in Italy. Copley also referred to a copy after Raphael in Smibert's studio when he wrote Henry Pelham, "I will refer you than [then] [to] the Coppey at Smibert's of the Holy Family, which although a Coppey of Raphael, is not withstanding very different from his Painting. I will explain to you in what it differs; the Original, which is at Florence, I have seen, and find that it has nothing of the olive tint you see in the Copy, the read [red] not so bricky in the faces, the whole Picture finished in a more rich and correct manner. you remem[ber] the hands of the Virgin & of the St. John, they are very incorrect in the one you have seen, but in the original they are correctly finished and the whole Picture has the Softness and general hew of Crayons, with a Perlly tint throughout."[2] Oskar Hagen believed that Copley's description of Smibert's copy indicated that it was made for Raphael's *Madonna dell' Impannata,* but it is more likely that it refers to the *Madonna della Sedia,* during the eighteenth century the most highly regarded of Raphael's works.

NOTES

1. Foote 1950, p. 124.
2. Ibid., p. 122.

249 Copy, *Madonna,* after Raphael, 1720

Provenance: Sold in 1720 to an unnamed buyer in Florence
Notebook: [October 1720], p. 76: "Octobre 5 received for another Coppie of the Madonna of Rafaelle"
Literature: Saunders 1979, vol. 1, p. 27

Probably a second copy of the *Madonna della Sedia* (see cat. no. 248).

250 Copy, *Madonna,* after Raphael, 1720

Provenance: Sold in 1720 to an unnamed buyer in Florence
Notebook: [April 1720], pp. 75–76: "April 23 receved for a Coppie of Ra: Mad [Raphael's Madonna]: 11 Sp: pistols"
Literature: Saunders 1979, vol. 1, p. 27

Probably a copy of the *Madonna della Sedia,* which was the most famous of the three madonnas by Raphael in the Ducal collections.

251 Copy, *Venus, Cupid, and Little Dog,* after Titian, 1720

Provenance; Sold in Florence in 1720 to unnamed buyer
Notebook: [July 1720], p. 76: "receved 4 pistols in earnest of a Coppie of a Vennus of Tician one pernice"
Literature: Saunders 1979, vol. 1, pp. 29–30; Chappell 1982, pp. 134–35

This is apparently a copy of Titian's *Venus, Cupid, and Little Dog* in the Uffizi. Smibert's reference to "pernice" refers to the partridge on the window sill. Smibert later owned another copy of this painting, which he also may have painted. This latter copy was in Smibert's Boston studio when John Singleton Copley referred to it as "The Picture of a Naked Venus and Cupid at Smibert's is Copy'd from one of Titiano's in the possession of the Grand Duke of Tuskany which hangs over the Celebrated Titian Venus; but is by no means equal to it."[1] In the eighteenth century Titian's *Venus, Cupid, and Little Dog* hung over the better known Venus of Urbino.

NOTES

1. Copley-Pelham 1914, pp. 340–341.

252 Cotton

Notebook: [August 1732], p. 91, no. 68: "Mrs. Cotton H.P. 1/2 35–0–0"

253 Cradock

Notebook: [May 1729], p. 87, no. 6: "Mrs. Creduck H.P. littell 1/2 35–0–0"
Subject: Probably the wife of Judge George Cradock of Boston; Cradock's daughter Elizabeth married the son of Francis Brinley (1729–1816); Elizabeth Cradock Brinley died in London, 1793

254 Currin

Notebook: [January 1739], p. 95, no. 161: "Mr. Currin [a copy] 3/4 paid"

255 Curven

Notebook: [August 1730], p. 89, no. 39: "Capn: Curven 3/4 2–0–0"

256 Cushing, Reverend Caleb

28 3/4 × 24
Provenance: Descent in family to Caleb Cushing; his niece Miss Margaret W. Cushing, Newburyport, Mass., by 1949
Notebook: Not recorded
Literature: Foote 1950, p. 150
Subject: Reverend Caleb Cushing (1672–1752), Harvard, 1692; minister in Salisbury, Mass., 1698–1752

Foote observed that the portrait "is not particularly characteristic of Smibert's work." As no photograph of this portrait is known, the attribution to Smibert cannot be verified.

257 Davanport

Notebook: [August 1744], p. 99, no. 231: "Mr. Davanport 16 Guinnes"
Subject: Possibly Addington Davenport, father of the wife of the younger Benjamin Faneuil

258 Deane, John

Notebook: [March 1727], p. 84, no. 141: "Mr. Dean Govarnor of / Fot Will Bengall whole lenth 33–12–0"
Subject: John Deane, governor of Fort William in Bengal, 1723–1725; married Mrs. Jocanima Maira Bonkett, May 3, 1712

259 De Boos

Notebook: [March 1726], p. 82, no. 106: "Mr. De Boos a KC payed"
Subject: Probably Claude Dubosc (c. 1682–c. 1745), a French engraver who came to England c. 1712 to help N. Dorigny engrave the Raphael cartoons. Vertue 1930–1955, vol. 3, p. 28, was probably referring to this portrait when he observed "of many pictures of Mr. Smybert's doing a head done of C. Dubosc Engraver. on a Kit-Cat. well disposed. strongly painted tho' clear. the action mightily well disposed & like him."

260 De Lancey, Oliver

Notebook: [December 1742], p. 98, no. 211: "Mr. Oliver Delance H.P. 1/2 16 Gunnes"
Subject: Oliver De Lancey (1716–1785), brigadier general in the British army: "He had a fine mansion at Bloomingdale, a few miles from New York, which was burnt during the revolution, . . . at the close of the war, going to England, he made Beverley his residence where he died in 1785, aged 68 years and was buried in the choir of the cathedral of that place" (Jerome B. Holgate, *American Genealogy: A History of Some Early Settlers of North America* [1851], p. 121); brother of Susannah Delancey Warren, who married Peter Warren (cat. no. 137) in 1731; friend of Peter Faneuil (cat. no. 130)

261 Dennie, John

Notebook: [September 1736], p. 94, no. 127: "Mr. John Dennie 3/4 6 Guinis"
Subject: John Dennie, a Fairfield (Conn.) merchant who rented warehouses in Boston during the late 1730s and spent part of the fall of 1736 in Boston (Henry Caner to "John Dennie Fairfield Mercht in Boston," November 19, 1736, Henry Caner Letterbook, 1728–1778, University of Bristol Library)

262 Dennie

Notebook: [September 1736], p. 94, no. 128: "Mrs. Dennie 3/4 6 Guinis"
Subject: Probably wife of cat. no. 261

263 Diswell, William

Notebook: [c. 1722–1723], p. 78, no. 3: "—Willm. Dizell Paint[er] 3/4 2–2–"
Subject: Probably William Diswell, painter-stainer, son of John Diswell, Blacksmith, London; bound to Francis Browne, 1695

264 Dixson

Notebook: [December 1726], p. 83, no. 124: "Mr. Dixson 14–14–0"

265 Dizell

Notebook: [c. 1723–1724], p. 79, no. 32: "Mrs. Dizell a present"
Subject: Probably the wife of cat. no. 263

266 Dorrell

Notebook: [November 1725], p. 82, no. 96: "Mr. Thoms. Dorrell Clargiman 3/4 16–16 o [price includes following portrait]"
Subject: Possibly Rev. Thomas Dayrell of Lillington Dayrell in Buckinghamshire, who owned a house in Oxford

267 Dorrell

Notebook: [November 1725], p. 82, no. 97: "Mrs. Dorrell 3/4 16–16–0 [price includes preceding portrait]"

268 Dorreyl

Notebook: [1724], p. 79, no. 49: "Mr. Dorreyl 7–17–6"

269 Dorreyl

Notebook: [April 1725], p. 80, no. 72: "Paul Dorreyl Esqr. 3/4 8–8–0"

270 Dracke

Notebook: [March 1728], p. 85, no. 163: "Mrs. Francis Dracke O S A presant"

Subject: Possibly the wife of Francis Henry Drake (1694–1740) of Buckland and Nutwell Court, Devon, who died at his lodgings at Covent Garden, January 26, 1740; first surviving son of Sir Francis Drake

271 Draper, William

Notebook: [February 1725], p. 80, no. 65: "William Drapper Esqr. of Adgcomb 1/2"
Subject: Probably William Drayer of Adycombe, near Croydon, Surrey

272 Drummond

Notebook: [c. 1723–1724], p. 79, no. 30: "Blare Drummond 7–17–6"
Subject: Possibly a member of the family of Blair Drummond House, Stirling, Scotland

273 Drummer

Notebook: [February 1731], p. 90, no. 50: "Mrs. Drummer H.P. KK 30–0–0"
Subject: Possibly (1) Dummer (c. 1679–May 19, 1739), wife of Jeremiah Dummer, colonial agent (Harvard, 1699); or (2) Dummer, wife of William Dummer, lieutenant governor of Massachusetts, 1716–1730

274 Eainsworth

Notebook: [1724], p. 80, no. 59: "Roland Eainsworth Esqr. 1/2 15–14–0"
Subject: Possibly Roland Ainsworth, a London merchant

275 Edwards (Chan?)

Notebook: [c. 1722–1723], p. 79, no. 24: "Mr. Edwards' Mr. Chan: 1/2 15–15–"

276 Emes

Notebook: [August 1728], p. 86, no. 174: "Mr. Emes 3/4 present"

277 Engs, Anne

35 1/2 × 28 in
Notebook: Not recorded
Literature: Foote 1950, p. 217
Copy: A nineteenth-century copy, according to Foote, "descended through the Phillips and Rowe families to the late Caleb Loring Cunningham, Milton, Mass. Now [1949] owned by Mrs. Cunningham."

Subject: Anne Engs, born Boston, October 20, 1715; daughter of William Engs and Anne Adams Engs; married Capt. John Phillips, September 29, 1734; died November 17, 1794

Foote only saw the Cunningham family copy of this portrait. He described it as showing "an attractive young woman with brown hair and eyes, nearly full front against a dark background, her left shoulder slightly advanced. She wears a pink silk gown, cut low, with white trim, with four white stripes and tassels across her corsage. A dark scarf is thrown over her right arm and carried around behind her. Her left hand holds what appears to be a silver-headed cane." As no photograph of either the copy or the original is now known, the attribution to Smibert cannot be verified.

278 Errington

Notebook: [August 1727], p. 85, no. 157: "Mrs. Errington 3/4 8–8–0"

279 Erroll, Countess of

Notebook: [c. 1723–1724], p. 79, no. 31: "The Countess of Erroll 3/4 7–17–6"
Subject: Either (1) Lady Anne Drummond (b. 1655), wife of John Drummond, 12th earl of Erroll (d. 1704); or (2) Mary (d. 1758), eldest daughter of Lady Anne, who succeeded to the title countess of Erroll on the death of her brother Charles Hay, 13th earl; married August 1722

280 Ervin

Notebook: [March 1738], p. 95, no. 151: "Capn. John Ervin H.P. L 1/2 1 Guinias"
Subject: Possibly John Erving, husband of cat. no. 87

281 Eveline

Notebook: [March 1738], p. 95, no. 152: "Mr. George Eviline KK 9 Guinias"

282 Fairen

Notebook: [May 1726], p. 82, no. 110: "Mr. Fairen a Coppie 3/4 8–8–0"
Subject: Possibly a portrait of Henry Ferne (cat. no. 28)

283 Faneuil, Benjamin

Notebook: [February 1744], p. 98, no. 229: "Mr. Bn. Funnell H.P. 1/2 16 Gunnes"
Subject: Benjamin Faneuil (d. 1787), brother of Peter Faneuil;

agent of the East India Company and one of the consignees of the tea tossed into Boston harbor. On July 7, 1771, (CP, part 1) Smibert's son Williams wrote his cousin Thomas Moffatt, "I spent the day very pleasantly yesterday at the house of an old acquaintance of my father. Mr. Benj. Fanuil which brought back many years to my remembrance—he enquired very particuly about you & your situation-he is a lively sprightly old man about 80."

284 Faneuil, Mrs. Benjamin

Notebook: [June 1739], p. 96, no. 166: "Mrs. B. Funnell H P 1/2 12 Guines"
Subject: Anne Bureau Faneuil, mother of Peter Faneuil (cat. no. 130)

285 Faneuil, Peter

1743
full-length
Provenance: Commissioned by the selectmen of Boston to hang in Faneuil Hall, 1743; damaged by fire, January 13, 1761; continued to hang in Faneuil Hall at least until 1775; replaced with a copy by Henry Sargent, 1807
Notebook: [March 1743], p. 98, no. 214: "Mr. Peter Funnell whole Lenth 32 Gunnis"
Copy: By Henry Sargent, commissioned February 4, 1807, by the selectmen of Boston, who appropriated "350 dollars for the purpose of procuring an elegant picture with frame complete of Peter Faneuil, Esq., to be placed in a suitable position in Faneuil Hall, Mr. Wright was desired to employ Mr. Henry Sargeant [Sargent] to paint the same in the best manner & to complete it as soon as possible"[1]
Subject: See cat. no. 130

At a meeting of the Boston selectmen on March 30, 1743, soon after Faneuil's death, it was voted "that Messrs. Jeffries, Hancock & Cooke be a Committee to provide a Frame for the Picture of Peter Faneuil Esq. Deced in the best manner they can." The following December they wrote to Christopher Kilby in London: "The Inhabitants of the Town of Boston at a meeting in September 1742. Voted, That the Select men of this Town be desired to procure the picture of Peter Faneuil Esqr. to be put in Faneuil Hall at the Expence of the Town. which Picture being now furnished by Mr. Smibert We find upon Enquiry that a Frame for said Picture can be got in London Cheaper & better than with Us. We therefore beg the favour of You Sir to procure & Send a Neat Gold Carved Frame of Eight feet in length & Five Feet in Wedth by the first Ship in as small a box as may be, as it will reduce the Freight. Your Expence for the same shall be remitted as soon as known, which Frame we hope may be bought for about Eight Guineas."[2]

NOTES

1. December 7, 1743, in Foote 1950, p. 82.

2. Report of the Record Commissioners of the City of Boston: Selectmen's Minutes from 1742/3 to 1753, p. 11. Quoted in Foote 1950, p. 82.

286 Faneuil, Peter

Notebook: [August 1744], p. 99, no. 230: "Mr. Peter Funnell Copey 1/2 16 Guinnis"
Subject: See cat. no. 130

287 Forbis

Notebook: [June 1725], p. 81, no. 84: "Mr. Forbis 1/2 16–16–0"

288 Forward

Notebook: [January 1727], p. 83, no. 126: "Mr. Forwood 1/2 16–16–0"

289 Frame

Notebook: [June 1740], p. 96, no. 183: "Mrs. Frame H.P. 1/2 20 Guines"
Subject: Possibly Margaret Penn Freame (November 7, 1704–February, 1751), daughter of William Penn and his second wife, Hannah Callowhill; married Thomas Freame in 1727 and accompanied him to Philadelphia in 1734, returning to England in 1741

290 Frankland

Notebook: [February 1740], p. 96, no. 173: "Mr. ——— Frankland KK 12 Gunns"
Subject: Possibly (1) Charles Henry Frankland (1716–1768), Boston customs collector, 1741–1747; or (2) Frederick Frankland

291 Frankland

Notebook: [July 1743], p. 98, no. 220: "Mrs. Frankland a bill on KK 12 Gunnes"
Subject: Possibly the wife of cat. no. 290

292 Franks

Notebook: [September 1740], p. 97, no. 204: "Mr. Franks H P 3/4 10 Gunnes"

293 Franks

Notebook: [September 1740], p. 97, no. 205: "Mrs. Franks H P 3/4 10 Gunnes"

294 Funnell

Notebook: [March 1740], p. 96, no. 175: "Mrs. Funnell [a copy] 1/2 12 Guines"
Subject: Possibly a copy of Mrs. Benjamin Faneuil (cat. no. 284)

295 Furness

Notebook: [April 1725], p. 81, no. 74: "Sr. Robert Furness his Eldest daughter 3/4 8–8–0"
Subject: Probably Anne Furnese (d. 1747), daughter of Sir Robert Furnese (1687–1733), 2nd baronet; married John St. John of Lydiard Tregoze, near Swindon, Wiltshire, April 17, 1729

296 Gibones

Notebook: [February 1730], p. 89, no. 31: "Ms. Gibones H.P. 3/4 20–0–0"
Subject: Possibly (1) Lucy Gibbons, daughter of John Gibbons (January 11, 1687–June 23, 1760), Boston physician, who in 1718 was one of the chief contributors to the new pulpit for King's Chapel (he had converted to the Anglican church); or (2) Ann Gibbons, older sister of Lucy Gibbons, baptized at Brattle Square Church, December 28, 1712

297 Gille

Notebook: [March 1727], p. 84, no. 134: "Mr. Gille 8–8–0"

298 Glen, Andrew

Notebook: [February 1726], p. 82, no. 102: "Mr. Andrew Glen 3/4 8–8–0"

299 Glen

Notebook: [May 1725], p. 82, no. 109: "Mr. Glen 3/4 8–8–0"

300 Glenister, Edmund

Notebook: [1724], p. 80, no. 46: "Mr. Edmund Glenister 16–16–0"

301 Gordon

Notebook: [c. 1722–1723], p. 78, no. 18: "Miss Gordon 3/4 7–17–6"

302 Gould, Nathaniel

Notebook: [October 1726], p. 83, no. 122: "Mr. Nathanial Gould 1/2 16–16–0"
Subject: Either (1) Nathaniel Gould (c. 1697–1738) of Crosby Square, London, a director of the Bank of England, 1722–1737; or (2) Nathaniel Gould (1661–1728) of Stoke, Newington, Middlesex, and Bovington, Hertfordshire; knighted April 14, 1721; a director of the Bank of England, 1697–1709 and 1713–1728, and sometime governor of the Russia Company

303 Gowidg

Notebook: [November 1743], p. 98, no. 223: "[Mr. Gowidg] his Lady 1/2"
Subject: Possibly a relative of James Gooch (cat. no. 69)

304 (Gowidg)

Notebook: [November 1743], p. 98, no. 222: "Mr. Gowidg 1/2"
Subject: Possibly a relative of James Gooch (cat. no. 69)

305 Graeme, John

Notebook: [October 1725], p. 82, no. 94: "Mr. John Graeme 3/4"

306 Graeme

Notebook: [October 1725], p. 82, no. 95: "Mrs. Graeme 3/4"

307 Graham

Notebook: [April 1725], p. 81, no. 74: "Mr. Graham Apothicarie to the King 3/4 8–8–0"
Subject: Either (1) Thomas Graham, admitted to the Apothecaries Guild in 1698; or (2) his son Daniel Graham, apprenticed to Daniel Malthus, brother-in-law of Thomas Graham; made free in 1721

308 Graham

Notebook: [May 1725], p. 82, no. 79: "Mrs. Graham a Coppie 3/4 6–6–0"

309 Graham

Notebook: [May 1725], p. 81, no. 80: "Mr. Graham another 3/4 8–8–0"

310 Grant, Sir Archibald

Notebook: [October 1725], p. 82, no. 93: "Archaballd Grant Esqr. 1/2" (entry crossed out)
Subject: See cat. no. 34

311 Hacks

Notebook: [May 1725], p. 82, no. 108: "A littel head for Mr. Hacks 3–3–0"
Subject: Possibly a commission from the Hucks family

312 Hall, Mary, 1730

32 (?) × 25
Provenance: Mrs. E. W. Taylor, Cambridge, Mass., by 1949
Notebook: [September 1730], p. 89, no. 41: "Ms. Marey Hall H.P. 3/4 20–0–0"
Literature: Foote, p. 161
Subject: Mary Hall (1713–1795), daughter of Hugh Hall of Barbados, later of Boston; married (1) Adam Winthrop; (2) Captain William Wentworth (1705–1767), son of Lt. Gov. John Wentworth of New Hampshire

Foote, who saw the portrait, described it as follows: "The head and bust of the subject are shown nearly full front against a shaded background with spandrels in the lower corners. She is a pleasing young woman about twenty years of age, with a rather long neck, round face, brown eyes and brown hair, a curl of which hangs over her left shoulder. She wears a golden-yellow gown, with white muslin trim at her bosom. The portrait closely resembles that of the painter's wife, Mary Smibert, in the way the subject is posed for presentation according to a conventional formula." According to Foote, the portrait had the following label with it: "This is Grandmother's / Great Aunt Mary Hall, / daughter of Hon. ——— Hall / of Barbadoes, wife of / Capt. William Wentworth / Son of Lieut. Governor / John Wentworth / Born 1713 Died 1790 [sic] / at Portsmouth, N.H."[1]

NOTES

1. Foote 1950, p. 161.

313 Hall, Sarah

1730
32 (?) × 25 in
Notebook: [September 1730], p. 89, no. 42: "Ms. Sarah Hall. H.P. 3/4 20–0–0"
Literature: Foote 1950, pp. 205–20 (Foote mistakenly states that this portrait is reproduced in NEHGS *Register* [July 1888], Wentworth Genealogy, vol. 1, p. 308)
Subject: Sarah Hall (c. 1712–1790), daughter of Hugh Hall of Barbados, later of Boston; sister of Mary Hall (cat. no. 312); married John Wentworth, son of Lt. Gov. John Wentworth of

New Hampshire, 1732; died in Portsmouth, N.H., March 26, 1790[1]

Foote accepted this painting as by Smibert on the basis of a photograph.

NOTES

1. Foote 1950, pp. 205–206.

314 Hall

Notebook: [June 1727], p. 85, no. 153: "Mrs. Hall pyd."

315 Hall

Notebook: [August 1727], p. 85, no. 156: "Doctor Hall pyd."

316 Hallowell, Benjamin

Notebook: [May 1733], p. 91, no. 79: "Mr. Ben^n Halloway H.P. KK."
Subject: Benjamin Hallowell, commissioner of customs, Boston, 1764–1776; built a mansion in Roxbury at the corner of Boyleston and Centre Streets in 1738, vacating it in 1775; the furnishings, which included "a number of family pictures," were left behind when he fled Massachusetts in March 1776

317 Hamilton, Andrew

Notebook: [July 1740], p. 97, no. 186: "Mr. A. Hamelton Sr. H P 1/2 20 Guns."
Subject: Andrew Hamilton (1676–August 4, 1741), lawyer and attorney general of Pennsylvania; a leader of Philadelphia's Presbyterian community

318 Hamilton, Andrew, Jr.

Notebook: [July 1740], p. 97, no. 190: "Mr. A. Hamelton Jr. H P 3/4 10 Guns"
Subject: Andrew Hamilton, Jr. (d. 1747), son of Andrew Hamilton (cat. no. 317), who married Mary Till, December 24, 1741, a daughter of William Till

319 Hamilton, James

Notebook: [June 1740], p. 96, no. 182: "Mr. James Hamelton 3/4 a Present"
Subject: James Hamilton (1710–August 10, 1783), son of Andrew Hamilton (cat. no. 317); lawyer; member of the Pennsylvania Assembly, 1734–1739; remained unmarried

A full-length portrait of Hamilton was painted in 1767 by Benjamin West (see Helmut von Erffa and Allen Staley, *The Paintings of Benjamin West* [New Haven, 1986], pp. 514–515).

320 Hamilton, James

Notebook: [July 1740], p. 97, no. 189: "Mrs. James Hamelton H P 1/2 20 Guns."
Subject: See cat. no. 319.

321 Hamilton

Notebook: [1742], p. 97, no. 207: "Mr. Hamilton a Copey 1/2 16 Gunnes"
Subject: Probably a copy of one of the Hamilton portraits Smibert painted in Philadelphia in 1740

322 Hancock, Mrs. Thomas (?)

29 1/2 × 24 1/4 in
Provenance: Mrs. Lydia B. Taft, Milton, Mass., by 1949
Notebook: Not recorded as presently identified
Literature: Foote 1950, pp. 163
Subject: See cat. no. 56

Foote, who examined the portrait, concluded that if it was of Mrs. Thomas Hancock it would have had to have been painted late in Smibert's career, as the sitter looked about twenty years older than the woman depicted in cat. no. 56. He described the portrait as follows: "The head and bust of the subject are shown above spandrels in the lower corners, nearly full front, her head turned slightly left against a plain, grayish-green background. She is shown with light brown hair, and brown eyes. She wears a greenish-blue gown, with white muslin guimpe." As no photograph of this portrait is now known, the attribution to Smibert cannot be verified.

323 Handcock

Notebook: [March 1730], p. 89, no. 36: "Ms. Handcock H.P. 1/2 40–0–0"
Subject: Possibly (1) a member of Thomas Hancock family; or (2) Mrs. George Berkeley's traveling companion

324 Hay

Notebook: [August 1728], p. 86, no. 172: "Mr. Hay K.C. 10–10–0"

325 Heugs

Notebook: [1724], p. 79, no. 36: "Mr. Heugs a Clargeman 3/4 7–7–0"
Subject: Possibly Rev. Mr. Hughs, chaplain to the bishop of Rochester

326 Heugs

Notebook: [1724], p. 79, no. 37: "Mrs. Heugs 3/4 7–7–0"
Subject: Probably the wife of cat. no. 325

327 Hill, Samuel

Notebook: [c. 1722–1723], p. 78, no. 15: "Mr. Hill 7–17–6"
Subject: See cat. no. 11

328 Hill

Notebook: [May 1743], p. 98, no. 216: "Mr. Hill 1/2 16"

329 Hope

Notebook: [c. 1722–1723], p. 78, no. 5: "———Hope of Rot: 3/4 7–17–6"
Subject: Possibly Archibald Hope (1664–1743), who was christened in the Scots church in Rotterdam in 1664 and set up as a merchant there

330 Hope

Notebook: [September 1729], p. 88, no. 16: "Mr. Hope 3/4 20–0–0"

331 Hubbard

Notebook: [November 1731], p. 90. no. 55: "Mrs. Hubbard H.P. K.K. 30–0–0"
Subject: Possibly Mary Jackson Hubbard, daughter of Jonathan Jackson and Mary Salter Jackson; sister of Edward Jackson (Harvard, 1726); married Thomas Hubbard (b. 1702), initially the proprietor of a brazier's shop, later treasurer of Harvard College and commissary general of Massachusetts; "In 1730 the Hubbards removed from the First Church to the Old South where their beautifully carved pew with its gorgeous silk furnishings was a thing of note" (Sibley and Shipton 1873–1956, vol. 6, p. 490)

332 Hucks, Robert

Notebook: [c. 1722–1723], p. 78, no. 10: "Mr. Robt. Huck's 3/4 7–17–6"

Subject: Robert Hucks (1699–1745) of Hampden, near Abingdon and Aldenham, Hartfordshire; king's brewer; M.P. and treasurer of the Foundling Hospital, 1744; represented Smibert in his effort to be repaid the artist's loan to Sir Archibald Grant (see app. 2)

333 Hucks, Robert

Notebook: [June 1725], p. 83, no. 114: "Mr. Robert Hucks small pyd"
Subject: See cat. no. 332

334 Hucks, William and Robert

Notebook: [June 1727], p. 84, no. 149: "Mr. Willm. & Mr. Robt. Huckes / in one Cloth 1/2 33–12–0"
Subject: Robert Hucks (cat. no. 332) and his father (bef. 1678–1740), William Hucks, lived on Great Russell Street, Bloomsbury, and in Wallingford, Berkshire. William was an M.P. for Abingdon, 1709–1710, and Wallingford, 1715–1740, and an owner of the Horn Brewery, Duke Street, Bloomsbury. He was responsible for the erection of the statue of George I on the steeple of St. George's, Bloomsbury.

335 Hucks

Notebook: [January 1726], p. 82, no. 100: "2 heads in Littele for Mr. Hucks 4–4–0"

336 Itchiner

Notebook: [August 1726], p. 83, no. 119: "Mr. Itchiner a Clargeman 3/4 16–16–0 [price includes following portrait]"
Subject: Possibly William Itchiner (d. 1730); Oxford, 1696; rector of Christian Malford, Wiltshire, 1705–1730

337 Itchiner

Notebook: [August 1726], p. 83, no. 120: "Mrs. Itchiner 16–16–0 [price includes preceding portrait]"
Subject: Probably the wife of cat. no. 336

338 Jackelle

Notebook: [December 1736], p. 94, no. 130: "Mr. [Blicket/] Jackelle 15 3/4 6 Ginnes"

339 Jackson

Notebook: [January 1726], p. 82, no. 101: "Ms. Jackson a Child wholl lenth in a 1/2 presant"

340 Jackson

Notebook: [February 1727], p. 84, no. 131: "Mr. Jackson Counseler 3/4 8–8–0"

341 Jackson

Notebook: [March 1727], p. 84, no. 137: "Mr. Jackson Counseler Coppie 3/4 8–8–0"
Subject: Probably a replica of cat. no. 340

342 James

Notebook: [May 1733], p. 91, no. 75: "Mr. James H.P. 3/4 25–0–0"

343 Jennyns

Notebook: [c. 1722–1723], p. 78, no. 11: "Mr. William Jennyns 3/4 7–17–6"
Subject: Possibly William Jennings, who in 1725 was a member of the Society for the Promotion of Christian Knowledge

344 Johns

Notebook: [June 1738], p. 95, no. 155: "Mrs. Collman Johns. H.P. 3/4 6 Guinnias"

345 Johnson, Andrew

Notebook: [c. 1722–1723], p. 78, no. 6: "——— And: Johnson Eng. a Head payd"
Subject: Probably Andrew Johnston, an engraver who had a shop at the Golden Eagle on St. Martin's Lane, London; a close friend of Smibert's and fellow member of his church in London

346 Jones

Notebook: [August 1744], p. 99, no. 234: "Mr. Jonnes a Bill for the wholie [this and the preceding four portraits]"
Subject: Probably John Jones, husband of Mary Anne Faneuil Jones, sister of Peter Faneuil

347 Johnston

Notebook: [1724], p. 79, no. 42: "Capn. Jon. Jonston 3/4 7–17–6"
Subject: Possibly Captain John Johnston, who was captured at Alamanza, 1707

348 Justice, Henry

Notebook: [c. 1722–1723], p. 78, no. 7: "——— Henry Justice. Kit-Cat 11–11–"
Subject: Henry Justice (d. 1763), admitted to Trinity College, Cambridge, April 27, 1716; exiled to Italy, 1736; died at the Hague, 1763

349 Keay

Notebook: [July 1728], p. 85, no. 169: "Mr. Keay a Coppie / 4 g[uineas] p[aid] 3/4 8–8–0"
Subject: Probably a replica of cat. no. 35

350 Kilby, Christopher

Notebook: [September 1739], p. 96, no. 172: "Mr. Crs. Kilbe 3/4 6 Guinies"
Subject: Christopher Kilby, the Massachusetts agent in London

When this portrait was completed it was delivered to Thomas Hancock, as Kilby was then in London. Hancock reported its arrival to Kilby in a letter (see p. 00). The preceding December 24 Hancock reported to Kilby, "your children are well, I had Sally at my house and to Mr. Smyberts, she knew your picture very well" (Hancock Papers, TH-3 Letterbook 1735–1740, New England Historic Genealogical Society).

351 Kiler

Notebook: [September 1740], p. 97, no. 198: "Capn. Kiler H P. KK 15 Gunnes"
Subject: Possibly Capt. Johannes Schuyler (1688–1746/7)

352 Larabe

Notebook: [March 1736], p. 93, no. 118: "Capn. Larabe H.P. 34/ 6 Guinias"
Subject: Probably Capt. John Larabee (1686–1762), made captain of Castle William in Boston Harbor, 1723.

Captain Larabee also had his portrait painted by Joseph Badger (Worcester Art Museum).

353 Lawson

Notebook: [1724], p. 79, no. 40: "Coll. Lawsons Son George 34/ 7–17–6"

354 Lessel's

Notebook: [October 1731], p. 90, no. 54: "Mr. Lessel's a youth 3/4 20–0–0"

355 Lewis

Notebook: [September 1743], p. 98, no. 221: "Mrs. Lewis 3/4 8 Gunnes"

356 Londonderry, Lord

Notebook: [c. 1722–1723], p. 79, no. 25: "Ld. Londonderry 1/2 10–10–"
Subject: Thomas Pitt (1688?–1729), 1st earl of Londonderry, M.P. for Wilton, 1713–1727; governor of the Leeward Islands, 1728–1729; died at St. Kitts, September 12, 1729

357 Loyde

Notebook: [July 1732], p. 91, no. 66: "Mrs. Loyde H.P. 1/2 40–0–0"

358 Marischal, Earl

Notebook: [1724], p. 79, no. 39: "Earl of Marishall a coppy 1/2 10–10–0"
Subject: Probably George Keith (1693–1778), 10th earl marischal; eldest son of William, 9th earl marischal, and Lady Mary Drummond; succeeded to the earldom May 27, 1712; supported the Pretender, escaped to France, and in 1759 was pardoned by George II and came to Scotland from Prussia; returned to Prussia in 1762

359 Martin

Notebook: [April 1739], p. 95, no. 163: "Major Martin 1/2 12 Guinns"

360 Maull

Notebook: [March 1728], p. 85, no. 161: "Mrs. Maull 3/4 8–8–0"
Subject: Possibly the wife of Henry Maule, dean of Cloyne, bishop of Cloyne, 1720

361 McKintosh

Notebook: [August 1738], p. 95, no. 157: "Mrs. Mary McKintosh H.P. 1/2 12 Guinies"
Subject: Possibly Mary Palmer McIntosh

362 Midleton

Notebook: [July 1743], p. 98, no. 219: "Mr. William Midleton 3/4 8 Gunnis"
Subject: Possibly a relative of Henry Middleton (1717–1784), who married William Bull's sister Maria Henrietta Bull in 1762

363 Miln

Notebook: [May 1725], p. 81, no. 77: "Mrs. David Milns Son 1/2 10–10–0"
Subject: The son of Mr. and Mrs. David Miln (cat. nos. 12, 14)

364 Mitchell

Notebook: [March 1728], p. 85, no. 160: "Mrs. Mitchell and Daughter 1/2"

365 More

Notebook: [September 1740], p. 97, no. 202: "Ms. F More H.P. KK 15 Ginnes"

366 Morris, Governor Lewis

Notebook: [August 1740], p. 97, no. 193: "Gor. Morres H P 3/4 10 Guinnes"
Subject: Lewis Morris (1671–1746), governor of New Jersey; buried at Morrisania in New York

367 Morris

Notebook: [May 1739], p. 95, no. 164: "Captin Morris H.P. 3/4 6 Guines"

368 Morris

Notebook: [August 1740], p. 97, no. 194: "his [Governor Morris's] Lady H P 3/4 10 Guinnes"
Subject: Wife of New Jersey governor Lewis Morris (cat. no. 366), either (1) Isabella Graham Morris or (2) Catalynte Staats Morris

369 Morris

Notebook: [1742], p. 97, no. 208: "Gor. Morris a Coppey"
Subject: Probably a copy of Smibert's 1740 portrait of Lewis Morris (cat. no. 366)

370 Morris

Notebook: [1742], p. 97, no. 209: "his [Governor Morris's] lady Do"
Subject: Probably a copy of Smibert's 1740 portrait of the wife (cat. no. 368) of Lewis Morris (cat. no. 366)

371 Muilman, Mrs. Peter

Notebook: [September 1725], p. 81, no. 92: "Mrs. Mullman or C. Fillips 1/2 16–16"
Subject: Teresia Constantia Phillips (1709–1765), undoubtedly the most notorious of Smibert's sitters. She was the eldest daughter of Thomas Phillips, who rose to the rank of captain in Lord Langdale's regiment. She was in London by 1717, where she completed her education at Mrs. Filler's boarding school. By 1721, at age twelve, she claims to have been the lover of the future 4th earl of Chesterfield. By 1723 she was married to Henry Muilman, a Dutch merchant of good standing, and over the next forty years had numerous lovers and a series of marriages. At one point she determined to blackmail her paramours by publishing *An Apology for the Conduct of Mrs. Teresia Constantia Phillips, more particularly that part of it which relates to her Marriage with an eminent Dutch Merchant.* She died February 2, 1765, "unlamented by a single person." Her portrait was also painted by Highmore and engraved by Faber as the frontispiece to her *Apology.*

372 Negro

Updike 1907, vol. 1, p. 523, in speaking of Smibert, noted, "His first essay in colours is said to have been the portrait of a young Negro, brought from Martinique to Scotland." This comment, given a degree of validity by Foote 1950, p. 206, may well be apocryphal, for it is otherwise unsubstantiated.

373 Nisbit

Notebook: [May 1725], p. 81, no. 78: "Doctore Nisbit a Littell 1/2 a presant"
Subject: Possibly Robert Nesbitt, son of Mr. John Nesbitt, a dissenting minister in London; studied medicine at Leyden, where September 1, 1718, he was "entered on the physic line"; attended the lectures of Hermann Boerhaave and received the degree of doctor of medicine on April 25, 1721; admitted a Fellow of the Royal Society on April 22, 1725

374 Nisbit

Notebook: [March 1728], p. 85, no . 162: "Mr. Nisbits son 3/4 pyd."

375 Noris

Notebook: [June 1737], p. 94, no. 141: "Capn. Noris and Lady N.P. 1/2 13 guinias"
Subject: Possibly Matthew Norris (d. 1739), who married Euphe-

mia, daughter of Lewis Morris (cat. no. 366); commissioned a captain in the Royal Navy, 1724, and was for some time a commissioner of the Navy at Plymouth in England.

376 Norris

Notebook: [April 1727], p. 84, no. 142: "Mr. Norris 3/4 8–8–0"

377 Oliver

Notebook: [March 1736], p. 93, no. 119: "Mrs. A. Oliver H P. 1/2 12 Guinias"

378 Osburn

Notebook: [May 1738], p. 95, no. 153: "Mrs. Mary Osburn H.P. KK 9 Guinias"

379 Osburn

Notebook: [July 1743], p. 98, no. 217: "Capn. Osburn 3/4 8 Gunnes"
Subject: Possibly John Osborne, long a member of the Massachusetts council

380 Otway, Charles

Notebook: [c. 1722–1723], p. 78, no. 13: "Capt: Charles Otway 3/4 7–7–"
Subject: Possibly (1) Charles Otway (1690–1753), who became a lieutenant general; or (2) Charles Otway (d. 1767), son of James Otway (cat. no. 15)

381 Otway

Notebook: [c. 1722–1723], p. 78, no. 8: "Coll: James Otway's Lady. 3/4 7–7–"
Subject: Probably the wife of James Otway (cat. no. 15)

382 Otway

Notebook: [c. 1722–1723], p. 78, no. 9: "Do. [Ditto, Col. James Otway's] Son Stan: [Stanhope] Boy, W. Length 10–10–"
Subject: Probably Stanhope Otway (d. 1750), who was admitted to Trinity College, Cambridge, 1732–1733, then to the Inner Temple, April 10, 1733; fourth son of James Otway (cat. no. 15); a victim of the Black Assizes, May 19, 1750

383 Otway

Notebook: [c. 1722–1723], p. 78, no. 21: "Capt. [Fra ?]n: Otway 3/4 7–7–"
Subject: Possibly Francis Otway, son of James Otway (cat. no. 15); served in the army, 1718–1749; made captain by 1722, major by 1740, and lieutenant colonel by 1746

384 Otway

Notebook: [c. 1722–1723], p. 79, no. 23: "Mr. Richd Otway 3/4 7–7–"
Subject: Possibly (1) Richard Otway, son of James Otway (cat. no. 15), who served in the army, 1712–1718; or (2) Richard Otway (d. 1750), who matriculated at Cambridge in 1723 and became rector of Boughton, Malherbe, Kent, 1724–1750

385 Otway

Notebook: [1724], p. 79, no. 34: "Ms. Otway 3/4 7–7–0"
Subject: Probably a daughter of James Otway (cat. no. 15)

386 Otway

Notebook: [August 1728], p. 85, no. 171: "The Rd. Mr. Otway 3/4 8–8–0"
Subject: Possibly (1) Richard Otway (d. 1750), rector of Boughton, Malherbe, Kent, 1724–1750; or (2) Thomas Otway (1704–1732), who graduated from Cambridge, 1727–1728, and was rector of St. Augustine, Norwich, by 1730

387 Oxanard

Notebook: [May 1740], p. 96, no. 176: "Mrs. Oxanard H P 1/2 12 Ginnes"

388 Palmer, Charles

Notebook: [c. 1722–1723], p. 78, no. 2: "——Charles Palmer 1/2 10–10–"

389 Palmer, Thomas

Notebook: [September 1737], p. 95, no. 147: "Judge Palmer H.P. 1/2 12 Guines"
Subject: Probably Thomas Palmer, justice for the county of Suffolk, 1737, and one of the founders of the Brattle Square Church

390 Palmer, Thomas

Notebook: [February 1743], p. 98, no. 212: "Mr. Thomas Pallmer 3/4 8 Gunnis"
Subject: Possibly the same sitter as cat. no. 389

391 Palmer, Mrs. Thomas

Notebook: [May 1743], p. 98, no. 213: "[Mr. Thomas Palmer] his Lady 3/4 5 Gunnes"

392 Palmer

Notebook: [March 1728], p. 85, no. 164: "Mr. Palmer 3/4 8–8–0"

393 Palmer

Notebook: [April 1728], p. 85, no. 166: "Mrs. Palmer 3/4 8–8–0"

394 Palmer

Notebook: [August 1729], p. 88, no. 11: "Mrs. Pallmer H.P. 1/2 40–0–0"

395 Partridge

Notebook: [February 1730], p. 88, no. 29: "Mrs. Partrige H.P. 1/2 40–0–0"
Subject: Probably Mrs. William Partridge, mother of Mary Partridge Belcher, wife of Governor Jonathan Belcher (cat. no. 185)

396 Pemberton, Ebenezer

Notebook: [June 1733], p. 91, no. 80: "The Revd. Mr. Pemberton 3/4 25–0–0"
Subject: Ebenezer Pemberton (February 6, 1704/5–September 9, 1777), son of Ebenezer Pemberton (d. 1717), pastor of Old South Church; Harvard, 1721; sent to the Presbyterian church in New York in 1727, where he remained until called to New Brick Church in Boston, 1754; while living in New York he traveled frequently to Boston and kept up his contacts there

397 Pemberton, James

Notebook: [January 1737], p. 94, no. 131: "Mr. James Pemberton Jr H P 3/4 6 Guinnes"
Subject: James Pemberton (August 2, 1713–July 28, 1756), eldest son of James Pemberton and Hannah Penhallow Pemberton of Boston; brother of Samuel (cat. no. 96), Hannah (cat. no. 100), and Mary (cat. no. 101); merchant banker; Harvard, 1732; member of Old South Church; in 1734 purchased the lovely

estate from which Pemberton Square takes its name; married Hephzibah Bradford, October 12, 1752, who is named as executor and sole inheritor in his will

398 Pepperrell

Notebook: [January 1737], p. 94, no. 132: "Collr. Pepperll H P. KK 9 Guines"
Subject: Probably Sir William Pepperrell (cat. no. 138)

399 Perri

Notebook: [October 1729], p. 88, no. 26: "Mrs. Perri. H.P. whole Lenth in 1/2 45–0–0"
Subject: Possibly a relation of Elizabeth Perry, who was married to Jean Paul Mascerene (cat. no. 41)

400 Phillips

Notebook: [July 1746], p. 99, no. 237: "Mrs. Philips 1/2"
Subject: Possibly Mrs. Gillam Philips (April 16, 1708–1778), born Marie Faneuil; eldest sister of Peter Faneuil; married Gillam Phillips, 1725

A portrait of Mrs. Gillam Philips was known in the 1870s and was described as follows: "Represents a pretty woman holding in her left hand a jewelled bracelet, which she has just passed around her right arm. It [the portrait] is in the possession of her great-great-grand-nephew Mr. W. Eliot Fette" (MHS, *Proc.,* vol. 16, p. 390).

401 Phillips

Notebook: [August 1744], p. 99, no. 233: "Mr. Pillips H.P. 1/2 16 Gunnies"
Subject: Probably Gillam Phillips, married to a sister of Peter Faneuil; he was in the family book business with his brother Henry

402 Portein

Notebook: [c. 1722–1723], p. 78, no. 17: "Mr. Francis Portein's Son / a Whole Length Boy 18–18–"
Subject: Possibly Samuel Portein (d. 1737), son of Francis Portein (d. 1726), who was alderman for Aldgate ward, 1724, and sheriff, 1726

403 Potter

Notebook: [July 1726], p. 83, no. 117: "Mrs. Potter O.S. 10–10–0"

404 Powese

Notebook: [1724], p. 79, no. 44: "Mr. Powese a youth 1/2 15–15–"

405 Protheroe, Capt. George

Notebook: [March 1732], p. 90, no. 59: "Capt. Protheroe H.P. 1/2 40–0–0"
Subject: Captain George Protheroe, an Englishman and captain of the *Blandford,* the ship that brought Gov. Jonathan Belcher back to Boston from England in 1732

406 Protheroe, Mrs.

Notebook: [April 1732], p. 90, no. 61: "Mrs. Protheroe H P 1/2 40–0–0"
Subject: Wife of George Protheroe (cat. no. 405)

407 Provost

Notebook: [September 1740], p. 97, no. 200: "Capn. Provost H P. KK 15 Guinnes"

408 P ?

Notebook: [c. 1722–1723], p. 78, no. 19: "Dr P⟨illeg.⟩ Proffessor of Law / at Ca[mbri]dge 3/4 7–7–"
Subject: Possibly Wharton Peck (d. 1777) of Norwich; matriculated at Cambridge, 1711, and was a fellow there, 1718–1731; chancellor of Ely, 1728–1777

409 Allan Ramsay

c. 1717–1719
Provenance: The artist; his wife, Mary Smibert; her son Williams Smibert; his cousin Thomas Moffatt; bequest to George Chalmers, Berkeley Square, London, by 1786
Notebook: Not recorded
Engraved:

1. (see figure 20) by Theodor Vercruysse (c. 1646–1723), 1721
 6 1/2 × 4 1/4
 Inscribed: "I.S.P.—T. Vercruysse S."
2. (cat. no. 409a) by George Vertue (1684–1756), 1728
 6 5/8 × 4 1/4
 Inscribed: "Allan Ramsay/ I. Smibert P.—G. Vertue S."
3. by I. Basire (d. 1758), 1731
 4 1/2 × 2 3/4
 Inscribed: "Allan Ramsay / I. Smibert.P.—I. Basire Sculp."
4. by "P.S." 1733
 5 5/8 × 3 3/4
 Inscribed: "P. S. Sculpt"

Literature: Foote 1950, pp. 207–208 ("ALLAN RAMSAY, NO. 2"); Saunders 1979, vol. 1 pp. 17–18
Subject: See cat. no. 7

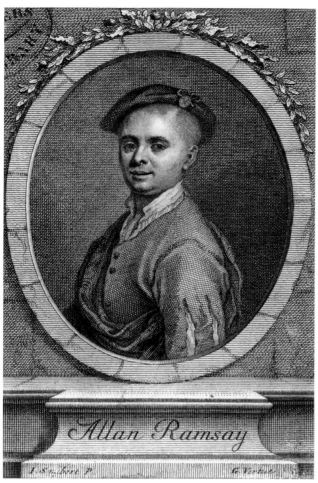

409

410 Rennold

Notebook: [1724], p. 80, no. 57: "Counseller Rennolds his child 3/4 8–8–0"
Subject: Possibly child of James Reynolds (1686–1739), of Lincoln's Inn, M.P. for Bury St. Edmunds, May 16, 1717–March 16, 1725; university counsel, Cambridge, 1718; counsel for the Prince of Wales, 1718

411 Riges

Notebook: [September 1740], p. 97, no 195: "Capn Riges K K 7 gs. 19 Guinies"

412 Roberts

Notebook: [July 1725], p. 81, no. 89: "Mr. Roberts Counclor K. C pyd"

413 Ross, Lady

Notebook: [1724], p. 79, no. 43: "My Lady Ross 3/4"
Subject: Probably the wife of William Ross (1656–1738), 12th Lord Ross of Hawkhead

414 Ryall

Notebook: [September 1739], p. 96, no. 171: "12 Guinies"
Subject: Probably the father of Isaac Royall

415 Ryalle

Notebook: [June 1739], p. 96, no. 167: "Colln. Ryall"
Subject: Probably the father of Isaac Royall

416 St. Aubyn

Notebook: [March 1727], p. 84, no. 136: "[Sir John St. Aubyn] his Lady a coppe 3/4 8–8–0"
Subject: Wife of Sir John St. Aubyn (cat. no. 18)

417 Salt

Notebook: [1724], p. 80, no. 53: "Mr. Salt 1/2"

418 Savage

Notebook: [September 1746], p. 99, no. 241: "Mr. Savage 3/4 8 Guinnis"

419 Sawbrige

Notebook: [1724], p. 79, no. 45: "Mr. Sawbrige his young son 1/2 31–10– [price includes following portrait, cat. no. 420]"

420 Sawbridge

Notebook: [1724], p. 79, no. 46: "his [Mr. Sawbridge's] young daughter 1/2 31–10– [price includes preceding portrait, cat. no. 419]"

421 Scot

Notebook: [January 1727], p. 83, no. 125: "Dr. Scot 3/4 5–5–0"

422 Scot

Notebook: [February 1727], p. 83, no. 130: "Capten Scot 3/4 7–7–"

423 Seeman, Enoch, c. 1723–1724

Notebook: Not recorded
Literature: Vertue 1930–1955, vol. 3, p. 12; Foote 1950, p. 208
Subject: Enoch Seeman; born in Danzig, 1694; brought to London at a young age by his father, a painter; the younger Seeman was a moderately successful portrait painter who followed the fashion of the day, living in St. Martin's Lane; died in London, 1744

On Vertue's list of the "Names of Living Painters of Note in London and their pictures by whom painted," he includes "Mr. Enoch Seeman . . . [by] Mr. Smybert."

424 Shirley, Governor William

Notebook: [1742], p. 97, no. 210: "Govr. Shirley—Rd. 50 3/4 8 Guinnes"
Subject: William Shirley, born at Preston, Sussex, England, December 2, 1694; son of William Shirley, a London merchant, and Elizabeth Godman Shirley; Cambridge, 1715; called to the bar; married Frances Barker of London, with whom he had nine children; after practicing law in London for eleven years he emigrated to Boston in 1731; succeeded Jonathan Belcher (cat. no. 185) in 1741 as governor of Massachusetts; served as governor, 1741–1745, again in 1753; in his first term of office he conceived the idea of the joint British-colonial attack on the French fortress of Louisbourg in 1745; died March 24, 1771[1]

NOTES

1. J[ames] T. A[dams], "Shirley, William," *DAB*, 1928–1937 (1964 ed.), vol. 9, pp. 120–122.

425 Shirley, Gov. William, 1746

Full-length
Provenance: Commissioned by a group of Boston merchants and hung in Faneuil Hall at least until 1775
Engraved: Mezzotint, by Pelham, 1747
 Stauffer 2474; Smith 35
 1 7/8 × 9 7/8
Inscribed: "His Excellency William Shirley Esqr Captain General & Governeur in Chief &c of the / Massachusetts Bay in New England, & Colonel of one of his Majesty's Regiments of Foot. / To whom this Plate (done from the original painted by Mr. J. Smibert at the request of several Merchants & / Gentlemen of Boston as a Memorial of their Grateful Acknowledgments to his Excellency for his signal services in / the Preservation of Nova Scotia from falling into the Enemy's hands in 1744 & the Reduction of the Island of Cape / Breton to the Obedience of his Majesty in 1745.) is Humbly Dedicated by his Excellency's Obedient Servt P. Pelham 1747"
Impressions: Metropolitan Museum of Art; National Portrait Gallery

Notebook: [July 1746], p. 99, no. 236: "Governer W. Shirley a W. Lenth 32 Gunnis"
Literature: Foote 1955, p. 209; Oliver 1973, p. 155, 156 rep., 158, 171–172; Saunders 1979, vol. 1, pp. 232–233; vol. 2, pl. 182; Miles 1983, pp. 53, 55, rep. fig. 126
Subject: See cat. no. 424

See figure 126

For his mezzotint Pelham reduced the format from full-length to knee-length.

426 Sinners

Notebook: [April 1727], p. 84, no. 143: "Mr. Sinners 3/4 8–8–0"

427 Slater

Notebook: [May 1740], p. 96, no. 177: "Mr. Slater H P 3/4 6 Gunnes"

428 Slater

Notebook: [May 1740], p. 96, no. 178: "Mrs. Slater H P 3/4 6 Gunnes"

429 Smethurst

Notebook: [June 1743], p. 90, no. 64: "Mrs. Smethurst H.P. 3/4 20–0–0"

430 Smith

Notebook: [September 1740], p. 97, no. 203: "Mr. W Smith H P 3/4 10 Guinnes"
Subject: Probably William Smith (October 8, 1697–November 22, 1769), son of Thomas Smith and Susanna Odell Smith; Yale, 1719; married (1) Mary, daughter of Rene Het and Blanche Du Bois Het, May 11, 1727; (2) Elizabeth Scott Williams, widow of the Rev. Elisha Williams, fourth rector of Yale; lawyer, defended Peter Zenger (1735); founder of the First Presbyterian Church in New York City

431 Sober

Notebook: [June 1740], p. 96, no. 184: "Ms. P Sober KK H.P. 15 Guines"
Subject: Possibly the daughter of John Sober, who is mentioned in James Hamilton's payment to Smibert for a number of his Philadelphia portraits (see p. 00)

432 Sparks

Notebook: [August 1725], p. 81, no. 90: "Mr. Sparks Ironmunger 3/4 8–8–0"

Subject: Probably Robert Sparke, admitted to the ironmongers guild, June 28, 1700

433 Sparks

Notebook: [December 1725], p. 82, no. 99: "Mrs. Sparks niec to Mr. Sp. 3/4 8–8–0"

Subject: Probably niece of Robert Sparke (cat. no. 432)

434 Stacey

Notebook: [June 1725], p. 81, no. 83: "Mrs. Stacey his sister 1/2 16–16–0"

Subject: Sister of Borlase Richmond Webb (cat. no. 464)

435 Stirlin

Notebook: [June 1727], p. 85, no. 152: "Mr. Stirlin and Lady and / two Children O S or 1/2 L 42–0–0 in one cloth"

436 Taitham

Notebook: [May 1728], p. 85, no. 167: "Mr. Taitham Jwnr. 1/2 16–0–0"

437 Tamesz

Notebook: [April 1727], p. 84, no. 144: "Mr. John Tamesz 1/2 15–15"

438 Taylors

Notebook: [June 1740], p. 96, no. 179: "Mrs. Taylors H P 1/2 20 Guns."

Subject: Possibly Mrs. Abraham Taylor, wife of Abraham Taylor (cat. no. 447)

439 Tewrill

Notebook: [October 1734], p. 93, no. 103: "Mrs. Tewrill H.P. 3/4 25–0–0"

Subject: Probably Jane Colman Turell (d. March 26, 1735), daughter of Rev. Benjamin Colman (cat. no. 229); married Rev. Ebenezer Turell (cat. no. 104), August 11, 1726

440 Thomson, Stephen

Notebook: [c. 1722–1723], p. 78, no. 1: "Mr Steph: Thomson 3/4 6–6–"

441 Thornhill, Sir Robert

Notebook: [December 1728], p. 85, no. 159: "Sr. Robert Thornhill a Copi 1/2 15–12–0"

Subject: Possibly a posthumous portrait of either (1) Sir Robert Thornhill (d. 1726) or (2) his father, Sir Robert Thornhill (1686–1715), who attended Cambridge and was knighted, April 9, 1715

442 Thornhill

Notebook: [June 1727], p. 84, no. 150: "Mrs. Thornhill 1/2 16–16–0"

443 Thornhill

Notebook: [June 1727], p. 84, no. 151: "Mis Thornhill 1/2 16–16–0"

444 Thornhill

Notebook: [December 1727], p. 85, no. 158: "Mr. Thornhill 1/2 16–16–0"

445 Till, Mary

Notebook: [July 1740], p. 97, no. 191: "Ms. M. Till H P 1/2 20 Gunies"

Subject: Mary Till, daughter of William Till; married Andrew Hamilton, Jr. (cat. no. 314), December 24, 1741

446 Turell, Samuel

Notebook: [July 1736], p. 94, no. 124: "Mr. Turrell Sigr. HP 3/4 6 Guinies"

Subject: Capt. Samuel Turell, husband of Lydia Stoddard Turell and father of Rev. Ebenezer Turell (cat. no. 104); "The Captain was a mariner who was gradually accumulating property and acquiring the status of a merchant. He held minor town offices and was a member of a Mather church where little Ebenezer was baptized when three days old" (Sibley and Shipton 1873–1956, vol. 6, p. 574)

447 Tylors

Notebook: [June 1740], p. 96, no. 180: "Mr. Tylors H-P 1/2 20 Guns."
Subject: Possibly Abraham Taylor (1703–1772)

448 Tylors

Notebook: [June 1740], p. 96, no. 181: "His son [Mr. Tylors son] H.P 1/2 20 Guns."
Subject: Possibly John Taylor (b. 1735), painter; son of Abraham Taylor (cat. no. 447)[1]

NOTES

1. Arthur S. Marks, "An Eighteenth-Century American Landscape Painter Rediscovered: John Taylor of Bath," *American Art Journal*, 1978, pp. 81–83.

449 Unidentified Man

29 1/2 × 24 1/2 in
Provenance: Purchased in New England by the antiques dealer Joe Kindig, Jr., York, Pa.; purchased by Dr. Fiske Kimball, Lemon Hill, Pairmount Park, Philadelphia, 1926
Literature: Foote 1950, p. 194

Attributed to Smibert by the owner and William Sawitsky. A photograph of the portrait was examined by Foote and the attribution to Smibert accepted. However, as no photograph of this portrait is now known, the attribution to Smibert cannot be verified.

450 Upton

Notebook: [August 1726], p. 94, no. 125: "Mrs. Upton 3/4 6 Guines"

451 Vassall, William

Notebook: [January 1744], p. 98, no. 227: "Mr. W. Wassell 1/2 16 guinnes"
Subject: William Vassall (November 23, 1715–May 8, 1800) "lived all his life on the proceeds of his Jamaica plantations without engaging in any business or profession" (Sibley and Shipton 1873–1956, vol. 9, p. 351); lived on Sumner Street opposite Trinity Church, in which he was active; married Ann Davis (d. 1760)

Jones 1930, p. 285, reports, "[Vassall's] will discloses the fact that he bequeathed portraits of himself and his first wife, Ann Davis, of his daughter, Sarah, of his deceased son, William, and of his eldest surviving son, William, all drawn by Smibert, to the latter son, William.

452 Vassall, William

Notebook: [January 1744], p. 98, no. 228: "Mr. W. Wassell's son Will 1/2"
Subject: Son of William Vassall (cat. no. 451)

453 The Virtuosi of London

c. 1724
"a whole length," approximately 50 × 100 in
Notebook: Not recorded
Literature: Vertue 1930–1955, vol. 3, p. 24; Foote 1950, p. 208; Saunders 1979, vol. 1, pp. 65–67

See page 44

454 Wainwright

Notebook: [February 1730], p. 89, no. 32: "Mrs. Wainwright HP 3/4"
Subject: Possibly Mary Dudley Wainwright (1692–1774), twelfth daughter of Gov. Joseph Dudley; sister of William Dudley (cat. no. 49); married (1) Francis Wainwright (Harvard, 1707; d. 1722), a Boston merchant; (2) Captain Joseph Atkins, of the British Navy, April 1730

According to Sibley and Shipton 1873–1956, vol. 5, p. 406, "a portrait of her was some years ago in the possession of Mrs. Mary Russell Curzon of Curzon Mill, Newburyport."

455 Waldo, Brigadier General Samuel

1747
Notebook: Not recorded
Literature: Foote 1950, pp. 95–96; Sadik 1966, p. 58
Subject: Samuel Waldo (1694–1771), wealthy merchant and proprietor of a large grant of land on the Penobscot River in Maine; second in command to Sir William Pepperrell (cat. no. 138) at the siege of Louisbourg; Smibert painted a portrait of his sister, Mrs. Edward Tyng (Anne Waldo), in 1733 (cat. no. 86)

According to a diary of Edward Waldo, examined by Virginia Robie in 1914, Smibert painted a portrait of Samuel Waldo in 1747. According to Robie's account, Edward Waldo described a visit to Smibert's studio as follows: "Spent the morning with my illustrious cousin Samuel who is having his Likeness made by the renowned Mr. Smybert. It promises to reflect great Honour on Both though prodigious deare at the Price. I was favorably impressed by Mr. S. whose Ingenuity is equalled by his Industry and surpassed by his Deportment."
After the diary, which was owned by a Waldo descendant (Edward Waldo Pendleton, Bloomfield Hills, Michigan) was examined by Robie, it was entrusted to a restorer for conservation. Unfortunately, the result was the complete disintegration of the diary, and Robie's account is the only

information on its contents. Robie also noted: "An important part of the diary relates to Smibert's comments on his Waldo patrons, including the youthful Joseph, the gracious Anne Tyng, sister of the General, and the great Samuel himself who proved a difficult subject. Being painted, to this man of action, was evidently a greater strain than battle and siege, and all his real estate trials in Maine and elsewhere. From time to time he would lose the pose and pace the floor to the great perplexity of the artist."

Robie also reported that Smibert painted portraits of other members of the Waldo family: Mr. and Mrs. Edward Waldo, Sr.; Mr. and Mrs. Edward Waldo, Jr.; and Joseph Waldo (see Foote 1950, pp. 209–211); and that some of these portraits were painted at the Waldo home in Windham, Conn., when Smibert visited there. None of these portraits survives, however, nor is any of them recorded in the notebook. Until some other documentary evidence, or one or more of the portraits themselves, comes to light, these attributions cannot be verified.

456 Walpole, Sir Robert

Notebook: [February 1726], p. 83, no. 103: "Sr. Robert Walpole a Coppie 3/4"
Subject: Robert Walpole (1676–1745), statesman and Whig leader; M.P., 1701–1742; first lord of the treasury and chancellor of the exchequer, 1715–1717, 1721–1742; defeated in House of Commons and retired to his family home, Houghton, 1742

457 Walpole

Notebook: [February 1726], p. 82, no. 104: "2 heads in littel for [Sir Robert Walpole] 4–4–0"

458 Wanton, Gideon

Notebook: Not recorded
Literature: Foote 1950, p. 211
Subject: Gideon Wanton, governor of Rhode Island, 1745–1746 and 1747–1748

Alan Burroughs at one point had in his possession a photograph of Gideon Wanton that he believed might be by Smibert for Feke. Foote never saw the photograph, and as neither the portrait nor the photograph of it are now known, the attribution to Smibert cannot be verified.

459 Ward

Notebook: [June 1725], p. 81, no. 81: "young Mr. Ward of Hakney 1/2 16–16–0"
Subject: Possibly the son of John Ward (d. 1755), M.P. from Hackney

460 Warren

Notebook: [June 1738], p. 95, no. 154: "Ms. Warren 1/2 12 Guinias"

461 Warren

Notebook: [May 1739], p. 95, no. 165: "Mrs. Warren KK 9 Guinies"
Subject: Possibly Susannah De Lancey Warren, wife of Sir Peter Warren (cat. no. 137)

462 Wassell

Notebook: [January 1744], p. 98, no. 226: "Mr. Wassells Daughter 1/2 16 Guinnes"
Subject: Probably Sarah Vassall (b. 1739), daughter of William Vassall (cat. no. 451)

463 Wassell

Notebook: [December 1743], p. 98, no. 224: "Mrs. Wassell Bills 30 st. 1/2 16 Gunnes"
Subject: Probably Ann Davis Vassall (d. 1760), wife of William Vassall (cat. no. 451)

464 Weeb

Notebook: [June 1725], p. 81, no. 82: "Weeb Esqr. son to the Generall 1/2 16–16–0"
Subject: Probably Borlase Richmond Webb (c. 1696–1738) of Biddeston, Ludgershare, Wiltshire; second son of Gen. John Richmond Webb (d. 1724); his elder brother was excluded from their father's will

465 Weeb

Notebook: [August 1725], p. 81, no. 91: "Mr. Weeb a Coppie 3/4"
Subject: Probably a replica of cat. no. 464

466 Wells

Notebook: [January 1734], p. 92, no. 85: "Mrs. Wells H.P. KK 37–10–0"
Subject: Possibly the wife of cat. no. 467

467 Wells

Notebook: [March 1734], p. 92, no. 87: "Capn. Wells HP. K.K. 37–10–0"
Subject: Possibly Samuel Welles, justice of the peace for the town of Boston, 1726–?; member of Old South Church and an acquaintance of Nathaniel Williams (cat. no. 475)

468 Whiteker

Notebook: [September 1740], p. 97, no. 196: "Mrs. Whiteker 3/4 10 Guinnes"

469 Whiteker

Notebook: [September 1740], p. 97, no. 197: "Mr. Whiteker 3/4 10 Guinnes"

470 Wickhom, Reverend Henry

Notebook: [1724], p. 80, no. 61: "Mr. Henrey Wickhom Clergeman 3/4 8–8–0"
Subject: Henry Wickhom (d. 1772); son of Henry Wickhom of York and grandson of Tobias Wickhom, Dean of York; admitted to Queens' College, Cambridge, in 1717; rector of Guiseley York, 1724–1772

471 Willard, Eunice

Notebook: [September 1729], p. 88, no. 14: "Ms. Ewnice Willard HP 3/4 20–0–0"
Subject: Eunice Willard (June 16, 1695–July 26, 1751), daughter of Samuel Willard (1639/40–1707), pastor of Old South Church (1678–) and vice-president of Harvard College, and Eunice Willard; never married; lived with her brother Josiah Willard (b. 1681), who for many years was secretary of Massachusetts Bay Province

472 Williams, Anne

Notebook: [July 1729], p. 88, no. 10: "Mis. Anne Williams H.,P 3/4 20–0–0"
Subject: Anne Williams, sister of Mary Williams (cat. no. 44), wife of John Smibert; married Belcher Noyes (1709–1785, Harvard, 1727), gentleman and professional speculator in frontier lands, nephew of Jonathan Belcher (cat. no. 185), 1726

473 Williams, Anne Bradstreet

Notebook: [September 1729], p. 88, no. 15: "Mrs. Williams HP 3/4 20–0–0"
Subject: Anne Bradstreet Williams, wife of Nathaniel Williams (cat. no. 475); mother of Anne Williams (cat. no. 472) and Mary Williams (cat. no. 44), wife of John Smibert

474 Williams, Elisha

Notebook: [September 1736], p. 94, no. 129: "The Rd. President Williams 3/4"
Literature: Franklin Bowditch Dexter, ed., *The Literary Diary of*

Ezra Stiles, D.D., LL.D., President of Yale College (New York, 1901), vol. 3, p. 558; Foote 1950, p. 212
Copy: By Reuben Moulthrop (1763–1814), painted in 1795 and now owned by Yale University. The copy is signed in lower right corner, "R. Moulthrop, pinxit," and inscribed in the lower left corner, "Rev. et Hon. Elisaus Williams, Rector Coll. Yale, ob. July 25, 1755, Aet 61"
Subject: Elisha Williams (1694–1755), son of Rev. William Williams of Hatfield, Mass., and his first wife, Elizabeth Cotton; Harvard, 1711; married Eunice Chester, daughter of Thomas Chester and Mary Treat Chester, February 23, 1714; rector of Yale College, 1726–1739

Williams's portrait was painted in Boston during his visit there.[1] His portrait is recorded in Stiles' diary (558) as follows: "Jan. 20 (1795) . . . Received Rector Williams's Picture by Smibert, taken about 1736 while he was Rector of Yale Coll. He died 1755, aet, 61 cir." To this entry was added the following footnote: "The picture now belonging to the College is a copy by Moulthrop; the original, which still remains in the family was sent for the purpose of having this copy made."

NOTES

1. Jonathan Belcher to Captain Whiting, October 5, 1736, Belcher Letterbooks, Massachusetts Historical Society.

475 Williams, Nathaniel

Notebook: [September 1729], p. 88, no. 20: "Dr. Williams HP. 3/4 20–0–0"
Subject: Nathaniel Williams (August 25, 1675–January 10, 1738/9), schoolmaster, missionary, and physician; John Smibert's father-in-law; son of Deacon Nathaniel Williams and his second wife, Mary Oliver Shrimpton; master of Boston Latin School, 1703–1733; member of Old South Church, where he occasionally preached; chosen rector of Yale College, 1723, but declined; purchased his father's former residence on the east side of Court Street, 1733; married Anne Bradstreet in Barbados, c. 1698–1700/1, where he had gone as a missionary

476 Witherden

Notebook: [1724], p. 79, no. 35: "Mr. Witherden 1/2 10–10–0"

477 Wollaston, John

Notebook: [March 1725], p. 80, no. 69: "J. Woollaston Esqr. 1/2 29–8–0"
Subject: Possibly John Wollaston who attended Wadham College, Oxford, March 24, 1707. He was the son and heir of Richard Wollaston of Wormley Hertfordshire. He was called to the Middle Temple, May 15, 1713

478 Wollaston

Notebook: [March 1725], p. 80, no. 70: "[J. Woollaston] his Sister a
Kit-Cat 29–8–0"

479 Woodcock, James

Notebook: [August 1738], p. 95, no. 156: "Mr. James Woodcock
1/2 12 Guines"

The receipt for this painting is included in the Hancock
Papers (TH–1), New England Historic Genealogical Soci-
ety, Boston: "Boston Decr 1738 / James Woodcock Dr to
John Smibert / for his picture 12.12 Sterling 63. / a frame
13.14.10 / a case 18 / .. 14.12.10 77.12.10"

E. Misattributed Works and Fakes

This section of the catalogue considers works mis-
takenly attributed in print to Smibert. Works that
have unsubstantiated verbal attributions and are sty-
listically uncharacteristic of Smibert are excluded.

A number of portraits with forged signatures and
fabricated provenances appeared on the New York
art market between 1917 and 1930. Most of these
originated with Mr. and Mrs. Robert M. deForest,
little-known New York art dealers, and then were
passed on to dealers with established reputations like
Frank W. Bayley of the Copley Gallery, Boston. These
paintings are discussed in my essay, "The Eighteenth
Century Portrait in American Culture of the Nine-
teenth and Twentieth Centuries," in *The Portrait in
Eighteenth Century America* (Newark, Del.: University
of Delaware Press, 1993).

480 Dean George Berkeley (?)

Present location unknown
Provenance: Said to have been bought at George Berkeley's home,
 Whitehall; E. R. Lemon, Sudbury, Mass.; purchased by Frank
 Bulkley Smith, 1917; sold at auction by American Art Associa-
 tion, New York, 1920; purchased by "Seaman," acting as agent,
 for $650
Literature: Foote 1950, p. 238

Charles Henry Hart examined this portrait and accepted
it as by Smibert: "Doubtless a contemporaneous replica of
the canvas in the Worcester Art Museum, which is signed
and dated Jo. Smibert, fc., 1728. It is an extremely good
example of Smibert at his best, and particularly interesting
from the close relations that existed between the subject
and the painter." In this instance, however, Hart's opinion

is valueless as he was part owner of the portrait acquired by
Worcester, and the signature turned out to have been
forged. Foote rejected the Smibert attribution. The paint-
ing is not characteristic of Smibert.

A photograph of this portrait is in the Frick Art Refer-
ence Library.

481 Richard Checkley

Essex Institute
Literature: Foote 1950, p. 215
Subject: Richard Checkley (1694–1742)

As Foote concluded, this portrait dates from an earlier
period than Smibert's.

482 William and Samuel Clark

Museum of Art, Rhode Island School of Design
36 1/2 × 49 1/2
Provenance: Henry Warren, 1923; purchased by the Rhode Island
 School of Design
Literature: Bayley 1929, p. 369; Foote 1950, pp. 216–217; Patricia
 Mandel, "American Paintings at the Museum of Art, Rhode
 Island School of Design," *Antiques*, vol. 110 (November 1976),
 p. 973 rep.
Subjects: William Clark (b. February 23, 1739) and Samuel Clark
 (b. October 16, 1744) sons of William Clark and Sybil Adams
 Clark, of Boston

This appears to be an English portrait, c. 1725. Neither
the wide range of colors nor the brushwork is character-
istic of Smibert. The identification of the subjects is er-
roneous.

483 Mr. and Mrs. Alured Clarke

Commander and Mrs. Hugh Heaton, Rhual, Flintshire, Wales,
 1943
Literature: *Country Life*, vol. 93 (June 25, 1943), 1147 rep.

This appears to be an English portrait, c. 1740–1750. It
is not characteristic of Smibert's work.

484 Mrs. Jethro Coffin

Nantucket Historical Association
30 × 24
Literature: Foote 1950, p. 216; Louisa Dresser, "Portraits in Bos-
 ton, 1630–1720," *Journal of the Archives of American Art*, vol. 6,
 no. 3–4 (July–October 1966), pp. 32–33 rep
Subject: Mary Gardner (1670–1767), wife of Jethro Coffin of
 Nantucket

The painting was probably done c. 1710–1717 and
seems similar to the work of the Pollard Limner.

485 Reverend Andrew Croswell

Society for the Preservation of New England Antiquities
29 3/4 × 25
Provenance: Gift of Anna Crowsell, 1936
Literature: Sibley and Shipton 1873–1956, vol. 8, opp. p. 386 rep.

The work is not characteristic of Smibert and seems closer in style to that of Joseph Badger.

486 Nathaniel Cunningham

Present location unknown
Literature: Bayley 1929, p. 373 rep.; Foote 1950, p. 217

As Foote concluded, this appears to be the work of Joseph Badger.

487 Mrs. Jonathan Edwards, Jr. (?)

Present location unknown
Literature: Bayley 1929, p. 381 rep.

This appears to be an eighteenth-century portrait of British or Irish origin.

488 Daniel Farnham

Present location unknown
Provenance: Armitage Whitman
Literature: Sibley and Shipton 1873–1956, vol. 10, pp. 364–366 rep.
Subject: Daniel Farnham (1719–1776), lawyer; Harvard, 1739

This portrait dates from later than the period Smibert painted and appears close to the work of Joseph Badger.

489 The Fall of Icarus (Fisherman and Boat)

Bowdoin College Museum of Art, Brunswick, Me.
Pen and wash on paper
10 1/2 × 8
Inscription: In ink on the back of the mount, "John Smibert," below which is written "13."
Provenance: Bequest of James Bowdoin III to Bowdoin College, 1811
Literature: Bowdoin 1885, p. 30; Frank Jewett Mather, Jr., "Drawings by Old Masters at Bowdoin College Ascribed to the Northern Schools," *Art in America,* vol. 2, no. 11 (February 1914), p. 116; Bowdoin 1930; Foote 1950, p. 232; Sadik 1966, p. 217; David P. Becker, *Old Master Drawings at Bowdoin College* (Brunswick, Me., 1985), pp. 227–228, where the subject is identified as the fall of Icarus

This drawing may be Italian, c. 1600, and is definitely not by Smibert. As Foote concluded, it was probably acquired from Smibert's studio at the time its contents were dispersed. It may well have been one of the drawings Smibert brought with him to America or acquired later for sale in the color shop.

490 James Flagg

Private collection
17 × 13 (oval)
Provenance: By descent to Benjamin Gould; Benjamin Apthorp Gould I; Benjamin Apthorp Gould II; Mary Quincy Gould (Mrs. Albert Thorndike); her daughter Miss Rosanna D. Thorndike, Boston, by 1948; Vose Galleries, Boston, 1981; private collection, 1981
Literature: Foote 1950, pp. 154–156; Alan Burroughs, "Two Portraits of Children by Feke," *Art in America,* vol. 39 (February 1951), pp. 3–5 (attributed to Feke)
Subject: James Flagg (1739–1775), son of Gershom Flagg IV of Boston

At one point this portrait had a label on the back written by Benjamin Apthorp Gould II, which read, "James Flagg, a son of Gershom Flagg, painted by John Smibert, an artist who died in 1751." The portrait, however, is stylistically unlike Smibert's known portraits of children. It appears to be by Robert Feke, who painted portraits of his parents, Mr. and Mrs. Gershom Flagg IV (Wadsworth Atheneum, Hartford, Conn.).

491 Hannah Flagg

Private collection
17 × 13 (oval)
Provenance: See cat. no. 490
Literature: Foote 1950, pp. 154–156; Alan Burroughs, "Two Portraits of Children by Feke," *Art in America,* vol. 39 (February 1951), pp. 3–5 (attributed to Feke)
Subject: Hannah Flagg, born 1741; daughter of Gershom Flagg IV of Boston

This portrait, like that of James Flagg (cat. no. 490), appears to be by Robert Feke.

492 Portrait Caricature of a Man (Grand Duke Cosimo III)

Bowdoin College Museum of Art, Brunswick, Me.
Black and white chalk on brown paper
6 7/8 × 5 1/4 (164 × 134 mm)

Inscription: In ink, "Cosmo the 3ᵈ—Grand Duke of Tuscany, from the life, by John Smibert"

Provenance: Bequest of James Bowdoin III to Bowdoin College, 1811.54

Literature: Bowdoin 1885, p. 29; Frank Jewett Mather, Jr., "Drawings by Old Masters at Bowdoin College Ascribed to the Northern Schools," *Art in America,* vol. 2, no. 11 (February 1914), p. 116; Lee 1930, p. 119 rep.; Bowdoin 1930, no. 73; Hagen 1940, pp. 50–51; Foote 1950, pp. 232–233; Sadik 1966, p. 216; Chappell 1982, pp. 134–135, rep. fig. 2; David P. Becker, *Old Master Drawings at Bowdoin College* (Brunswick, Me.), 1985, pp. 228–229

See figure 22

This caricature probably dates from the seventeenth century and is Italian in origin. As Foote concluded, it was probably acquired from Smibert's studio at the time its contents were dispersed. It may well have been one of the drawings Smibert brought with him to America or acquired later for sale in the color shop. As Becker noted, Chappell ventured the tantalizing identification of the subject with Antonio Magliabecchi (1633–1714), the Florentine scholar and librarian to the Medici.

493 Dame Elizabeth Frey

S. D. Thomas, Four Winds, Rushy Lane, Risley, Derbyshire

30 × 24

Provenance: The painting has hung in the Latin School at Risley for a number of years

Literature: *Country Life,* vol. 161 (March 10, 1977), p. 570

Subject: Elizabeth Frey (d. 1721), daughter of Anchitel Grey and granddaughter of Sir Henry Willoughby

The attribution to Smibert is unfounded. The work appears to be by an unidentified English artist, c. 1715.

494 Head of a Cherub

Childs Gallery, Boston

19 × 26 3/4

Inscription: On back, "Presented to the Rev. D. A. Haskins by Mrs. R. H. Gore, April—Gardiner, Mass (Me. Maine?) 1897 / Cherub by Smybert From Old Master / Trinity Church Boston"

Literature: Norton 1979, pp. 82–83 rep.; Saunders 1979, vol. 1, p. 205n43; Childs Gallery, *Painting Annual,* 1980, p. 10 rep.

This cherub head and two others owned by Trinity Church, Boston, were attributed to Smibert in the nineteenth century. Those owned by Trinity Church were inscribed by Phillips Brooks in 1887, "they were done by Smybert." Norton established that they are the work of John Gibbs, Jr., of Boston.

495 Reverend William Hooper

Study Collection, National Portrait Gallery Washington

Brown ink, over pencil, on paper

Inscription: At the bottom in block lettering, "The Revᵈ. William Hooper.———"; on the line below in script "taken by Mʳ. Smibert———"

Provenance: Discovered in the manuscript collection of G. Brown Goode (1851–1896) in the Smithsonian Institution, with no prior history

Subject: William Hooper (1702–1767), first minister of Boston's West Church, which Smibert joined in 1737Smibert; like Smibert, he was active in the Scots Charitable Society, and he baptized three of Smibert's children

The drawing is probably a nineteenth-century fake. The paper appears to have a watermark (only ten percent of it is visible) that was used by the London firm J. Whatman, which would place its manufacture after Smibert's death.

496 Sir Charles Knowles, Bt

Portsmouth Atheneum

Literature: Bayley 1929, p. 399; Foote 1950, p. 218

Subject: Knowles was a British naval officer at Louisbourg.

The attribution of this portrait to Smibert, as concluded by Foote, is mistaken. It appears to be by an unidentified British or American artist, c.1750–1760.

497 Sir Thomas Longueville, Bt, and His Family

Present location unknown

75 3/4 × 99 1/2

Provenance: Painted for the Longueville family and by descent to present owner, Peter Longueville, 1978

Literature: Christie's, London, 3–17–78, lot 120 (attributed to Smibert), b.i.; Christie's, London, 7–24–80, lot 120 (attributed to Smibert)

Sir Ellis Waterhouse examined the painting at the time it was auctioned and discovered that it is signed with the initials of Pieter Van Bleeck (1697–1764), an artist born at the Hague who was active in London by 1723.

498 Benjamin Lynde, Jr., c. 1752–1756

Frederick S. Moseley III

29 1/2 × 24 3/4

Provenance: Granddaughter of subject, Mary Lynde (Mrs. Andrew Oliver); Dr. Fitch E. Oliver, 1867; purchased from the widow of Dr. Fitch E. Oliver by Frederick Moseley, Boston, c. 1910; Mrs. Frederick S. Moseley; Mr. Frederick S. Moseley III

Literature: Winsor 1880–1881, vol. 2, p. 558; *The Diaries of Benjamin Lynde* (Boston, 1880), p. xx; Sibley and Shipton 1873–1956, vol. 6, opp. p. 250 rep.; Burroughs 1943b; Foote 1950, pp. 219–220.

Copies: 1. In *The Diaries of Benjamin Lynde* it is stated a copy was owned by Samuel H. Russell, Boston. 2. Mrs. Fitch E. Oliver had a copy of this portrait made in 1910 when she sold the original to Mr. Moseley

Subject: Benjamin Lynde, Jr. (1700–1781), son of Judge Benjamin Lynde (cat. no. 121)

This portrait appears to be the work of Nathaniel Smibert.

499 Reverend Timothy Minot

Mrs. Stedman Buttrick, Sr., Concord, Mass.
39 × 34 1/2
Provenance: Descent in the Minot family to the Brooks family; Mary Brooks (Mrs. Stedman Buttrick, Sr.)
Literature: Sibley and Shipton 1873–1956, vol. 6, p. 258 rep.; Foote 1950, pp. 170–171; Mooz 1970a, pp, 106, 159; R. Peter Mooz, "Hannah and Gershom Flagg," *Bulletin* (Wadsworth Atheneum), 6th ser., vol. 8, no. 1–3 (Spring and Fall 1972), pp. 65, 73 rep.; Peter Benes, *Two Towns: Concord and Wethersfield* (Concord, Mass., 1982), pp. 16–17, no. 17
Subject: Timothy Minot (1692–1776), born in Concord; Harvard, 1718; taught school in Concord for more than forty years; preached as a supply in Concord and elsewhere

This portrait appears to be the work of Robert Feke.

500 Mrs. Timothy Minot

Mrs. Stedman Buttrick, Sr., Concord, Mass.
39 × 24 1/4
Provenance: See cat. no. 499
Literature: Foote 1950, pp. 171–172; Mooz 1970a, pp. 106, 159; R. Peter Mooz, "Hannah and Gershom Flagg," *Bulletin* (Wadsworth Atheneum), 6th ser., vol. 8, no. 1–3 (Spring and Fall 1972), pp. 65, 73 rep.; Peter Benes, *Two Towns: Concord and Wethersfield* (Concord, Mass., 1982), pp. 16–17, no. 18
Subject: Wife of Rev. Timothy Minot (cat. no. 499)

In spite of some overpaint and restoration, this portrait appears to be the work of Robert Feke.

501 The Parting of Hector and Andromache, c. 1750

Museum of Fine Arts, Boston, 64.2053
49 1/4 × 39 1/2
Provenance: Eliza W. Fuller and Mary F. Storer Cobb, descendants of Smibert's in-laws, the Williamses, Cambridge; Mrs. Genevieve

M. Fuller, Milton, Mass.; her son Henry M. Fuller, Milton, Mass., and her niece Mrs. R. G. Fuller; deposited on loan at Museum of Fine Arts, Boston, 1921

Literature: Virgil Barker, *American Painting* (New York, 1950), p. 174; Foote 1950, pp. 109, 231; Boston 1969, vol. 1, no. 883 (attributed to Smibert); vol. 2, fig. 5

Foote noted that "on the back [the painting] bears a label, alleging it to be the work of Smibert," but the label is no longer there. The painting, which may well have come from Smibert's studio, seems to be the work of at least two hands. The two figures on the left appear to have been painted by Nathaniel Smibert.

502 Design for a Circular Dish

Bowdoin College Museum of Art, Brunswick, Me.
Pen and brown ink with brown wash
Diameter 6 1/4 (159 mm)
Inscription: In pencil, by an unknown hand "John Smibeth [*sic*]"
Provenance: Bequest of James Bowdoin III to Bowdoin College, 1811.56
Literature: Bowdoin 1885, p. 30; Frank Jewett Mather, Jr., "Drawings by Old Masters at Bowdoin College Ascribed to the Northern Schools," *Art in America*, vol. 2, no. 11 (February 1914), p. 116; Bowdoin 1930, no. 75; Foote 1950, p. 232; Sadik 1966, pp. 216–217

The drawing, as described by Sadik, depicts "soldiers leading sheep and cattle into a town and mules with provisions on their backs out of it into a military encampment with tents, with a battle scene in the background." Most scholars who have examined the drawing believe that it dates from the sixteenth century and is Northern European in origin. Becker suggests it is German (from Nuremberg) and dates from the mid-sixteenth century. Foote concluded that this drawing was probably acquired from Smibert's studio at the time the contents were dispersed, and this seems quite plausible. It may well have been one of the drawings Smibert brought with him to America for his own study or acquired later for sale in the color shop.

503 Reverend Edward Payson

Mr. William M. V. Kingsland, New York
30 × 25
Provenance: The subject; his nephew Rev. Phillips Payson; his son Phillips Payson; his son Samuel Payson, until his death in 1860; purchased from the estate of Samuel Payson by Mr. Harold Fletcher; his sister Elizabeth Fletcher; M. L. Walker, Brighton, Mass., 1926; William M. V. Kingsland, New York, by 1979
Literature: Foote 1950, pp. 206–207
Subject: Edward Payson, born in Roxbury, Mass., June 20, 1657; son of Edward Payson and Mary Eliot Payson; Harvard, 1677;

ordained, 1682, as colleague of Rev. Samuel Phillips of Rowley, whose daughter Elizabeth he married in 1683; seventeen children; after her death in 1724 he married Elizabeth, widow of Samuel Appleton of Ipswich; died August 22, 1732

This portrait and that of Rev. George Phillips (cat. no. 506), Edward Payson's brother-in-law, are virtually identical. They both appear to have been made c. 1725–1735 but are painted too mechanically to be by Smibert. They may be by an as yet unidentified artist, for they do not seem to be by any of Smibert's known contemporaries.

504 Col. William Pepperrell

Present location unknown
30 × 23
Provenance: The subject's daughter Dorothy Pepperrell Prescott; her great-great-granddaughter Millicent Jarvis, Jamaica Plain, Mass., by 1894; Adm. Reginald R. Belknap, Newport, R.I., by 1949
Literature: Bolton 1919–1926, vol. 2, p. 437 rep.; Boston 1930, p. 69 rep.; Foote 1950, p. 220
Subject: William Pepperrell (1646–1734), father of Sir William Pepperrell (cat. no. 138); Boston merchant; justice of the peace, 1690–1725; judge of the Court of Common Pleas of the Province of Massachusetts Bay, 1694–1702, 1708–1720; and lieutenant colonel of the militia

The portrait, as recognized by Foote, was probably painted c. 1705–1715, well before Smibert's arrival in Boston.

505 Sir William Pepperrell, Bt, 1750

Mrs. Arthur L. Shipman
49 3/4 × 39 3/4
Signature: l.r. "George Allen fecit 1750"
Provenance: Descent in Pepperrell family to 1815; given to a member of the Sheafe family; loan to the Portsmouth Atheneum, 1815; great-great-granddaughter of Sir William Pepperrel, Mary Pepperrell Sparhawk Jarvis (Mrs. Hampden Cutts), 1864; her daughter Mrs. Underhill A. Budd; Kenneth P. Budd, New York; Mrs. Kenneth P. Budd, New York, by 1949; Mrs. Arthur Shipman, Hartford, Conn.
Literature: Metropolitan Museum of Art, Catalog, Exhibition of Colonial Portraits (New York, 1911), p. 62 rep.; Foote 1950, p. 180; Miles 1983, p. 66n
Copy: A copy was owned in 1949 by Mrs. Everett Pepperrell Wheeler, New York; this or a second copy, painted by H. D. Pratt, is now owned by the Maine Arts Commission, Augusta (illustrated in Neil Rolde, "The William Pepperrell Mansion," Down East, vol. 22, no. 8 [May 1976], p. 43)
Subject: Sir William Pepperrell (see cat. no. 138)

Foote believed that this portrait was by Smibert, yet a recent cleaning of it led to the discovery of the signature of George Allen, an otherwise unknown artist.

506 Rev. George Phillips

New-York Historical Society, 1950.238
30 1/8 × 25 1/4
Provenance: The subject; his son George Phillips (1698–1771), Smithtown, N.Y.; his son Samuel Phillips (1728–1806); his son Samuel Phillips; his son George Smith Phillips (d. 1881) of Smithtown, N.Y.; William Roe, Newburgh, N.Y., c. 1856); his great-grandson William J. Roe, Newburgh, N.Y., by 1942; Waldron Phoenix Belknap, Jr., Boston, 1942; bequest of Waldron Phoenix Belknap, Jr., to the New-York Historical Society, 1950
Literature: Foote 1950, pp. 181–183; Belknap 1959, p. 214; NYHS 1974, vol. 2, pp. 621–622.
Copies: 1. A nineteenth-century copy in oils was owned in 1949 by Charles Francis Brush, Woodbridge, Conn. 2. Painted by Miss Katherine Janeway for the late E. Hicks Herrick (photograph at New-York Historical Society)
Subject: George Phillips; born June 3, 1664; son of Rev. Samuel Phillips and Sarah Appleton Phillips of Rowley, Mass.; Harvard, 1686; preached at Suffield, Conn., 1690–1692, and Jamaica, N.Y., 1693–1697, before settling in Setauket, N.Y., 1697; married Sarah, daughter of William Hallett, Jr., c. 1697; died 1739

A portrait of the sitter is mentioned in his will dated January 18, 1736/37. Around 1942 William J. Roe, the owner of the portrait, stated that it had been acquired by his grandfather, William Roe "in about the year 1856 and was painted by John Smybert about 1730." The portrait, like that of Phillips's brother-in-law, Rev. Edward Payson (cat. no. 503), however, appears too mechanical to have been painted by Smibert. It may be by an as yet unidentified artist, for it does not seem to be by any of Smibert's known contemporaries.

507 John Pitts

Detroit Institute of Arts
35 1/4 × 27
Provenance: By descent to Lendall Pitts; Mrs. Lendall Pitts; Detroit Institute of Arts, 1958
Literature: Daniel Goodwin, Jr., The Dearborns: A Discourse Commemorative of the 80th Anniversary of the Occupation of Fort Dearborn (Chicago, 1884), rep. in reverse; Foote 1950, p. 183; Detroit Institute of Arts, Eight Generations of the Pitts Family, exh. cat. (Detroit, 1959), pp. 18–19
Subject: John Pitts, born in England, 1668; settled in Boston, 1694; died 1731

Although Foote considered the portrait to be by Smibert, it is clearly much more similar to the work of Joseph Badger. The subject has been misidentified and may well be John Pitts's son, James Pitts (b. 1710), whose wife was painted by Smibert (cat. no. 106).

508 Portrait of a Boy, formerly **John Taylor**

Milwaukee Art Museum
50 1/8 × 40 1/8
Inscription: lower right, "Smibert 1743"
Provenance: G. Bodmer, Bexhill, England, 1913; at Christie's, London, 1913, not brought up for auction; Ehrich Galleries, New York, 1921; purchased by the Sears Academy of Fine Arts, Elgin, Ill., 1922; Michael Hatcher, Milwaukee, 1972–1976; purchased by the Woman's Club of Wisconsin as a gift to the Milwaukee Art Center (now the Milwaukee Art Museum), 1976.
Literature: Foote 1950, p. 245 (as not by Smibert)

The painting has two labels on the back, which read "John Taylor, Esq. grandfather of Dr. Taylor Gordon" and "This picture was presented as a gift to Gordon Stonehouse Hughes by his grandfather, Dr. Taylor Gordon." The portrait appears to be an eighteenth-century painting of British or Irish origin to which a forged Smibert signature has been added.

509 Portrait of a Man

Fitzwilliam Museum, Cambridge
29 7/8 × 24 7/8
Provenance: Sale Christies, 3/19/04, lot 35 (attributed to W. Aikman); gift to the Fitzwilliam Museum from Charles Fairfax Murray, 1908
Literature: Fitzwilliam Museum, *Principal Pictures* (1912), p. 1; C. R. L. Fletcher and Emery Walker, *Historical Portraits* (1919), vol. 3, p. 84; J. W. Goodison, *Catalogue of Paintings*, vol. 3, *British School* (Fitzwilliam Museum) (Cambridge, 1977), p. 233 (attributed to Smibert)

This portrait is not typical of Smibert and appears to be by an unidentified British or Irish artist.

510 Portrait of a Man, formerly **Dean George Berkeley**

Worcester Art Museum
30 × 25
Inscription: lower right, "Jo. Smibert f./ 1728"
Provenance: Formerly owned by Charles Henry Hart and sold jointly by him and Frank W. Bayley to the Worcester Art Museum, 1917
Literature: *Worcester Art Museum Bulletin* (October 1917), p. 45; Dunlap 1918, vol. 1, frontis.; Bayley 1929, p. 347 rep.; Lee 1930, p. 118; New Haven 1949, no. 37 (for purposes of comparison to legitimate Smibert portraits); Foote 1950, pp. 237–238 (as not by Smibert)

At the time the Worcester Art Museum acquired this portrait they were provided with a detailed but fabricated provenance (see Foote 1950, p. 237). The portrait may be either a legitimate eighteenth-century portrait to which a forged Smibert signature has been added or, as Foote thought, a more recent portrait painted in eighteenth-century style.

511 Portrait of a Man, formerly **Joseph Crawford**

Present location unknown
30 × 25 1/2
Provenance: Sold by M. Knoedler (dealer) to Vose Galleries, Boston, 1925; purchased by the Wadsworth Atheneum, Hartford, Conn., 1930; bought back by Vose Galleries, 1965; sold at auction
Literature: *Art News Annual*, May 27, 1927; *Bulletin* (Wadsworth Atheneum), vol. 8, no. 4 (October 1930), p. 28; Foote 1950, pp. 216–217 (as not by Smibert)

This appears to be an eighteenth-century portrait of British or Irish origin.

512 Portrait of a Man, formerly **Thomas Fitch**

Yale University Art Gallery, 1934.302a
50 1/2 × 40
Inscription: lower left, "Jo. Smibert fecit 1738"; a letter on the table is inscribed "Thoˢ. Fitch Esqʳ. / Norwalk"
Provenance: Mr. and Mrs. Robert M. deForest, New York; purchased by Francis Garvan; gift of Francis Garvan to Yale University, 1934

This is an eighteenth-century portrait of British or Irish origin to which a forged Smibert signature has been added.

513 Portrait of a Man, formerly **Rev. Alexander Garden**

National Gallery of Art
Inscription: "J.S. 1734"
Provenance: Macbeth Gallery, New York; purchased by Thomas B. Clarke, New York, 1916; Thomas B. Clarke Collection, 1916–1931; Estate of Thomas B. Clarke, 1931–1936; A. W. Mellon Educational and Charitable Trust, Washington, D.C., 1936–1937; National Gallery of Art
Literature: Brooklyn Museum, *Catalogue of Exhibition of Early American Paintings* (Brooklyn, 1917), opp. p. 81; Bayley 1929, p. 385 rep.; Foote 1950, pp. 239–240 (as not by Smibert)

This is an eighteenth-century portrait of British or Irish origin to which a forged Smibert signature has been added.

514 Portrait of a Woman, formerly Mrs. William Greene

Present location unknown
30 1/2 × 25
Inscription: "Jo. Smibert pinx 1734"
Provenance: Vose Galleries, Boston, as agent for Frank W. Bayley, 1928; exhibited at the Exhibition of American Portraiture, 1750–1850, Rhode Island School of Design, 1936; exhibited at the Corcoran Gallery of Art, November 1937–March 1938
Literature: Bayley 1929, p. 393 rep.; Foote 1950, p. 240 (as not by Smibert)

This is an eighteenth-century portrait of British or Irish origin to which a forged Smibert signature has been added.

515 Portrait of a Man, formerly Jeremiah Gridley

Harvard University Law School
30 × 25
Inscription: lower right, "Jo. Smibert fecit 1731"
Provenance: Mr. and Mrs. Robert M. deForest, New York; Frank W. Bayley, Copley Gallery, Boston, by 1927
Literature: Bayley 1929, p. 395 rep.; Massachusetts Law Quarterly, vol. 14, no. 2 (September 1930), p. 42; Boston 1930, p. 42; Burroughs 1942, p. 114; Foote 1950, pp. 240–241 (as not by Smibert)

This is an eighteenth-century portrait of British or Irish origin to which a forged Smibert signature has been added. The portrait was examined in the 1940s by Sheldon Keck, paintings conservator at the Brookyn Museum. He concluded that the signature on the portrait "is definitely later, probably over 150 years later, than the original paint underneath."

516 Portrait of a Man, formerly Governor Joseph Jenckes

Present location unknown
10 × 8, oval
Inscription: "J. Smibert fecit, 1729"
Provenance: Exhibited at the Pennsylvania Academy of Fine Arts, 1926
Literature: Rhode Island Historical Society, Collections, vol. 27, no. 3 (July 1734); Foote 1950, pp. 241–242 (as not by Smibert)

This is an eighteenth-century portrait of American, British, or Irish origin to which a forged Smibert signature has been added.

517 Portrait of a Man, formerly Stephen De Lancey

National Gallery of Art
30 × 25
Inscription: center right, "J. Smibert, fecit 1734"; the painting formerly had a label pasted to the back that read "Portrait of my father by Smibert. James De Lancey"
Provenance: Mr. and Mrs. Robert M. deForest, New York; purchased by Thomas B. Clarke, New York, 1921; Thomas B. Clarke Collection, 1921–1931; Estate of Thomas B. Clarke, 1931–1936; A. W. Mellon Educational and Charitable Trust, Washington, D.C., 1936–1947; National Gallery of Art
Literature: "John Smibert's Portrait of Stephen Delancey," Art in America, vol. 9 (December 1922), pp. 54–55 rep.; American Magazine of Art, June 1928, p. 97; Virgil Barker, The Arts, vol. 13 (May 1928), p. 277; Bolton 1919–1926, vol. 3, pp. 755–757, 945; Foote 1950, p. 239 (as not by Smibert)

This is an eighteenth-century portrait of Dutch origin to which a forged Smibert signature has been added.

518 Portrait of a Man, formerly identified as Lt. Gov. Spencer Phips

Private collection
Inscription: "Jo. Smibert fecit 1740"
Provenance: Mr. and Mrs. Robert M. deForest, New York; Frank W. Bayley, Copley Gallery, Boston, by 1928; Henry L. Shattuck, Boston, 1928
Literature: Bayley 1929, p. 417; Coburn 1929, opp. p. 182; Boston 1930, p. 70; Foote 1950, p. 242 (as not by Smibert)

This is an eighteenth-century portrait of British or Irish origin to which a forged Smibert signature has been added. The portrait was sold by Bayley for $2,500.

519 Portrait of a Man, formerly Benjamin Pratt

Harvard University Law School
30 × 25
Inscription: lower right, "Jo. Smibert fecit 1741"
Provenance: Frank W. Bayley, Copley Gallery Boston, 1928
Literature: Bayley 1929, p. 419 rep.; Frederick W. Coburn, "John Smibert," Art in America, vol. 17 (June 1929), opp. p. 182 rep.; Harvard Alumni Bulletin, vol. 31, no. 18 (January 31, 1929); Massachusetts Law Quarterly, vol. 14 (September 1930), p. 41; Annette Townsend, The Auchmuty Family (New York, 1932), p. 26; Foote 1950, pp. 242–243 (as not by Smibert)

A label on the back reads, "Chief Justice Benjamin Pratt, Property of Dr. Samuel Auchmuty, Rector of Trinity Church; left in my care, Lambert Moore, Clerk of Trinity." When the portrait was examined at the Fogg Art Museum, the conservation department noted that "the paint of the

signature covers the crackle and the abrasion of the gray background, which can be seen through the transparent resinous paint of the signature, and this would indicate that the signature is of later date than the painting." The portrait is an eighteenth-century painting of British or Irish origin to which a forged Smibert signature has been added.

520 Portrait of a Man, formerly John Read

Addison Gallery of American Art, Phillips Academy, Andover, Mass.

30 × 25

Inscription: "Jno. Smibert fecit 1738"

Provenance: Mr. and Mrs. Robert M. deForest, New York; William Macbeth, Inc., New York, 1930; purchased by Thomas Cochran, February 10, 1930, for $3,500 from MacBeth Gallery (through Frank W. Bayley, Copley Gallery, Boston); anonymous gift to the Addison Gallery, 1930

Literature: *Creative Art*, vol. 11, no. 1 (July 1931), rep.; Addison Gallery, *Catalogue of the Permanent Collection, Addison Gallery of American Art* (Andover, Mass., 1931), rep.; Sibley and Shipton 1873–1956, vol. 4, p. 370, opp. p. 370 rep.; *Massachusetts Law Quarterly*, vol. 16 (1930) and vol. 22 (1737), rep.; New Haven 1949, no. 24 (for purposes of comparison); Foote 1950, pp. 243–244 (as not by Smibert)

521 Portrait of a Man, formerly identified as John Smibert, by Peter Pelham

Present location unknown

29 1/2 × 24 1/4

Inscription: On the back of the canvas, in ink, "Portrait of my friend Smibert drawn by P. Pelham / Jahleel Brenton. / Copied from the original inscription on the back of this picture by / J. Oliver / Liner / New York"

Provenance: Purchased by Thomas B. Clarke, New York, c. 1922; A. W. Mellon Educational and Charitable Trust, Washington, D.C.

Literature: Bayley 1929, p. 43 rep.; Foote 1950, pp. 235–236 (as not by Smibert)

This appears to be an eighteenth-century portrait of British or Irish origin to which a forged Smibert signature has been added.

522

522 Portrait of a Man, formerly Lt. Gov. William Tailer

Brooklyn Museum, 1943.230

50 1/4 × 40 1/2

Inscription: lower left, "Jo. Smibert, pinx, 1730"

Provenance: Mr. and Mrs. Robert M. deForest, New York; Frank W. Bayley, Copley Gallery, Boston; Luke Vincent Lockwood; Brooklyn Museum, 1943

Literature: Bayley 1929, p. 429 rep.; Boston 1930, p. 87 rep.; William Sawitsky, "Portrait of Captain and Mrs. Johannes Schuyler: A Hitherto Unrecognized Work of John Smibert," *New-York Historical Society Quarterly Bulletin*, vol. 18, no. 2 (April 1934), pp. 32–33 rep.; Burroughs 1942, p. 114; New Haven 1949, no. 31 (for purpose of comparison); Foote 1950, pp. 244–245 (as not by Smibert); Saunders 1989, pp. 66–75 (as by Thomas Gibson)

Sheldon Keck, paintings conservator at the Brooklyn Museum, examined the portrait in the 1940s and concluded that the signature "is definitely later, probably over 150 years later, than the original paint underneath." The portrait is virtually identical to other portraits, such as of Sir William Pynsent (Earl of Rosebery) (cat. no. 522a), by Smibert's London contemporary Thomas Gibson (c. 1680–1751) and is the only portrait among the forged Smiberts that can be linked directly to a specific eighteenth-century artist.

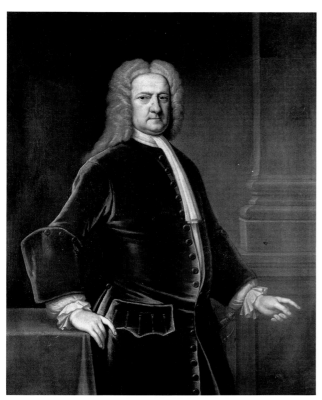

522a

523 Portrait of a Man, formerly Oxenbridge Thacher

Metropolitan Museum of Art, 54.196.1

49 3/4 × 39 3/4

Inscription: Lower left, "Jo. Smibert fecit. 1731"; on the back of the frame, "Oxenbridge Thacher of Milton"

Provenance: Mr. and Mrs. R. M. deForest, New York; Frank W. Bayley, Copley Gallery, Boston, 1930; Vose Galleries, Boston, 1930; purchased by Chester Dale, 1930; bequest of Chester Dale to the Metropolitan Museum of Art, 1954

Literature: *Art News*, July 12, 1930, rep.; William Sawitsky, "Portrait of Captain and Mrs. Johannes Schuyler: A Hitherto Unrecognized Work of John Smibert," *New-York Historical Society Quarterly*, vol. 18 (April 1934), pp. 33, 35 rep.; Foote 1950, pp. 245–246 (as not by Smibert); Gardner and Feld 1965, p. 284 (as not by Smibert)

The deForests provided Frank Bayley with a lengthy but unsubstantiated provenance for this portrait. Laboratory tests at the Metropolitan Museum of Art revealed that the inscription was added in the twentieth century.

524 Portrait of a Woman, formerly Mrs. George Berkeley

Berkeley College, Yale University

30 × 25

Inscription: "Jo. Smibert fecit"

Provenance: Mr. and Mrs. M. deForest, New York; Copley Gallery, Boston, 1925; Frank W. Bayley, to Vose Galleries, Boston, as agent, 1928–1930; Hiram Burlingham; sale, American Art Association, Anderson Galleries, Inc., 3/23/34; purchased for $45 by the Fellows of Berkeley College

Literature: Bayley 1929, p. 351 rep.; Foote 1950, pp. 238–239 (as not by Smibert)

This is an eighteenth-century portrait of British or Irish origin to which a forged Smibert signature has been added.

525 Portrait of a Woman, formerly Susannah De Lancey

National Gallery of Art

36 × 28

Inscription: "Jo. Smibert, fecit 1746"

Provenance: Mr. and Mrs. Robert deForest, New York: purchased by Thomas B. Clarke, New York, 1924; Thomas B. Clarke Collection, 1924–1931; Estate of Thomas B. Clarke, 1931–1936; A. W. Mellon Educational and Charitable Trust, Washington, D.C., 1936–1947; National Gallery of Art

Literature: *Portraits by Early American Artists of the Seventeenth, Eighteenth, and Nineteenth Centuries Collected by Thomas B. Clarke* (Philadelphia, 1928); Foote 1950, p. 246 (as not by Smibert)

This is an eighteenth-century portrait of British or Irish origin to which a forged Smibert signature has been added.

526 John Rindge

Bayou Bend Collection, Museum of Fine Arts, Houston

32 1/2 × 24 1/2

Provenance: Miss Mary Tilotson Stone, New York; bequest to her cousin Miss Helen Keeling Mills, Kent, Conn., 1930s; Mrs. Robert Blumbacher, Salt Lake City, Utah, 1939–1962; Vose Galleries, Boston, as agent, 1962; Bayou Bend Collection, gift of Miss Ima Hogg, Museum of Fine Arts, Houston

Literature: Foote 1950, pp. 221–222; David B. Warren, "American Decorative Arts in Texas," *Antiques*, December 1966, p. 802

Subject: John Rindge (1695–1740), son of Isaac Rindge and Elizabeth Dutch Rindge of Ipswich, Mass; moved to Portsmouth, N.H., c. 1710, where he later married Ann, daughter of Jotham Odiorne of Portsmouth; merchant, member of the Provincial Assembly, and commissioner to Great Britain to settle the boundary dispute between Massachusetts and New Hampshire

The portrait is not characteristic of Smibert and appears to be by an as yet unidentified British or Irish artist.

527 Captain Johannes and Elizabeth Schuyler

New-York Historical Society, 1915.8
54 × 71
Provenance: Descent in the family to Philip Schuyler, great-great-great-grandson of the sitters; bequest of Philip Schuyler to the New-York Historical Society, 1915
Literature: William Sawitsky, "Portrait of Captain and Mrs. Johannes Schuyler: A Hitherto Unrecognized Work of John Smibert," *New-York Historical Society Quarterly Bulletin*, vol. 18, no. 2 (July 1934), pp. 19–37; New-York Historical Society, *Catalogue of American Painting* (1941), pp. 168–169 (as by Smibert); Foote 1950, pp. 222–223 (as more likely to be by John Watson); NYHS 1974, vol. 2, no. 1821 (as by an unidentified artist); Black 1979, pp. 84–85
Subject: Johannes Schuyler (1668–1747), prominent Albany landowner and politician; mayor of Albany, 1703–1706; and his wife, Elizabeth Schuyler (c. 1662–1737)

Mary Black (1979, pp. 84–85) has convincingly shown that this double portrait is the work of John Watson.

528 Rev. William Shurtleff

Massachusetts Historical Society
30 × 25 (76.3 × 63.9)
Provenance: Gift of Mrs. Susan Parker and Mrs. Lucretia Lyman to the Massachusetts Historical Society, September 29, 1836
Literature: *Century Magazine*, July 1893, p. 388 rep.; B. Shurtleff, *Descendants of William Shurtleff* (1912), vol. 1, p. 8; Sibley and Shipton 1873–1956, vol. 5, p. 396 rep.; Foote 1950, p. 223 (as not by Smibert); Oliver, Huff, and Hanson 1988, p. 94
Copy: A copy was painted in 1879 by Mrs. L. A. Bradbury for the South Church in Portsmouth, N.H.
Subject: William Shurtleff, born in Plymouth, Mass., April 4, 1689; son of Capt. William Shurtleff and Suzannah Lothrop Shurtleff; Harvard, 1707; pastor at New Castle, N.H., until 1732; pastor of the South Parish, Portsmouth, N.H., 1733–1747; died May 9, 1747

This portrait is not the work of Smibert and may be by an as yet unidentified American artist.

529 Rev. Seth Storer

First Parish of Watertown, Mass.
29 1/2 × 24 3/4
Provenance: By descent to the maternal grandparents of Langdon Warner, Cambridge, Mass., by 1930; gift to the First Parish of Watertown
Literature: G. R. Robinson, *Great Little Watertown* (Watertown, Mass., 1930), rep.; Malcolm Storer, *Annals of the Storer Family* (Boston, 1927), p. 50; Foote 1950, p. 192 (as by Smibert).
Subject: Seth Storer, said to have been born in Saco, Me., May 27, 1702; son of Col. Joseph Storer and Hannah Storer of Wells, Me.; Harvard, 1720; minister in Watertown, 1724–1774; mar-

ried Mary Coney of Boston, May 9, 1734; died November 27, 1774

Foote accepted this as "one of Smibert's most pleasing pictures of Puritan ministers"; it seems closer, however, to the style of Nathaniel Smibert.

530 Rev. William Tennent, Jr.

The Art Museum, Princeton University
30 × 25
Provenance: Descent in Boudinot family to Mr. and Mrs. Landon K. Thorne, New York; gift from Mr. and Mrs. Landon K. Thorne to the Art Museum, Princeton University, 1966
Literature: Donald Drew Egbert, *Princeton Portraits* (Princeton, N.J., 1947); H. Backlin-Landman, "Boudinot Family Portraits in the Art Museum of Princeton University," *Antiques*, vol. 93 (June 1968), pp. 772–773 rep. fig. 7
Subject: Rev. William Tennent, Jr., trustee of Princeton College, 1746–1747; brother of Rev. Gilbert Tennent, one of the founders of the college

Although the portrait dates from the period when Smibert painted, the smooth finish is uncharacteristic of his work.

531 Mrs. Tweedy (?)

Rhode Island School of Design, 1909–118
38 1/2 × 31 1/2
Provenance: Bequest of Mrs. Hope Brown Russell, 1909
Notebook: Not included as presently identified

When the portrait was acquired by the Rhode Island School of Design it was thought to be by Smibert. It was shown to Foote in the 1920s, who thought it was by Feke. During the 1960s the painting underwent a partial restoration and is now difficult to evaluate. From the neck down, much of the portrait has been repainted. What remains of the face, however, suggests the work of Feke rather than Smibert.

532 Captain Edward Tyng

Yale University Art Gallery, 1930.52
49 3/4 × 40 3/8
Provenance: Descent in the family; heirs of Rev. Timothy Hilliard, by 1902; his descendant Miss Mabel Harlow, Boston; purchased by Francis P. Garvan, 1929; presented by Francis Garvan to the Yale University Art Gallery, 1930
Literature: William Goold, *Portland of the Past* (1886), opp. p. 247 rep. (attributed to Blackburn); *Bulletin of the Associates of Fine Arts at Yale University*, vol. 4, no. 3 (October 1932), p. 149 rep.; Foote 1950, pp. 225–226 (as not by Smibert); Barbara M. Ward and Gerald W. R. Ward, *Silver in American Life*, exh. cat. (Boston, 1979), p. 93, fig. 35.

Subject: Edward Tyng, born in Boston, 1688; son of Edward Tyng, who was appointed governor of Annapolis Royal, Nova Scotia, but was captured by the French on his way to his post and taken to France, where he died; the younger Edward Tyng was commissioned captain of the fortifications in Boston, April 1740, and four years later captured a French privateer cruising off Cape Cod, in gratitude for which the merchants of Boston presented him with an impressive silver cup by Jacob Hurd (Yale University Art Gallery); commanded the frigate *Massachusetts* in the expedition against Louisbourg, 1745; married his second wife, Anne Waldo (1708–1754, cat. no. 77), 1731; died September 8, 1755

As Foote concluded, this portrait is not by Smibert and appears to be by an as yet unidentified artist.

533 Richard Waldron III

Present location unknown.

49 × 39

Inscription: On a table and held down by the sitter's right hand is a document that reads, "Salus Populi Supprma Lex"

Provenance; The sitter; his son Thomas Westbrook Waldron; his son Daniel Waldron; his daughter Mrs. C. Waldron Dimick; her daughter Frances Dimick Parry; her daughter Miss Catherine Dimick Parry, Kittery Point, Me., by 1949

Literature: Foote 1950, p.195

Copy: According to Foote, a "poor copy" at one time belonged to the Society for the Preservation of New England Antiquities and was on loan to the Wentworth Gardner House, Portsmouth, N.H.

Subject: Richard Waldron (1694–1758), born in Portsmouth, N.H., 1694; son of Richard Waldron and Eleanor Vaughn Waldron; married Elizabeth Westbrook, 1718; judge and councillor and for many years secretary of the province of New Hampshire after his appointment in 1737

Although Foote accepted this portrait as by Smibert, it is not typical of his style.

APPENDIX 1

References to Smibert in Vertue's Notebooks

In 1722 George Vertue began to record impressions of Smibert among his numerous memoranda about the London art world. All of these notations, in the order in which Vertue made them, are listed here. Volume and page references are to Vertue 1930–1955.

(3:11) John Smibert a Scotsman born studyd in the Academy several years. went to Italy 1717 returned after three years stay there. a good ingenious man paints & draws well ⟨born 1688⟩

(3:14) Mr John Smybert first apprentice in Edenbourough servd 7 years to a house painter and plaisterer. in all that time tho' he had a strong inclination to drawing & studying but no oppertunity to improve came to London. many difficulties to get into imployment first to coach painting. then coppying of paintings for dealers for 3 or 5 years yet never copyd any thing from ye life. till he came to ye Accademy. haveing never drawn from plaister. after this went to Edenborough there first try'd to paint faces. after came to London & set out to Italy. when he came to Florence there from ye great Dukes pictures he copyd several particularly the Card. Bentivolio of Vandyke & many other heads makeing that his whole study after Titian Raphael Rubens. &c. at Rome he painted several persons from the life. Naples &c. at his return already several good heads especially men. the Lord Carpenter in Armo 1/2 lentht very well. ⟨an old Lady setting in a chair admirably well done. several other very good portraits one large peice being a Club of Virtuosi. or a groupe of the Rosa Coronians.⟩

(3:24) in the large painting peice of the Virtuosi of London *design'd & begun* ⟨*1724*⟩ by Mr. Smibert. are the following persons. its divided into three groupes. in the Middle. Harvey. painter bald head. . . . Wotton . . . Gibson. on the left Keller setting. at the Harpsicord. Kinkead setting looking up backwards. Cope standing with a fiddle in his hand leaning. Bartaudi behind him. on the right side . . . Vertue holding a print . . . Bird looking in . . . Smybert behind & Poit. pointing up. . . . Lens on the Easel a profil.

(3:28) of many pictures of Mr Smyberts doing a head done of C. Dubosc Engraver. on a Kit-Cat. well disposd. strongly painted tho' clear. the action mightly well disposd & like him

(3:30) 1726. Covent Garden Piazza inhabitted by Painters. ⟨a Credit to live there.⟩ Mr· Gouge at James Street Corner opposite to that . . . Ellis next. Russel . . . Murray. Sr. J. Thornhill . . . Swarts. . . . Wright . . . Smybert . . . Angellis . . . Vander Vaart . . . Zinke

(3:36) in a few days after Mr. Smibert left England, to go to the West Indies. New York. or Bermudas taking all his pictures Effects entending there to Settle. according to a Scheme propos'd by Dean Barclay. to lay the foundation of a College for all sorts of Literature on Bermudas. & professors of several sciences. to Instruct the Indian children in the Christian faith, & other necessary educations. to which end the Dean had made great Solicitations. at Court in the last reign. & had obtain a grant of 20000 pound from some of the plantation revenues to be employ'd in making a settlement there. of a College & several fellows. to which design the Dean had engag'd, or perswaded several gentlemen of fortune & Substance to join with him in this project. 3 or four of them. sett out with ⟨ye Dean. &⟩ Mr. Smibert. on that account not paid prevented by the Death of the late King—

Mr. Smybert had very good business here, a great many friends generally all of them dissuaded him from leaving here a certainty. for an uncertainty. but he warm'd with imaginations of the great success of such a design. & the pleasure of a finer Country & Air. more healthfull he being often a little enclind. to indispositions. or hip, or Vapours . . . & also having a particular turn of mind towards honest, fair & righteous dealing—he coud not well relish, the false selfish griping, overreaching ways too commonly practiz'd here. nor was he prone to speak much. in his own praise. nor any violent ways but a descent modesty. which he thought in such a retirement. as at Bermudas he might live quietly & for a small expence. & make a great advantage. by

ready money declaring he rather sought repose, than prof-itt. he was a good like man. born at Endenburgh & now about 45. or 6—⟨furthermore its said that the Dean & Smibert took with them two young Gentlewomen. of good fortunes. both sisters. & married one to yᵉ Dean⟩

(3:42–43) Mʳ Smybert painter being settled at Boston New England. with others a Friend of his. there inscribd a Poem to Mʳ. Smibert on the sight of his pictures. which was trans-mitted here & publishd in the Courant Apr. 1730. it begins:

> Ages our Land a barb'rous Desert stood.
> And savage Nations howl'd in ev'ry wood,
> No Laurel Art &c. . . .
> Till the great year the finishd Period brought
> A Smibert painted, and a . . . wrote
> ⟨the Poets name not printed⟩
> Still, wondrous Artist, let thy Pencil flow.
> Still warm with Life, thy blended colours glow.
> Raise the ripe Blush, bid the quick eyeballs roll,
> And call forth ev'ry Passion of the Soul.
> Let thy soft shades in mimic Figures play
> Steal on the Heart, and catch the mind away.
> In the same Studies Nature wee pursue,
> I the Description touch, the Picture you.
> Yet, Smibert, on the kindred Muse attend
> And let the Painter prove the Poet's Friend.
> &c. &c.

(3:54) Mʳ Dahl Mʳ· Richardson & Mʳ. Jarvis are the three foremost Old Masters—the next Class. are those (gener-ally) that studied in the Accademys here, under Sʳ. G. Kneller. Sheroon Laguerre Thornhill. Mʳ. Gibson. Mʳ. Vanderbank Mʳ. Huysing Mʳ. Highmore Mʳ. Dandridge Mʳ. Smibert abroad at Boston New England Mʳ. Hogarth small figures s⟨Mʳ⁻⁻Mʳ⁻⁻⟩Zemans two brothers but did not study in those accademys Mʳ. Jos. Goupy water colours Mʳ. Bernard Lens Water Colours Mʳ. Fred. Zinke Enameller.

(3:69) My picture painted by Mʳ. Gibson. 1723. begun by Mʳ. J. Vanderbank. ⟨long before⟩ also by Mʳ. Hysing begun. painted amongst the Virtuosi by Mʳ. Smybert. drawn. & in small water Colours by my self begun in Oyl by Mʳ. Dan-dridge. Drawn on paper by Sʳ. Jam. Thornhill 1733. painted excellently by Mʳ. Richardson Senʳ.

(3:161) having lately heard from an acquaintance & famil-iar country man of Mʳ. John Smibert painter. who went to settle at Boston in New England above two three & twenty years ago. their he met with good encouragement in busi-ness and imployments, being a sedate man. he marryd a woman. of some considerable fortune soon after. by her he had several children. brought forward a nephew of his Mʳ. Moffet in his business, who still follows the same—
but Mʳ John Smibert I was told dyd, about March was twelve-month—that is March 1751—and left a widow and two children—in very good circumstances—in the art of

painting he was a skilfull painter, had made great improve-ments by study in England and at Rome, were he staid a considerable time, at his return to England he was well esteemed by the Curious and the Judges of Art. but he was not contented here, to be on a level with some of the best painters. but desird to be were he might at the present, be lookt on as at the top. [V.26, B.M. 17b] of his profession then, & here after—in which no doubt, he there suceeded in. and Smiberts name in after Times. by his works will be there remembered—in a superior degree—

(6:35) [Members of the Rose and Crown Club]

Bird	Cheron
Laguerre	Ant Cope
Cock	Humphrys Porson
Dʳ. de la Cotte	John Smybert
Mʳ Tillemans	Baron
Dubosc	Angelis
Ross	Walton
Zinke	Scott Parmentiere
Babel Music	Clause
Mʳ.	
Isa. Whood	Hogarth
Casteels	Faber
Monˢ. Symon	Watteau
Wooton	Ellys
Mʳ. Kinhead	Dandridge
Boule	Rysbrake
Dobberman	Hamilton
Duguernier	Heckle
H Hysing	Lens Jun.
Andrew Hay	Parbury
Werenberg	Scotin
Schryder	Kirkall
Harper	Moser
Keller	Vanlo
Cooper	Dupuis
Udal Price	Scheemaker
Gautiere	
Sʳ Edm	Conclusion 174 2/3
Anderson	
Thornhill	
Gouge	
Rowley	
Hill	
Roberts	

APPENDIX 2

Correspondence

(Smibert to Sir Archibald Grant, Monymusk Papers, National Archives of Scotland)

Boston New England
January 19, 1733/4

Dear Sir

I received yours of September the 11th & am heartily sory for your misfortunes & can asure you, I should be glad of any opportunity where in I could be of use to you & if your interest & inclinations should ocasion your coming over here, you wil find me readier in deeds then words the narrowness of my fortune wil not allow me to be so generous as my inclinations are my family has increased & is likely to hold on, besides little behind hand, so that I can not without hurting my family make so large an abatement, as I should otherwise chearfuly do; however, knowing you friendship to me I have it with you to make the abatement as litle as may be, but if your circumstances requires it I wil forgive ye interest & be satisfied with the principal, which is about as much as you desired. Mr. Hucks [Robert Hucks (1699–1745), a brewer whose portrait Smibert painted while in London] has the bond & the management of all my money so I desire you would pay it to him by midsumer acording to your proposal; my affairs are ordered so that a disapointment would be of damage to me in a former leter I wrote you my design of buying a farm about 10 or 12 milles from this town, but my friends dissuaded me from it, a country life being what I never had tried & I am entirely a stranger to farming. so I gave over the project, at least for the present & have now got into a house of my father in laws, who has built me a large & handsome painting room & showroom in al respects to my satisfaction. My family is well & sallute you & yours I hope to see, or at least hear of your being in more flourishing circumstances.
I am Dear Sir Your most Sincere friend & Servt:

JOHN SMIBERT

(Smibert to Sir Archibald Grant, Monymusk Papers, National Archives of Scotland)

Boston May 20 1734

Dear Sir

I wrote you the 19th of Janr. last which I hope you have received. Since my writing to you I have put in execution a Scheme that I had then in view. the first thoughts of which was ocasioned by some difficultys I had bout leting a Shop there is in the House my Father in Law has built me. I found the inconveniences that would attend its being let were more then the profit would ballance this put me upon keeping of it for a printshop with Fanns Colours and other things in my own way. Johnie taking the trouble of it. This was aproved of by al my friends here and I have wrote to London for a Cargo of goods proper for this country which I expect over here Soon, and am persuaded wil answer very well for I bought some colours here that there is considerable demand & something to be got by them. I have now wrote for another suply to come here in the Fall, which necesitates my writing to you at present to put you in mind of paying the money to Mr Hucks, who has the bond, by mid sumer acording to your proposal, my affairs are so circumstanced that a Disapointment would be a very considerable damage to me. but I know your readines to serve me so need not say any more of it. My family is well, my wife joins with me in good wishes to your Lady, yourself and family. I am Dear
 Sir
 your Sincere friend
 and
 obedient Servt
 JOHN SMIBERT

(Attached to preceding letter)

July 12, 1734

Sir

Mr. Smibert has wrote to me, that you was to pay me the £60 due to him in Bond, this Midsr; which was to be delivered up to you without Interest, and in confidence of it has DRAWN on me for £60, and has given Directions for the laying out the money in necessaries to be sent to New England. Pray let me know what you propose doing, If I knew your Lodgings would wait on you, or should be glad to See you at My House

Yr Humble Servt
ROBERT HUCKS

(Dean George Berkeley to Smibert, present location unknown; published in the *Gentleman's Magazine and Historical Chronicle*, CI 1831)

Cloyne, 31st of May 1735

Dear Mr. Smibert,

A great variety and hurry of affairs, joined with ill state of health, hath deprived me of the pleasure of corresponding with you for this good while past, and indeed I am very sensible that the task of answering a letter is so disagreeable to you, that you can well dispense with receiving one of mere compliment, or which doth not bring something pertinent and useful. you are the proper judge whether the following suggestions may be so or no. I do not pretend to give advice; I only offer a few hints for your own reflection.

What if there be in my neighborhood a great trading city? What if this city be four times as populous as Boston, and a hundred times as rich? What if there be more faces to paint, and better pay for painting, and yet nobody to paint them? Whether it would be disagreeable to you to receive gold instead of paper? Whether it might be worth your while to embark with your busts, your prints, your drawings, and once more cross the Atlantic? Whether you might not find full business at Cork, and live there much cheaper than in London? Whether all these things put together might not be worth a serious thought? I have one more question to ask, and that is, whether myrtles grow in or near Boston, without pots, stones, or greenhouses, in the open air? I assure you they do in my garden. So much for the climate. Think of what hath been said, and God direct you for the best.

I am, good Mr. Smibert,

Your affectionate humble Servant,

G. CLOYNE.

P.S.—My wife is exceedingly your humble servant and joins in compliments both to you and yours. We should be glad to hear the state of your health and family. We have now three boys, doubtful which is the prettiest. My two eldest past well through the small-pox last winter. I have my own health better in Cloyne than I have either in Old England or New.

(Smibert to Sueton Grant, Newport Historical Society)

Boston September 22 1735

Sir

I suppose your patience is quite tired in expecting your Arms, etc.—but it was impossible to send them sooner. the frame makers having so much work bespoke before, and being also not disposed to work any more than necessity forced, occasioned me to call upon them at least twenty times, before Mr. McSparran's frame and yours, could be got from them. Last week I put them on board a Conecticut Sloop bound for your Port, Capt. Thorp. they are Carefully packed up and the case is directed for you, which I hope wil arive safe & be to your satisfaction. Mr. McSparran Picture is in ye case which I desire you to inform him of and ye

reason for its not being sent sooner. give my service to him and my respects to Mrs. Grant. I am Sir your most obedient Humble Servt,

JOHN SMIBERT.

In the case is

A Naval fight, Mantuanes	0-16-6
Scipio's Victory, C. Cort	0-11-0
the Virgin, C. Moratt	0-16-0
frames for ye above	0- 6-0
the Harlots Progres—Hogarth	1- 5-0
the coat of arms	3- 0-0
a gold frame for ditto	3-10-0
a glass for ditto	0-10-0
your half of the case cost	0- 4-0
	£11- 6-6
Received	10- 0-0

(Allan Ramsey to Smibert, present location unknown; published in the *Gentleman's Magazine*, vol. 54, 1784, p. 672)

Edinburgh, May 10. 1736

My dear Old Friend,

You health and happiness are ever ane addition to my satisfaction. God make your life ever easier and pleasant—half a century of years have now row'd o'er my pow, that begins now to be lyart [liard, gray]; yet, thanks to my Author, I eat, drink, and sleep as sound as I did twenty years syne; yet, I laugh heartily too, and find as many subjects employ that faculty upon as ever; fools, fops, and knaves, grow as rank as formerly; yet here and there are to be found good and worthy men, who are ane honour to humane life. We have small hopes of seeing you again in our old world; then let us virtuous, and hope to meet in heaven. My good auld wife is still my bed-fellow; my son Allan has been pursuing your science since he was a dozen years auld—was with Mr. Hyffidg, at London, for some time about two years ago: has been since at home, painting here like a Raphael—set out for the seat of the Beast, beyond the Alps, within a month hence—to be away about two years.—I'm sweer to part with him, but canna stem the current, which flows from the advice of his patrons, and his own inclinations. I have three daughters, one of seventeen, one of sixteen, one of twelve years old, and no rewaly'd draggle among them, all fine girls. These six or seven years past I have not wrote a line of Poetry; I e'en gave o'er in good time, before the coolness of fancy that attends advanced years should make me risk the reputation I had acquired.

> Frae twenty-five to five-and-forty
> My Muse was nowther sweer nor dorty;
> My Pegasus wad break his tether,
> E'en at the shagging of a feather,
> And throw ideas scour like drift,
> Streaking his wings up to the lift:
> Then, then my saul was in a low,

That gart my numbers safely row,
But eild and judgement gin to say,
Let be your sangs, and learn to pray.

I am, Sir, your friend and servant,
ALLAN RAMSAY.

(A letter of May 10, 1736, to Smibert from Allan Ramsay is now lost. It was once in the possession of John Greenwood, who sent it in 1784 to the *Morning Herald*. Greenwood's letter is in the Whitley Papers, Department of Prints and Drawings, British Museum, London.)

Morning Herald Sat Aug 28th
1784

To The Morning Herald
Mr. Editor.

The papers having mentioned the death of Allan Ramsay Esq. portrait painter to his majesty it put me in mind of a letter in my possession which was written by his father, the famous. Scotch Bard to Mr. John Smibert a portrait Painter who left England with Dean Berkeley, afterwards. Bishop of Cloyne to settle in Bermudas, That project miscarrying Mr. Smibert went to Boston, married & died. As the letter gives some account of Mr. Ramsay, in his youth, it may serve to illustrate any future anecdotes of English Artists & not be unexceptable [*sic*] to both painters & poets.

I am, Sir

Leicester Square Your most obliged Servant
Aug:24 1784 JOHN GREENWOOD

(Smibert to Arthur Pond, Archives of American Art)

Boston Jully 1st 1743

Dear Sir I wrote you the 6th of May by Capt. Bonner & then troubled you with 2 Bills one on Messr; Tyrons for £30 and the other on Messr: Walter Hayter & Sons for £11— the 2d Sett of which Bills are now inclosed as also a Bill of Lading for eight Guineas & Twenty-five oz and a half of silver plate. I have for a long time intended to send for yᵉ pictures etc which my Nephew left with you, but delayed on act. of the war, which as there is no apearance of being over think, it now best to have them over here again, for as you long ago wrote me you had sold none of them, nor though it likely you should. I am in hopes I shal make something of them here so desires you will order them to be carefully packed up in a good case & sent by the first opportunity for this Port & insure on the Virtu cargo for £150. I must further trouble you to buy me 3 doz 3/4 Cloaths strained, & two whole Length Cloaths which pray order to be good and carefully rolled up & put in a Case. Fann Paper ten Reams this is an article which se shal probably want considerable of so would desire you to write yᵉ mans name you buy it of & where he lives that we may send to him directly without troubling you again. there are many women that paints Fanns for the country use and as they buy the Collours of us the paper has of late come naturally in to be an article in the Shop let it be of the sort commonly used for cheap Fanns &

should be glad yᵉ man would Send a Sheet or 2 of the different sorts of paper with yᵉ prices. Lake of the Common midling sort about two Guineas and of good Lake about two Guineas more. Prussian Blew 50 1 2 shillings per pound. Do 6 1 @ 20 shill or a Guinea per pound. Do 6 1 @ 18 shill. per pound. that may be had cheapest of yᵉ maker M Mitchell at Hoxton who you may send to by a peny post letter or a Porter. the old Cups and spoons are a commission from my Wiffe who desires you will be so good as to get her a Silver tea pott of the middle size but rather incling to yᵉ Large and weighty yᵉ fashion she leaves intirely to you only would not have the top with hinges, but to take of. I have sent a Sketch of yᵉ Arms which I know you wil take care to get done by a good engraver with proper Ornaments. I do not expect the old silver wil pay for the tea pott which I would have a pretty one. what remains of ye money after paying for those articles and al charges on Board please to lay out in gold leaf.

I am sorry the State of the Virtu is at so low an ebb. if the arts are about to leave Great Britain I wish they may take their flight into our new world that they may, at least remain in some part of the British dominions. remember me to al my old friends among the Painters. I would willingly have acknowledged your favours by something from this Country but can think of nothing worth sending that is our own produce. amongst ye Pictures with you my Nephew tells me he thinks you used to like ye Venus Nymphs etc. by Poolenburgh. be so good as to accept of that picture to remember me by or any other of the Pictures you like except ye Scipio & if there be any of ye drawings that you fancy pray take them. when you write me let me know the State of Painting, who makes a figure, & what eminent ones are gone of ye stage. as for my self I have as much as keeps my employed, has my health better than I could have expected, having near 3 years ago recovered from a dangerous ilnes, but thank God has had no return of it. I am happy in 4 clever Boys & lives as easily as my friend could wish me. ye affairs of the shop with my Nephew goes on well he Joins me in respects to your Father & to Messr. Knaptons. I shal not make any further apollgys for the trouble now given you only assures you I wil not try your patience every year but only now and then. I am Sir your most obliged humble serⁱ.

John Smibert

P.S. please to insure besides ye £150 on the Pictures, etc. at your house, £50 more for the money you lay out in al £200 I wish you could send 2 copies of a Pamphlet Published by A Millar entitled as I remember ye Apostles no Enthusiasts by—Campbell of St. Andrews.

(Smibert to Arthur Pond, Department of Manuscripts, British Library, London)

Boston, March 24, 1743/4·

Dear Sir: I had the favour of yours by Capt. Anstill with the Virtu Cargo and bill. the other things in good order. for your care of which and present of the prints I am much your debtor. You know I was always fond of Landskips so

that you could not have sent anything more to my taste and I assure you I esteem them as the finest Collection of Prints in that way I ever saw. the smal sett I have sold and desire you will send 5 setts of the 7 numbers on' the smal paper which with the sett already received wil amount to eight guineas allowing the 20 per cent for those who sell them again. its probable more will sell but we wil try them first, you may send one of every Print you do perhaps some of them may hit the General taste of this place.

All the things you sent are good and bought well. The season for Fann painting is not yet come so there has been no opportunity to try the papers and mounts but no doubt they will answer. I now trouble you for some small matters to come with the prints as by invoice anexed. to pay for these things inclosed are a Bill for £12.12.0 on Fredk Frankland Esq and a Bill of Lading for some gold and silver as is specified in the Bill. We are very sorry for the loss of Mr. Charles Knapton who was a worthy man. You act. of the state of painting and the Painters with you shows a very fickle temper and is no recommendation of your great Town. as you do not mention the Lady's head after Titian to be amongst the Pictures stolen by the frame maker I hope you forgot to put it up with the others and that its stil at your house. if it is, be so good as to send it with the things now wrote for. the tea pot is a mighty pretty one and so much liked that you [will] be troubled with my nephew's request for a friend. He joins with me in our respects to your Father and al friends I am, Dear Sir your most obliged Humble Sert

JOHN SMIBERT.

Sir:—I hope youl excuse the trouble I now give you, occasioned by the Tea Pott you sent which is admired by all the Ladies and so much that in behalf of one of them (who I assure you has great merit) I must beg he favour of you to send such another one of the same fashion and size only the top to have a neat hinge, for the payment of it the silver is appropriated. If it should not be enough to pay it and engraving the arms according to the Sketch and Insurance do not let that prevent its being done in the same manner as the last desiring you wil forgive this freedom I am Sir Your most obliged humble sert.

JOHN MOFFATT.

half length Cloats primed 1 doz.
kit kat do 1 doz. 1/2 to be rolled up as the last
Pallet knives 1 doz. black led pencils of different sizes about 1/2 a guineas' worth
Black a more street pencils pointed about 1/2 a guineas' worth, but no fitches
Silver leaf six thousand it cost about 10 shil per thousand
Prints 5 setts of the 7 numbers smal paper
A set of ships published by Lempriere and sold by H. Toms in Union court Holburn.

These ships I want sometimes for to be in a distant view in Portraits of Merchts etc who chuse such, so if there be any better done since send them. but they must be in the mod-

ern construction. the last edition of Perspective commonly calld Pricks, the rest of the money after paying for insurance (for tho of small value yet its best to be insured) and charges please to lay out in Post paper and a writting paper, called Pott paper the article of paper will be easy to you as you have occasion for much, tho of another kind. You will please to send the above out by Capt. Jones on one of the first ship.

Coined silver sent	£13 d 10 dwt.	Gold 4 Pistol piece	17–8 gram
Old Plat	£14 2	Coined gold	£4, 13, 0.

(Smibert to Arthur Pond, Department of Manuscripts, British Library, London)

Boston, N.E., March 15, 1744/5
Dear Sir,—I had the favour of yours Capt. Carrey with yᵉ cargo in good order, for your care which & present of yᵉ Prints I am much obliged, yᵉ View from Greenwich & Antiquities by P. Panini please more here than yᵉ others and I hope some number of them wil sell. last August I wrote you & inclosed a Bill for £8.8.0 on Mr. Elliakim Palmer to be laid out chiefly in Fann mounts, but I hear yᵉ Vessel was taken & carried into France. I now enclose you yᵉ 2d of that Bill with one for £18 on messrs. Samuell & Wm. Baker, which I must trouble you to lay out by yᵉ invoice anexed to be sent by the first opportunity & insured.

at present here is litle talked or thought of but war, our forces are imbarking for Cape Breton, four Vessels force are sailed to ly off Lewisbourg harbour to prevent any succours or provisions going in. this Expedition is a great undertaking for this Country if it succeeds wil be of great importance & be a terrible blow to France as it wil effectually destroy their fishery & make yᵉ navigation to Canada very dangerous. but if it dos not succeed we shall be almost undone here, for our best men, the flower of yᵉ country are going & yᵉ expence wil be a prodigious sum of money, which if we are not assisted in yᵉ charges of it from home must ruin this Province. but I hope we shal not be deserted by our Mother Country. my Nephew thanks you for the care of his commission which pleases much. our respects to your Father. I am Sir your most obliged humble sert.

JOHN SMIBERT

This comes by the *Elthan* man of war, who convoys yᵉ mast Ships. there has been an Embargo here for more than 6 weeks & still continues.

gold leaf 3000
Views of Greenwich and Antiquities P. Panini a doz of each
3/4 Cloaths of 1 doz Dark Prussn: Blew 3 1 about 18 or 20 Shill per 1
Fann mounts 1 doz @ 8 Shill. 3 doz Do @ 4/6
20 doz do @ 1/6
40 doz @ 1 shill. and about 10 or 15 Shill. worth of coloured prints slight and cheap for Japanning. please to advise of ye Price of Franckfort black by the hundred, and send a specimen of fann mounts printed but not coloured of ye cheapest sorts.

To Mr. Arthur Pond Painter in great Queen Street Lincolns in fields London.

(Smibert to Arthur Pond, Department of Manuscripts, British Library, London)

Boston, April 6th, 1749

Dear Sir,—The first of last moneth I wrote you & inclosed two Bills of Exchange one for £15 on Mr. Bethel yᵉ other for £33 on Mr. Partridge & now inclose you the 2d of each of those Bills & ye first of another for £15 on Mr. Bethel making in al £63.00 which I must trouble you to lay out in the underwritten articles & to get the Cargoe insured. I hope you have received yᵉ first letter where in yᵉ Prussion Blew was desired to be got ready, but in case you have not and can not soon get the sorts wrote for, desires you wil take what sorts there is ready that you like best your self, for as several of yᵉ articles are much wanted would be glad to have them sen by the first vessel, the last things you sent came here safe but received no Letter.

I'm ashamed to give you so much trouble, but you have encouraged me & there is none of my friends so well acquainted with the people who deal in those articles, as for myself I need not tell you that I grow old, my eyes has been some time failling me, but is [I'm] stil heart whole & hath been diverting my self with somethings in the Landskip way which you know I always liked. I had lately a present of a Cast of yᵉ modell for Shakespears Monument from my friend Mr. Schymaker [Peter Scheenmakers (1691–1781)] which pleases me much. when you see him please to make my Compliments to him, and to Mr. Gibson [Thomas Gibson (1681–1751)] of whose welfare I should be glad to know. If you have got the little Picture of Mischan & yᵉ Lady after Titian back again (for I think you wrote you had lent them) should be glad you sent them with this Cargoe. my Nephew sends his service to you, with our services to your Father I am Sir your most obliged humble sert.

JOHN SMIBERT.

Prussian Blew 4 1 @18 or 20 Shill
Do 6 1 @12 or 15 Shill
Do 10 1 @8/ or 9 Shill
Do 20 1 @4/ or 5 Shill
Pallet and Stone Knives 1 doz of each
Brown Pink 1/2 1.
Carmine 1 oz.
gold leaf three thousand Please to direct that the gold
silver Do 4000 and silver leaf be carefully
done up in a box by it self.
3/4 Primed Cloaths 3 doz.
Kit Kats 1 doz.
1/2 Lengths 2 doz
2 gold frames for 2 Pictures 20 inches by 14 inches and a half. the pictures are not extraordinary, so would not go higher than 12 or 15 Shill. apiece.
a French Bible a good Edition and neatly bound. this is for my second Son a present from my Nephew whose favorite he is.

Red chalk 1 1.
Pencils (blackamore Street) in sorts 20 Shil. value
Fann Brushes or tools for Portraits 20 Shil. value
200 doz black and whilte mounts @ 8 d per doz
50 doz colloured mounts at one shil. per doz
50 doz Do @ one Shill & six pence per Doz
10 doz Do @ 2 or 3 Shil. per Doz
10 doz Do @ 4 or 5 Shil. per doz
2 doz Do @ 6 or 8 Shil. per Doz
1 doz Do @ 10 Shil. per Doz
Black and whilte mounts 20 Doz @ one Shil per doz
Do 10 doz @ one Shil & six pence per doz
Silver paper 1 Doz 3 Shill
Do 1 Doz @ 4 Shill
Black mounts for mourning smal paper 20 doz and 20 doz larger paper Do we know not ye Price of ye black mounts but suppose the smal paper may be a Shilling a dozen and the larger eighteen pence a doz.

(Smibert to Arthur Pond, Department of Manuscripts, Chamberlain Collection, Boston Public Library)

Boston, New England, Dec'r 28th, 1752

To
 Mʳ Arthur Pond
 Painter in great Queen Street
 Lincoln inn fields
 London

Sir,—No doubt you have long ago heard of the Death of Mr. Smibert, and which I ought to have acquainted you of before now, as I know the regard you had for him & yᵉ obligations we are under to you. He had been for many years in a Declining State of health, and for some years unable to paint at al, but to yᵉ last preserved his cheerfulness & serenity of temper, free from al uneasiness & happy in his family. He has Left a Widow and three sons, yᵉ eldest is apprentice to a Merchant, yᵉ second inclines to Painting & seems to me of a Promising Genius, yᵉ youngest is at yᵉ Grammar School. my Honest Uncle never was rich, but Lived always handsomely & with great reputation. He hath left enough I hope with prudent management to put his Children in yᵉ way of doing well in yᵉ world & which you may easily think I am not unconcerned about.

a friend here who valued Mr. Smibert much, has wrote a Character or Epita[p]h to be put on the Tomb. I have sent you a Copy of it for your opinion & your friends, it wil apear too long and perhaps might be shortned to advantage. I shal be glad of your opinion of it & would acquaint you that ever since Mr. Smibert died I have intended something should be erected to his memory. yᵉ tomb Joins to a wall which will admit of but a smal monument, yᵉ measure of which will now be sent. Mr. Scheemaker was Mr. Smibert's friend & therefore yᵉ properest person to apply to, what I would desire to be done, is yᵉ Inscription on Marble with some little ornament as you & Mr. Scheemaker shal think best, if it can be done for about twenty Guineas

and should be glad of two or three diferent drawings that we might choose from, what pleases best here. I am a stranger to ye expence of marble monuments but as this is only ye marble and ye writting & some litle ornament, perhaps it may be done for near that money. however I am forced to take the freedom to trouble you in this affair for there are none of Mr. Smiberts friends who can so well direct me in this affair as you & I suppose you are no stranger to Mr. Sheemaker but must be acquainted with him.

I am ashamed further to trouble you with ye inclosed Bills of Exchange one for fifty and ye other for twenty Pounds, to lay out in sundry articles as per Invoice anexed, the remittance is made ye larger that we may not soon give you the like trouble. my Aunt & I Jointly cary on the Collour business & every thing goes on as in my Uncles life time. Gratitude obliges me to do al I can for ye interest of so worthy a Persons familly as wel as ye nearnes of my Relation. if this Commission could be made easier to you for ye future by applying to ye Fann man & some of ye other people directly, you wil please to direct me, ye Bill for fifty pounds is drawn by so good a man as that its certain wil be duly honoured, nor do I doubt ye other Bill being so too, but in case that should be protested must desire you to get ye whole of ye Fann Mounts sent & the remainder in Prussian Blew, for as we are near out of Fann mounts it would be of great advantage could you favour us with them by the first ship after you receive the money, and let the whole value be insured. I wish ye taste here was good eneough for ye Prints of your Landskips, etc. but there are few virtuosi here, ye Roman Ruins pleases & now & then there are a customer for them. Mrs. Smibert with her Sons Joins me in their Respects to you. I shal be obliged for your ordering the cargo particularly the Fan mounts as soon as possible. I am with the greatest respect Sir, your most obliged Humble ser't,

JOHN MOFFATT.

one Bill of Exch. drawn by Peter Bulkeley on
 Christopher Kilby Esqr. for £20.0.0
one Do. drawn by John Erving Esqr. on Mr.
 William Hodshon for 50.0.0
 Sterling £70.0.0
Invoice of the particulars, ye above Bills are desired to be laid out in & marked S. M.

	no.	
Ordinary white Fan mounts 5 groce		@ 5/
Plain printed mounts 16 groce		@ 8/
Colloured mounts	8 groce	@ 12/
Do	8 groce	@ 18/
Colloured mounts	& guilt 1 groce	@ 30/
Do	1 groce	@ 36/
Do	6 doz	@ 6/
Do.	2 doz	@ 10/
Do.	2 doz	@ 12/
Black & white mounts	1 groce	@ 12/
Do	2 groce	@ 18/
Do	1 groce	@ 24/
Black mounts 3 groce @ 12/		2 12/
Do	1 groce	@18

Childrens mounts Collored 3 groce about 8/ or 9/
the 4 Prints of ye Roman Buildings & Ruins by
 Panini twelve of each print
Prussian Blew 6 1. about 18/ or 20/ per pound
Carmine 1 OZ
Stone knives 1 doz.
Pallet Do 1 doz.
Black Lead pencils 6 doz chiefly large sort
3/4 Primed Cloathes 3 doz.
Kitkat Do. 1 doz.
Gold leaf 2000 & some gold Beatters skin
Crayons to the value of a Guinea
Black chalk & some French Chalk about 5/ or 6/
 worth.

If there should not be Fan mounts exactly of ye above prices, please to do what you think best, only that they be near ye above prices, what is now wrote for wil I imagine, with the Insurance, Cases & shipping Charges etc. be near about the £70.0.0 now remitted, if there be any Left it may be laid out in gold leaf, Pruss. Blew or ye plain printed mounts, either of them as wil be ye least trouble.

The tomb Joins to the Brick wal of ye Burying ground & wil admit a monument of a little more than 5 foot wide, but as the wal is but Low I believe 5 foot wide wil be sufficient to alow for a proper heighth, the Inscription wil require a large piece of Marble & that is what I principaly regard. as for any show I would avoid it & desire what litle ornaments can be afforded to be in ye plain & good taste, which you wil please to direct Mr. Scheemaker, and to favour us with 2 or 3 sketches with ye Estimate of ye charge, that so we may choose what wil please best here. Mr. Smibert had a great friendship for Mr. Scheemaker to whom please to give my service. I doubt not but He wil readily do what is in his power to ye memory of ye deceased.

(Arthur Pond to John Moffatt, Department of Manuscripts, British Library, London)

 To Mr. John Moffatt Boston, New England
 By ye Devonshire, Capt. Jacocks.
London, May 10, 1757.
Sir,—Your letter of the 15th Decr. came to my hands ye latter end of february, and I have this day sent the two boxes to be shiped in two different Ships being the last which go this Spring. you have only one sort of Prussian Blew of a fine deep Sort and I could now [not] get any other I liked ready made; I could not under a fortnight get any flake white, without going to the Collour Shops, who sell it dear, but have sent one pound for the present. many things are so dear on account of ye war and ye Insurance so high Your money is all laid out, if you want more of any of ye articles I shal get them on your Order .not knowing where

directly to get any Indian Ink at a good hand, have put up one Stick of my own which desire you to accept of.

I am Sir your most humble Sert.

ART. POND

Some of the things I divided by Gues Consequently not exactly equal.

Porter & Shipping last cargo Six Shillings remained in my hands...............	0–14–9
A Bill now Sent......................	60–0–0
	£60–14–9

the word Painter is not necessary in my direction, and I may leave [it] off.

Fann Mounts........................	38–15–0
Carmine one oz very fine..............	1–1
two doz stone knives	1–4–0
one doz pallet knives	0–6–0
four pounds fine Prussn. Blew 18/.......	3–12–0
two pounds English Safron 1–14–0......	3–8–
one pound flake white 0–1–4	0–1–4
one pound French Sap Green...........	0–13
one pound Distiled Verdigres	0–15
Boxes, Porter & packing	0–14–6
Insurance on two pollicys	9–18–0
	60–7–10
Ballance...................	6–11
	60–14–9

part of the Insurance to be returned if with Convoy
Shipping charges to be paid

(Department of Manuscripts, British Library, London)

Boston New England, Jully 2ᵈ 1759
Gentlemen,—I lately Saw an advertisement in a London news paper of ye Sale of Mr. Ponds Collection by Order of His Executors.

Mr. Ponds death gives me much concern as I am under great obligations and have received many favours from him. but I should not have troubled you with a Letter were it not on account of Some goods He was to Ship for me. ye state of ye affair is Just this. Decr. 15th 1756 I wrote Mr. Pond & inclosed a Bill of Exch. for £60.0–0 Sterling and febr. 10th 1757 I again wrote him with a Copy of ye articles wrote for & the 2nd. of ye Bill and no doubt you wil find those Letters amongst his papers. Mr. Pond favoured me with an answer dated may 10th 1757 a Copy of which is here unto anexed by which you wil see he did not mention in what Ship the other half of ye goods were to be sent and as I never heard further from him, concludes ye Ship must either have been taken or Lost. now as you have the Pollicy it wil be easy to know by what Ship and if either taken or Lost there can be no difficulty in getting ye Insurance paid. this is the reason of writing you Gentn desiring you wil be so kind as to receive the Insurance for me as you have the Pollicy, ye Bearer Mr. James Erving of this place wil be very ready to Assist in ye affair and when you have received the money, please to pay it to Mr. Erving who wil pay the charges arissing and give you ye proper discharge. I must desire another favour more and that is to let Mr. Erving know of whom Mr. Pond used to buy the Fann mounts for I have given Mr. Erving a Commission to get me a parcel of ye same person if you can direct him to ye man. I hope you will excuse this trouble & if ever it is in my Power to do any Service for any of Mr. Ponds friends in this part of ye World it would give me a Singular Satisfaction to Gentlemen your most obedient Humble Sert.

JOHN MOFFATT.

P.S. The goods by Capt. Jacocks came Safe.
To the Executtors of the Will
of the Late Mr. Arthur Pond
in London.

The Administration and Inventory of Smibert's Estate

Smibert died intestate. The administration of probate and the inventory of his estate is recorded in the Suffolk County Probate Records, Suffolk County Court House, Boston, vol. 45, pp. 359–360, and vol. 46, p. 552:

Edward Hutchinson Esq. Commissioned by his Excellency William Shirley Esq Captain General and governor in Chief in and over his Majesty's Province of the Massachusetts Bay in New England by and with the Advice and Consent of the Council to be Judge of the Probate of wills & for granting Letters of Admisn on the Estates of Persons deced having Goods Chattels Rights or Credits in the County aforesᵈ Suffolk within the Province aforesaid. To Mary Smibert Widow & John Moffatt Painter both of Boston in the County aforesaid Painter deced, having while he lived and at the time of his Decease Goods Chattels, Rights or Credits in the County aforesaid, lately died Intestate whereby the Power of committing Admᶜion and full Disposition of all and Singular the Goods, Chattels, Rights & Credits of the said deced and well and faithfully to dispose of the same according to Law, and also to Ask, gather Levy recorer & receive all and whatsoever credits of the said deced, which to him while he lived & at the time of his Death did appertain, and to pay all Debts in which the said deced stood bound, so far as his Goods, Chattels, Rights and Credits can extend according to the value thereof, & to make a true & perfect Inventory of all and Singular the Goods, Chattels, Rights & Credits & to Exhibit the same into the Registry of the Court of — Probate for the County aforesaid at or before the sixth Day of Decʳ next ensuing: & to render a plain & true Account of your said admᵒion upon Oath at or before the sixth Day of Sepʳ which will be in the year of Our Lord One Thousand Seven hundred & fifty two, and I Do hereby Ordain, Constitute & appoint you admᵒors of all and Singular the Goods Chattels Rights & Credits aforesaid In testimony where of I have here onto set my Hand & Seal of the Court of Probate Dated at Boston the Sixth Day of Septʳ Amony Dom 1751

Andʷ Belcher Reg r. Edw. Hutchinson

The Inventory of the Estate of Mr. John Smibert, late of Boston Painter, deced taken by us the Subscribers in February, 1752.

The easterly half of the House and Land in Queen Street .	£446.13.4
Fourteen acres of land in Roxbury	186.13.4
A House lott of land in Westerly part of Boston .	10.
Plate, 109 oz. & 15 penny wt	36. 6.4.
Silver watch and seal & 2 rings	8. 2.8.
Wearing apparel 12.12, Library 11.18.5 . . .	24.10.5
Fire arms & silver hilted sword	3.17.4
Colours & Oyls 307.16.5 35 portraits 60.5.4	368. 1.9.
41 History Pieces & pictures in that Taste . .	16. 0.0.
13 Landskips 2.13. 2 Conversation Pictures 23.6.8 .	25.19.8
Bustoes & figures in Paris plaister & models	4. 5.8
Prints and Books of Prints 11.12.8 Drawings 4.16 .	16. 8.8
Pillows, prospect glass & magnifying glass, foyles & flutes .	1.11.4
An Eight Day Clock 9.6.8 Desk and book case £8. .	17. 6.8
Escrutore £2. Table linnen 9.18.8 Sheeting do £16.9.11 .	28. 8.7
Two pieces of brown linnen	5.15.8
4 feather Beds Bolsters & pillows Bedsteads & Curtains .	21. 6.8
3 feather Beds Bolsters & pillows Bedsteads	8. 0.0
12 pr. of Blankets & 3 Rugs	3.12.0
Two silk quilts & a coverlid	4.13.4
five Looking Glasses 6.17	11.10.8
China and Earthen ware	3.17.4
Three Chests of Drawers & 1 table 5.13 4 Easy chairs & Couch 1.17.4	7.10.8
three doz & 10 chairs 12.3.4. Ten tables 4.6 5 carpets 2.4. .	18.13.4
Pewter 8.9.2 Iron and tin ware 11.2.11	19.12.1
Brass and Copper Ware.	13.19.2
Bell metal skillits 49/2 oz.	2.12.9

Gross of glass bottles 1.2 Lumber in the Gar-
rett 2.1.4 . 3.13.4
Negro girl Phillis 25.13.4. Horse chaise &
runners 24.5.4 . 50.18.8
Cloaths press, Chest, Boxes, Brushes, Bas-
kets, Bellows. 1.16.8
 £1387. 4.9

David Cutler Joseph Gale Jn° Greenwood
Suffolk Cy By the Hon^{ble} Thomas Hutchinson Esq Judge
of Probate & Mary Smibert & John Moffatt Adm^{rs} pre-
sented the within written & made oath that it Contains &
perfect Inventory of the Estate of John Smibert deced So
far as hat come to their Knowledge & that if more hereafter
Appears they will cause ye same to be added. The Subscrib-
ing appraisers were also sworn as the law directs.
 T Hutchinson
Boston Sept^r: 22 1752
 Exam^d

APPENDIX 4

Smibert's Epitaph

When John Moffatt wrote to Arthur Pond on December 28, 1752 (see app. 2) to place an order for goods, he also informed him of Smibert's death. Moffatt requested Pond's assistance in having a "smal monument" carved, and enclosed the following epitaph written by "a friend here who valued Mr. Smibert much," which he asked to have cut into the stone. The original Latin is followed by an English translation by Henry Wilder Foote (Foote 1950, pp. 106–107, 249–250):

EPITAPH

Quis Desiderio sit Pudor, aut modus
Tam Chari Capitis? Hor:

In Tumulo hocce contiguo Conditur quicquid caducum et mortale habuit, Vir Optimus Joannes Smibert Pictor celeberrimus cujus in Arte sua Laudes debitas, etiam Italia, picurae alma Nutrix, olim agnovit. In Brittania vero, Superiorem haud temere invenies, — quales minime multos. Quin mirum, igitur, si in America, quam, Salutis gratia, Natali praetulit solo, ne vel Æmulum invenit aut reliquit: Quorum argumenta diutina, ex Senentia optimorum Judicum, Imagines plurimae, multa cum Arte et Scientia, Manu sua eleganter depictae.

Sed quanta quanta sit haec Laus, opposita tamen Moribus suis eximiis, prope nulla est. In his enim colendis maxime studium Operamque foeliciter collocavit, Qui in omni Vitae Statu verae et infucatae Virtutis Examplar edidit. Hominum nempe, Communitatis, Membrum inprimis dignum, si quidem hoc efficitur, Vitae, Solertiâ Integritate immaculatâ, Indole placidâ, benignâ et humanâ unà cum Morum Facilitate et Simplicitate jucundâ atque ingenuâ. Maritus, Parens, amantissimus; officiorum in suos quosque Observantissimus; Amicus, porro, sincere Benevolus, Fidus, Constans, Coronidis denique loco, Is, cujus universa Vita praedicabat. Animum intime imbutum Reverentia et Charitate in DEUM O.M. *Cujus Cultur assiduus devotissimusque extitit, nec non Vera Fide et Spe Vivida in Christum Jesum: Quibus Animam piam Suffultus, Deo, qui dedit, Tranquillus et Laetus, reddidit, IV° Non: Aprilis, Anno Ærae Christianae Vulgaris M, DCC, LI.*

Natus erat Edinburgi Britannorum Septentrionalium IX° Kal. Aprilis Anno M, DC, LXXX, VIII, Parentibus honestis Oriundus. Uxorem, quam charam semper habuit, utpote vere piam et amandam, nunc, proh dolor! viduam maerentem, duxit III°. Kal. Augusti, Anno M, DCC, XXX, Mariam, Filiam natu maximam Reverendi Doctique Viri, olim Vita functi, Nathanaelis Williams,

Bostoniensis: Cujus Conjugii Proventus Septem Filii, duaequae Filiae, quorum Filii quatuor, duaeque Filiae, in eodem cum Patre requiescunt Tumulo; Caeteri Supersunt.

Lector, si Talem amare et imitari possis, Beatus evades.

EPITAPH

Why should there be shame or limits to the longing for one so dear?—Hor. *Carmina* I, xxiv

In the adjacent tomb are buried the frail and mortal remains of the excellent man, John Smibert, a famous painter, to whose art, even Italy, dear nurturing mother of painting, once recognized that praises were due. In Britain too, you will surely not find his superior, very few who are his equal. It is therefore not strange if in America, which he preferred for health's sake to his native soil, he neither found nor left a rival. Because of their great art and skill, numerous pictures, painted with elegance by his hand, will offer, in the estimate of the best judges, enduring proof of these facts.

But however great this praise of him, it is little compared to his excellent character. Particularly in the cultivation of his character, he combined in felicitous manner zeal and effort, and in all circumstances of life, was an exemplar of true and unadorned virtue. He was a singularly worthy member of the community by reason of his unstained integrity of life, a calm, kindly, and humane nature, together with an affability in behavior, and a pleasing and ingenuous simplicity. He was an affectionate husband and parent, mindful of his duties to each member of his family, friendly, sincerely helpful, loyal, and stable; in sum, his whole life was a sermon. His soul was deeply imbued with reverence and love of God in his greatness and goodness., In his worship he was steadfast and very devoted, with true faith and a living hope in Christ Jesus. Supported by these, happy and at peace, on the second day of April in the year 1751 of our Christian era, his pious spirit was returned to God who had given it.

He was born of honest parents at Edinburgh in Northern Britain on the twenty-fourth day of March in the year 1688. He married his wife, Mary, whom he ever cherished, truly a dutiful woman, worthy of his love, and now, alas, his grief-stricken widow, on the thirtieth day of July in the year 1730.

She was the eldest daughter of a reverend and learned man, formerly departed this life, Nathaniel Williams of Boston. Of this union were born seven sons and two daughters, of whom four sons and two daughters rest in the same tomb with their father; the others survive.

Reader, if you can cherish a man such as this and seek to be like him, you will be ever blessed.

References

Allen 1933 Robert Joseph Allen, *The Clubs of Augustan London*. Cambridge. Reprint 1967.

Apted and Hannabuss 1978 Michael R. Apted and Susan Hannabuss, eds., *Painting in Scotland, 1301–1700: A Biographical Dictionary*. Vol. 7. Edinburgh, Scottish Record Society.

Arnot 1779 Hugo Arnot, *A History of Edinburgh*. Edinburgh.

Ayres 1985 James Ayres, *The Artist's Craft: A History of Tools, Techniques, and Materials*. Oxford.

Bayley 1929 Frank W. Bayley, *Five Colonial Artists of New England: Joseph Badger, Joseph Blackburn, John Singleton Copley, Robert Feke, John Smibert*. Boston.

Belknap 1953 Waldron Phoenix Belknap, "Feke and Smibert: A Note on Two Portraits." *Art Bulletin*, vol. 35, pp. 225–226.

Belknap 1959 Waldron Phoenix Belknap, *American Colonial Painting: Materials for a History*. Cambridge, Mass.

Berkeley 1784 George Berkeley, *The Works of George Berkeley D.D. Late Bishop of Cloyne in Ireland. To Which is Added, an Account of his Life, and Several of his Letters to Thomas Prior, esq., Dean Gervais and Mr. Pope. . . .* Dublin.

Berkeley 1948–1957 George Berkeley, *Works*. Edited by A. A. Luce and T. E. Jessop. 9 vols. London.

Berman and Berman 1982 David Berman and Jill Berman, "The Fountain Portraits of Bishop Berkeley." *Apollo*, vol. 115, pp. 76–79.

Black 1979 Mary Black, "Tracking Down John Watson." *American Art and Antiques*, vol. 2, no. 5 (September–October), pp. 78–85.

Bolton 1919–1926 Charles K. Bolton, *The Founders: Portraits of Persons Born Abroad Who Came to the Colonies in North America before the Year 1701*. 3 vols. Boston.

Bolton 1933 Theodore Bolton, "John Smibert: Notes and Catalogue." *Fine Arts*, vol. 20, pp. 11–15, 39–42.

Bolton 1939 Charles K. Bolton, "John Smibert's Date of Birth." *New England Quarterly*, vol. 12, pp. 375–376.

Boston 1930 *Loan Exhibition of One Hundred Colonial Portraits*. Museum of Fine Arts. Boston.

Boston 1969 *American Paintings in the Museum of Fine Arts, Boston*. 2 vols. Museum of Fine Arts. Boston.

Boston Selectmen 1885 Report of the Record Commissioners, W. H. Whitmore and W. S. Appleton. Vol. 14, *Boston Town Records, 1742–1757*. Boston.

Boston Selectmen 1886 Report of the Record Commissioners, W. H. Whitmore and W. S. Appleton. Vol. 15, *Records of Boston Selectmen, 1736–1742*. Boston.

Boston Selectmen 1887 Report of the Record Commissioners, W. H. Whitmore and W. S. Appleton. Vol. 17, *Selectmen's Minutes, 1743–1753*. Boston.

Bowdoin 1870 *Catalogue of the Bowdoin Collection of Paintings, Bowdoin College*. Brunswick, Me.

Bowdoin 1885 *Catalogue of the Bowdoin College Art Collections*. Brunswick, Me.

Bowdoin 1906 *Decriptive Catalogue of Art Collections at Bowdoin College*. Brunswick, Me.

Bowdoin 1930 *Descriptive Catalogue of the Art Collections at Bowdoin College*. Brunswick, Me.

Bowdoin 1950 *An Illustrated Handbook of the Bowdoin College Museum of Fine Arts in the Walker Art Building, Brunswick, Maine*. Brunswick, Me.

Bowdoin 1981 Bowdoin College Museum of Art, *Handbook of the Collections*. Brunswick, Me.

Bridenbaugh 1932 Carl Bridenbaugh, "High Cost of Living in Boston, 1728." *New England Quarterly*, vol. 5, pp. 800–811.

Bridenbaugh 1938 Carl Bridenbaugh, *Cities in the Wilderness: The First Century of Urban Life in America, 1625–1742*. New York.

Bridenbaugh 1948 Carl Bridenbaugh, ed., *Gentleman's Progress: The Itinerarium of Dr. Alexander Hamilton, 1744*. Institute of Early American History and Culture at Williamsburg, Va. Chapel Hill, N.C.

Bridenbaugh 1962 Carl Bridenbaugh, *Mitre and Sceptre: Transatlantic Faith, Ideas, Personalities, and Politics*. New York.

Brown 1900 Abram E. Brown, *Faneuil Hall and Faneuil Hall Market, or Peter Faneuil and His Gift*. Boston.

Brown 1945 Frank C. Brown, "John Smibert, Artist, and the First Faneuil Hall." *Old Time New England*, vol. 36, pp. 61–63.

Brown 1980 Iain Gordon Brown, *Sir John Clerk of Peni-*

cuik (1676–1755): Aspects of a Virtuoso Life. Ph.D. diss., Cambridge University.

Brown 1987 Iain Gordon Brown, *The Clerks of Penicuik: Portraits of Taste and Talent*. Edinburgh.

Brunton and Haig 1849 George Brunton and David Haig, *An Historical Account of the Senators of the College of Justice of Scotland, from Its Institution in MDXXXII*. Originally by Sir David Dalrymple Hailes. Re-edited and continued, with biographical sketches and copious indexes. Edinburgh.

Buhler 1970 Kathryn C. Buhler and Graham Hood, *American Silver: Garvan and Other Collections in the Yale University Art Gallery*. 2 vols. New Haven.

Burke 1976 Joseph Burke, *English Art, 1714–1800*. Oxford.

Burke's Peerage 1970 *Burke's Peerage*. Edited by Peter Townsend. London.

Burroughs 1936 Alan Burroughs, *Limners and Likenesses: Three Centuries of American Painting*. Cambridge.

Burroughs 1942 Alan Burroughs, "Notes on Smibert's Development." *Art in America*, vol 30, pp. 109–121.

Burroughs 1943a Alan Burroughs, *John Greenwood in America, 1745–1752*. Andover.

Burroughs 1943b Alan Burroughs, "Paintings by Nathaniel Smibert." *Art in America*, vol. 31, pp. 88–97.

Caldwell and Rodriguez Roque 1994 John Caldwell and Oswaldo Rodriguez Roque, *American Paintings in the Metropolitan Museum of Art*. Vol. 1.

Caw 1908 James L. Caw, *Scottish Painting Past and Present, 1620–1908*. Edinburgh.

Champlin and Perkins 1913 John Denison Champlin, Jr., ed., and Charles C. Perkins, critical ed., *Cyclopedia of Painters and Paintings*. 4 vols. New York.

Chappell 1982 Miles L. Chappell, "A Note on John Smibert's Italian Sojourn." *Art Bulletin*, vol. 14, no. 1, pp. 132–138.

Clerk 1892 Sir John Clerk, *Memoirs of the Life of Sir John Clerk of Penicuik, Baronet, Baron of the Exchequer, Extracted by Himself from His own Journals, 1676–1755*. Edited from the manuscript in Penicuik house with an introduction and notes, by John M. Gray. Edinburgh.

Coburn 1929 F. W. Coburn, "John Smibert." *Art in America*, vol. 17, no. 4, pp. 175–187.

Colden 1918–1937 New-York Historical Society Collections, *The Letters and Papers of Cadwallader Colden, 1711–1775*. Vol. 2, *1730–1742*. New York.

Collins Baker 1951 Charles Henry Collins Baker, review of *John Smibert, Painter*, by Henry Wilder Foote. *Connoisseur*, vol. 128, p. 123.

Colston 1891 James Colston, *The Incorporated Trades of Edinburgh, with an introductory chapter on the rise and progress of municipal government in Scotland*. Edinburgh.

Colum 1935 Padraic Colum, "Berkeley and the Modern Artist." *Saturday Review of Literature*, vol. 12, no. 7, pp. 3–4, 14–15.

Colvin 1954 Howard Montagu Colvin, *A Biographical Dictionary of English Architects, 1660–1840*. Cambridge.

Conroy 1971 Graham P. Conroy, "George Berkeley and the Jacobite Heresy: Some Comments on Irish Augustan Politics." *Albion*, vol. 3, no. 2, pp. 82–91.

Copley-Pelham 1914 *Letters and Papers of John Singleton Copley and Henry Pelham, 1739–1776*. Edited by Guernsey Jones. Vol. 71. Massachusetts Historical Society. Boston.

Corbett and Norton 1964 Margery Corbett and Michael Norton, *Engraving in England in the Sixteenth and Seventeenth Centuries: A Descriptive Catalogue with Introductions*. Cambridge, Eng.

Cowan 1923 William Cowan, "The Maps of Edinburgh, 1544–1851." *Book of the Old Edinburgh Club*, vol. 12, pp. 209–248.

CP Public Record Office, London. Chancery Masters' Exhibits, Curgenven v. Peters (C. 106-193).

Craven 1986 Wayne Craven, *Colonial American Portraiture*. Cambridge, Eng.

Croft-Murray 1962 Edward Croft-Murray, *Decorative Painting in England, 1537–1837*. Vol. 1. London.

Croft-Murray 1970 Edward Croft-Murray, *Decorative Painting in England, 1537–1837*. Vol. 2. Feltham, Middlesex.

Cunningham 1947 Cecil Willet and Phillis Cunningham, *Handbook of English Costume in the Eighteenth Century*. London.

Dalton 1910–1912 Charles Dalton, *George the First's Army, 1714–27*. 2 vols. London.

Defoe 1724–1726 Daniel Defoe, *A Tour Thro' the Whole Island of Great Britain*. 2 vols. 1724–1726. Reprint. 2 vols. New York and London.

Detroit 1959 Detroit Institute of Arts, *Portraits of Eight Generations of the Pitts Family, from the Seventeenth to the Twentieth Century*. Exhibition catalog. Detroit.

Detroit 1974 Detroit Institute of Arts, *The Twilight of the Medici: Late Baroque Art in Florence, 1670–1743*. Exhibition catalog. Detroit.

DAB 1928–1937 *Dictionary of American Biography*. Edited by Dumas Malone, under the auspices of the American Council of Learned Societies. 22 vols. New York. Reprint. Edited by Allen Johnson and Dumas Malone. 11 vols. 1964. New York.

DNB 1885–1901 *Dictionary of National Biography*. Edited by Sir Leslie Stephen and Sir Sidney Lee. 66 vols. London.

Dolmetsch 1970 Joan Dolmetsch, "Prints in Colonial America: Supply and Demand in the Mid-Eighteenth Century." In *Prints in and of America to 1850*. Winterthur, Del.

Dow 1927 George Francis Dow, *Arts and Crafts in New England 1704–1775, Gleanings from Boston Newspapers Relating to Painting, Engraving, Silversmiths, Pewterers, Clockmakers, Furniture, Pottery, Old Houses, Costume, Trades and Occupations, &c. . . .* Topsfield, Mass.

Drake 1856 Samuel G. Drake, *The History and Antiquities of Boston, from Its Settlement in 1630 to the Year 1770*. Boston.

Dresser 1935 Louisa Dresser, ed., *Seventeenth Century*

Painting in New England. Worcester Art Museum. Worcester, Mass.

Dresser 1959 Louisa Dresser, "The Ferne Portraits: Two English Paintings by John Smibert." *Worcester Art Museum Annual*, vol. 7, pp. 12–19.

Dunlap 1918 William Dunlap, *A History of the Rise and Progress of the Arts of Design in the United States.* New ed., edited by Frank W. Bayley and Charles E. Goodspeed. 3 vols. Boston. 1st ed., 1834.

Einberg and Egerton 1988 Elizabeth Einberg and Judy Edgerton, *The Age of Hogarth. British Painters Born 1675–1709.* Seattle.

Eliot 1937 Samuel A. Eliot, "A Cradle of Liberty, Being the Story of the West Church in Boston, 1737–1937." *Proceedings of the Unitarian Historical Society*, vol. 5, pt. 2, pp. 1–13.

Englefield 1923 William Alexander Devereux Englefield, *The History of the Painter-Stainers Company of London.* London.

Essex Institute 1936 Essex Institute, *Catalogue of the Portraits in the Essex Institute.* Salem, Mass.

Evans 1982 Dorinda Evans, *Mather Brown, Early American Artist in England.* Middletown, Conn.

Evans 1956 Joan Evans, *A History of the Society of Antiquaries.* Oxford.

Feld 1963 Stuart P. Feld, "In the Latest London Manner." *Metropolitan Museum of Art Bulletin*, vol. 21, no. 9, pp. 296–309.

Fleming 1961 John Fleming, "Sir John Medina and His 'Postures.'" *Connoisseur*, vol. 148, pp. 22–25.

Flexner 1947 James T. Flexner, *First Flowers of Our Wilderness.* Boston.

Fogg Art Museum 1972 Fogg Art Museum, *American Art at Harvard.* Exhibition catalog. Cambridge.

Foote 1930 Henry Wilder Foote, *Robert Feke, Colonial Portrait Painter.* Cambridge.

Foote 1935 Henry Wilder Foote, "Mr. Smibert Shows His Pictures, March, 1730," *New England Quarterly*, vol. 8, pp. 14–28.

Foote 1950 Henry Wilder Foote, *John Smibert, Painter.* Cambridge, Mass.

Foskett 1972 Daphne Foskett, *A Dictionary of British Miniature Painters.* 2 vols. London.

Foster 1889 Joseph Foster, *The Register of Admissions to Gray's Inn, 1521–1889, together with the Register of Marriages in Gray's Inn Chapel, 1695–1754.* London.

Fraser 1871 Alexander Campbell Fraser, *The Life and Letters of George Berkeley.* 4 vols. Oxford.

Friedman 1984 Terry Friedman, *James Gibbs.* New Haven.

Fussell 1974 George Fussell, *James Ward, R.A., Animal Painter, 1769–1859, and His England.* London.

Gardner and Feld 1965 Albert TenEyck Gardner and Stuart P. Feld, *American Paintings: A Catalogue of the Collection of the Metropolitan Museum of Art.* Vol. 1, *Painters born by 1815.* New York.

Gaustad 1979 Edwin Scott Gaustad, *George Berkeley in America.* New Haven.

George 1925 M. Dorothy George, *London Life in the Eighteenth Century.* New York. Reprint. 1965. New York.

Gerdts and Burke 1971 William H. Gerdts and Russell Burke, *American Still-Life Painting.* New York.

Gibbs 1728 James Gibbs, *A Book of Architecture, Containing Designs of Buildings and Ornaments.* London.

Gifford 1989 John Gifford, *William Adam, 1689–1748: A Life and Times of Scotland's Universal Architect.* Edinburgh.

Goodyear 1974 Frank Goodyear, *American Paintings in the Rhode Island Historical Society.* Providence.

Graduates 1867 *List of the Graduates in Medicine in the University of Edinburgh from MDCCV. to MDCCCLXVI.* Edinburgh.

Graham 1909 Henry Grey Graham, *The Social Life of Scotland in the Eighteenth Century.* London. Reprint. London. 1950.

Graham 1956 Ian Charles Cargill Graham, *Colonists from Scotland: Emigration to North America, 1707–1783.* Ithaca, N.Y.

Grant 1700 Francis Grant (Lord Cullen), *A Brief Account of the Nature, Rise, and Progress, of the Societies for Reformation of Manners &c in England and Ireland; with a Preface Exhorting to the use of Such Societies, In Scotland.* Edinburgh.

Gray 1892 *Memoirs of the Life of Sir John Clerk of Penicuik, Baronet Baron of the Exchequer. Extracted by Himself from His Own Journals, 1676–1755.* Edited from the manuscript of Penicuik house with an introduction and notes by John M. Gray. Edinburgh.

Green 1866 John Green, *Evan's Music and Supper Rooms, Covent Garden, plus odds and ends about Covent Garden and its vicinity, the ancients drama, the early English divinity and controversial plays, &c; compiled from various sources by John Green, also a selection of madrigals, glees, songs, choruses, &c., sung . . . in the above rooms. . . .* London.

Grimm 1981 Claus Grimm, *The Book of Picture Frames.* New York.

Gunnis 1968 Rupert Gunnis, *Dictionary of British Sculptors, 1660–1851.* London.

Gwyn 1974 Julian Gwyn, *The Enterprising Admiral: The Personal Fortune of Admiral Sir Peter Warren.* Montreal.

Hagen 1940 Oskar Frank Leonard Hagen, *The Birth of the American Tradition in Art.* Port Washington, N.Y.

Hallam 1990 John Hallam, "The Eighteenth-Century American Townscape and the Face of Colonialism." *Smithsonian Studies in American Art*, vol. 4, nos. 3–4 (Summer/Fall), pp. 145–162.

Hamilton-Phillips 1985 M. Hamilton-Phillips, review of *Sir Godfrey Kneller and the English Baroque Portrait*, by J. Douglas Stewart. *Art Bulletin*, vol. 67, no. 2, pp. 337–339.

Harris 1979 John Harris, *The Artist and the Country House: A History of Country House and Garden View Painting in Britain, 1540–1870.* London.

Harris 1966 Neil Harris, *The Artist in American Society: The Formative Years, 1790–1860.* New York.

Haskell and Penny 1981 Francis Haskell and Nicholas

Penny, *Taste and the Antique: The Lure of Classical Sculpture, 1500–1900*. New Haven.

Hill 1890 Hamilton Andrews Hill, *History of the Old South Church (Third Church) Boston, 1669–1884*. 2 vols. Boston.

Holloway 1988 James Holloway, *William Aikman 1682–1731*. Edinburgh.

Holloway 1989 James Holloway, *Patrons and Painters, Art in Scotland 1650–1760*. Edinburgh.

Honour 1954 Hugh Honour, "John Talman and William Kent in Italy." *Connoisseur*, vol. 134, pp. 3–7.

Honyman 1939 Robert Honyman, *Colonial Panorama, 1775: Dr. Robert Honyman's Journal for March and April*. Edited by Phillip Padelford. San Marino, Ca.

Hope 1989 Valerie Hope, *My Lord Mayor*. London.

Houghton, Berman, and Lapan 1986 Raymond W. Houghton, David Berman, and Maureen T. Lapan, *Images of Berkeley*. Dublin.

Huntsinger 1936 *Harvard Portraits: A Catalogue of Portrait Paintings at Harvard University*. Compiled by Laura Huntsinger. Edited by Alan Burroughs. Cambridge, Mass.

Ireland 1794–1799 Samuel Ireland, *Graphic Illustrations of Hogarth, From Pictures, Drawings, and Scarce Prints in the Possession of Samuel Ireland, Author of this Work*. 2 vols. London.

Irwin 1975 David Irwin and Francina Irwin, *Scottish Painters at Home and Abroad, 1700–1900*. London.

Jackson 1932 Joseph Jackson, *Encyclopedia of Philadelphia*. National Historical Association. Harrisburg, Pa.

Jaffe 1975 Irma B. Jaffe, *John Trumbull, Patriot-Artist of the American Revolution*. Boston.

Jaffe 1976 Irma B. Jaffe, "Found: John Smibert's Portrait of Cardinal Guido Bentivoglio." *Art Journal*, vol. 35, no. 3, pp. 210–215.

Jarrett 1965 D. Jarrett, *Britain, 1688–1815*. New York.

JBIII Bowdoin College, Special Collections, Mss., "Catalogue of Pictures belonging to the Estate of the late Hon. James Bowdoin Esq. bequeathed by him to Bowdoin College."

Johnson 1924 Melvin M. Johnson, *The Beginnings of Freemasonry in America; Containing a Reference to All That Is Known of Free Masonry in the Western Hemisphere prior to 1750, and Short Sketches of the Lives of Some of the Provincial Grand Masters*. New York.

Jones 1930 E. Alfred Jones, *The Loyalists of Massachusetts, Their Memorials, Petitions and Claims*. London.

Keith 1883 Charles Penrose Keith, *The Provincial Councillors of Pennsylvania Who Held Office between 1733 and 1776, and Those Earlier Councillors Who Were Sometime Chief Magistrates of the Province and Their Descendants*. Philadelphia.

Kerslake 1965 John Kerslake, "The Date and Early Provenance of Smibert's George Berkeley." *Art Quarterly*, vol. 28, no. 3, pp. 144–153.

Kerslake 1977 John Kerslake, *National Portrait Gallery: Early Georgian Pictures*. 2 vols. London.

Killanin 1948 Lord Michael Morris Killanin, *Sir Godfrey Kneller and His Times, 1646–1723, Being a Review of English Portraiture of the Period*. London.

Kinghorn and Law 1987 Alexander M. Kinghorn and Alexander Law, "Allan Ramsay and Literary Life in the First Half of the Eighteenth Century." In *The History of Scottish Literature*, edited by Andrew Hook, vol. 2, pp. 65–79.

Kirby 1952 Paul Kirby, *The Grand Tour in Italy (1700–1800)*. New York.

Lassels 1698 Richard Lassels, *An Italian Voyage, or, A Compleat Journey Through Italy*. 2 pts. London. 1st ed., 1670.

Lee 1930 Cuthbert Lee, "John Smibert." *Antiques*, vol. 18, pp. 118–121.

Lee 1969 William Lee, *Daniel Defoe: His Life and Recently Discovered Writings. Extending from 1716 to 1729*. 3 vols., London. Reprint. New York, 1969.

Lewis 1961 Lesley Lewis, *Connoisseurs and Secret Agents in Eighteenth Century Rome*. London.

Lewis 1975 Alison Shepherd Lewis, *Joseph Highmore: 1692–1780 [An Eighteenth-Century English Portrait Painter]*. Ph.D. diss., Harvard University.

Lillywhite 1963 Bryant Lillywhite, *London Coffee Houses; A Reference Book of Coffeehouses of the Seventeenth, Eighteenth, and Nineteenth Centuries*. London.

Lincoln's Inn 1896 *The Records of the Honorable Society of Lincoln's Inn: Admissions from A.D. 1420 to A.D. 1893, and Chapel Registers*. Vol. 1. London.

Lippincott 1983 Louise Lippincott, *Selling Art in Georgian London*. New Haven.

Luce 1949 Arthus Ashton Luce, *The Life of George Berkeley, Bishop of Cloyne*. London.

Macky 1722 John Macky, *A Journey through England. In Familiar Letters from a Gentleman Here, to His Friend Abroad. . . .* 2nd ed. London.

MacMillan 1986 Duncan MacMillan, *Painting in Scotland: The Golden Age*, Oxford.

Maitland 1753 William Maitland, *The History of Edinburgh, from Its Foundation to the Present Time. . . .* 9 vols. Edinburgh.

Manners 1987 *Manners and Morals, Hogarth and British Painting, 1700–1760*. Exhibition catalog. London.

Mannings 1983 David Mannings, "Notes on Some Eighteenth-Century Portrait Prices in Britain." *British Journal of Eighteenth Century Studies*, vol. 6, pp. 185–196.

Marshall 1962 Dorothy Marshall, *Eighteenth Century England*. New York.

Marshall 1976 Rosalind K. Marshall, *Childhood in Seventeenth Century Scotland: The Scottish National Portrait Gallery, 19 August–19 September, 1976*. Exhibition catalog. Edinburgh.

Marshall 1988 Rosalind K. Marshall, *John de Medina, 1659–1710*. Edinburgh.

Martin 1931 Burns Martin, *Allan Ramsay: A Study of His Life and Works*. Cambridge, Eng.

Mathias 1959 Peter Mathias, *The Brewing Industry in England 1700–1830.* Cambridge, Eng.

McCorquodale 1979 Charles McCorquodale, "A Dark Century: the English Taste for Later Tuscan Painting." *Connoisseur,* vol. 200, pp. 170–176.

McElroy 1969 Davis Dunbar, *A Century of Scottish Clubs, 1700–1800.* Edinburgh.

Meyer 1984 Arline Meyer, *John Wootton, 1682–1764, Landscapes and Sporting Art in Early Georgian England.* London.

MFA 1969 Museum of Fine Arts, Boston, *American Paintings.* 2 vols. Boston.

MHS *Proc.* Massachusetts Historical Society, *Proceedings.* 1791–1981.

Miles 1983 Ellen G. Miles, "Portraits of the Heroes of Louisbourg, 1745–1751." *American Art Journal,* vol. 15, no. 1, pp. 48–66.

Monod 1989 Paul Kléber Monod, *Jacobitism and the English People, 1688–1788.* Cambridge, Eng.

Monymusk Papers 1945 *Selections from the Monymusk Papers (1713–1755).* Translated and edited by Henry Hamilton. Edinburgh.

Mooz 1968 R. Peter Mooz, "New Clues to the Art of Robert Feke." *Antiques,* vol. 94, no. 5, pp. 702–707.

Mooz 1970a R. Peter Mooz, "The Art of Robert Feke." Ph.D. diss., Univ. of Pennsylvania.

Mooz 1970b R. Peter Mooz, "Smibert's Bermuda Group—A Reevaluation." *Art Quarterly,* vol. 33, no. 2, pp. 147–157.

Morrison 1952 Hugh Morrison, *Early American Architecture: From the First Colonial Settlements to the National Period.* New York.

Murray 1980 Peter Murray, *Dulwich Picture Gallery: A Catalogue.* London.

Neal 1747 Daniel Neal, *History of New England, containing an impartial account of the civil and ecclesiastical affairs of the country, to the year of Our Lord, 1700. To which is added, the present state of New England. With a new and accurate map of the country. And an appendix containing their present charter, their ecclesiastical discipline, and their municipal-laws.* 2 vols.

NEHGS *Register* New England Historic Genealogical Society *Register.* 1847–1896.

New Haven 1949 *The Smibert Tradition.* Exhibition catalog. Yale University Art Gallery. New Haven.

Newport History 1968 "A John Smibert Letter in the Manuscript Collection of the Newport Historical Society." *Newport History,* vol. 41, pp. 45–49.

Nisser 1927 Wilhelm Nisser, *Michael Dahl and the Contemporary Swedish School of Painting in England.* Uppsala.

Norie 1890 Anonymous, *James Norie, Painter, 1684–1757.* Edinburgh. Privately printed.

Norton 1979 Bettina A. Norton, "Anglican Embellishments: The Contributions of John Gibbs, Junior, and William Price to the Church of England in Eighteenth

Century Boston." In *New England Meeting House and Church: 1630–1850,* edited by Peter Benes. Boston.

NYHS 1974 New-York Historical Society, *Catalogue of American Portraits in the New-York Historical Society.* 2 vols. New Haven.

Oliver 1960 Andrew Oliver, ed., *Faces of a Family.* Privately printed.

Oliver 1970 Andrew Oliver, "Smiberts Come to Light." *Antiques,* vol. 97, no. 6, p. 920.

Oliver 1973 Andrew Oliver, "Peter Pelham (c. 1697–1751), Sometime Printmaker of Boston." In *Boston Prints and Printmakers,* pp. 132–173. Boston.

Oliver, Huff, and Hanson 1988 Andrew Oliver, Millspaugh Huff, and Edward W. Hanson, *Portraits in the Massachusetts Historical Society.* Boston.

Ormond 1971 Richard Ormond, "Some Little Known English Paintings on Exhibition in Florence." *Connoisseur,* vol. 177, pp. 166–174.

Park 1917 Lawrence Park, "An Account of Joseph Badger, and a Descriptive List of His Work." *Proceedings of the Massachusetts Historical Society,* vol. 51, pp. 158–201.

Parsons 1856 Usher Parsons, *The Life of William Pepperrell, Bart, the only native of New England who was created a baronet during our connection with the mother country.* 2d ed. Boston.

Paton 1902 Henry Paton, ed., *Register of Interments in the Greyfriars Burying-Ground, Edinburgh, 1658–1700.* Scottish Record Society. Edinburgh.

Paton 1908 Henry Paton, ed., *The Register of Marriages for the Parish of Edinburgh, 1701–1750.* Edinburgh.

Paulson 1971 Ronald Paulson, *Hogarth: His Life, Art, and Times.* 2 vols. New Haven.

Peacham 1962 Henry Peacham, *The Compleat Gentleman: The Truth of Our Time, and the Art of Living in London.* Edited by Virgil B. Heltzel. Ithaca, N.Y.

Pears 1982 Iain Pears, "Patronage and Learning in the Virtuoso Republic: John Talman in Italy, 1709–1712." *Oxford Art Journal,* vol. 5, no. 1, pp. 24–30.

Pears 1988 Iain Pears, *The Discovery of Painting.* New Haven.

Pennsylvania Academy 1971 Pennsylvania Academy of Fine Arts, *Philadelphia Painting and Printing to 1776: An Exhibition in Conjunction with the Seventeenth Annual Winterthur Conference and with the Cooperation of the Historical Society of Pennsylvania.* Philadelphia.

Perkins 1878 Augustus T. Perkins, "Notes on Blackburn and Smibert." *Proceedings of the Massachusetts Historical Society,* vol. 16, pp. 392–399, 474–475.

Perkins 1879 Augustus T. Perkins, "Notes on Blackburn and Smibert," *Proceedings of the Massachusetts Historical Society,* vol. 17, pp. 94–97.

Petrie 1877 Adam Petrie, *The Works of Adam Petrie, the Scottish Chesterfield, MDCCXX–MDCCXXX.* Edinburgh. Printed for private circulation.

Pevsner 1940 Nikolaus Pevsner, *Academies of Art, Past and Present*. Cambridge, Eng.

Phillips 1964 Hugh Phillips, *Mid-Georgian London*. London.

Piper 1963 David Piper, *Catalogue of Seventeenth-Century Portraits in the National Portrait Gallery, 1625–1714*. Cambridge, Eng..

Piper 1975 David Piper, ed., *The Genius of British Painting*. New York.

Piper 1978 David Piper, *The English Face*. Reprint. London. 1st ed., 1957.

Plant 1952 Marjorie Plant, *The Domestic Life in Scotland in the Eighteenth Century*. Edinburgh.

Plumb 1975 J. H. Plumb, "The New World of Children in Eighteenth-Century England." *Past and Present*, vol. 67, pp. 64–95.

Porter 1982 Roy Porter, *English Society in the Eighteenth Century*. Harmondsworth, 1982.

Praz 1971 Mario Praz, *Conversation Pieces; A Survey of the Informal Group Portrait in Europe and America*. University Park, Pa., 1971.

Pricke 1679 Jean Dubreuil, *Perspective Practical (Diverses méthodes universelles . . . pour faire des perspectives)*. Translated by Robert Pricke. 2d ed. London, 1979.

Prown 1966 Jules David Prown, *John Singleton Copley*. 2 vols. Cambridge, Mass., 1966.

Prown 1970 Jules D. Prown, review of *The Notebook of John Smibert. Art Bulletin*, vol. 52, no. 3, pp. 330–331.

Quick 1981 Michael Quick, *American Portraiture in the Grand Manner, 1720–1920*. Exhibition catalog. Los Angeles and Washington, D.C.

Raines 1967 Robert Raines, *Marcellus Laroon*. London.

Raines 1980 Robert Raines, "Peter Tillemans, Life and Work, with a List of His Representative Paintings." *Walpole Society*, vol. 47, pp. 21–59.

Ramsay 1945–1974 *The Works of Allan Ramsay*. Edited by Martin, Oliver, Kinghorn, and Law. Edinburgh.

Ramsay 1965 George Daniel Ramsay, *The Wiltshire Woollen Industry in the Sixteenth and Seventeenth Centuries*. London.

Rand 1932 Benjamin Rand, *Berkeley's American Sojourn*. Cambridge.

Ribeiro 1983 Aileen Ribeiro, *A Visual History of Costume in the Eighteenth Century*. London.

Ribeiro 1984 Aileen Ribeiro, *The Dress Worn at Masquerades in England, 1730–1790, and Its Relation to Fancy Dress in Portraiture*. New York.

Richardson 1715 Jonathan Richardson, *An Essay on the Theory of Painting*, London.

Richardson 1722 Jonathan Richardson, *An Account of Some of the Statues, Bas-Reliefs, Drawings and Pictures in Italy, &c*. London.

Riley 1971 Stephen T. Riley, "John Smibert and the Business of Portrait Painting." In *American Painting to 1776: A Reappraisal*, pp. 159–180, Charlottesville, Va.

Rogers 1884 Charles Rogers, *Social Life in Scotland, from Early to Recent Times*. 3 vols. Edinburgh.

Rogers 1981 Malcolm Rogers, *John Closterman: Master of the English Baroque*. London.

Rogers 1983 Malcolm Rogers, "John and John Baptist Closterman: A Catalogue of Their Works." *Walpole Society*, vol. 49, pp. 224–279.

Ross and Brown 1916 Thomas Ross and G. Baldwin Brown, "The Magdalen Chapel, Cowgate, Edinburgh." *Book of the Old Edinburgh Club*, vol. 8, pp.1–78.

Rossi 1967 Filippo Rossi, *The Uffizi and Pitti*. New York.

Rouquet 1755 André Rouquet, *The Present State of the Arts in England*. London. Reprint. London. 1970.

Rowan 1972a Alistair Rowan, "House of Monymusk, Aberdeenshire." Part 1. *Country Life*, vol. 152, pp. 950–953.

Rowan 1972b Alistair Rowan, "House of Monymusk, Aberdeenshire." Part 2. *Country Life*, vol. 152, pp. 1046–1050.

Sadik 1966 Marvin S. Sadik, *Colonial and Federal Portraits at Bowdoin College*, Bowdoin College, Museum of Fine Arts. Brunswick, Me., 1966.

Saunders 1979 Richard H. Saunders, "John Smibert (1688–1751): Anglo-American Portrait Painter." Ph.D. diss., Yale University.

Saunders 1984 Richard H. Saunders, "John Smibert's Italian Sojourn—Once Again." *Art Bulletin*, vol. 66, pp. 312–315.

Saunders 1989 Richard H. Saunders, "A 'Smibert' Portrait Reattributed to Thomas Gibson." *American Art Journal*, vol. 21, no. 4, pp. 66–75.

Saunders and Miles 1987 Richard H. Saunders and Ellen G. Miles, *American Colonial Portraits: 1700–1776*. Washington, D.C.

Scottish National Portrait Gallery 1956 Scottish National Portrait Gallery, *Scottish Groups and Conversation Pieces*. Edinburgh.

Scottish Record Office 1972 Scottish Record Office, National Register of Archives, Source Lists: Art and Architecture. Edinburgh.

SCS4 New England Historic Genealogical Society, Boston, Scots Charitable Society Records, Minutes of the Society 1657–1738/9, vol. 4.

SCS5 New England Historic Genealogical Society, Boston, Scots Charitable Society Records, Entry Book, 1744–1774.

Sedgwick 1970 Romney Sedgwick, *The House of Commons, 1715–1754: The History of Parliament*. 2 vols. New York.

Sellers 1957 Charles Coleman Sellers, "Mezzotint Prototypes of Colonial Portraiture: A Survey Based on the Research of Waldron Phoenix Belknap, Jr." *Art Quarterly*, vol. 20, no. 4, pp. 407–468.

Sells 1964 Arthur Lytton Sells, *The Paradise of Travellers: The Italian Influence on Englishmen in the Seventeenth Century*. Bloomington.

Shirley 1912 *Correspondence of William Shirley, Governor of Massachusetts and Military Commander in America, 1731–1760*. Edited by Charles Henry Lincoln under

the auspices of the National Society of the Colonial Dames of America. 2 vols. New York.

Sibley and Shipton, 1873–1956 John Langdon Sibley and Clifford K. Shipton, *Biographical Sketches of Graduates of Harvard University, in Cambridge, Massachusetts.* 19 vols. Cambridge, Mass.

Simon 1987 Robin Simon, *The Portrait in Britain and America: With a Biographical Dictionary of Portrait Painters 1680–1914.* Boston.

Sizer 1952 Theodore Sizer, review of *John Smibert, Painter,* by Henry Wilder Foote. *Art Bulletin,* vol. 34, no. 1, pp. 69–70.

Sizer 1953 Theodore Sizer, ed., *The Autobiography of Colonel John Trumbull, Patriot-Artist, 1756–1843.* New Haven.

Sizer 1967 Theodore Sizer, *The Works of Colonel John Trumbull.* New Haven.

Skinner 1966 Basil Skinner, *Scots in Italy in the Eighteenth Century.* Edinburgh.

Smibert 1969 *The Notebook of John Smibert.* With Essays by Sir David Evans, John Kerslake, and Andrew Oliver, and with notes relating to Smibert's American portraits by Andrew Oliver. Boston.

Smith 1884 John Chaloner Smith, *British Mezzotint Portraits; Being a Descriptive Catalogue of These Engravings from the Introduction of the Art to the Early Part of the Present Century. . . .* 4 vols. London.

Smybert 1855 "John Smybert," *The Crayon,* vol. 2, pp. 113–114.

Snow 1828 Caleb H. Snow, *History of Boston, the Metropolis of Massachusetts, from Its Origin to the Present Period; with Some Account of the Environs.* Boston.

Society of Antiquaries 1798 London Society of Antiquaries, *A List of the Members of the Society of Antiquaries of London, from Their Revival in 1717 to June 19, 1796.* London.

Speck 1977 William Arthur Speck, *Stability and Strife: England, 1714–1760.* Cambridge.

Stauffer 1907 David McNeely Stauffer, *American Engravers upon Copper and Steel.* 2 vols. New York.

Stevenson 1954 Robert Louis Stevenson, *Edinburgh; Picturesque Notes.* London.

Stewart 1968 J. Douglas Stewart, "Sir Godfrey Kneller and the Evolution of the English Baroque Portrait." Ph.D. diss., University of London.

Stewart 1971 J. Douglas Stewart, *Sir Godfrey Kneller: Catalogue of an Exhibition at the National Portrait Gallery.* London.

Stewart 1983 J. Douglas Stewart. *Sir Godfrey Kneller and the English Baroque Portrait.* Oxford.

Stoye 1952 John Walter Stoye, *English Travellers Abroad, 1604–1667: Their Influence in English Society and Politics.* London.

Strange 1855 *Memoires of Robert Strange.* Edited by J. Denniston. 2 vols. London.

Stuart Papers 1902–1903 Historical Manuscript Commission, *Calendar of Stuart Papers Belonging to His Majesty the King, Preserved at Windsor Castle. . . .* 7 vols. London.

Sturgess 1949 Herbert Arthur Charlie Sturgess, *Register of Admissions to the Honourable Society of the Middle Temple.* 3 vols. London.

Survey of London 1900 *London County Council Survey of London.* Edited by J. R. Howard. London.

Talley 1981 Mansfield Kirby Talley, Jr., *Portrait Painting in England: Studies in the Technical Literature before 1700.* London.

Taylor 1938 Henrietta Taylor, ed., *The Jacobite Court at Rome in 1719.* Edinburgh.

Tuckerman 1867 Henry T. Tuckerman, *Book of the Artists: American Artist Life, comprising biographical and critical Sketches of American Artists: preceded by an historical account of the rise and progress of art in America.* New York.

Turell 1749 Ebenezer Turell, *The Life and Character of the Reverend Benjamin Colman, D.D., late pastor of a church in Boston New-England, who deceased August 29th, 1747.* Boston.

Updike 1907 Wilkins Updike, *History of the Episcopal Church in Narragansett, Rhode Island, Including a History of Other Episcopal Churches in the State.* 2d ed. Boston.

Vertue 1930–1955 George Vertue, *Notebooks.* 7 vols. Walpole Society, Oxford. Vol. 18, 1930 (Notebook I). Vol. 20, 1932 (Notebook II). Vol. 22, 1934 (Notebook III). Vol. 24, 1936 (Notebook IV). Vol. 26, 1938 (Notebook V). Vol. 29, 1942 (Index). Vol. 30, 1950 (Notebook VI).

Walpole 1826–1828 Horace Walpole, *Anecdotes of Painting in England: With Some account of the principal artists; and incidental notes on other arts; collected by the late George Vertue. . . .* Vol. 2 (1771, released 1780). New edition, edited by James Dallaway. London. Reprint. 1969.

Wanley 1966 Humfrey Wanley, *The Diary of Humfrey Wanley, 1715–1726.* Edited by C. E. Wright and Ruth C. Wright. 2 vols. London

Warden 1970 Gerard B. Warden, *Boston, 1689–1776.* Boston.

Warren 1975 David B. Warren, *Bayou Bend: American Furniture, Paintings and Silver from the Bayou Bend Collection.* Houston.

Waterhouse 1953 Ellis K. Waterhouse, *Painting in Britain, 1530–1790.* London. 3d ed., Baltimore, 1969.

Waterhouse 1979 Ellis K. Waterhouse, "Florentine Painting in the Seventeenth Century." *Apollo,* n.s., vol. 109, pp. 32–37.

Waterhouse 1981 Ellis K. Waterhouse, *The Dictionary of British Eighteenth Century Painters in Oils and Crayons.* Woodbridge, Suffolk.

Watkins 1917 Walter K. Watkins, "The New England Museum and the Home of the Art in Boston." *Bostonian Society Publications,* 2d ser., vol. 2, pp. 101–130.

Watson 1923 Charles B. Boog Watson, "Notes on the

Closes and Wynds of Old Edinburgh." *Book of the Old Edinburgh Club*, vol. 12, pp. 1–156.

Watson 1929a Charles B. Boog Watson, ed., *Register of Edinburgh Apprentices*. Scottish Record Society. Edinburgh.

Watson 1929b Charles B. Boog Watson, ed., *Roll of Edinburgh Burgesses and Guild-Brethren, 1406–1700*. Scottish Record Society. Edinburgh.

Watson 1930 Charles B. Boog Watson, ed., *Roll of Edinburgh Burgesses and Guild-Brethren, 1701–1760*. Scottish Record Society. Edinburgh.

Webber 1969 Ronald Webber, *Covent Garden, Mud-Salad Market*. London.

Wharncliffe 1887 James Archibald Stuart-Wortley-MacKenzie Wharncliffe, 1st baron, ed., *The Letters and Works of Lady Mary Wortley Montagu*. London.

Whinney and Millar 1957 Margaret Whinney and Oliver Millar, *English Art, 1625–1714*. Oxford.

Whitley 1928 William T. Whitley, *Artists and Their Friends in England, 1700–1799*. 2 vols. New York. Reprint.

Whitman 1842 Zechariah Whitman, *The history of the Ancient and honorable artillery company from its formation in 1637. . . .* Boston.

Williams 1956 Ralph M. Williams, *Poet, Painter, and Parson: The Life of John Dyer*. New York.

Wilson 1808–1814 Walter Wilson, *History and Antiquities of Dissenting Churches and Meeting Houses in London, Westminster and Southwark*. 4 vols. London.

Wilson 1891 Sir Daniel Wilson, *Memorials of Edinburgh in the Olden Time*. 2 vols. Edinburgh.

Wilson 1984 Michael I. Wilson, *William Kent: Architect, Designer, Painter, Gardener, 1685–1748*. London and Boston.

Winsor 1880–1881 Justin Winsor, *The Memorial History of Boston including Suffolk County, Massachusetts, 1630–1880*. Boston.

Wood 1951 Marguerite Wood, ed., *Edinburgh Poll Tax Returns for 1694*. Edinburgh.

Wood and Armet 1954 Marguerite Wood and Helen Armet, *Extracts from the Records of the Burgh of Edinburgh, 1681 to 1689*. Edinburgh.

Index